THE AWKWARD EMBRACE

THE
AWKWARD
EMBRACE

The Creative Artist and
the Institution in America

AN INQUIRY BASED ON INTERVIEWS WITH NINE MEN
WHO HAVE—THROUGH THEIR ORGANIZATIONS—
WORKED TO INFLUENCE AMERICAN CULTURE

B Y

Joan Simpson Burns

ALFRED · A · KNOPF
New York 1975

THIS IS A BORZOI BOOK
PUBLISHED BY ALFRED A. KNOPF, INC.

Since this page cannot legibly accommodate all acknowledgments, they appear on page 512.

Library of Congress Cataloging in Publication Data
Burns, Joan Simpson.
 The awkward embrace.
 Bibliography: p.
 Includes index.
 1. Arts and society—United States. 2. Arts, Modern—20th century—United States. I. Title.
NX180.S6B87 1975 301.2 74–21303
ISBN 0–394–49563–2

Manufactured in the United States of America
First Edition

For Jim,
who makes all things possible

THE MEN	THEIR ORGANIZATIONS*
Turner Catledge	*The New York Times*
Hedley Donovan	Time Incorporated
Lloyd Goodrich	Whitney Museum of American Art
William Jovanovich	Harcourt, Brace & World
Goddard Lieberson	Columbia Records
W. McNeil Lowry	Ford Foundation
Harry Huntt Ransom	University of Texas System
Frank Stanton	Columbia Broadcasting System
Frank Thompson, Jr.	United States Congress, House of Representatives

*When interviewed.

"... established institutions set most of the ground rules for both stability and change in contemporary America."
— Christopher Jencks and David Riesman,
The Academic Revolution

"The mere suggestion that [the artist] can be profitably directed . . . causes his hackles to rise."
— Joseph Wood Krutch,
Creative America

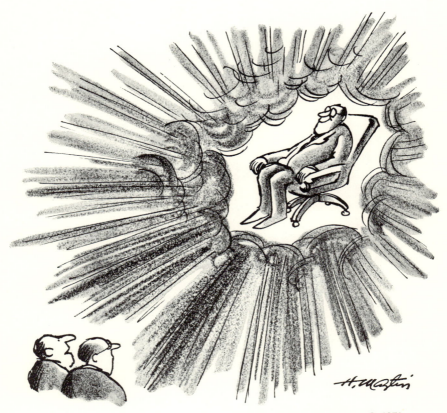

"*In 1948, he was made vice-president and treasurer. Then, in 1953, he was promoted to president and director. In 1960, he was named chairman of the board, and then, last Friday, in an unprecedented move, he was apotheosized.*"

CONTENTS

W. McNEIL LOWRY:

I've always had some doubts as to the wisdom of the Foundation's having its own real estate in New York, but, I think, when you consider the large sum of money in rental and maintenance over the years and look at this building—I do not think that this is one of those office buildings that will be torn down in twenty years. So I think there's no real problem in justifying it. I think that it does make a statement about this area of New York and architecture.

❊ ❊ ❊

I have, as you've gathered, a kind of a Spartan—I won't say self-denying—kind of attitude about philanthropy, but I don't like to sit in a plush environment and talk to an artist or somebody wanting to make a study or whatever about a small sum of money, you know. That's a psychological bit, I guess. But I don't feel apologetic about being in this building—because of the aesthetic contribution that Roche has made. Oh no, I don't feel apologetic about being in here.

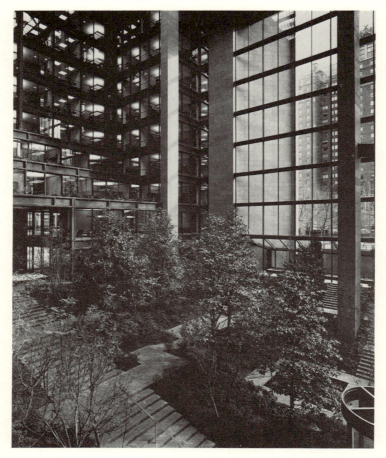

The New York Times *on November 12, 1969, called this building a "corporate Crystal Palace" and said, "Architect Kevin Roche is considered one of the country's best. He is the successor to the late Eero Saarinen, with whom he worked on New York's CBS building, and he is responsible for the provocative and much-admired Ford Foundation headquarters."*

TENANTS OF THE HOUSE

THIS BOOK CONSIDERS what the editor-in-chief of *Time* magazine, Hedley Donovan, calls "the balance between the rights—or possibilities—of the individual, and the necessities—or claims—of organized society." This is the Awkward Embrace in which we are all engaged, but I have contrasted artists as a group and particular managers as two extremes in any discussion of individualism versus institutionalism, since artists are radical beyond any political activism, to my way of thinking.

Obviously, there are gradations of dissent: this book is also about the possibility of transcending groups, as well as an attempt to discover what characteristics enable people to fit into them. It was written to find answers by describing actions to suggest how our culture has been shaped—most specifically in the 1960's, a decade when social rather than economic issues predominated and the arts received more attention and support in America than they had at any other time in its history.

Which elements in our culture should participants accept and which should they fight against? Irving Howe believed that the decade was marked by "a radicalism without immediate political ends but oriented toward criticism of a meretricious culture."[1] But, in retrospect, was that in fact what our culture was? So diverse, with so many methods of dissemination new enough to seem excitingly like ends in themselves, it appeared fragmented. And the nine men considered in this book—this new and not so new class of managers—this "Establishment" as some saw them—were men with a superior grasp on those fragments, at the particular angles from which they came to them. But indeed that grasp itself was what appeared

"meretricious"—a bond resulting less from interlocking growth, living and valuable, as from the smooth gluing together of dead objects into something rather like a "found" collage.

Notions of an everyday ideal had to change if for no other reason than that more was available. But the more that was available was not easily—and certainly not immediately—translatable into an improvement in quality. A process adequate to handle, much less select or encourage the best from, so much of substance was hard to develop. Leonard B. Meyer defined culture as a "learned probability system."[2] Increasingly, emphasis came to be put on, merely, handling techniques. The computer had been hailed as solving all our problems and attacked as dehumanizing. By the end of the decade, electronics had come to seem certain to provide more adequate ways of handling vast amounts of material but less and less likely to provide answers to human problems.

Any kind of change had come to appear desirable, and this attitude was not confined to the radicalized. In the arts, the emphasis on anything that was different seemed a fad likely to continue but only until economic problems became urgent. The arts exist in a setting where they must compete for aid and attention, and the unusual amount of both they received during the sixties was at least partially due to an unusual set of circumstances: the general affluence prevailing in America—the culture boom having been caused by the availability of products (whatever their caliber) and of money—and the presidency and subsequent death of John Fitzgerald Kennedy.

Too, the arts were able to compete successfully, said Adolf Berle, because of a changed property system in the United States. He spoke of the

> . . . emergence of the American state partly as an administrator of wealth distribution, partly as a direct distributor of certain products. In notable areas production for use rather than production for profit is emerging as the norm. Education, scientific research and development, the arts, and a variety of services ranging from roads and low-income housing to non-profit recreation and television constitute a few illustrative fields. . . . Increasingly it is clear that these noncommercial functions are, among other things, essential to the continued life, stability and growth of the non-statist corporate enterprise.[3]

That is to say, the corporate system itself must become a patron if the system is to survive, with the "control" developing into "a purely neutral technocracy, balancing a variety of claims by various groups in the community and assigning to each a portion of the income stream on the basis of public policy rather than private cupidity."[4]

In anthropological terms, the production of basic goods and services is a maintenance (or survival) system: art, religion, magic, music, etc., are

projective systems which develop subsequently and are more or less empha-
sized in different cultures. Now, in our affluent society, the two were in-
creasingly intertwined. Any services not needed or sponsored by the
industrial system tend to be slighted, said John K. Galbraith.[5] In the past
this included art, or what might be called "the aesthetic dimension of life,"
but increasingly the arts had a new place as part of the economy.

All organizations have their own "technostructure," which was defined
by Galbraith as embracing "all who bring specialized knowledge, talent, or
experience to group decision-making."[6] A bureaucracy of institutions having
to do with the dissemination of cultural objects has been growing: the
handling of information, aesthetic and other, not only technologically but
institutionally, is the warp of this book. The fields discussed herein—tele-
vision, book publishing, magazines and newspaper publishing, museums,
universities, foundations, recording—are all, in effect, communications
media, and educative. The political area has been included as a special case,
as setting up or dealing with such. A gigantic middle structure has been
created, formed of organizations that mediate between artist and audience
but that have their own special characteristics. These middlemen include
such groups as the Associated Councils of the Arts, the National Endow-
ment for the Arts, and the Ford Foundation no less than business corpora-
tions like Time Inc. and the Columbia Broadcasting System.

Former Federal Communications Commissioner Nicholas Johnson has
insisted that "the broadcasting establishment" is "without question the
single most economically and politically powerful industry in our nation's
history."[7] A sociologist[8] considered "mass cultural communications" such a
basic industry that "only the blind cannot see that whoever controls the
cultural apparatus . . . also controls the destiny of the United States and
everything in it." But the "cultural apparatus" consists not only of television
networks: it is the whole educative process, socializing on the one hand and
transmitting culture on the other. And that process no single person or
group of people can control completely, as witness modern Russia. By con-
trast, even in its imperfect state, the United States is a free society. If that
idea about control of the "cultural apparatus" were strictly true (rather
than containing an element of truth, as does the notion of an all-powerful
business community), then Frank Stanton and Hedley Donovan, in that
order, would have emerged as the most powerful single persons in the
United States by virtue of the positions they held at the Columbia Broad-
casting System and Time Inc., respectively. Yet, obviously they were not
and are not: that their power is limited seems to me self-evident, but I
hope to show it as so in what follows and to suggest answers to the ques-
tion of who is in control.

What is it that entitles a person to decide what the quality of someone

else's life will be? As I saw people while working on this book, I was told repeatedly that I would have to justify my choices, that there are many men in the United States as capable and as articulate and as influential as those I selected. However, my criteria limited my choice. Someone had suggested that I write about a square mile of the Establishment on New York's upper East Side, comparable to Washington's "square mile" of political power. But I did not have the training to do an area study, and, besides, I was more interested in the single individual than in groups. So I set out to select nine men at the top of their fields, all generally having to do with culture as defined herein. These were my criteria: first, that each had to have made a significant contribution, in the opinion of his peers, in his particular area;* second, that each, during his working life, had to have been associated primarily with a particular organization; third, that each at the time of our interviews had to be still actively engaged. My fourth criterion was perhaps the most important: none of the nine men was to have been helped along by wealth or social position on the part of his family.

Seven of the nine men have made their efforts in New York—a city frequently described as the most aggressive in the world but also, more importantly as far as this book is concerned, as the cultural center of America. Not Harry Huntt Ransom, however, a Texan who became chancellor of the University of Texas System. Nor Frank Thompson, Jr., congressman from New Jersey.

Thompson was born and raised in Trenton, and in fact none of the nine men was born in New York. William Iliya Jovanovich, the son of a coal miner, was born in (Sunnyside) Louisville, Colorado, in 1920. He headed the publishing firm of Harcourt, Brace & World (as it was then called). The Ford Foundation, Time Inc., and the Columbia Broadcasting System are represented in these pages by three men who also came from the Midwest. W. McNeil Lowry was born in Columbus, a little town near the Missouri and Oklahoma borders in the southeastern corner of Kansas, on February 17, 1913; Hedley Donovan was born in Brainerd, Minnesota, in 1914; and Frank Stanton was born in Muskegon, Michigan, in 1908.

All of my principals have considerable reputations in their own fields—and some, outside—but three in particular I chose not only for that reason but also because they were connected with organizations that provided useful entry points into my subject. Turner Catledge, a small-town Southerner from Philadelphia, Mississippi, was at the time that I saw him the executive editor of *The New York Times*. Lloyd Goodrich, director of the Whitney Museum of American Art, was included for reasons which I hope will be apparent in the sections concerning him. He was the oldest of my

* I am sorry to say that no women were recommended, although I queried some, and the consensus shown on the men selected was remarkable.

subjects, having been born in Nutley, New Jersey, in 1897. Goddard Lieberson was born in England. He was the president of Columbia Records, as it was called at the time of my interviews with him.

I intend to consider all of these men from what C. H. Waddington called a "biological point of view"—that is, regarding living organisms (in this case named Lowry, Donovan, Stanton, Jovanovich, Lieberson, Catledge, Ransom, Goodrich, and Thompson) as "nodal" points in an extremely complex network of "interactions, relations, transactions."[9] These nodal points are the centers that keep off anarchy. But Waddington goes on to add that the organisms remain fully alive only "in so far as this network is respected"—that social structure which permits such personal entities to survive. Here, our culture is that network.[10]

Sir Isaiah Berlin, in *The Hedgehog and the Fox*, wrote:

> . . . the sum of the actual experience of actual men and women in their relation to one another and to an actual, three-dimensional, empirically experienced, physical environment—this alone contained the truth, the material out of which genuine answers—answers needing for their apprehension no special senses or faculties which normal human beings did not possess—might be constructed.[11]

So he believed Tolstoy felt.

If any single statement can adequately sum up the attitude with which I began this project, it is that. For surely, if something as irritatingly amorphous as "culture" really exists in the United States, one ought to be able to find its real connections with the lives of men. William Jovanovich points out that many contemporary critics share my feeling (although he does not) that information is usable (he calls it "safe"—that is, not processed, manipulated, or other-directed) only if it is verified by one's own sensibility. But also, that those same critics maintain "a steady attitude of dissent from contemporary society."[12] This attitude of dissent I do not share.

Some wit commented that when a writer doesn't know how to begin, he looks in the dictionary. All right: what does the word "culture" mean? Consider, for example, the position of the, at that time, newly formed Associated Councils of the Arts. During 1966–67, in the throes of defining its organizational role, members used the word in so many different ways that finally the staff suggested it be outlawed.

And in what way was Barnaby Keeney, head of the National Endowment for the Humanities and past president of Brown University, using the word when interviewed in Washington? He said: "University presidents aren't, generally speaking, the best people to talk about when you're talking about culture. They lead so complicated a life that culture is almost a hobby for them." By implication he meant a specific relationship with the

arts, because certainly universities and their presidents are very much a part of our culture.

W. McNeil Lowry of the Ford Foundation noted:

Everybody who is today talking about culture in the United States is talking about a component mixture of the creative and performing arts, the humanities, the aesthetics of our environment, the exposure of people to artistic and creative influences.

"However," he went on to say, "this doesn't allow me to talk to everybody, because I don't use the word that way."

Obviously that didn't keep him from talking to me although, like "everybody," I do. But I can't avoid also using "culture" as defined by Webster's Unabridged Dictionary:

The complex of distinctive attainments, beliefs, traditions, etc., constituting the background of a racial, religious, or social group.[13]

Or, as it is used by anthropologists, simply to mean a system of adaptation on the part of groups of people, the defining of a process.[14]

The poet T. S. Eliot, in his *Notes Towards the Definition of Culture*,[15] suggested that it includes all the characteristic activities and interests of a people. In a particular connection and in a way, one can even speak (and people do) of a "television culture." Frank Stanton would be unlikely to use such a phrase. Nevertheless, in his capacity as president of CBS, he had to regard entertainment, for example, as a characteristic interest on the part of a number of television watchers.

Those systems which comprise our culture become more visible when we examine specific organizations. And each individual institution interlocks in more or less obvious ways with other institutions. James Reston of *The New York Times* spoke of a triangle formed by the university-foundation life, the communications media, and the government. McNeil Lowry saw in that combination the seeds of the decay of higher education. When the Ford Foundation funded the Public Broadcast Laboratory, a collaboration was called for between television, foundation, university, and the public (or audience): that was a more complicated working setup than most. But there are unseen interconnections when institutions act according to their own purposes on ideas that are "in the air" at a particular time, the *Zeitgeist*.

Actions, undertaken by such as these men, constitute power. What each was and did had an effect greater than that of many more visible men. But their effects will remain in time only as expressed by future circumstances. The sculptor Theodore Roszak said, "It takes a long time for an artist to be understood." Managers may never have made any *thing* to be understood: they leave behind them no objects of the sort that artists make, though they

sometimes leave embodiments of a semi-permanent nature—such as the CBS building or the Alley Theatre building—that might not have existed in a particular form if they had not lived. And managers are relatively easily replaceable within their own organizations—even by lesser men, since the organic life of an institution is supportive.

How much does anyone choose of his particular role? If you wish, as reader you can try to decipher that from what I can tell you about the early lives of the people involved in this book. My impression is that people usually have more limited choices than they think they do and that it is just as well for them as adolescents not to know this: that we arrive at major turning points only once or twice in our lives and, while there, make crucial decisions blindly, not knowing what prices we will have to pay later on.[16]

Everyone quotes Robert Frost: "Two roads diverged in a wood, and I— / I took the one less traveled by, / And that has made all the difference."[17] But look at his life.[18] He was not notably successful in any occupation other than that of poet. While it is apparent that he managed his life badly, he managed the material of his life superbly. How, then, is it profitable to regard him as a failure rather than as a great poet?

Do people become artists because they fail to manipulate satisfactorily their environment, perhaps from very early on in their lives? Do people become culture managers or art promoters because they lack the talent necessary to become artists? Or is the answer simply that what is appropriate for one person may not be appropriate for another because personality differences are real and do exist by virtue of a coming together of complicated hereditary and environmental factors, unique in every person. Should we not celebrate differences? "Glory be to God for dappled things," sang another poet, ". . . all trades, their gear and tackle and trim./ All things counter, original, spare, strange . . ."[19]

So I have seen part of my job as discovering the particular abilities of each of these nine men. I have not attempted a scholarly work but have tried to present a feeling for our culture through personality. I have included myself not as Intellectual, since, for me, ideas are tools; not as Manager, since, for me, that turned out to be an insufficient role; but as Participant-Observer, in a highly personal modification of the role employed by the anthropologist.

The nine men contributed their time in the form of taped interviews which were unstructured except, somewhat, chronologically. Almost all of these were made in 1966–68. For the use of a recorder and for the transcription of tapes, I am greatly indebted to the Oral History Research Office at Columbia University. Innumerable others helped me in many ways, and I am grateful to them all. Quotations not otherwise attributed came from

interviews. Each man saw at least a portion of the completed manuscript so that he could check the accuracy of the quotes attributed to him. The context in which they appear is mine.

By my association with these nine I have been both privileged and educated. When Eric Goldman, at that time cultural adviser to President Lyndon Johnson, was asked what his interest would be in reading a book such as this, he commented that he would like to see what lies the nine men told. "I know what he means," McNeil Lowry said some time later: "They'll put certain constructions on controversial things where they were in conflict with other people or ideas." But that makes no difference because it is necessary to look at their stated points of view.

Lowry said that he was looking forward to settling down with his transcript and that it was like seeing a mirror reflection of himself. But here is Ozenfant: "All thanks to Daguerre; he revealed clearly that exact imitation, item for item, cannot reproduce nature, but that only EQUIVALENTS can. . . . To imitate something is merely to snuff it."[20]

I have set down to the best of my ability what truth I found and have tried to indicate *whose* truth I am talking about at any particular moment. Some deletions were made by me in the final manuscript but only where I felt they would not injure my book as a whole but would injure, disproportionately, the person involved.

I take it for granted that everyone is biased, no matter how impersonal his tone. So I have dropped the conventional pretense: I *want* the reader to know, when I make an observation or include particular material, just what my experience was during the eight years I worked in New York—at *Partisan Review* and the Readers' Subscription Book Club and Basic Books, at CBS, with the Associated Councils of the Arts, for Harcourt, Brace & World (some of those concurrently). Perhaps my observations are more accurate on that account than those of any "outsider" could be. Undoubtedly they are more biased. But I benefited by never becoming too much of an "insider."

In any event, my experiences got me thinking, and I wanted to learn more, to try to figure out the meaning of some of the things that happened. Certain of the assumptions and biases with which I began this work have changed, and I hope the same will be true of the assumptions and biases that most readers will bring to my book. The progression herein is intended to be suggestive, its logic not necessarily immediately apparent. I have tried to make a book which in itself is a metaphor—in the hope of enabling the reader to "penetrate the concrete shell of the world of things by combinations of objects that would have little in common but the underlying pattern."[21] My best hope is that the reader will find life in these pages and will consider himself rewarded, whatever his discomforts.

William Jovanovich once wrote, "A book that is created from a writer's passion, from his search for reality, is a rare thing and ought to be valuable because it is uncommon and unrepeatable."[22]

J.S.B.
High Mowing
Williamstown, Massachusetts
December 1971

POST-PREFACE

THE READER WILL NOTE that a considerable interval occurred between the date at the end of the preface, when the manuscript was effectively completed, and the book's publication. The book was delayed during this period while a series of prolonged legal negotiations took place after William Jovanovich, one of the nine men interviewed, refused the author use of portions of his interviews and attempted to prevent the inclusion of material based on what others had to say about him.

A settlement whereby I agreed to remove certain material while retaining the elements I felt necessary to the integrity of the book was finally achieved. The manuscript was then brought up to date in 1974.

I have to thank Maurice Greenbaum and Andrew Boose at Greenbaum, Wolff & Ernst; Anthony Schulte and Ashbel Green at Alfred A. Knopf, Inc., for their help and interest. I have most of all to thank my husband, without whose unwavering support through that trying period this manuscript would never have been published.

<div align="right">

J.S.B.

June 1975

</div>

PART I

"An old man in a dry month
Being read to by a boy"

PART I

"An old man in a dry month Being read to by a boy"

CHAPTER 1

PROVIDING THE THRUST

(The man is allowed by the organization to lead it)

I STILL REMEMBER my first glimpse of Frank Stanton. He was, after all, president of CBS, a company for which I had at that time only recently gone to work. He was constantly talked about inside the organization—and semi-derogatorily. He was a legend for never going home at night before he'd cleaned up his desk. Other broadcasters rarely saw him; and most Americans did not have the faintest idea who he was.

His reputation within the company included a passion for detail verging, so it was said, on the ludicrous: he was reputed to have supervised the design of the numbers on the clock faces in the new CBS building, for instance. But I gave him personal credit for getting me out of the black hole of Calcutta. I didn't think I could survive long where I had to spend my work week in a dark, soundproofed room with no windows and heavily draped walls. Although I had joined CBS as technically part of management, there simply was no more room in the old Columbia Records building on Seventh Avenue, and so I had been put in a studio, long unused for recording. I counted on having light and space and air at 51 West Fifty-second Street. I went over to look at the new building while it was still under construction, as soon as I'd seen the blueprints and what was to be my new office marked on them. Although the halls were still littered with boards and dust, three men came walking along as I was standing just inside the door. There was no doubt who was with whom. The shorter of the two in front, with sandy, reddish hair, briefly stared at me. I didn't know but suspected it was Stanton, touring his building.

Some two years later I was no longer an employee. I was asking a

3

great many people to suggest names for a book I had in mind, about how and why people were successful in corporations. The fact that it was already contracted for by a publisher was sufficient introduction in the minds of most. For instance, William Paley, chairman of the board of CBS, agreed to see me. I entered the elegant, ground-floor building lobby as if I had not previously been one of a number of faceless employees pouring in and out: the receptionist solicitously placed me in an elevator programmed not to stop until it had reached the top (this was how top management avoided the crowds). Paley's secretary led me through the mossy, carpeted hallways. "Cashmere," she told me proudly as she reached over and stroked the soft, pinkish walls. Paley's office—crammed with embroidered pillows, fine paintings, examples of craftsmanship—was the most sensuous I was to see while working on this book.

When I explained that I was looking not only for men of stature who had risen within the hierarchy of particular organizations but also those whose family backgrounds had included neither wealth nor social position, he said in that case Dr. Stanton certainly would be an appropriate choice. Then he seemed to lose some of his interest in this specific situation and set himself to talking generally.[1] He had been a colonel in the U.S. Army during World War II, deputy chief of the Psychological Warfare Division at Eisenhower's headquarters in Europe for the Allied Expeditionary Forces. Psychological services as well as mass media, he stressed, did not have the power to change people—"only perhaps reinforced what was already there." His conversation was as smooth as his appearance. Did he really see television as a weak medium?

A philosopher remarked that

> the most general sense which can be attached to the notion of power is that it marks the ability of one person or group of persons to influence the behavior of others, that is, to change the probabilities that others will respond in certain ways to specified stimuli.[2]

Taking that philosopher's remark as true, reinforcing—which would change the probabilities—constitutes considerable power. Reinforcement is the most common "attitude effect," said Joseph T. Klapper.[3] Ideally a parent reinforces the best qualities his children have and tries to starve those traits he considers undesirable. And a psychiatrist does not have as his aim "persuading" his patients. He too is attempting to change probabilities of behavior by reinforcing areas culturally considered most healthy.

In Stanton's notebooks, where I found mimeographed copies of his speeches some months later, the following statement occurred:

> Mass media are basically instruments of communication. In a democracy the powers of mass media in the fields of social ideas and political atti-

tudes are not persuasive but stimulative. They nourish the opinion-forming process.[4]

He spoke proudly of television's strength. But he was saying something similar to what Paley had said. The chairman had essentially been talking about maintenance, when he spoke of strengthening tendencies already present. As such he was positing a basic service. Stanton's terms, "stimulation" and "nourishment," act to create change but not in kind: "persuasion," ruled out by Stanton as well as by Paley, implied a change in kind. I had heard rumors that the two men did not get along well, but obviously they were in basic agreement.

At the time that I went to see Chairman Paley, CBS was an established success. In 1966 revenue and sales had totaled $814,534,000, on which CBS showed a profit of $169,118,000.[5] But some thirty-eight years earlier, when William Paley joined the company, it had been losing money.

In mid-1926, a violinist named Arthur Judson paid a visit to David Sarnoff[6] of the Radio Corporation of America. Judson was proposing to give up art for management: why not, he asked Sarnoff, a bureau that would for fees provide artists to broadcasters? Sarnoff, who was to become president of RCA in 1930, was even then something of a legend. Himself an immigrant from Russia at the age of nine, he had been brought up in the slums of New York's East Side, at first contributing to the support of his family and then becoming its mainstay. He had no formal education beyond elementary school and, after graduation, had gone from the distribution of newspapers to a job as messenger boy for a cable company. He practiced telegraphy at home and joined Marconi as an office boy in 1906. In 1912, at the age of twenty-one, he gained fame by relaying telegraphed news of the sinking of the *Titanic*. In 1919, he became commercial manager of the newly formed Radio Corporation of America, which was the old American Marconi Company transformed. Marconi employees in general had been retained, although major ownership and dominant control of the new corporation was vested in General Electric, and the American Telephone and Telegraph Company (AT&T) also became owner of a block of stock.[7]

In 1926, Sarnoff was in the process of organizing the National Broadcasting Company. Reputedly he told Judson that he would put him in charge of supplying artists and programming for the new chain. Although NBC, when it went on the air in November 1925, consisted of not one but two chains—a "red" and a "blue"—Judson was not hired. Upon being told that his services were not after all needed, he retorted in that case he would organize his own network. Sarnoff apparently saw this as no great threat, for, according to Judson, he roared with laughter and said, "You can't do it!" Sarnoff told Judson that even if he had stations, he would be unable to get lines.[8]

As a result of protracted negotiations, NBC had just contracted with AT&T for a web of wires. The background to this was very complicated, but basically what had happened was that in 1924 a dispute had flared up between AT&T and what was known as "the Radio Group"—GE, Westinghouse, and RCA. The Radio Group had an understanding among themselves, dating from 1923, that each would "operate three high-powered stations, jointly achieving almost national coverage and stimulating set sales from cost to coast."[9] However, AT&T refused their requests for the use of lines as links between stations, having itself taken up "toll broadcasting" in 1922 with spectacular results. The dispute was settled only in 1926, the pie was divided, and as a result AT&T stepped out of active broadcasting while NBC, the subsidiary of RCA, got the wires it needed.

Some forty years later, AT&T was still dominating a congested ground relay system while COMSAT (the Communications Satellite Corporation, a private organization chartered by Congress),[10] which handles international traffic, was pushing to establish a domestic satellite system to supplant AT&T as the prime carrier of television within this country. Stanton's recommendation in 1969 that the TV industry construct its own private satellite relay system rather than pay an increase in rates of $20 million a year to AT&T apparently touched off this dispute. AT&T's response revealed sheer corporate greed. An official described his company's position as being that

> the thousands of miles of cable and microwave facilities now leased on a wholesale basis to the television industry might be used on a retail basis for individual customers. The earnings potential [would be] possibly greater than the $65 million a year sought from relaying TV.[11]

AT&T, back in 1927, confirmed Sarnoff's prediction that the United Independent Broadcasters, as Judson called the new company organized in January of that year, would be unable to get lines—"for at least three years,"[12] they said. Judson had been joined by George A. Coats, "promoter par excellence," and J. Andrew White, a sportscaster. Coats speedily got twelve stations to contract, including WOR, which was to be their point of origination in New York. He then headed for Washington to put pressure on the Interstate Commerce Commission, which had jurisdiction over telephone matters and therefore over AT&T.

"Each station was guaranteed $500 a week for ten hours of its broadcast time. The venture was thus committed to an outlay of $6,000 per week before it had a hint of a sponsor."[13] According to broadcasting historian Erik Barnouw, "the Judson-Coats network venture had aspects of a Horatio Alger tale. At desperate moments a mysterious rich person would turn up."[14] Mrs. Christian Holmes—also a good friend of the New York Phil-

harmonic orchestra—put up $6,000 for travel expenses for Coats's trip to Washington and very quickly ran her investment up to $29,500.[15]

Judson and associates did not want to run a network: from the first they had only wanted to supply talent and programs. Adolph Zukor of Paramount Pictures expressed interest in taking over. So did Bernarr Mac-fadden. The Victor Talking Machine Company was interested. But early in 1927 two things happened: RCA acquired the common stock of the Victor Talking Machine Company from a banking syndicate;[16] and the Columbia Phonograph Record Company bought what was later to become CBS. It provided $163,000 in funds to Judson and his associates. The new company, the Columbia Phonograph Broadcasting System, contracted with the Judson Radio Program Corporation to supply talent, with the understanding that it could resell the programming to sponsors.[17]

At that point most of the independents were not selling time, and of the 732 broadcasting stations in the United States, less than a hundred were network-affiliated. By September of that year, CPBS had only sixteen stations. Their plan was to program the ten hours in two-hour periods on four evenings each week, plus two hours on Sunday afternoon. On September 18, 1927, the network opened with a broadcast of the Deems Taylor–Edna St. Vincent Millay opera, *The King's Henchman*, with Metropolitan Opera artists. But they soon found themselves unable to meet their payroll and owing $40,000 worth of line charges to AT&T. The Columbia Phonograph Record Company declined to make further investments. Judson wired Mrs. Christian Holmes, and her office sent a check for $45,000. But the record company was pulling out.

New backers made an initial payment of $135,000 for the network—Isaac and Leon Levy of an affiliated Philadelphia radio station and a subway builder named Jerome H. Louchheim, also of Philadelphia. Louchheim feared he was buying the controlling interest in a bottomless pit, and indeed under a new name, the Columbia Broadcasting System, the deficits continued. Louchheim wanted Leon Levy to go to New York and assume the presidency, but Levy was reluctant. He suggested another Philadelphian, William S. Paley, the son of a Russian immigrant. Paley had successfully tried some radio advertising for his family's cigar business. He was then twenty-six and restless: he was also ambitious and, as Barnouw says, looking for something suitable.

How suitable this new opportunity was became quickly apparent when, in a few years under Paley's leadership, CBS began to outstrip NBC. By 1931,

> CBS had 408 employees, featured 415 special events, carried 97 international programs from 19 points of origin, and broadcast 19 appear-

ances by the President, 24 by Cabinet members, and 65 by U.S. Senators and Representatives. And it made a net profit of $2,346,766.[18]

In contrast, Sarnoff's NBC by 1931 had

> 1359 employees, exclusive of talent. That year, according to statistics supplied to the Federal Radio Commission, the NBC networks featured 256 special events, carried 159 incoming international programs from 34 points of origin, broadcast 28 appearances by the President, 37 by Cabinet members, and 71 by U.S. Senators and Representatives. It also made a net profit of $2,325,229.[19]

CBS could sell time to national sponsors on a network of 79 stations coast to coast, without consulting those stations in advance. Station purchases had been arranged under Paley, but the hookup consisted primarily of affiliates under contracts described as brilliant business coups, worked out by "wheeler-dealer Sam Pickard, who stepped straight from the Federal Radio Commission into a CBS vice presidency."[20] Paley had brought an end to the beginning.

He had, though, come into an already set situation. The American system of broadcasting by that time consisted—and still consists in spite of tremendous changes—of government allocation of channels which are controlled privately, although regulated by a public commission, and are operated for the most part on funds provided by the sale of air time. Broadcasting was not regarded as a public utility.

By the time I saw Stanton at a CBS stockholders' meeting in 1967, he had replaced Paley as president some years earlier. The two men sat up on stage with a number of other officers of the corporation. I watched from the back of the auditorium. William Paley was genial; Frank Stanton sat near him, alert but lacking color in his manner; the other officials seemed bored.

Later on, I was to attend a stockholders' meeting of Harcourt, Brace & World and be struck by the way in which the manner of William Jovanovich, its president, resembled that of William Paley on this occasion, in the smoothness of a perfunctory performance. One of the devices for securing consent is to take it for granted that everyone is in agreement, but more important, the manners of both Paley and Jovanovich were a perfect blend of deference toward the stockholders and awareness of their own power. (Willie Morris speaks of "the guarded instincts of superior professionals.")[21]

Paley was queried by a woman who insisted on reading a statement. He turned to his aides for answers and handled each question for the most part seriously although sometimes, seemingly, rather lamely. It was evident

that he and the woman had two different frames of reference. She as a stockholder was alarmed by the prospect of CBS buying a company—the publishing house of Holt, Rinehart & Winston—that had a lawsuit against it unsettled. Her attitude was that of someone who thought there was such a thing as total predictability or protection. His attitude was that he had consulted his experts and understood the situation well enough to know how unlikely that lawsuit was to turn into something important. Adolf Berle, in his description of the modern corporation, wrote:

> As the number of stockholders increases, the capacity of each to express opinions is extremely limited. No one is bound to take notice of them, though they may have quasi-political importance, similar to that of constituents who write letters to their congressmen.[22]

Paley permitted what he may have thought of as a crackpot woman to have her say and treated her with politeness—no doubt used to such interruptions year after year on such occasions.

The degree of a stockholder's power depends upon the available sanctions (as, indeed, does that of a parent or a voter). It is possible, though difficult, wrote Berle,

> to bring a stockholders' action against the corporation and its management, demanding that the corporation be made whole from any damage it may have suffered in case of theft, fraud, or wrongdoing by directors or administrators. Such actions are common, though few stockholders are involved in them. They are a useful deterrent to dishonesty and disloyalty on the part of the management.[23]

Although the broadcasting industry is regulated by a government agency, nowadays the Federal Communications Commission, stockholders are also protected by "an entire battery of legislation set up by the Securities and Exchange Acts," which, however, has "essentially little to do with the conduct of [a] corporation's affairs beyond requiring regular publication of information considered accurate by accounting standards, and prohibiting speculative activities by corporate administrators."[24] Unless she owned a controlling interest in the corporation, as for instance did the Ochs-Sulzberger family in *The New York Times*, that stockholder's objections could make little difference. Agreement on deals is reached by management before such meetings and the stockholders' vote is, usually, only a formality. Some economists have come to believe that, given the myth of shareholder control, corporate power ought to be curbed not only through anti-trust actions, which are unreliable, but also through nationalization of such business corporations as Lockheed and ITT, the existence of which may be regarded as justifiable only insofar as they serve public purposes—and that,

as a minimum, the secrecy allowed such corporations ought to be done away with.

William Paley permitted a certain period; then he announced what was going to happen—we were going to watch a Cronkite newscast while the ballots were being counted—and went on in spite of another interruption. Stanton sat silently through it all.

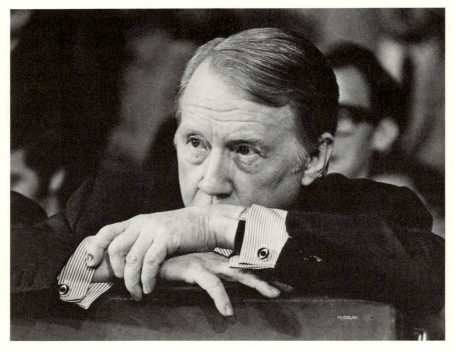

Dr. Stanton, one of this country's "leading communicators," keeps his mouth almost shut as he talks and completely shut when he does not. (He wears the CBS-eye colophon on his cuff links.)

WHILE PALEY was establishing CBS, Frank Stanton was a student at Ohio University. In 1932, in graduate school he became interested, as he put it, in "the whole question of comprehension and flow of information as between the eye and the ear," and he wrote to both CBS and NBC, checking to see whether they had done any experimental work in this area. "CBS responded promptly," Stanton said, "and with a lot of questions of its own, saying they were interested in finding out whether a commercial should be done one way or another, etc., and NBC gave me a very polite, beautifully typed letter that said absolutely nothing.

"I took some very simple material," he continued,

and set it out in type and then had it recorded. Then I exposed it, either visually or orally, to groups of students for whom I had a great deal of test information, in terms of their general intelligence scores, etc., and then made experiments by testing after the exposure to find out whether they had gotten the salient points of the message one way versus the other.

When Stanton spoke of visual reception, he did not mean television, which at that time was virtually unknown. A patent application had been filed on December 29, 1923, for a "practical but crude, partly electronic television system,"[25] and in 1927 Adolph Ochs, publisher of *The New York Times,* saw a TV scanner at the Bell laboratories.[26] The first television drama was broadcast in 1928, but television's major development was not to occur until after World War II. In 1932, Stanton was dealing with the printed word. Early in his career he found aural presentation most effective; later on, he found television even more so—leading to the comment that he could find proof of the superiority of whatever he happened to be engaged in.

Stanton went on to say of his paper that it "did not constitute anything by way of my thesis or any paperwork on my Master's program, but I did it as a part-time or side project. . . . It was later published in one of the psychological journals." This was not, however, his first piece of research into radio. During his senior year, Stanton had taken on someone to do his legwork when, for a course in the business school, he volunteered a survey paper on the economics of advertising on the radio and on the growth of radio stations.

Where did he obtain his information?

"Just got on the typewriter," he said, "and wrote everybody that I could. I got all the trade papers and got a lot of information and started collating it and pulling it together, that's all there was to it. I hired a girl, a sophomore—I had a lot of material that I wanted to include, a lot of appendices that I wanted to type, and I started her typing things I knew I wanted to put in the back of the report, and things sort of snowballed. I wanted to get the thing out, so I paid her to do a lot of reading for me and pulling stuff out, and she typed the whole report, and I guess that's the first time I had ever used anyone to do the legwork for me on an article. Dottie Pierce was her name."

"The world of scholarship puts a premium on the lone, personal effort," wrote Fred Hechinger, "and therefore is exposed to loneliness."[27] Around 1970—perhaps their extent a sign of the times—profitable businesses had sprung up, selling research papers to students: a business abhorred by their professors. But this was not new. Turner Catledge used

to "write themes for boys for a dollar apiece" while in college. Stanton's scholarship very quickly emphasized the kind of communal activity that was to become increasingly common, but only as an adjunct to the university proper. One of the most important reasons why survey research did not develop inside academe, said Peter H. Rossi, is the organizational setup of academic departments:

> Essentially, an academic department is a collection of scholars whose work is only minimally integrated in a division of labor sense. . . . Departments do not engage in common scholarly enterprises in which a research task is broken down into components, each member of a department taking one component as his contribution.
>
> Large scale survey research in the universities is conducted by institutes and centers whose organization principles involve a hierarchy of command and a distinct division of labor. . . . The director's role is more critical to the proper functioning of a research center than a chairman's role is to the prosperity of a department.[28]

Paul Lazarsfeld, professor of sociology and director of the Bureau of Applied Social Research at Columbia University, spoke of how well known the main features of the research bureau had become. "There is a division of labor in the essential work: writing and pre-testing questionnaires, analyzing tables, and drafting reports."[29] But he did not point out, as did Rossi, the degree to which individual freedom is lost in such a setup. Institute personnel have little freedom to control their own activities. They live in an interdependent microcosm—as in fact do even the presidents of organizations—but researchers are not scholars under such circumstances, although:

> When a social research center is working well, it is indeed an exciting locale for one's work. One can feel the excitement in the snatches of conversation at lunch or in the visits made by colleagues to each other's offices.[30]

This same excitement is of course frequently present during the production of a television show. It too is a cooperative venture, the work of each member vital to the work of the others: but in both cases, the thrust is provided by the director. "Coordinating and guiding this [the survey center's] work is an administrative as well as an intellectual challenge," said Lazarsfeld, who loved it. He thought that a bureau director was "probably a new kind of professional for whom recently the name 'managerial scholar' has been created,"[31] but it was only the context that was new.

To Lloyd Goodrich, director of the Whitney Museum of American Art, research was something that was conducted independently and primarily by the person who intended to use the material. He understood the necessity of loneliness, but then he had started out to become an artist. Although he enjoyed the idea of administrative leadership, he never lost the notion that "as in everything, it has to be one man who does it." When offered the job of "research curator" at the Whitney around 1935, he thought the title ridiculous. Mrs. Whitney's principal assistant, Mrs. Force, apparently thought the title of Assistant Director would be a problem so far as other members of the staff were concerned, but he suspected her motives. "Maybe it was just her strange desire not to share the throne," Goodrich said. "That's a mean thing to say, but it's true."[32] Nevertheless, he accepted the job and for six or seven years "got up" exhibits in the historical field, retaining that title until 1947 when he became an associate curator. The museum as an institution, and indeed Mrs. Force as a personality, helped Goodrich crystallize his own identity. CBS did not serve that function for Stanton.

Publication of his audio-visual paper had brought Stanton to the attention of CBS:

> When it was published, CBS was interested in getting the reprints of it and so forth. I felt then, as I have many times since, that there's a lot of very sloppy interview work going on in the whole measurement field. I made a device to record the mechanical movement of the dial, so that I would know what had been turned[33]—whether somebody was listening to it was another question. I proposed to put this device on a sampling of receivers in homes. I wrote to CBS and I wrote to NBC about it, and I wrote to a number of people in the industry, and again I got a very good response from CBS—the kind of a letter that would thrill any student.
>
> My thesis was a critique of the then current methods for measuring listening behavior, and a new plan. Of course now there are all kinds of devices for doing this, and there are systems, national services, that depend on this basic approach: a mechanical device that will record what channel or what station is tuned in.
>
> So the technique has survived, and it was from that—I would say about a year before I finished my work at Ohio State—CBS asked me to come over and wanted to take a look at what I was doing, because there were implications in it for the research they were doing. Customers were buying on the basis of less than adequate information, and of course if CBS could give the advertiser better information, it put CBS one notch ahead of its competitors.

And so, in 1935, for fifty-five dollars a week, he came to CBS, but management of his work experience had begun long before that in Stanton's life—about the time he was in second grade, if his memory is correct.

FRANK STANTON WAS BORN on March 20, 1908, in Muskegon, Michigan. His father was a teacher in the manual arts department of the high school there for only a year. "It was my mother's family that pulled her back from the cold winters in Michigan to the slightly less cold winters in Ohio," Stanton said. They returned to Dayton, where his father taught in the public school system and later became manual arts supervisor for the district.

Stanton's mother was some eight years younger than his father and had been a student of his. During the course of her adult life, she made pottery, worked in metal and wood, and became a proficient weaver. Stanton said, "I was carrying, you know, baskets of plaster and wood shavings and so forth from a time I can hardly remember." Her looms were set up in the guest room—which "was never used as [such]"—and elsewhere in the house, and she had her own kiln and potter's wheel. She also occupied herself with taking care of Stanton's brother, who was a diabetic.

Stanton's father was also a Sunday-school superintendent,

> active as a layman in the church, and because he had to get down there at the crack of dawn every Sunday morning to open the church and do all the things that had to be done, he insisted that the rest of the family had to be there too, and I always thought this was sort of an unnecessary chore.

Stanton regarded church as more of a social—connected with Scouting—than a religious activity and did not attend church as an adult. "My mother," he said, "was much less, if you will, religious, as I recall her, in those days than she is now. Of course now she's entirely wrapped up in the church" (at age eighty-four).

"I remember many disagreements with my parents," Stanton said, and in another context remarked that his father had "a pretty low boiling point."

> I just exasperated my father by never being able to read the clock right. I don't know why, but I remember that very clearly. Every time I see one of these clocks in the toy catalogue where there's an arrangement, you can move the hands for teaching—I suppose it's for teaching a youngster how to read a clock—I think of my father and say, it's too bad he didn't have that kind of a thing, because he had to take the

alarm clock and take a pair of pliers and move the hands around, and it was so much fun to give him the wrong answer and see him explode.

"Did he kiss and hug you too?" I asked.

"No," Stanton replied, "he would never—he'd give me the shirt off his back, but there never was any great affection shown. That doesn't mean that he didn't feel it."

"Did he spank you?"

"Yes, I think I recall—I think only once that I can recall. But the emphasis in the family, as far as my mother and father were concerned, was much more, work with your hands."

They did not have many books around, "by current standards," as Stanton put it.

I guess you would have to say that they had very few books. My father read, more than my mother, but he read a curious kind of mixture. He read a lot of trade journals; many of them were professional journals. The course work, the extension work he took, obviously that had him reading materials related to that. But outside of his course work, the things that he read were in poetry, in journals related to his teaching work—and that, I think as I think about it now for the first time, probably was in part because his responsibilities spanned such a wide range of trades. You see, he had mechanical drawing, he had cabinet work, he had the print shop, he had automotive training, he had foundry and forge—he had almost all the mechanical trades that were then in existence under his supervision, and he wasn't trained, either professionally in whatever course work he took or in his own experience, in all of those fields. Yet he had schools that were training youngsters in those various fields, so that in each of those areas there was a teacher's quarterly or monthly trade journal of some kind, and those were just fun to read, for me. I mean, I pored through those.

"I did the usual things," Stanton said, "—insisted on changing schools because I didn't think the school I was going to, where they wanted me to go, was good enough."

This was during his freshman year in high school, and during his sophomore year he ran away from home: "I got as far as, I think, Tennessee."

"Where on earth were you headed for?"

"I didn't know, I just wanted to get away. I didn't have any program."

"What was making you unhappy?"

"I don't recall what it was, and it obviously wasn't important, because I didn't stay away very long, but all I mean is, all I was indicating was that I wasn't by any means a model child."

"You sound as if you were quite independent."

"Yes, and this I think was a great disappointment to my father," Stanton continued.

Not that he didn't want me to be independent, but I think he realized that when I became solvent under my own power, that there was very little parental control left. I was like every other youngster that I ever knew . . . sold *Saturday Evening Posts*, and I made a lot of money carrying papers. I say a lot of money—I mean, it was a very well-paying job, because what I did, in a curious kind of way, was—the newspapers didn't systematize the way the routes were laid out for the youngsters: they would have a distribution point, as perhaps they still do, I don't know—where they would dump the papers, and someone would count out the papers for each boy that came and got sixteen or forty or fifty, and then wherever he delivered those was none of their business. But there might be as many as twenty or twenty-five boys at one drugstore corner to pick up papers and then start out in all directions. And I discovered that some of us were working the same territory.

I also had some customers, basically I guess friends of my mother and father who said, you know, wouldn't it be nice if I delivered their paper. But it would be to hell and gone way off of my route. So what I did was to take a street map and block out my area, and then find out who else was in my area. Then I took the customers who were outside and traded them off. I also bought customers—in those days you could buy them. Maybe you still can. But there was a going rate, so I kept buying them, taking my savings, to get a concentrated route. I laid out the route between the drugstore where the papers were delivered and my home, so that I was always working back towards home base. It was a very efficient route when I was finished: I could do it much quicker, and I had many, many more customers.

And it got to the point where on Sundays my route was so heavy and the Sunday paper in those days was much heavier than the daily paper but of course nothing like *The New York Times* or I wouldn't be here to talk about it! But I had to have a wagon, a good-sized wagon with staves on the sides to stack up these Sunday papers, and I had to make two trips. So I got a junior kid in the neighborhood to work with me on Sundays, and I ultimately sold him the route.

I was in the second grade when I started carrying, had my first paper route, and that was the Dayton *Herald*. That was a lousy route and it was not a very distinguished paper. Then I switched over and got one of the Dayton *Daily News* routes. I don't recall when that was but I know I was in second grade.

Then I was very fortunate. I had an opportunity to work in a men and boy's clothing store on Saturdays, and when I went to high school, I started working there in the afternoons after school closed. In

those days I was making, as I recall, fifteen to twenty dollars a week.

I saved some of it for going away to school and used the rest for the things that I wanted in the way of clothes. It wasn't anything extravagant, but I dressed myself and took care of all my own expenses.

That's when I say that my father, I think, regretted my independence, because he had no real control. I remember one time having bought something that was rather expensive and saying unkindly, what difference did it make—he didn't have to pay for them, it was my own money I was spending. This is a pretty mean thing to have said. But I know that it took the props right out from under his argument, really, in the sense that he had no real reason to be critical of how I spent my money.

And it wasn't because he wouldn't give me money. It was just because I didn't want to take any. I wanted to be on my own. And that started—as I say, I was in the eighth grade, or seventh grade, when I started working at that store, and I know that to buy my own dinners and lunches and things was great. You know—what did it cost? Thirty-five cents, in those days. I don't think my parents ever put a nickel into clothing or anything else, as far as I was concerned, from the time I started working there. I never had an allowance as a child at all.

Stanton's salary, as president of CBS, was $200,000 a year in 1968, with $148,000 in "paid-out, additional compensation." He then owned 324,809 shares of CBS common stock, worth in the neighborhood of $13 million.[34] He was sixty years old at the time. The black leader Eldridge Cleaver claimed that wanting to become head of "General Motors"—presumably meaning, the head of any large corporation—was a sickness.[35] That is not the common reaction in America when, say, *Time* magazine reports that General Motors chairman James Roche was the highest paid U.S. executive in 1967, earning $733,316 in salary and bonuses.[36] We admire success.

Fortune magazine, in May 1968, listed 153 individuals whose net worth was over $100 million. While Stanton is not among the super-rich as they are counted in these days of centi-millionaires, he has been well paid. He is a member of what has been called the New Class—those "who entrepreneur their way through society by means of an educational qualification rather than by property ownership, and who take as the object of their efforts not the accumulation of personally held property, but a higher and more secure organizational tenure."[37] It is not sick to want security, and in certain organizations it improves one's position to demand it. Too, it is common to define security as financial. Our heroes and our artists are those who do without, and they frighten us.

Stanton had no intention of crying, with Othello, that his occupation

was gone. In 1968, corporate material noted that his contract with CBS provided, among other things,

> for his employment as a senior executive of CBS until December 31, 1971, and for his serving as a consultant to CBS until December 31, 1987, or his earlier death. During the consultative period, he is to receive (i) compensation at the rate of $100,000 per year adjusted yearly for increases in the cost of living index since 1966 and (ii) office space, secretarial assistance and other facilities and services similar to those made available to him during the employment period.[38]

Stanton retired to head the American Red Cross. He planned his retirement as efficiently as he had planned his life. (See note 39 for his résumé.)

The position of W. McNeil Lowry at the Ford Foundation was seemingly much less secure, for although he too depended on an organization to enable him to play his role, he had no contract. Foundation officials commonly do not. "So we're all free," Lowry said. "I'm equal. I'm even with the Ford Foundation every night. And they all know that." Who then had the power: Lowry or the Ford Foundation? CBS or Stanton? Christopher Jencks and David Riesman believed that ". . . the power or influence of a given job is hard to quantify. The closest approximation is probably pay."[40] Lowry's salary in 1968 was $55,000, less than a quarter of Stanton's. Stanton was involved with the arts and with culture in America: whose influence was greater?

CHAPTER 2

STRUCTURAL FIT

(Work in an appropriate place brings power)

Murray Kempton, in reviewing a book about *The New York Times,* pointed out that its managing editor, Turner Catledge (as well as other members of the staff), was a servant—that the "real power" is the inviolable property of the pleasant young man who inherited the *Times.*[1] But is the ability to hire or to fire the only test of power? Catledge's own achievements earned him the position to which he climbed: that of executive editor. The nine men on whom this book is based were all modern-day Horatio Alger figures, in a sense, although none of them married the boss's daughter and only one, William Jovanovich, came from what would have been called a lower-class family. The others grew up in the reaches of the middle class. Such terms were being redefined by social scientists as our affluent society became stratified rather differently. All these men were more or less members of that so-called New Class[2]—the elite of a corporate society who exercise influence by virtue of their roles in organizations.

The historian Christopher Lasch asked: if classes are "understood as active agents of long-run historical change," is the New Class a social class?[3] The historical change is the turnabout from capitalism to corporatism—if indeed that has occurred. Adolf Berle suggested that there are now two parallel systems operating, that a *shift* from capitalism to corporatism has not, in fact, occurred.[4] Lasch takes the rise of corporatism to signify the demise of the profit motive, which he hopes in turn will end, in his words, the institutional necessity of that moral lapse, aggressive individualism.

Whether it is regarded as a moral lapse not infrequently depends upon whose interests are involved, and whether they are those of the group or of the individual. Aggression against "wrong-acting" individuals, whether they be criminals or artists, is sanctioned. When the individual is aggressive in his own behalf, he is considered immoral. But "aggression on behalf of the group receives support from the immediate social environment."[5] Businessmen who made fortunes at the expense of society were tainted with immorality—but envied: in the 1960's, "elite status, leadership in any form, is achieved and kept today by catering to the masses—not by plundering or oppressing them."[6] Student radicals in the 1960's believed they were catering to (or helping) the masses—as did black leaders, labor leaders, politicians, broadcasters—and their immediate social environment grew to sanction aggression.

The problem was one of finding a group. Paul Lazarsfeld suggests that there is such a thing as "structural fit"[7]—that when a man has a relatively high proportion of successes, he is in an appropriate environment. There is no doubt that these nine men were individuals who found structures where their already acquired life styles were an advantage or who took readily to the life styles required of them in the context in which they found themselves.

"About the New Class," Lowry said:

> I don't believe, for example, that Frank Thompson, if I understand what you mean by New Class, is a member. I think Frank Thompson is a particular individual who was elected to Congress and therefore came into an influential position. And I know many other members of Congress that if Thompson is a member of the New Class so are they—and so many that it almost loses its force as a specification or characterization. And then I come to someone like Lloyd Goodrich, and I'm all the more convinced that Lloyd does represent a particular group of people who had in the thirties a particular mission. But his membership in the New Class I don't understand. His membership among museum directors we all understand. . . .
>
> Is it not true, in your opinion, that the particular men you have selected, in any other decade or generation of the last century—that is, the last hundred years not just the twentieth century—could have reached positions from which to influence development [of] the nature and quality of American life? That this is a continuing historical manifestation of the American Republic and not a sudden historical evolution of a particular class? Maybe that's vanity on my part. But maybe it is a different kind of commitment or understanding of the American society historically.

Lowry claimed that any one of these people came to a point where he could influence society by virtue of his personality. He suggested I ask

such questions as: What happened when you were a child? What was your family life? Why did you want to do this? And so on.

> You're not putting us on a couch or giving us a lay person's psychoanalysis, but you are looking for the inner personal and moral springs, you see.

"In other words," he said, "I think the explanations of why these [particular people were successful, are influential] are not broadly social." I thought he was saying that men with superior talents would always have influenced what went on, but he was most of all remarking on "some kind of compulsive drive—ethical, psychological."

Bazelon bases "New Class" achievement on educational status, excepting "special organizational training" and "marginal brokerage persons."[8] All nine men are included in *Who's Who in America*,[9] where their earned degrees are listed as follows (and it's interesting to consider this list in light of C. Wright Mills's assertion[10] that our institutions are controlled by a small group of men who have attended the same schools):

STANTON: Ph.D. Ohio State University, 1935.

JOVANOVICH: A.B. University of Colorado, 1941. (Graduate courses at Harvard and Columbia universities.)

LIEBERSON: (Student, University of Washington; Eastman School of Music.)

THOMPSON: LL.B. Wake Forest College, 1941; LL.D. Rider College, 1962. (Admitted to the New Jersey Bar in 1948.)

CATLEDGE: B.Sc. Mississippi State College, 1922.

GOODRICH: (Educated at the Art Students League and the National Academy of Design.)

LOWRY: A.B. magna cum laude, University of Illinois, 1934, Ph.D. 1941.

DONOVAN: A.B. magna cum laude, University of Minnesota, 1934; B.A. Oxford University (Rhodes Scholar), 1936.

RANSOM: A.B. University of the South, 1928; A.M. Yale, 1930, Ph.D., 1938. (Student at Harvard, 1929–30.)

The three Ph.D.s are: the university chancellor, the foundation vice-president, and, surprisingly, the president of the television network. Two of the men had specialized training, one in music (now the president of a record company), the other in art (who became the head of a museum). The politician owns the law degree. The three men whose businesses involve production of the written word—books, newspapers, magazines—did not attend elite educational institutions, but the book publisher and

the magazine editor, unlike the newspaperman, went on to more prestigious universities—at least briefly—after completing their undergraduate educations. Five at some point considered academic careers. One of these (Ransom), of course, actually took up higher education as his occupational choice and eventually became the chancellor of a university system.

Although providing "education for responsible leadership"[11] used to be regarded as a prime obligation of the university, education in the formal, limited sense charted above was only one factor in the success of these men. Lack of it or of attendance at an Ivy League college does not decisively limit a career, although, as Lowry said, "I think what has happened in this society to people like either me or my son means that, if you have the motivation to do it, the Ph.D. is a very useful thing, whether or not you become a scholar or a professor; and I think it will give [my son] just a little bit more elbow room and a few greater choices." Education makes more alternatives available.

But an appropriate occupational choice still is no guarantee of outstanding success. A sociologist, Norman Birnbaum, suggests manipulative skill makes the difference.[12] This is not acquired through attendance at an educational institution—it depends not only on a particular kind of talent but also on the effectiveness of a person's emotional organization.

Can someone *will* his admission to a social class? Apparently this was almost what William Jovanovich did, which makes his achievement all the more extraordinary. As sociologists say, he adopted "anticipatory norms." He believed that people tend while young to form the attitudes of and to conduct themselves like the class to which they aspire rather than the class in which they find themselves. He did not remain in the class in which he found himself. He said:

> My father was born in 1890, in a village not far from what is now Titograd in Montenegro. It was then called Podgoritsa, which means "under the mountain." He was born in a little village. It's a very clannish society, of course; in fact, half the people from this village seemed to be named Jovanovich, and the other half Radulovich. This, by the way, is the origin of the patronymic system among Slavic peoples. In such a place, of course, to say your name was Jovanovich would be almost meaningless, so you have to identify yourself by your father. In my case, I would not say my name was Vladimir Jovanovich but I would say it was Vladimir Ilyich—my father was named Iliya.
>
> His father was a stonemason. He died at age thirty. . . . At age fourteen my father went to Boka Kotor, which is the beautiful bay which is at the foot of Mount Lovćen, which is the peak that guards the northern entrance to Montenegro. You go right up from the bay of Kotor to Lovćen—an impossibly high road—and there is the vast range of Karst mountains. This is the harshest, most brutal land in Europe.

Montenegrins are a heroic, Homeric people whose chief occupation has been war for seven centuries—this has inbred in them the attitudes which are quite extraordinary. I suppose you'd call them Byzantine attitudes. The men are not given readily to work. The women work hard and age fast, while the men are tellers of tales and warriors. And of course after World War I, when the wars ceased, this created an intolerable strain in Montenegrins, because in a sense the men hadn't a tradition of farming—there was very little farming you could do in those Karst mountains—or sheepherding. You find in Montenegrins now a tremendous restlessness, a rage.

Do you feel you have that in you too?

I do. You know, Rebecca West in *Black Lamb and Grey Falcon* describes a Yugoslav in a seaside restaurant declaiming and raging about the soup being cold. You just know he was a Montenegrin.

When my father was seventeen, he decided to emigrate, as many Montenegrins did. But unlike other groups, mainly Italians, to some extent the Greeks, although less so, Montenegrins did not often bring wives and families. They came alone, and the whole Montenegrin society in America is distinguished by bachelors.

My father borrowed money from a Montenegrin who had been here. I'm not quite sure whether he mailed it to him or whether the Montenegrin had returned. But the passage from Bar, which is the only port in Montenegro, all the way to America was forty dollars. His mother walked with him from Komane. Of course there are no roads—there were no roads in Montenegro at all. He had a pair of shoes but he carried them around his neck so as not to wear them out. At Bar he got on an Adriatic tramp steamer to Trieste, then on a train to Hamburg, and finally on a ship to America. When he got here, he went to Pittsburgh, where he worked in the steel mills, where there were a lot of Montenegrins. South Slavs, on the whole, as immigrants, have been steelworkers and miners. They've done the hardest work. There was still the unrest—this was 1907—following the Homestead strikes in Pittsburgh. He ended up by striking a foreman who, he recalled years later, was a German. He got fired and went to Chicago and went to work on the Navy pier, which was just being built then.

. . . he was almost as tall as I am, but much more powerful. Had tremendous hands and a great, massive head. He went on down to Carbondale and there he ran in to the first stirrings of the Ku Klux Klan. Southern Indiana and southern Illinois have very much the sort of patterns of the South, and the Ku Klux Klan may have drawn on that. They were not only against Negroes, as you know, but against foreigners generally and Catholics. He of course wasn't Catholic—he was Orthodox—but there were some kind of outbreaks near the mines. I never found out exactly what. At any rate, he left and went to Colorado,

where he worked in the mines south of Pueblo in a place called Walsenburg, which was made up of mines in the hills, below the Rockies, and there he met my mother.

My mother's story is, she was born in 1889 in a small town near Novi Targ, outside of Crakow, Poland. She had even a more desperate time of her childhood than he did. Her mother, whom I knew as a very old woman, and who died at the age of ninety-four, and my mother both look very much like Madame Curie. My mother went to live with an uncle at the age of seven, and she slept in the barn almost from that time until, I guess, she was thirteen. Then at age fifteen, she left for America with a ticket furnished by the Botany mills. The Botany mills, in Paterson, New Jersey, used to send agents through Central Europe recruiting workers. This was 1904. They paid the way of her and her brother to come to America to work in the mills. And so, at age fifteen, with a tag on her—she had no schooling, she'd never been in a schoolhouse in her life—she and her brother came. For forty-seven years afterwards, she thought she landed in New York City, and it wasn't until she was past sixty that she learned that she landed in Baltimore. She and her brother got separated, through some mishap, when they got off the ship, and he got lost. He actually wandered about Pennsylvania, and finally found refuge with a German farmer; six months later, he was discovered there, and so they were reunited. Of course, neither of them spoke English—neither did my father when he came across. My mother was illiterate, although my father could read and write Serbian.

She went to work in the Botany mills at age fifteen—and she was extremely proficient. She learned very quickly to run a weaving machine, making men's suits. In fact, she became so proficient—they were paid on piece work and she made about three dollars a week—she ran two machines, facing each other across an aisle. She's always been swift and clever. At that time the IWW was organized in the factory, and there were some Bulgarians who persuaded her to join the IWW. They went on strike shortly afterward and to this day she has a strong prejudice against Bulgars, because they lost her her job.

. . . Meanwhile her mother came to this country and went out to Colorado to run a boardinghouse for miners. Her first husband had died and she'd married again, a man who was twenty-five years younger than she was. My mother went out to Colorado to help her and to live with her. My father was a boarder—in this coal-mine settlement—in this boardinghouse, and he met her, and they were married. He was twenty-three, she twenty-four.

It was 1913, a time when there was ensuing the strike that Upton Sinclair wrote about in *King Coal*. This was the famous strike of the Ludlow Massacre; the strike that established the United Mine Work-

ers. It lasted thirteen months, and involved violence. There were Mexican scabs brought in. It finally was ended only by the intervention of the U.S. Army. And my father camped up on the hogback with the other miners, with guns, shooting at scabs, and, while living under a tent, my mother gave birth to my oldest sister without a doctor—just a neighboring woman helping out. Finally, President Wilson sent in the Army. The strikers had to give up their guns, and some were blackballed in the mines. My father took off for Iowa, where there was strip mining. My family lived there for a while, extremely poor and extremely harassed. Then they came back to Colorado, went south again to work in the mines, but there was an explosion, a lot of miners were killed, and he was again out of work. My mother actually found him this job up in Sunnyside, in northern Colorado, where I was born. They went there, and I was born in 1920.

My oldest sister was born in 1914; my youngest sister in 1915; and one child born in 1918 lived only a week. I was born in 1920, as I say, in this company house in this company town. That mine began to have water seepage and explosions—it was the beginning of the end for that mine—and so my father was out of work again. My mother took me—I was a babe in arms—and my two sisters, got on the Interurban railway to Denver. There she borrowed some money from my Kum, my godfather, who was a Montenegrin miner, and went to see a Galician woman, who took her into a rooming house where she worked cleaning rooms. And she got enough money together, while my father stayed up in Sunnyside, and she rented a house in the old main part of downtown, where she then took in boarders and roomers. My father came down, and he got a job with the local utility, called the City Service Company, which is the gas and light company, digging ditches in the streets. He worked from 1921 until he retired in 1956 for this company, and rose to be a foreman about 1926. He had a little working gang of three or four men. Over a period of years my mother got somewhat bigger houses, keeping rooms.

Did she learn to write English?

Well, she never did learn to write. She can read a little bit in English. She kept getting bigger and bigger apartment houses, until finally, about the time I was ten, she had bought a thirty-two-room house. Montenegrin coal miners would come down from the mines. My father, having a house, now was the person they came to see. Lonely people: they came down from the mines and stayed in cheap rooming houses or hotels, and then would just come in the afternoons and sit through the evenings. They and my father would talk. He became president of the Serbian Lodge—they had a little mutual-aid insurance society—but in any event was the center of a group of Serbians and Montenegrins.

. . . I remember the first house my mother got. It was in a neighbor-
hood mainly composed of Mexicans, Chinese—Arapaho Street in Denver.

Did you have friends at school?

No. I didn't speak English until I went to school at five. I spoke Ser-
bian, and I understood both Serbian and Polish. My mother spoke
Serbian with my father, rather than Polish, although he knew Polish.
We didn't have neighbors; the only people I saw from the outside were
these roomers, these transients, these coal miners who rather regarded
my father as a kind of leader among them.

Jovanovich said:

Isolationism was a geopolitical thing in a sense. The Rocky Mountain
West wasn't close to anything: it wasn't close to urban centers; it wasn't
close to any other country, it was in the middle of the country where
there's lots of space. It's almost a matter of geometry. Everywhere you
looked, up and over and across, there was lots of room. This not only
gives you a sense of freedom, in a sense, but it also gives you a sense
of detachment. In the West, the economic-social-political phenomena
came from the East, and they took a long time to get West. The so-
ciologist Robert Merton and I once talked about "the cultural lag."
Fifteen years ago, we were saying, it still took two or three years, even
with transatlantic flying, two or three years for sets of ideas or trends
of thinking to move from the East to the West Coast. Well, translate
that back to the twenties and thirties.

That kind of isolation was lessened during the twentieth century by
the growth of electronic communication. Jovanovich remembered that at
age thirteen he had listened to Franklin D. Roosevelt's first "fireside chat"
and had wondered "just what my mother got out of that Groton-Harvard
accent."

Had he defined it as that at the time?

Well, obviously it didn't sound like the kind of English she was used
to. I remember at the time saying to myself, now isn't it amazing how
personality works, she's terribly reassured, she's trusting of this person,
and yet on a level of communication there's no point of contiguity here,
you see. It was my first lesson, I think, in personality on the American
scene. FDR was the first person I recognized in American life. Every-
thing up to then had been historical—or impersonal.

People seemed to feel that Roosevelt "was talking to them directly
as individuals, knew their problems, and was interested in them."[13] And
yet what was being transported then as now was myth: because it was
contraction—that is, only an image standing for "a complex process that
ordinarily extends over a long period."[14] Nevertheless, it was a *whole,*

or what Marshall McLuhan came to call "the inclusive image":[15] the world has been contracted to a more handleable size; the globe has become no more than a village, he said. Satellite broadcasting of course, long after Roosevelt's day, contributed to this idea.

As network broadcasting became a force in American life, one of its effects was to create a new kind of national consciousness, changing the character of regional and local considerations, said Barnouw.[16] This change was most obvious so far as styles of living based on consumption of goods were concerned. Consumerism might be called one example of that "commitment and participation" McLuhan considered more important than substance in the modern world. What happened in broadcasting supported McLuhan's claim that technology integrates, but he went further and said fragmentation had become obsolete—no longer would there be "splitting and dividing as a means of control."[17] He saw us as having arrived at entities that would somehow exist instantly without being the sum of their own parts. But while he was positing the inclusive image, not *an* inclusive image, he meant a diverse and continuous series, which seems contradictory. Perhaps technology has merely added to the size of the images we are able to see at any particular moment, the area to which they can be distributed, how many there are and how quickly they come on us. What happened to America during the Depression has become myth, but the discrete parts of that inclusive image were composed of individual suffering.

The poverty of his parents and his early experiences left Jovanovich with no desire to have his own children work their way up in the world. "I've told these kids," he said, "that there's no need for them ever to worry about money, and that I would give them money when they were young . . . and I made up my mind I would never, never make my children ever feel the lack of money or have to wait on it. I think it's made these boys, who are so ambitious, as I say, and strait-laced, as I say, also so free and easy they probably don't feel that, as long as they can do something that interests them, they ever *have* to struggle for a living."

Would it bother him if his children did nothing? "No, I don't think it would. I've told them I thought the only ultimate personal use of money was liberty, if it could bring you some liberty then it was worthwhile." But what did liberty mean to him? Jovanovich as president of Harcourt commissioned consultants to set up a company retirement plan which was presented to the board of directors and which was duly adopted. Under it, like any other employee, he could retire at age fifty-five. Yet he was sufficiently wealthy to have left before then and could easily have excused himself by reason of his health. Long after he became a million-

Harcourt, Brace & World also has a diversified product line. In 1964, 79% of the $46 million corporate sales was in textbooks, 12% in juvenile and adult trade books, and 9% in educational tests. Harcourt is the sales leader in the high school segment with a 15% market share that represents 54% of the company's textbook sales. Other textbook sales are evenly divided between the elementary and the college field. Harcourt's textbook products are highly regarded because of their emphasis on editorial quality. English is an important subject area. The company recently established a Special Projects Department to explore new techniques such as manipulative toys, audio-visual devices, etc.

Management is highly respected in the trade. The President, William Jovanovich, is considered by many to be the most brilliant publisher in the industry, and his immediate subordinates are generally considered to be very able.

Financially, Harcourt compares very favorably with the rest of the industry. In the past five years, both earnings and sales have increased at about 12.5% per year compounded. The 1964 return on sales was 10.8%, the return on equity, 24.3%. In 1965, sales increased by 11.9%, and net profits, by 20.4%. The company is strongly established and well organized for the future. The outlook is excellent, although the role of the President is quite important in this instance to keep the wheels rolling.

—FROM *The Textbook Industry,*
PAMPHLET DISTRIBUTED AS A "SERVICE TO
INVESTORS" BY ARTHUR D. LITTLE, INC.,
FEBRUARY 1966

aire, long after he had suffered a heart attack, he continued to spend himself day after day on his publishing house, proud to think that Wall Street rated its stock by his personal strength.

When Jovanovich could not perform brilliantly, he did not like to play. He wanted what he did to appear effortless even while wanting credit. He did not like to think of his move upward in the corporation as having been a struggle, and sometimes he would attempt to make less accessible or to discredit the views of others who had been involved with him.[18] He had great pride. Self-preservation had rendered him conservative, yet there was something not quite respectable to him about that either. When he was at war with himself, he relied on his minions to

save him. He needed men and women who were personally loyal to him and he got them because he rewarded them and because he was compellingly attractive and good at manipulating: it did not bother him to be confronted with viewpoints different from his own. But it embarrassed him to know the details of others' misfortunes, although he was frequently overgenerous with his help if they would "confess" (his word). He could not help believing that if others could not cope with what had happened, they were in some way inferior. Just as, one felt, if *he* could not cope with what was happening he was afraid of being thought inferior himself.

When he appeared before financial security analysts, he seemed at ease, very much a cultured person with a controlled sense of humor. Only once did his manner break, and that was when an analyst asked an annoying question during the period immediately following his talk. After responding harshly, Jovanovich modified his tone right away. He wanted something from those present, although undoubtedly he would have denied this. But it could be seen from the fact of his presence. One might guess that he cared less for his stock options and the price of the stock he owned than for the appearance of that company which was an extension of himself.

He was determined to set his sons above the struggle.

Did he ever think about how it classically ended up?

"Yeah, but again, those are models, you see. And I'm not sure that I want to borrow any models here."

He had in fact again adopted anticipatory norms and was contributing to those circumstances which would tend to predefine the place of his sons in our culture. He had removed the idea of work as an issue—or as an ethic—for them and had been able to do so by virtue of his own success. Just as Jovanovich himself was not working within the form of his father, he did not expect his children to. *His* form was that of a businessman, although publishing is a special kind of business.

An article in *The New York Times* about the Harvard Business School pointed out that "the implicit, insistent lesson of most undergraduate education [is that] business is vulgar, business is dull, business is for fourth-raters, business will take away your soul."[19] However, the idea that going to college would permit you to earn more money during your lifetime began early—"surely before 1871"[20]—and must have influenced the decisions of many who did not intend to become businessmen.

It is hard to perceive business ends if they are not what one student thought when he said that "learning things is a waste of time and making money is not a waste of time."[21] But the acquisition of money certainly was not the only motive of any of the nine men on whom this book is based, even the three who are businessmen. Paradoxically, money may

DRAWING BY DAVID LEVINE. REPRINTED WITH
PERMISSION FROM THE NEW YORK REVIEW OF BOOKS.
COPYRIGHT © 1968, NYREV., INC.

*This cartoonist portrays Henry Luce, the founder of Time Inc.,
using money to lure his trained rats into their maze. But
why men respond is infinitely more complicated than that.*

turn out to be more important to their sons if they cannot find vocations.

William Jovanovich told the following story about his son, a recent
Harvard graduate at the time:

[Stefan] worked for [a large-circulation magazine] last summer and
really was appalled. I think he was so offended and so shocked, I don't
think he'll ever get over it . . . he'd never read *The History of England*
by Macaulay, so he began to take these leather-bound copies with him
to New York on the train. One day I said to him—he was about on
Volume Four, after about two weeks—and I said, "Stefan, I know you're
not that great a reader in speed, when the hell are you reading?" He
said, "Well, I read at the office." And I said, "Well, surely you've got
something to do, they're paying you magnificently for a summer job."
He said, "Well, there really isn't anything to do." And I said, "Surely
the very act of your sitting there reading Macaulay must create some
kind of unrest." "Well, I'll tell you what I do," he said, "you remember

as a kid when you used to read comics behind your textbook?" I said, "Well, I didn't ever do that, but I know it's a common American pattern." He said, "Well, I've reversed it; I read Macaulay behind copies of [the organization's own magazine]."

Stefan was relating to those cultural values to which his father had introduced him, not to those of the magazine world in which he found himself: these he professed to scorn although he was willing to participate in that world, presumably out of curiosity, a sense of the prestige involved (even among his contemporaries, or perhaps—paradoxically—especially there), and the lack of a more basic interest. "A truly relevant education," said his Alma Mater, would have made him aware not only of the experiences he was likely to encounter but also of those about which he *ought* to be concerned.[22]

Jovanovich's son might have answered, as did Texas journalist Ronnie Dugger, that "the implication of being independent of power is not anti-power: it's simply a mode of trying to be relevant." But Stefan's attempts to be relevant would always be based on a sense of himself that was different from that of people who came from more impoverished backgrounds. Stefan had lived much of his young life in Briarcliff Manor, where an official of the corporation for which he had worked that summer was a neighbor.

" 'It's so much more easier [*sic*] for affluent children to rebel,' said Prof. Arthur Bierman, a 43-year-old physics teacher close to the radicals. 'Their problems are more spiritual.' " He was quoted in an article on the front page of *The New York Times* in 1968, which further pointed out that "a series of incidents—including a radical attempt to thwart job interviews in a college of financially insecure students where jobs and money are extremely important—appear to have led to a distrust, perhaps revulsion, towards radicals at C.C.N.Y., where radicalism and political activism once had such impact."[23]

We have observed Jovanovich associating with radicals while growing up but not with those of his generation. He appears to have seen early on a different world, one to which he wanted to belong. While he was proud of his origins, nevertheless he perceived himself as something other than them. So did young radicals in the 1960's perceive themselves, but their aspirations were opposite. Yale psychologist Kenneth Keniston discovered that young people during the sixties were afraid both of manipulating and of being manipulated. "For many of them," he wrote, "power based on capacity and role [seems] confused with domination and sadistic control."[24] To align oneself with the "managers" was distasteful.

So it was also to McNeil Lowry, who insisted that he was not a

manager. Sculptor Theodore Roszak called him a "grand orchestrator," a phrase suggesting capacity and role rather than manipulation. Anyone who manages well, whatever he is called, must have a bias toward "creating alternatives, working with possibilities, facing uncertainty and guiding one's actions by the rational assessment of probabilities."[25] Perhaps an artist behaves in similar fashion up until the moment when his material hardens, and then he must leave that decision, or piece of work, and face up to possibilities again, now broadened because of past achievement. This style is not limited to business executives, but all good managers are creative, whatever their own fashion, being what the architect Eero Saarinen called "form givers."

"Our enterprise," said publisher William Jovanovich, "is to make known, to make public, the substances of education, and these we take to be all serious works that entertain, that instruct, and that inform people in the conduct of their lives and professions."[26] He had no doubt as to the value and meaning of his business, although he was interested in its profit-making aspects as well. "And it seems to me," he said, "that work is one of the ways in which we experience—it's one of the ways we find out where the others are." He would not have agreed with the radical dissenter Mark Rudd, who in a speech at Harvard declared, "There is no meaningful work in this society."[27]

Rudd, although he attended Columbia in the sixties, was not a typical student, but quite a few of his contemporaries agreed with him and some of an older generation as well. "Why can't we *give* them more meaningful work? Why don't we have more organizations like the Peace Corps?" cried a parent.[28] She and Rudd failed to understand that people grow into their work, it is not "given" to them. Not only do careers themselves show this but also the way that professions are chosen (see D. E. Super's list of "Determinants of Occupational Behavior" in the notes).[29] However, as a government study team pointed out, there is a discrepancy between the "democratic and self-affirmative" individual, our ideal, and the "boring, dehumanized and authoritarian" work with which he is often confronted.[30]

When Erik Erikson made the point that in dealing with identity crises psychologists and psychiatrists have not paid enough attention to the value of work,[31] he was not making the same point as that parent. Norman Podhoretz, in connection with his own career as editor of *Commentary* magazine, pointed out that professionalism comes from the calm sense of being a participant in an ongoing enterprise.[32] Which, for a time at least, Rudd seemed to become. His revolutionary activities may have been his way of resolving an identity crisis.

Men must have meaningful work, but the definition of "meaningful" is unique to the individual. Individual differences, said a psychologist, are re-

lated to the timing of the emergence of basic needs, to the specific environ-
mental situation at that stage, and, to some unknown extent, to genetic
elements.[33] None of the nine men under discussion started out wanting to be
what he became.

"What do all these guys want?" asked a middle manager, a Galbraithian
technocrat who, by "these guys," meant anyone who was at all striving but
primarily the "successful." He answered his own rhetorical question, "They
want money, that's all." But if that had been the case with these nine, their
lives would have been grotesque jokes, which they were not. Perhaps in the
dead of night some of them wonder about the extent to which their own
consumption preoccupies them, but none was primarily after money and
perhaps that is one of the many different reasons they achieved. As we have
already seen with Jovanovich and Stanton, nor was free time one of the
rewards they wanted. Commitment and participation, as McLuhan claims,
were indeed important (when were they not?). But the questions *commit-
ment to what?* and *participation in what?* remained equally so. The notion
that content had ceased to matter was only a fad.

"Meaningful" work—like "happiness"—can only be judged relatively,
and seeing relationships in the widest possible context is the work of intel-
lectuals. Berle has said that the power of the mass media, though great, is
not determinative but that the influence of the intellectual community may
be.[34] What is an intellectual? It is a person concerned with wholeness, pro-
portion, style (as is the creative individual) rather than with fragmentation
and specialization (as is the technician). Theoreticians and artists alike are
form givers. "It is important, I think," said Arthur Schlesinger,

> to distinguish the intellectual from the artist, with whom he is sometimes
> confused: one is a man of general ideas, the other a man of concrete per-
> ceptions. It is equally important to distinguish the man who offers ideas
> from the man who offers intellectual services—the man who lives for ideas
> in general, so to speak, from the man who only uses particular ideas for
> practical purposes—the man for whom ideas are a joy* from the man for
> whom they are only a tool. So in the nineteenth century a new class arose
> to meet the specialized needs generated by rising living standards and
> evolving technologies—lawyers, schoolmasters, doctors, engineers, civil
> servants, journalists, managers, intellectual bureaucrats and technicians
> of all sorts. Some were true intellectuals in addition, but by no means all.
> Nor, on the other hand, have all true intellectuals been employed in such
> quasi-intellectual pursuits. A delight in general ideas may erupt anywhere
> —even among politicians, bankers, longshoremen and women of leisure.
> It is the disinterested passion for large ideas, not the professional manipu-
> lation of small ideas, which marks the intellectual.[35]

* "And a goal," says James MacGregor Burns.

A journalist on *The New York Times* commented that Catledge as executive editor had good ideas within predefined limits. He was not given to re-examining the larger context but in conference would come up with good working ideas. Although alert, Catledge was not an intellectual by the above definition (a relatively common one).

Members of the so-called New Class, although professionally concerned with integration à la McLuhan, were not likely to be intellectuals. They were consumers and managers of intellectual (and artistic) items. Goddard Lieberson was one such, but not because he did not attend college. Many—perhaps most—of the millions of college graduates in this country are not intellectuals. Nor, it must be added, are professors, necessarily. Henry Luce is said to have believed he could have been a tip-top intellectual, if only he'd had the time.[36] Publishers are not necessarily intellectuals, Jovanovich recognized:

> Of course in trade publishing you can run across people who are unintellectual. There're heads of houses I know who are poor readers, and some of them can't write an English sentence with style. And this is not to say, you know, that there aren't good people in publishing, but it means that not necessarily an intellectual cadre of people manage publishing.

Jovanovich unswervingly regarded himself as an intellectual, and his interest in ideas was rather unique in the publishing industry. However, shrewd in context, he used that interest from time to time, proud that it was available. He was brilliant, but did he realize that such an application or manipulation for practical ends would tend to disqualify him as an intellectual in some people's eyes? Later on he began to collect honorary degrees, but while he was on the rise he functioned most splendidly in those situations where someone could discover he was not just a salesman or a businessman but on top of that an intellectual, so that he was rarely if ever in a situation where he would be judged as an intellectual by his intellectual peers. For instance, while selling textbooks as a college traveler he caught the attention of a "rather fusty lady professor at Indiana":

> . . . and she said, "I really can't see you now," and I said, "Well, ah, I'm sure one's always faced with that," I said. "It's what Cotton Mather said, 'If I had more time I'd be brief,' "—and she said, "Oh," she said, "I'm working on Cotton Mather now," and I said, "The cloth stuck with gold." She said, "What are you doing selling books?" She said, "Come in here and sit down," you see. Part of this was a bit of conwork [he laughs] in order to make a quick connection. I don't know why I suddenly remember that, I haven't thought of it for years.

Jovanovich took delight in solving problems practically and cleverly.

To the critic Harold Rosenberg, today's intellectual is the "intellectual

employee," and he thought that such accepted "a more total identification with his role than other workers, in that the editorial director, the designer, the copywriter, etc., sells himself more completely in terms of both psychic energy expended and number of hours worked. . . . If the free artist or the founder of a great enterprise builds his life exclusively out of the substance of his work, today's intellectual unbuilds his life in order to live his job."[37] Rosenberg asked, ". . . who is a greater victim of what Whyte calls the split 'between the individual as he is and the role he is called upon to play' than the member of the intellectual caste newly enlisted *en masse* in carrying out society's functions?"[38]—but Jovanovich had never become a member of the intellectual caste nor in fact should he have.

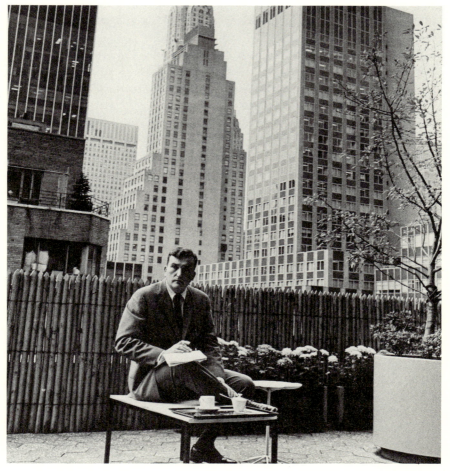

William Jovanovich on the terrace outside his office at Harcourt, Brace

Time to reflect is necessary for those interested primarily in ideas, and such time is not part of an ordinary working day at an office. Jovanovich made up for this lack to some extent by what tended to be quiet evenings, when he would read or watch television with his wife, who during the day had taken care of her requirements for a somewhat more sociable life but who tended to stay close by home in case she was needed. Jovanovich, after he became president of Harcourt, had employees and acquaintances, his acquaintances being authors like Mary McCarthy and Charles Lindbergh and establishment figures like the head of *Reader's Digest*, with whom Jovanovich went to the opera perhaps twice a year, their wives joining them.

As an administrator, "a degree of inwardness is lost," said Professor John Silber. If he had known Jovanovich, he might have been speaking of him. He was in fact speaking of his own boss, Harry Ransom, chancellor of the University of Texas System, but he might also have been speaking of himself since becoming chairman of the Philosophy Department there and, after that, president of Boston University. One could speculate that this was the way all of these men preferred their lives—that only bearing the inwardness and loneliness of the scholar and intellectual (or artist) would have burdened them too much, in some unknown way.

Would Jovanovich ever have gone to Washington? "No," said someone who had known him a long time: because he wouldn't have wanted to be under even the President of the United States. The distinction was between serving as opposed to helping, and it revealed his kind of pride. Stanton served President Johnson. He was characterized as "a frequent guest" by Sergeant Keener, who had a desk immediately outside the oval office.

Stanton said:

> The President took me down to show me the office [right after he moved in] and how he had changed it, because he had moved some of his own things in. The thing that hit my eyes immediately was the fact that the desk was blocked up on, oh I guess, two- or three-inch mahogany blocks. Obviously it hadn't been designed for that kind of mounting. He asked me what I thought of how the office looked, and without getting into any comments because I didn't think that it had been outfitted very well, I made some wisecrack about the President of the United States sitting as a desk that had to be propped up on blocks. And he had a quick answer as to why—because of his height and the height of his knees he had to have the desk sitting up higher. I said he either had to have a desk that was to his size, or that desk had to be changed. So he said, "Well, change it." He said he didn't want to get a different desk, he wanted that one because he'd used it when he was in the Senate and for sentimental reasons he damn well was going to keep it, whether I liked it or not, but if I didn't like it, fix it.

. . . I went down later one day when he wasn't there or wasn't using the office and made photographs and precise measurements of the desk and then came back here and designed a whole new apron which incorporated the higher footings. . . . I did the designing on it. I had a cabinet man here in New York who does a lot of my work—we made all the pieces so that all we had to do was go down and take some off and put on some new.

When we got there, things had not been done. Some of the things had been taken off the top of the desk. The phone hadn't been disconnected, and the drawers and everything were all filled with personal things. I had to remove those with his secretary, because she didn't realize what this job was going to entail. . . . There were two phones, the big phone that he has to his left, which is one of these call-system phone arrangements, and the other phone just looked like a private line to something. I put that down on the floor and then I said [to the three cabinet-makers, finisher, and helper who had gone down with him], "Let's turn the desk on its side and have a look at what the problem's going to be." We began to move the desk, and I don't think we had it more than six inches off the floor, tilting it, when Secret Service came in from two of the three doors into the office. Scared me half to death. They immediately had gotten the signal that something was happening in the President's office. They didn't know we were in there. That is, that particular detail didn't know we were in there. What had happened was that the phone that I had put on the floor, which was fastened partially to the desk underneath, the wire snaked out. . . . it's the Hot Line to Moscow, and I had disturbed that circuit—and the Secret Service was in there so fast, with guns drawn—that was the funniest thing you ever saw.

Well, as a result of that, when they found out what was going on . . . the Secret Service insisted on every piece of wood that I had taken down, all had to be taken over to the lab and fluoroscoped and checked and everything. Well, you know, I felt like I was a culprit. But it's a good thing they did, except that this could all have been done—we lost a couple of hours that morning waiting to have that wood all checked. And the thing that broke my heart about it was, these guys acted like ruffians when they picked up this beautiful wood. It had all been hand-rubbed, everything was set to go into place, and we had wrapped—each piece of wood had been wrapped in tissue paper and in kapok so that when it went down, it was like a piece of jade. And these guys just took this wood, picked it up off the floor and threw it in a box. I got angry, and—you know, they just acted like they couldn't care less about the way the thing looked. They didn't do too much damage. We rubbed it out when it came back. But I insisted on having one of our people go along to handle it, when they—and they wouldn't let us go along at all. . . . Then there was a detail there throughout the entire day while we worked. The guy just sat there all day long.

Stanton was reputed to have disliked President Johnson intensely and yet he served him. Stanton's morality consisted of applying his values, and his values were those of the craftsman, appropriately vesting an office. The plainest definition of an intellectual is that of a man who is interested in ideas for their own sake; morality—something else—is concerned with the application to life of values derived from ideas. Stanton's ideas and values perhaps derived in some part from his father's trade journals. He was to do well in a technological society.

MORALITY ON
THE PLAINS OF TEXAS

(A context for dissent)

"OBVIOUSLY IDEAS WERE very real to both your mother and your father," I said to Chancellor Harry Huntt Ransom.

"Yes, yes," he replied, "ideas and, as I look back, a kind of resolute idealism that I guess by mere definition would be the height of impracticality today. In her case particularly that idealism served her in adjusting under incredibly difficult circumstances to a life that was very full, although never affluent."

What did he mean by a sort of idealism that would be difficult nowadays?

Early in life she had made up her own mind about the complete equality of religions, cultures, and national origins, so that even today I think she would be considered a liberal. The idealism, however, was not motivated by political convictions or anything of that sort: it was based, in her case, on religion. It was quite literal, and sometimes it was difficult for her to manipulate social and professional contexts which were hostile toward it. . . . She was absolutely resolute, a little on the puritanical side, not in the sense of mere restrictions or moral concepts but in the sense of independence and hardheadness of deep conviction, based on religious idealism.

. . . I don't think I could go on with my work, except in a purely blind routine fashion, if it weren't informed by a great many beliefs that are religious. For example, take the business that we confront constantly,

Chancellor Ransom in his office

the underprivileged Texas Mexican or the problem of racial relations with the Negro. According to any definition hereabouts, I am liberal in these areas. But my liberalism does not come from such arrangements as the economic order of the valley farmers or the political attractions of some of the joint ethnic movements. I simply believe that human beings are human beings.

Chancellor Ransom said, "I think there are points at which we are imponderable to ourselves, and when we reach the place where there just aren't any answers, we are either blank and frustrated, or we rely on something that we have not concocted or analyzed. This comes around sooner or later to something that can be called religion."

American colleges and universities in the 1960's were shaken by those students who had gotten a new religion—the idea that these institutions which suddenly appeared so vulnerable could be so modified and changed as to solve a set of problems different from the traditional ones of education. What had given them this idea? Possibly men like Ransom, but not because he yielded to the students.

Ransom presided over the University of Texas System, one of the largest universities in America, renowned for champion football teams and for its special library collections. Ransom has said that he "relies on support of both by university alumni"—a politician's way of putting it. The two elements coexisted for a time along with an over-all non-acceptance of national academic norms.[1] Department by department this last was steadily changing during the fifties and the sixties.

By the latter half of the sixties, some 28,000 students attended classes at its Austin campus, where the English Department alone was the size of a small college. Texas **still had** "not attracted a significant number of out-of-

state students," said Jencks and Riesman, but it drew from a state which was "really a small empire, combining Southern and Western attitudes and individuals" and had "a comparatively heterogeneous student body, including enclaves of almost every sort."[2] It is, however, important to note that by 1973–74 the University of Texas still had only 412 black and about 1,600 Mexican-American students in an enrollment of 41,000.[3]

Like other such institutions during the sixties, the University of Texas faced disruptive action on the part of its students, particularly those who were members of the radical Students for a Democratic Society. This group was founded in 1962 when 59 students from 11 colleges, meeting in Port Huron, Michigan, called for "a democracy of individual participation."[4] They struck a responsive chord. By 1968, *Time* estimated that the SDS had about 6,000 members paying national dues. It claimed chapters on 250 campuses and was estimated as a rough amalgam of 35,000. By 1969, *The New York Times* reported 70,000 members on some 350 campuses. The group remained relatively unknown even after the furor at the University of California's Berkeley campus in 1964 but achieved notoriety when it succeeded in closing down Columbia University in the spring of 1968, which perhaps accounted for what was estimated as the doubling of its already good-sized membership in a year's time. By the end of the decade, sociologist Robert Nisbet was to write, ". . . 'participatory democracy' in university affairs has not only sapped the foundations of any coherent system of authority, but also created a setting of instant and chronic politics that makes serious teaching and study all but impossible."[5]

Hindsight (in the form of Wilson Carey McWilliams)[6] now tells us that the SDS effectively died in 1969. Certainly the willed brotherhood began to cool and the more violent splintered off to become "Weathermen." By the early seventies the SDS student was an anachronism on campus, where ideology was dwindling and a modicum of civility returning. (Ronald Berman, however, noted that "life on campus has become tolerant of failure but not of disagreement.")[7] The popularity of liberal-arts majors began to decline along with the economy and droves of students turned toward more serious career preparation.

Compared with what was happening on other campuses, the University of Texas' troubles in this respect were mild but symptomatic. In 1967, when Ronnie Dugger and I met at the Driskill, Austin's seedily aristocratic hotel with its own place in history, he described the situation to me:

> You see, you have a lot of students here who are provocateurs, and non-students who are just itching to put the university in a position from which it cannot extricate itself without a stink. I mean, you know that.

That as a matter of fact was the basis of a conversation I had one time with one of these people around Ransom: that you sort of had to come to an interior decision of your own whether you wanted the university to be put in an impossible position, which it could be or not, and I didn't. I thought Ransom had brought it a long way. I wanted communication between the administration and the people who *would* communicate out of the SDS's environment.

Dugger had been a student at the university and had then become editor-at-large of *The Texas Observer*, an independent, liberal sheet that serves as gadfly to Texans and has achieved a national reputation.

The Texas Observer reported one of the regents of the university as saying that Ransom's success with the Board of Regents could be attributed to the fact that he was not a political liberal and the board itself was basically a conservative body. "Ransom is a liberal in the sense that he is for the individual and for the underdog. . . . He is, you might say, apolitical"—a judgment with which Ransom agreed.

Dugger said that Ransom "was very political in a way":

If he went to testify at the legislature his testimony was always very on the point and very managerial and businesslike, and he seldom made a stirring announcement. I was mentioning to you his series of columns in *The Texas Quarterly*, the principal characteristic of which, as I said, is that they are dealing in apparently vague and suggestive ways with highly civilized ideas, but these ideas are never stated clearly in the sense that something comes to a point, that you can isolate. . . . He never really committed himself.

Which allowed people to believe anything they wanted to believe.

Said Logan Wilson, former chancellor at the University of Texas System and under whom Ransom had come up through the ranks: "[Willie Morris[8]] thought Harry Ransom was a good deal more liberal than I was. Actually, he has a much more permissive style of administration."

"As an academic politician," Dugger said, "Ransom had insulated the university for a time from the pressures of the philistines in the business community and in the legislature. The university had become a fairly tranquil place, with the disputes and debates regarded much more tolerantly than they had been in its past. Then the SDS learned that Hubert Humphrey was coming to Austin to speak, and they wanted to hold a meeting to plan a demonstration. Ransom issued a statement quite unlike him, quite unlike the style we'd become accustomed to—with high visibility for controversiality—attacking SDS and prohibiting their meeting."

"It's not like the Army," Logan Wilson said. "A military officer gives

orders and they get obeyed: you don't run a university this way. You have to persuade professors to go along with you."

Ransom said,

> When I was dealing with the Air Force I learned then, in the military establishment, things that have been invaluable to me in educational administration. I think most significant—this sounds a little bit pompous, but it's true—are the possibilities in a very rigid organizaton (such as sometimes our academic departments profess) of preserving a highly individualistic talent.

Ben J. Grant, who was to become executive vice-president of *U.S. News and World Report*, got to know Ransom when they both were assigned to the training-aids division of the Army Air Forces and then the School of Applied Tactics at Orlando, Florida. Ransom did not care for his situation there, and Grant, who had become involved with the production of *Air Force* magazine, brought Ransom up from Florida to the Pentagon in 1944 and set him to work on a handbook for the Army Air Forces, which was to be printed and distributed by Pocket Books, a commercial paperback publisher. Ransom stayed in Washington until 1946, finally as director of the *Air Force* editorial office and "sometime liaison officer" with agencies like the Office of Education. He bought a house in Alexandria, where he lived with his mother, to whom he was devoted, and Grant rented living quarters only a block or so away. Ransom did not have a wide acquaintance: Grant was his closest friend in Washington. Even so, Grant never discovered that Ransom was not an only child (having half brothers and sisters). Ransom did not talk much about his early life, Grant said, nor did he "volunteer very much of a personal nature."

> So far as I'm aware, Harry's living with his mother did not delay his marriage to Hazel or influence it at all. This I just don't know about. . . . We didn't have very much social contact because Harry was working very hard. He was working on his book at night. Pretty nearly every night, in my recollection, he went to the Library of Congress and after Hazel came to town she went with him. They worked together at the Library of Congress with source material.

The bibliography of English copyright history on which Ransom was engaged was circulated rather than published and he "stopped this work when photocopying of records at institutions such as the Library of Congress and British depositories provided fast, accurate accounts."

"Hazel" was Hazel Louise Harrod, who had been a teaching assistant at the University of Texas, where Ransom had gone in 1935 as a three-quarter-time instructor in the English Department. Ransom attained the rank of major during the war and afterward returned to the University of Texas.

He and Miss Harrod were married in 1951. He was "obviously a scholar," Grant said: a "studious" man, "pleasant . . . soft-spoken . . . quick smile" and "very likable."

What did he want then?

"To continue his career in education." Ransom never considered anything else, said Grant, who never heard him suggest that he might follow a literary career.

I could not make out what Ransom's wartime experience might have taught him of "the possibilities in a very rigid organization . . . of preserving a highly individualistic talent," unless it was that people could always do their own work on their own time. But I wondered to Ransom some twenty years later whether, "running a university in these times . . . you don't perhaps have to think more than other men in other kinds of organizations about the problem of permitting individualistic behavior." Ransom tended to agree.

"In the first place," he said, "universities have changed. This one is not remotely what it was. Though a state university, it really was relatively homogeneous, and easygoing, and except for lack of finances and specific problems like that, was unperplexed in the Depression years. Now the university is a regular concourse between two coasts and two countries, Mexico and Canada. Its population has completely changed. Even with the heavy weight of recent tradition and conservatism in Texas, all of the tradition early in Texas was individualistic. The activists presently arrayed in the United States aren't anything like as active—socially, politically, economically—as the early populists in Texas. Brann,[9] for example, who unluckily got dubbed 'iconoclast.' In his context, he would make most of the present activists look like pussycats."

Ransom's point was that the conservatives in Texas are also individualistic, which keeps the whole state in constant flux. He went on to say:

> There is an area where the university is going to continue to have problems [this was in 1967]. This last spring the point had come when a student organization publicly announced that it was going to take over the campus and its administration. I had to put my foot down and say, "You are no longer a member of the student organization group." These were the Students for a Democratic Society.

SDS events throughout the country were widely publicized in spite of the small percentage—estimated at 2 percent—of radicals in a national student body of some six million. *Look* magazine, in its October 1, 1968, issue, carried the remarks of an SDS "leader" at the University of Texas. Gary Thiher thought the group there had "a different style," not resembling SDS at Wisconsin, Columbia, or San Francisco State, for example.

But his remark that "we are trying to get the students to see that *they* should be controlling the university" seemed not so very different.

Most of the nation's 2,300 colleges and universities either had not been disrupted or else had encountered only flurries. The news media— press and TV—undoubtedly helped to exaggerate the disorders simply by focusing on them. But from an administrator's point of view, sometimes the problem seemed to lie in the refusal on the part of black or white students to negotiate: they were trying to change the game itself. Mark Rudd candidly stated that the issues were so much "baloney." In an open letter to Grayson Kirk, president of Columbia, Rudd wrote, "If we win, we will take control of your world, your corporation, your university, and attempt to mold a world in which we and other people can live as human beings. Your power is directly threatened since we will have to destroy that power before we take over."[10] And, as Ransom said,

> the newest organizations in dissent at the University of Texas—I presume like those in many other parts of the country—have refused to elect presidents and vice-presidents and secretaries: they have a momentary chairman or foreman or boss. They deliberately don't call their organizational leaders by titles. This itself is a recognition of the fact that everybody is presiding. I must say this causes, for an elder like me, some confusing conversations.

College and university presidents tended to think in terms of effecting a balance—classic American politics, but, under circumstances where one side refuses to negotiate, obviously impossible. So a balance was effected by calling on the law, which sometimes was represented by policemen, although by tradition the university was a sanctuary where police were not supposed to intervene. Terrible events began to occur. In California, one boy was blinded and maimed by his own bomb. At the University of Texas, one of the pickets at the Humphrey speech—a member of the SDS—was arrested the next day for "abusive language" during the event. Not long afterward, he was dead, shot at the grocery store where he worked in what looked like a robbery.

A report to the National Commission on the Causes and Prevention of Violence stated in 1969 that there were

> only two inherent limitations on such an escalating spiral of force and counterforce: the exhaustion of one side's resources for force, or the attainment by one of the capacity for genocidal victory. There are societal and psychological limitations as well, but they require tacit bonds between opponents: one's acceptance of the ultimate authority of the other, arbitration of the conflict by neutral authority, recognition of mutual interest that makes bargaining possible, or the perception that

acquiescence to a powerful opponent will have less harmful conse-
quences than resisting to certain death.[11]

This lack of tacit bonds led ultimately to the slaughter of students at
Kent State and Jackson in 1970.

As the fifties had come to a close, elements of mutual interest had
appeared to be lacking on campuses but in fact were not. What was
lacking, increasingly through the sixties, was the trust which would pro-
vide the means to find them. One theory was that the democratization of
the university had given it less authority and made it appear vulnerable
and therefore less trustworthy. Other establishmentarian institutions were
attacked, including *The New York Times*. The publication of a story in
the *Times* about Grayson Kirk "enraged dozens of readers who saw Dr.
Kirk as a villain of the uprising, a reactionary administrator whose inepti-
tude had fomented the discord, and whose tolerance of the university's
involvement with government military research projects was an affront
to the integrity of Columbia."

> On May 2 [1968] eighty-two young people assembled outside Punch
> Sulzberger's home at 1010 Fifth Avenue, demonstrated for forty-five
> minutes, and chanted: "*New York Times*—print the truth!" They charged
> that the *Times*' reporting of the Columbia protest had sided with the
> administration and had shown little understanding of the students' po-
> sition, and they also questioned the ethics of a *Times* publisher [Sulz-
> berger] who served as a trustee of a university that was regularly in
> his newspaper's headlines.[12]

Another theory, maintained by Lewis Feuer,[13] was that this was a
complicated generational revolt. But a student who had been at Berkeley
insisted that generational conflict was

> so ancient and archetypal a social mechanism—certainly it functions
> in almost every revolution, political or artistic—that it affords little in-
> sight into the campus turmoil.[14]

Neither side had an entirely tenable position. It was widely recog-
nized that students had legitimate grievances—depersonalized teaching,
for a starter (Ronnie Dugger points out that "of the 1965 graduating
class at Berkeley, only 8 percent had received any individual instruc-
tion").[15] But the last of the sixties saw the blacks, who undeniably had
more grievances, disassociating themselves from the SDS as their purposes
became increasingly differentiated. "I do not find [idealism] to be a mo-
tivating source of political activism among the students I've known," said
a participant.[16] It was obvious and in fact so stated by the New Left,
anti-establishment students that they chose specific issues largely to attract
uncommitted but idealistic students, taking advantage of the gulf that

existed between these and administrations.[17] *Harper's Magazine* printed an article which claimed that

> radical ideas have shown the ability, in the last decade, to spill over to great masses of people who are not actually radical. The jargon is appropriated, the assumptions taken over, and these apparently super- ficial things inevitably become a part of the way people behave. TV may have something to do with this diffusion of what are, not so much ideas, as styles.[18]

By the very end of the decade it was not only despairing parents who began to wonder whether, in the future, a college education would be considered less necessary for "success." Undoubtedly not in the so-called professions—law and medicine, for example. But as for the general cultural background that colleges and universities had hitherto been considered as providing, might not television successfully do that?

Style was the rage, and it became a commonplace that America's young people thought the "Establishment" was anyone over the age of thirty. Discontent focused on that vague, amorphous monster. But their elders knew things were not that simple. Joseph Kraft, in *Profiles in Power*,[19] commented that the Establishment had been located by Richard Rovere in the Council on Foreign Relations and by Theodore H. White on the East Side of Manhattan, where those who controlled the communications media tended to live; that C. Wright Mills thought Labor and the Military had "coopted" into the Establishment and James Newman declared so had the Scientific Elite; that Karl Meyer said the Washington Press Corps was Establishment-oriented. Stewart Alsop defined the Establishment as a group of men with "Eastern classical, liberal educations, moderate-liberal political views. . . . Rich enough not to worry about money . . . and strongly imbued with the notion that 'public' office is a public trust."[20] Dissenting students saw a vulnerable establishment close at hand.

Semanticist S. I. Hayakawa, newly installed president of San Francisco State College, at first was to stand out among institutional heads in his refusal to negotiate with students. Then, as initial astonishment wore off, repressive measures became more commonplace. In Texas, the rules of the Board of Regents were found by a court to be "of the same force [as] a like enactment of the legislature,"[21] and the nine regents ruled that anyone participating in a disruptive demonstration could be expelled. This was something other colleges had been reluctant to do, believing it constituted overly severe punishment since it would automatically cancel student deferments and render the rebels vulnerable to the draft, which in turn opened up the possibility of service in Vietnam.

Ransom's blame fell on outside elements—somewhat the way an affectionate father might blame outside influences for his own child's bad behavior. "The element," he said, "that puts me sometimes in a false role —it's false to me—of seeming to be fairly heavy-handed about the uses of campus schedules and properties and so on, is the fact that the great change has come about by penetration of the campus by people completely outside the campus." But another observer, Kenneth Keniston, commented of the United States at large:

> . . . student activists generally *are* students: the much-touted "nonstudents" involved usually turn out to be graduate students, plus a few students on leave of absence, ex-students, and students' wives. Whatever evidence is available—and increasing amounts are—consistently suggests that student activists are selectively drawn from among the most talented and committed students in the humanities and social sciences, that they are largely concentrated at the most academic colleges and universities, and that in most cases their professed public motives are quite adequate to explain their behavior. Perhaps the basic motive of such activists is their desire to make public their private convictions, indignations, and sense of moral outrage—and to change specific sectors of society so that they will no longer be so outrageous.[22]

But Ransom professed not to see the situation at the University of Texas that way. "The Stokely Carmichael incident [in which hostility was expressed toward Carmichael as a black], for example," Ransom said, "which actually was a boring, purely routine, although it was mounted as an enormous spectacle with a whole lot of advance publicity and organizers and money raisers and so on, was at least fifty to sixty percent energized outside the university campus. It was during the week that followed that the SDS decided that they were going to abandon all rules of the university, without regard to any kind of protection of anyone concerned, and without any kind of arrangement with the university, hold a Sunday meeting in protest. When they were stopped from doing this, they focused on Vice-President Humphrey, who is perfectly capable of taking care of himself, and the law enforcement officers who are quite capable of taking care of him in the other sense. They immediately thought somehow there must be some kind of skulduggery from the White House or the Governor's Mansion or something or other; and that the university was being manipulated politically." But why should this thought not have occurred to the more knowledgeable students, in view of the university's past?

John Silber, at the time chairman of the Philosophy Department, in a moment of youthful exuberance and naïveté, as he put it after the fact, said, "The Board of Regents is composed primarily of politicians, who's kidding whom?" He told about the time "some of our more naïve pro-

fessors and even doubly naïve students got up a petition that Frank Erwin should either resign as state chairman of the National Committee of the Democratic Party or as a regent of the University of Texas, because he should not have this conflict of interest. Well, I'm wondering, *what* conflict of interest? I don't *want* a regent who's not a politician. If that guy can't shepherd our appropriations bill through the legislature, he's not ever gonna do us any good—then we have all the disadvantages of the regents butting into the affairs of the university and none of the corresponding advantages of his getting our appropriations bill through the legislature. I'll settle for Erwin's intrusions on campus if Erwin will deliver the appropriations bill.[23] And I think we have a damn good bargain when we have that. What I don't like are these third-rate politicians who are on the Board of Regents, but when you get a first-rate politician like Erwin, I'm delighted."[24]

How about members of the state legislature?

"Yeah, well, they're relatively insignificant—I thought you were talking about important politicians. Why Harry Ransom should spend time talking to an individual legislator is hard for me to see: he'd have to talk to a hundred and fifty of them. If he talks to a guy who has some directing role with regard to them, he can save his time."

Silber said Ransom had made a bad decision about that 1967 SDS meeting because he'd been poorly advised by the Dean of Students. "We need to remember," Silber said,

> that this was just after Stokely Carmichael had been on the campus, and the administration had been deluged with threatening phone calls —you know, "This nigger won't leave the campus alive." "If you let that nigger speak, he's going to be shot before he can get off campus." You know. The telephone lines were ringing all day long with these threatening phone calls. And they must have had two hundred policemen on that campus when Stokely Carmichael came—to see to it that he *didn't* get shot.
>
> They discovered that there'd been a tremendous purchase of—oh, something like twenty or forty dozen eggs by a fraternity. I'm told that the chairman of the Board of Regents went to see the fraternity—the president of the chapter—and told him they'd better start getting out skillets and frying those eggs because he damn sure didn't want to see 'em on campus. And if they wanted to put an end to the fraternity system at Texas, just let those eggs appear on campus in the form of something being thrown, and the University of Texas would probably discover it could live without those fraternities. And no incident happened. But the administration was legitimately concerned. It was concerned to the point where it would not have been unreasonable, though I think it would have been a mistake, had the administration called off

the speech by Stokely Carmichael. They didn't call it off; it went through and there were no disturbances. But it was a very harrowing period and it called for the hiring of many extra officers.

Ransom said:

Frankly, what concerned me was that there were no campus cops available to take care of such a demonstration on Sunday, and with twelve hours', twenty-four hours' or so, notice there was no way of making the kind of protection that we'd given Stokely Carmichael six days before available to people who were being threatened by telephone constantly in my office—physical and reasonable protection.

The *New Republic* felt that Ransom had "squelched students who speak out against establishment-sanctioned opinion."[25] The magazine pointed out that he had said "the university didn't have the men to handle the rally which had been called by the fifty-member Students for a Democratic Society," and for which three hundred people had turned out.

But Ransom stated that the numbers game was beside the point:

Of course, if we are talking about twenty-seven-odd thousand students, the group that could predominate here on the campus in the total community are students who are doing their very best, and sometimes at great sacrifice, to get an education. Sometimes they are under high pressures which they themselves create (this is a major problem which we are trying to redress with a new counseling system).

Within the group of dissidents (which changes, incidentally—it's a very fluid condition) and leaving out those people who are no longer members of the university, or who never have had any connection with Texas or the university, I don't think there is a predominant group, and I think students would be the first to say so.

"But our problem, our real difficulty," he went on to say,

comes in a curious mélange that everybody—including of course me—*everybody* tries to oversimplify academic society by saying there is a single issue. There isn't. There are all sorts of disruptive conditions, beginning with the basic one that the college and university experience among students who are still here studying is itself a series of traumatic changes. Youngsters don't move from freshmen at seventeen to graduate students at twenty-two without going through tremendous changes.

It seems to me an asset which we may be mishandling—that students do consider themselves, prior to graduation, citizens of the community and the state and the country. I think we are in a much more parlous condition in the academic community in 1967 than we were in, say, 1962, when our protests began to mount. I think these are much graver protests than they were. They are by and large among the more intelligent students, and many of them are very intelligent, more cogent.

"My only concern," Ransom continued, "is—well, two things. One is the preservation of some sort of respect for law; and second, of course, locally my immediate concern (because I am not a law officer nor do I pretend to be) is the preservation of the process of the university. . . .

"No, my attitudes haven't changed. . . ." But the context in which he found himself had.

DRAWING BY ROBERT DAY. © 1967
THE NEW YORKER MAGAZINE, INC.
REPRINTED BY PERMISSION

"As president of a great university, sir, what would you say is the most significant change you have observed in the last twenty years?"

CHAPTER 4

THE DREAM OF A COMMUNITY OF SCHOLARS

(*Individualism within the institution*)

WILLIAM JOVANOVICH HAS SAID, "One of the aims of education is to make you respectful of learning and humanism, even if you don't participate in it, even if you don't pursue it yourself. It is not the strongest aim of education, of course." What are the purposes of a university? In 1915, the American Association of University Professors declared them to be:

A. To promote inquiry and advance the sum of human knowledge.
B. To provide general instruction to the students.
C. To develop experts for various branches of public service.[1]

Laurence Veysey argues that three new concepts had entered the picture between 1890 and 1910—utility, research, and the diffusion of liberal culture—at which time the modern university assumed its present form.[2]

The legitimacy of any major institution cannot depend upon agreement of purpose, said Robert Nisbet. Answers were arrived at only through "continuous historical function, through common, if diversified, effort over long periods of time . . . and, often, through collisions between the university and other institutions."[3]

Ramifications of the changes became more complicated as the century progressed. Few might doubt, for example, that research or the promotion of inquiry on an individual or programmatic basis should be consistent with "the aims, objectives, and potential capability of the institution."[4] But was applied research—especially as it related to war—

consistent with the basic purposes of a university? Many students thought not. They attacked government funding, which had increased tremendously in the period between World War II and 1970, as antithetical not only to the interests of the student but also to the best interests of society. In fiscal year 1967, among non-profit institutions the University of Texas ranked 109th with defense contracts totaling $4,618,000.[5] Ronnie Dugger later reported:

> Dean of Sciences Sam Ellison told me, one day after going over the figures in 1972, that sixty or seventy of the science faculty, about a fourth of them, consult for pay, and that about half the engineering faculty are in continuous consulting relationship, but he refused to let me see the list of these specific relationships. . . . More explicitly, Ellison says a professor can work for outside interests "four days a month without any reduction in your salary," that is, about a fifth of a five-day week.[6]

"University complicity," this was called. But on the other hand, many educators wondered whether the aims of the university ought not be redefined to connect basic research more closely with the needs of American communities. They saw supported research not only as helping the university to pay its bills but also as beneficial to "the educational, scientific and technological development of the United States,"[7] and to its cultural development. Nisbet saw the authority of the university lessened by the professoriat pursuing grants: the university's function should remain its traditional one of neither research center nor the setting for that creative work which constitutes high culture.[8]

In 1930, Abraham Flexner—who had conceived the Institute for Advanced Study at Princeton and served as its director—defined the appropriate attitude of the university professor toward practice. He said:

> Pasteur was a professor of chemistry. In the course of his professional career, the prosperity and well-being of France were threatened by silkworm disease, by difficulties in the making of wines, in the brewing of beer, by chicken cholera, hydrophobia, etc. Pasteur permitted himself to be diverted from his work in order to solve these problems, one after another; having done so, he published his results and returned to his laboratory. His approach was intellectual, no matter whether the subject was poultry, brewing, or chemistry. He did not become consultant to silk-worm growers, wine makers, brewers, or poultry men; he did not give courses in silk-worm growing, wine-making, or chicken raising. The problem solved, his interest and activity ceased. He had indeed served, but he had served like a scientist, and there his service ended. This is not the usual way in which the American university does service.[9]

The academy had built both its achievements and its pretensions on the possibility of objectivity, said Jencks and Riesman.[10] But was it possible

or desirable to be objective in a world in which so much was so patently wrong? Students began to elevate anti-intellectualism into a cult of "experience." Two views of education, the experiential and the professional, "wrestle like brothers, two-thirds in earnest," wrote the associate director of a study on the future of liberal-arts colleges.[11]

Linking the two modes of knowing adequately depended on the abilities of particular teachers whose jobs were made harder as student-teacher ratios rose and as the end of the 1960's saw an open-enrollment policy go into effect at the City University of New York while a host of other academic institutions attempted to accommodate students who would not earlier have been considered qualified for admission. The University of Texas, however, had generally maintained admission policies which were not discriminating.

"Let us not discuss the University of Utopia . . . but the University of Texas, which comes earlier in the alphabet," Ransom said.[12] It would be a waste of time, money, and mental power to let everyone graduating from high school into a state university; proper counseling would help students to see where it was not to their advantage. On the other hand, Ransom indicated, the assumption that the college population is an intellectual elite neglects the idea of counseling as a tool and limits or postpones opportunity for "the highly motivated but poorly prepared student."

Ransom believed, he said, in a third policy: one which "assumes that different disciplines require different abilities." Where would he guide the poorly endowed student? asked his interviewer, Mr. Dugger, and reported that Ransom did not like the term. "Climbing to the Acropolis they may get there on their knees," he said, "but by golly a lot of 'em get there." Individual development could legitimately be regarded as the primary aim of education, he was inclined to believe. But some believed such super-humanitarianism was detrimental to what *they* saw as the primary aim of education. Did this not slow the classroom pace? asked Mr. Dugger. Dr. Ransom replied, "It obviously does not—either in the good or the bad sense—produce the intellectual elite which many universities would like to produce."[13]

This dichotomy was an old story. Philosopher Paul Weiss stated the other side of the argument as follows:

> To maintain the highest possible standards of *education for responsible leadership* remains one of the prime obligations of the universities, those of the future even more so than those of the past. . . . The most important task is to give that scarce supply of individuals with superior talents, paired with responsibility, a challenge and opportunity to develop their native faculties to the maximum; this means placing quality above quantity, with a premium on excellence. Public support for this precept is one

of the adaptive contributions society must make if the evolution of both universities and society is to be kept in a dynamically self-adjusting correspondence.[14]

But Weiss also believed it vital to strengthen and broaden mass education: followers must be able to understand convincing arguments on the part of their leaders; they must never merely comply with dicta.[15]

It was the obligation of the state university to take on the task private colleges shirked, Ransom believed. He was, John Silber said, willing to postpone a day of fulfillment for the institution out of concern for the individual. Ransom's belief in the possibility of help to others was religious, by his definition of religion already given. "If Harry has a major fault," professor of English Ernest Mossner said, "it stems from one of his major virtues, his enthusiasm. His enthusiasm sometimes leads people to think he can do more for them than he really can, when the pennies are counted."[16] His audience would come away from his presence vaguely uplifted but later unable to say exactly why. "I've been Ransomized," said some.[17]

This bespectacled, stocky, five-two, and, toward me, somewhat wary man with a crew cut had in 1961 become chancellor of the University of Texas System, an enormous complex with ten components spread throughout the state. The bulk of the main campus lies between Guadalupe and Red River streets in Austin. Here, where the principal administrative offices of the University at Austin and of the University System were housed, a 307-foot tower, erected in 1937 and faced with a clock, marked the campus.

"This architectural curiosity," as Ransom put it, was also designed as a library and as such assisted, or tested, "scholarly pertinacity, depth of bibliographical penetration, breadth of comparative studies, and sophistication of intellectual judgment. In other words, it is unusable by freshmen and sophomores," said he.[18]

Ransom's offices were on the first floor, toward the south. Paneled, distinguished, library-like, they contained some remarkable art, not the least of which was a Tchelitchew portrait of Edith Sitwell. Ransom told me he changed the paintings in his office every few months and regarded them as a sort of test for people—a "Rorschach." I remembered Barnaby Keeney's remark that culture is almost a hobby for university presidents. The State Capitol, to be seen above the treetops, perhaps half a mile away, vividly symbolized the role that political power plays in the life of a state university.

Lowry had said:

When I first met Ransom, he wasn't even a dean. I met Ransom because I went to his house to look at some of those Hudson River School paintings. That's the only reason. Because I was noodling around the country about everything, including painting and including the kind of thing that he was doing in *The Texas Quarterly*. He was just a professor that

was known to be interested in those things. [He impressed Lowry on that occasion] very well. Better than he has struck me since. No, look, he's a very good man in that position and he has got a kind of independence because of his scholarly claims. He has dignified university administration and shined up for the region, see, the image of a professor because he's just as political and savvy and trustworthy in an administrative crisis or a political crisis as another Texan would be, but also constantly gives out emanations that are about bringing the best minds to Texas and paying what's necessary to get them there and giving them the freedom and responsibility to work. And he's doing it.

In the summer of 1967, as I looked down from the tower, the red-tiled roofs of the university buildings appeared neat and attractive in spite of the brown dust of much construction going on around them. The small police boxes, where guards occasionally stopped cars on Speedway, a broad avenue through the campus, as well as on the drive leading to the administration building, seemed to me much in evidence. I turned out to be almost the only person on the campus walks although the university was in summer session. It occurred to me later that others might know more than I did about the heat of a Texas summer. It was overwhelming. I would walk a few yards only to stop and rest under the next shade tree, my perfectly healthy but unaccustomed heart thumping away. I did not stay long in Texas, partly because the situation seemed much more accessible than the others about which I planned to write, although to my mind it had more of an interesting cast of characters accompanying the star player.

"She has a remarkable character: she is a very brave, very intelligent and completely devoted person," said Ransom. "I never have seen any greater institutional devotion here or anywhere else than hers at the University of Texas—completely altruistic."

Ransom, predictably, was not the only one of the nine men to have a dedicated woman working for him. So did Stanton and Jovanovich; and also Congressman Thompson, Hedley Donovan, and W. McNeil Lowry. Catledge (who had male secretaries)[19] and Lieberson and Goodrich, apparently not.

Frances Hellums Hudspeth,[20] a lady inadequately described as Dr. Ransom's executive assistant and also as being rude, showed me the Undergraduate Library and Academic Center, which were combined in a single structure completed in 1963. The (per brochure) "limestone, shellstone, granite, mosaic tile and heat-absorbing glass" building appeared to her as the university's finest possession. Although too crowded by other buildings to show itself off to best advantage, its interior varied spaces—from open plaza arrangements to individual study carrels to small rooms glassed in for music and conversation—in a manner apparently attractive to students,

since it was well used. Too, students had an open-shelf library of some 60,000 volumes to browse through.

"The tremendous growth of graduate programs, the equally great problems of library security in a building with a more complicated design than a prairie-dog village [the main administrative and library building], the faculty's quiet surrender to textbook selections and cheap reprints," said Ransom, had made such a library difficult to effect at an earlier date.

"When Harry developed that thing," Silber said, "people on that campus called it 'Harry's Folly.' Why? Well, they didn't think that the undergraduates needed a special library and that they wouldn't use it. Why, that thing is so crowded, right now. It's been crowded ever since it opened."

The libraries at the University of Texas were Ransom's pride and joy. Although bibliography became one of his major concerns only gradually at the University of Texas, he was interested early in his life in the collecting of books and, as he put it, "in the physical properties of the book," by his father, who taught Latin and Greek in a Galveston high school.

> My first memory of my father is his running up and down the halls chanting one of the Homeric passages or another. He was a relatively small man, with fiery red hair and a temper that went with it but that was governed mainly by his ability to explode his emotions with words. He came out to Texas to teach because the family was pretty well impoverished in North Carolina, after not being impoverished. He was a man who in the sloppiest kind of Southern rhetoric was a casualty of the post-Civil War period.
>
> He was a classicist but unlike most of us in these days a very broadly based one. For example, he was an excellent mathematician, very much interested in science, very much interested in all sorts of people . . . [including] persons from other climes and other environments and other cultures. He was not the sort of pal-companion father but very affectionate and very attentive to my interests in ideas and language even during his critical illnesses, until he died.
>
> For a relatively poverty-stricken teacher in those days, he had a large library. He was a book collector in what we would now consider a modest sense, but what in those days was for the family a hideously extravagant arrangement. My half brothers and half sisters were nearly grown when I became aware of books at all, so that the books around me were my father's books and their books. My father had no prissy or pedagogical notions about reading, he simply thought it would be a good idea for me to read things like translations of the *Iliad* because it was an exciting story, not because it was a classic. So I opened my eyes on books which I didn't understand, I'm sure, fairly early. . . . I learned to read long before I started school.

His father died while Harry Ransom was young, and his mother, who

had been trained as a medical missionary, took her son from Galveston to Tennessee, where she supported the two of them by hospital work in Sewanee. There, not far from Nashville, Ransom attended a series of private institutions, including the Sewanee Military Academy.

"Everybody in town knew Harry," said Eli Avent, a childhood friend, "and liked him, although he was something of a lone wolf and had a temper under his friendliness that many a kid around here learned to respect. He was what we call 'birchy'—easy to peel off and work with, but tough."[21]

Ransom earned his B.A. in Sewanee, at the University of the South, in 1928. "I worked at a miscellany of odd jobs," he said, "from washing the dishes in a hospital to office boy for the *Sewanee Review*. . . . I found the inky side early—nearly all the jobs had something to do with print."[22]

> When I went to Yale, I went as a confused and undetermined major. I wasn't sure I wanted to go into English. I worked for the Associated Press for some time—I was a sports writer, but in those days, sports writers covered everything from football games to bootlegging trials—and I thought perhaps I might go into journalism. I had taken a premedical and a classical major at college. Very soon after that I came to know Mr. Tinker, who was of course a great book collector.

Professor Chauncey Tinker directed Harry Ransom's doctoral paper. "I found it impossible in those days to think of a Ph.D. in the way in which graduate schools were offering it," Dr. Ransom said,

> and by his grace and lenience was allowed to go to Harvard for an interim to look at the problem of literary property, copyright, at the whole history of the ownership of ideas and literary texts. Then I came back to Yale to finish an essay on literary property, not philological in any sense. I was clearly a bastard Ph.D. and have gone on with my interest in copyright, and in most recent times I have kept learning as co-chairman of the President's Commission on Patents. To the extent that I have a specialty that I can call scholarly—really it is not as scholarly as it is merely amateur—it's in the area of the ownership of ideas and copyright.

After becoming dean of the College of Arts and Sciences in 1954, at the University of Texas, Ransom got the idea of using funds to buy twentieth-century manuscripts, first editions, and "documents connected with modern English and American literature."[23] This particular field was relatively uncollected at that point.

During the 1920's, first editions, etc., had been widely collected in England and America: through the 1930's, manuscripts—which had not sold especially well before—brought "dismal" prices, and it was not until the late 1950's that this began to change.[24] When it did, the change was attributed in no small measure to the buying habits of the University of Texas.

One good, and odd, result was that poets began to make more money from the sale of their manuscripts than they could from the sale of their poetry. Texas, though called the "Moloch of the Market,"[25] woke other institutions to the value of finding funds for manuscript acquisitions.

"Ransom taught them to acquire," said John Fleming, a Manhattan rare-book dealer. He called Ransom a "Grand Acquisitor"—a vulgar phrase —and repeated it twice in succession, underlining the "Ac" to be sure I got the point. Ransom was one of two great collectors in this century, he said (the other being John Quinn, so he believed), and Fleming spoke of how frequently he was on the phone to Texas, giving the chancellor advice not only on acquisitions for the libraries but on other institutional matters as well. Ransom has an "intuitive feeling for what's important and what's not," said this salesman.

Fleming first encountered Ransom around 1957, at a private party in Texas, and remembered that Ransom told him he had always wanted to meet him and that if it was the last thing he [Ransom] did, he was going to build the greatest library. Ransom was unusual in his assumption of this responsibility, Fleming said: "Lots of college presidents resent spending money on rare books and manuscripts." Fleming added that the greatness of a library most frequently depended on either the head librarian or the chief bibliographer. "Some of [Ransom's] personal interests were quite incidental to my backing him for the presidency," Logan Wilson said: book collecting, for example, was just one of a number of things needed to run a university.

The 1960's were "marked in collecting history by the scale, comprehensiveness and speed of acquisition of manuscripts of living writers."[26] Early in the decade, *The Texas Observer*, a somewhat biased source if for no other reason than its location in Ransom's home state, declared the Humanities Research Center at the University of Texas, with Ransom as its director, among the "top ten research centers in the country, with especially strong holdings in the moderns such as Pound and Shaw and Lawrence and Cummings and Kipling." And by 1966, *Life* magazine—perhaps a less biased source—valued the university's collection of rare books and manuscripts at more than $100 million and said that it was one of the "half-dozen finest" in the United States.[27] By the early seventies, some educators and collectors rated the research center on a level with those at Harvard and Yale.

Ransom had conceived of a lecture program, a quarterly journal, and the building of a library collection as natural concomitants—imagining that those who lectured could provide their script as a manuscript for the journal and be persuaded, once so connected, to contribute or sell their papers to the library. Apparently he was right, and Celia Morris, who had been a student at the University of Texas,[28] seemed to feel Ransom's persuasive

success was due in no small measure to the fact that he was genuinely idealistic. She added that Ransom felt close to Texas, wanting to make something of it. "No one would ever resist an invitation to go to the Far West, in Texas," Roger Shattuck said: people like Edith Sitwell and T. S. Eliot (who was paid a thousand dollars) became missionaries for the university and a mythology about it existed until late in the sixties, at which time Texas began to seem just another university.

Ransom was an extraordinarily talented fund raiser, although he is said to think it vulgar to talk about money. " 'Harry Ransom,' [said] Regent J. C. Thompson, who heads 7-11 Food Stores, Oak Farm Dairies and other businesses, 'is the finest salesman I've ever known.' "[29] Joe Frantz, Texas historian, said:

> In my opinion Harry Ransom is the greatest single thing to happen to the University [of Texas] in the second third of the twentieth century. He generated more excitement and a feeling that things could be done than we've had before or since. He was not a great manager, but he was a spectacular promoter.[30]

Much else was in progress or planned on the campus at the time of my visit, including a presidential library and a school for public affairs linked together and named for Lyndon Baines Johnson. The President, said *The New York Times*, "has long chafed under the Eastern view of Texas as an uncultured land and he hopes that locating an outstanding school there could help overcome this image."[31]

The university formed a foundation to help raise funds for the Johnson memorials and asked President Johnson to join the faculty, which he declined to do, but as he left the White House he said he looked forward to teaching a few courses. Johnson visited the campus occasionally after his retirement but did not teach any regular course. The presidential library, during the early 1970's, averaged two thousand visitors a day. There was no staff overlap with the university but some joint sponsorship of symposiums on education, civil rights, and urban affairs as well as lectures and conferences, according to Ransom. The School of Public Affairs was funded as an academic division of the university, and the legislature appropriated $400,000 a year for its regular operations.[32] This it could well afford to do.[33]

Not only does the university receive a large number of gifts and legacies from private individuals, not only does it receive annual support from the state legislature, but receipts from oil and gas bonuses, leases, and royalties have gone into a permanent fund that by 1966 totaled over $478 million. How that came about is quite a story.

"Of all the fabulous things in the Lone Star State," wrote John Gunther, "the most fabulous is quite possibly the University at Austin."[34] Founded

in 1881, it was endowed, in perpetuity, with two million acres of land, a block in central-west Texas that was not considered particularly valuable at the time. Funds from it were obtained by the Regents primarily through cattle-grazing leases. Then, in 1923, oil was discovered. "Today," wrote John Lehmann in 1969, "there are 5,600 oil wells and 130 gas wells, and more than forty million barrels of oil are produced annually on University lands."[35] Two thirds of the income from this source goes to the University of Texas System.

Texas is not the richest institution, per student, in the United States. There are a number of ways to rank funds—one is through the market value of their endowment, and in that case 1963 figures indicate that Texas' $275,769,000 (at that time) endowment placed it only behind Yale and Harvard[36] among both private and public institutions. By 1967, it had the second largest endowment, behind only Harvard: half a billion dollars, not counting the capital value of the oil lands.[37] "If they sold all that and bought stock, they'd be a lot wealthier than Harvard is," said Logan Wilson, who regarded as one of the successes of his administration a change in the very conservative investment policy. At the end of fiscal 1972, the University of Texas fund totaled two thirds of a billion dollars, with $11 million being earned yearly in stock dividends.[38]

The average per student, however, is in some ways a more significant figure, with Harvard itself outranked:

The California Institute of Technology (a private technological institution): $84,874

The Colgate Rochester Divinity School (a private, theological institution): $69,812

Harvard University: $67,925

Texas, with its $11,613 average per student, was outranked by sixty-one other institutions.[39]

In 1963, the total endowment for all higher education amounted to about $9.36 billion,[40] and an interesting comparison can be made with foundation assets for approximately the same period, which were estimated at $12 billion.[41] Robert S. Morison commented that university endowments are now a "less accurate index of financial strength. Many of our best universities," he said, "depend quite happily on regular legislative appropriations," and added that grants from the federal government and industry also have become regular enough to take the place of endowment income.[42] Some of these grants, however, must be given for those very activities to which students were objecting, and "quite happily" seems rather an over-

statement even in Ransom's case, in view of his constant involvement with legislators.

In October 1967, *Fortune* magazine estimated that by 1973 the combined deficits of twenty sample private colleges would amount to $45 million. The last two decades had been marked by a shift from private to public institutions on the part of a majority of enrolled students. And although fees were increasing, costs were going up even faster[43]—partly, one presumes, because increasingly funds were being used on other than the teaching of students (including the acquisition of rare books and manuscripts; the collection of manuscripts serves as a general expression of faith in "intellection and sensibility"[44] and as such is of great value, but the process of collection *can* have little to do with education). If there were other possibilities for channeling those same funds, it was a situation about which students might have some legitimate complaints. But a situation in which they were for the most part powerless. Certainly they had been able to do nothing about "one of the Texas regents' most original contributions to higher education, a $1 million [chancellor's] mansion."[45] (This mansion, built after Ransom's retirement, was occupied by his successor, Dr. Charles A. LeMaistre, regent Erwin's personal physician.)

At Texas the income from the endowment used to be only for buildings. "Some people," Logan Wilson said, "thought that was all they *could* use it for. This was a matter of persuading the board to use it for salaries and books and building up the libraries." Fund raising is expected of the presidents of private colleges and universities, and the heads of state institutions are expected to be able to handle effectively both budgets and politicians—Wilson and, after him, Ransom no less than other college or university heads, although financial problems bulk larger elsewhere than at Texas.

Logan Wilson said, "Harry Ransom is first of all an academician and a scholarly type who has some flair for administration. It's not often you find this combination." Lowry said Ransom's greatest image of himself was "as a faculty colleague, not as an administrator." Mrs. Morris told me she wasn't sure how the university had survived with Ransom running it, and a number of people commented on what a haphazard administrator he was. Ransom himself admitted it: "I think I'm a perfectly terrible administrator," he said. "I came into administration by working with students: I was a counselor in Plan II for the B.A. degree. In rapid succession I worked in other offices, but my administrative work is carried on by very able colleagues. I am not systematic—look at this table!" It was covered, but papers and books were piled, not thrown, on.

A university has been defined as "a large body of talent surrounded by people who want to give it money,"[46] some of which it doesn't necessarily

want. Ransom's presumed lack of administrative ability may have been useful to him in covering up other reasons for his behavior. Take what happened, for instance, when the Ford Foundation in 1963 became interested in the idea of funding a National Translation Center at the University of Texas.

Lowry said:

> We had busted our buckets over two other translation projects that we never managed to find a handle for—one about the theater, about new plays, back and forth, and one about the opera libretto. We spent an awful lot of time with a negative result on those two—not negative results as to the objects but how to do it. The machinery was so large that it was incommensurate with the end. It really takes—for a play it take two playwrights and a director and a linguist all working together, which is hard to arrange, particularly when you're talking about Sweden or someplace far away.
>
> . . . In that climate, Peter Davison in Boston wrote a letter to the foundation saying, "Don't you think a good idea would be some kind of national and international program in translation?" . . . Peter Davison's on the Translation Center board as a result of his interest, but his own model of what he thought about it is not the model that we accepted. It helped stimulate our interest, and it gave me an excuse to talk about it at the board long before we got it up—and this is one of these cases, too, where fortunately one of the members of the staff kept bugging the others about it. Gertrude Hooker was very much interested in this because of her background. . . . She kept on pushing until we got to the decisive stage of how to set it up and I got more involved.

The Ford Foundation sold two professors at the University of Texas on the idea: Roger Shattuck and William Arrowsmith, both Easterners ("Shattuck attended St. Paul's and Yale University, and Dr. Arrowsmith went to Princeton and Oxford universities") and both already having been awarded "a clutch of scholarships and grants."[47] Lowry said:

> We didn't have any trouble selling [the idea of the center] to Arrowsmith and Shattuck, because of a [university-sponsored symposium held at Texas in 1959 on "The Craft and Context of Translation"]. . . . It wasn't very easy to tie Ransom down and get him to accept a grant, because he kept talking about all of the the money *he* could put into such a thing. . . . You can't talk to him by phone or letter. He won't answer his mail. No. I had to fly down there finally. Mrs. Hooker on my staff went down once before but never did see Ransom. . . . He's just disorganized. And also, though this was clearly our initiative and we wanted it that way, he really would have been happier if we had made it a part of *The Texas Quarterly* or the university or so on instead of a separate deal, but it drew on his people. And when we found out that this was the way he

wanted to do it, I had to find out, you know: Was he serious? Would he let separate accounting go on? And would he defend it if it got into trouble? Things get into trouble in Texas—less so than they used to but they still do. And he said that he would. We had a very good conversation about that.

Well, then after we were ready to make the grant, we had a terrible time getting a letter of application from him, which we needed for the record. He's not indecisive. He just procrastinates. And I don't always know what he's thinking. But I'm not saying that he's the slightest bit insincere. He's interested. He's shown his interest in this subject before. Somebody had to find the money for that "Craft and Context" conference. That was independent of the Ford Foundation and preceded what we did by about three years.

About a year and a half elapsed between the time that Arrowsmith and Shattuck heard about the idea and its actual funding:

ARROWSMITH: I feel that he is often extremely slow in acknowledging suggestions and doesn't like to move on. Though I really suspect it was his response to the attitude of the regents, which is always "a lot of state money, we can do it better here." The suspicion of big foundation money in Texas itself, which he was reflecting.

SHATTUCK: . . . we were very surprised that he didn't jump at it from the beginning.

ARROWSMITH: . . . all the Ford Foundation was waiting for was just a statement of interest from Ransom.

The project, after it was funded in 1964, more or less lost the first two years because its first director was badly chosen. He got the job "by a fluke," Lowry said. ". . . there were reservations all along the line," but "you can't beat somebody with nobody." However, "it didn't work—not entirely owing to his insufficiencies, not entirely. The climate under which he started necessarily put Shattuck and Arrowsmith into the important positions and [the first director] felt less autonomy by seventy-five percent than [Keith Botsford, the second director] faced." Lowry said the loss of the first two years was

not a characteristic of Ford Foundation projects in the arts, but it is not uncharacteristic of many voluntary organizations in our particular sector where writers and scholars and publishers are involved. It's not. I don't say that you can afford to lose two years to straighten it out again, straighten out personal relations, straighten out communications, straighten out concept—an awful lot.

In fact, the center never was straightened out and came to an end when the Ford Foundation stopped supplying funds toward the end of the decade.[48]

In view of Ransom's lack, generally, of a systematic approach, how did Ransom himself account for his rise at the university? "I think that would be presumptuous of me," Ransom said. "I am not sure it's been a rise, honestly. I personally believe that in the academic order of things the most important merely administrative assignment is deanship: perhaps chairmanship of a department, but probably deanship of a college. And I have to say that people who have 'risen' in academic work, including work at this university, are mainly those who have done a good job in professorship."

Mrs. Morris attended the last class Ransom ever taught and remembers that he had an extraordinary capacity for personal recollection and detail. He rose because he was single-minded, not frivolous, and had no bad habits, she said. "Everyone was excited when he became chancellor, thinking Logan Wilson had been unapproachable and here was somebody who would be different."

He rose, said John Silber, because he had a lot of ideas: "He is as imaginative and speculative and non-regimented an administrator as I've ever met."

He rose, said Mrs. Hudspeth, because of his ability to get along and because of his brilliant mind.

The chancellor had the dream of a community of scholars on the plains of Texas. He surrounded himself with young men of high caliber who in turn attempted to attract others. Some had been recruited earlier, while Ransom had been dean of the College of Arts and Sciences: at the time of my visit in 1967, Sigmund Koch had just been lured from the Ford Foundation to become a university professor. "When you're coming up," someone who didn't want to be quoted told me, "you've got to outbid established institutions to get the same quality of man they can get for less money." But scholars in certain fields were attracted by the library. The idea of the "university professor"—to lift individuals out of departmental confines, thereby permitting them to teach whatever they wanted (which presumably would facilitate interdisciplinary studies)—was not new. The title signified a reward, as did the pay. "Why *wouldn't* he want to go?" asked Mac Lowry, himself remaining at the Ford Foundation, of Sigmund Koch: "Look at what he will get."

What would he get?

"Well," said Lowry,

he's got an endowed chair there, a university-wide professorship, no departmental duties, collaborative support from three departments—fine arts, psychology, and philosophy—pick his own students and his own courses, make what public lectures he wants to, go away on his own research, nine-month contract each year, tenure, big salary—one of the

biggest I ever heard of, better than Harvard in the humanities and social sciences. You see, Ransom—this is characteristic of your man—this trust fund, which endowed this professorship, Ransom has been holding in his pocket for three years. This is the first time that he has filled it. He waited until some special guy came down the pike. Silber talked to him about Koch.

How did Silber happen to know Koch?

LOWRY: Do you know things that you're not telling?

No.

LOWRY: Well, I think that Silber was involved in two or three seminars or symposia or scholarly things where Koch had given papers at Texas.

Would Koch, when he sent out feelers saying he was interested in going back to the academic life, have written to Silber?

LOWRY: I think so. Or some of the standard backers and admirers of Koch would have written to Silber. Yes. No, Silber didn't find it out otherwise, I don't think.

Was not Silber in this instance functioning as Ransom's man?

LOWRY: As evaluator of Koch, yes.

Which is interesting because, technically, he wasn't in a position to do so.

LOWRY: Why?

Well, he's chairman of the Philosophy Department, as I understand it, and, although he is a university professor, there are other university professors as well.

LOWRY: But that isn't the way Ransom works. I don't think that anybody is closed out from lobbying Ransom about anything. I think it's a bit—it's like Kennedy running Washington. Don't tell anybody but the guy himself what he is supposed to do. Nobody knows what anybody is supposed to do except Ransom. That's the way that Kennedy opened the "new frontiers."

Were improved educational circumstances all that Ransom had in mind? Ronnie Dugger thought it possible, and probable, that Ransom also had in mind the creation of a group that would support him or, in any event, keep down his visibility as a target. "Harry doesn't show them his hand," Silber said. "I show them my hand—you want to cheat?—go ahead. And I get beat. I'm getting tired of getting beat."

"Ransom's backed some of the Young Turks on the faculty," Logan Wilson said. "Some of these people are troublesome characters at times—Silber, for example." Other men on the faculty before Koch who held uni-

versity professorships: John Silber, Donald Weismann, Donald Carne-Ross, and William Arrowsmith.

Arrowsmith is a classicist with many highly regarded translations to his credit. *The New York Times* has described him as "one of the most outspoken critics of today's graduate scholarship . . . [his] criticism of graduate education attacks essentially its lapse into pedantry and self-serving ritual, along with its hostility toward uncertified artist-scholars."[49] At the time, the Ford Foundation was funding a program aimed at improving graduate education, and Lowry was thinking hard about whether artists *ought* to be connected with universities. The word "uncertified" is the tip-off. That hostility arose from differences in basic interests on the part of artists as opposed to scholars and administrators in educational (and other) institutions.

Arrowsmith carried an idealistic look on his attractively open face. Someone remarked that he was a man so "incredibly passionate that he reshapes events in terms of his own involvement." (Sydney Hook's event-*making* leader?) He had a talent for making himself loved in spite of being known as "a chronic griper." His boss (Ransom) described him as "an absolutely extraordinary, exciting man":

> My chief official experience with him grew out of his introducing a motion of no-confidence in my administrative work and his brilliant editorship of a volume on Italy.

He was also known as an effective teacher who established rapport with his students and at that time was managing to do so also with a larger audience through the lecture circuit and through articles on education, especially on the proper role of a teacher. He interested me because, while he energetically maintained a wide correspondence, he seemed to lack a practical instinct—that is, concrete thoughts on how to put his more general ideas into effect. Arrowsmith's chief complaint seemed to be that the university professorship was not a meaningful title since it was not automatically vested with power. "Harry," said John Silber, "expects other bright people to do some manipulating on their own."

During the year in which I saw him, Arrowsmith had taken a sabbatical from Texas and was to be at the Center for Advanced Studies at Wesleyan University in Middletown, Connecticut—an interesting place, among other reasons, because it tended to harbor briefly many who seemed uncertain about the direction of their careers. Daniel Patrick Moynihan went from a position in the Kennedy administration to the directorship of the Institute for Urban Studies at Harvard-MIT via the Wesleyan Center, and then to Nixon's White House as a Special Assistant. Richard Goodwin, a member of both the Kennedy and Johnson administrations, was also there for a time.

Unexpectedly, the deanship of the College of Arts and Sciences at

Austin came up for grabs in September 1967, with the death of the incumbent. Although Arrowsmith was uncertain about what he wanted, he felt, so he said, that it was not the deanship, which he hoped would go to Silber, and it did—perhaps in part because of Arrowsmith's uncertainty.

Earlier that year, during the student controversy, "Ransom's Boys" had played particularly interesting roles. According to Ronnie Dugger, "Silber got his tail in a crack with the left-wing students at the university because he rose at a mass rally and defended the necessity of regulations. I wasn't there," Dugger went on to say, "and so I didn't hear what he said, but it was presented to me by some of the students of the left as a square attitude. I don't know whether it was or not, but anyhow there was a general feeling among the SDS kids that Silber had gone too far in that defense, in effect, of Ransom." Dugger continued:

> During the same controversy Shattuck carried a statement that he—you see, Shattuck was in a very interesting situation. Shattuck had the trust of the students on the left, and I think incidentally, the students on the left are the really interesting ones intellectually, whether you are leftist or rightist or what, because they are the ones that are thinking and they are generally high-quality students academically. They are really interesting kids: the new wave, sort of.
>
> For a while, there was a complete breakdown between Ransom and the leftist students: they weren't communicating at all. And I remember talking to Shattuck one night and saying, "My God, see if we can't get a connection between them, because otherwise it could become . . ." And actually it did become somewhat damaging to the university as a free place, which it had been.
>
> My impression is that Shattuck got a statement from Ransom, a conciliatory statement—and he carried it over and read it to a rally of the SDS-style students. Subsequently there was a little mimeographed sheet put out by that group, it was circulated, it identified Shattuck as a spokesman of Ransom, and this piqued Shattuck.
>
> You see what's happening? They are starting to typecast.
>
> In other words, when the university became controversial *qua* academic freedom, the people who were around Ransom, who regarded themselves as free men, suddenly became vulnerable to suspicion fair and unfair. They began to shimmy in what had been a stable situation, so that whatever pressures had caused that—to use the commonplace word—crisis, they had ramifications into Ransom's own structure of intelligence and power in the university community.

Faculty upset occasionally benefited dissenters elsewhere; it also created tragic breaches. At Colgate, Vincent Barnett later suggested that the tremendous pressures created by faculty, alumni, students, and townspeople on the president tended to encourage appeasement of the students.[50]

But at Cornell, a divided faculty forced the resignation of President James A. Perkins after he acceded to the demands of blacks carrying firearms. One small footnote to that incident came when McGeorge Bundy, as a vote of confidence, gave Perkins $50,000 of Ford Foundation money to handle in any way he personally wished, in his own office, so *The New York Times* reported. Lowry's cherished dictum, noted on other occasions having nothing to do with Cornell, was that at foundations properly "the staff proposes and the board disposes." Bundy, as president of the Ford Foundation, was staff but he did not apparently, on this occasion, check with his board.[51] In none of these cases was a breakdown in communication the issue.

In 1960, before his troubles with the SDS, Ransom had stated his fear that indifference on the part of the faculty would be, as he said, "much more dangerous to the intellectual welfare of the community than the incursions of mechanics, and profit motives, and cost-accounting, and tidy demands, and very untidy international and national controversy."[52] The more voices the better, he felt. And in 1965 he was reported as saying, "There is no policy at the University of Texas concerning staff members or students who demonstrate as individual citizens."[53] (The Carnegie Commission on Higher Education in 1973 endorsed political activities by individuals acting as citizens while believing that formal espousal of causes by the college or university was inconsistent with the pursuit of truth rather than power.)[54] Academic freedom was a reality at Texas, due primarily to Harry Ransom, said members of Ransom's faculty.

But in 1967 a feeling of dissatisfaction was expressed by many of the people I saw, and they were often the ones who had been closest to Ransom in the past or felt they had been—a feeling that this "natural and cordial man"[55] to whom everyone was drawn had increasingly turned his face in the other direction: toward the Board of Regents and influences outside the academic community with which he had to deal. However, that the university was in a totally different situation than it had been a short twelve years before was indisputable.

The Rainey controversy, during World War II, had tremendous repercussions. Homer Price Rainey had become president of the University of Texas in 1939. An ordained Baptist minister, he had steadfastly stood for freedom of thought, whether liberal or reactionary. By 1943, after a series of incidents, things reached the point where the more reactionary regents were trying to change the tenure rules safeguarding academics so that "undesirables" could more easily be gotten rid of, and Representative Martin Dies (Democrat, Texas), chairman of the notorious congressional committee, was stating that the University of Texas was a den of communism, fascism, and atheism. On October 12, 1944, after a number of other incidents, Rainey issued a sixteen-point "indictment" of the regents, charg-

ing that academic freedom was at stake, and on November 1 of the same year was fired. (Regents are appointed by the governor of the state and, presumably, hence are not immune to political pressures, though in my observation bosses usually fire subordinates who "indict" them.) In June 1946, the American Association of University Professors, having undertaken a lengthy investigation, formally placed the university on its list of censured administrations because of "attempts by a politically dominant group to impose its social and educational views."[56]

"I was away during the controversy most evident between the very conservative and the liberal groups here on this campus," Dr. Ransom told me, "the so-called Rainey controversy. It was good fortune for me to be in the Air Force at that time."

In the early 1950's, the University of Texas was desperately trying to come up in the world. ". . . there were still," said Ransom, "very vocal people, influential in the university's future—actually, some of them members of our Board of Regents—who assumed that the university was at least in part representative of the conservative attitude." Ransom had become a full professor by 1947 and in 1951 moved into administrative work, becoming assistant dean of the Graduate School, and in 1953, under the new president, Logan Wilson, became associate dean.

Wilson was an extraordinarily liberal Southerner. *Time* magazine reported that he "raised salaries to attract better teachers, made Texas the first state university in the country to require entrance tests for all students. He launched a $35 million building program, aimed at scientific prestige with a new computer center and an atom smasher. . . . Two-thirds of [the endowment income] is now going into new schemes for academic 'excellence.' "[57] Wilson, looking back over his presidency, commented that "changing the curriculum entails all the physical and psychological difficulties of moving a cemetery."[58]

Ransom moved steadily up under Wilson, becoming dean of the College of Arts and Sciences in 1954 and vice-president and provost of the Main University in 1957. "As a matter of practicality I could do more for the development of the libraries in the Southwest by getting into administrative positions," he said. "I was a little bit surprised," Logan Wilson said, "that he had as much administrative interest as he did." By 1960, Ransom had become president of the University of Texas under Chancellor Wilson, and the legislature had begun to accept the importance of quality in higher education. Wilson said, "There was much less criticism on the floor of the capitol." The situation continued to improve after Ransom replaced Wilson as chancellor—Silber thought because Ransom engaged in a continuing program of adult education: "Harry's courses in adult education were taught to regents and influential businessmen and politicians who control

the destiny of Texas University." But Wilson, from his new vantage point as head of the American Council on Education in Washington, D.C., believed they had been helped by "a general change in climate all over the country —higher education was no longer regarded as a luxury."

"The best example of change I know," said Ransom in 1967,

was an insurance lawyer, politician, former Secretary of State [of Texas], who became chairman of our board about eight or nine years ago—a man named W. W. Heath, who is now ambassador to Sweden. He came on the board absolutely determined to run this place like an insurance company, like a corporation. He was deeply convinced of his own prejudices, and what's more, capable of putting them into action at that point. But within six years he did change so completely that he was capable of what I think is one of the greatest comments on academic freedom.

I had approved the coming to the campus of a self-described "Christian communist" speaker, who was to give a fifty-minute lecture on communism, and in good conscience I had to go to the chairman of the board and say that I had done this and I assumed that he would dis-approve it, and if he wanted my resignation he could have it. He didn't take the matter lightly. He said, "Well, if this communist can upturn everything the university is doing and change the ideological or the polit-ical, the moral and academic patterns and good order of any individual in the university, you've lost the cause anyway, so let him come." I went out of the office somewhat weak-kneed—I still look back on that as one of the astonishments of my administration.

The board as now constituted, and this is reflected clearly through the administration, is a group of complete individualists. One of them is a regional director of the American Civil Liberties Union. That would have been considered utterly impossible twenty-five years ago. They come out typically with divided opinions in conference, and unanimous opinions or consented opinions in final actions, and have, I think, created a new atmosphere at the university.

"In a big complex university such as [California]," Logan Wilson said, "the day when the president can run the place is long since past: there aren't going to be any more Eliots, any more Hutchinses, any more of these people who've made over institutions in their image. This is just impossible. In the first place, nobody wants this any more. This genteel athoritarian-ism just wouldn't be accepted any more."

Many observers believe that university presidents should be appointed for a term of years—say, ten—and no more. That what contributions they make occur in their first few years; that their position is comparable to that of chief executive in a very large corporation, with tensions of equal or greater magnitude since they must be spokesmen for faculties that are typically neither cohesive nor decisive, deal with students, regents, and the

like—and are expected, like the President of the United States, to be not only the chief executive but also the ceremonial head of state.[59] And that under all of these pressures, they tend to burn out quickly. Barnaby Keeney became famous for his statement that ten years would give Brown University all that he had to offer. Beginning in 1973, presidents of the twenty-nine colleges comprising the State University of New York would be installed for five-year terms only, announced its trustees.[60]

But "it is a literal fact," said Ransom, "that nobody in educational administration in the United States isn't in demand somewhere else, because there is such an enormous shortage of administrators." The State of Texas paid Chancellor Ransom a salary of $21,000 during the fiscal year 1967, and "private sources" brought that figure up to $42,000 in a curious system of salary supplements, making Ransom among the better-paid heads of institutions of higher learning in the country. The mean[61] salaries for university presidents in 1966–67 were $31,119 (public) and $35,301 (private).[62]

Ransom was atypical in that he had come up through the ranks. But, he said,

> I've often talked with colleagues in other institutions, especially the larger, complex universities, private and public, about that condition of administrative career. It certainly is a very different thing to begin as a $1,300-a-year paper grader, as I did at the University of Texas thirty-two years ago, and except for time off for research leaves in England or service in the Air Force, to stay at the same institution all those years. There is a tremendous advantage in it which sooner or later— I've discovered—becomes an occupational disease: you have the advantage of seeing a much wider span of the institution's development. Of course, the danger is that if you kept preoccupied with what happened before in all the roots of the new academic growths, you can very easily quit looking ahead.

He added that it was not simply a matter of "a presidential or chancellorship's exhaustion in work."

Had Ransom changed in the last ten years? Of course he had, Silber said, he's "gone through things he can't go through again." Other members of the faculty agreed that Ransom had changed, for whatever reason, and by 1967 thought the situation at Texas was no longer as inviting as it had been. One of the reasons, Roger Shattuck said, was that "we were no longer in touch with the man who as a dean was able to stir up a lot of activity to bring in people personally that he wanted to have, as he recruited some of us and recruited others. But as president and then as chancellor, he has had to practically turn his back on the university and face toward regents, national groups, and all kinds of outside commitments. It has, I think, left a kind of vacuum."

William Arrowsmith said, "I'll make a much stronger statement than you have. I would say Ransom was a great dean and a mediocre chancellor."

Shattuck said, "He worked closely with a small group of the faculty who were editing *The Texas Quarterly*[63] with him. . . . We saw a lot of Ransom—saw him every week, in fact, quite regularly when he was dean and then vice-chancellor. But it changed very rapidly when that kind of arrangement turned out to be too ponderous and he went into the chancellor's office."

"It may be true," said Arrowsmith, "that his reputation for being a great dean was based on an active faculty by and large who saw him in action. Nobody ever knew what he did as chancellor. It's hard for a faculty to know what a great chancellor is, since by and large the operations of the chancellor don't have the kind of effect that a dean's actions have."

"This must be a kind of classic situation," said Shattuck, "where a man who is ready to go upstairs forms a number of personal relationships between key people and working people in his organization and then disappears from sight, and they feel they are still operating under some kind of personal relationship with him. There is a kind of understanding, and yet the man is no longer there, he is no longer available: his work, because of his fast ascent in the organization, has taken him elsewhere. And that's where the stalemate set in, I think."

That was the reality in Texas. Here is a statement of the theory:

Once in the senior job they [the new administrators] appear to lose all sympathy and understanding for the problems of their subordinates . . . with promotion, group loyalties change and there is some feeling on the part of subordinates that the earlier identification of the manager with their professional group has gone and the new identification with the management team gives insufficient weight to old loyalties.[64]

Ransom himself obviously was aware of this sort of complaint: "I think it's an inevitable result of any sort of administrative process," he said,

that first of all, unless he is very careful, one gets out of touch—as I said earlier—with the whole array of different kinds of interests in a university. In the second place, he has to make decisions with which some of his closest friends and colleagues just simply don't agree: they sometimes don't know the reason. In the third place, he spends a great deal of his time in public affairs, which I once scorned and which they still do.

"This is a pipsqueak example," he continued, "but I have some colleagues, for example, who just as a matter of principle don't think it makes any sense for a faculty member to attend commencement. Well, I agreed with them. I never went to a commencement exercise until I had to go officially, and one or two of them are restive with me for not abolishing commencements—the commencement ceremony, that is."

"Harry's not transparent," Silber said. "He doesn't indulge in the crassest forms of cronyism."

Did Silber see Ransom more or less frequently than he used to?

"I see him more frequently," Silber said. And then he paused before adding, "I never made it a habit to drop in on Harry Ransom: I've never been entertained at his home."

Have other professors been entertained at his home?

"Not to *my* knowledge. Harry is a loner—I guess he always has been; I guess he always will be. So far as I know, his social life is virtually nonexistent. If he has one, it's a very exclusive association and I don't know anyone who is part of it." Mrs. Hudspeth said flatly, "He has no personal friends" and "There is nothing else [he or I] would rather be doing."

Silber said that nowadays (1967) Ransom was engaged in the responsibilities of the University System, which were a great deal more abstract, and that his preoccupation with the System might lead him to sever his connection with the Main University.

The specific complaints I heard were connected with areas in which Ransom had been particularly strong in the past. It was said, for example, that he had not taken advantage of the changed climate, which he'd had a hand in accomplishing, to move ahead vigorously—wherever "ahead" was. And where Ransom had been credited with the recruiting of bright young men, he was now accused of a lack of ruthlessness in firing or retiring faculty;[65] where he had developed research centers and special libraries, scholars complained of not being able to use the material.

Disorganization in the collections, with items remaining uncatalogued and in cartons, made research difficult, so I was told. The lag in cataloguing is attributable only in part to cost: cataloguers are in short supply, said C. L. Cline, head of the Manuscripts (Permissions) Committee at the University of Texas at Austin. He reported it as a lonely job and said even librarians don't like to do it.[66] But there were also complaints about a curious reluctance on the part of the administration to let scholars use the material. John Silber, in 1967, said that "a great deal of it was still in crates and boxes" and added he hoped this was the only problem. He was not suggesting something might be either morally or legally wrong,

but neither was he indicating the possibility that administrators and scholars might have different ways of looking at the problem of access to materials.

"It is the conviction of the Manuscripts Committee that materials in the Humanities Research Center serve a better purpose when made available to mature scholars—wherever they may be," wrote C. L. Cline, "—rather than to local apprentices who too frequently may do little more than spoil the materials for more capable hands. Even so, numerous requests made by Ph.D. candidates at Texas and elsewhere are granted each year."[67]

That the collections had made the university known all over the world was not in question: "You can't go to any foreign country without people knowing of the collections at Texas, and this is a major contribution," Arrowsmith said. Ransom attributed difficulties only to questions of property ownership and copyright, aside from lack of staff. Scholars did not seem to realize that they were not automatically entitled to use whatever they happened to want, Ransom said. "The writer or his heirs, publishers, earlier scholars, all have special claims to consideration." On retiring from the chancellorship in 1970, Ransom remained active in the development of special collections until 1973. That same year, he commented that as fast as the material arrived, it was opened for study "to undergraduates as well as to eminent scholars."[68]

"One of the major complaints about Ransom," Shattuck said, "was that he had not done a good job in the library. Now that sounds ironic. When I left, there was still no order department that ordered independently of orders that come in from the individual departments. . . . Harry had starved the library staff for his rare books." During the last year Shattuck was at Texas, "faculty committees were formed about the library," he said, "the inadequate services, the underpaid staff, the poor quality of the library school, the lack of funds which had been developing over the few years before that, and the reason that was constantly found was that funds had been so sopped up by the purchase of collections and special books and so on that the basic operation—day-to-day operation of the library, cataloguing and everything else—had fallen behind." Ransom commented that numerous committees had made "numerous studies of every aspect of the libraries" and that some had been helpful, others not. However, in 1970, it was discovered that the library had "descended to fiftieth among fifty major universities in spending for new books and bindings."[69]

Ransom's talents with regard to educational innovation seem from the beginning to have struck some as uncertain and so, interestingly enough, were the complaints in that area by the men around him. Silber

was moving toward the idea of community service for a university, but he had not brought this up in his discussions with Ransom.

Silber, in 1967, said:

I would like to have a chance to show what can be done with a university in an urban center. I'd like to turn a university loose on a community—I think a university could transform a community and in the process transform the whole conception of what a university is. That's an opportunity for UCLA; it's an opportunity for USC. It's an opportunity that only comes to relatively few universities. It's an opportunity that could come to a place like Yale but never will. But Yale has a pretty good excuse of being born too soon, you know, and it's so imprinted with another conception of a university that it probably couldn't make the adjustment, any more than Harvard could.

Sociologists Talcott Parsons and Gerald M. Platt[70] tended to agree with Silber's view that the university must come out into the world rather than with Nisbet's belief that, to survive, it must retrench. And Silber, when he became president of Boston University in 1970, was to get his chance.

Sebastian de Grazia wrote:

Theories entwined with intent or practice look on the world as needing some change, believe that it can be changed at least in part as desired, hold that man can accomplish such change with—or else without—the help of the gods. They are bound up with the idea of work that cut a victorious path from the Dark Ages in the nineteenth century. . . . The theory of theory-plus-practice looks on man and earth as malleable objects, whereas the theory of knowledge for its own sake has no such active intent; it is more at peace with the world.[71]

Ransom was not especially interested in urban problems—was more scholarly, Silber said. He thought the difference lay in their respective temperaments: "Harry's not as grubby as I am—Harry's not going to go out and get his hands as dirty as I'll get them, and he's not going to get his ego cuffed around—as frequently. Or cuff anybody else's as frequently."

Many educators in the late 1960's, as urban problems increased at an alarming rate, seemed to feel that public service indisputably was part of the role of a great university. Clark Kerr, former chancellor at the University of California, said, for example, that the question was not whether they should so engage but rather whom should they serve and for what? From the office of the president of Harvard came a statement about the nature of those connections at *any* university.

"First," said the Committee on the University and the City, "what are referred to as 'urban' problems in fact transcend the boundaries of

cities and include almost the full range of issues confronting an industrial society; to address urban problems is to address almost every domestic social and political question one can conceive.

"Second, every faculty of the University is now involved to some important degree in examining these issues in the United States, throughout the world, and in various historical periods. . . .

"But if relevance in the sense of 'useful' or 'topical' is one test of the kind of learning to be found in some faculties," the committee went on to say,

> it is not the only test even in those places and may not be a test at all in other faculties. The education provided in professional schools would be defective and incomplete if it did not include—indeed, if it were not organized around—a concern for the central theoretical issues of the discipline. But the work of the historian, the philosopher, the literary critic, or the mathematician cannot easily be judged by standards of practicality and thus the efforts of such persons cannot easily be "mobilized" to deal with urgent social issues.[72]

Who can change our culture for the better? The individual as anarchist, à la SDS, or Students for a Defunct Society (as some wit termed them)? Not hardly at all. "The customs, the behavior and the aesthetic expressions of man fall into certain forms which, though subject to periodic re-examination and change, 'are not to be thrust aside by the slovenly, nor senselessly smashed,'" said John Gardner, at that time head of the Urban Coalition.[73] Grayson Kirk noted that universities are particularly vulnerable to violence: ". . . by nature and definition [they are] hospitable to the free interchange of all ideas and doctrines. They have assumed that the members of each group will have the same respect for contrary opinions that they demand for themselves. When a group asserts that the justice of its views legitimatizes recourse to violence, a university is ill-prepared by organization and temperament to cope with the threat."[74]

William Butler Yeats wrote:

> Civilization is hooped together, brought
> Under a rule, under the semblance of peace
> By manifold illusion; but man's life is thought,
> And he, despite his terror, cannot cease
> Ravening through century after century,
> Ravening, raging, and uprooting that he may come
> Into the desolation of reality. . . .[75]

Those students missed the boat, Silber thought: there were so many important social causes that they *could* have espoused at Texas, where various forms of discrimination continued. "The challenge is to learn how

to create," Gardner went on, "not to discredit or smash, a pluralism of large organizations—because the large scale is the condition of modern society—which serve the individual."[76]

This "learning to create" is best achieved in decentralized, non-authoritarian systems. Silber said:

> Martin Meyerson sits up there in Buffalo [in 1967][77] and puts together a new chart for how a college ought to be run—creates civil war on nine fronts in terms of his chart. It may work, it may not work. What does it depend on? Not on his chart. It's no damn good—anybody can look at that who knows anything about education and know it's lousy. But it might still work, because Meyerson's a very persuasive and dynamic man. *If* he gets the right people into that lousy chart, he may get a good, functioning, educational program out of it. But if he has the best chart or table of organization in the world and weak, ineffectual people in it, he won't have an educational program no matter how elegant the table of organization may be.

Jencks and Riesman thought "the pattern of finance, the character of the board, and the choice of a chief executive" today (as opposed to the nineteenth century) "probably have less effect on the character of undergraduate education than the sources of faculty and students."[78] Silber placed his faith in upgrading, department by department, the quality of the men hired. "We haven't made very much progress in Texas these last four years in terms of tables of organization," he said, "but we've made substantial progress in terms of men." On becoming dean, he announced to his faculty that he regarded good teaching as equivalent to publication.[79]

The very thing that makes it difficult to mobilize a university is its strength—that is, its decentralization. It is "vital" and "essential," said the committee at Harvard, that universities continue to exist as collections of separate organizations.

> The departments, faculties, students, schools, institutes, centers, museums, houses, administrators and groundskeepers that together make up "the" university are quasi-independent entities that seem, as someone has observed, to be "linked today only by the steam tunnels." And within many of those entities, professors jealously guard the right to determine, without interference from above or outside, the subjects to be offered, the degrees to be conferred, and the appointments to be made. . . . "the" university does not exist.

The committee doubted whether "centrally generated policies or recommendations respecting the direction of the work in the separate faculties are a proper or effective means for exercising leadership in a university." Grayson Kirk thought the regents or trustees not only had the legal

authority but also the responsibility to direct the university's affairs, although in practice they delegated certain kinds of policy to various faculties.[80] Ransom said of his role: "It is a parliamentary rule, even if it were not an academic tradition, that the presiding officer is not competent to speak for a body and only by courtesy to speak to it."

"One thing you'll find out when you meet him, I am sure," Dugger said, "is what sort of person he is. He is a very urbane human being, and pleasant . . . it's hard to articulate. . . . He agrees to the things that civilized men concur in. He is a civilized man in his values, and the people around him have sometimes expressed terrible frustrations to me, never with his decisions, his sympathies, his empathies, his responses, when in disagreement or displeasure. It's his execution of his expressed intentions. People don't put Harry down on a person-to-person basis. Sometimes they just don't get what they want out of him that they thought they were going to."

Arrowsmith commented that "Ransom had more diplomatic skill than courage. Courage was never his long suit. But he played his cards too close to his chest for any of those who were putatively on his side to know how much freedom he actually possessed, and what his necessities were." "Ransom is a man of enormous, really incredible, modal ignorance —or innocence," Silber said.

> He doesn't know the difference between what's actual, what's possible, and what's necessary. And as a result he confuses these things all the time, and he believes that something that's not even possible is already actual. On occasion, he had to create actual positions, facilities, and even academic programs in order to make actual what he had inadvertently told someone was actual. Some of his greatest achievements were a direct consequence of his modal innocence. It is, I think, the central key to his greatness.

Ransom was less and less able to resolve crises, Shattuck said. There were so many intervening layers of authority that he was no longer running the university. He had gotten so high into power politics and Texas society that it was difficult for him to make a dignified retreat, but he had said all along that he was going to retire into his books, since, after all, copyright and bibliography were his real interests. Dugger comments that by 1967 Ransom

> had seen and heard enough to know that he wanted to get out of Erwin's [Frank C. Erwin, Jr., chairman of the Board of Regents] way. In the official language, "upon his request . . . he was released from many duties relating to the University of Texas at Austin." This did not describe the actual change. He turned away from the chancellorship itself

and back to his special collections. Having given his followers and his place an excited dream, he retreated into his private one.[81]

In May 1970, Ransom resigned the chancellorship, an unexpected move that cut short his full term, after which his primary concern was development projects. There is general agreement that Ransom is not a man who enjoys conflict and that by becoming chancellor emeritus in January 1971 (retaining his office, staff, complete salary, and free chancellor's home) he could accomplish whatever he wanted.

In the spring of 1970 a great deal of discussion about the College of Arts and Sciences was occurring. Regent Erwin and Dean John Silber are said to be men who want their own way. Erwin in particular, unlike Ransom, thrives on conflict. The faculty and the dean had recommended that the college not be broken up into separate divisions but, during the summer, the regents did just that, perhaps in an attempt to take some power away from Silber. Silber continued to oppose "quite respectfully," Shattuck said. After being asked to resign, Silber was summarily dismissed as dean by LeMaistre, then chancellor-elect, and his job was abolished. No reason was given but the move was widely assumed to have been caused by pressure from Erwin. Erwin is said to have told Silber that same day:

> You don't ever want to take another administrative job where you're not top man. I don't think you'd have any difficulty in dealing with a board of governors. I think you'd be able to con them into doing whatever it was you wanted them to do. On the other hand, you can't afford to take another administrative position where you have to report to people who are substantially less competent than you are. That's essentially the problem.[82]

Erwin seems to have figured Silber had only a small faculty constituency and a lot of enemies. But Silber as dean had gone out "talking enough in the state to get a group of supporters and direct constituents who were monied people, cultured people, who were *not* first loyal to the Board of Regents [and] this then looked like a threat," Shattuck said. Silber was fired "because he began to examine the internal workings and budgetary priorities of the university."

By that time, Silber didn't expect Ransom would do much. "We had become disenchanted with the real power Ransom was able to muster," Shattuck said. Ransom comments that he attended group meetings to which he was invited and at which he spoke candidly, that "Professor Silber's deanship was terminated" during Ransom's absence from the campus, a decision made by officers with "the authority to act," and that "any further public statement . . . after these decisions would have added

only emotionalism to a problem already charged with emotion." He said his influence on Erwin was "approximately the same as that of most other administrators." Others on the University of Texas–Austin campus noted that Erwin had cooperated in getting the chief things Ransom wanted for the university. Ransom said Silber "got into trouble," as this interviewer put it, because he was a decisive and imaginative person who took very strong positions and was disinclined to yield. Such people often do "get into trouble," Ransom said.

Erwin struck out strongly at Shattuck's sabbatical and at the University Professors, considering them free-loaders. Shattuck left, Arrowsmith left, and so did another classicist, Donald S. Carne-Ross. Dr. Norman Hackerman, president of the Austin campus, departed to head Rice University; Silber went to Boston. The dream of a community of scholars on the plains of Texas was shattered. Shattuck commented that "not dissident students or faculty, but Regents and administrators took a series of actions that plunged the university into factional dispute."[83] Shattuck's departure was perhaps the most regretted as Silber's "substantial progress" seemed lost.

In 1971, Erwin stepped down as chairman of the board in an attempt to make peace. Mrs. Lyndon B. Johnson became a regent. The era during which, Ronnie Dugger claimed, the University of Texas was dominated by businessmen (1963–73)[84] was drawing to a close. The one ahead did not look promising. But the outlook for other universities was not much better. In 1973, scholars and educators felt they had to give warning that the crisis had not abated in spite of lessened violence and intimidation.[85] Pressures still threatened the nature of undergraduate education and a false emphasis remained on its socialization function. Many of the proposals for university reform, like Nisbet's, resembled former ideals. "The University—any university," the committee at Harvard had said, "has a special competence, a special nature. That competence is *not* to serve as a government, or a consulting firm, or a polity, or a pressure group, or a family, or a kind of secularized church; it *is* to serve as a center of learning and free inquiry."

Joseph Kraft has written that "to inspect the Establishment, to watch the supposed titans of science, industry, academia, and the communications world is to behold a crowd of the puzzled and perplexed, straining by every modern form of divination . . . to find out what they should think";[86] and Jovanovich thought that

> When you're young, you have a rudimentary idea that the top people closely guard their prerogatives, and there's an establishment that knows exactly what it's doing, and that its members plot their moves ahead and follow a sequence in the exercise of their powers. But it turns out

to be far less literal than that. A good many times the people who have power don't know what they're doing; they aren't exercising authority or leadership in ways you think they are.

Arrowsmith believed that "administrators possess very real powers, of which they very seldom make full use. Too many abuses of administrative power convince me to the contrary." Ransom struggled no less than others in the strands of a great web, but more successfully, at least to the extent that one of those close to him could say, "He has all this power—why doesn't he *do* something?"

CHAPTER 5

VACANT SHUTTLES

(*Loyalty to institutions*)

THE GENTLEMAN QUOTED at the end of the previous chapter thought of power as a commodity—something that could be spent. Ransom "could do the opposite if he wanted to." But men keep power only by exercising it within self-limiting situations: that is, if they did anything they pleased, they would not long hold powerful positions.

There are really two questions here. The first is: How much power does any single person have within an institution? David Bazelon, in *Power in America,* wrote:

> I very much believe in being an individual; but when I take inventory on the matter, I measure my personal options rather than my state of mental grace. That is because I do not expect to satisfy my desire to be individual according to the fate of a mere image. On the contrary, I know that individuals require power in order to be or remain such, and I am convinced that power in our society, certainly in my educated urban part of it, is seldom separate from some aspect of organization bigger than any single person. Therefore, I never view my individualism as prospering in an inverse relation to the extent of organization.[1]

The individual's power may then depend upon the maintenance of institutions. Adolf Berle wrote of this. He said:

> The care and feeding of institutions is a primary concern to any power holder. His first preoccupation is with the mandate on which the institutions are constructed and through which they confer power on

him. Mandates evolve with conditions and therefore have to be flexibly interpreted. Loyalty to the mandate from the men at every level in the institutions has to be preserved. Involved in this is the fidelity the power holder himself must demonstrate, both to the institutional mandate and, within its terms, to the individuals constituting the institutions; and it must be added, fidelity to the conception or spirit of the institution as well as to the mandate.[2]

The second question is: To what extent is the institution itself powerful, i.e., can affect American culture? Jencks and Riesman wrote that "few would deny that established national institutions play a much larger role today than they did a century ago and that their dominance is likely to increase."[3] Sociologist Daniel Bell thought a particular "established national institution"—the university—had become the most powerful in American life. Hedley Donovan, speaking at Vanderbilt University, allowed as how this might be so. But he added that "many academics and intellectuals are uneasy about this. They still have what my colleague Max Ways of *Fortune* calls a certain 'prudery' toward the whole idea of power. Some of them would be more comfortable if they could still think of big business as the real power in the United States—and then all the high-minded men, all the truly independent spirits, could simply line up against big business—and against power. Things have grown much more complicated than that and, in my opinion, much more interesting."[4] But power had certainly passed to the universities as a source of supply.

Jencks and Riesman saw no single institution as all-powerful. The character of American life is determined "in good part," they stated,

within such diverse and sporadically conflicting enterprises as the Chase Manhattan Bank and the Treasury Department, the Pentagon and Boeing Aircraft, the Federal Courts and the National Council of Churches, CBS and *The New York Times,* the State Department and the Chamber of Commerce, the Chrysler Corporation and the Ford Foundation, Standard Oil and Sun Oil. It is not determined to anything like the same extent by small businessmen, independent professionals, or eccentric millionaires. This does not, of course, mean that farmers, doctors, or Texas oilmen are without influence. It does mean that they exercise influence through organizations like the Farm Bureau and the American Medical Association, and that they exercise influence mainly on other large institutions rather than directly on other individuals. Big, well-established institutions have in some cases crowded smaller and more marginal competitors entirely off the stage. This is the case, for example, with national news magazines and automobile manufacturers, to take two dissimilar cases. In other enterprises, such as local newspapers and home construction, small entrepreneurs can still break in.

In others, such as intellectual quarterlies and fashion design, off-beat individuals can sometimes find a niche. Nevertheless, it seems fair to say that established national institutions set most of the ground rules for both stability and change in contemporary America.[5]

But, Riesman pointed out in *The Lonely Crowd*, "the activities of these institutions are subject to veto by a wide variety of vested interests both within each institution and within the larger society."[6] The nature of these vested interests made it likely that the question, of whether a man in Frank Stanton's position might improve television programming, had no simple answer.

Anthropologist Loren Eiseley flatly stated that the "corporation boards of amusement industries . . . deliberately plan the further debauchment of public taste,"[7] and Newton Minow will long be remembered for his characterization of TV as a wasteland (Minow was chairman of the Federal Communications Commission before he joined the staff of the Columbia Broadcasting System—a move from the regulatory agency to the industry being regulated has not been uncommon in our history). But broadcasting historian Erik Barnouw aptly commented:

> With detailed documentation it could be shown that commercial broadcasting was venal, boorish, corrupt, tiresome. . . . With equally detailed documentation it could be shown that commercial broadcasting was varied, educational, cultural, magnanimous.[8]

He was speaking of the early 1930's, but this is just as true today. And another historian reminds us that as a nation we "have always fallen too easily for the notion that complex historical developments are the result of the machinations of little groups of nasty men."[9]

A managing editor of *Life* magazine declaimed that "news is what an editor decides it is,"[10] and this suggests that perhaps there are small groups of men in many institutions who *think* they control more than in fact they do and by their conviction have so persuaded others. (Of course, what a magazine or newspaper chooses to print may not be news.) Perhaps William Paley was attempting to persuade by denying even the obvious extent of his power. On the other hand, the more visibly powerful an organization, the more likely it is to be attacked or regulated—good reasons to decry one's own power and peddle that of others. The power of broadcasting as a medium was quickly apparent.

Its development was rapid after the end of World War I, but no conspiracy forced its development as a commercial enterprise. Much confusion prevailed and not much forethought. By 1925, as Barnouw points out, the question of how radio was to be financed had become urgent. Programming costs were going up, both because of the coverage of pub-

lic events and because of demands for payment on the part of artists who at first had been only too pleased to donate their time. But most important, technological changes required capital. Toll broadcasting—the selling of time—begun by AT&T was growing. By 1932, the salesman had become "the trustee of public interest, with minimal supervision. . . . There never had been a moment when Congress confronted the question: shall we have a nationwide broadcasting system financed by advertising?"[11] The concentration that had occurred by the end of the 1920's, when the two hundred largest American corporations (exclusive of banks) "controlled almost half the corporate wealth,"[12] made this system easy to effect and leading advertising agencies became rich.

"Almost all forms of enterprise that would dominate radio and television in decades to come had taken shape," worte Erik Barnouw,[13] and listed them as: advertising agencies, independent producers, transcription syndicates, recording companies, script syndicates, station representatives, merchandising services, trade papers, press agents, trade associations, and unions—along with the stations and networks themselves. This whole structure had become a possibility from the moment Thomas Edison created a vacuum tube from an incandescent lamp. He was granted U.S. patent number 307,031 in October 1884, and all subsequent inventions derived from that father patent. Industrialization made those possibilities practical.

The history of inventions has been that improvements replace but new developments coexist. (Even Marshall McLuhan by the end of the sixties had decided to permit linear communication to continue.) Radio was revitalized by the development of television—videotape did not seem likely to replace broadcasting any more than records had radio. Again, as with education, the chance of more choice promised benefit.

Was color television an improvement or a new development? Stanton at one time believed that eventually there would be only color TV[14] and based his advocacy of a color system on that belief, because it happened to be compatible with technical developments within his company and with his estimate of the market, in spite of a personal preference for black-and-white. (This preference may indicate something about his character if it is true, as Marshall McLuhan and Harley Parker say, that "black and white TV is automatically inclined toward movement just as surely as color TV is inclined toward stasis and iconic values.")[15]

Television after the end of World War II underwent scrabbling of the sort radio had undergone after World War I. Not until 1951 did the FCC finish allocating the twelve VHF (Very High Frequency) channels, which to all intents and purposes were the ones which mattered. But even before that, in 1946. CBS had petitioned the FCC for approval of

Quantitative facts: Black-and-white single frames—individual still photographs—are quiet. (Kitchen in the Stanton home photographed by him.)

standards for color television, hoping to put their own system on the market. The FCC responded by deciding that no available color system was good enough to approve. Dr. Peter Goldmark, who headed the CBS laboratories, was later quoted as saying, "If there could have been agreement while the number of black-and-white sets still was small, we could have avoided black-and-white TV entirely. Think of all the money people would have saved, and all the enjoyment they have missed."[16]

By 1950 black-and-white sets were already widely in use, and the mechanical color system Goldmark had developed for CBS could not be received through these. Nevertheless, the CBS system was favored that year by the FCC (and that favoritism later upheld by Supreme Court decision) over the RCA compatible, electronic system, because of the superior quality of the pictures. But the RCA system was to prevail eventually by being the more salable. This is an interesting business story and is told somewhat as follows in a biography of David Sarnoff.[17]

In January 1945, the FCC conducted new hearings on the issue of television and asked for demonstrations. "The result was merely a reaffirmation of the prewar specifications. With respect to CBS's demand, the agency ruled that television could not 'be held in abeyance until a wide-channel system in the ultrahigh frequencies can be developed and proved.' "

(RCA had a system in operation on a very limited basis before the war: the system proposed by CBS had not been technically worked out. This was, of course, with regard to black-and-white, not color.)

"That CBS seemingly lacked faith in the prospects of television was evidenced when the network rejected four of the five licenses assigned to it by FCC. It was an expensive gesture of contempt," said Eugene Lyons, Sarnoff's biographer (and cousin), and pointed out that "in due time CBS would buy these discarded licenses for telecasting stations for sums running into tens of millions. . . . CBS had made a comprehensive study of the TV potential. The unpleasant verdict was that, whatever its ultimate values, the medium faced 'seven lean years'—a barren stretch of huge outlays and meager returns. . . .

"A new and, in the light of what we now know, rather remarkable argument for deferring television was added to the old inventory," wrote Eugene Lyons. "While continuing to insist that ordinary monochrome TV was not ready, CBS now contended that *color* television was around the corner. The public, it implied, should not be forced to buy the 'intermediate' black-and-white stage, but asked to wait for the completed package. The color system constituting that package was one that CBS itself had been perfecting for many years. It was the traditional mechanical process based on motor-driven whirling discs adapted to color. GE and RCA engineers had also done a lot of work on such color devices through the years but put them aside in favor of all-electronic research."

After the initial petition by CBS in 1946, the FCC held a new set of hearings in September 1949 that lasted until May of the following year, with RCA resting its case entirely on compatibility. "Even Frank Stanton, president of CBS, admitted under questioning that compatibility was 'desirable' and that his system did 'not fully satisfy this feature.' But CBS spokesmen—and there is no reason for doubting their sincerity—simply did not believe that compatible all-electronic color could be perfected." Lyons said that Dr. Goldmark thought such a possibility doubtful. He also adds that Sarnoff was one of the few American industrialists who did not need an interpreter in talking to scientists or on scientific issues—but neither, of course, did Stanton.[18]

"On October 10, 1950, the FCC approved the noncompatible set of standards. . . . This time, because television had become so large a part of daily life, popular interest ran high. Sarnoff planned to take advantage of this fact. By means of well-publicized periodic demonstrations of all-electronic color progress, he would in effect appeal to public and industry opinion and thus place the FCC on the defensive. At the same time he appealed to the law. Within days after the decision was announced, RCA

brought suit in a Federal District Court in Chicago asking it to 'enjoin, set aside, annul, and suspend' the Commission's order. The decision, it charged, contravened the testimony. . . .

"The Federal District Court ruled against RCA. . . . An appeal was carried to the U.S. Supreme Court, which on May 28, 1951, sustained the lower court. . . . Neither the lower nor the highest court had considered the substance of the FCC decision but had ruled only on its legality." Sarnoff pointed out that if federal commissions, boards, and other agencies are to be held to the principle of checks and balances, "there ought to be some place to go where a judicial review of the substance and not merely the form of a case can be secured." This issue, Lyons maintains, "is at the heart of the continuing debate on Big Government."

In any case, CBS allowed its authorized color system to languish "because it learned the hard way what the opposition had foreseen," Lyons wrote, "that the introduction of noncompatible color was an economic impossibility." On December 17, 1953, the FCC, in an about-face, approved the specifications of the National Television Systems Committee, which were almost identical to those of RCA, Lyons said.

Who had the power in that situation?

A certain variety of choice will always, presumably, be inhibited by economic feasibility. But variety of choice can also be inhibited by other facts, one of which is that people cannot want what they do not know exists. In the case of television, what appears on the screen is infinitely more important than the color in which it appears. Broadcasters claim that mass-audience preferences are being served, that the public does choose its programming: but the polls bring reactions primarily to material preselected by the networks, advertising agencies, and the top advertisers. There is no doubt that television retains on the air those programs to which a majority responds, and in that sense can be said to be serving its taste. "It is easy to reach the degree of culture that prevails around us; very hard to pass it," Ralph Waldo Emerson wrote in the nineteenth century. If minority tastes were more frequently served, might not the prevailing degree of culture be raised? Irving Howe called "programmed receptivity" the new thing in the 1960's, part of the remarkable absorptiveness of modern society. And McLuhan had made a glorious infatuation with trash acceptable, Howe said[19]—presumably even to artists and intellectuals. But this last was apparent mostly within cliques in New York City.

Still, perhaps more minority tastes were being satisfied than television's critics would admit. *Fortune* magazine commented on one element of this problem when in 1967 it reported that "upper-income and college-educated viewers—of whom there are more and more—tell interviewers

that they are watching less and less," but went on to observe that Nielsen ratings show this isn't true, that they just won't admit watching. Intellectuals (which upper-income and college-educated viewers are not necessarily) tend toward what has been called "reality" programming: news, sports, and documentaries, but the watching practices of the "better-educated" are "remarkably similar" to those of the rest of the population.[20] Lazarsfeld thought TV would not provide news if it were not for the intellectuals.

"Most intellectuals do not understand the inherent nature of the mass media," wrote Leo Rosten. "They do not understand the process by which a newspaper or magazine, movie or television show is created. They project their own tastes, yearnings, and values upon the masses—who do not, unfortunately, share them. . . . Intellectuals seem unable to reconcile themselves to the fact that their hunger for more news, better plays, more serious debate, deeper involvement in ideas is not a hunger characteristic of many. They cannot believe that the subjects dear to their hearts bore or repel or overtax the capacities of their fellow citizens."[21]

And here is Frank Stanton:

> Democratic procedures, to some extent even democratic values, necessarily involve quantitative considerations, about which intellectuals are always uneasy. . . . I return to a central point: that some sort of hostility on the part of the intellectuals toward the mass media is inevitable, because the intellectuals are a minority, one not really reconciled to some basic features of democratic life. . . . They constitute the outposts of our intellectual life as a people, they probe around frontiers in their splendid sparsity, looking around occasionally to see where—how far behind—the rest of us are. We are never going to catch up, but at least we shall always have somewhere to go.[22]

Sociologist Herbert Gans put it this way: "Sociological analysis indicates that the hostility of the critics toward popular culture is based not only on differences in aesthetic standards but also on the class differences that create conflict in so many other institutions and, of course, on the disproportion of power and influence between high culture and its politically or numerically dominant competition."[23] Someone who thinks that in truth the power and influence are television's might say that Stanton could well afford to be modest and unhostile. Someone who—like myself—thinks that the ultimate power resides with artists and intellectuals can find his stated attitude remarkable.

Stanton concluded by saying, "We in the mass media have probably been negligent in not drawing the intellectuals more intimately into our counsels, and the intellectuals, by and large, have not studied the evidence carefully enough before discussing the mass media. The mass media need

"How long must I endure this insult to my intelligence?"

DRAWING BY HANDELSMAN; © 1969
THE NEW YORKER MAGAZINE, INC.

the enlightened criticism, the thorough examination, of the intellectuals. When the latter are willing to promise us these, we shall all make progress faster and steadier."[24] But intellectuals *had* criticized and examined.

". . . I and my friends in the arts, or I and my friends in the universities, or in journalism, have despaired of ever directly influencing what happens on commercial television, so why should we think about it too much, you know?—on a content basis," McNeil Lowry said.

Now if that bird [the satellite] flies, and the two things that we're seeking to do is get rid of the tyranny both of time and of money, which afflict commercial television, it's just like starting all over again, in a way. It's like saying you're asked to plan a BBC that doesn't exist. And that's a very exciting challenge. But I've already tested the water out a little bit, and even very exciting people in the arts have never

thought about this, because they've just despaired of doing anything about it. They see educational television but they say, "Well what's the use, what I want to do I can't do on *those* budgets." And they see commercial television as hopeless—even people who you know break their back trying to do something with artistic or cultural standards, with a few exceptions that you can think about.

. . . if any of these double-domes we've got working on this project are correct—

"What was that expression? 'Double-domes'?"

Double-domes. That's a slang thing about a guy that is *only* a specialist on *very* technical specialized subject matter. . . . They think that revolutionary changes in telecommunications—much more than this satellite submission that we made on August 1st [1967] to the FCC reveals—are in the wing.

Harcourt, Brace had applied for five ultrahigh-frequency licenses: What did Lowry think of that as an investment? "UHF will be as good as the wattage behind it," he said. ". . . since there is obviously another leap forward . . . the UHF is a great investment. [That leap forward] will eliminate long lines, telephone hookup, and reduce the cost of land lines, communications, and since UHF stations can now be bought more cheaply than VHF, if Jovanovich puts his money in UHF and then the cost of land lines is eliminated, or graphically reduced through satellite technology, well, he's better off than if he bought a VHF because he's paid a lot less money. But look, that ought to be checked."

With a limited VHF spectrum, the encouragement of UHF had been seen as in the public interest. With urging from the FCC, Congress in 1962 had passed a law requiring television sets to be manufactured so that they could receive UHF as well as VHF channels. But the ultrahigh frequencies did not carry the signals as well as the very-high frequencies and consequently required more expensive outlays in the way of equipment—hence Lowry's remark about UHF being as good as the wattage behind it. Which few of the UHF broadcasters were able to afford. And for the most part, those areas which they were attempting to develop already had network-affiliated stations. Lack of network affiliation meant lower revenues for the UHF stations, which in turn meant they had less to invest in improving the quality of programming.[25] By 1970, Harcourt's interest in UHF had receded. Attempts to overcome such difficulties seemed likely to prove unprofitable. The firm's strength lay in programming for which it did not have to own or operate stations. Broadcasting had little in common with book publishing, but perhaps more im-

portantly, satellite broadcasting itself was being eclipsed by another development.

This development was that of the Community Antenna Television systems, or cable television as it came to be called. The original idea, back in the 1950's, had been to provide the television audience with more channels than their own sets could receive the signals for, even with roof antennas, and with better reception on those channels that they had previously been able to receive. The signals from already existing broadcasting stations would be taken out of the air by a single high-power antenna centrally located and from there transmitted to individual sets by means of wires installed either as a separate ground system or—most cheaply—via already existing telephone company equipment, depending upon the permission (not always forthcoming) of regional telephone companies. Did these cable companies have the right to transmit programs without payment to the originating source? The Supreme Court, in 1968, decided that they did, noting that the 1909 copyright law required payment only for actual performance. Thereafter what was at stake became increasingly apparent.

In the past, the number of stations in any given area had been limited by the usable broadcast bands. The industry had been based on an economy of scarcity. Suddenly technology made it possible, by use of the CATV coaxial cable, for home viewers to receive programs over possibly more than forty different channels where before they might have received only six (or fewer) VHF stations. The more channels available, the smaller the audience that could be guaranteed to advertisers at a particular time on a particular show. The market would be scattered; less of a monopolistic system would prevail. Comparing a coaxial cable to a telephone wire, said FCC commissioner Nicholas Johnson, was like "comparing Niagara Falls to a garden hose."[26] In fact, a Brookings Institution report in 1973 noted that legitimate criticisms of the industry were linked to the relatively scarce number of TV channels and that solutions probably could not be worked out as its structure stood.[27] A technical solution to the lack of viewing options had become possible.

The FCC had been ruling since 1962 on the cable systems and the courts had upheld their authority to do so, specifically the Supreme Court in 1968. In general, the FCC had retarded the growth of these systems in order to "integrate the CATV operation into the national television structure in a manner which does not undermine the television broadcast service," said FCC chairman Rosel H. Hyde to members of the House of Representatives in 1969. Was this not against the public interest? Were there not fundamental issues here of free speech and freedom of the press?[28] That same Brookings study noted that cable TV, pay television, and satellite development were being hampered by restrictive rules and costly regulatory

procedures although they represented the best hope for improving the medium.

From the beginning, the problem of regulating broadcasters had been a tricky one. The Department of Commerce had originally handled the licensing of radio stations, the first being in 1920, the year before Herbert Hoover became Secretary. However, it quickly became apparent that more regulation was needed than the mere handing out of licenses. Hoover was of the opinion that the country, including the broadcasters themselves, was "unanimous in its desire for more regulation."[29] He asked Congress for the authority, since the situation had not been covered in the radio law of 1912.

In 1926 a court decision held that Hoover did not have even the authority he had been exercising: in January 1927—at which time there were already some 732 radio stations in the United States—the Dill-White bill became law. It was, reports Erik Barnouw,[30] complete and historic although administrative decision would help to define it. The basic provisions were seven:

1. The government would control all channels but not own any. Later on, it was to be established through the courts that regulating could be done only at the federal level, not by the states.

2. Licenses or transfers were to depend on stations serving the public interest, convenience, and necessity. Adolf Berle later pointed out that these short-term exclusive licenses for the use of specific wavelengths

> were granted to private companies but rapidly ripened into an uncodified but thoroughly recognized expectancy (if not right) that the licensee companies, through renewal of their licenses, would continue to enjoy the wave-length frequencies assigned them. Temporary licenses, plus expectancy of their renewal, became the basis for dollar-value markets for radio and TV stations, big and little. The statist right thus became engulfed in a "private property" institution.[31]

3. The government could not censor the content of particular programs, but "obscene, indecent, or profane language" could be censored. This led to various debates later on about whether review after the fact to make sure the public was being served constituted censorship as well as a violation of the First Amendment to the Constitution of the United States, which states that

> Congress shall make no law respecting an establishment of religion, or prohibiting the free exercise thereof; or abridging the freedom of speech, or of the press; or the right of the people peaceably to assemble, and to petition the Government for redress of grievances.

4. Those guilty of monopolistic practices could not be licensed. Historically, however, much of the FCC's activity in this area, as pointed out elsewhere, has depended on the bent of particular commissioners.

5. The licensing authority—the Federal Radio Commission as it was then called—was to be an independent bipartisan commission of five members appointed for a period of one year. After that the authority was to revert to the Secretary of Commerce. However, later amendments prolonged the life of the commission until 1934. Barnouw writes that its career

> was weird, to the point of straining belief. It belongs in the annals of politics but had a fateful impact on broadcasting. . . . "Probably no quasi-judicial body was ever subject to so much congressional pressure as the Federal Radio Commission."[32] . . . The importance of congressional assistance in dealing with the FRC became notorious,

although the granting of licenses involved technical training that, presumably, congressmen did not have.

6. The commission was authorized to regulate stations tied in with broadcasting chains.

7. The Radio Act of 1927 provided that matter broadcast for a consideration must be "announced as paid for or furnished, as the case may be, by such person, firm, company, or corporation," but other than that it did not regulate the method of industry financing.

The Federal Radio Commission went out of business in 1934 with the passage of a law creating the regulatory agency in a new form: the Federal Communications Commission, as it remains today. This new act changed the previous law only in minor ways: the local radio station was still expected to exercise individual responsibility. When the seven commissioners (among them, some holdovers) took office in July of that year, appointed by President Roosevelt and confirmed by the Senate, they were immediately confronted with the handling of an incredible number of licenses—some fifty thousand, according to Barnouw.

The end of the 1930's saw radio in its heyday and the beginnings of commercial television. In 1941, the FCC found it necessary to emphasize the need for neutrality on the part of licensees. When World War II broke out, further development of television was postponed—materials, assembly lines, technical skill, had to be used for other, more immediately necessary electronic devices. By the end of the war, radio standards had declined so far that the new FCC chairman, Paul Porter, in his first speech to the National Association of Broadcasters in 1945, was moved to suggest a "new approach to the problem of deteriorating programming."[33] "Before the war," Barnouw writes, "approximately one-third of network time had been commercially sponsored; by the end of the war, it was two-thirds. . . . For some years license applicants had been asked to outline their program plans. Chairman Porter suggested that it might be time to start comparing

promise and performance. It seemed a mild suggestion." Within a short time, a preliminary check put a number of stations on "temporary" licenses. Porter wanted a full report, which was put together by an FCC staff member with the help of an outside consultant.

> After checking and revision, the report was printed and ready for release by March 1946. Its title . . . *Public Service Responsibility of Broadcast Licensees* . . . became known as "the blue book" [because of the color of its cover]. . . . In trying to arrive at future policy on renewals, the blue book looked to industry leaders for applicable standards. It quoted NBC president Niles Trammel, CBS president William Paley, and others. They had made eloquent statements about commercial excesses and about the important role of sustaining programs in (1) providing balance; (2) dealing with subjects unsuitable for sponsorship; (3) serving minority interests; (4) serving needs of non-profit groups; (5) experimenting with new techniques. . . . On the basis of standards derived from these industry leaders, the FCC proposed in the future to examine for renewal purposes the time devoted to *sustaining programs*, to *local live programs*, to *discussion of public issues*, and to the station's ability to resist *advertising excesses*.[34]

Initial praise was followed by attack: the new NAB president "apparently felt that broadcasters should never—tacitly or otherwise—have conceded to the FCC the right to interest itself in programming—even past programming. Any FCC decisions based on programming were in his view 'censorship,' violating the freedom of speech guarantees in the Communications Act and the Constitution. He apparently considered it a life-or-death matter for the industry to discredit and defeat the blue book."[35]

Stanton became president of CBS in January 1946. In the summer of that year, "Station WBAL, the Hearst station in Baltimore—a major exhibit of horrors in the blue book—applied for a Baltimore television channel. The FCC decided to grant it, even without a hearing. . . . It was clear by the end of 1946 that the blue book had indeed been bleached. It might remain as a statement of principle, of mysterious status, but would not be a guide to action. It had been a bold effort to give meaning to 'public interest' but it had failed. Broadcasters knew it and were soon proceeding as if it did not exist."[36] The FCC chairman said, "This matter is principally in the hands of the licensees of the thousands of stations throughout the country. They are the ones to whom listeners should give credit for fine service; and they are the ones whom listeners should hold responsible for service that is not good."[37] President Nixon's administration, in the early 1970's, echoed the sentiment.

Barnouw further pointed out:

In this situation a "power move" by the FCC—such as the chain report or the blue book—promptly produced "power moves" in Congress: speeches of protest; demands for investigations, resolutions; proposed amendments to the Communications Act. This had become a ritual cycle. In the blue book saga it was enacted in classic form.[38]

"You Fellows Go Right On Talking — I'll Let You Know When I Reach a Decision"

FROM HERBLOCK'S SPECIAL FOR TODAY
(SIMON & SCHUSTER, 1958)

By 1948 only about a hundred television broadcasting licenses had been issued, but the sale of television sets was growing rapidly: at the beginning of 1947 only some 5,000 had been in use; by October 1950 there were 8 million; and by the start of 1952, 15 million.[39] After station licensing, temporarily halted, was resumed by the FCC, the American Broadcasting Company, owned by Westinghouse, ended up with 146 affiliated stations; the National Broadcasting Company, owned by RCA, with 206; and the Columbia Broadcasting System with 201.[40] These were the three

commercial networks and each owned five stations, the maximum allowed by law.

By 1969, half of the broadcasting licenses in the nation were conglomerately owned. That year, *The New York Times* reported, "a total of 155 publishers, including many of the country's most prominent newspapers, have a financial stake in 260 of the 496 commercial stations. A total of 160 stations, often furnishing the revenue to keep major newspapers alive, are wholly owned by elements of the press. In 44 areas, the only TV station is also owned by the only local paper, a category of particular interest to the Department of Justice.[41] A similar pattern prevails in radio."[42] In 1972, FCC commissioner Nicholas Johnson pointed out:

> In the nation's 11 largest cities there is not a single network-affiliated VHF television station that is independently and locally owned. All are owned by the networks, multiple-station owners or major local newspapers—and many of these owners are large conglomerate corporations as well. Compounding this problem, most national news comes from the two wire services, AP and UPI, each serving approximately 1,200 newspapers and 3,000 radio and television stations.[43]

As for cable TV, by 1970 more than half the cable systems in the United States belonged directly to the broadcasting industry or to the phone company.[44] Time Inc. was an early investor. CBS explored CATV through a new corporate division, the CBS/Comtec group, and acquired interests in Manhattan, California, and Canada.

The FCC since its inception had been accused of using financial resource too predominantly as the basis on which licenses were distributed. That it could use some muscle to effect a pluralism of involved interests was not in question. Belatedly, it developed an interest in these communications conglomerates, an interest fostered by antitrust factions in the Justice Department and in Congress, as well as by two of its commissioners, Kenneth Cox and Johnson. Of course, it could refuse or cancel a license if in its opinion the broadcasting station was not serving the public interest, convenience, or necessity, but in practice that was seldom done. Renewals, coming up every three years, had for the most part been routine —occasionally scandalously so. But in 1969, the FCC did deny license renewal to the Boston Herald-Traveler Corporation for its NBC-affiliated station in Boston "largely on the grounds of concentration of ownership."[45] Subsequently, Senator John A. Pastore, long a friend of the broadcasting industry, sponsored a bill in the Senate to make licenses unchallengeable except where the FCC had already canceled for cause—on the dubious basis that security would make broadcasters more responsible. FCC regulations, in 1970, also were able to force CBS to "spin off" its domestic cable

television and program syndication businesses into an independent new company, Viacom. The Ford Foundation by 1974 was contributing funds to a public-interest law firm, the CCC (Citizens Communications Center), which negotiated agreements between broadcasters and citizens groups, sometimes litigating in connection with station license renewals and challenging FCC policy.

As soon as a regulatory agency becomes less responsive to pressure groups, Congress takes more of the pressure. *The New York Times* claimed that "the broadcasting industry's lobby is one of the most formidable and efficient in Washington,"[46] and an FCC commissioner wrote that most countries "recognize that in any country in which public opinion is relevant to public policy, the power of those who control the mass media is far greater than that of elected officials."[47] Does that mean that Frank Stanton had more power than, say, President Johnson? Did that commissioner believe that Frank Stanton was one of "those who control the mass media"?

> Periodic confrontations of public power and private power appear to have become characteristic of our social system. In such struggles—as between FCC and commercial broadcasters—each side has power but does not know its full extent. The law is ambiguous. Neither side presses hard for clarification, for clarification involves risks. Each contents itself with manipulating what Professor Louis L. Jaffe of Harvard has called "the margin of doubt." This shifty, shadowy kind of relationship characterizes all manner of government-industry dealings. Personnel changes, political shifts, bring an ebb and flow of effective influence.[48]

"In a democracy the best protection of the 'free market place of ideas' is the variety of publics that read newspapers and watch television and the many interests engaged in the business of purveying information and opinion," wrote James MacGregor Burns and Jack W. Peltason.[49] Among the elements that worked to distribute power and to provide diversity, as listed by FCC commissioner Johnson at the end of the sixties, were "the Public Broadcasting Corporation, subscription television, cable television, direct satellite-to-home broadcasting, common carrier channels, standards for 'public access' to the mass media in accordance with the Supreme Court's *Red Lion* decision, FM and UHF station development, more educational stations, community supported stations like Pacifica, home access to audio and video libraries of programs, home video records, and tape and disc players."[50] There was the ambitious National Citizens Committee for Broadcasting, which had as its goals the improvement of programming through continuous monitoring and evaluation, more effective regulation of broadcasters, more emphasis on public-interest requirements, including air time for minority opinions and cultural experimentation, and a study of

economic concentration in electronic communications. Not only the *Red Lion* but other Supreme Court decisions ruled against the sole interests of broadcasters. In 1943, the Court had ruled that the First Amendment did not prevent the government from requiring a license (*National Broadcasting Co. v. United States*). And then there had been that cable TV decision in 1968. A Supreme Court decision in 1974 echoed the 1968 decision, with CBS suing Teleprompter in a test-case suit, by stating that CATV operators do not violate copyright laws when they pick up TV signals from distant markets. Ironically, while the former decision had permitted cable television to survive, the later one seemed retrograde. It came at a time when royalty arrangements were being worked out on a basis that would reward copyright owners—hopefully encouraging creativity.[51] In 1970, Ralph Lee Smith pointed out yet another element: it had become more and more apparent that the interests of another powerful Washington lobby, a segment of the electronics industry, diverged from those of the broadcasters.

> The political importance of "The Future of Broadband Communications" [title of a presentation to the FCC in 1968 by the Industrial Electronics Division, Electronic Industries Association] lies in the fact that IED/EIA is the first major industry group to break ranks with both the broadcasters and the cable TV industry, and to call for an immediate national commitment to wire the country. IED/EIA is also one of the few lobbies in Washington that may be a match for the broadcasters.[52]

The Ford Foundation granted $2.5 million in 1972 to the Urban Institute to establish and operate a Cable Information Service through 1976. It would supply city and state government officials with technical assistance and nonpartisan analyses of cable issues; with information by technical, legal, and economic experts and explanations of the franchising process, even drawing up model franchise agreements, etc., for those cities requesting them. (A RAND Corporation study noted that "the development of cable television demands more decision-making by local communities than most technologies have required in the past.")[53]

The commercial interests engaged in the business of purveying information and opinion began to combine at an alarming rate, even before it became apparent that the unexpected technological development of the cable would force change on the broadcasting industry. "Dealing with the problem [of the changing or expanding requirements of an institution] is one of the reasons—perhaps the chief reason—for the power holder's existence," wrote Adolf Berle.[54] Network executives responded not by attempting to raise the level of programming, which they already knew was no bulwark against the future, but by diversifying and conglomerating.

In speaking of "the curious circumstance of electronics and broadcast-

ing companies rushing, like lemmings to the cold sea, to buy publishing houses," William Jovanovich noted:

> Within the past few years, Xerox, RCA, IBM, Litton Industries, Raytheon, ITT, and CBS have acquired holdings, usually at extravagant prices, in book publishing houses. Typically, the public announcements of such acquisitions propose that whereas RCA, for example, produces the "hardware" of communication, and whereas Random House (which was bought by RCA) produces the "software," their alliance is logical and self-serving.

But a research analyst at Oppenheimer & Co. warned "the large complexes" that they were not in the hardcover book business but "in the business of marketing and updating information."[55]

" 'Hardware-software' is the shorthand for the concept that the essential nature of information is not determined finally by its creator or compiler," Jovanovich said, but "rather, it is determined by the system in which creation, transmittal, and consumption are at once a part, each reinforcing the other."[56] Information becomes a "ware," or an article of commerce, when its origination presupposes its consumption, he said.

And, indeed, television shows are a good example of this. Their "essential natures" are usually not determined by individual creators or compilers but under a "system in which creation, transmittal, and consumption are at once a part, each reinforcing the other." Alvin Toffler, in speaking of the "culture system," refers to these three elements as "creator, disseminator, consumer" and discusses the feedback relationship they have with each other.[57] Where television has been most successful, a strong individual, such as an Edward R. Murrow, has come along to change the balance between these elements, has forcefully made the creative act outweigh transmittal costs (the involvement with advertisers) and consumption (as measured by the polls).

The networks have been powerful in the past primarily because they *have* responded to economic realities. "I come from a commercial organization," Stanton told the National Press Club in the late 1950's.[58] They have been in the business, as Robert Eck put it, of delivering audiences to advertisers,[59] with policy set in light of limited but intense competition. An interesting example of this competition occurred in 1948 when CBS attempted to close the gap that had existed between it and NBC for the previous twenty years, during which NBC had ranked first in top-rated programs, advertising revenues, and profits.

CBS rapidly succeeded in pre-empting first place by luring radio stars away from NBC on capital-gains deals—setting them up as corporations. Sarnoff could have made the same deals but apparently objected to them

as a matter of principle—he thought the star system would give performers the upper hand. "An NBC official said privately, 'The General, I think, got himself involved emotionally in what was a problem in cold business. . . . He felt, I think, that [the performers] were being "disloyal." . . . Some of us thought of talent simply as a marketable commodity, that's all.' "[60]

If a network gets behind in the rating game, it begins to lose the highest advertising rates and accounts (though, curiously, *Fortune* magazine in 1967 commented that the rise in advertising rates had been accompanied by "a steady erosion of potential commercial effectiveness"). Dr. Stanton's working life had been devoted to what he saw as the realities of the situation. While the New Class may be regarded as the "non-owning" class, in whatever terms profitability is put, an individual in an organization must keep it in mind simply in order to remain a part of that organization. It is true that financial profits accrue to members of the New Class personally in a different way from those capitalists who own their own businesses, but their position might be made *more* rigid by that regard for company profits rather than less—which I doubt is what Christopher Lasch had in mind when he spoke of the desirability of an end to aggressive individualism. It has been suggested that the separation of ownership from control would lead to the looting of firms by their managers. Robin Marris and William Baumol believe managers are sufficiently rewarded by *growth*.

"Sometimes," Stanton said, "I think maybe we ought to be larger only because we would get a certain kind of protection if we were larger, and we could do things that we can't do when we're smaller. . . . If you were larger, you wouldn't have the exposure that you have when you are primarily in one thing, such as we are [e.g., the broadcasting business]. Or if we were privately owned."

"If you were privately owned, what do you think would happen differently?"

"Well," Stanton replied, "it wouldn't be the demand on you from the standpoint of your shareholders, and even personnel from that point of view, for the stock to grow in value." He continued:

> If you wanted to say that this season or this year we're going to try something that's going to cost us a lot of money, just as a bold effort in a particular area, you're inhibited to a certain extent because you've got a commitment to make a certain level of profits for your shareholders; people have invested in your company with the understanding, certainly not with the understanding but with the expectation that they're going to make a certain return, and you may not have the right, if you will, the moral right, to jeopardize their earnings by making a decision that might take you in an entirely different direction.

For example, some time ago I felt that it might be fine to shake up

the whole schedule of television and to take a night of the week—on the theory that you have a program here on one night and a program here on another night that are—let's say, that appeal to smaller audience groups, either generally by content or by form. Maybe the thing to do would be to put that kind of programming all together in one night and not program by discrete half hours or hours but just take seven-thirty to eleven o'clock and program it as a whole night. But this means less income for the stations that we don't own, that depend on us for income. So we've got a responsibility to them, and we're locked into the structure that way.

If we were privately owned, so that the chairman [William Paley] and I could say to each other, "Let's go ahead and try this thing. It may fall on its face but we can try it"—if we lost our own shirts, well, that's that. But if we had thousands of stockholders involved, this would be, and is, a much more difficult decision to make. . . . When you're publicly owned, it's more difficult to do it than when you're privately owned, that's all.

Even if the chairman had maintained his virtually sole ownership of the company, by this time, with the size of the company, it would be pretty ridiculous to see all of his family tied to one investment, so to speak, so that he's forced by the facts of life to diversify his own holdings.

By 1966, there were 41,000 holders of CBS stock.[61] Stanton said:

I wasn't party to his decision to make the—when [Paley] sold his interest down to where he now has it. So I don't know what motivated him, but I imagine I know, and that was that he'd built this thing to the point where it wasn't wise to have all of his eggs in one basket, so he diversified the same way a company diversifies. But this has a blanketing effect occasionally on making a bold move in which you might jeopardize the profits of the company.

Paley was reputed to see himself as the guardian of culture against Frank Stanton. Erik Barnouw, in his history of broadcasting, is in general admiring of William Paley while he barely mentions Stanton. But Barnouw does tell a story about Norman Corwin, one of the most admired radio writers, running into Paley on a train in 1947 and having dinner with him, and of their conversation during that dinner:

CBS was at this moment under attack over a matter involving William L. Shirer. The Shirer broadcasts had been moved by CBS to a time period he considered inferior, and he resigned. To admirers of Shirer it seemed CBS was trying to muffle a notable wartime voice; his liberal views were said to be responsible. The dispute coincided with charges by Oliver Bryce, in the *New Republic*, that two dozen left-of-center commentators had been dropped from the four networks—by sponsor or

network action—since the war. Paley was disturbed over the Shirer dispute and told Corwin he had had no intention of penalizing Shirer. Paley was getting congratulations from some quarters for having disposed of Shirer, and said he was not happy about this. He foresaw a "wave of reaction."

They talked about Corwin's future. Corwin later carried away a recollection of Paley picking at a salad. "Well, you know, you've done epic things that are appreciated by us and by a special audience, but couldn't you write for a broader public? That's what we're going to need, more and more. We've simply got to face up to the fact that we're in a commercial business." Paley described the situation as highly competitive, and getting tougher. If the network did not reach as many people as possible, "why then we're not really making the best use of our talent, our time, and our equipment."[62]

So private ownership was not the answer either.

"I'm not using this as an excuse for lack of innovation," Stanton said, because you can still innovate within the structure. But if you're going to make a bold move, and tear up a whole night of programming and restructure it, this would have effects not only on our own profits but on the profits of a lot of the stations that we have to be affiliated with. . . . And if you ask me to block out fifty-two weeks of programming for such a thing, I'd be hard-pressed to do it, but I think I could pull together a group of creative people who could begin to fill in a good part of it. You could move "CBS Reports" into the ten-to-eleven—I'd start it with a mixed schedule at the beginning of the evening. I'd start it with things that appealed to the family group as a whole, and then I'd thin the audience out in terms of special interests as I went on during the evening. In other words, I'd taper off or up into a more select audience as I approached eleven o'clock. That's if I did different programs and one fed into the other, but if I did a whole evening of the opera, why of course I'd start right off at seven-thirty with a very small audience.

Now, that kind of programming—that concept wouldn't excite a lot of advertising support. Not that the sponsors would sponsor the programs. They don't any more. About eighty percent, I guess better than eighty percent, of our schedule is now just bought on an announcement basis. But you would have a very small audience for that to begin with, and probably never get the size audience—I know you wouldn't, not in my lifetime would you ever approach the audience sizes that you have now. So this would be taking roughly a seventh of the nighttime schedule, and reducing the circulation, which is the same thing as saying you're reducing the income and therefore the profits.

In 1969, television profits before federal income tax represented about 70 percent return on tangible investment (as opposed to an average of about 20 percent for all manufacturing industries).

Later, when asked, "What do you think he [Stanton] *could* do and what do you think his personal inclinations would be to do aside from his role as industry spokesman?" Lazarsfeld replied, "Seen from the side of Stanton, I don't think he could think of anything any more, himself."

I asked Dr. Stanton if he felt there was any chance of his idea coming to pass in the next few years.

"Well, yes," he replied, "there's a chance. It might come to pass, curiously enough, by something that I have been very eager to see get off the ground, and that's through what is incorrectly called educational television."

Too many excuses had been made for educational (public) television on the grounds that it lacked funds—although it did, in spite of massive grants (some $250 million in two decades) from the Ford Foundation and money from other sources, including CBS. Ford Foundation grants had gone to individual public stations, to the National Educational Television Network, and to a "Public Broadcast Laboratory" as a two-year experiment, the best though indirect result of which was the establishment by the Johnson administration of a public corporation for broadcasting. The report of the Carnegie Commission on Educational Television had led to that act in 1967. CPB (the Corporation for Public Broadcasting) had created the Public Broadcasting Service as the national distribution arm for TV programs, with WNET/Channel 13 as its New York affiliate and a major production center for national programming. The situation of the National Educational Television Network had pointed up the question (leaving aside the problem of talent, which would always be in short supply) of where, realistically, the money for desired improvement in television programming could be expected to come from: advertising revenues or educational institutions, foundations or the federal government, audience fees or local communities? Or from all of these sources and others besides? A reduction in costs was inherent in cable TV. Frederick W. Ford, retiring president of the National Cable Television Association, forecast in 1969:

> I expect substantial development very soon in the nationwide distribution of Public Broadcasting Act programs, many of which may be distributed on cable television channels in prime time by way of domestic satellites, which will no doubt interconnect cable systems for non-entertainment-type programming.[63]

By 1974, there were 150 public television licensees operating 244 stations. Priorities included children's shows, public affairs, humanities, "target" audiences (minorities, the elderly), and education. News-oriented programs were the greatest source of controversy in the system, the ques-

tion being: Should an industry supported partly by government funds engage in public affairs? Nixon's White House in 1973 put pressure on the chairman of the Corporation for Public Broadcasting to eliminate any transmission of public affairs programs via the Public Broadcasting System network.[64]

When the White House lobbied to block a compromise plan designed to adjust relations between the CPB and the public television stations, which would have allowed the stations to retain a large measure of control in national programming, Thomas B. Curtis, chairman of CPB, resigned. All but nine of 143 stations polled chose public affairs as their top-choice program category. The Ford Foundation made it clear that it would "withhold from the stations some $8 million for national programming until it is assured the stations will retain control of the interconnection network." Irving Kristol, a Republican appointee to the corporation's ruling board, said "the present [1973] 'struggle for the soul of public broadcasting' was between 'the conception of the Carnegie Commission—calling for some networking, but with a predominance of local control—and the conception of the Ford Foundation[65] and Fred Friendly, which is essentially for an American version of the B.B.C.' " He said the attempt was not to centralize control on the part of the Administration but, in fact, to decentralize (some pointed out that the call for a return to localism arose because the single station could not afford to be a threat)—but Kristol wanted the board to at least share control of scheduling (which to him was power) with the Public Broadcasting Service, a union of the network and the stations.[66] President Nixon had tended to think the media anti-Administration and apparently tried to get rid of those who had a habit of being critical— Frank Reynolds as anchor man of ABC nightly news and Daniel Schorr of CBS News. Nixon had vetoed a substantial two-year increase in funding for public television in 1972 because of the "liberal bias" in programs and commentators.[67] The situation was turned around when Dr. James R. Killian, who had been chairman of the Carnegie Commission report, was voted chairman of PBS and called for reaffirmation of public-affairs programs as an "essential responsibility" of public broadcasting. He believed that the Watergate scandal would help assure its freedom from political control.[68] *The New York Times* on June 1, 1973, reported an agreement between the Corporation for Public Broadcasting and the Public Broadcasting Service whereby "programs not financed by the Corporation for Public Broadcasting would have access to the network linking the country's public TV stations." During the long controversy over who was to decide what programs got funded by the CPB and how programs were scheduled for transmission, the American Civil Liberties Union and the Network Project had filed suit to force the corporation to divide its funds among the various

public stations and the centers that prepare programs for public TV without reference to what types of programs were being prepared. The fundamental aim was to prevent any form of centralized control over programming on public TV either on the part of CPB or the Public Broadcasting Service.[69] The June 1973 agreement also guaranteed local stations a percentage of future federal funds, and in August, President Nixon signed legislation authorizing $110 million in appropriations by the CBP for the ensuing two years. By February 1974, the White House was urging on Congress a five-year funding bill asking for graduated annual appropriations reaching $100 million at the end of the fifth year, presumably because the idea that public television might become the "fourth network" in the United States had been supplanted by a new system under which each local public station could select and pay for the national programs it wanted.[70] Programs would be syndicated, instead of "ordained" by a central source and sent out in a national schedule. The Public Broadcasting Service, which had been the central programming source, would become the distribution means only. This was called the "marketplace cooperative" plan, which was more expensive but provided diversity. The Ford Foundation planned to gradually withdraw from support of public television from then on.

Leo Rosten thought that "to replace publication for profit by publication via subsidy would of course be to exchange one set of imperfections for another,"[71] but "replace" is the key word in that sentence. Why not have educational television, commercial broadcasting, government-supported broadcasting, cable television as a public utility and common carrier, and as much else as was possible?

Curiously enough, educational TV might have profited by more attention to certain commercial standards.[72] There at least the programs had a kind of excellence: that is, they managed to do extremely well what they did, albeit sometimes with extreme lack of imagination, as witness this item from the *Saturday Review*:

> Last year, after CBS had presented Vladimir Horowitz in a special, televised concert, an NBC executive was heard to remark that the program was a "disaster" because it was viewed by "only nine million people." How odd then (considering the fact that the executive's comment probably reflected prevailing opinion at his network) that this season NBC should turn up with a ninety-minute special of its own, *NBC News Presents Arthur Rubinstein*.[73]

John Updike once wrote of James Agee, that talented poet who worked for Time Incorporated, ". . . [his] undoing was not his professionalism but his blind, despairing belief in an ideal amateurism." So with

much of educational television. Those who worked in this area appeared to believe that what was done for no profit was *for that reason* superior— and, conversely, that engaging in a profitable enterprise automatically rendered one a prostitute.

Leo Rosten wrote:

> Publishers and producers are undoubtedly motivated by a desire for profits. But this is not *all* that motivates them. Publishers and producers are no less responsive than intellectuals to "ego values"; they are no less eager to win respect and respectability from their peers; they respond to both internalized and external "reference groups"; they seek esteem— from the self and from others.[74]

An aquaintance said, "I think Frank Stanton has lost his soul and knows it." He said, "You see, Frank is the only intellectual who *could* have been a real leader, cultural leader, of the industry and who became an attractive Chamber of Commerce figure."[75]

CHAPTER 6

DEEPER MOTIVATIONS

(Power of the institution)

THIS "EXTREMELY INTELLIGENT, extremely charming, extremely handsome"[1] man, Frank Stanton, joined CBS in 1935, having just gotten his doctorate from Ohio State University. At the time of my interviews with him, he had been with the company for thirty-two years. He remembered his first contacts in terms of the company rather than the individuals who answered his letters, and his interests were in the quantification of behavior patterns.

Stanton said:

> When anyone moves from one area to another, he brings along with him a lot of his interests and relationships, and when I came to CBS I was still very interested in methodological work.
>
> Shortly after I came here, at one of the meetings of the American Psychological Association, I met Hadley Cantril. We blocked out a rather ambitious program, and quite out of the blue one day we got word that the Rockefeller Foundation had made a grant to us. By this time it was the summer of '37 and I didn't want to leave [CBS]. Nothing had really changed except that by that time I was so thoroughly absorbed with my responsibilities here and had begun to make research a factor in the decision-making process here, that it was great fun and very stimulating, and I was up to my neck in day-to-day problems and thoroughly enjoying it.

Lazarsfeld said, "At the time that I really came to know him very closely, let's say 1937, it was so predictable where he would end."

"Why?"

"Oh, I mean, working two hours longer than anyone else; whenever one of the executives wanted to know something, Frank had anticipated it three weeks before and had all of the information. It was so unique a center. Then leaving out how intelligent, how competent: but the motivation! I don't know. . . . First, he's a little clerk; then he becomes Director of Research; then already during the war he became in charge of all the owned and operated stations. I'm sure there was never any doubt at any level that *whatever* the next important job, it would go to Stanton."

Stanton said:

Well, when I came in of course they didn't have a research department, so my first job was to organize the department. And the company was growing very rapidly, the whole industry was on an upswing. . . . At the time I left the research department and moved up into management, I believe we had a staff of ninety-four people, so it was a sizable department.

Well, we did all kinds of things, things that we don't do now because they have been taken over by industry, industry-wide efforts. But, for example, I was involved in decisions as to what stations to affiliate with the network. I made coverage studies. I made audience studies. I did work in selecting programs, in terms of audience reaction to programs. I would take a pilot program and test it. There were all kinds of things. So I was involved in scheduling questions, I was involved in market research—that is, in helping the sales department interest advertisers in sponsoring programs. I got deeply involved in what stations were to be affiliated with the network. That's how I first met [President] Johnson, was in that connection.

I got less involved, but to a certain extent I was involved in financial matters. I developed a system for forecasting sales and profits, not so much profits as the profitability of certain sales. I could generally give the management an answer on the results of sales faster than the accounting department could, because I was using statistical methods as against accounting procedures. I organized a library and reference service. I started the first executive clipping service or reading service that was started for the company. These were things that really weren't all research but they were things that because I had proposed them, they said, "Why don't you do them?" As I say, because we were expanding at that time, this was a fascinating period because the company was small to begin with, and as it grew you had to add new functions, and a lot of these functions came into my department, in part I suppose because I stuck my neck out and said, "Let's do them."

Stanton stayed at CBS: he and Hadley Cantril became associate directors of the Office of Radio Research at Princeton University, funded by the Rockefeller grant, and Paul Lazarsfeld was appointed director. Lazarsfeld

rewrote their proposal. "I think he called ours the Old Testament and he wrote the New Testament," Stanton said.

"I remember the first year or so of this big Rockefeller project that Frank and I wrote so slowly together," Lazarsfeld said.

I got Frank to drive to Princeton, especially on Sunday afternoon. When we drove back, there was the typical Sunday-evening jam. As soon as Frank approached and it was clear that nothing would move, he turned off the ignition because—I think some people still do it—it could catch fire: it minimized a little bit of danger. So twenty times from Princeton to New York on a Sunday evening he would turn off the ignition.

"But," Lazarsfeld added, "I would rather have a crash than be so aware."

Lazarsfeld said, "I *told* you, there is a *great* generosity. Then take the fabulous character of Winnie, his secretary; she's been with him for twenty years. She dies for him."

Lazarsfeld felt that he, too, had been a recipient of what he thought of as generosity. "As a recent immigrant," he said, "much of the authority I had derived from the good will of my two associates," speaking of the Office of Radio Research in the late thirties.

And then for a variety of reasons, quite violent conflict between Cantril and me came out. Finally, the Rockefeller Foundation had to decide either the project would stay in Princeton and then I would resign as the director or I would stay as director and the project would go to another university. Stanton had a many-houred meeting with them. Stanton advised the Rockefeller Foundation to move the radio project from Princeton to Columbia and reconfirm me as director. And here I am, what you almost, while it's technically not true, at least, a Jewish refugee who doesn't look right and doesn't talk right, and you would have made the misprediction that it was completely in Stanton's interests to side with Cantril—but because it was outside his company work.

"Are you implying that if he had been given that kind of decision to make in the corporation, he would have opted *always* for the safe choice?"

"I think so," Lazarsfeld said.

The association, however, proved a fruitful one for Stanton as well, and CBS was often to commission projects from the Office of Radio Research. Sometimes after radio shows—Orson Welles's "The Invasion from Mars" and the Kate Smith War Bond Drive, notably—Lazarsfeld would feel some urgency and telephone Stanton, who would then provide money from his CBS research budget for "immediate preliminary work."[2]

As a social scientist, as a man, as a small boy, Stanton had been as much interested in the quantitative as in the qualitative side of things. His preference for the tangible showed in his liking for crafts, architecture,

and photography, among the arts. It showed in his preference for facts over entertainment (of course, he may have been entertained by facts). My idea was that Stanton's talent was different from the sort that could shape the content of television shows. His career and his interests suggest he may have needed rigidity and structure in order to feel safe. The very essence of television is fluidity. But Lazarsfeld believed that Stanton was a cultural leader on leave of absence and that no one had given him leave. "But you must understand," he said, "Stanton is one of the three really interesting people I've met in my whole life. Anything about Stanton interests me. I find him endlessly interesting."

I asked Stanton if he did not air some shows that were repugnant to him personally, and he told me that his own interests were "largely in the hard news, public affairs, and in the serious drama," and added, "I don't think that in a mass medium the program structure should be the taste of one individual. I wouldn't presume to be trying to set what the country should see." He said, "Not that the country sees only CBS, but I think we have to recognize the tastes and desires of the audience as a whole. Oh sure, there's a lot on the schedule that not necessarily is repugnant but just doesn't appeal to me. I just want to be sure that what we do have on is done as well as we can do it, if there are people that want to see that kind of program." Speaking of the television audience, Stanton had said, "We must help lead without losing our followers by getting too far ahead." He sounded like a past vice-president of Harcourt, Brace. The shrewd textbook publisher, James Reid had said, must never move too far ahead of the "great moderate mass of teachers."[3]

A sociologist wrote: "American society should pursue policies that would maximize educational opportunities for all so as to permit everyone to choose from higher taste cultures. Until such opportunities are available, however, it would be wrong to expect a society with a median level of education still below high school graduation to choose from the higher taste cultures, or for that matter, to support through public policies the welfare of the higher ones at the expense of the lower ones. Moreover, it would be wrong to criticize people for holding and applying aesthetic standards that are related to their educational background, and for participating in taste cultures reflecting this background." Herbert Gans italicized all of the above and then added, not in italics: "This value judgment might be called *aesthetic relationism*; it is a normative restatement of the concept of aesthetic pluralism used to describe the existence of diverse taste cultures."[4]

What Gans believes is that the implications can be disagreed with. He goes on to suggest that the television industry *not* try to help lead as Stanton says he wants to do but use social-science research to determine what the

precise standards are of the various subcultures and then have program-
ming more faithfully reflect these, on the basis that current measurements
are inadequate and in any case only show what audiences will watch, not
what they think is good.

McNeil Lowry agreed that evaluations were needed—but "of existing
mass media programs that were not launched with an artistic objective
but may be having an aesthetic or perceptual effect yet unknown" and
of Ford Foundation projects, specifically that at the Roberson Center,
where television programs were being designed to stimulate aesthetic per-
ception and affective response in young children. (Here the Public Broad-
casting staff, the Children's Television Workshop, psychologists of various
kinds, arts-in-education specialists, and visual and performing artists were
involved.) Although the broad objective of social development operated
in Lowry's division at the Ford Foundation, as it did in the other divisions
(for instance, he spent more in 1973 for the arts in education—as differ-
entiated from "strict formal training of the professional"—than in direct
aid to individual artists), his main concern in this area was with the ar-
tistic potential of television:

> . . . in this part of the Foundation—not about NET or PBL or the
> public broadcast corporation or instructional television—but as one of
> the arts—[we began in 1967] to explore television as ten years [before
> that] we began to explore theater.

Lowry was interested in the problem of making drama an art form on
television and the question of whether multimedia could be used to de-
velop new audiences for artistic productions, to bring in new revenues.
He was going to confront telecommunications "both directly and through
overlap with other concerns"—that overlap being use of the arts "to give a
sense of individual and cultural identity to minorities." He also wanted
dissemination of Foundation-supported projects through audio-visual
means. Under the category "special pilot objectives," his division of hu-
manities and the arts began to work toward new forms of telecommuni-
cations involving the arts. While spending in this area did not displace
other priorities, as Lowry put it, nevertheless it outranked many and was
expected to continue to do so in projections of divisional spending through
the decade of the seventies. Lowry said, "If we don't beat the advertising
companies and the broadcasting networks to the punch in the very com-
plicated field of telecommunications, a few years down the road is going
to be too late." He was interested in affective, perceptive, aesthetic prob-
lems—ideas about form and content—as distinct from cognitive learning.

Stanton thought "the idea thing . . . just tough to regulate" and for
that reason—no doubt among others—consistently fought against govern-
ment regulation:

. . . because the temptation is to get into the content side. . . . No doubt there are plenty of things—I'd be the first to say it, there are a lot of things that can be improved in broadcasting. But I'd like that improvement to come from the industry itself, in its interplay with its audience.

What did he think the interplay consisted of? How did he get clues?

Well, you get systematic clues on a quantitative basis by seeing what the audience does when it has the choice of eight or nine stations in television in New York, and you have a variety of things on at any one time.

"The Smothers Brothers create a lot of mail for me," Stanton said in 1967.

Well, anything that begins to be topical and touches on current events and the war in Vietnam—he's got one coming up Saturday night that was referred to me for my judgment before they let it go through, about the President having announced that you couldn't travel, or trying to discourage people from traveling, and one brother said—

Here Stanton broke off and asked me, "Do you know the Smothers Brothers show at all?"
"Yes."

Well, the bright one says to the dumb one, "You can't travel any more," and the other one doesn't know anything about it. He says, "How come?" and the other says, "The President asked us to cooperate." "Oh, if the President wants us to cooperate, we'll cooperate. Where can't we go?" "Well, you can't go to Germany, you can't go to Italy, you can't go to France." I think he makes some passing crack about De Gaulle. Then he goes on down the countries, so he says, "Gee, that's fine." He says "Hey, you guys out in Vietnam—all of you come home, come home, you can't travel any more."

But now I know what's going to happen. We'll get a blast on this from Washington, that we're encouraging this kind of attitude. We won't get it from the doves, we'll get it from the hawks, of course. We get it from the hawks about the Smothers Brothers all the time, because they're needling the Establishment. My own code on that is that I generally am much more relaxed about it than I think some of my colleagues are. It makes me very—I feel very sensitive about trying to play God in some of these situations and say what the public shall see and what they shall not see.

Tom Smothers complained to the FCC that the network told him there ought to be no social comment in an entertainment program. In view of the programs of his that had previously been aired, his complaint

*"I ask the chamber's indulgence at this time to reply to the
Smothers Brothers."*

sounded a little silly. "The commission has no standards in this area,"
said Commissioner Cox. Smothers left Cox's office unclear as to who was
the bogeyman,[5] but it's hard to blame him for being confused about that.

Barnouw, in his account of the 1950–51 period, wrote: "Who was in
charge? The FCC? Its powers were limited. The stations licensed by the
FCC? Theoretically the system was built on their sovereignty, but they
had surrendered it to the time-brokerage firms called networks. The net-
works? They had relinquished much of their time, and the choice of con-
tent, to advertising agencies. The agencies? They took orders from sponsors.
The sponsors? They spoke of their responsibility to stockholders. . . ."[6]

John Gardner, when delivering the Godkin Lectures at Harvard, said,
"Deep in our tradition is the notion that if everyone pursues his own

business, the common interest will be served," and added that the only trouble with this notion was that it wasn't true.[7] By "common interest," he did not mean what the above segments had in common: all too obviously, with the exception of the FCC, that was making money. Gardner meant the public interest, for which the FCC was the sole, inadequate representative in the above cycle. How utopian to believe that individual communities would of their own volition neglect profitable narrow interests for unprofitable wider responsibilities. Here again the checks and balances came from a kind of pluralism: Congress; the occasional power of a man in Stanton's position to move in public-spirited directions; the existence of an articulate, unfearful public; and frequent criticism from other media.

It has been suggested that the media do not criticize one another, but *Time* and *Newsweek* carry press sections, "CBS Views the Press," or used to, and there are newspaper critics of television. It is rarer for a newspaper to criticize another newspaper, but the affair at the end of Catledge's career (see page 434), the internal difficulties at *The New York Times*, were exposed by the Washington *Post*. During the middle and latter half of the sixties, "an extraordinary amount of criticism of the *Times* [was] published in various periodicals and magazines—*Commentary* and *Encounter, The Saturday Evening Post, Esquire, The Public Interest,* among others. . . . Until 1968 Mrs. Sulzberger had been convinced, as were nearly all the editors, that there had been little merit in the published criticism."[8]

Here is *Vogue,* that marvelously silly high-fashion magazine with its contingent of tame intellectuals,[9] on February 15, 1969:

> Tom Smothers of the Smothers Brothers television show whose act is that he is a brilliant liberal, but whose reality is that he is a bright, Johnsonian consensus taker with the Brothers' program shown to seventeen of the CBS-TV network affiliates on closed-circuit television the Friday night before the Sunday appointment with its public.

"I consider the network fear-ridden," said Smothers. "After [a sermonette involving God, young people, and the communications gap] we got a letter from a priest saying, 'Jesus would have thought it was funny.' And CBS said, 'Jesus doesn't have to answer our mail.' "[10]

Which *I* think is funny.

"There are such things as questions of taste," Stanton said, "and we've stepped over the line on taste ourselves, regretfully, but I'd rather have an occasional break in the policy than to have people play it so safe that everything is bland, and God knows there's enough blandness in the world as it is, in mass media particularly, and this I think is the nature

of mass media, so that when you do get a little bit of abrasiveness in a broadcast, this doesn't bother me."[11]

Fortune magazine described television in the 1960's as trending away from escapism toward reality. The most prominent single issue changed from the rigging of quiz shows and other such questionable practices (which, while raising particular moral problems, seem to me less important than the issues involved in handling the news, for instance) to the violence shown on the screen and its effect on people, especially children. The television audience was estimated to have put in 109 billion viewer-hours in 1966.[12] When the shocking assassinations of Martin Luther King and Robert Kennedy came in 1968 only a few short years after the assassination of President Kennedy, upon cries of public outrage an attempt was made by the industry to police itself, even to the extent of removing violent acts from already taped shows. But if, as a Los Angeles psychoanalyst suggests, excessive viewing in itself "renders children passive, denying them the normal outlets for aggressive energy until that energy accumulates to the point where it explodes in some form of violence or destructive action,"[13] what kind of policing is possible? The very fact of television's existence is under attack and in order to meet such criticism, the industry would have either to abolish itself or to rely on parents to handle its influence on their children.

The *number* of violent acts shown on the television screen is to a certain extent irrelevant. As Neil Compton put it in *Commentary* magazine, "It is well known that a violent argument between husband and wife in a domestic drama can be more disturbing to juvenile viewers than half a dozen shootings in a typical Western which, though exciting, does not dramatize a situation with which they closely identify."[14] Herbert Gans's essay in *Social Problems* suggests there have been confirming scientific studies.

A Presidential Commission on violence found underlying their report[15] the assumption that "nature provides us only with the capacity for violence; it is social circumstance that determines whether and how we exercise that capacity." And further, that "most psychologists and social scientists do not regard aggression as fundamentally spontaneous or instinctive, nor does the weight of their evidence support such a view. Rather they regard most aggression, including violence, as sometimes an emotional response to socially induced frustrations, and sometimes a dispassionate, learned response evoked by specific situations." It is hard to see television providing social circumstance, simply because there is no interaction.

Dr. Robert Wallis wrote:

[The] word *encountered* (instead of *experienced*) marks . . . the specific difference between a vital phenomenon and its eventual electronic reproduction. The sensation of repetition felt by the child, the recognition of repetition by an electronic machine already more intelligent and obligatorily selective because of its construction and the adult who constructed it—these are different sides of the same essential and initial element which is the seed of *internal time*. . . . Electronic registration is certainly an assessment but . . . assessment is not memory and does not deserve the name.[16]

If this is true, it is hard to see how television corrupts, although another psychoanalyst could comment, "It is not difficult to see why watching television could be a godsend to those in whom interpretive activity produces anxiety" and yet regard it as a "morbid regression."[17]

Arthur Schlesinger noted that "experiments show that such programs [as the Western, the adventure program, and the crime drama], far from serving as safety valves for aggression, attract children with high levels of hostility and stimulate them to seek overt means of acting out their aggressions."[18] There have been studies that suggest some children may imitate the violent behavior they see on television,[19] but on the other hand there have been studies that suggest television violence may help to reduce or control aggressive behavior,[20] and the Surgeon General's report, issued in 1972, came to the conclusion that experimental findings "provide suggestive evidence in favor of the interpretation that viewing violence on television is conducive to an increase in aggressive behavior, although it must be emphasized that the causal sequence is very likely applicable only to some children who are predisposed in this direction"[21]—thus confirming what Paley had to say earlier. Pornography has come to be psychiatrically disassociated from problems of crime,[22] and it is possible that violence on television will also come to be disassociated from such. Action for Children's Television (ACT), a pressure group formed in 1968, was strongly concerned with another aspect of the effects of television on children: its petition before the FCC in 1974 contended children were a "public interest" requiring special protection and asked for the removal of all commercials from children's TV.

Perhaps adults like programs such as "Gunsmoke" or quiz shows because they give them no real problems but present simple solutions of the sort we daydream about. Interestingly, ". . . very few images and incidents seen on television turn up in the dreams of analysands," said psychoanalyst Donald Kaplan. "The implication is that the television medium is practically devoid of interpretive demands upon the viewer. . . . television ranks so highly as a leisure-time activity because it can be related to without very much cognition [that process of knowing that involves

awareness and judgment] on the part of the viewer and thus affords the most convenient relaxation of the sense of reality."[23] Television has been called automated daydreaming, which reminds me that social scientists believe a certain amount of dreaming is healthful. "The dream," says Wallis, "puts the dreamer back automatically to an inferior and more primitive stage of mental life" (i.e., that of childhood) and is detached from memory. What brings about dreams is an "immense number of affective images localized in relation to the relatively small number of authentic remembrances retained."[24]

In other words, a flooding which provides a respite from experience. The elements of television unmistakably consist of that "immense number of affective images." It has been pointed out that where there is an excess of communication, rats, for instance, are rendered psychotic. Perhaps that respite is a necessary concomitant to our modern excess of information. Tension on television is only superficially maintained, according to T. W. Adorno: the "longing for 'feeling on safe ground'—reflecting an infantile need for protection, rather than [the] desire for a thrill—is catered to."[25]

André Malraux speaks of differences in ways of seeing: "The man-in-the-street's way of seeing," he says, "is at once synthetic and incoherent, like memory. . . . The non-artist's vision, wandering when its object is widespread (an 'unframed' vision), and becoming tense yet imprecise when its object is a striking scene, only achieves exact focus when directed towards some *act*. The painter's vision acquires precision in the same way; but, for him, that act is painting."[26]

Television watching is not an act on the part of the viewer so much as absorption and, when it is extensive, perhaps indicates the extent to which a particular individual is already having trouble with the real world. The number and kind of acts of violence a normal person comes in contact with in a way that he patently knows is unreal, I believe affects him in a more indirect way: that is, his time could be more profitably spent. Perhaps disturbed children watch more TV; rather than that the more children watch the more disturbed they become. If there is any preference, as Daniel Boorstin suggests, for the "images" projected by the popular media over actual, personal experience,[27] I suggest this is the basis for it. Sociologist Gans wrote:

> The conclusions of all present studies of effects and other data cited suggest that popular culture is not a social problem either for the majority of its audience or for high culture. Further research is needed, however, to determine to what extent violent content, meretricious advertising, superficial or distorted informational content, and public censorship of controversial sexual, political, and religious content may

affect the entire audience, and especially children, the emotionally disturbed, especially in terms of long-range effects.

Although no firm conclusions can be reached until such research is conducted, the present evidence convinces me that however much of the content of today's popular culture deviates from the aesthetic standards of high culture, and from the universal standards of truth and honesty, the effects of that content are not socially dangerous except to the minority who for reasons of age or emotional and social marginality cannot cope with the content distortion. I am further convinced that they would be helped more by policies that do away with the causes of their problem than by even the most drastic alterations of popular-culture content.[28]

When in 1969 the U.S. Surgeon General was asked to investigate the effects of violence on the screen, he was reported none too enthusiastic about the assignment, although in later editions of *The New York Times* this report changed, perhaps as he adjusted to political reality. It is hard to get direct evidence on intangibles, but the fact of an attempt to do so may, in itself, help to eliminate some of what has been called the pornography of our time. Climates are created through a variety of pressures, and reforms tend to rely on the prevailing climate. ("In 1922 John Sumner, actively suppressing books he considered obscene, stated: 'We do not want books published that inflame the passions of the 80% mentally immature to the degree that they may commit vicious crimes on the mature 20%.'")[29] Good politicians take advantage of the wind, as Fred Friendly did when he steamed away from CBS in indignation because an executive who had just come in over him approved a rerun of "I Love Lucy" instead of the televising of George Kennan's testimony before Congress on Vietnam.

Although Frank Stanton did not take that departure lightly, he remarked to me rather mildly that if "Fred" had not quit over this issue then he would have over another, eventually. Stanton had said in a speech to broadcasters:

We can wander unintentionally—all of us—into a lethal trap if we let our dissatisfaction with the handling of specific issues, which are variable, and of events, which are transitory, compromise our adherence to basic principles, which are constant.[30]

Was the issue one of basic principles or one of temperament? Certainly Friendly thought it one of basic principles. He had often felt unpleasantly constrained at CBS. He believed almost too much in the power of an individual to effect change. His behavior was individualistic, and although emphasis on self as opposed to the group has been called a modern phenomenon, with the rise of corporatism the group has been re-emphasized.

And television's frame unmistakably was corporatism. However, during Friendly's years at CBS he got away with a method of operating, described by himself in his book *Due to Circumstances Beyond Our Control,* that would have been even less permissible in another kind of organization.

"In 1953," Friendly wrote, the Edward R. Murrow program "*See It Now* enjoyed something close to autonomy. Our mandate came from William S. Paley and Irving W. Wilson, the president of Alcoa."[31] It is true that in spite of that autonomy they suffered occasional censorship—as in 1956 when both Sevareid and Murrow, taking the same tack, appealed an executive decision "directly" to Paley but "without result."[32] These happened to be good guys: some bad guys (i.e., producers of junk) also got censored. As someone else has pointed out, censorship *always* exists, to a greater or lesser degree. But when CBS decided not to run an ad for a Murrow-Friendly broadcast, the two placed it anyhow on their own (Friendly, in his book, does not say whether this was with permission from CBS). The particular program was a success. Jack Gould, broadcasting critic for *The New York Times,* wrote that it was "perhaps the first time a major network . . . program [took] a vigorous editorial stand in a matter of national importance and controversy."[33] Murrow and Friendly believed without a doubt that they were performing the best possible service for CBS, and Friendly, at least, felt that the CBS management might have congratulated his team. However, it didn't. He accounts for this as follows:

> I know that there was uneasiness in the CBS high command—the feeling being that if there was to be a broadcast as controversial . . . it ought to be the decision of the management and not simply of Murrow and Friendly.[34]

That seems quite likely.

Again, for a show on Senator Joseph McCarthy, they took an ad on their own. Of that occasion—indubitably holy cause—Friendly wrote:

> [We] decided that rather than involve them in any of the decision-making, we would simply exercise our prerogative and do it on our own. . . . It would be unfair to [Sig Mickelson] to involve him in the editing process in this isolated instance, when we were not inclined to accept any major changes.[35]

Nor, perhaps, inclined to lose any of the credit.

Although Friendly portrays himself as fighting to the end, his history strikes me as redounding to the credit of CBS, which, although obviously upset, not only kept him on but allowed the programs to continue and on the whole allowed Murrow and Friendly to go their own way.

Perhaps, however, this was because they frequently managed to do controversial subjects in a non-controversial manner, as Alexander Kendrick has suggested.[36] William L. Shirer said someone at CBS once pointed out to him that Murrow did not do the McCarthy telecast until the Army had already taken McCarthy on—the implication being that someone else had started the rat hunt and Murrow and Friendly joined in only when it had become somewhat safer to do so.

Murrow's own tenure at CBS came to an end when he began to operate as an independent not only in his programs but in speeches outside the organization. Shifting roles, he became less effective. Murrow's talent *was* of the sort that could shape the content of television shows. What he lacked was the ability to manage change. He ought never to have accepted the job of vice-president in charge of news and public affairs, Shirer said. Murrow was "a broadcaster, not an executive."[37] Paley and Murrow were responsible for his (Shirer's) leaving CBS, Shirer said, when he had sponsor trouble because of his liberal views; Murrow was in charge of "dumping" him. "Stanton sided with me," Shirer said, "but couldn't put it over with Paley. . . . I have no illusions about Stanton but he was decent to me."

When Murrow asked to be let out of the vice-presidency, Stanton "moved to make Murrow a member of the CBS board of directors."[38] Although Murrow had "exercised his personal prerogative to take matters to the chairman [Paley] directly, thus avoiding his immediate superior, Frank Stanton," Stanton thought Murrow had done well as an executive. Murrow's directorship

> placed him within the CBS decision-making apparatus that instituted the loyalty oath, engaged in black listing, and took the first steps toward the diversification of interests that would dilute and deflect the original commitment to broadcasting pure and simple.[39]

Paley felt "that while Murrow did not actually like being a member of the board, and avoided the practice, what he did like was the idea, in a sense the status, of membership."[40] Kendrick remarks that Murrow was in an unusual position for someone who hated the executive function and "whose broadcasting role transcended, and indeed denied, corporate inhibitions." There was a

> growing consensus within the board of directors—of which Murrow was a member—that the network should not engage in strong partisanship on basic issues, even though it was partisanship on behalf of democratic ends. . . . The corporate psychological pattern may have been set, even if only subconsciously, against the man who was "bigger than the network."[41]

Kendrick's implication, that jealousy may have been involved in Murrow's eventual severance, was probably correct, but it may not have been the basic problem. Kendrick's book *Prime Time* gives an interesting account of Murrow's relations with Stanton. Both joined CBS the same year but had very different careers. It appears to be commonly held that Murrow and Friendly were "right" and the network "wrong." But the functions of the men involved were dissimilar, their personalities appropriate for their particular work—and the tensions between them inevitable. Increasingly, Murrow began to criticize the industry in public statements which make it clear that he had come to believe the easiest way to force change was to attack. His health had begun to fail, which may have given him a different perspective. In any event, having moved himself that far outside the structure, it was necessary for him to go the rest of the way.

As for Friendly, if he had wanted to resign over an issue, one might think he would have done so earlier than 1966; might, in fact, have done so in the late forties or early fifties when blacklisting swept the industry and was particularly virulent at CBS.[42] Barnouw, in his history of broadcasting, wrote:

The year 1947 was dominated by a monomania. The concern of the nation was a search for traitors. . . .

[Shortly after the war,] while considering license applicants the FCC began getting unsolicited memoranda from J. Edgar Hoover, director of the Federal Bureau of Investigation. Concerning a group applying for a California license, Hoover wrote: "I thought you would be interested in knowing that an examination of this list reflects that the majority of these individuals are members of the Communist Party or have affiliated themselves sympathetically with the activities of the communist movement."

The FCC asked Hoover for more specific information. It pointed out that rejected applicants were by law entitled to a public hearing. Could the FBI supply information that could be presented as evidence? Hoover said this would be impossible, because its sources had to be kept confidential.

The FCC, where Charles Denny was still chairman, dispatched its own investigator to California. He reported that it was impossible to determine who was a communist and who was not, but that the people referred to were, on the whole, well regarded. Their main political activity had revolved around efforts to reelect President Roosevelt. The FCC, having no basis for unfavorable action that could be defended in court, simply refrained from acting. The applicants knew nothing of charges made against them; they only knew there was delay. But the result, Durr [one of the FCC commissioners] felt, was "to deny the

application by not acting on it." He was disturbed over this and re-
ferred to it at a meeting of educational broadcasters in Chicago. This
resulted in a Washington *Post* column by Marquis Childs—which brought
the problem into the open.

This was in November 1947, and Denny had resigned in October of that
year. Barnouw goes on to say:

> FBI director Hoover was furious. In a statement to the press he said
> the FBI was only being helpful, doing its job. It passed along infor-
> mation and did not "evaluate this information," he said, although most
> observers felt his memorandum had been an evaluation.[43]

Congress had been holding public hearings during 1947 on com-
munism in the film industry. In 1950 there appeared *Red Channels: The
Report of Communist Influence in Radio and Television,* a book whose
bulk was out of all proportion to its weight. An incredible number of
those engaged in the broadcasting, advertising, motion picture, and theat-
rical industries quickly yielded to the notion that controversial people—
whether proven Communists or not—were bad for business.[44] CBS estab-
lished "a sort of loyalty oath"[45] in 1950, and in 1951 appointed an execu-
tive specializing in security.[46]

Something happened to me at CBS which echoed that witch hunt.
In 1964 I proposed—via a buckshot memo to, among others, the presi-
dent of Columbia Records, Goddard Lieberson ("buckshot" because I
was too inexperienced to know how ineffective that approach was likely
to be)—a recording of the poetry of Andrei Voznesensky, a young Russian
whose fame in this country was to be promoted by excellent translations
done with the aid of Patricia Blake and Max Hayward. An anonymous
hand scrawled the word "Communist" across one copy that was returned
to me. Later on, the record was produced when I tried a different tactic,
but the joke—if that's what it was—recalled those shameful earlier years.

John Cogley, author of *Report on Blacklisting: Radio-Television,*

> found that two companies, the Columbia Broadcasting System and Bat-
> ten, Barton, Durstine & Osborn, were especially zealous in institution-
> alizing blacklisting. Artists have generally concurred with this conclusion.
> There was irony in the finding, for these companies had been especially
> noted for the vigor and range of their programming.[47]

Barnouw is overly kind to Paley, saying (on page 282 of *The Golden
Web*) that he didn't want things to be that way. But Paley was boss—
as chairman of the board and as principal stockholder—although Stanton
was then president of CBS. Who was responsible? Is this one of those
things that Stanton now thinks he might have handled differently? Scien-

tist Vannevar Bush thought that every chief executive ought to have a chairman to test ideas against;[48] in general, Paley let Stanton go his own way, but Paley would interfere at crucial points. William L. Shirer told me CBS invited Red Channels in.

Paul Lazarsfeld said:

> No, no, look. No, that's not the way to raise a question. It's more complicated than that. The way that you have to start out, if you ever have given thought to this kind of problem, is that there are no answers. "What is the right relation between government and business leaders?" —there is no answer.
>
> You can spend—most of us have spent years of our lives, so the moment someone claims he has an answer, he's already wrong. And Stanton has maneuvered himself into a position where he has to make assertions—"that is the best" and "that's only two and two" and "that's all good for the United States"—for which he's much too intelligent.

Lazarsfeld reminded me of experiments that showed if someone kept repeating something they had used as a device, they came to accept it themselves.

The historian Ernest Nolte spoke of the lie "which the intellect sees for what it is but which is [felt to be] at one with the deeper motivations of life."[49] But Lazarsfeld felt that Stanton neither believed nor disbelieved the things he said. "Intellectually, it is not possible that Frank with his brilliance believes. Look—not that the opposite is true."

And what had Friendly done? He mentioned *Red Channels* in his memoir only to say, "Luckily [it] did not contain the name of our first choice, though both of the [other men being considered for that particular job] were listed."[50] The first "See It Now" program had been aired in November 1951. Friendly became president of CBS News in 1964, a position he held for two years. *Fortune* magazine described his leaving as "in a noisy dispute over policy and internal lines of authority." Those who read *The New York Times* got little inkling other than that he departed for holy cause, and he got substantial and front-page coverage.

A political scientist points out that people usually climb to get recognition, not power; the notion of people getting up so that no one can tell them what to do is false. "The higher up you get, the more constraints on you," he said.[51] But whether you climb depends on how you take those constraints. And people *not* in high positions tend to think those who are exaggerate those constraints—or, at least, characterize them to others in ways that, while perhaps not untruthful, certainly suit their own purposes.

PART II

"Whispering Ambitions"

CHAPTER 7

AT THE HOT GATES

(*Stepping into power*)

GALBRAITH BELIEVED power to be located in the organizational structure *per se,* which includes all levels: decision making is internal and beyond the reach of any one individual.[1] Jencks and Riesman tended to agree:

> . . . even the managers of the most centralized organizations, public or private, believe they have little room for maneuver. They feel hemmed in by rivals for power within their organization, by competitive organizations, by their prospective clients, by their lawyers and their boards of directors (or fellow directors), and even by their subordinates. The latter, especially, exercise power in many ways that deserve more attention than they have gotten.

As, for instance, in Fred Friendly's case. However:

> Boards of directors sometimes go along with their company president because they have no ready replacement and because they fear he may take another job if he is not given his head.[2]

The most sensitive issue to be found in the corporate hierarchy is "management's *practical* authority versus the authority vested by law in the board of directors"[3] (my italics). Jovanovich noted that "a president of a corporation is subject to restraints, evaluations, and assessment. The directors are responsible to the shareholders; they represent the shareholders. They're supposed to judge the management. It's very subtle business because the management is itself on the board of directors." In situations where the board consists almost entirely of management, as in the case of CBS, it seems reasonable to assume that more power is deliv-

ered into the hands of the chief executive officer—Stanton, as president, in that case.

Sometimes the separation of responsibilities meant long-range planning versus day-by-day operations of the company, although the two inseparably meshed. Conflicts inevitably occur. The degree and kind of power a man is able to exercise in particular situations depends not only upon his board but on his own personality, and a strong will often is the outstanding trait of the successful manager. Hedley Donovan's closest friend (not very close in recent years) commented, "He's got a very strong will." A Harcourt, Brace official close to Jovanovich said he always wanted to dominate a gathering, and if he could not, he didn't stay around. Jovanovich, at the time of our interviews, had no chairman on his board: he functioned as such. In 1970 he formally became chairman and the firm was renamed Harcourt Brace Jovanovich.

The chairman of the board—William Paley at CBS, for instance— is not usually designated as the seat of final corporate authority: company bylaws frequently specify only that he will preside at board meetings and that someone other than the chairman be the chief executive officer—Stanton, for instance. But the board, while delegating power, can't divest itself of responsibility.[4]

Jovanovich said:

I think . . . one can make a very neat rationale in describing the relationship between shareholders, directors, and management. But in actual practice it's a murky relationship. Some directors of some corporations are large shareholders, some are not shareholders at all. Some directors are in the management. Some boards of directors are dominated by the management; others are dominated by outsiders. And there are a hundred variations. . . .

In most situations—probably in most corporations and certainly in academic institutions too—the use of power is almost accidental. Power can be an artifact or a substance or essence that just is lying around and you pick it up. Most of the time there is an area in which power can be exerted if only somebody will exert it.

Jovanovich found himself repositioned in 1953, when he and others in the firm saw power lying around to be picked up and he succeeded where they did not.

In midsummer 1953, I was stricken with a heart attack. I was still in a junior capacity as an associate editor in the school department. I was put into the hospital, and stayed away from work from July until November. I came back to work in November. While I was away, the revolt against Mr. Meek and Mr. Deighton was in full bloom. Several people came out to my house, Mr. Scott did and Mr. Reid and Mr.

McCallum, who was our chief college editor, and said that this was happening, and what did I think about it?

Dudley Meek was at that time the manager of the textbook department while Lee Deighton, a senior executive at Harcourt, was his closest associate. Spencer Scott had been president of Harcourt, Brace since 1947. James Reid, editor-in-chief of the textbook department and Jovanovich's immediate superior, had been with Harcourt since joining as a textbook salesman in 1924, not long after the founding of the company.

It is noteworthy that this cast consisted of characters involved with textbook publishing as opposed to trade publishing (fiction, poetry, children's books, non-fiction for the general public), which is chancier financially. And it is interesting to note, in what follows, that the editors lined up against the executives.

What was Jovanovich's response to those queries in 1953?

I was obviously concerned for my life. I was thirty-three years old and had been gravely sick. I don't think I was anxious over the result of what they had to say. In effect, they were asking in what way would I continue if Mr. Meek and Mr. Deighton were forced out. It was not really much of an issue. It seemed to me that it was all going to happen anyway. Even had I not been ill, I believe I would not have felt I had to side with anybody. Yet, when they came out to see me, they said, "What role do you want in this organization?" I said that if they were going to go ahead, then I would insist on being head of the school department. The problem arose, then, that if Mr. McCallum was to be head of the college department, where would Jimmie Reid fit? He was, after all, superior to both of us—McCallum and I were not even directors of the firm, or, for that matter, officers of the firm. Where would Reid function? It was clear that Mr. Brace and Mr. Scott and Mr. Hastings Harcourt, each in his own way, were not willing for Jimmie Reid to be head of a department. I proposed that I would be head of the school department, McCallum head of the college department, and Jimmie Reid would be editor-in-chief of both. I knew when I proposed it it wouldn't work. There wasn't any other way to do it. I thought, "Something will work out of this, in which we can all work productively, but we're not even going to get into the next day unless somebody says, 'All right, let's do it this way.'" . . . [Harcourt] wouldn't have gone bankrupt that year or the next year or the year after. but . . . It was like one of these Keystone comedies: here's a Model-T Ford racing up around a corner and making the turn, and it isn't going to make it—it is suspended in air for a moment.

Others have described the atmosphere as one of secretiveness and dissension. Jovanovich throughout his career was a shrewd judge of such ten-

sions. I had previously noted, about working for a corporation like CBS, that people tended to talk a lot about who was "up" and who "down." They thought it really mattered and tended to treat one accordingly. Association with someone who had incurred the wrath of a superior would endanger their own position, and no one wanted to be expelled from the in-group. Pressure was put on in the corridors. This of course is also true of society at large. In Jovanovich's case, he wanted to be part of the firm but to have more power in it and had an intuition about how to manage that.

Jovanovich was and is generally accounted a superb editor. But it should be borne in mind, as John Fischer, former editor of *Harper's,* said, "In comparison with elected officials, corporate managers, or university deans, an editor commands only a small quantum of power—usually far less than he thinks."[5] Jovanovich was in the process of becoming a corporate manager, and what happened during the next year completed the change-over. But to understand that story, we must first take a look at the history of Harcourt, Brace.

The firm was a relative newcomer, books having been published in America since 1638, when the first printing press arrived. Many of the publishing houses founded in the nineteenth century were still extant—among them, Appleton, Lippincott, Wiley, Harper & Bros., Putnam, Scribner's, Van Nostrand, and Little, Brown—when Alfred Harcourt and Donald Brace left Henry Holt & Co. to establish their own company. They began with $40,000 capital. Jovanovich notes:

> Sinclair Lewis actually invested some of his own money, which was later repaid. Harcourt, Brace was advanced credit by Quinn and Boden, the printers in New Jersey. They hit it lucky almost at once. In 1919, they published Keynes's *Economic Consequences of Peace,* probably the most unlikely title for a bestseller, which sold a tremendous number of copies.
>
> Alfred Harcourt and Donald Brace were each thirty-nine years old in 1919. Alfred became president; Donald, vice-president. As the years went by, they gave or sold some of their stock to others in the company. Gus Gehrs, who had been sales manager at Henry Holt, came over and was given some stock, and S. Spencer Scott, who had been Henry Holt's chief salesman of textbooks, came over with them; he obtained some stock. Incredibly, these two men, Harcourt and Brace, very shrewd, very intelligent, never seem to have anticipated that a question of stock ownership would ever arise as a means of contesting and determining power between them. Apparently, because they were youngish, and because they had the world by the tail, they couldn't imagine that they would ever disagree.

JUNE 16, 1969, VOL. 195, NO. 24 | CONTENTS, PAGE 35

ABA CONVENTION, PART I
FIRST-TIMERS
CHILDREN'S BOOKSHOPS
CENSORSHIP THREATS
RELIGIOUS PUBLISHERS GROUP

PUBLISHERS' WEEKLY
THE BOOK INDUSTRY JOURNAL

ON A HOT AFTERNOON IN 1919, on July 29th, the incorporation papers were signed and a new publishing house was created. Alfred Harcourt and Donald Brace were now on their own. Within a few years they published Sinclair Lewis, Carl Sandburg, T. S. Eliot, Maynard Keynes, James Weldon Johnson, E. M. Forster, e. e. cummings, Virginia Woolf, W. E. B. Du Bois, and many other writers who have marked the conduct of our times. During the past half-century there have been great changes in this house. We are now a very large company, with almost three thousand employees and with public shareholders. Our influence on American education, from kindergarten to postgraduate and professional learning, is significant and salutary. Yet we have kept a certain style through the years, a style of independence, of taking risks on our own, of keeping our main attention on books. We are easily recognized as the house that began at One West Forty-seventh Street. Each of our three subsequent offices has been on the same street. Each of our four presidents worked only for Harcourt, Brace once it was created (the first three gained their apprenticeship from a great publisher, Henry Holt). This year we published *The Complete Plays of T. S. Eliot,* reissued Carl Sandburg's first book on our list (1919), *The Chicago Race Riots,* and as his publisher saluted E. M. Forster on his ninetieth birthday. We lunch now and again with two poets, Louis Untermeyer, whose first book was on the 1919 list, and Melville Cane, who as a lawyer drew the incorporation papers, and is today a Harcourt director.

Perhaps it is not difficult to combine innovation with tradition in publishing if one can keep in mind that the basic element in our profession is, simply, the sentence: a statement of serious intent, whether in art or instruction, that is created singularly by a writer, purveyed and defended by publishers and booksellers, and accepted freely by readers. Perhaps. We shall need more time to find out.

William Jovanovich

"Within a year after its formation, Harcourt, Brace & Company became one of the most successful of the newer publishing houses."[6] Sales by 1921 amounted to $720,262.[7] The textbook division was considered important from the beginning and by 1930 was functioning profitably: "One of the firm's most successful series for high schools, Adventures in Literature, came to it through James M. Reid, one of its young editors."[8]

The publishing house was only mildly affected by the Depression, and some of its early authors remained mainstays for a long time. The year 1935 saw the publication of Lindbergh and Simenon books, as did 1970.

Harcourt's only son, Hastings, became sales manager in 1935, in violation of a pact Alfred Harcourt had made with his partner not to allow relatives in the organization, and shortly thereafter Reid, Dudley Meek, and Hastings were made directors of the company. Jovanovich believed that, by 1940, Alfred Harcourt

> would have been old enough to be hoping that his son would succeed him. His son was not thought to be suitable by others in the firm. In 1940, Alfred wanted to advance Hastings in the trade department, but Donald Brace objected. At this point, the Harcourts owned something like thirty-nine percent [of the stock], and the Braces owned something like thirty-nine percent, and Mr. S. Spencer Scott, who was head of the textbook department, owned something like twelve percent and so effectively held the swing vote.
>
> Mr. Scott sided with Mr. Brace. Mr. Harcourt said that, unless his wishes were met, he would resign from the firm. I do not think the old man, great publisher that he was, ever thought seriously that anybody would take him up on it, but in point of fact they did. Mr. Brace became president in 1941 and Mr. Harcourt retired to California, still a decisively large shareholder, still in touch with the firm, still a director, but out of the business, hurt, frustrated, very sad, I think.

In 1943 then, Scott was vice-president and general manager; Reid and Meek were in charge of the textbook division, which by that time was doing 60 percent of the company's business; and the two Harcourts remained on the board of directors—an arrangement which seems to have worked out smoothly.[9] During the 1940's, textbook sales expanded rapidly.

> Mr. Brace was president from 1941 until 1947 [Jovanovich said]. He was getting on in years, and Mr. Scott then became nervous that Mr. Brace would never retire. Because of this, and because of other circumstances I do not know fully, he realigned himself with Mr. Harcourt. Pressure was brought upon Mr. Brace to retire.

By 1948, Brace, because of illness, had surrendered the presidency to Scott and became chairman of the board. "In the reorganization, Meek was made treasurer and Reid secretary."[10] The senior Harcourt arranged with Scott to return to the firm on a part-time basis and Brace, opposed, retired in 1949.

> Now in this period from 1947 to 1953 [Jovanovich said], the company was naturally in an unstable situation, with people in the firm uncertain over what would happen. We were all aware of this disruptive

bitterness between the Harcourts and the Braces. It was real, and tangible. But the firm got along. The trade publishing didn't suffer too much, but it lost a little vigor. . . . Mr. Scott had little experience in trade publishing, and not much real interest in it. He was sales-minded; he was not an editor. He was a good manager. He was president up to the end of 1954, when I succeeded him.

In 1953, Alfred Harcourt, suffering from cancer, resigned as a director, and his son Hastings took his father's place on the board. He assumed his father's part-time position as well as his voting stock, and dissension among the directors followed. This was the year in which Jovanovich had his heart attack. Of that period Charles Madison, in his history of publishing in America, notes simply: "Instigated by Hastings, Scott, suspecting Meek's antagonism, dismissed him together with Lee Deighton who had been a director since 1942 and sales manager of the college division."[11] Deighton subsequently became chairman of the board at Macmillan.

Jovanovich had become head of the school department and a vice-president, and "both Jovanovich and McCallum had also become directors at Hastings's urging."[12] Some wondered if Jovanovich was a bit of a hypochondriac. He had previously abused his health and was to continue to do so even after his heart attack. "Some mornings he would come in and the staff had better watch out."[13] And he always "drove himself terrifically."[14] But apparently he did not usually reveal nervousness to those outside the firm, either then or later.

Then, in the summer of 1954 [Jovanovich said], Mr. Scott was getting more and more uneasy because he felt that Mr. Brace was not sympathetic to him. Mr. Scott shouldn't have wondered at this; after all, he had sided first with Donald Brace and then with Alfred Harcourt. But he did wonder about it, and obviously Hastings constituted, for him, a great threat. He disliked Hastings, and Hastings disliked him. During the summer of 1954, Alfred Harcourt died of cancer, and his death injected a certain urgency in the situation, because now Hastings Harcourt was in control of his father's stock, about thirty-nine percent of the whole. In September of 1954, Donald Brace and Hastings were ready to depose Mr. Scott, whom they felt could not lead the firm in a period of its tribulation. At this point I became aware of this. Mr. Scott and I didn't get along particularly, not as a result of any politicking, but we just didn't have anything in common. He wasn't editorial-minded, and in the conduct of the company's affairs, he was conservative. He did not oppose my work, but he did not support it either. There was no relationship.

Donald Brace was still coming into the office three mornings a week, although he was seventy-six. "He didn't have any specific duties, I ex-

pect," Jovanovich said, "but he answered correspondence from old friends and advised people. I respected him, and I admired him. He was a gentle, sweet man. I knew Alfred Harcourt only briefly, but I liked him too. He was not a gentle, sweet man, but he was a vigorous man and I think a publishing genius, there's no question about that. Alfred Harcourt had more genius than Donald Brace, but Donald Brace was a very competent man."

An associate said he did not know how much chance WJ had to talk with Donald Brace during that crucial transitional period, but he remembers the two of them lunching, after which Brace commented on Jovanovich's "brilliance." This was when WJ was actively being considered for the presidency. Did WJ have different attitudes toward particular people before and after he got power? One official gave his opinion that both he and Jovanovich had been sycophants. The extent to which Jovanovich had outflanked and outmaneuvered McCallum and Reid must have become apparent when McCallum, alone with Jovanovich one day, reputedly asked him why he didn't go after the presidency.

I went to Mr. Donald Brace in October of 1954 [Jovanovich said], and said, "Mr. Brace, I know what's happening: this firm is heading for the rocks, and there are only two people who can save it. You are one, and I'm the other. I'm telling you that either you become president again, in which instance I'd be happy to work with you, or I become president; otherwise, I'm not going to stick around." And I said, "I'm going to California on a business trip and I'm taking a train. It takes thirty-seven hours to go to California on a train, and, when I get to California, you either telephone me and say, 'Yea' or 'Nay,' or don't telephone me and I won't come back to the company." He said to me, "Well, this is all rather dramatic, isn't it?" And I said, "Yes, it is dramatic, but this is the moment."

I got on the train, I went to California, and got to San Francisco. I did not call Mr. Brace or Hastings Harcourt or any other large shareholder. I did call John McCallum once or twice. Finally, Mr. Brace phoned me and said, "Well, all right, you'll be president." So I said, "Okay, I'll fly back." Then I came back, and Hastings was there. The old man, Donald Brace, who had not been noted for decisiveness and had not been noted to stand up to anybody, incredibly, sick as he was —I didn't at the time know whether he knew he had cancer, but in fact he had it by then, and this was the last gasp—knew that he had to do something if this firm to which he had given his life was going to survive, and he bestirred himself and did it, and he talked Hastings into it.

When I returned, it was agreed that I would be president, Mr. Harcourt would be chairman, but I would be chief executive officer.

I had, in the summer of 1954, become a director and a vice-president as head of the school department. The same summer, I became vice-president and I became a director. I was only a director six months before I was president.

McCallum was a vice-president, and Reid was, and Reid was a director, subordinate to McCallum and me in these two departments, but he had been director since the 1930's. I was thirty-four years of age, Jimmie Reid was twenty years older than I was, McCallum was ten or eleven years older than I was, Hastings was sixteen years older than I was. Practically everybody in the firm was older than I was. . . . There were several candidates: Mr. Brace, me, McCallum, Reid, Reynal, Hastings; or the company could have continued with Mr. Scott. Perhaps because of this it was a vacuum. Somebody needed to act decisively, and I guess I was the only one who would, or who dared to. But, in that very first meeting, I told Donald Brace and Hastings Harcourt that I intended to preside over this firm, that, if the directors didn't like what I was doing, they always had the easy means of removing me. Donald Brace was, I think, gratified and relieved, because there really hadn't been anybody doing that since 1940, and this was 1954. So we began. Jimmie was very cooperative, McCallum was, everyone else was. I stayed close to the work at hand . . . which was keeping the college and school sales forces out in the field, happy, not restless, not uncertain of their futures, getting the textbooks out, reorganizing the manufacturing department. . . . I didn't get intimately into trade publishing, which I was tempted to do.

James Reid said Jovanovich's first six years as president accomplished

not so much a change of direction but an intensification of the policies and directions editorially that I had set up in both college and high school. . . . Bill saw to it that there was always more money—publish more books and get the money to finance them, you see. The more daring —he's in many ways a very daring person. One of the most daring things he ever did was to fire Hastings Harcourt. . . .

Hastings sort of took credit, you know, "Bill is my boy." Right after Bill became president, Hastings was chairman of the board. And had an office there. . . . Anyway, he just got in Bill's hair, so that Bill couldn't function with full efficiency. Hastings was always, you know, bursting into his office, and this and that, you know, so Bill just finally said, "One of us has got to go [Reid has been chuckling as he relates this], and I think it's you, Hastings." [And here Reid laughed outright.]

"How could Jovanovich do that, though?"

Just by sheer guts. Hastings knew down in his soul that he couldn't run the company the way WJ could. So he took it.

Reid retired in 1963 after some thirty-eight years; McCallum had resigned in 1962. Both left Harcourt, Brace somewhat prematurely. "It's dangerous to get too close to Bill," Reid said.

Madison calls Jovanovich "a rare combination of intelligence, erudition, temperament, and business acumen."[15] Becoming president gave him his chance. Madison wrote:

> It is significant that these management upsets had little effect on the firm's publishing activities—owing largely to the fact that most authors were either unaware of the changes or indifferent to them; their primary interest being in the effective promotion of their books, and this the company did well.
>
> The shifts and upsets notwithstanding, the firm was growing rapidly in the 1950's. Its total sales in 1957 were $17,799,573. Jovanovich was sanguine about the future prospects of the textbook market and about his ability to meet the strong competition of other publishers. . . . When the board of directors appeared bearish for financial reasons, Jovanovich began to consider "going public" in order to obtain more capital. [In July 1960 this occurred.] The month before the firm's stock was split nine for one, and the leading stockholders were persuaded to place 28 percent of the total shares—493,425 shares—on public sale over the counter.[16]

A merger was effected with the World Book Company through an exchange of stock, and the firm's name was changed to Harcourt, Brace & World. Jovanovich allocated two million dollars toward the expansion of a new elementary division, and the corporation "more than doubled its sales in five years, totaling $51,317,000 in 1964."[17] Jovanovich said:

> I don't think anybody who hasn't lived with it can appreciate what it really means to try to run an enterprise, direct it, and preside over it with decisiveness, if you know that in point of fact your power is really illusionary, because at any moment two human beings can speak to each other and cause it to be over with. And that's what it was like from late 1954 until, really, late 1961. . . . I lived for six years as president with absolutely no stock backing whatsoever. . . . It ended when two things happened in 1960 and 1961. We bought World Book Company, which diluted the ownership of the original Harcourt, Brace owners, because they had to give up shares for exchange, naturally. And we went on the New York Stock Exchange. To go on the New York Stock Exchange, shares had to be sold to the public, with the result of a further dilution. So it wasn't until those two circumstances occurred that the situation in Harcourt, Brace was stable.

"Now how did it happen that you went public?"

Going public, as it's called, is a natural consequence in the corporate history in which a small group of owners is faced with two circum-

stances. Death duties, estate taxes, constitute one. In Harcourt, Brace the three chief owning families had not, after 1957, been in the business. They didn't earn a livelihood themselves from salaries; they weren't professionally engaged in the business. Therefore, their personal interests were somewhat remote from the business, yet their main income was derived from dividends from the business.

A business is founded by a couple of men; thirty years go by, the men die, and their families are faced with large estate taxes. The heirs want a marketable interest. Now, a closely held corporation, in which shares are not traded to the public, is not a readily marketable equity. In other words, Mr. Harcourt, owning thirty-nine percent of Harcourt, Brace, couldn't readily sell his interest at a price that he could be sure was equitable, because who would want to buy thirty-nine percent of a business in which two other people can always exercise control? It's too big a commitment with only a minority position. Even if you did find a buyer, there is no good means of evaluating the worth of it. The stock market, after all, provides a way to measure current values. Every day on the market somebody says, "I think Harcourt, Brace's shares are worth X number of dollars," and somebody else says, "I agree, I'll sell you mine for X dollars."

. . . I might say that my income went up in rather dramatic increments. I started at $50 a week in 1947 when I got the job as a salesman. The first year I made, I don't know what it was, less than $3,000. The second year I must have made short of $4,000. The third year I went up to $6,000. The fourth year I went up to $8,000, next to $11,000; then I went up to $18,000, then to $33,000. Then I went to $75,000. That's when I became president.

And built a house on a hilltop. "He had to be on a hilltop," Reid said a few times. John McCallum was the last executive vice-president. After that, any possible succession was not clearly slated until Jovanovich became chairman of the board, at which time Paul Corbett was named president and chief operating officer.

JOVANOVICH HAD TAKEN command. When William Paley offered Stanton the CBS presidency, Stanton's demurral—his own account of the event suggests—rested on his felt ignorance of the man with whom he would have to deal. (Actually, theorists on vocational development have pointed out that each decision concerning the occupancy of a position involves exploration before establishment and maintenance.[18] The differing styles of exploration are accounted for by different situations and different personalities, not by different goals.) Stanton said:

I don't believe I can fix the time on that. I believe I first met him when he was—at about the time he had decided to go into OSS, or rather, OWI, during the war. I don't think I'd met him up to that time. Perhaps I had, but the only time I was ever alone with him on a face-to-face basis was the day he asked me to take the presidency of the company. It's the first face-to-face meeting I'd ever had with him.

William Shirer said he and Murrow and Paley talked overseas about what was going to happen after the war to news broadcasting, especially when television "came in," and Paley had wanted both Shirer and Murrow at CBS. Shirer said Paley did not talk about Stanton, but when Shirer came home from time to time it was obvious that Stanton "was completely running things at CBS."

Stanton said:

[Paley] came back from the war in, I believe, September of 1945. He was still in uniform, and I had come back from Washington that day, and I remember there was word that the executive vice-president was going to have a reception for him, and all the department heads and officers were invited to this reception. I believe it was a Friday night. I scurried back. I got word of it, I guess, while I was in Washington and came back up earlier than I normally would, went to the reception, and during the reception he asked me whether I was going to be working the next day, or going to be in the office, I guess was the question. I said I was, and he said, "Let's have lunch together." I thought he meant here [the building that formerly housed the CBS offices]. Then we saw each other later during the cocktail party and he said something about, "You know how to get out to my place?"

I said, "No, but I'll find out. Is that where you want to have lunch?" and he said "Yes."

I didn't have a car, because everybody got rid of their cars during the war, or at least I got rid of mine, so the next day I rented a car and drove out. The man with whom I had worked very closely, the executive vice-president [Keston]—I had said at the cocktail party, "I understand we're having lunch with Bill tomorrow" (this was before I knew it was out in the country). He said, "You are, but I'm not."

I thought there was sort of an ominous note to the way he said what he did, so I called him that night at home and said, "What's this all about?"

He said, "Well, have lunch and see what it's about." He made some flip remark. It was a very friendly comment. He told me how to get there. I didn't even know where Bill lived. I knew he lived out on Long Island some place but I'd never seen the place or been near it.

So I drove out, and there were . . . six or seven for lunch . . . and after lunch, it was raining, it was a cold and miserable day—

"Did your wife go with you?"

—no, no. Bill said something about, "I feel like I'd like to take a walk. Anybody want to take a walk?" Well, I thought this was my cue, so— because the lunch was just small talk. . . . So we took a walk and he said, "I don't know what I want to do, now that I'm back, but I don't want the responsibility of running the company, and I'd like you to be president."

I hope I had the good sense to say "thank you" but I'm not sure that I did. We sat down in the rain, under an umbrella down by the pool, and I wanted to get some idea about what his plans were, and he said he didn't know what he was going to do, but he didn't want the responsibility, and he wanted to turn the thing over to me.

I remember telling him that he didn't know me, and the other side of that comment was that I didn't know him, but I didn't say that, and I said I'd like a little time to think about it. . . . He said that he had known of my work and knew enough about me to be satisfied that he wanted me to take the job. I asked him why he didn't—why Paul Keston wasn't the man to do it, and he said that he had talked about it with Paul and Paul didn't want to take it on.

So I asked for a couple of weeks to think about it, and we walked back up to the house, and just as we were going in the door he turned to me with a smile on his face and said, "Well, then, you'll take care of all the arrangements and the announcements?"

I said, "But I haven't agreed to do it yet," and he said, "I know, but I'll leave it in your hands," or something like that.

I went away for a weekend then, not that weekend but I guess the next week I took some time off and rented an old beat-up Plymouth— no, in fact, I think I had to buy it in order to use it—and went up into New England, my wife and I, just to get away and think a little bit and try to sort things out, and we reached the conclusion that even though I didn't think I was up to it, I couldn't say no to it, and I'd give it a try for a year.

So I reconciled myself to wanting to take the job on, but there wasn't anybody here to tell that I would take it on, because Paley was gone. He came back just before Christmas, and I didn't see him—I knew he was in the building, but our paths didn't cross, and he didn't make any effort to get hold of me, and I must say I didn't make any effort to get hold of him, because I was a little sensitive about going up and knocking on the door and saying, "Well, here I am, all scrubbed and ready to take on the job."

And I came to the conclusion that he'd had a change of heart, that having been back now for a couple of months and getting adjusted to civilian life again, maybe he was regretting that he had made the offer to me, and I was very nervous, I didn't know what to do.

I think it was just about this time of the year—I think a day or two before Christmas—I was waiting for the elevator on the executive

floor where my office was, and he came out with a friend of his, a lady that I knew who was a very close friend of Bill's, each of them carrying a lot of Christmas packages and so forth, and Bill said, "Gee, where have you been? Haven't seen you for some time," or something like that. It was very friendly. "You know so and so?" and I said I did and we talked a bit, and he said, "Been expecting to hear from you."

I said, "Well, I've been expecting to hear from you," and he said, "You want to talk about it now?" So the packages were put down, and the young lady was asked to wait, and we went back in the office, and I then said to him, I hadn't seen him, that he'd been away, and I just could only come to the conclusion that he'd changed his mind about this thing and if he had, I'd understand.

No, he hadn't, there wasn't any change of mind at all; he was just waiting to hear from me, as to when I'd do it.

So I said, "Well, I guess the next board meeting is—" whenever it was, the sixth or seventh of January. "Should we do it then?"

He said, "That's good enough. You go ahead and make the arrangements." . . . I don't know that he was even at the board meeting, although I'm sure he was, but at any rate, I was made president in January 1946, and there I was with the job. I would have done it a lot differently than I did if I had it to do over, but at any rate I did it the best I could at the time. I had to learn a lot of new things. . . .

WHILE RELATING THESE INCIDENTS, neither Stanton nor Jovanovich attempted to present the points of view of the others involved. "There is usually a high degree of agreement among subjects in the visual perception of everyday situations," wrote psychologist David Rapaport.[19] Although these were neither visual nor everyday situations, probably the participants would generally agree on what had happened. But we know, however, that memory is influenced by emotions. Jovanovich and his associates perceived that interval in California differently, perhaps because of pride on his part (or "the avoidance of arousal of pain through memory")[20] and complex biases on the part of his associates. Freud suggested "projection" as the term for someone "organizing his percepts, memories, and behavior according to the 'pleasure principle,' and attributing to the outside world that which is painful and tension-creating."[21] Stanton's story stops at the edge of projection. Both stories speak less of trust between men than of need.

Hedley Donovan's step into the top position is a different story, although, like Jovanovich's, it involves a man who had been a founder and then began to get old. "To the top performers of his establishment," John Kobler wrote,[22] "Luce developed a strong, deep, possessive attachment,

but only those in long residence grew conscious of it because he was incapable of articulating emotion. It lay hidden, disguised. These special relationships had the intensity of a love affair that remains unexpressed yet sensed on both sides, which was why, when a protégé ran counter to Luce's dyed-in-the-wool convictions, or left him, he felt personally betrayed." Although "open exchanges of warm feelings unsettled Luce,"[23] he regarded Time Inc. employees as family, and Donovan's rise in the corporation might be accounted for by a special talent—that of being a good son—although publisher Philip Graham once said of Donovan that he never made a professional mistake. Collected and careful, Donovan never made impetuous comments or remarks. Biology accounted for it, thought his associate James Shepley.

When Henry Luce died in 1967, *The New York Times* stated in his obituary[24] that "in 1959 . . . Mr. Luce, without consulting others in the organization, personally selected Mr. Donovan as his chief editorial deputy." (Luce, it might be said here, regarded Time Inc. as primarily an editorial organization.) "How about that?" I asked Donovan.

"This business about his appointing me without consultation is something that is not so," he said.

> He gave somebody an interview at the time I was appointed editorial director—some newspaper—where he obviously got rather vexed by a question that seemed to him to imply that he had to go through some great machinery of consultation. And he gave an answer which was perfectly true, which was that he had picked me without consulting anybody. Well, that—you know, he decided in his own mind at a certain point he would like me to do this and he discussed it with me before he discussed it with anybody else. But then, before actually doing it, he consulted and/or informed quite a number of people. But [from the interview] it came out sounding very sort of brusque and peremptory and almost as if he had rammed me down other people's throats or something.
>
> That's a wonderful example of how things that are not quite right get embedded in newspaper files and get repeated over and over again.

Now, psychologist Kenneth Keniston has said that for the 1960's generation of young radicals, "the acceptance of leadership roles, particularly when they entailed the possibility of exercising authority and power . . . seemed difficult."[25] Donovan's doubts were of a different order. When it appeared that he might get the top job at Time Inc., he seems to have worried not about taking on responsibility but about becoming vulnerable, as in the following account.

By 1959 Donovan, as managing editor of *Fortune* magazine (a spot where, one of his co-workers noted, he was able to keep out of trouble

because Luce was more directly involved with *Time* and *Life* magazines during the workday), routinely had dinner with "Harry" Luce four or five times a year. But Luce "would have had dinner at least that many times if not more with, I'm sure, the managing editor of *Time* and the managing editor of *Life* and the president of the company and various people," Donovan said. "Then he might have groups of us there in various mixtures."

A particular evening that year followed "the usual but not invariable" course. Clare Luce was not there, which meant that Mrs. Donovan had not been invited. The two men had cocktails, dinner was without wine but they had more to drink afterward. They talked about *Fortune* but Luce did not invite Donovan's opinions about the other magazines—that would have been considered bad form, Donovan said.

After a while, Luce "said in a somewhat apologetic way that he had to bring up something 'rather personal.'" He then asked Donovan whether, "in a few years or so,"[26] he would like to become editor-in-chief of the whole establishment. Perhaps the question came up at that time because Luce had suffered chest pains the previous year and, after a pulmonary embolism complicated by a coronary occlusion, had been put permanently on a drug to prevent blood clotting. Donovan was then forty-four years old, and Luce shrewdly was settling on a man, James Shepley said, "more able to find satisfaction in carrying on" than having the fire of a creative entrepreneur. What Luce had dedicated his life to would be in safe hands.

As Donovan told it some years later, he wasn't sure he was ready to leave the job he then had. He enjoyed being managing editor of *Fortune* and thought he was good for a few more years. Besides, "I couldn't have gone back," he said. He imagined that a step to the side might be possible, perhaps to do something like writing a column for *Life*, which "wouldn't involve supervising anybody else and wouldn't be embarrassing to the then managing editor of *Life*. . . ." But, Donovan said, "you can't just jump down one executive notch."

Luce summarized their talk at the end of the evening: "'Well, it is left, then,' he said, 'that you are complimented by my suggestion and will at least think about it, and I am complimented by your suggestion that the present editor-in-chief is good at his job.'"[27] Donovan "didn't consider, actually, that we had settled the matter that evening, although it later became apparent that [Luce] thought it had all been settled."

In addition to Donovan's doubts about whether he wanted to do it and, he says, whether he was the best person to do it (a "certain lack of humility" was essential to his job at *Fortune*, he had once written), Donovan didn't see why Luce had to commit himself several years ahead.

"Later, you know, I might look less qualified and somebody else might come up who seemed much more qualified. I just told him as I was leaving that he should stay flexible about it, but he just kept insisting that he was glad to commit himself."

In June of that same year, 1959, Luce asked Donovan to become "editorial director" then and there. "I didn't know in advance whether I would like it or not," Donovan said, "and I didn't know whether I would like working that continuously and closely with him and the top publishing management of the company and not having my own magazine to run but rather being more of an all-purpose executive. I felt there were some difficult aspects to the job—the editorial director would come between Luce and the managing editors who had always had direct access to him, and also they were very much senior to me both in age and in the length of time they had been managing editors of much bigger, more important magazines." But Donovan already knew what it was like to manage and basically had confidence in his own abilities. In fact, he seems never to have lacked that. And he must have been an astute politician, for apparently he insisted that Luce discuss his elevation with the others and "in effect, get their permission or approval." Donovan said:

> This was quite vexing to him because he didn't see why he couldn't do what he wanted to and why he should have to discuss things with so many people and so forth, but he finally agreed he would do that. While I was in Europe he wrote me that he had his conversations with them and they had approved. Then at least the first year as editorial director, I was still kind of making up my mind about whether I wanted to be editor-in-chief, because they're rather similar jobs.

Donovan's rise to editor-in-chief came up again in the spring of 1964. About halfway through his stint as editorial director, in 1962, Donovan had become a member of the board of directors. There had been one or two people in the past who had held the editorial director position, but none of them had been put on the company board, so that, Donovan said, "I would suppose at that point it was rather generally taken for granted someday I would be Luce's successor." Successor to the man Dwight Macdonald described as being "a tragicomic human being who was pulled one way by his respect for Facts, his personal decency, his missionary do-goodism and his genuine intellectual curiosity and the other way by his obsessive prejudices in favor of God, America, capitalism and power."[28] Successor to the man who "welcomes argument so ardently," Hedley Donovan said, "that it takes a certain amount of intellectual courage to agree with him when he is right, as is bound to happen from time to time."[29]

Donovan explained that, "through an odd, unimportant technicality"

which he said he'd never understood, the editor-in-chief of Time Inc. was
not technically an officer of the corporation. Luce himself had not been,
as editor-in-chief, but of course he had in the past held several other
positions as well. Each year at a particular board meeting, the appoint-
ment of Henry Luce—and subsequently of Hedley Donovan—had to be
extended for the following year.

> Again I think somewhat to [Luce's] annoyance, I wanted him to ad-
> vise each member of the board of directors personally before [my ele-
> vation to editor-in-chief] was announced. Once again, he didn't quite
> see why he should always have to tell so many people about everything,
> but he did—he did do that. Of course, he did the inside directors and
> the ones most involved in the management of the company. He dis-
> cussed it with them in advance. The only technicality was just the
> board meeting on the day of the annual stockholders' meeting, when
> they officially appointed me on his recommendation.

Protestant, a Republican and a free-enterpriser (by which, Luce ex-
plained, he meant that he was "biased in favor of God, Eisenhower, and
the stockholders of Time Inc.").[30] Luce had always found it hard to yield
personal authority. But it was Donovan, not Luce, who decided that *Life*
should endorse its first Democratic presidential candidate in 1964.[31] Al-
though Luce gave "suggestions" rather than "orders" to Donovan, Luce's
influence continued to be pervasive until his death in 1967, at which time
he owned some 16 percent of the Time Inc. stock. Kobler remarks that
in 1964 Luce's dividend income amounted to more than $1,250,000.[32]

> The corporation was a munificent employer. Under a retirement plan,
> for which it paid the entire cost, and a profit-sharing plan, to which
> it contributed 5 per cent to 10 per cent of salary, staff members of long
> service could look forward to a cozy future. Time Inc. further offered
> five weeks' vacation, free life insurance amounting to two years of sal-
> ary, health insurance, of which it paid 60 per cent, loans at 3 per cent,
> and under an education benefit plan, half the tuition of after-hours
> courses that any employee cared to study. For top key employees, who
> earned in salary, fees, and bonuses between $90,000 and $130,000 a
> year, the retirement and profit-sharing plan plus a stock option plan
> yielded an accrual of many hundreds of thousands.[33]

At the time of Luce's death, Donovan as editor-in-chief was receiv-
ing an annual salary of $165,000, the same as that of the other two men
with whom he shared (in what they considered a "partnership" arrange-
ment) primary responsibility for the fortunes of what had been Luce's
organization. Andrew Heiskell, in charge of long-range planning, was
chairman of the fourteen-member board composed of bankers, business-
men, and lawyers. James A. Linen, whose grandparents had subsidized

Luce's father when he first went to China as a missionary, ran the company's day-by-day affairs as its president. Donovan described himself as a "political independent"; Heiskell and Linen were "moderate Republicans." Heiskell reported that he and Linen and Donovan did not go to the board of directors for approval "without total agreement."[34] And how was this agreement achieved?

Triumvirate at Time: *Hedley Donovan, editor-in-chief, James A. Linen, president, and Andrew Heiskell, chairman of the board.*

Luce had once (in 1939) described Time Inc. as structured to keep the business and editorial functions separate, in theory at least, all the way up to the top:

> Each division [he said] is led, operationally, by a Publisher and a Managing Editor. The Publisher is the one man who is concerned with all aspects of his magazine—its general well-being. He is responsible for profit and loss . . . *but* he cannot give orders to the Managing Editor. . . . The Publisher reports to the President of the company and the Managing Editor reports to the Editor-in-Chief. What happens between the Editor-in-Chief and the President is a secret—*all* except the verdict.[35]

Donovan said he doubted whether he himself saw more than a tenth, averaged out over a year, of what went into the magazines before they went to press. Certainly Linen and Heiskell would not see anywhere near

that much, he said, being informed only when "something major" (in Donovan's words) was about to be printed or when policy was being shifted—for example, when *Life* came out against the bombing of North Vietnam in 1967, Donovan and his associates having concluded that U.S. policy wasn't working.[36] "Linen and Heiskell are not in the direct line of editorial responsibilities," Donovan said, but added, ". . . the three of us have a very intimate and close relationship, and we're talking to them all the time about all sorts of things."

Donovan pointed out that he considered himself obliged to consult a great many others in the organization, principally the editors. "We are seldom in total agreement about anything," he said, ". . . but I think it's important not only to get the benefit of everybody's experience and judgment . . . but for everyone to feel that they have been heard and been consulted with and that they can respect the process by which we arrived at [a particular] position." Donovan went on:

> . . . We're having discussions all the time every day about all sorts of public issues and positions, [but] many on one subject, fairly intensively over just a few weeks, are not too common.
>
> We had quite a round-robin of discussions and memos last summer [1966]. Come to think of it, it was probably at least as much as we did on Vietnam just now—on the whole subject of NATO and American relationship with Europe and De Gaulle and what view we should take in those areas of American foreign policy.
>
> At least a half dozen times a year, we have a pretty serious economics discussion among the editors of all magazines as to the state of the business outlook and what—what, if anything, we advocated in regard to it.
>
> Well, both in my present job and in my previous job as editorial director, a very large part of my time was taken up with that kind of thing. And then before that I was managing editor of *Fortune* and a fair bit of any of our managing editors' time on any of our magazines goes into these policy questions and positions.

"Is *Time* biased? You'd better believe it," ran one of their ads. Henry Luce pointed out that after the facts were collected, the pattern into which they were put would naturally finally have meaning "in the context of a certain general philosophy we may have about values."[37] Luce served the "essential cause of financial success," W. A. Swanberg claimed.[38] Not so, said Donovan: money was not first among Luce's values but business success was important to him, and he had a kind of educator-missionary zeal to learn things himself and inform others. The "certain general philosophy" that served as context was now of course Donovan's. Thomas Griffith noted that "journalists who once spoke of their objectivity now

generally accept fairness as the criterion of their performance."[39] Donovan said he worried less about fair-mindedness because they'd had no serious problem with it for many years, just occasional mistakes and excesses. Now he worried about whether "we're being intelligent, perceptive, interesting." His son Mark described his father's philosophy as: "The intelligent thing to do is the moral thing to do." "You know," Donovan said, "I'd listen to their disagreements, but I would finally have to take the responsibility for the position that I thought we should take"— yet there were limits to his freedom.

He pointed out that he and Heiskell and Linen were all members of the board of directors.

> We hold our jobs from the board of directors. I'm responsible to [them], in the sense that they can fire me and hire a new editor-in-chief if they want to, but I'm not responsible to them in the sense of checking with them collectively or any of them individually about an editorial position of Time Inc. I'm responsible in the end just to my own conscience on that. I might or might not, out of friendship, courtesy, talkativeness walking along the hall, tell various of them something that we're about to do, but it would not be in the sense of seeking their approval. Now, if the board didn't like the job I was doing as editor-in-chief, they would hire a new editor-in-chief; but, knowing the board and its standards and the general tradition of the company, whoever they hired would also be somebody who would only be responsible to his own conscience on matters of editorial policy. Now, if he's a bad editor-in-chief and antagonizes people and the magazines all start going to hell, well, obviously they'd fire him too. But this is what I mean by a slightly metaphysical distinction as to the nature of the two different kinds of responsibility. I'm responsible to the board for the general conduct of my office for the benefit of the company, but not for my views, which in the end have to be my views. Linen and Heiskell are very sensitive to that distinction and we've worked very closely together for a good many years now and they have never intruded in the slightest in anything that would be considered my affair. They're very courteous and open in keeping me informed on what's going on in their areas of responsibility, but in the last analysis I would not have the same size vote as they would on a decision in the strictly publishing business side of the thing. If they thought we ought to commit $70 million to a new paper mill, I might or might not have some relevant views, but in the end it would be their views that would prevail in that.

Presumably as when in 1973 Temple Industries, a forest-products combine, was merged into Time for 15 percent of Time's stock. At a special stockholders' meeting, Heiskell was asked "whether there wasn't

a 'great danger' that the Texans would wind up 'running the whole show,'" to which he "replied curtly, 'If you're very worried, let that be your worry; it's not mine.' "[40] Business decisions of this and other kinds did irrevocably influence the content of the magazines. Luce, of course, in a policy memo had stated:

> . . . Every single writer and every single researcher is directly in the business of trying to sell magazines. . . . Any writer who is not en-thusiastic about the job of increasing our circulation *by his own writing* is here on a misunderstanding.[41]

And some years later, Andrew Kopkind, a correspondent in *Time*'s Los Angeles bureau, discovered reporting was his lesser function: " 'First of all, I was a drummer for the largest, most powerful publishing cor-poration in the world.' It was his opinion that the gulf most Time edi-torial people thought existed between them and the corporate side was fictitious, 'only in their minds.' "[42]

KNOWLEDGE AS POWER

(The young man, having learned from the old man, replaces him)

THE PARENT MAGAZINE, *Time*, had been started by Luce and Briton Hadden, Luce's schoolmate, in 1923. By the 1970's, Time Inc. had become an enormous publishing empire, its revenues climbing steadily upward until they reached almost three quarters of a billion dollars.[1] Additions had begun early in its history, but without Hadden, who died just before the launching of *Fortune* magazine in 1930. Devoted exclusively to the business community, *Fortune* was founded partly to take care of overflow from that section of *Time* magazine. Then in 1931, Roy Larsen promoted a newsreel type of documentary, *The March of Time*, which began on radio, became a film series in 1935, and for a while during its fifteen-year life-span was run by CBS. *Life* magazine, primarily pictorial, was founded on an acquisition in 1936 and, perversely, almost floundered when it became too much of a success too fast, with circulation outstripping advertising contract prices. The company had a brief fling at running *Tide* magazine and the *Saturday Review of Literature*. By 1944, it owned a 12½ percent interest in Sarnoff's Blue Network. A monthly "think" magazine was proposed in 1945 but never got beyond the dummy stage: "Personal, intellectual journalism simply couldn't fit into the Time Inc. scheme of things,"[2] said the man Luce had appointed to run it. (Dwight Macdonald, an insider, said the real difficulty was the "corny style and philistine values" of the prospectus.[3]) After World War II, Time Inc. acquired a paper company and transportation and storage facilities.

When Luce spoke with Donovan in 1959 about taking on more au-

thority, the corporation consisted of not only *Time, Life,* and *Fortune* magazines but also *Sports Illustrated* (founded in 1954) and *Architectural Forum* and *House and Home* (acquisitions). Donovan has been credited with setting up a corporate development office early in the sixties[4] (which seems to contradict his statement of responsibilities), under which the pace of mergers and acquisitions quickened. In 1961, a book division (Time-Life Books) was formed with striking success—it quickly began handling 10.5 million books a year and by 1973 had revenues of $141 million, approximately half those from the magazines.[5] A paperback book club for executives was profitable. In 1967, Time Inc. acquired the Book Find Club and the Seven Arts Book Society. Soon thereafter, Time-Life Records was founded, and the New York Graphic Society became a subsidiary. Little, Brown, a venerable American publishing house, was acquired in 1968. By 1969, Time Inc. had interests in French, German, and Mexican publishing companies. The already established Time-Life News Service provoked a search for newspapers to acquire and a chain of suburban weeklies in Chicago was purchased in 1969 with Time Inc. proclaiming its encouragement of the dissemination of local news.

The basic impetus was to branch out horizontally into the reaches of the "communications industry."[6] The corporation had early acquired its legal quota of television and radio stations (five and four, respectively) and now began to invest heavily in what publisher and vice-chairman of the board Roy E. Larsen called "the *next* generation of electronic communication"[7]—i.e., cable television. Time Inc. executives saw ahead and followed what was becoming a trend. And in 1973, Time Inc. invested heavily in the hotel pay-movie field through an affiliate, Computer Television, Inc.

Two new magazines, *Money* and *People,* were begun in the early seventies, "trying if possible to reach at least some people you're not already reaching with what you're already printing," Donovan said. He saw the readership of *People* as being composed of a higher percentage of women. When asked if it was a gossip magazine, he said he didn't recoil from the word but didn't equate gossip with female.

Time Inc. also owned 5 percent of a movie company, Metro-Goldwyn-Mayer, and that investment had not been profitable. (James Aubrey, ousted from CBS in 1956, became MGM's president in 1969.) Time Inc. stock dropped in 1969—advertising declined, and *Life* magazine especially was hurt. Publication was finally discontinued at the end of 1972. Perhaps television, also pictorial, had spoiled its market. Perhaps an editorial genius had been lacking during its last years.[8] Perhaps rising mail rates and printing costs forced its demise. Whatever, the drop in the sales of *Life* was part of a general pattern of financial problems for the magazine in America

—just as the program of expansion and diversification had been the general pattern for large corporations in America during the sixties. *Architectural Forum* and *House and Home* had been dropped in 1964. Other ventures also proved unprofitable. Springdale Laboratories, a center for research and development in the graphic arts which had been operated for twenty-five years, was disbanded in 1970. Time Inc. sold most of its radio and television stations in the early seventies and gave up its cable television interests with the exception of Sterling Manhattan. The 1973 Annual Report commented that "although Sterling has been unprofitable, and will remain so in 1974, we believe that the long-term potential of this cable system justifies further investment for development." The General Learning Corporation presented a particular problem.

Harcourt, Brace had been one of the early pioneers in the field of teaching machines after Jovanovich first talked with behavioral psychologist B. F. Skinner in 1958.[9] Some experimentation in the field revealed such mechanical hardware to be "gimmicks," or "badly grafted innovations," and the machines as such were dropped although Harcourt continued to experiment with programmed learning in book form. Time Inc. entered the teaching-machine field in the sixties, after acquiring the well-established textbook company Silver-Burdett, by joining with General Electric to form the General Learning Corporation. Francis Keppel, former dean of the Harvard School of Education and an Assistant Secretary of Health, Education and Welfare, became chairman of its board. By the end of the decade, this venture had not been notably successful; however, it was reorganized rather than dropped.[10]

Luce believed that knowledge was power. (Then, was selling knowledge distributing power?) Robert Hutchins, formerly chancellor of the University of Chicago, had remarked, "I might even say that Mr. Luce and his magazines have more effect on the American character than the whole education system put together."[11] Donovan believed Time Inc. to be in the "education business." The distinguished literary critic Edmund Wilson once called *Time* magazine's report of the world "caricature without a purpose," but that wasn't quite accurate. In all aspects of what the organization did, the idea was to inform people speedily about the surface of the world in which they live and give them the feeling that they are in touch (Donovan's phrasing). Jovanovich had commented that the firm of Harcourt, Brace worked to make known "the substances of education," which was quite a different purpose (as was Wilson's).

Take, for example, the lavish and instant culture available in such Time-Life books as the one on Michelangelo. A system known as "negative option," practiced by most book clubs (themselves a twentieth-century phenomenon started by entrepreneur Harry Scherman with the Book-of-

the-Month Club in 1926),[12] made it supremely easy for the consumer to obtain books not unduly priced in such a period of general affluence as the sixties. In fact, once joined, it was hard *not* to buy books. Marshall McLuhan considered himself surrounded by contemporaries for whom print was an incidental and forgotten form, but his staunch supporter William Jovanovich commented that people were reading more books than ever before. (Here Stanton's early distinction—in his case between radio sets turned on as opposed to people actually listening to them—is useful: Was it that people were reading more books or *buying* more books?) One prevailing argument was that television lowered the capacity for the printed word: but those who spend all of their spare time watching television, Jovanovich claimed, never read books before television came in.[13]

Time-Life Books certainly intended, and tended, to educate, but only

in the most superficial sense. In fact, they may have operated as spoilers, by giving a sense that the information provided therein was complete when it was not (and could not be, by the nature of things). And after the reader had feasted on such a surfeit of visual riches, how disappointing and drab by comparison encountering the single work of art in its flesh might be. The package, wrote Ada Louise Huxtable, is "one of technology's most ubiquitous products, wherein the illusion of variety, unaffecting fundamental realities, can be most cheaply achieved."[14] *Newsweek* described such corporate purposes when it talked about the "common garden art book" as in both design and advertising selling itself to the public as a surrogate for the art it depicts ("buy me and save yourself, it says, in effect, a trip to the real thing").[15] Luce's writers "thought of the story as a commodity to be sold, like any other commodity, and they packaged it as attractively as their talent allowed."[16]

This not infrequently resulted in the bizarre juxtapositions so characteristic of the sixties. Advertisements in *The New Yorker* magazine for furs and perfumes and expensive cars flanked such articles as James Baldwin's "The Fire Next Time," a cataclysmic vision provoked by hatred springing out of a reality in which these items figured little (although some felt they were powerful symbols). We had to deliberately impoverish ourselves, as when our artists, choked by communicated riches, invented (or indulged in) *arte povera* or anti-art, or as when our youngsters, choked by affluence, went South to work in the civil-rights movement or later tried to go back to the earth in communes.

The original Time Inc. had in fact been more involved with this enrichment of the surface than Time under Donovan was to be, although it was in the sixties that Time Inc. acquired at enormous expense a machine designed, so far as one can see, to replace Luce. (Inside the corporation it was supposed to aid creative layout, which it did not.) T. S. Matthews, a past editor, apparently had thought Time part of the entertainment business.[17] *Time* magazine's style had been essentially the double epithet and the inverted sentence as aids to lively and concise writing. Perhaps *Time*'s example was responsible for more colorful use of language in modern newspapers and magazines, a good influence. But good only when the color was not gotten through error, misplaced emphasis, or quasi-deliberate slanting—accusations made against *Time* magazine.

But less often under Donovan. Donovan was a very moral man, Thomas Griffith reported. "He believes in right and wrong, you know." What gave Griffith that idea?

> Because I know how much he cares about how things are said . . . and summations of an argument and what isn't fair: this comes up constantly. And maybe it's a difference between people who came up on

and were attracted to a lively, provocative magazine like *Time*, as I was, where you just generally are busy being bright and always trying to get good phrases and so on—well, Hedley will always never mind the phrase and go for the point. . . . He's not big on personality and invective kind of journalism.

Life magazine especially was to suffer from lack of the definite personality that had been Luce's, but Donovan was to provide a better method for the sorts of generalizations that are not usual in journalism. Luce had only mimicked these.[18]

Donovan, as noted, had come up on *Fortune* magazine. After the war, he might have gone back to the Washington *Post*, where he had been a reporter, but instead chose to look around in New York. ". . . about every other place I went, I got some kind of a job offer, which was quite a contrast from 1937, when I had first looked for publishing jobs in New York in the Depression. I had some kind of offer from *Newsweek* and the *Herald Tribune* and *The New York Times* and Time Inc." He had not met Luce but had read *Fortune* on and off for many years. "I was kind of finally torn between *Fortune* and *The New York Times*," he said, "but the *Times* offer didn't get quite completely definite at the same point as the *Fortune* offer and the *Fortune* offer was also slightly more money . . . well, just in general, it attracted me very much. I was particularly attracted by the idea of *Fortune* assignments giving you enough time really to dig into something pretty hard in contrast to daily newspaper work."

Donovan continued:

Well, I first saw Eric Hodgins, who was then the—was a former *Fortune* managing editor and publisher—and was then a vice-president of Time Inc. in charge of quite a postwar recruiting effort they were making. . . . He had been traveling around the country, partly physically and partly by letter, the last months of the war, telling people that if they knew people who might be promising material for Time Inc. and were now in the service to let him know so he could try to get in touch with them when they were free to come to work and could be interviewed.

My sister was then working for Time Inc. as a—what they then called reader relations representative in Minneapolis, which consisted of, you know, of—if a clergyman wrote in an angry letter to the editor of *Life*—"You should do such and such"—they had a policy then, for a few years, of actually sending somebody to go call on him and discuss it.

They wouldn't do it for just anybody, but for somebody who sounded to be of some substance or people, you know, who wanted five hundred reprints of something or other that had been in *Life* and that kind of thing. They had quite a number of young men and women doing this in about fifteen cities for several years, which was partly public

relations, partly also a way of breaking in these people and bringing some of them into the company.

In any case, she wrote to Eric Hodgins that she thought her brother would be a good person for him to look up after the war, and I had meanwhile, without knowing his name or his job—had, after the war had ended, I had written the Time Inc. personnel department to see if I could have an interview with somebody. Well, Eric subsequently made a great story out of this. He was searching all through the files of the Navy for a Lieutenant Donovan while I was searching for him and so on, which wasn't all that exciting.

But anyway, I had an interview with him and he sent me over to the then managing editor of *Fortune*. His selection or steer was that *Fortune* would be the best place in the company for me to go, and he sent me there with his recommendation that this fellow looks like a good risk for a few months or some such thing. Then Paine interviewed me and, as I say, he definitely offered me a job.

So *Fortune* was my first encounter really with serious, professional, intensive editing. . . .

"I can remember in particular the first story I was put on," Donovan said.

Fortune was doing a complete issue on housing in the postwar—the early postwar housing situation. And I was supposed to write the lead story to kind of round up, to introduce the whole issue and in general discuss the housing story. Then there would be other specific articles on, you know, the building labor unions and prefabrication and other particular aspects. Well, I went around and spent about a month traveling to different cities and looking at their housing shortages, like Chicago and St. Louis and Louisville.

. . . [as] a Washington *Post* reporter, where we almost never traveled or except occasionally in a political campaign—so this was the first time that I had worked for a publication where, if you thought it would be interesting to go to St. Louis, you went to St. Louis and you didn't have to get four vouchers countersigned by the business office and so forth. The whole attitude toward travel and entertaining and how you moved around and did your work was far more liberal than a newspaper during the Depression. So I liked being able to travel freely and being able to go to places where you thought you ought to go to get your material. . . .

Part of the time I had a researcher with me, which would be the normal *Fortune* procedure, but I forget why, for some reason I didn't have a researcher most of the time on that story. But well, I accumulated masses and masses of stuff . . . and then wrote it in a far, far too long first draft, you know, of ten thousand or eleven thousand words. Well, the managing editor told me this was all really quite hopeless. I

mean, he wasn't as discouraging as that in his language, but there wasn't very much of it that he thought was usable and, for one thing, he found it all too stiffly put and in a kind of formal way. . . . Well, I had to agree on reflection that this was so.

Donovan hadn't been mad about it, he said.

I wasn't totally surprised. I mean—that is, what I'd written didn't seem to me of the same quality as things *Fortune* printed. I guess the only place I would have disagreed with him or been aggrieved—feeling was that he didn't see the value of more of my research or didn't see the value of my research as much as I did. Because, you know, I had proved things twenty times over at various places and had endless interviews, facts, statistics, and he seemed to feel that one or two would suffice. Well, when you go to that much work accumulating the stuff, naturally you like to use it. . . . Well, that, as I later came to learn, was a very common phrase about *Fortune,* or *Time* or *Life* too for that matter, among editors—is, well, "He's got too much of his research showing." Well, then, after he—after I had my first go-around or two with the managing editor, then I went back and did a second draft, which was pretty completely different from the first. Well, then, this was getting somewhat closer, but still wasn't exactly right, so I did a third draft—then was getting quite close. And then he, as I remember, passed me along to his colleague Bill Furth, the executive editor of *Fortune* and another great editor in a somewhat different way—not the big rippings up, as a rule, that Paine would sometimes do, but a superb copy editor and a very strong feel for story organization and logic and literary quality and so on. So I think he put me through the final drill, and so eventually it got printed. . . . Paine was a really brilliant, large-strokes editor. He was not too interested in kind of word-for-word stuff . . . but for these big instincts about an article, he was really terrific and extremely imaginative at inventing stories or dreaming up assignments.

. . . in general, I'd say people who strongly object to very much editing are not attracted to jobs here, so that it's a somewhat self-sorting proposition. . . . I had simply never worked in that kind of journalism before, so I found it enormously stimulating and very, very difficult. For one thing, the length of these *Fortune* articles were, you know, six thousand or seven thousand words, which is a form in itself, and then they have to have a definite structure, which a newspaper story in a sense doesn't. You just—you know, the old standard rule-book way and so forth and the first paragraph and then just go on until you run out of gas and stop. And then maybe it's a little too long for the newspaper's purposes and they cut from the bottom. But a *Fortune* story has to have a beginning and a middle and an end and it has to foreshadow certain things before you get all the way into them, so that the first five or seven hundred or even thousand words is considered the lead, which *Fortune*

writers agonize over terribly—has to touch the main—everything, in a sense, that's coming without going so far into it as to remove all interest.

. . . I think, if I recall, that special issue was the April issue, and I started work on *Fortune* December 1, 1945, so I spent almost all of three months—December, January, February—on it, which would be about twice as long as would normally be considered par for a *Fortune* story. It was a little foolhardy of them, in a way, to put a brand-new writer on this lead story, which was rather crucial to the whole issue. For the same reason, they allowed themselves three months, and I guess they figured that, you know, if I didn't do it the first time, there was still some margin for error, or that even, if necessary, somebody else, some more experienced character, you know, if I had come up with a total fiasco, could probably have come in the middle of January and salvaged the thing . . . I was surprised that I was assigned to it . . . it could be all sorts of commonplace explanations because almost everybody else was busy on something else. I mean, they didn't necessarily regard it as a great honor or anything.

Donovan's unexcitability about his initial failure to produce an adequate article perhaps enabled him to complete the assignment satisfactorily. In the course of our interviews, I wrote a note to myself: "Can't get him to show an emotion except a sort of sense of humor. Nothing he says shows a bias that might demonstrate fear or anger or love or even liking." His son Mark commented that he had never seen his father angry and never heard him swear.

There was something touching about everyone else I encountered but not about Donovan. But perhaps I thought that because he did not seem vulnerable but made me feel vulnerable. His attraction was sexual but without softness. He was a powerful-looking man, big and handsome in his early fifties, with a certain amount of boyish charm but something slightly brutish about his looks. Without smiling, he described himself moving rocks on his beach. "Do you move rocks for aesthetic purposes?" I asked: "Why do you move them?" "Aesthetic. Weight control," he answered. "I love to move rocks, yes." When I asked James Shepley what he thought gave Donovan the most personal satisfaction, Shepley replied, "Piling rocks up so Long Island Sound doesn't encroach on his front lawn" and "beating his son Mark on the tennis court [Donovan's own]." Donovan's Sands Point neighbors were mainly Republican, by Donovan's own characterization. This community of friends, some of whom had known Donovan in his Washington days and followed him to Port Washington, sang together "fine old Irish ditties"—Donovan's "attractive, reserved" personality was "just good fun" for an evening. Clifford Porter commented, "I'm trying to think whether we have any artistic temperaments in our group, I'm not

sure that we do . . . his reaction would be no different than a number of ours: we wouldn't seek someone out of that type. . . ."

Donovan was also "Establishment" in that he was oriented toward belief in what he read, although he knew that misinformation accumulated and was perpetuated by repetition—incorporated, even, in those developing data banks. One of the symptoms of the sixties was the growing number of people who mistrusted the normal avenues of acquiring information—parents, magazines, newspapers, government, etc.—and trusted only facts they were able to verify firsthand (not only limited and limiting but a virtually impossible job in a complicated society). Jovanovich pointed out that this trend was a form of dissent, but it was not that necessarily. Only if dissent is held to be part of the normal process of attachment to a society. Everyone prefers to have his beliefs verified by experience. Most people like to believe what they are being told is true. Each person repeats in his life the necessity of finding out for himself.

DRAWING BY STAN HUNT; © 1967
THE NEW YORKER MAGAZINE, INC.

"I was supposed to contact you, but I'm not sure I have."

Of the men I met Donovan was the hardest to figure out. Sometimes my interviews with him seemed extremely difficult. He tended to be laconic and to mutter. For instance, we started out at the very beginning this way, talking about the outline for this book:

 HD: It sounded to me like an awful lot to cover.
 Pardon me?
 HD: It sounded to me like an awful lot to cover.
 It is very complicated and very complicated putting it together, which is what I am trying to do now.

HD: Yes. (Pause)
But I have so much material and it's all fascinating.
HD: Yes. (Pause)
Well, thank you. Okay, may we start at the beginning of your life?
HD: Yes. (Pause)

That sounds rather like a comedy routine. I may strike myself as comic sometimes but I doubt that Donovan ever thinks of himself as absurd, and he is not. James Reston has described him as being one of a remarkable generation who came in the twenties and thirties out of the progressive political tradition of the upper Midwest—in Donovan's case, Minnesota.[19] Like Stanton, the man Donovan describes as perhaps his best friend is a man he seldom sees: however, when asked to describe Donovan's character, time and again public-opinion analyst Richard Scammon came back to the word "judgmental." Donovan's son said he would scold his children not by telling them they had been bad but, rather, foolish. Hedley Donovan was always watching from a distance, measuring things. An old friend commented that not much cropped out of him, and he didn't know to whom Hedley would turn if he had a serious personal problem.

Another man, who had worked at Time Inc., said that Donovan and Henry Luce resembled each other in their moral rectitude. However accurate that remark about Luce, whom I never met, I don't think he had Donovan quite right. Was it perhaps more that they were sure of themselves, or uninterested in the areas where they were not? Clare Boothe Luce reputedly felt bitter about her husband on one occasion because he had never known, so she said, what it was like to suffer a defeat. It is hard to imagine either Luce or Donovan wasting time with or being interested in the defeated. The two men shared, Shepley thought, "orderly thought, careful decision making, intense intellectual activity."

Why had Donovan turned out the way he did? What had his childhood been like? It seems, on the surface, to have been extraordinarily smooth. His father had been a mining engineer and geologist, an executive of the E. J. Longyear Company. Both of his parents had been born in Minnesota, as was Donovan in 1914. "It's a little hard to describe the financial layer that I grew up in," Donovan said.

I don't quite know if it exists any more in the same way. I suppose that my father during most of the 1920's, although I never knew exactly and to this day I would be embarrassed to ask him and he would be embarrassed to tell me, I suppose that his salary probably

was around six or seven thousand dollars a year. In that period and with those prices, three children, you could live comfortably, but there certainly was very little to spare. In addition to that, my father, having grown up as one of eight children of a very poor country clergyman, was brought up in an intensely frugal way, and even in subsequent years, when he sometimes could have afforded to spend somewhat more on something, had a very thrifty attitude. My mother somewhat less so. I mean, she hadn't been brought up in quite such straitened circumstances but certainly was not, in any way, extravagant. And so, I'd say between their two backgrounds and the fact that they certainly didn't make any large amount of money, we were brought up with very little to spare for anything that, you know, seemed marginal or seemed like a luxury.

Donovan started delivering the Minneapolis *Journal,* one of two newspapers subscribed for by his parents, at about the age of twelve.

Well, the family felt that the additional money that my brother and I could earn would be very useful and we ought to do it. And, as I say, in effect, earn our own spending money. So I was not, from that point on, I was not getting any allowance. I was earning my allowance.

The E. J. Longyear Company during the Depression had difficulties comparable to those of other industrial or commercial firms, Donovan said, but he considered that his family never knew real poverty in spite of the fact that during that period they "were certainly living extremely frugally."

My brother and I were both in the University [of Minnesota] at the time and, with various kinds of part-time jobs, pretty much paid all of our expenses. I mean, we weren't paying our room and board. We were living at home—but tuition and clothes and books and fraternity fees and all that kind of thing we pretty much earned and had a variety of summer jobs and things.

My brother and I shared a bedroom. My sister had her room, my parents [theirs], then there was a guest room. Sometimes my grandmother was staying with us, if she wasn't working or was on vacation. And there was a maid's room up in the attic. We had a maid most of the time until sort of the depths of the Depression. Of course, those were the days when you could. Scandinavian girls coming off the farm for seven or eight dollars a week. . . .

If I could undo it or do things, I think my paper route was kind of unfortunate because at a fairly early age, twelve to sixteen, I was tied up after every afternoon. That is, I had to leave school directly and go carry the papers. Well, that meant that all kinds of clubs and activities or teams that one might have been interested in at school,

you couldn't do. And, because of the Sunday-morning paper, that pretty much tied me down every weekend unless—well, my brother and I would trade it off between us and, sometimes if I had something very special that I wanted to do, well then he would carry my half of the route or vice versa. But, it meant that for those years, I was kind of cut off from any extra activity in the school.

"Did your father actually weigh [the additional money] against the clubs and associations that you would have had after school? Did he think of it in those terms?"

"Well, he may have thought about it some, yes. Again, I think in his—in comparison with his life as a child, ours was so much more comfortable in a way. I mean, we weren't having to get up and chop wood or milk cows or things like that at five in the morning or wear old clothes that some parishioner had given his father to distribute among his children."

"Was he a sensitive man?"

"Yes. I think normally so. But I don't think that he would have thought of his children as being deprived if they had to do an hour and a half work a day to earn some money, and that the money would be helpful and that it was not bad for the children to do this."

Had Donovan in turn put his children to work? No, he thought it was much better for them "to be doing something further in school or sports or something than working at a regular, daily job." But on the other hand all of his children, he said, "in series, have had to do most of the lawn mowing at my house. Well, you know, I could afford to hire a lawn service to do it. There's quite a bit of it. But I have some feeling that it's not a bad thing for them to do a certain amount of work around the place where they live and feel some responsibility for it. And so then, I pay them modest rates, not what you'd have to pay the yard service."

Donovan's grades had not suffered:

My brother and sister and I were all getting practically all A's, so my parents had no cause for complaint about not studying well enough. My sister, I think, never got anything other than an A in either high school or university.

"Did you?"

Well, not quite. I think that I had one C and one B at the university. . . . Otherwise I had A's in high school. I had a B in physics and I think a B once in Latin.

The house in which they lived "is fairly typical now of decaying, sort of square, boxy, midwestern frame houses, built around, I suppose,

1905," Donovan said. "It had a big front porch, like a veranda all the way around, and then a smaller back porch, but, you know, high ceilings, and the house kind of perches up above the ground. Nothing elegant at all." It was furnished with what Donovan characterized as rather undistinguished sofas or easy chairs, "such as you would have bought in 1910 if you had just been married, and they would tend to be recovered or re-upholstered every ten years or so." There were also "two or three very nice old pieces, some from my father's family, some from my mother's. And occasionally, with great reluctance, something might be thrown out and replaced." The house was simply and comfortably and not very attractively furnished, he thought, looking back.

Neither of his parents was particularly interested in decor—or in art. Of the pictures on the walls, Donovan remembered specifically a "handsome, big engraving of Westminster Abbey" and "a couple of Raphael reproductions in circular gold frames." A relative gave as a present to him and his brother one Christmas "a wonderful, long strip about three feet long and ten inches deep, of one of those knights, you know, going out in front of a lot of Tuscan hill towns," and they put it up in their bedroom. "As a matter of fact," Donovan said, "it is one of the few things that I ever took out of the house for one of my children. We put it in our eldest son's room in my house, and it's still there."

"Neither of my parents was at all musical or much interested in music really," Donovan said; they did not have a piano, but they did have a phonograph and a radio. "Although I would say that we were never the first on the block to have them," Donovan added. However, his mother had been very much interested in the theater:

> The National Theatre Guild, I think, had a fairly good traveling company in that era, and they would come for maybe a ten-day or two-week season of three or four things in a city like Minneapolis. And, if they did four things, I suppose that maybe we would get to two of them or something like that.

The family was highly sociable: "We did a lot of family game playing," Donovan said. "We were all very fond of little things like charades . . . quite intensely competitive. So, when a lot of company or other relatives—after dinner we would divide up in teams and go at it. My parents had always been very fond of bridge, so they taught all of us to play bridge at quite an early age. . . . My children are all very fond of bridge, so I sort of started playing again with them," Donovan added.

"Who would you say was most influential on you during that period? Your father? Your mother? A particular friend? An adviser? Did you go to church?"

Yes. Well, I'd say my father and mother most so. We had a very interesting clergyman at our church who was a Welshman named David Bryn-Jones and kind of a Fabian socialist, mildly so, and sort of a pacifist. Quite an interesting thing that a very conservative, Republican kind of congregation would take him on and admired him enormously. . . . He gave a great many sermons of a kind that are very commonplace today but were much less so then in, say, like Minneapolis, where he would talk about social problems or issues or the world situation and then, at the end of the sermon, maybe just barely relate it to some scriptural point. But he certainly had something to do with my getting interested in public affairs and politics and so on. My history teachers did, I'm sure, in the sense that—I guess that history was really my favorite subject.

His mother had been an English teacher, and there were quite a few books in the house. She tended to read novels and plays; both parents were fond of detective stories. His father was an avid reader, so Donovan said, mostly of history and biography.

My father has always been very interested in politics and public affairs, and there'd be a good deal of conversation about that kind of thing at home. So those things, combined with interest in writing and, I guess, some literary injection from my mother—well, the two things, in a sense, kind of meet in journalism in a way. And I suppose—well, by the time I got to college, I intended to major in history. I thought then that I'd like to go into university work and be a historian but I began to get distracted more and more by the current news, although I'd always been—oh, I can remember, for instance, when I would have been only fourteen at the time, I was enormously interested in the Hoover–Al Smith election. My father was and is a very stout Republican and was quite anti–Al Smith, not only because he was a Democrat but also a Catholic and a "wet," and there were quite—I was also strongly for Hoover, and I think the first political bet I ever won —I bet one dollar on Herbert Hoover against one of my high school friends.

Donovan said, "Around age eleven or so a friend of mine and I had a neighborhood newspaper that we printed. A third friend had a basement and a boy's printing set, you know. . . . We called our newspaper the *Colfax Parrot* . . . I think that we printed five or six issues of it [with neighborhood news]. Then we could also run advertisements for what was known as the Colfax Stamp and Stone Company, which was a vehicle of ours." Diversification and conglomeration at an early age! "I worked on the junior high paper. I did enjoy, you know, writing things," Donovan said.

Many magazines came into the family home, including *Time*. "We started taking *Time* very early," Donovan said. "I think not charter subscription, but I'd say about the second or third year. About the time that I was ten or eleven, I think that we began having *Time*, and I liked that very much, especially the saucy way it was written and all that kind of thing. My brother and I a few years later when we were in our teens would, you know, write letters to each other in *Time* style and things like that.

We had the *Atlantic, The Saturday Evening Post, National Geographic.* . . . I think we took the *Literary Digest*, the old *Life*—the funny magazine. A very nice magazine. It was the magazine that the present *Life* bought the name of to be able to use. But it was a gentle, less sophisticated version of *The New Yorker.* It had, you know, wonderful things

BEHAVIOR

On February 21, 1969, a Pan American Boeing 707 chartered by Time Inc. and comfortably configured for sixty-two first-class seats and a bedroom compartment took off from San Francisco carrying—along with Scotch, bourbon, gin, vodka, beer, wine, champagne, Cointreau, Drambuie, Benedictine, crème de menthe, cognac, and the company doctor—twenty-five U. S. businessmen. Their abiding interest in foreign affairs had won them invitations to join *Time*'s fourth News Tour since 1963, this one a sixteen-day sprint through eight Asian nations during which it had been arranged by the Time-Life News Service that the leaders of all eight would appear on cue to answer questions. Most of the Time Inc. hierarchy went along for the ride, including Hedley Donovan, Andrew Heiskell, and James A. Linen, the corporation's governing group; Henry Grunwald, the new managing editor of *Time*; James R. Shepley, the magazine's publisher and official tour host, who explained in a press release that the two dozen guests were traveling at their own expense (everything, that is, but the plane fee) "as responsible, concerned American citizens rather than as representatives of their business enterprises," and John A. Meyers, *Time*'s advertising sales director, who apparently had not gotten around to reading the release when he observed, with a grin, that almost all the guests were *Time* advertisers with annual budgets in the magazine ranging from $200,000 to $2 million .

The tour was organized down to the last snow pea. Bottles of mineral water and at least one memento (wooden dolls in Korea, pewter cups in Malaysia, cigars in the Philippines) appeared in everyone's hotel room at each stop. *Time*'s public-affairs department, which arranged the blitz, assigned one girl specifically to make sure that Philip Morris cigarettes and Seagram's whiskey were conspicuously on display in the plane and in the hotel hospitality suites so that Hugh Cullman, executive vice president of Philip Morris Inc., and Edgar M. Bronfman, president of Joseph E. Seagram & Sons, Inc., wouldn't get grouchy. No detail was too small for the alert leaders of the public affairs corps. At a small, pre-tour luncheon, the ten young ladies traveling as support troops were advised in a "morals lecture" that moonlighting with any of the guests would result in immediate dismissal but that nocturnal activity with fellow Time Incers was a matter of individual conscience.

After a stop in Hawaii to get the Big Picture from the Pacific command, and then in the Philippines to interrogate President Ferdinand Marcos and bounce around the poop deck of the presidential yacht in a conga line led by Mrs. Marcos during a bash on Manila Bay, the already weary travelers flew into Saigon (choice of entrees on that leg: Le Coeur de Filet de Boeuf Rossini or Le Poulet sauté Adobo). At Ton Son Nhut Airport, the News Tour boarded two air-conditioned military buses and sped downtown to the Caravelle Hotel accompanied by four jeeploads of U. S. and South Vietnamese troops, weapons at the ready. Around the hotel, more soldiers blocked off the streets and plainclothes security guards took up posts throughout the lobby and corridors. Burton Pines, a member of *Time*'s Saigon bureau, reported that the military "provided what has undoubtedly been the heaviest guard for any nongovernment civilian group which has ever visited the country." Back in New York, Jason McManus, a senior editor and notorious spoilsport, was so annoyed by the bureau's lackluster coverage of the Communist offensive during the tour's visit that he fired off a cable suggesting Pines and his colleagues spend less time with rubberneckers and more with the war. But Pines, like other *Time* correspondents along the route, was only following orders from higher up to dutifully record the tour's every official move; after the trip, all the dispatches were neatly put together for the guests in a souvenir memory notebook labeled,

"Confidential, Not For Publication." The tour received special briefings from U. S. commander General Creighton Abrams, Ambassador Ellsworth Bunker, and President Nguyen Van Thieu. At a Chinese dinner of shark-fin soup, pigeon, and Vietnamese brandy in the presidential palace, Thieu, in rare form, remarked that he had taken "special precaution to save Cholon [Saigon's Chinese section] from the offensive to be sure and have these ingredients." That night, Steve Walden, an eager newcomer to the public-affairs department, braved the city's curfew armed only with a piece of identifying paper. Well into the morning, he drove a jeep back and forth between the Caravelle and *Time*'s bureau getting out the *Daily Bugle*, a ten-page news roundup Telexed nightly from New York that Walden mimeographed and distributed to the door of each slumbering executive so he could awake to piping hot news, particularly yesterday's close of his company's stock. "The stocks kept going down during most of the trip," recalls Walden. "There was quite a bit of grousing."

In Thailand, the tour bestowed upon King Bhumibol Adulyadej a $25,000 gift for school construction; in Singapore, Prime Minister Lee Kuan Yew warned over lunch that the U. S. should not withdraw too hastily from Vietnam, and in Tokyo, the entourage found not one but two transistor radios in its hotel rooms, one from the local Sony company, the other from News Tourist Robert H. Platt, president of The Magnavox Co.

From Tokyo, the now exhausted travelers flew back to San Francisco, and then on to New York. After two days of recuperation, they reassembled in the Cabinet Room of the White House with President Nixon for an hour-long session of show-and-tell. A tough act to follow, Time Inc.: eight Asian kingpins and now coffee with the President. And a memory book to show the grandchildren. And, for the desk back at the office, an ashtray from the Saigon bureau made of a howitzer-shell casing.

by Robert Benchley, and it had John Held's drawings and it was the one-degree-less-sophisticated humor of the 1920's especially. It was kind of its peak. Then as *The New Yorker* got better and more popular, it kind of drove *Life* out of business as a matter of fact.

My family started taking *The New Yorker* I guess around 1930 or so. Again, for that period, they brought a lot of magazines in the house, plus two or three children's magazines. You know, things like *Boys' Life*, *Youth's Companion*, and some of those.

And "each of us children would have some books of our own that we bought or had been given to us," Donovan said. "I was very fond of history and especially American history and would occasionally use some of my modest earnings to go to a book sale and buy a forty-nine-cent publisher's remainder type of thing." Apparently there were no bookstores near his neighborhood but he remembers some of the Minneapolis department stores as having good book departments. "As a matter of fact, I still have at least a dozen American history items that I think I bought in that era."

Donovan as a boy collected stamps—because they were "handsome" but also because "they had the associations with all of these places—that intrigued me. I had a lot of geography and atlases and maps." It is hard to believe that whatever dreams he had could have begun to

LIFE, FEB. 2, 1968.

Across the conference table Kosygin talked to Life's *Donovan, Hunt, and Young. To Kosygin's left are Soviet Press Chief Zamyatin and Felix Rozental (arms folded), a Soviet citizen employed in* Life's *Moscow Bureau.*

approach what was later to be his reality. The description of one of the trips he took as an adult (see page 166) would be inconceivable to most youngsters and, in fact, almost so to many adults, although in a certain sense it has become commonplace. Less commonplace was a talk with Kosygin in the Soviet Union.

Although he had an early interest in faraway places, Donovan did very little traveling as a young man except for family vacations. These usually lasted two weeks and were likely to be spent at "a lake somewhere in northern Minnesota or northern Wisconsin," where he learned to swim at an early age.

He first went out of the state when he was about ten. He and his brother went by train to a small town not far from Colorado Springs "by ourselves, and then, while we were out there, for a couple of months my uncle and aunt took us on a wonderful trip up in the mountains in a Model-T Ford, and we went over Independence Pass—camped out, fished . . ."

He had been an "enthusiastic" Boy Scout starting at age twelve, and "that included quite a lot of camping and overnight hikes," and he would go to Scout camp for two weeks each summer "during those years." On being queried whether he would like to do that nowadays, he answered, "No, really not," and then remarked with equanimity that his kids were "not inclined that way."

Stanton:

My recollection really begins to pick up about 1912, when I was four years old. I remember very clearly a long trip across the country in a Model-T Ford runabout with camping equipment and so forth. The three of us, my mother, my father, and I, drove from Dayton, Ohio, to Newburgh, New York, which seems like a trip into outer space now because of the amount of preparation that was made for it. In those days there weren't any routes, in the sense of any road maps or US 40's or anything of that kind. You simply had what I think they called the American Automobile Club Bluebook, which gave you instructions about driving down a road until you came to a church, then making a right turn and going so far and taking a left turn and so forth. We camped out, as we made the trip across the country. Where now it takes an hour and a half or so in the plane, it took, I believe, the better part of a week for us to make that trip. . . .

It was my first presentation to my father's family, and my father was that kind of a guy. I think he liked the idea of trying something different, instead of going on the train. He wanted to drive. He built all the camping equipment and modified the body of this little Ford runabout (I still have photographs of it), in which he carried all the

camping gear on the running boards and on the back of the car. It was a two-seater, so they had to build a third seat in the front where I sat, and it was a bit of an adventure for that particular period. That was over fifty years ago. Of course, it would have been much more of an adventure if we'd gone in the other direction, to the Coast, but nevertheless crossing the Alleghenies in a Model-T Ford when there were nothing but dirt roads, in rain, was something that—was great.

I remember all kinds of hardships of travel, in the sense that it was difficult to get gasoline, difficult to get food, it was difficult to get permission to camp on a farmer's lands. When I say it was difficult to get food, there wasn't any shortage—it was just a matter of not having a Howard Johnson's at every turn in the road.

"Did your parents own the car?"

Did they own it? Yes. There wasn't any Hertz in those days.

He was, I think, making a joke, but it may be that it was beyond him to imagine *borrowing* from anyone, which would mean being dependent on them. "Wasn't this rather unusual, for teachers at that point?" I asked.

Well, when you come to think about it, I guess perhaps it was. I still have the bill of sale on the car. I think the car was $325.

"Which would have been a fair amount of money then."

Oh, it was a lot of money in those days, sure. My father's salary as a teacher couldn't have been more than $1,500 a year, I would guess. [But we weren't dependent on just his salary] because he did other things in his spare time that brought in some income, but all they had was what he made. There wasn't any family contribution or anything of that kind.

Stanton learned to drive while in his teens.

JOVANOVICH ATTENDED a manual-training high school whose population was "about a third Negro, a third Mexican and Oriental, and a third white." Jovanovich noted that, during the war, "because I lived in a downtown section, I was probably the only college student on [the draft board's] roll" (and he was to be directly commissioned as an officer rather than drafted). Jovanovich seems to have all of his life, up until the time that he became president of Harcourt, Brace, gravitated toward people in a higher class. Later on, Jovanovich was to say of George Orwell, "He is the only liberal one doesn't come to dislike for being intense."[20]

It can be said of Jovanovich that his personality is recognizably that of the authoritarian as defined by Adorno and others.[21] While he was being interviewed, Jovanovich and I sat at a small, round table in a corner of his

office, sometimes over lunches consisting of only soup and coffee. While working in the firm as an editor, I sat on a sofa-like arrangement of chairs, the cocktail table in front of me, while WJ sat in the swivel chair at his desk some four yards away, indicating to me, I thought, that a certain informality was allowable but he was boss. He also, under this arrangement, was far enough away so that it was difficult for me to tell what expressions he had on his face: a situation that left me vaguely dissatisfied. I had somewhat the same feelings I used to have as a child, about God looking while I used the bathroom—i.e., it gave the proceedings a certain formality. Gossip, in the present instance, was one of those forbidden things. But on the other hand—since all of these men were complicated human beings—sometimes when WJ walked me to the door of his office (where, I thought, he knew he could easily escape by handing me out), we would become chatty. Occasionally he would come all the way through his foyer, out along the private reception area, and even to the elevators on the other side of his weighty, orange-red double doors—having become so interested in our small talk about personalities. As an employee, infrequently I came up with others in the firm and then we all sat a great distance away while he sat behind his desk. But when there was something tangible for him to work on with a group, everything was moved to that little round table. There was no doubt that working situations made him feel less uneasy. (Jovanovich says he spends 95 percent of his working day at the little table.) According to Adorno, "the emphasis on 'distance,' the fear of 'close physical contacts' may be interpreted as corroborative of our thesis that, for this syndrome [that of the authoritarian], the ingroup-outgroup dichotomy absorbs large quantities of psychological energy. Identification with the familiar structure and ultimately with the whole ingroup becomes, to this kind of individual, one of the main mechanisms by which they can impose authoritarian discipline upon themselves and avoid 'breaking away'—a temptation nourished continuously by their underlying ambivalence."[22] The patterns in Jovanovich's life can be related to the above description, but care should be taken not to overdo the comparison. Such characterizations are topology which, as Adorno points out, "is not quite reputable since it never catches the unique and is not statistically valid."[23]

A second point to be made is that Jovanovich himself was careful with his life, in spite of his gambler's instinct, and not only because of his health. He found what he liked and he copied it. James Reid has said, "Not only did Bill drop the middle initial after becoming president of HB, he remodeled himself in several ways. He became more careful and conservative of his dress and more frequent with the haircuts. Not that he had ever been careless about either. He joined the Union League Club,

high meeting place of New York conservatives and a far cry politically from the young man who, only six years earlier, had voted for Henry Wallace's third party."[24] In some ways Jovanovich outdid the White Anglo-Saxon Protestants, as witness the following exchange, which was incorporated in the 1966 Annual Stockholders' Report:

Dear Mr. Jovanovich:

We are interested, as principals, in buying your company for cash.

If you are interested in selling, please send us financial statements and price.

> [pseudonym] John J. Jourdain
> Executive Vice-President
> Molière and Company

Dear Mr. Jourdain:

For sometimes serious and sometimes footless reasons, a number of huge corporations in the field of communications have regarded this publishing house as the prime object of their desire to acquire, to possess. We remain, however, not for sale to anyone.

Your letter has a directness that is breathtaking, inasmuch as it comes from a corporation that is unrelated to communications and, I presume, unacquainted with it, and was dispatched without the customary genteel intercession of someone who knows the people in this Company. I admire your approach as an example of what can only be called capitalistic camp.

> Yours truly, etc.

But a main point to be made is that Jovanovich had not in fact changed in any basic sense. The "Establishment" he had succeeded in joining did not exist as he had imagined it while underneath, looking up, yet he continued to believe in what he had imagined as a kind of ideal.

I joined a fraternity at the University of Colorado [he said] on the advice of a wise teacher, who said, "You ought to do it, because if you don't, you'll never realize it wasn't important." A high school teacher who was originally from New England, went to Wellesley, came out to Colorado, lived in a nice old Denver house—it looked like President Eisenhower's mother-in-law's house—in the east section of town. She lived near the old plot of ground which is now a park, but once was divided up into Catholic, Protestant, Jewish cemeteries. It had years before been abandoned and was overgrown with wild flowers. I remember sitting out on her terrace, and there were the mountains in the background. I went there frequently. I must have been a rude, angry adolescent, yet she was a woman of grace. She took an interest in me, worried about my health—I was terribly skinny, if you can believe it. I was fat up to about the age of

fifteen, and then went totally the other way. She worried about my health, about my reading, and, I suppose, although she never said so, worried about my manners too.

Had she directed his reading?

Not so much. The one thing that one can get a little soppy about, but nevertheless there's some truth in it, is that everyone has an English teacher in his background, somewhere. Even if they weren't intellectually rigorous themselves, their very love of reading communicated itself to you as a student. . . . I was graduated from high school with a superlative record, and won the scholarship to the University of Colorado, which paid tuition—I think it was something like $60 a year, so the whole scholarship for the four years was only worth about $240, but still, that was something. . . . I went up to the university and got a job for room and board waiting tables in the fraternity house. They didn't have many such jobs and obviously it was a great inducement to join, so I did. I went up and after the first year they couldn't offer me the job any more, so I moved over to a sorority house and got a job as a waiter there. I didn't move my membership, obviously! I moved my employment. And stayed at that job for three years and became headwaiter in the sorority house. I was able to go through the university, with that and summer jobs. Then upon graduation in 1941, I had received the Shattuck Fellowship to Harvard that Dr. George Reynolds and Howard Mumford Jones pretty much were instrumental in getting for me. . . . I was Junior Phi Beta Kappa. At the university they had two societies, the outstanding junior men and the outstanding senior men, only about five people in each group, and I was a member of each in turn. I was editor-in-chief of the university yearbook. In short, I had an outstanding record.

I had enormous respect for books, of course. I still do, almost exaggeratedly. It pains me to read *Publishers Weekly* when I see "non-books" publicized. Somehow I feel it's all a betrayal of what a book is. Of course, trivial books have been published since the beginning of time. The sheer form of a book doesn't in any way warrant its importance. For somebody who grew up in a house in which there were no books, in which learning was prized because it obviously was a medium toward becoming somebody, you can see a book would have a kind of empyrean worth.

In later years, Jovanovich expected certain behavior on the part of the Cass Canfields of the world, a subcategory being the Alfred C. Edwardses (that is, they were gentlemen), even while understanding that they represented a view of the publishing profession as it no longer existed. But the idea that it had once existed as represented by his expectations of these men, he did not wish to relinquish. And he saw himself, in school and later, as one of them.

When people did not behave properly he removed himself even while

attempting to make them do so. For example, he considered the revision of the copyright law the most serious problem facing his industry: and he withdrew Harcourt, Brace & World from the American Book Publishers Council because of what he felt was that group's weak attitude toward the revision pending in Congress, at the same time declaring to his colleagues within Harcourt, "We must remain active . . . in promoting industry-wide understanding of the copyright issues." Which indeed he did.

Luce had believed that he was handing on not an institution but a kind of journalism. Jovanovich would be handing on only a business, for those Waspish notions of class responsibility *as such* were no longer so meaningful in the nation at large and were important in his microcosm only insofar as he himself was able to make them work profitably, as in the case of his association with and loyalty to Charles Lindbergh. Jovanovich's talent, like that of Luce, would be of no use in a future without him, but what existed in the future in the way of an organization would do so because that talent had existed. The introduction to his farsighted five-year plan, formulated in 1967, was excellently written and bore the earmarks of having been composed by Jovanovich himself. One felt he understood the basic aspects of most of those things with which the company dealt, some of which were highly technical, and so was in a position to query the experts.

Like Time Inc. and CBS, he had diversified, taking Harcourt, however, only into what he considered related businesses—that is, those which would advance "our own learning of how to compose information by various media." In 1967, he acquired Home State Farm Publications, Inc., with seven periodicals, and that same year Guidance Associates, an educational film company. The year 1968 saw the acquisition of the F. A. Owen Publishing Company, the Brookhill Publishing Company, the Nebraska Farmer Company, which published *Nebraska Farmer* and *Colorado Rancher & Farmer*, and the Ojibway Press, which published twenty-one business periodicals. In 1969, Harcourt took over Academic Press and, in 1970, five German publishing companies, but the discontinuance of these latter had to be planned by 1974. Nor had the acquisition of an English publishing house worked out well. ". . . reinforcement comes with getting something right," Jovanovich said, harking back to B. F. Skinner. "One very rarely learns very much from one's mistakes. I think you learn from certain experiences that occur when the mistake was made. People are always saying— it's part of our moralism—'Well, you certainly learned from that mistake.' I've never learned very much from mistakes. As a matter of fact, you know, every mistake I've ever made of serious consequence I knew was a mistake before I did it."

Then why had he done it? Could he think of one?

"Usually for reasons of vanity or restlessness."

The investment in UHF he did not consider to have been a mistake, since it had cost relatively little and had consisted chiefly of exploratory applications (under Federal Communications Commission procedures, Harcourt had some two years in which to decide whether it wanted to proceed with the actual construction of television stations). Jovanovich believed in learning by doing rather than by commissioning feasibility studies which were in themselves expensive. At the time of the Harcourt investment, 40 percent of the television sets in use in the United States could receive the ultra-high frequencies and a recently passed federal law had required all new television sets be equipped to do so.

Although undergoing periods of consolidation, Harcourt had done well in the sixties, going from net sales of $27,572,127 (and 686 employees) to sales and revenues of $98,706,179 (and 2,871 employees) in 1968, with net income remaining a good percentage of net sales. (Note that net sales had almost doubled even the 1968 total by 1974, going to $176,886,000, but by then net income was down to $2.16 per share.) The 1967 report pointed out:

> A heavy concentration on elementary and secondary schools, both public and private, is the main thread in the fabric of Harcourt, Brace & World, Inc., publishing and will continue to be such during the next five years. Demography, of course, favors our position: in 1965 there were 48,600,000 children enrolled in the schools of America, 31,900,000 in elementary schools, and 16,700,000 in secondary schools. This is a huge and increasingly well-funded market.[25]

Like most acquisition programs, Jovanovich's was designed to broaden the base of the company and make it less vulnerable to changes in a particular market.

Success was not Harcourt's alone; the 1960's had been a decade of general prosperity for the nation and for other members of the book publishing industry also. The nature of the industry was changing: small family businesses were becoming large corporations, many of which were acquired by even larger corporations with basically different natures. We have seen CBS acquiring Holt, Rinehart & Winston. RCA took over Knopf, Random House, Pantheon; Litton owns a substantial minority position in Atheneum; and we have also seen Time Inc. purchasing Little, Brown. Publishing by 1968 was a flourishing $2.5 billion industry, transferred from genteel craft into big business. We have seen money as an inadequate measure of power; similarly, the *volume* of books is an inadequate measure although it had "discernible social impact," Jovanovich thought, by which he meant that books were able to change attitudes. Unlike William Paley, he was proud to state this belief since, unlike television, no one saw this aspect of

books as pernicious (censorship involved itself with something else)—what power they had seemed muted by comparison, in spite of books like Ralph Nader's *Unsafe at Any Speed*, which forced actual changes in the practices of the automobile industry. But suspicion of these practices already existed, and perhaps that book, like others and like television, did not diametrically change attitudes so much as reinforce and strengthen elements already present. It is interesting to note that there is no definitive evidence that even schooling changes men's values.

"Young people's ultimate cultural class," said Jencks and Riesman, "may be almost entirely determined by such factors as genetic ability, family structure, social connections, and so forth. Schools and colleges may simply be a sifting device for separating those whose talents and inclinations fit them for one cultural class from those whose talents and inclinations fit them for another. But whatever the cause-effect relationship, there does seem to be a strong correlation between educational attainment and cultural class."[26]

Jovanovich had gone to the University of Colorado, waited on tables, gone on to Harvard, left, and returned to Cambridge as a naval officer for a course in accounting, functioned as supply officer, been discharged from the Navy, studied briefly at Columbia before going to work at the publishing house where he was to rise so rapidly. He had been sifted out by, among others, Prudence Bostwick at the high school in Denver, Howard Mumford Jones, with whom he did graduate work in literature at Harvard, and then, later, by James Reid and Donald Brace at Harcourt, Brace. But he was not equally good at such sifting. It was not his talent. "WJ's great lack was his inability to pick good people," an associate said. WJ "never listened, always performed, even one-to-one, which made it hard for him to judge people."

He maintained a distance between himself and others and guarded himself against fumblers, whom he disliked intensely. Jovanovich said:

> In the firm, I'm not too good at firing people, I confess. I usually work myself up into a kind of puritanical fervor—admitting that somebody hasn't done right—and then I'm able to do it. But it's got to be the Protestant ethic at work. I've got to feel that the person has wasted his opportunity, has been dilatory for capricious reasons—in short, has not done right, has not saved for the future, has not saved himself.

Who is to say if the reasons have been "capricious"? Adorno notes that "no-pity-for-the-poor" is characteristic of the authoritarian personality—that is, a rejection of what is "down."[27]

Nepotism once had nearly wrecked the firm. Would Jovanovich hire one of his own sons, both of whom had literary tendencies? He might ap-

propriately *not* do so because of those literary tendencies unless they were combined with other talents, since his own had been used effectively as only part of the set of tools needed to manage professionally a large corporation of a distinctive nature.

How DIFFERENT WAS Lloyd Goodrich's childhood from that of these other men, more nearly comparable to that of Jovanovich's sons with their mild exhibition of artistic leanings.[28] Goodrich's father was a lawyer of some means. Jacqueline Kennedy's grandparents, the Bouviers, lived next door to the Goodriches in Nutley, New Jersey, where Lloyd was born in 1897, the youngest of five children. There he grew up, except for a year spent in New York City, where the family lived on Riverside Drive while his father tried for a judgeship.

Goodrich's paternal grandfather had been a Republican judge, but his father was a Democrat with socialist leanings, which more nearly resembled his mother's side of the family. Her sister, Caro Lloyd (Withington), had become a communist and was one of three owners of the *Daily Worker*. Her brothers were Henry Demarest Lloyd, the author of *Wealth Against Commonwealth*, and Demarest Lloyd, a playwright and Washington correspondent for the New York *Tribune*. The judge died when Goodrich was young, but his mother's parents lived in Nutley while he was growing up. Her father had been a clergyman in the Dutch Reformed Church who left the ministry and went into real estate. Goodrich felt more at home with his mother's relatives.

The household was orderly, managed by a mother whom Goodrich remembers as having remarkable vitality but as being gentle and quiet. Both parents had a sense of humor, but his mother was more worried than her husband over his lack of financial success. As Lloyd grew older, family resources diminished, and a Winslow Homer painting bought by the grandfather in the 1880's had to be sold sometime around 1918. His gregarious father enjoyed drinking and smoking, although his mother disapproved. Goodrich's brothers and sisters more nearly resembled his father in their social tendencies, but Goodrich was more like his mother. He tended to have a few close friends, and some of them he kept into adult life. Reginald Marsh was one such. He and Lloyd had met in a private elementary school, Miss Hawley's, and from the Marsh family Lloyd Goodrich learned about art. It was something of a shock for him to go into a public high school, but he adjusted, he said, and got fairly high grades all the way through. He was considered a bit of a prig, too much of a "swatch," but his studies meant more to him than anything else. Languages he enjoyed; math he loathed.

His parents gave him books, and he remembers reading Shakespeare at about the age of twelve. For some years his father had read poetry to neighborhood children on Sunday afternoons from four to five-thirty, ending with a short story, and when Goodrich was in his teens, his father formed an adult history class. It met once a month at various houses, with papers read. Goodrich also remembers an occasion when his father took over the town hall and read aloud from Tennyson's *Idylls of the King* "to the accompaniment of piano music composed by a friend of ours. This took a lot of courage in Nutley, New Jersey, at that time. It was considered effeminate, and he did it as a public performance." Goodrich gave his own first public talk when he was seventeen, on "the whole history of painting," using slides. His mother wanted him to become a painter, and he himself had formed such a resolve as he was going into his teens. His father was sympathetic.

After graduating from high school, and encouraged by his parents, he enrolled in the Art Students League of New York, which he attended for four years, broken in the middle by one year at the National Academy of Design. He grew more and more critical of his own work until finally he experienced a nervous crisis—perhaps what Erikson has characterized as an identity crisis—as a result of which he abandoned painting. He understood himself as having a talent for color and motion but as not being much of a draftsman. It was "not only a question of financial support," he said,

> but also, I suppose, a deep questioning of my creative ability. I think that an artist who is a born artist doesn't have these doubts. He knows that he can transform nature into art. I didn't. I saw nature. I saw art. I didn't see the transition I could make between the two.

He contrasted himself and Reginald Marsh: "He had this tremendous drive always. . . . A painter has to be, to a certain extent, a single-track mind. . . . I think my whole artistic motivation was more in the realm of emotion and in a certain way in the literary content in art." He remembered summers spent in Sakonnet, Rhode Island, where the Goodriches had a cook, a maid, a hired man, a horse, "and all that."

> As a child I loved nature. . . . I remember that Shelley, Keats, and Wordsworth meant a great deal to me as an adolescent, and I looked at landscape, the actual landscape, the real world of Sakonnet, somewhat through their eyes. I remember that particular times of the day, particular lights, could suggest lines of poetry to me.

Malraux stated, "What makes the artist is that in his youth he was more deeply moved by his visual experience of works of art than by that of the things they represent—and perhaps of Nature as a whole."[29]

Goodrich believed that being an intellectual might possibly make one less creative, although I don't know whether he ever applied the word "intellectual" to himself. Malraux also speaks of how "for over a century our approach to art has been growing more and more intellectualized. The art museum invites criticism of each of the expressions of the world it brings together; and a query as to what they have in common."[30] When

"Fine-Arts Catalogues: Foundation has assisted production of catalogues of some thirty-five museum collections."

A page from the 1965 Annual Report of the Ford Foundation

research psychologist Anne Roe visited Goodrich at his museum, in connection with her studies on the personalities of artists, she found him interested in a way that enabled him to be particularly helpful to her—that is, he had ideas based on or resembling psychoanalytic concepts about relationships between personality and art. He had considered his own analysis, undertaken about the time he decided to abandon painting, to be the "most educational experience of [his] entire life."

In 1918 he appeared before a draft board and was rejected because of a heart murmur, although he was doing hard labor with Marsh and other college boys at a shipyard in Mystic, Connecticut. It was never again found and he was accepted when he applied for Officers' Training. But the war ended. In the fall of 1918 he went to work for the Consolidated Steel Corporation and spent three or four years in that business with two firms, both of which folded. He then joined Reginald Marsh's older brother in an ironworks shop which also was not successful.

Goodrich then found a publishing job. His sister had worked for Macmillan at one time, and Goodrich, knowing someone in the company through her, was able to get work in the religious department as an editor. This area was not his choice, although he, along with the rest of his family, had regularly attended the Episcopal Church, but it was the only spot available. He had liked "the emotional side of the church service"—the choir, the organ music, the murals that had been sponsored by his father. His mother had taught in the Sunday school. At Macmillan, Goodrich wrote and read and was especially involved with the production of books, "which fascinated me from the beginning." He had joined the firm in 1923 and left in the fall of 1925, having in the meantime married.

It was not until 1924, when he started to review books for *The Arts*, a magazine subsidized by Mrs. Gertrude Vanderbilt Whitney, and to write criticism, that he began to find himself. Of his mother, he said, ". . . later on when I made more success as a critic and later as a museum person, that was the main thing to her as far as I went, but for a long time she would ask me every now and then, 'Don't you do any painting? Don't you feel like doing some painting?' " His early training and his artistic talents were to be as invaluable to him as Goddard Lieberson's training and talent were for *his* later role.

STEEPLECHASE SWINGS, A 1935 ETCHING BY
REGINALD MARSH

The Round

CHAPTER 9

ASPECTS OF LEADERSHIP

(Participation in process)

DURING ONE OF MY 1967 visits to the CBS building where I'd had an office a few years earlier, I walked around the "rectangular doughnut" designed by Eero Saarinen[1] to the offices of one of the commercial artists. He had achieved some success in the managerial hierarchy but, to my great surprise, he told me that he hated Stanton. I was taken aback by the strong word and surprised at his openness. "*Why?*" I asked. "Because he stifles creativity," the vice-president replied. But did Stanton? I wondered.

I remembered something that had happened to me while working there. One Saturday my designer, Ira Teichberg, and I had tacked up—along the length of those white walls that made up the inner core of the tower—the paste-up of an entire book, a biography of the late John Kennedy. We had been creating a manuscript in the most expensive way possible—as we couldn't have afforded on our own time and money—by setting the type and then reshuffling. Those 241 pages represented over a year's hard work. We planned to study the flow of pictures and type from page to page, to see if a continuous progression had been achieved. It took all of our available time to put up what are called "mechanicals," and we went home expecting to return on Sunday and look at them with fresh eyes. But when we arrived back, the walls were blank, their whiteness representing the devil.[2] Ira and I looked for a guard. When located, he informed us that nothing was allowed on the walls without the personal approval of Dr. Stanton. One of the cleaning women, with the guard's help, had taken our work down. He went on to say that, however, she might still have the sheets in her broom closet. We were lucky: she did. But I was angry at

Stanton himself for making rules that precluded the *use* of his building.

For consider it his building, he did. "That, more than anything else, I guess, is the story of my life in the last ten years," he was to say. Sculptor Theodore Roszak told of how Stanton had gone to Saarinen's backyard, where the architect had all sorts of materials lying around, and had picked the granite for the building along with Saarinen. Roszak said, "The people who commission these works, who buy art, always like to feel they're participating—that they're part of the process—but they're not." The more commercial artist felt pricklier about a manager pre-empting his artistic decisions—perhaps because he was defensive about being inside the system and so in a position where this was more easily accomplished. But most probably because he thought they could be pre-empted where Roszak knew they could not. But although neither artist would give Stanton much, nevertheless he was part of the cultural process.

Culture *is* the consumption of objects, said Hannah Arendt,[3] and Stanton one way and another participated in and made consumption possible. It has been remarked that only primitives become infatuated with things. Randall Jarrell, in his essay "A Sad Heart at the Supermarket,"[4] called such (pejoratively) "the ideal consumers." Hedley Donovan believed that Americans express their individuality through their selection of things (he also, however, believed that being a leader was not a bad way to express individuality).[5] Adolf Berle pointed out that "consumption for personal use is an expression of personality, guarded from invasion," and that the area between personal use and public interest—as in the case of pornography—wavers, depending on cultural pressures.[6] Stanton evidently believed that those objects allowed to express the individuality of an employee must be passed on and judged as art. His feelings about the CBS building made this sort of control at least understandable, though not, to my mind, even after I got over my anger on that Sunday, entirely defensible. I still remember a company officer making a secretary take a cartoon picture of Snoopy off the wall over her desk. But, on the other hand, I remember Columbia Records salesmen smashing iguanas against the hotel wall during a convention in Miami, and who knows what they might have put up, given the chance. Actually, as the reader may recognize, in that last remark I am myself making a false equation between behavior and taste, or behavior and advances in the external marks of civilization.

Saarinen felt that the truly twentieth-century environment ought to be impersonal both in setting and in furnishings but intended his buildings as personal statements. People ought to express their personalities, he said—but he gave to others only the choice of what he called ornamental or non-structural elements such as "paintings and sculptures, flowers, vases,

heirlooms, books, legitimately handicrafted objects from travel or exotic parts of the world or the past, and so on." He believed that "great architecture is always informed by one man's thinking"—and, indeed, in the CBS building some have held that he prefigured his own death.

"From the beginning," Saarinen wrote,

I imagined CBS as a dark building. A dark building seemed more quiet and dignified and appropriate to this site. . . . It should also look permanent.[7]

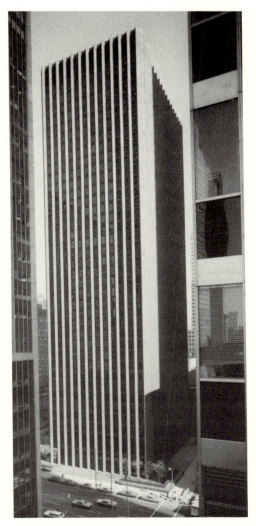

CBS Headquarters Building

Theodore Roszak said:

> Nobody understands works like that—artists are appreciated for the wrong reasons. Nobody, including Stanton, understands fully—it takes time to be understood, to be evaluated properly.

Saarinen himself considered it such a direct and simple structure that he had no doubt its beauty would be recognized. "The verticality of the tower," he wrote, "is emphasized by the relief made by the triangular piers between the windows. These start at the pavement and soar up 491 feet."[8] This relief changes as one moves around the building, so that the effect is sculptural. Indeed, Roszak considers Saarinen to have unmistakably sculptured all of his buildings. The M.I.T. chapel on which they collaborated appears as a single unit.

Stanton:

> One of the reasons why we wanted to go to stone was because we knew we were going to be surrounded by the steel and glass. . . . It takes a bit of doing to get something that's right and also different, because there are so many people competing for the same kinds of things.

Our interview was held during the Christmas season and I commented that the effect *was* totally different, "and the tree decorations are so delicate against the massiveness of the building."

Stanton:

> Sure. And in the restaurant, or in the bank [both on the ground floor], you look up at those tall windows and you see that little shower of lights—it's really quite heavenly.

His comment made me remember that vice-president, who had paused for a moment and then added, as if it was the ultimate epithet, "The man has no taste," knowing that Stanton prided himself on his taste.

I translated "no taste" into "submits on the television screen to the tastes of the audience," without asking if that was what the vice-president meant (he could equally well have meant that Stanton rejected what he thought of as his best work), and went on to speculate about what it was that my friend wanted from a leader. The vice-president was a man who had drifted from organization to organization during his early career, until he came to CBS, where an attachment had sprung up between him and the president of a division. He had been happy there and, basically, well treated—in terms of salary, in terms of time off to do what he pleased, in terms of running his own show. But he needed to be personally connected to a superior, and Stanton was not accessible in that fashion. Attraction to a supervisor can be an important source of influence. Stanton's influence did not, apparently, depend on attraction. Donovan thought that a leader was more effective if he simply was being talked about. In most companies

when the employees had lunch together, Donovan quoted Galbraith as saying, they talked about sex or money or sports or the stock market, but the employees of Time Inc. talked about Henry Luce. Luce had been "an inexhaustible source of stories, jokes, anecdotes, quotations, and so forth." Stanton, although talked about, was remote—that same vice-president had angrily noted that he passed people in the hall with his head down—but Lazarsfeld at least thought this was alienation from himself. It certainly was not from the group.

What is the appropriate distance from a group for a leader to maintain? He must simultaneously do two things, Abraham Kaplan said: "He must be very, very close to you and he must also be very far away from you."[9] Speaking of artists, Daniel Bell thought of alienation as often a positive virtue, a way of distancing oneself from an event. "To distance oneself was to create a degree of self-consciousness. And in so doing, one could perceive that the claims of doubt became prior to the claims of faith."[10] The claims of doubt were not strong enough in those graphic artists or writers who were operative in commercial organizations.

Jovanovich could maintain relations with editors and authors because he too, on the other side of his seductiveness, had a certain standoffishness. His own slight alienation helped him re-evaluate the industry in which he found himself, using a wider context.

Stanton was not sufficiently alienated to evaluate his industry objectively, although the psychological tone of his life seemed most solitary. It was characteristic of him to be easily irritated and also characteristic of him to be very controlled. Unexpectedly, he told me the following story about his childhood:

> The thing that got under my skin about my mother's family was that they were possessive, they tried to smother you, and I resented it at an early age and very deeply. I don't believe I ever characterized it to myself, but I certainly didn't—I had a cousin who was about my age, and she used to get in my hair, only when the families were together. She was a nuisance, I thought. This wasn't because I was allergic to girls, it was that she was one of these sweet little girls that always did everything right and could play the piano and always had to show off for her grandparents, and this annoyed me. But she was, I guess, a little on the snoopy side. She wanted to know everything I was doing and so forth. In those days I was fooling around a great deal with mechanical toys, and I remember having burned her pretty badly—well, not badly, but I mean I frightened her because I gave her something that was hot to hold, in an effort to discourage her from coming around my quarters.

He and Ransom had no children, but Ransom believes in God, which, presumably, would make him less solitary.

The sociologist George Homans made a statement that appears to describe Stanton as a child and as a man. "A member of a group acquires high esteem," Homans wrote, "by providing rare and valuable services for other members. But these are obviously not the only services a member can perform: he can also perform services that, without being rare, nevertheless have their value. Prominent among them is conformity to norms of the group—a norm being a statement of what behavior ought to be, to which at least some members of the group find it valuable that their own actual behavior and that of other members should conform. Since a norm envisages that a relatively large number of members will behave similarly in some respect, conformity to norm cannot be a rare service: any fool can conform if he will only take the trouble." (Jovanovich clearly knew the value and the limits of conformity.)

". . . Therefore," Homans continued, "if all a man did was conform, he would never get much esteem, though he would always get some. But it does not follow that if conformity will not win a man much esteem, non-conformity will not lose him much—if he has any to lose. For his failure to conform, when the other members see no just reason why he should not, deprives them unfairly of a valuable service, and so earns him their positive hostility."[11] One can imagine Stanton's father might have had mixed feelings when the boy insisted on being independent at what many would consider an inappropriate age.

Hubert Humphrey made an interesting distinction between McNeil Lowry and Frank Stanton. Stanton, he said, was a *head* man, someone who influenced by his "special pursuit of excellence" rather than by activity which changed specific things. In other words, he thought, Stanton could shape the general taste, although the former Vice-President thought Stanton had not been doing all he might. Lowry was extremely influential inside the Ford Foundation, Humphrey said, and simply interested in people's (artists') self-expression.

Dr. Homans wrote that "for a long time psychologists tried to discover some single trait of personality, or set of traits, the possession of which was apt to make a man a leader. . . . Recently the psychologists have contented themselves with saying that leadership does not depend on the personality of the leader but on the nature of the relation between the leader and his followers."[12]

Hadley Cantril believed that to understand these problems it was necessary to begin "*first* by relating the individual to his reference and membership groups and then proceed to the finer details of personality problems."[13] But it is equally possible (although perhaps less useful) to start with those aspects of personality that are genetically derived. Individual differences on the part of observers can be attributed to glandular

activity and other temperamental factors, the functioning of basic drives such as those for food and sex, and general physical vitality and intelligence[14] no less than can individual differences among the observed. These points of reference contribute to explanations of success but are difficult to sort out from the effects of societal pressures since they too are susceptible to change.

Psychologists have also tried to discover what traits artists have in common. One psychologist answered the question of how artists differed from other people by declaring that they didn't, *as people* (her italics).

"So far as I can determine," psychologist Anne Roe said, "there are no personality or intellectual traits and no constants in their life history which characterize them all and set them off from all other persons."[15] Her study, made in 1941, was based on twenty especially successful American painters (in terms of shows and recognition by their peers), those "who have been extraordinarily successful in the peculiarly difficult profession of the artist." She quotes another psychologist,[16] who summarized artists as being different from other people in having higher degrees of manual skill; energy output and perseverance; aesthetic intelligence; perceptual facility; creative imagination; and aesthetic judgment. But she points out that not all of the above are necessarily present in every artist and all may be present in non-artists. Her Rorschach tests indicated about half of the group were startlingly lacking in both "perceptual facility and creative imagination."

These results, she stated,[17] present us with two alternatives: (1) "Our ideas of what constitutes 'creativeness' in terms of personality structure are inadequate"; or (2) "a creative personality is not a prerequisite to success as an artist in our society."[18] She considered these alternatives "not altogether mutually exclusive." Although she felt that a few generalizations could be made about the group, she was careful to point out that "these generalizations could apply equally well to many other groups of successful professional men. All [of the artists]," she wrote,

> . . . are of better than average intelligence, ranging up to very superior, and in general they have a much stronger tendency towards abstract thinking than the population at large. Most of them are sensitive, non-aggressive persons, with a rather passive emotional adaptation. They are extremely hard-working, and although they have considerable superficial freedom with regard to hours and place of work, the self-discipline required to effect the rather routinized lives that are characteristic of most of them is probably much greater than is generally appreciated.[19]

"This may have been an important factor in their attainment of success," she adds.

McNeil Lowry observed:

If you count the undergraduate and teaching, I was around the university for around eleven years. But it was long after that before I realized that some of the people who were the most focused and concentrated in the arts were the least humane in the ancient sense of humane learning, the least liberally educated. And the most distorted, concentrated in their interests. And this distortion almost—in some cases, in some categories of artists—was almost a hallmark of their success. I found this particularly in theater directors. I found it greatly among actors, who in most cases are the least educated of people that I know who still are interesting people. I found it in composers and musicians too, some of this distortion, though not so much. I found it in painters and sculptors —though again perhaps not quite so much. The only kind of creative artist I know where the factor of distortion seems less characteristic and less necessary is among the writers, and I think a man can be a highly educated, humane person and still be an artist as a writer.

Lowry's remarks, made in New Orleans, on the personality of the artist were widely circulated: "*The New York Times* and others began to test my empirical conclusion with psychoanalysts and others interested in 'the creative personality.' The unwelcome burden the true artist assumed of being unable to live out the humanist ideal of a balanced life was superficially or deliberately misunderstood by many self-styled or would-be artists crossing my path. They thought 'distortion' was enough! Often such a one would say to me about my words on the artist's personality: 'Oh, how insightful. That's myself, you know.'"

Roe's point about artists enjoying considerable superficial freedom yet being extremely hard-working is also true of the most apparently satisfied of the nine men of this book. Success for managers as well as for artists comes from a commitment of time. And Hedley Donovan considered that stamina—which permitted one to make such a commitment—was an underrated factor in anyone's success. Power lay not in their superficial freedom but in their commitment. The reward of the artist for his work—and the serious artist has been shown to be a person who works constantly to solve those problems central to his art, problems difficult for other people to understand or even to see—is power over his material, and it is this that anchors him. He exercises influence not through institutions but through the objects he creates which are then used by institutions. But most of the work in this world is of a kind that can only be done in closer connection with organizations.

The lives of all nine men have in common a lack of that removal from society which best permits an artist to function. Even John Kenneth Galbraith, who could say, "The artist may be more of a social being than the legend holds. It is noticeable that he regularly eschews, in practice, the

cruel isolation which, as a deeply creative being, he is supposed to suffer in principle. His flocking and nesting tendencies are no less convivial than those of accountants, engineers and high executives"—even Galbraith had to add, "*But he does, in his work, enfold the whole of his task within himself. He cannot work on or with a team.*"[20] (My italics.) Galbraith was repeating the premise that artists and intellectuals must always hold a portion of the self beyond the world's reach. But this alienation—for individualism always implies a certain degree of separation from social reality —is not solitariness or isolation. And if "the artist may be more of a social being than the legend holds," it may also be that those who function within organizations are more lonely than they appear.

To create art certainly requires the exploitation of isolation to promote reliance on one's own judgment, to make decisions, to be autonomous, to paraphrase Abraham Kaplan's comment about leaders.[21] But the administrator in lone grandeur, unlike the artist, is in trouble. He pays a price, Kaplan said, "in terms of the other major aspect of leadership, which requires that in some sense or other he represent the shared interests of the group as a whole."[22] Stanton represented in the first instance the shared interests of his group, and he was a good corporate executive because he did so. It would have greatly displeased those with and for whom he worked if it had been otherwise. He could have been accused of elitism—an undemocratic political doctrine—if he had been more objective in his evaluation standards and included in his decision making to any great extent elements which were irrelevant to the special interests of his group.

"I can't possibly pass judgment, with the company as big as it is," Stanton said, "on all of the people who participate, but I try to do the top officers. Then I decide what each division gets by way of a kitty." It was December 1967, and he was speaking of events that had occurred a week earlier. "I was to come down here last Saturday morning," he said—referring to his office. "I was to have gone into my ivory tower the night before and made my decision." (But, as we have seen, his decisions were not "ivory tower" ones.)

> I had the top financial officer and the top personnel officer waiting to get the word as to what we were going to do, because the board meeting was this Wednesday. I also knew I had to get home and get my bag packed to go to Washington for [Lynda Johnson's] wedding. And they kept me and they kept me and they kept me, and I left here about eleven-fifteen. I got here, I came in downstairs, and one of the men in the lobby said, "The operator's been trying desperately to get you."
>
> So I called the switchboard here, and they said that the White

House had been on the phone. So I called back, and it was the President, and he must have been on the phone for forty-five minutes—it was after twelve o'clock when I got off the phone—about some things that weren't of too much consequence, but at any rate it was a long conversation, and he had his grandson on his knee.

I said, "I thought you'd be busy today."

He said, "No, I'm the most unnecessary guy around here." Obviously he didn't have anything to do—that's why he was talking on the phone—and I was going crazy.

I'd no more than got off the phone and got these guys in here and was sitting here working with them against time, arguing, because nobody was entirely satisfied . . .

Did it happen every year that no one was entirely satisfied?

Oh, it doesn't make any difference whether profits are up or profits are down, nobody gets what he thinks is enough or his share. I don't mean the guys are pigs or anything of that kind, I just mean that they fight for their own parts of the company. And Goddard [Lieberson], you see, was out in Tokyo on a negotiation, and I had an obligation to look after his children, so to speak, and one of the other group heads was in England at another meeting having to do with some other part of the business. So two of the group heads were here, two of the group heads were gone, and this made it a little more awkward because I'd much rather have them here hitting me over the head with baseball bats than to be responsible for them. So, you know, it's a sticky wicket.

Anyway, these lights were blinking back here [showing a panel behind his desk], and one of the boys said, "Your phone must be ringing its head off." The phones weren't turned on, so I didn't hear them. I picked it up . . .

"I guess you'd better not put this on your tape," Stanton said. He told me off the record that Lyndon Johnson had called back with various plans for the young couple to honeymoon in privacy.

Now Stanton did not represent the individual interests, *as such*, of either Lyndon Johnson or of any single person at CBS. He only represented their interests in connection with their roles in particular organizations. For instance, later on he made a comment about Lieberson's upsetting the balances between the internal divisions at CBS, which he said was a little exasperating at times.

You don't start going off with strange organizational structures in one of the groups, because as soon as you do, it begins to upset the balance in some of the other groups. Now Goddard, he couldn't care less about what the other groups have to do. That's an exaggeration, but on occasion he's perfectly willing to ignore some of the operating

procedures that have to be uniform across the company, and if he wants to do something, why, he wants to do it. That's what I meant by being a little exasperating at times. Because he thinks the law department was put there to frustrate him, and they're not there for that purpose. There are certain things you have to do. You've got stockholders, and you've got things like the FCC and the Stock Exchange and so forth, and, as I say, maybe Goddard's right, these are unnecessary frustrations, but . . .

The record division at CBS, headed by Goddard Lieberson, had interested me because there had seemed to be so many employees performing their tasks inadequately—by *my* standards, that is. Their ideas of excellence appeared geared to what sold, and their ideas about "art" struck me as messy. Notions of how their work fit into various wider contexts—and I do not mean Stanton's—seemed quite lacking. In other words, they weren't intellectuals. I used to think a great deal about what kind of expectations managers apparently had as opposed to the kind I felt they ought to have. There were a few quiet, productive people around, but except for Stanton they never seemed to get on, while others who were constantly negotiating seemed to do very well.

Of course, concentration on work can mask the inappropriateness of a person for a particular job. This was true in my case; and it was what Lloyd Goodrich meant when he spoke of his work as a clerk in the claims department of Consolidated Steel while in his early twenties: "You could get involved in the minutiae of a job like this and take a certain amount of satisfaction in it, whereas the job as a whole really is quite repugnant to you." David Bazelon claimed that "concentration on work, especially non-people work, in effect delivers the power of the organization to the people-oriented non-concentrators."[23]

Lieberson said, "We have a rather formidable team of people here. . . . Somebody comes in to meet with our group. When they see the vitality and the understanding of these men and their intelligence, their high grade of intelligence, I think they're all amazed.

"I have a penchant for lawyers," Lieberson continued, "because they think logically and clearly, most of them, and I think the training they've had gives them some cultural background, in addition to a very clear way of thinking that's not—oh—not too frequently messed up with emotionalism or other things."

"I'm interested in this," I replied, "because I would guess it's the sort of temperament that, outside of business, you weren't very fond of." I thought of the number of musical and performing artists he knew.

"Well, that's right," Lieberson said. "But—bringing it outside, I find them, I find that these men who are intelligent have much wider inter-

ests and are much more intelligent about the outside world and what's going on in it, than people who are restricted in their capacities to understand."

Was he talking about businessmen *per se*?

"Yes," he replied.

These aren't—because I don't think these are businessmen, in the old sense of the word. They're really not. And then, of course, some of them—Clive Davis had all his life been interested in the music business and the entertainment business, even though he's a lawyer. He's read *Variety* since he was in school, you know.

"Oh, did he?"

Oh, sure. So he's not new to the game, and he's got some feeling for it. Then I think another reason is that law pays badly, really, except for really a very few. It's not the best. And I think that if a person has imagination, as a lawyer, he finds that practicing law is restricting, as fascinating as they might find it. Well, also, some of it is coincidence.

I suggested to Mrs. Lieberson that her husband might enjoy business, this business at least, because he got a sense of the drama of personalities meshing. Mrs. Lieberson said, "No." She "didn't think so." What would be his reward in such a situation aside from the most obvious ones? "Money and power, you mean?" she said. "I don't know. I don't know. I think he's terrifically good at it, yeah, he gets money and power."

Edward Ziegler, in *The Vested Interests*, wrote:

There is on the one hand the innovative, informal climate typical of rapid growth that usually accompanies charismatic leadership. On the other hand there is the more restrained, highly structured climate that emerges with economic maturity and that is accompanied by the evolution of a new kind of leadership, archonic.[24]

Lieberson had become president of Columbia Records in 1956. In 1965, the company was in the process of being reorganized. I had been doing some reading on modern corporations and found it relatively common that after a period of great expansion almost inevitably a company would be restructured and the hierarchy made considerably more rigid. Dr. Stanton remarked that this was quite true and that it was a function of size: "You become more formal in your relationships." Harcourt, Brace, during Jovanovich's presidency, had become a large firm and one can guess how exhausting the attempt to run it personally was. Both kinds of rigidity are likely to make for difficulties in contacts with artists.

Would Lieberson like to talk about the corporate restructuring of

Columbia Records? "Well, actually," he replied, "really I didn't know that [what had happened in his company was typical of other corporations]. . . . Of all the books I can't read, business books are at the top of the list. I can't read any publication about the American Management Association."

Lieberson considers himself an intellectual. Speaking of his childhood, he said, "My life was an intellectual life; the people I dealt with were intellectuals. The only thing we respected was that. I was never judged on anything else."

At the time of our interviews, he said:

> Gee, I've been reading Karl Jaspers . . . I was interested in reading it, some of the origins of Existentialism, which I am not particularly devoted to, but I just wanted to see some of the background. I don't like Heidegger very well.

And speaking of the magazines he read:

> I get *Harper's* and *Atlantic* and I find I don't read them very much. Unfortunately. I don't know why. I think they're probably things I should read. I don't know why I can't get interested in it. Maybe it's the format, the paper. I don't know. But it's easier to read *Encounter*.

It struck me early on that Lieberson always said, "I don't know why," when he was talking about something of which he was proud. For instance, he had said, "I started writing down music very early, I don't know why." It seemed his way of saying that something was instinctive with him, just as he seemed to be saying about his reading habits that he instinctively had better taste than to read magazines which were not intellectual—were not in, say, with *The New York Review of Books* crowd, of whom he counted Robert Lowell a particular friend. (This was before Willie Morris became editor of *Harper's Magazine*.) When I worked under Lieberson I thought of him as having no ideas in the intellectual sense, nor did he need to, but occasionally interesting intuitions. He was a version of the Flower Child, but his instincts were shrewd and not naïve.

He may never when young, as he says, have been judged on anything other than his intellectual abilities, but apparently he, to use his own words, was "always adulated for playing the piano." His earliest musical memories were from his mother, who sang Puccini arias. Lieberson speculates that his parents were interested in cultural activities because they were Jewish. Nathaniel Weyl, in *The Creative Elite in America*, suggests there may be good statistical reason to accept as fact the idea that Jews play a predominant role in the arts in America.[25]

Lieberson said his mother "somehow managed to get together whatever money was necessary for tickets—all that sort of thing."

It seems that this least intellectual of the nine men was one of two who had come close to being creative, serious artists. Pressures on Goodrich and Lieberson from their early environment had been *toward* their becoming artists, but they did not anyway. In 1963, a psychologist reported "the fascinating fact that among people above the feeble-minded level there is no relation between creativity and intelligence. Creativity is more related to an openness of emotions, a sensitive intellect, self-understanding and a broad spectrum of interests, including some thought of as characteristically feminine."[26] This, in a way, describes Lieberson. And he was creative, although not as an artist.

During my two-year stint at CBS–Columbia Records, I had worked with practically no one but Ira Teichberg because of the nature of my job (the only book editor) and mostly for Goddard Lieberson. I felt he had no talent for the written word, but since he was a musician and a businessman, I did not expect him to. He, however, thought that he did, and this occasioned some difficulties between us. All of his writing that I knew about while there was considerably reworked by others, including myself. He didn't think he needed protection, and he didn't so long as no one in the literary world took his writing seriously. His "special projects" were a good example: since they existed to give a gloss of prestige, it was not necessary that they have real substance. Trying to add it only made problems—for everyone. I was told that I "did not fit into the corporate structure." I did not understand and wanted to learn the why of what had gone wrong, although I knew it couldn't be done by asking Lieberson directly, because it was not in his interest to tell me even if he knew.

If I did not fit into a corporation, still it had been possible for me to structure and carry out something unique. I had the immense advantages of an extremely talented designer and unlimited funds. Someone arranged that part of the deal. I had another advantage in that I was left alone. Lieberson was to say to me of his employees (almost as if I had never been one), "I try to allow them their caprice, their own sense of development. . . . Once you give the direction, then I think you have to let people alone." His wife said:

Goddard does *not* like all of the things—slow comprehension about certain things, things that are left undone. Improvement [?] is his big pet peeve, you know. When Goddard, in other words, gives an order of some kind and somebody goes one step further, out of who knows what reason—"Oh, I thought you wanted me to do this"—in

other words, making blunders and being efficient in the wrong direction.[27]

Although some of our conferences had struck me as resembling a cartoon, by George Dole, captioned "When I want your opinion, Harper, I'll give it to you!"—Lieberson obviously knew about a certain notion of what constitutes a modern-style executive, who, according to Donald Schon in his book *Technology and Change,*

> works to enable people within the organization to learn to innovate. . . . He codes, not imposes, his ideas about substantive projects; he does not regard himself as the principle source of ideas. Instead he attempts to build resources for innovation. To the extent that he is manipulative, he manipulates the process by which ideas come into being and turn into reality. He attempts to teach and create models, but on the level of process rather than on specific accomplishment. His assumption is that it is possible, without relaxing standards of performance or deflecting attention from the work at hand, to enable people in the organization to use their own potential for innovation and to set a style in the organization for doing this.[28]

Since few of our conferences affected what actually went on, I had regarded Lieberson's manipulation as weakness, my originality as strength. In this situation, I seemed to have been mistaken about both.

What, I asked myself while drawing unemployment insurance and feeling somewhat panicky, does it take to succeed in a business corporation: How do you lick those bastards? A certain amount of comedy entered the situation when, after all my agonizing, some years later Midge Decter (who had followed me at CBS) commented offhand that "nobody" stayed longer than two years, that was a long time. But more importantly, I did not realize at the time that the power to fire me was not a very great power. In fact, the use of it meant a certain weakness, for it deprived Lieberson of valuable services even though it removed from his environs a certain discomfort. His basic problem—that of using artists (primarily musicians) profitably—remained. A psychiatrist, Thomas S. Szasz, wrote, "The subordinate person's inadequate task-performance is often tolerated—indeed is covertly fostered—because the superior person has relinquished the value and goal of proficiency and has adopted in its place the value of manipulating those under him."[29] While at CBS, I believed that such was Lieberson's style. This was the other side of the idea that attraction to a supervisor could be an important source of influence. Yet brood on it as I would, what I saw as inadequate performances were satisfying the stockholders: Columbia Records, in sales, led all other companies in the industry. Perhaps the "monotonous, or-

ganic hum" of corporation life[30]—a process with its own momentum—
could take unto itself everything but disruption, including the disruption
of a success such as the one Ira Teichberg and I had provided with
the Kennedy biography. The inability of the CR sales department to
merchandise the industry oddity we had created (that is, it wasn't a rec-
ord) bears this out. Sales in the *book* industry went well.

When I asked Lieberson to see me, I was counting on his vanity.
I began to tape the story of his life and felt so strongly about the situ-
ation that three interviews were all I could take. Yet the strangest thing
happened: I found that I liked him, seeing him in this different con-
text. I was not an employee: I had become someone to whom he was
playing (as from a stage), presenting an image of his best self—intelli-
gent, charming, amusing. Even simpatico: at one point we discussed our
problems with our respective sons. With ease and spontaneity, "he made

Goddard Lieberson

considerable efforts on behalf of people who were often only acquaintances. To those who did not know him well and to those not disposed to examine closely motives or responses, ——— was a singularly delightful friend and companion."[31] These words were written of Cocteau, but when I read them I was struck by how well they fitted what I knew of Lieberson. People who went to parties in New York were invariably the ones who knew who he was. One lady wrote me, after I had left the city, "I saw Goddard (under the most favorable circumstances) and he was at his most witty, and beautiful—a pleasing sight." The sociologist Max Weber had used the term "charisma" in what he called "a completely value-neutral sense."[32] Lieberson had charisma.

After having known him for some twenty-five years, his talented wife still considers him extremely interesting. She said:

> Here we were flying in Norway, in December, to see my mother, and Goddard said, "Oh, it's such a bore to sit on that train eight hours, you know, flying the Atlantic is one thing but eight hours on the train and then three hours by car, it's really impossible." My mother does live in a very curiously inaccessible place. So he said, "Isn't there some way that you can charter a plane?" and I said, "Well, I'll find out." Well, there was. Well, this is December, in Norway. [She laughed.] North of Norway. Everything went wrong. We did charter a plane. Goddard, who sits on a jet taking off for Los Angeles—you know how much he has to fly and how much he travels—he sits there and he rolls twenty-five-cent pieces to see whether we're still in the ascendancy or whether we've leveled off, I might say prayers over here, but he is contained but very nervous—admittedly now. In this flight, we flew into total darkness, winter afternoon, it became darker and darker, and the darkness was a snowstorm. The little plane had no radar, no radio, no communication, one engine, and I thought I was going to have kittens. And we were flying over a fjord and the pilot descended and descended and descended until we were skimming the fjord. I promise you, I mean off the water like that, so that he could see the water and also could see the coastline. Would you think that Goddard was nervous? Not at all. Chatting away, perfectly happy, and the pilot said, "Well, I think, I think I have to land now because I can't see any more and if you want to take a chance and you go so high, but then I think I will be lost," and I said, "Oh, come down, down," and we landed on the fjord in the middle, I promise you, of nowhere, and I said to Goddard, "Now what?" "Well, we'll find a taxi."
>
> Whereupon I just exploded with laughter, "A taxi! In the middle of where? What do you mean a taxi—here?" Well, he taxied up the little seaplane onto the shore, up to here I promise you in snow, lug-

gage and everything—there was a brand-new Mercedes-Benz taxi stand-ing there. Goddard said, "You see." I said, "How is it possible!" I spoke to him in Norwegian and said to him, "How is it that you are here?" He said, "*Ja, ja,*" he said. "Well, sometimes the ferry comes in and, I don't know, I was passing by."

Then we went into the—you know, I mean not a taxi like here in New York but a man who does taxi business—he drove us to the ferry, and since it was Christmastime the ferries weren't running. Would this faze Goddard? Not at all. I always think of Goddard as this high-powered—wants things to go like this—but this didn't faze him at all. By that time *I* was on pins and needles, and I thought what does Goddard think of Norway and he's made this trip on *my* account, *my* mother, and this and that. Last year, last December. So two hours later the ferry shows up [she giggles], chug, chug, chug, chug, chug, chug [we both laugh], and the driver says, "Yes, I will leave," and I said, "Oh no, you don't leave us now, oh no, no, no, no, you must come with us on the ferry, and stay with us and drive us home, be-cause on the other side, and there's nobody there either, we have to drive home." I go there two or three times a year to see my mother, but this was one of those times when everything went wrong. But what I'm trying to say about him is in these situations when *I* would blow my stack, he's perfectly calm, and, oh yes, that same trip—let something go wrong in the house or his office, in the matter of inef-ficiency, and somebody's going to hear about it in no uncertain terms, *but*—there he had told me, "Why don't we get the same pilot back to pick us up?" I said, "Goddard, the last experience was so terrible, the snowstorm, it's winter, it's January." "No, no, let's try it again." [She laughs.] Well, the plane arrived, with a patch of clear blue sky over here, and Goddard had told me not once but three times, "Don't forget your coat." I said, "Please don't tell me for the third time. Over my dead body would I forget my coat." He said, "Please don't say that," and I said, "All right, I won't forget it." On takeoff, with all the family, you know, waving good-by and the private, tiny, little one-engine thing, and we're ascending. I thought: "No, it is not pos-sible, I mean it's not possible—I've forgotten my coat." Now Goddard had told me three times, and I just sat there for thirty seconds, de-bating whether to say something or not. I knew that I had to, I said, "I'm terribly sorry, I have indeed forgotten my coat." Nothing. Ah-h-h-h. "That's all right, we'll turn back." I said, "Well, we'll miss our con-nection." "No, no, no, we'll turn back." We re-landed and shouting across the fjord and somebody rowing out like that with a mink coat and into the plane, and no fuss. And yet as I say the dichotomy in the personality, so funny, because if, if suddenly half a grapefruit is missing, or some other inefficiency within this household, I haven't

called somebody, *then* he minds. . . . Now maybe it's because on both occasions we were on vacation, there was no pressure involved. . . .

With subordinates, when Lieberson did not see their ideas or goals, he thought of them as slow: he had a certain fear himself of being thought so. His wife believed that many times he was kept back "by having ideas that can't be translated quickly because other people are more slow-thinking or slow-moving or what have you." What was it that interested him about people with whom he didn't have to be in contact? "First of all," she said, "they must not be bores."

Unlike others of the nine men, Lieberson's work was separate from the rest of his life. "Goddard never works at home," his wife said, and "I never think about him as a businessman. Never. It never occurred to me. I mean, when somebody says, 'Your husband is a businessman,' I think they're mad." Lieberson had "continuously new interests," but not, his wife quickly added, "in the ordinary sense as a hobby." He took up the study of religions, visiting monasteries; of Japanese brush writing, having visited Japan; of the Civil War, visiting the battlefields. (Some of his studies were tenuously connected with projects under way at CBS.) The Liebersons had a greenhouse on the roof of their town house with its proper address in Manhattan's East Sixties, and he took up gardening "intensely." And then a tragedy happened, his wife said: "He had all of the gadgets inside of it but of course it was untended most of the time during the week—he was a weekend gardener. But then a terrible frost came and a pipe burst and everything died inside. That was like wholesale slaughter." He did everything, in other words, but leave CBS in order to become an artist. His wife said:

That's the one thing I have against the whole hullabaloo, because it's so draining on a man, so very, very draining. I mean, you simply haven't got enough energy—come home, I mean like now, it's comparatively early, at six-thirty or quarter to seven, and then de-accelerate and go into another world in order to compose. I hope that our house in Santa Fe, once the to-do is over with, you know, of fixing it, that he will find some measure of peace there, that I hope we'll build a studio for him that he can just go. But I think that this is an interesting point, this business about composing versus non-composing, because our friend Lenny—Leonard Bernstein—is a person of multiple interests and took a sabbatical for the sole purpose of composing, and when he finally had nothing to do at all, he just sat apparently. I mean, it must be like being surrounded by deafening noise all the time and being suddenly put into the midst of—British Columbia—and suddenly there's no sound. Maybe it takes a long time to de-accelerate. Like a compression chamber, you know. . . . All I know is that

a man can't switch from a process . . . when he's been used to a different life altogether.

Interestingly enough, Lieberson's tendency indeed was toward that humanist ideal of a balanced life, as Lowry put it, which the true artist was unable to live out.

Goddard is "an incredible person on weekends," his wife said. "You know you think that everybody—ninety percent of people—want to sort of relax one way or another, but not Goddard." She described a bit of their social life, after having spoken in her attractive accent with a certain wistfulness of the days when their acquaintances had been primarily musicians:

> We knew Arthur [Schlesinger] through Marietta Tree, we spent a vacation together in Barbados and then visited again in Cambridge, then everything was percolating about the coming election, and then I don't know whether we brought Arthur together with the Stravinskys or how this came about—this was started that President Kennedy should give a dinner for Stravinsky at the White House. You know, there's a great deal of cultural goings-on all the time—Pablo Casals and all that, remember? This is how we came for the first time [of two] to the White House.

She recalled: "The enchantment of an evening, here in this house, of hearing [Goddard] talk to—Sir Isaiah Berlin, for instance, was a friend of ours—when he's here, I mean it's like a Ping-Pong game. Goddard steps into a higher gear, is so witty and fun to listen to." She spoke of having seen Galbraith "the other day" when she was at the Moynihans for dinner in Cambridge and he had walked in. The Liebersons knew Moynihan through Paul Horgan. "I met Paul Horgan in Santa Fe when he was chairman of the board of the opera." One of the Lieberson sons, Jonathan, had gone to Choate, President Kennedy's old school. When visiting, his parents would stay overnight with Paul Horgan, who had become director of the Center for Advanced Studies in Middletown, Connecticut. There, they met C. P. and Lady Snow, Moynihan, Herbert Read, Richard Goodwin, and so on.

KNOWING THE PRODUCT

(Ways of getting on)

LIEBERSON FIT WELL, if somewhat peculiarly, into corporate life. The son of an Englishman, he had been born in Hanley, Staffordshire, in April 1911. "My father had—a very curious thing," he said.

> The first rubber-heel factory in England. How he got it, I don't know. I guess it was the first. We forget how contemporary these things are —I mean, how recent. I don't know if it was the first—it was one. He was involved in that and involved in manufacturing shakos for the British guards.

When Lieberson was seven years old, the family left for Canada and eventually came to the United States because of relatives who lived in Seattle. There he grew up.

Thomas Griffith of Time Inc. also came from Seattle. He wrote of it in *The Waist-High Culture*:

> When one enthuses on his home town to someone unfamiliar with it, he stresses what is distinctive about it (in Seattle's case, the hillside streets coming down on one side to fresh lakes and on the other to salt water, and the view of distant peaks), yet the appeal of a home town is what is ordinary about it. . . . There was not one world, in Seattle, of doormen and elevator operators and taxi-drivers, and another of those served [unlike Griffith's—and Lieberson's—New York, presumably]. We sought an equality with them all, and would have thought ourselves snobs had we not. . . . But this Western attitude of considering no man better than you, and yourself no better than any-

one else, has its drawbacks too. It generates much worthy community activity and some that is only pleasant and harmless, but it inclines to a suspicion of those who would set themselves apart in any way. It is all right to have odd interests, so long as you are careful to depreciate them. But if your separate pursuit demands privacy and concentration it is apt to be regarded as an attempt to set yourself off from, and therefore above, your fellow man; one becomes defiant or apologetic, but in either case unnatural, or abandons his private disciplines and settles into the general ease. Skills which are spontaneous and communal are much appreciated: the ability to dash off a parody, but not the exacting solitude required to write a good poem; the capacity to entertain at the piano but not to play well, which compels too silent and respectful a hearing; and a talent for home decorating and a dabbling in paint will get you acclaimed as artistic—so long as you paint recognizable likenesses. There is, of course, a substantial minority whose standards of appreciation are considerably higher, but in the West one is apt to live not only among them but among everyone else—which may be why so many visitors from the outside world return cheering the Western setting, acclaiming its generous hospitality and casserole informality, but muttering about its intellectual sterility.[1]

Lieberson developed skills that were "spontaneous and communal." He was the youngest of five children by some ten years. One of his brothers taught him "to fiddle around" with the piano—"This was before I had lessons even—because he was by far the laziest of the family and I got diphtheria as a child, and he volunteered to stay home because we were quarantined. He was delighted that he didn't have to go look for a job.

"I started taking piano lessons early," Lieberson said. "My mother got a teacher, and my father threw out one because he found him hitting me . . . on the hands with a ruler. . . . I practiced and played, and I started composing very early. I went on to music theory and music history . . . and in high school—I played the piano all through that period, I played popular music—I was popular with the kids because of that."

I don't know what nuance I picked up that made me ask him what he had been afraid of during his high school years—I hadn't asked any of the other nine men that question. "Not a thing," he replied. "Not a thing. I wasn't afraid of anything. One of the things about being poor is that you're never afraid of that. . . . We had enough food. We used to laugh about it. I remember my mother used to buy chicken legs, and my sister thought a chicken had six legs. . . . My mother," he said,

was the wildest friend-gatherer in the world . . . always hysterically laughing. I remember playing in grammar school—I remember—my

mother had servants in England so she was terribly inept in everything.
I had the worst costume—the parents had to make bunny costumes—I
remember mine never fit, they never worked—and the two terribly
white strips to make me into a revolutionary soldier. She couldn't cook
—was famous in our house—when it said "home cooking" we used to
run like hell because she was so terrible—and she was always so good-
humored about it—we all were—there were gales of laughter—nobody
cared about that, which was good. She was famous for her ineptness
in the house, you see. And I remember once, I heard her peals of
laughter because I was supposed to be a spy for the Americans in the
Revolutionary play, and a fat girl sitting on the couch with the springs
weighed down, and I couldn't get under the couch. So here I was
exposed in full view to my captors, who had to avoid looking at me
[he laughs], and I was supposed to be hiding—that was my first ex-
perience in the theater. . . . I was, I guess, fourteen.

Lieberson's father stopped working when the brothers "pitched in."

There was no need for it really because we were a large family and lived
modestly in a small house that we owned, and—I remember getting
books for him. . . . He'd been born in Russia and he began reading late
in life.

We seemed to descend into poverty with considerable rapidity. I
remember everybody working. Including me. I started working early
in life—I did everything—in my life as I grew up—a good part of it
was in the depths of the Depression, my young years, although I never
felt it as that—I did everything. I worked as a postal telegraph deliv-
ery boy; I worked as a newspaper boy; I worked in a drugstore; I
worked in a grocery store—this was in addition to going to school.

At what age had he started? "Twelve—thirteen—that was 1923–24."

In spite of his various activities, by the time Lieberson got out of
high school he was pointed in a particular direction. "I had a friend,"
he said, "who had polio—named Don Bushell. He was an ardent friend.
As a matter of fact, the gym teacher, in a basketball game, made a
slurring remark about me, and Bushell hit him with his crutch. This
was a famous case. . . ." Bushell "gave a piece of music to George Mc-
Kay, who was a professor of composition at the University of Washing-
ton, and McKay got me a scholarship there, and I started studying with
him. I was there a very short time. He thought I should come East to
study," and a local group raised funds for that purpose.[2]

In New York, on a brief visit, Lieberson stayed at the apartment
of "a generous, darling fellow," a composer named Lehman Engel, who
"was living elsewhere. . . . When I got here," Lieberson said,

I met Aaron Copland, Virgil Thomson, Stanley Meisner—I came with
one letter of introduction to a man named Corn, who was interested

in amateur opera, and he introduced me to Raeburn, who introduced
me to other people. And before you knew it—I'm just amazed, when
I look back on it now, at how quickly I got on. But imagine, I knew
Aaron in those days! A long time ago. Aaron was in his thirties. It
suddenly occurred to me that all these people were homosexuals. I
thought: Are *all* American composers homosexual? As a matter of fact,
most of them were.

He had known about such things, he said, back in Seattle, where he had
grown up, but "hadn't related that knowledge to composers."

Lieberson was then in his late teens. On his way to New York City
he stopped off in Rochester, New York, where he played some music
for Howard Hanson, the director of the Eastman School of Music. Han-
son told him, Lieberson said, " 'Well, whatever happens when you get
to New York, you've got a scholarship here, if you want it.' He was very
impressed with me, I think, and with my music, and naturally I found that
irresistible."

Whatever happened in New York, Lieberson went back to Rochester,
where he stayed for almost ten years, during which time he became a citi-
zen of the United States, teacher at a country day school, music critic on a
local newspaper, and got married.[3] Toward the end of his twenties, he
decided to move on to New York. "I wish I could remember why," he said.

I think it was just that feeling, you know, that—as though I would get
no place there. I fought with the Eastman School of Music—I just
couldn't take what Hanson stood for, when finally I saw what it was. He
had all the money from Mr. Eastman, George Eastman, so he was in
control of things. He was reactionary all the way through—a man of
very shallow—a man who still has a position of terrific influence in this
country, nefarious and sinister, and he's always stood for the wrong
things, artistically, politically, in every way.

Had it required a certain amount of education on Lieberson's part to see
that? (For instance, coming to see that Hanson was a "musical conserva-
tive"?)[4]

"No," Lieberson replied. "A certain amount of familiarity with him.
Obviously I couldn't tell in one meeting. It was the politics of the school
I objected to. See, it always comes down to the head person. He was sur-
rounded by people who were chosen on the basis of their loyalty to him,
rather than their capacity as teachers. . . . Isn't that shocking?"[5]

Here is Mrs. Lieberson:

I'm sure [Goddard] demands a great deal of his secretary. A great deal.
What he does want is total loyalty to himself, coupled with the proper

amount of politeness, to fend off. What he doesn't want is an overextension of being friendly in the wrong way, and thereby exposing him.

By the time Lieberson arrived in Rochester he appears already to have lacked the goals of an artist. One can guess that he had gotten encouragement to be a musician but no good idea of standards from such a household as that in which he grew up and that he found poverty humiliating. Wit is a weapon against deeper feelings. His own easy popularity had shown him the way to, as he says, "get on."

"He sort of associates it with his mother if something goes wrong," his wife said. ". . . He adored his father, absolutely adored his father. His mother he makes fun of, but in a nice way. . . . You probably know more, in a funny way," she said, "than I do. . . . He does not talk very much about childhood background and so on. Nor does he see his brothers and sisters. It's a joke because I am an only child and I love family. Goddard who has a big family hardly ever sees them. I understand it in a way because he is like some [she sort of sighs] odd child. You know his brothers and sisters are so different it's incredible that they come from the same family. But totally. Sweet and nice, but I mean totally different."

How did she explain what had happened to him as compared with what had happened to his siblings? "Oh, I think that's nature. Inner drive of some kind. Something inside of him. Nobody can give him that, nobody can give you that, you know. You're born with it. I mean, why do any of us do the things we do? What drives us? I don't think it's so much pushing, or home conditions, or lack of pushing, or what have you. He did it all himself." Drive made artists, she said, and could not be taught: it was "an inner sort of demon." She did not discuss whether Lieberson's drive was toward the same goals as those of an artist: we seemed to have already settled that for whatever reason it was not.

She felt that giving money to their sons was crippling them in a way. It was a great problem because, she said,

> if you have hard-working parents who achieved certain things in life and who then want to enjoy, it's very hard because then come the children, and I always thought that the best way to live would be to live in Queens with me doing all the housework and cooking, and the children grow up in a modest atmosphere, because that's the way somehow these things work, but in this sort of atmosphere, to live nicely because we have worked, we want to have it, we enjoy it, doesn't train the children in a way. It's very difficult to do.

Lincoln Kirstein commented that the parents were without talent but that they had created two masterpieces—their sons.

Vera Zorina Lieberson spoke of coming over to the United States in the 1930's, on board ship with her mother, when she was with the Ballets Russes: "It's fine when you're seventeen and you come over on third-class and so on, and I didn't mind it. . . . Now, nothing doing." What she and Goddard had gotten, she felt they had earned. It was not terribly good for people, she said, to get things without earning them in some fashion. But of her husband she said:

> I think he does not appreciate his success as he ought to. I think that what he really and truly admires in life are the creative processes. He hasn't said it once but a thousand times—versus being creative in business, let us say, or running what . . . I mean, he's an utterly, utterly successful person. Nobody can deny that. I mean, in his field. Tremendously looked up to as being not just a man who runs this but really very creative. I don't think that it has given him any particular happiness, though. I think one good, well-written book or one marvelous composition would have given him more pleasure—inner satisfaction.

Lieberson is reputed to look on himself as a failure, having come to feel that he squandered his talents. Two early pieces, written before he came to New York, were published well after he became president of Columbia Records:

> Homage to Handel, Suite for Strings (1937). New York, Mills Music, Inc., 1965.

> String Quartet (1938). New York, Oxford University Press, 1965. (Recording: Galimir Quartet, Columbia Records, CMS-6412.)

The Eastman School of Music uses his

> Piano Pieces for Advanced Children or Retarded Adults (1963). Vol. 1: Five Songs Without Mendelssohn. Vol. 2: Six Technical Studies (Which Will Teach You Nothing). Vol. 3: Eight Studies in Musicology (Which Will Teach You a Great Deal). New York, Mills Music, Inc., 1964. (Recording: André Previn, Columbia Records, CMS-6586.)

While Edward Wallerstein was with Columbia Records as its president, Lieberson wrote "two pop songs with an actress who died." These were, perhaps, "Love Is a Sickness" and "Cradle Song," published in 1945. He also wrote a novel, *Three for Bedroom C*, published by Doubleday in 1947 and later made into a movie.

It seemed that Lieberson was at heart a performer. His wife had spoken of his moving into higher gear. He enjoyed himself tremendously producing show albums, and I once saw him perform at a sales convention scheduled in an unbelievable hotel in Miami Beach. I thought I liter-

ally had descended into hell. The air was charged, and when I ran across Lieberson in the lobby, his face was flushed and his eyes were glittering with excitement. He was to go on stage and introduce a Columbia Records recording star to the assembled convention, and this he did with witty brilliance and evident enjoyment. The salesmen loved their own. Then, retreating to the side, he sat on the floor behind the curtain, his feet sticking out under it, and by tapping them in time to the music managed to upstage the performer.

Again, I am reminded of James Lord's words about Cocteau:

> Yet because he was unprepared or unable to serve the needs of that talent for its own sake but compelled it to serve needs which are foreign to all serious creativity, this tension ultimately revenged itself by limiting the scope of his talent and inhibiting its fulfillment. . . .
>
> Cocteau obviously conceived of this anguish as the normal and in its own way admirable concomitant of creativity, and he apparently fancied that the drama in which he lived was the inevitable outgrowth of a struggle between moral and material values. This is nonsense. Not only in his life but in his works he repeatedly provides evidence to prove that he suffered for the sake of the public and not for the sake of art. He was forever worrying about his position, his influence, his popularity; and his efforts to enhance all three were unending.[6]

Lieberson has been more of a financial success than many of the nine men. Whatever his other assets, in 1972 he owned 42,794 shares of CBS common stock, worth only somewhat under two million dollars on the market. His basic salary was $130,000 that year, with $120,000 in "additional paid-out compensation."[7]

The restructuring I had seen at the Records division in 1965 was followed shortly by a regrouping in the parent corporation, CBS, itself. Lieberson said, "I went upstairs—"

"By upstairs, you mean?"

"No, no, no," he said. "Stanton. Stanton and Paley." He explained that this kind of grouping together came before Stanton appointed John Schneider president of the CBS Broadcast Group:

> But when he made the appointment of Schneider, then he wanted to make me this other appointment, this other group [the CBS Columbia Group]. But I held out for the—I didn't want to be a group vice-president. I thought that was not the way to do it. I held out for the group presidency. Why not? And I don't think that was very popular, but anyway, there we are.

These moves gave Lieberson and Schneider operating authority over more than 95 percent of the CBS activities, only excluding CBS Laboratories

and the New York Yankees. I was in Lieberson's office for a considerable time the morning his promotion was announced in the *Times* and was interested that his phone was quiet, although I don't know what, if any, significance that fact has. He may just have told his secretary to hold calls during our interview.

"WHAT DID Goddard Lieberson want?" I asked Edward Wallerstein. "Don't know," he answered. But then Wallerstein added, "He wanted to be successful and do anything that came his way" and "he wanted to rise rapidly."

CBS had acquired the Columbia Phonograph Company, Inc., in 1938, after Wallerstein had gone to William Paley and suggested that he buy a group of corporations called the American Record Company, in which it was included. "Ted Wallerstein had been an officer at—I don't know whether it was called RCA-Victor then or not," Frank Stanton told me, "but when we bought it, we hired him to run it."

Lieberson joined Columbia Records, as it was renamed, sometime in 1939 as an assistant to Moses Smith in the classical records department. No one in the company brought Lieberson in, Wallerstein said: he came directly from Rochester and was hunting for a job. He was married at the time to Margaret Lieberson. Wallerstein got the impression that he was "very bright," with "lots of humor." Lieberson replaced Smith as director of classical records within a few years. Wallerstein said Moses Smith "didn't get along with people." Columbia had taken "number-one position in the mid-forties," Wallerstein said: it was the largest company in the classical field as well as "number-one" in pop records, with big bands. So the emphasis had been on "getting along" with others rather than on the quality of the work performed. In the mid-sixties, the prevailing attitude of the management at Columbia Records was much the same: both parties in a disagreement were in error, and hysterical behavior was acceptable because considered "artistic" but real confrontations were not.

"Goddard was a young musicologist or expert in the classical side of the repertoire," Stanton said, "and that was the field he was working in. The popular records, which was the big side of the business in those days and still is, was run by another man." When Lieberson had been at Columbia Records about ten years (in 1949), Wallerstein made him executive vice-president and put him over all of A&R (artists and repertoire). He and Wallerstein used to see each other socially, and this continued long after Wallerstein left the company. "Goddard did excellently," Wallerstein said. Artists liked him, and while he had no business experience, he learned quickly. He "knew everybody" before long: a story in *The New York Times*

on January 23, 1943, noted that FDR had been honored by "five opera singers," Bidu Sayou, Rise Stevens, Salvatore Baccaloni, Erich Leinsdorf, and Goddard Lieberson, when they presented Eleanor Roosevelt with a record which they had made as a tribute to the President on his sixty-first birthday.

Lieberson also knew the top management at CBS. After the war, there had been meetings at the rate of "one a month or one every two months," Wallerstein said, composed of "top men in the record end [including Lieberson] and Paley and Stanton." Wallerstein did not get along with Stanton. It was not a matter of policy but of personality, Wallerstein told me. By 1950, about a year after Lieberson became head of A&R, Wallerstein was gone. When Wallerstein left the company, he suggested to William Paley that he "make either . . ."—but in talking with me Wallerstein caught himself up and decided that he had only recommended Lieberson to succeed him. But for some reason, Wallerstein said, CBS "thought it better to wait awhile." Lieberson had come in at a salary of $6,000 or $7,000, "probably jumped to around $20,000 when he became director of the classical department," Wallerstein said, and was making around $35,000 as executive vice-president when Wallerstein left.

"I set about trying to find the ablest young man I could to run the company," Stanton said.

I was introduced to a man by the name of Conkling, James B. Conkling. He was a young management man, musician—not of distinction but he knew the field—and had been working at Capitol Records, perhaps as the second man, maybe the third man at Capitol Records. At any rate, I went out to the Coast and hired him, brought him in to run the record company.

I remember Goddard and I were going down to—the Philadelphia Orchestra contract was in jeopardy or was being threatened by overtures from I would guess Victor, although perhaps it was someone else—but at any rate, Goddard and I went down to see the members of the executive committee of the Philadelphia Orchestra to persuade them to continue their relationship with Columbia Records. And on the train going down to Philadelphia, Goddard said to me—he wondered whether he had been considered when I selected Conkling and brought him in from the outside to run the company.

I said that I had considered him, but I felt that all of his life when I had observed him had been on the creative side, that he had none of the general management experience, none of the business side of the company at all, but that I would promise him that if he got into that area, and if there was to be a change in the future, I would certainly consider him at the time.

I had high hopes for Conkling. I thought that Conkling was a piece of manpower that had tremendous promise for general management in CBS, and so that was, I guess, the only conversation I had with Goddard about it, was on the train, but I did tell him that I thought that from his own point of view if he would get into some of the other sides of the business, sales and general management problems, that there wasn't any reason why he couldn't ultimately end up running the division, or it was then a subsidiary.

And in a few years, the then head of the television network division came up and told me one day that his wife was very ill and wasn't expected to live, and that sometime within the year—it would be at my pleasure, but sometime within the year, he wanted to be relieved. On the theory that when a man reaches that conclusion, the sooner you move the better, because in this case I felt that he was making the right decision and that I ought to do everything I could do to help him get out from under the load, I got hold of Conkling and had him come over for lunch and told him that Jack Vann was leaving and that I'd like him to move from the record company over into the television network and become head of that, as the next step up the ladder, because I had identified him as the man that would succeed me.

Jim said, "Let me think about it," and the next day he came back and said, "I want to resign."

So that troubled me very deeply, but he felt that the job I was offering, which was a tremendous increase in salary and certainly a much more prestigious job than he had, was more than he wanted to take on. He just didn't feel he could give it the time and the energy. He didn't want to devote that much of his life to the work. He knew the job, although he'd never been in it he was close enough to it to know what the demands were, and my having offered him the job—this set him to thinking about his future and what he wanted from life, and he thanked me for having offered it to him and having brought him to his senses, but he wanted to take life a little easier. He was a very young man . . . he certainly has enjoyed a full life since he left us.

Anyway, the day that Jim came over to see me and said, "I want out," I called Goddard and told him what had happened. Meanwhile he had done exactly what I had asked him to do, and that was that he had gotten much closer to the business side of operations, and I then, within a matter of minutes after Jim had said that he wanted out, I immediately then moved Goddard into the job, and that's the way it was. It just happened that quickly. . . .

I've always felt that the key people in the various divisions should be experts in the product end, rather than in the management end. . . . Goddard represented to me, and does represent to me, the ideal person for his particular position, because he knows product—you know,

it's a part of his life—and he's acquired the management skills. He's very creative in his management approaches.

Lieberson became president of Columbia Records in 1956. Some years later, when I asked for hard figures that might reveal Lieberson's success during those nine or ten years while he was primarily concerned with the record business, a vice-president at Columbia Records was to write me:

> CBS, like almost every other publicly held American corporation, does not reveal the sales or profits of its component parts. The usual explanation is that this information would give aid (but, in our case, no comfort) to competitors. In addition, recent court rulings make it impossible to share this information with others, even in confidence.

(The SEC eventually required divisional breakdowns in corporation reporting, effective with 1974 income.) Nevertheless, an idea of relative patterns of growth can be gotten from a variety of sources, including *Cash Box, Billboard* record market research, *The American Record Guide*, and the market research division of Columbia Records itself.

These sources reveal that during what were approximately Lieberson's first ten years as president of Columbia Records, 1955–65, the record market had just about tripled. The industry as a whole increased consumer sales from an estimated $250 million in 1955 to an estimated $650 million in 1965. The CBS Annual Report to the Stockholders said in 1955 that the sales volume for Columbia Records was the highest in its history and that, in August, the company had begun to produce more than a million long-playing records each month. Ten years later, the 1965 Annual Report said the record company had had the most successful year in its history, which the report dated back to 1889. Its sales had led the industry for the seventh consecutive year, even while the competition had been increasing. The fifties had seen the appearance of many new record labels and, by 1968, there were some 1,200 record manufacturers.

Unmistakably the company had done well under Lieberson. Equally unmistakably, it had taken part in a boom, and not only in the record market. The Gross National Product had gone from $397 billion to around $660 billion in those ten years. The greatest proportionate increase in population had been in the teen-age group, a market CR was slow to enter but did well in once there. The Columbia Record Club, for many years the most profitable division, had been launched in the fall of 1955 under James Conkling, just before Lieberson became president. Wallerstein credited the two of them working together and commented that such a mail-order business had only become possible after the long-playing record had become widely accepted.

THE FOUNDATION PATENT of the phonograph industry had been issued to Thomas A. Edison on February 19, 1878. Twelve years later, the first convention of the National Phonograph Association was held, and the first issue discussed was the fear that secretaries would face technological unemployment![8]

The Columbia Phonograph Company had been organized in 1889 and was loosely connected with the American Graphophone Company. In 1906, the two companies were reorganized, and at that point, after some seventeen years of business, their earned surplus was somewhat under $1,250,000. Victor had been in business only five years by 1906, yet its surplus was over double that amount. It had introduced the Victrola and was running away with the disc business. (Before 1900, most recordings had been made on cylinders.) Graphophones sold poorly by comparison, but it was a stock-market manipulation that brought disaster in 1923:

> Phonograph stocks were not listed on the New York Stock Exchange until 1919 when a New York financier bought control of the American Graphophone Co. stock. He changed the capitalization from 150,000 shares of $100 par value to 1,500,000 shares of no-par value. He then had this new stock listed on the New York exchange. The list price moved steadily upward until it was quoted at $65 per share. On that basis the new capitalization was over $90,000,000, although the actual assets of the company were less than a third of that.
>
> To create an income picture corresponding to this inflated capitalization, production and sales promotion were expanded. However, the product was not sufficiently improved to create the requisite demand and much merchandise remained unsold. The situation became observed by the investing public and the price of the shares dropped to below $5 per share. The financier who started this cycle of activities retired with a handsome profit on his initial investment, but the oldest company in the phonograph industry was ruined. The bankers kept it going a year or two, but in 1923, receivers were appointed.[9]

A London company put up money and revitalized the company, which subsequently, in 1927, put $163,000 into Arthur Judson's United Independent Broadcasters, then two years old. The combined companies were called the Columbia Phonograph Broadcasting System, but the liaison lasted less than a year, the phonograph company pulling out as large deficits continued on the broadcasting side. It was at that point that William Paley arrived from Philadelphia.

Ten years later, in 1938, he bought the American Record Company, including the Columbia Phonograph Company, for the sum of $700,000: a nice reversal of fortunes.

By this time there were an estimated 225,000 juke boxes[10] . . . consuming with a ferocious appetite for the latest hits, some 13 million discs a year. Popular record sales in the U.S. accounted for 88% to 90% of the number of discs and about 70% of the dollar volume.[11]

Columbia sold about 7 million discs that year.

Up to this time the rather limited amount of classical music recorded in the U.S. had been largely done by Victor. But now, with Columbia Broadcasting resources behind it, Columbia Records, Inc., began a more ambitious schedule of classical repertoire recording. . . . Columbia had in their laminated record . . . a product superior technically to that of Victor or Decca, with a smooth surface. These records stood up well to the punishment of the juke boxes and the new automatic record players which were becoming popular about this time.[12]

Intentional obsolescence became a part of our culture early in this century, because of rapid technological development and because of business needs. It was most apparent in the automotive industry but infected a great many others as well, including the recording industry. When World War II made it impossible for the major companies to record European symphony orchestras, they vied to place American ones under contract, too often disposing of "a superlative European waxing . . . to make room for a mediocre American product."[13] The only competing orchestra RCA Victor had was the Boston. Wallerstein had negotiated contracts with the Metropolitan Opera and the Philadelphia Symphony Orchestra. He could not remember that Goddard Lieberson had been particularly involved in this. After Wallerstein's presidency, such recordings became too expensive: classical records began to be recorded in Europe, where costs were lower. A set of circumstances during the war had helped to bring that about.

James Caesar Petrillo, so-called Czar of the American Federation of Musicians, was counting on the unavailability of European musicians when in 1942 he demanded not only an increase in recording fees but also a royalty payment on every record produced. Afraid of creating precedents, the recording companies demurred, and Petrillo called his strike. It dragged on and on until Wallerstein at Columbia Records, over two years later, was the first to settle. Back stocks were running out, and it had become apparent that not even the United States government and FDR himself could make the musicians go back to work until Petrillo got what he wanted. "The settlement resulted in no increase to musicians of recording fees, but the royalty payments to the union were used to set up a fund to

be administered by a trustee for 'organizing and arranging the presentation of personal performances by instrumental musicians on a regional basis.' "[14] These payments were estimated at two million dollars a year. Subsequently, it became standard for contract musicians to draw royalties. With record sales reaching $760 million by 1967,[15] in retrospect it seems only fair that artists should have had a proportionate share of the profits.

Lieberson had been divorced and remarried in the mid-forties. The new Mrs. Lieberson, Vera Zorina, had been successively a ballerina with the Ballets Russes de Monte Carlo; the wife of the famous dancer-choreographer George Balanchine; and a Broadway and Hollywood star. After marriage to Lieberson, she remained professionally active, although not as a dancer. She directed critically well-received performances at the Santa Fe Opera in New Mexico and acted in serious dramas, *Life* magazine taking special note of one at Yale that had been written by the poet Robert Lowell.[16] At the time of his second marriage, Lieberson was still in charge of the classical repertoire at Columbia Records.

Technical developments during the late forties were to make a great difference in what the companies would be able to record. RCA was developing discs at 45 rpm. It had acquired the Victor Talking Machine Company for $30 million in 1927, and by 1946 RCA and CBS, both of them broadcasters and the largest companies in that industry, held the strongest positions in the recording industry as well. The repertoire would change over the years from hit singles of, as Lieberson put it,[17] *Humoresque* by Dvořák, Paderewski's *Minuet in G*, and "O Sole Mio" to such recordings as Columbia eventually made of the complete symphonies of Gustav Mahler. And again the new developments were to render obsolete the equipment on which the old recordings had been played at a speed of 78 rpm.

In 1947, Lieberson contracted for an album, *I Can Hear It Now*, produced by Edward R. Murrow and Fred Friendly, which became one of the first long-playing records. "There had never been such a successful talk album," Fred Friendly wrote later, in *Due to Circumstances Beyond Our Control*, "but in 1947 Goddard Lieberson . . . faced with one of Jimmy Petrillo's perennial musicians' strikes . . . wanted material to keep the idle recording facilities busy."[18] *I Can Hear It Now* turned out to be a bestseller.

Columbia, in 1948, introduced what it called the "LP," a long-playing microgroove record which could play for about half an hour on one side and was considerably improved in dynamic range and high-fidelity frequency response, having less needle scratch or background noise. Dr. Stanton was to point out that price became another of its advantages: "The conventional 6-record album of 12-inch vinylite discs sold for $13.85

or $8.50 on shellac. The same music on a single 12-inch vinylite 'LP' recording retailed at $4.85."[19]

The outcome appeared clinched in the summer of 1949 when the National Association of Music Dealers opted for the LP at 33⅓ rpm and three of the four principal independents (Decca, London, and Mercury) adopted it.[20] By 1954, according to Stanton, more than two hundred companies were manufacturing records of the type introduced by Columbia Records.

Lieberson wrote:

> By the time LP records came along . . . we were ready to transfer to this new technique not only most of the standard symphonic repertoire, but a great number of records of contemporary compositions, particularly those in which the composer-as-performer was involved. This meant Bartók, Stravinsky, Poulenc, Copland, Piston, Schoenberg, Villa-Lobos. There was also a growing number of recordings made by the great American orchestras of heretofore unrecorded contemporary works, in cluding, in 1947, excerpts from *Wozzeck*. . . . It is boring to repeat once again how many recorded versions there are of all of the Beethoven symphonies, all of the Brahms symphonies, and those of Tchaikovsky— and those recordings still go on. But it was nevertheless true that despite the need for new repertoire, we were motivated by a pioneering spirit at Columbia when we were recording contemporary music. In most cases, we have had to wait until the 1960's for some of it to reach a public of any worthwhile size.
>
> Indeed, some dates of these early recordings of modern music may be of interest. In 1949 we recorded the complete string quartets of Béla Bartók, and the year before that we had done two operas by a new, young composer named Gian Carlo Menotti—*The Medium* and *The Telephone*. Another young composer recorded in 1950 was Leonard Bernstein, who conducted his *The Age of Anxiety*. In the same year, we released Charles Ives's Violin Sonata No. 2; symphonic and chamber music by Roger Sessions, Messiaen, Poulenc, Honegger; Edith Sitwell reciting her own *Façade* to William Walton's music; and Alban Berg's *Lyric Suite*. . . .
>
> In 1951, we issued the complete *Wozzeck* of Berg; in 1952, Schoenberg's Violin Concerto and Berg's *Lulu*; in the late fifties, we brought out the complete works of Webern, the complete piano music of Schoenberg, *Moses und Aron* of Schoenberg, and works by Boulez and others who were working under the influence of that school; in 1963, Schoenberg's Fourth String Quartet and his *Survivor from Warsaw*. In addition to serial music, we also issued during the fifties works by Honegger (*Jeanne d'Arc au Bucher*), Stravinsky's *The Rake's Progress* (as part of a program to record the entire works of this composer), and works by Kirchner, Foss, Carter, Chavez, and more.[21]

Lieberson's backing of avant-garde recordings gave him a status with musicians that he could not otherwise achieve.

Columbia Records' part in the ten years after Lieberson became president is suggested by the following excerpts from a rundown in 1967 by the *Saturday Review*.[22]

1957: Schoenberg—"more than half of the composer's available works have already been released by Columbia Records."

1958: "The first stereo discs appear." ["RCA Victor was the first of the majors, with its initial stereo disc releases appearing in July 1958," wrote Oliver Read and Walter L. Welch in *From Tin Foil to Stereo*. ". . . Columbia had been delayed because of its attempt to produce a 'compatible' stereo disc" (perhaps trying to take advantage of their unfortunate experience with color television). "Now that it had decided to go along with the universally adopted system, it was assured its stereo Lp's would also be on the market by fall. In short, 200-plus stereo discs were available in the stores by September 1958—and after that, the deluge!" In 1958 the authors also wrote: "The cartridge sound quality is now good enough for most homes, and the ease of handling the tape cartridge marks a genuine step forward in creating a mass market for the prerecorded tape." A decade later, records still dominated the mass market, which perhaps indicated what the response to videotape was likely to be.]

1959: May 4th—ground-breaking ceremonies at Lincoln Center. "Glenn Gould's Berg-Schoenberg-Křenek program (Columbia) proves him 'an alert and sympathetic friend of contemporary music.'"

1960: Glenn Gould debuts as composer on Columbia label.

1961: Columbia releases an "exemplary" Mozart piano concerto. "Blomdahl's space opera *Aniara* is released by Columbia, and Hindemith's *News of the Day*. . . ." After three years of stereo, Columbia claims a 30%–50% share of disc market.

1962: was "an exceptional year for [Columbia Records]." It released 6 Stravinsky discs on his 80th birthday, also Mahler's *Third Symphony*, with Bernstein conducting "a superb brief"; Sviatoslav Richter's first New York recital; Vladimir Horowitz; 2-disc *Music of Alban Berg;* White House program with Pablo Casals, etc.

Lincoln Center opens.

1963: Columbia releases one of two new recordings of *Bluebeard's Castle* by Béla Bartók. It reissues 1903 "Grand Opera Series."

1964: growing interest in tape cartridges.

1965: Schippers conducts Rossini's *Stabat Mater* (Columbia). Columbia issues Stravinsky's *The Rake's Progress*; Mussorgsky, etc.; a Bernstein recording of Nielsen's *Third Symphony*.

"The New York Philharmonic institutes a series of free summer concerts which are attended by an audience of astounding size, 'an unprecedented, unbelievable, and remarkable sight—also unforgettable.' "

1966: Ives vocal music on Columbia label, plus Carl Ruggles and two John Cage recordings.

"Noah Greenberg, founder of the New York Pro Musica and champion of old music and long forgotten traditions, dies at 46."

Columbia releases a Gould Schoenberg.

"4,000 public libraries throughout the nation including recordings in their service."

Speaking of the use of tape, Aaron Copland said, "The art I practice is in the process of being dismantled, broken down into its component parts, and put together in ways we never dreamed of. . . . There is a sense of adventure in the new music. . . . Good luck to them."

Columbia had recorded little of the more traditional opera music, but CBS invested regularly in musicals for a while, this being a good way to acquire the rights to cast albums. *South Pacific*, issued in the spring of 1949, had been the first "really big" (Wallerstein) LP record. Investing in shows had begun with *My Fair Lady* (based on George Bernard Shaw's *Pygmalion*): CBS had been the sole financial backer of the Broadway production, and 6 million copies of the original-cast album subsequently were sold by the records division.[23]

In 1963 the sum spent for classical music records reached $76.4 million, according to a former associate editor of *Fortune*, adviser to the Rockefeller Brothers Fund study of the performing arts.[24] A Twentieth Century Fund study[25] commented on "the often quoted statistics alleging that classical record sales have been growing much faster than sales of popular records. It was found on investigation that the data are in fact unavailable; whatever figures the individual record companies may have on their own sales are a closely guarded secret. Nor is it even clear how one would define the borderline between 'popular' and 'classical' records. At least some of the published figures had apparently been obtained by lumping all long-playing records in the classical category so that all Beatle albums were presumably grouped along with Buxtehude!"

By 1967, general affluence in the United States had put considerable sums of money into the hands of teen-agers and they had become a lucrative market. One quarter of the industry's cash sales came from the sale

of singles to teen-agers and juke boxes. Eleven thousand titles a year were being released, of which 3,700 were albums. Album sales broke down as follows:

> 12 percent classical; 5 percent original-cast Broadway shows; 5 percent movie sound-tracks; 12 percent jazz; 17 percent folk or country music; 30 percent popular; and 10 percent "teen beat" recordings. The rest consists of Latin American, comedy, and miscellaneous recordings.[26]

By 1969, unmistakably, classical sales were down. James Lyons, editor of *The American Record Guide,* said the classical record business was "shot to hell," comprising only 3 percent of total sales. Orchestras, he said, had become albatrosses around the necks of record companies—and "Goddard [whom he knew] now pays very little attention to the record business."

Lieberson's stint with the record company had put him in the top rank of officials at CBS. He had been elected a director of the corporation in 1956; he became senior vice-president of CBS in 1971. Clive Davis, who had become president of Columbia Records in 1967 as Lieberson moved upstairs, signed Janis Joplin, Laura Nyro, and others to double Columbia's share of the record market to 22 percent in the following three years. Rock reputedly moved from 15 percent of the firm's volume to more than 50 percent.[27] Davis "developed" Santana; Chicago; Blood, Sweat and Tears; Sly and the Family Stone. "One kind of music absorbed everything else in the '60s," he said. "In a sense it was a revolution."[28]

On May 30, 1973, *The New York Times* reported that Lieberson's "protégé" had been ousted and was being sued by CBS for "illegally spending almost $94,000 in corporate funds." Within days, it became public knowledge that federal agents investigating drugs had visited Columbia Records and that Clive Davis had been called before a Newark grand jury investigating payola and organized crime.[29] William Safire called hard drugs "the new currency of the record industry" ("what killed singers Janis Joplin and Jimi Hendrix," Myra Friedman said)[30] and noted that the charge lodged against Davis was so trivial in context as to arouse suspicion about just what CBS was covering up.[31] The context was an industry in which, by then, record sales amounted to $2 billion a year. CBS was now reporting by division, and net sales in 1973 for the "Records Group" amounted to $362.5 million; net income was $25 million.

Lieberson was returned to the CBS Records Group as its president: contrary to Donovan's dictum, he could step down, but his was an unusual case. His interest in recording classical music was resumed.[32] He remained less interested in the pop field, although he liked to point out that in the early sixties he had signed Bob Dylan, Simon and Garfunkel, and the Byrds.[33] Later on in 1973 he replaced Clive Davis as chairman

of the board of directors of the Recording Industry Association of America. The president of that association, Stanley M. Gortikov, had earlier referred to "recording industry critics as buckpassers and crybabies who badmouthed and tarred the industry concerning drug use, drug lyrics and the entire drug-culture connection with some parts of popular music."[34] Lieberson, like Jovanovich, was not good at picking people, but he had considerable shrewdness about the purposes for which they could be used. He efficiently compartmentalized rather than synthesized and, as a result, transcended no worlds.

NATURAL VICES

(The adoption of roles)

THE POET Andrew Marvell sang of

> . . . that ocean where each kind
> Does straight its own resemblance find;
> Yet it creates, transcending these,
> Far other worlds, and other seas;
> Annihilating all that's made
> To a green thought in a green shade.[1]

Could, in fact, new worlds be created without becoming part of the radical opposition—by transcending those institutions that too much resemble us? Not so, said the more vociferous of America's young in the 1960's. Not so, said critic William Pechter: "the people who thrive in such circumstances [as those at *Life* magazine, for example] are precisely those who are in no fundamental conflict with the prevailing values, and all the better for their psychic well-being if they fancy themselves as boring from within."[2] Lieberson did not fancy himself as boring from within; he fancied himself as other.

Jean Bloch-Michel believed the blunt fact was that no writer was forced to work for the mass media. The Mallarmés of our time, he pointed out, write in their studios while the others, avid for contact with and influence over the public, subject themselves to the exigencies of, say, television.[3] Or journalism, one might add, accepting more direct contact

and influence as leading to more direct change, if indeed that was what they had in mind rather than the development of their own interests, as sometimes it seemed Turner Catledge did.

Art critic Harold Rosenberg thought that "within these limits [accepting self-alienation in trade for social place] the deploring of 'conformity' is simply an expression of self-pity. The strategy of fighting the organization through secret resistance behind the outer-shaped mask (William Whyte) is, by the measure of the ancient intellectual tradition of denunciation or self-exile, only a dreary professional's ruse for holding on to the best of both worlds."[4] Not one of these nine men was self-alienated.

Cries from the college campus suggested students wanted *no* world, so caught up were they in a state of disunity and traumatic change in our culture at large. John Gardner, a director of Time Inc. as well as (at that time) chairman of the Urban Coalition, in the 1969 Godkin Lectures at Harvard University suggested that "every human institution needs some version of the Ombudsman, some procedure for the hearing and redress of individual grievances against institutions." He saw an urgent need to redesign large-scale organizations, both public and private, in order to make them hospitable environments for the individual. Did he believe in this possibility for Time Inc., or did he believe such a state of affairs already existed there?

Hedley Donovan thinks that " 'organization' is not necessarily the enemy of individualism." One can understand why he might feel that way. Not only is that stance healthy for him, given his position, but also he needs good minds and creative talent in the organization he heads—and a lot of them. The Luce magazines are the combined product of correspondents, researchers, writers, rewriters, editors, and checkers: they suction up talent, to use Max Lerner's phrase.

An artist has a positive relationship with an organization through his finished work. Not infrequently he also has a negative relationship. Lowry speaks of the effect of, for instance, the university on the painter or sculptor. "This is a subject I hear about all the time in the running conversations we keep up with artists," he wrote.[5] Alvin Toffler, in *The Culture Consumers*, noted that "W. McNeil Lowry, a vice president of the Ford Foundation and for seven years director of its program in the humanities and the arts, has charged that universities have 'in the main' sacrificed professionalism and have 'drifted along with the society in the perpetuation of the amateur and the imitator.' Mr. Lowry, a man of considerable personal influence because of the largesse he is in a position to distribute for the Ford Foundation, may or may not have a point here. But one hesitates to agree with his advice to university deans that: *'Under*

present conditions the best service you can perform for the potential artist is to throw him out.' "[6] (My italics.) Lowry commented:

> A few enjoy teaching as a second vocation and believe their own creativity does not suffer from it. Some enjoy teaching while believing their own work *does* suffer. The great majority endure teaching as a means of livelihood, suffer the fact that there may be only two or three students a year in whom they glimpse any potentialities of talent, agonize over that portion of their own creative quotient which ends in the canvases of amateurs, and yearn for the unlikely year when some agency like the Ford Foundation may permit them simply to paint.[7]

And, when universities offer "what looks like technical training of a potential artist in a curriculum normally dedicated to general or liberal education," they encounter difficulties, Lowry said. "In all the vague and current talk about the arts . . . and with some new artistic happening catching the vogue almost every day, it appears to be thought that art or even craft is completely relative and one performance as good as another provided it has either serious auspices or some peculiar insult of its own. . . . But when one is dealing with the training of a potential artist or artistic director, however young, the acceptance of merely amateur or superficial standards of the craft will ultimately appear fraudulent if even long after the student's departure from the academy."[8] Lowry thought the best thing a university could do for the artist might be to integrate him in the chronology of his art, which was an intellectual matter. Harold Rosenberg pointed out that "a good teacher will present all relevant points of view, but in painting and sculpture the first-rate artist is the least likely to do this."[9]

"As the universities increased their offerings in studio practice," Lowry wrote, "the professional teacher was joined by the professional artist, first as an 'artist in residence' and then as a regular member of the faculty. The principal economic base of the contemporary American painter and sculptor today, even among the top rank, is university and college teaching."[10] This was a process that had been paralleled in music, the drama, and creative writing.

But Eric Larrabee noted:

> It is rare in the arts to find a university department with a balanced threefold capability; the best of them gladly settle for two, and a depressingly large number must be content with one alone. Rarer still are the men who accept more than one of the three missions as their own responsibility. The artist-teacher, or the teacher-scholar, is sufficiently unusual to be high in demand, the darling of administrators hungry for talent. The artist-teacher-scholar is nonexistent. What one means by saying that a certain type does not exist is that living people

who exemplify it do not come forward. . . . But if one begins with a societal demand, with a felt and explicit need for which no other answer exists, then the obligation on universities to restructure and fortify their commitment to the arts will emerge forthwith.[11]

Just how a university might restructure and fortify its commitment to the arts was suggested by Lowry: "To face the necessary distortion of the primary objective of a university, to reflect that distortion in a highly concentrated curriculum, to open that curriculum only to the students with the most fanatical drives, to give to the artist-professor responsibility for testing both the drives and the talents—these motives and procedures may go part way toward producing a professional atmosphere. That is as strong as I can put it confidently."[12]

One psychologist who studied artist-painters by means of Rorschach tests found them not very adaptable, having an obvious disregard for everyday routine problems and "a certain fear of mediocrity."[13] Stubbornness—what Lowry calls "distortion as a way of life"—imposes on others and fits not at all well even into an institution in the business of fostering independent minds. Or other organizations either. John Galsworthy, in *The Forsyte Saga*, gave an excellent description of how artists or individualists subtly make social groups uncomfortable when he describes the reactions of the Forsyte clan, property owners, to the architect Bosinney.[14] The reverse is also true: managers make artists uncomfortable.

Robert Brustein, dean of the Yale School of Drama, read a letter from McNeil Lowry:

"Thank you for your letter of January 24th to which we'll give serious consideration. I am not sure that your plans are sufficiently developed for the program for this year and are sufficiently revealing in what the repertory company will be like for us to make a definite decision at a very early date."

And another, dated February 22:

"We are also anxious to be quite scrupulous on the other matter you and I discussed in my office—namely, to prevent any action by the Ford Foundation becoming influential in the future plans of the Long Wharf Theater."

"That, by the way, I forgot to tell you," Brustein said to me. "The Long Wharf looked like it was about to fold [this was 1965–66], and they felt if they made a grant to us, they would seem to be helping it to fold. Rockefeller was also very chary of this and didn't want to make us a grant as long as it would affect the future of the Long Wharf. So if the Long Wharf Theater got on its feet or folded, then they could discuss the grant with us, which they are now doing." Why did they feel they

couldn't fund both theaters at the same time? "I don't think they wanted to fund the Long Wharf."

Lowry had written:

> These plans appear to be hanging in balance. I hope I made it plain to you that in the pursuit of our objectives concerning strengthening the concept of the professional resident theater company, we have preferred to act only when the company's operations and the standards it maintains on the stage clearly existed and could be scrutinized. This policy has precluded specific consideration of assistance to many existing companies, including the Long Wharf.

Brustein thought Lowry contradicted himself by the two uses of "exist" in the above extract. In the rest of the letter, Lowry requested a consolidated budget of the whole company operation and a firm commitment from the Yale Corporation that it would assume costs after a definite period.

Brustein said:

> I have a very aristocratic notion of theater, and that is that the best theater comes out of at first a limited audience with limited support and only catches on after a number of years. This has been true of every great artist in every period. You've not been immediately successful. It's shocking, for example, that the Ford Foundation never supported the Living Theater, which was the most seminal theater we ever had in this country, I should think. Naturally it was unpopular: it was dangerous; it was connected with political causes that the Ford Foundation wouldn't want to have its name identified with. Well, you know, that's exactly what I mean. They've got to understand that supporting a theater doesn't mean supporting its political policies or even its artistic policies. All you're supporting is the drive and, you know, the capacity for creating a revolution, I think, in art. And they're not sufficiently interested in that sort of thing. They're do-gooders rather than revolutionaries, and we're in a revolutionary situation. I mean, nothing is going to change here unless it's revolutionized. The gradualistic approach has not worked in art.

The gradualist approach, the attempt to transcend pre-existing institutions or "schools" of art, may in fact dead-end artists.

Actually, the Ford Foundation *has* subsidized revolutionary, anarchist, obscene, nude, and other theater, and Lowry insists that no choice of repertoire has been taken away from artistic directors. Here as elsewhere the relationship between the artist and the organization seems to work best when the output of one is simply used or fostered by the other and the two do not work together directly.[15] How does that apply

to the other organizations described in this book? Authors do not do their work as such in publishing houses, and their relations with publishers are renewable rather than continuous. Universities are in a transitional state, but whatever direction their alliances take, their goals will remain differentiated from those of the artist, although they use him and his work in many forms. Journalists can be creative but are not Fine Artists. This is as true at *The New York Times* and Time Inc. as it is elsewhere. Artists produce material which can be used as news. A magazine complex such as Time Inc. is in a perilous position because it needs to incorporate talent that most closely resembles that of the artist. Television, however, is in the most difficult position because this is true there also but what happens is more closely scrutinized as to the public interest. (This is an argument for broadcasters getting out of the production business.) Congress involves itself, or should involve itself, totally with non-artistic problems, with legislation to serve the arts as another special-interest group. Record companies are show business, using artists. Museums are a special case.

In 1969, *Time* magazine's rival, *Newsweek,* reported[16] unsympathetically the firing of Bates Lowry (no relation to McNeil Lowry) from his position as director of the Museum of Modern Art (MOMA) with these words: "Lowry chose to explain his departure privately as the result of frustration—having to spend too much time running things and too little dealing directly with art. However, he was hired primarily for his proven administrative skills, and proceeded to try to run everything in sight. . . . Staff friction, however, was not basically what laid Lowry low. It was his arrogance toward MOMA's powers that be. . . . Like his counterpart in academe, the museum director should be a scholar, administrator, money raiser, a diplomat keenly aware of the demands of politesse and power." The magazine seemed more concerned to take Lowry to task for his relationships with the board of trustees (including William Paley) than for his expertise, which by implication was irrelevant. Lowry had been at MOMA for only one year, having resigned the chairmanship of Brown University's Art Department in order to take the position, presumably having previously been his own "counterpart in academe."

Eero Saarinen, when he commented that great architecture was always informed by one man's thinking, was careful to add that "architecture involves many people. It is true that it all has to be siphoned through one mind, but there is always teamwork."[17] This is not true of architecture alone, of course, but ramifications vary from area to area of the arts. Some—notably, the performing arts—require more teamwork than others. And we have seen Frank Stanton's participation. But a new profession called "arts management," a term that can make the blood run cold, came

along approximately in the sixties. Lowry in 1974 noted "so many kinds of technical assistance efforts going on that [they account] for more than seventy-five percent of our time." This was an accretion rather than a change, he said.

MOMA trustees settled their management problem by choosing a man who had been executive director of the New York State Council on the Arts and gotten along with everybody. Acclaimed "an able administrator," John Hightower was quoted in *Newsweek*[18] as having said, "Art is the process of living." Unlike his predecessor, Hightower had no back-

C.B.S. SEVERS TIES WITH LEGAL FIRM

43-Year Association of Colin and Paley Is Ended

A 43-year relationship has been severed between the Columbia Broadcasting System and its legal counsel, Rosenman, Colin, Kaye, Petschek, Freund & Emil. The firm, whose senior partner, Ralph F. Colin, had been associated with the network since 1927, was dismissed last month, and Mr. Colin resigned from the C.B.S. board of directors on Feb. 9.

Yesterday Mr. Colin and Dr. Frank Stanton, C.B.S. president, both declined to comment on the reason for the firm's dismissal. But it is known that the lawyer, until recently a vice president of the Museum of Modern Art and a member of the executive committee of the museum's board of trustees, had opposed the dismissal last spring of Bates Lowry, director of the museum for less than a year.

At a museum board meeting held on May 15, shortly after Mr. Lowry's ouster, Mr. Colin deplored Mr. Paley's dismissal of Mr. Lowry without his consulting the entire board of trustees. He stated privately to several fellow board members that he would resign from the board but would withhold his resignation until the end of the year so that it would not seem connected with the Lowry matter. He attended no board meetings, however, after May 15.

On May 16, Mr. Colin was summoned to Mr. Paley's office and dismissed without explanation as his personal attorney, a capacity in which he had served the C.B.S. chairman since his arrival at the network in 1928, a year after it was founded.

Last December, Mr. Colin wrote a letter of resignation to David Rockefeller, chairman of the museum, stating that "in view of recent happenings" he felt he could no longer be a "useful or effective" member of the museum board. On Jan. 26, while Mr. Paley was vacationing in the Bahamas, Mr. Colin was called to Dr. Stanton's office and informed that his firm's relationship with C.B.S. was to be terminated forthwith.

"The only reason given for this Mr. Colin wrote in his letter of resignation to the C.B.S.

board of directors, "was that the change would be 'desirable in the long run.' We have been told of no reason why this change had suddenly become desirable."

Mr. Colin, a noted art collector and administrative vice president of the Art Dealers Association, had attempted to resign from the museum board two years ago on the grounds that he and other trustees had not been consulted over Mr. Lowry's hiring. But he was persuaded to remain on the board at that time by Mr. Rockefeller.

Asked why the company had parted with Mr. Colin's legal services, Dr. Stanton said yesterday that he had "no comment" on the matter. But he denied speculation in The Wall Street Journal that linked the dismissal with advice given the network by Mr. Colin to comply with Government subpoenas for filmed interviews and reports concerning the Black Panthers.

"Mr. Colin was not to my knowledge consulted at any time about the subpoenas," he said. C.B.S. has elected Roswell L. Gilpatric, a senior partner of the firm of Cravath, Swain & Moore and former Deputy Secretary of Defense, to replace Mr. Colin on its board of directors.

THE NEW YORK TIMES, FEBRUARY 21, 1970.
© 1970 BY THE NEW YORK TIMES COMPANY.
REPRINTED BY PERMISSION.

Sidelight on the firing of Bates Lowry: a good example of what power can do and how disfavor is likely to come about through disagreement.

ground in art history. He described himself as "not a scholar." It seems appropriate that on the opposite page of that same issue, *Newsweek* reported sculptor Robert Morris, about to have his third retrospective at the Whitney Museum, as saying, "One mustn't think in terms of preconceived ideas like composition and the relationship of the parts." In just a few years, John Hightower was himself replaced.

The dissemination of art requires patrons and brokers. Yet elitists are trapped in a paradox: they despair of the improvement of the level of common taste (although some of this voiced despair appears an attempt to maintain their own sense of superiority) and yet they believe, along with Lowry (not himself an elitist), that vulgarity in the arts is helped along not only by the mass media but by "the proliferation of councils, commissions, festivals, committees, and community development programs which suggest that art is merely a label, merely a commodity, and that one man's or one group's imitation of it is as good as another's." Lowry abhorred the phrase "culture managers" to describe museum directors, foundation people, magazine editors, and the like.

The poet Randall Jarrell believed that those who might be labeled culture managers corrupt the artist, presumably by virtue of the contradiction inherent in their situation, and stated that belief in almost the same terms in which so many young people seemed to regard what society as a whole wanted from them in the 1960's. Jarrell's concern was with the man who ought to be a Fine Artist, and of him he said:

> Instead of stubbornly or helplessly sticking to what he sees and feels, to what seems right for him, true to reality, regardless of what the others think and want, he gives the others what they think and want, regardless of what he himself sees and feels.[19]

What I saw, while working in an office, as the most effective managerial style seemed to me more useful in a wider range of circumstances and also as more reassuring—that is, easier to cope with—than the mode of an artist. But I was beginning to discover that artists were no more threateningly illogical than most people, and that at least I understood and sympathized with what they were trying to do. Back during the period when I'd been trying to learn to work in an organization, I had been trying to develop useful behavior in that context but couldn't understand what the other people there saw as useful.

At a P.E.N. conference on "the writer as collaborator in other men's purposes," Melvin Lasky[20] noted that the writer did not create the style all by himself. If Truman Capote wrote non-fiction reportage, Lasky said, and not a novel, it was because "he was listening to his publisher"— but not, Lasky added, in a commercial or vulgar sense: Capote had also

listened to the *Zeitgeist,* or spirit of the times. In the "Proceedings,"[21] William Jovanovich is recorded as "retorting" that Capote "wasn't under any pressure," to which Lasky replied that Capote, like every writer, was "collaborating with other institutional purposes."

To Harold Rosenberg, the contention that this nation is, or might be, subordinated to such a master was "at least as ludicrous as it [was] alarming," even though "Orgmen reproduce themselves like fruit flies in whatever is organized, whether it be a political party or a museum of advanced art." There was groundwork for the conquest of America by this "type," he thought; but even though there was an increasing concentration of control and standardization of work, "for the individual, the last voice in the issue of being or not being himself is still his own."[22]

To work in an organization, Hedley Donovan said,

I think you have to have the emotional stability—temperament, you can have a certain amount if it seems to be closely associated with some aspect of your creativity. But if it seems merely eccentric or capricious or, I think, totally selfish or self-centered, then I think it's not compatible with operating executive jobs, at least. It may be okay for individual writers or photographers or artists.

Harry Scherman, when president of the Book-of-the-Month Club, said of his organization, "There is nobody here who is stubborn, and never has been," and went on to say that such a person causes trouble.[23] Stubbornness was not a desirable, valuable quality in his eyes. Fortunately for him, his business required no artists—only their products. Henry Luce had to say, "We require many people who are more or less temperamental." But being temperamental could not turn what his writers wrote into art.[24] Lloyd Goodrich, running an organization different in kind from either the Book-of-the-Month Club, Time, or the university, said, "When you've got a really original mind producing something, I don't mind his limitations as long as the central urge is solid." But he was not referring to the staff of the Whitney Museum. The matter was one of priorities, but of course these differed, too, from one cultural organization to another.

Lowry, for instance, said in a speech to the Missouri Arts Council: "Your first priority can't be ours . . . and our first priority will never be yours, which is to direct, focusing on the individual artist, an outlet for his career." And Lowry elaborated for me:

Then I pointed out where we collaborated in Missouri and how I meant that difference in objectives. We support the St. Louis Symphony, the Kansas City Philharmonic, the Kansas City Lyric Theater. We extended Young Audiences into the Midwest. We have art exhibits there. We

bought from an eight-state show that ran in Kansas City for three years. Okay, they sent the Kansas City Lyric, the Philharmonic, the St. Louis Symphony, and Young Audiences around the state. So why aren't we the same? We're not. We don't send them. They do. That's for them. But that there is an orchestra in St. Louis of professional standard that can make careers for professional instrumentalists—that's not their problem. That's our problem.

I did tell them that they did have one other thing to do which we couldn't do anything about and maybe they couldn't either, certainly not in their lifetime. That was changing the moral climate in their own communities. . . . I was not talking in abstract terms. I was talking about one illustration, among several, of one of my best friends who died many years ago—he was no older than I was—in a little town where I grew up.

From about eight o'clock in the morning until about two o'clock at night, he drew or painted every day that he could, all the way from the time that he was eleven till his death at about thirty. . . . He never did know whether he had it. I don't think that he quite did, but he would have known, he would have gone on to something more for himself if he hadn't begun to develop the mystique that he was unappreciated, not understood, alienated in his own community. So he started, you know, playing a role. It's all role playing. He started to drink heavily, take off his clothes sometimes, even experiment with drugs. I say "even" because this was thirty years ago when it wasn't common. . . . I knew such people when I grew up in my community, and some of them even died earlier than their longevity because of a total lack of nutrition that was as much emotional and intellectual as it was physical.

Were Goodrich and Lieberson starved and corrupted by our society? Were Jovanovich and Lowry, both of whom might have become writers?

Lowry was born in Columbus, Kansas, on February 17, 1913.

. . . both my father and mother were schoolteachers, little country school, and my mother taught for seven years before she was married, my father for only about three years before he went into business for his great-uncle. . . . My father had gone for two years to the University of Missouri, prior to the turn of the century, which was unusual in that little town where he was. And my mother had made herself a schoolteacher by normal-school courses in the summer after just ordinary school graduation, the equivalent of high school. . . .

My brother came first, and he could read very early, before he went to school. This must have been my mother. And they didn't keep him in kindergarten because he was too much trouble, he already knew

his book, and other books, you know. So they didn't put me in kinder-
garten following his experience, and I could already read, so when I
was five I went in the first grade instead. . . .

I think I was about three [when] my father came home with
twenty-four volumes of Mark Twain, and my mother said, "My God!"
you know, "What's this for?" And he said, "Well, the children have
got to read Mark Twain." "Well," she said, "they're not reading Mark
Twain yet. McNeil is only three and Marjorie"—she was, I guess, one,
and Bob was five, and Dad said, "Well, they're gonna." And we did.

Lowry's father had gotten the books from a "drummer"—a traveling
salesman who came through Columbus selling books. ". . . in our little
town what we had was books," Lowry said, "in our house, and books in
a library. We didn't have drama, except in the high school; we didn't
have music, except in the high school and on records; we didn't have
painting except in reproduction. You had to go three hundred miles to
a museum or a theater. . . . The importance—the *key* to the past and to
the world was the books first." Both parents read aloud to their children.
And, Lowry said, "I can't remember when I couldn't read. It was a pas-
sion—it was not compensation for anything." He continued:

> It seems fantastic but my normal consumption of books was about
> three to five a day, so I remember hundreds and hundreds of books.
> Starting when I went to school, I read every book that I was capable
> of reading, that I could find, and I remember that when I was twelve
> I had read many of the plays of Shakespeare but my aunt on that
> Christmas gave me a complete volume of Shakespeare which of course
> we had in the library but I didn't have at home. I had many of them
> but not the whole thirty-seven. And I read them all then that I hadn't
> read before. . . . I remember a lot of the children's books—the Oz
> books, the Burgess books, things that were quite national in circulation
> when I was a boy—I remember those—but those were only a fraction.

He guessed that his father had perhaps five hundred books in the house.

> But, you see, there was a Carnegie library, and there was a school li-
> brary, and I would go to the library and come back with an armload
> of books. And I had read most everything in that local library before
> I got out of high school. . . . One of the things that helped my educa-
> tion was the very poor health that I enjoyed as a kid. I was frequently
> afflicted with respiratory difficulties, leading in many, many cases to
> pneumonia, and in those days when you had pneumonia there was
> nothing to do but put you to bed, you know. I was among the first
> to take sulfa later and then the antibiotics. But back then there weren't
> any, and I was in bed a lot, sometimes as much as three months of
> the year, and there was nothing I could do to entertain myself except to
> read, and I read about five books a day.

Lowry said he had been a small child by comparison with his class-mates, because he had been younger than most in the same grades, and "organized sports were not for me." He had, however, done a great deal of playing out of doors, he said, some of which was "acting out things that we had read, like the Dumas novels and the Dickens novels, and the Scott novels."

When he was eight, the family moved to Oklahoma City, staying for four years. "Then the widow of my great-uncle Wright decided to sell *the* store, which was the biggest store in Columbus and had been since, I don't know, I guess about the late 1870's—a fabulous store—which she'd allowed to run down. He'd been long dead. She asked my father if he wanted to buy it. My father bought it, and we moved back to Columbus. . . .

"There were the main lines of two railroads that crossed at Columbus in those days," Lowry said. "They don't even have passenger cars on them any more. And I'd hear those trains at night and think about the fact that those rails ran off to the big world. It's exactly the kind of childhood that Mark Twain had, exactly the kind of childhood that Tom Wolfe had back in North Carolina, and he wrote about those train sounds and so on. . . ."

It was indigenous, midwestern America, Lowry said, "politically, socially, economically"—and largely Republican. But Lowry's father and grandfather had been "Bryan and Wilson types of Democrats. And this rhetoric of Bryan and the Populist reformers of that period[25] rang in my ears all through my entire childhood, from my father, from things that he read that I read and so on." He recalled:

> My father, all his life, read the Kansas City *Star and Times*, which came down a hundred and ten miles. He frequently read *The New York Times* on Sunday. My great-aunt, who lived in the same town, subscribed all her life to the New York *Herald* and then to the New York *Herald Tribune*. Republican gospel. We frequently had the St. Louis *Post-Dispatch*, we had *The Saturday Evening Post* and *Collier's* and stuff like that.

Politics had been his father's avocation.

> He read everything. He cursed out everybody. He engaged in political controversy all the time with his family and when we would talk politics, the house set way back from the road but people outside going down the street would think we were fighting. My mother's father, naturally being a GOP Civil War veteran, waved the bloody shirt and all that stuff. You know what they said about the Democrats. My father and mother separately were trying, naturally, to influence the

children and two of them, my sister and I, became Democrats and my brother finally became a Republican. But it was always hot and heavy, and we were always very much interested in hearing from my father, and we talked politics—you know, for fun—all the time.

Lowry said his father would "talk to his wife in the same kind of rhetoric that old man Gant uses in Tom Wolfe's *Look Homeward, Angel,* and the same kind of rhetoric of people in Twain's *The Gilded Age, The American Claimant,* or *Life on the Mississippi.* This *was* the style. This was the way people thought in the Midwest, in this style. All this Fourth of July oratory and so on came right out of their roots. It was a declamatory, semi-melancholy, very much put-upon kind of style. . . .

"And the fact is," Lowry said, "that I was born exactly eighty miles from the then geographical center of the United States and was very conscious of the midwestern pioneer, and of education as a way up and

*McNeil Lowry as a boy with his family (he is on the right). "Out"
was always there.*

out—which it had been for my father and was bound to be for his children. And the implication of 'out' was always there. That is, you became educated and you had ambition to follow some profession or interest, then you became a person mobile in the whole society."

Lowry said his family had made him feel part of an elite, morally and intellectually: that they'd sometimes said to him, "Well, that's all right for X to do but not for you," when talking about something a playmate had done. "They made me feel," Lowry said, "all the time, that if I didn't do it, I would let them down." And "it had been absolutely taken for granted from the day we were born that we would all go to college."

I graduated from high school in the same town where I was born, in 1929. I was just past sixteen. This high school was a county and community high school, so it had about five hundred students in it, and my graduating class had about eighty, even in a small town.

It had been an exceptional school, Lowry said, "all owing to one woman principal and the kind of people she put into it, all the discipline she exacted and the terrible assignments that she had handed out. Ethel Lock. . . . I've been in correspondence with her every Christmas since."

The English teacher had been a woman named Carrie Clayton. "I'll always remember," Lowry said. ". . . the greatest single teaching influence on me in high school. And this was natural because I knew that I was going on to college to major in English literature, I knew that when I was very young. . . . Starting when I was about twelve years old, I knew that I wanted to be both a writer and a professor, but primarily a writer. . . ." And "I knew when I started to college that I was going to get a Ph.D. It—but you see—it was sucking up books the way a monkey sucks up an orange in a cage."

The stock-market crash of 1929 was preceded by two successive wheat failures in Kansas, and my father's business was far too overpriced for what happened in that time, during the Depression. He was carrying very expensive suits and coats for women. . . . My brother was already in college, and on two grounds my parents argued against my going to school immediately upon graduation. One was that I was still too young. At sixteen. The other was they couldn't afford my going without some hardship to me or them. And they suggested that I lay off a year between high school and college and work for my father in the office, for his business.

Well, the sound of the Depression preceded the stock-market crash in the Midwest, and I got the idea while I was a junior in high school that to the ordinary college preparatory course, which was what I was taking, I should add two years of typing, two years of shorthand, and two years of bookkeeping, just as insurance, in case I had to do some-

thing for myself while I was going to college. And it came in very handy. [Lowry sort of laughed.] That's what I used that year working for my father, in his office. And then when I—at the end of the year—persisted and went off to the University of Illinois, I got a job immediately as a stenographer in the office of the Dean of Men. And I worked there every hour I wasn't in class, including four hours on Saturday morning, all the way through college. [That just about covered his college expenses, he said] except for some extraordinary medical expenses, which I continued to have, which my father covered, and except for my clothing, which he supplied. . . . I also went into debt at the same time. I lived pretty well.

When I got to the university, much to my surprise I found out that the freshman and sophomore introductory courses, except in one or two subjects I had never touched, like psychology and geology and things like that—it was already what I'd been having in high school. The standards for undergraduates just to get by, or even to make A's, at the University of Illinois between 1930 and 1934, weren't very high. I hope they're higher now—I think they are. However, the high school preparation is generally better, too. You see, when I got there I was marked out for an easy time, because a lot of kids had come from terrible high schools and still do, in some parts of Illinois—the university was drawing from the nation but mostly from Illinois. It wasn't such a compliment to me that I didn't have to work to make A's, though when I got to be a junior I began to take some very special courses like Chaucer and worked with a particular professor in literary criticism and so forth. I did a lot of work to prepare for his exams, write the papers, and so on. Only I never did any cerebration while I was in college until then. But I could do it and carry my outside job—and spend a lot of time with my friends—without any real sacrifice. I don't consider that I missed out on a great deal. I probably missed out on some social experience that I could have enjoyed.

. . . I became personally a friend of many of the faculty. This was not customary when I went to college, and at a big university like that some of the students thought they wouldn't be caught *dead* socializing with the professors—or that you were trying to swat up for a good grade, which wasn't true in this case, and I had a certain reputation, therefore, among the departmental members of the English faculty—before I was eligible as a junior to take a course I wanted to take from Professor Zeitlin in modern American criticism.

And—I was walking down the campus in fall of that year with Harold Hillebrand, who was a great personal influence on me, chairman of the department, interested in the drama—he's the man that I worked out this original playwriting interest for and won those playwriting prizes. We met Professor Zeitlin, who had a long bushy beard and beautiful eyes, and horribly red, red lips and looked like—if Jesus

Christ had been a brunette—he's usually rationalized as a blond—
he looked like that. But with flashing eyes and a terrific, biting mind.
And Hillebrand said, "I want to introduce you to Mr. Lowry, he's go-
ing to take your course"—you know, as if "lucky you." And Zeitlin said,
"Very pleased, very pleased"—he was always rather ill at ease, he
looked around, didn't even look me in the face.

We started off the course—he lectured the first hour meeting and
half of the next time. We had been reading Brownell's *American Prose
Masters*, and in the middle of the second meeting of the class, he
stopped and asked three questions without a pause and then said, "Mr.
Lowry?" I answered each of the three without a pause, and he said,
"No, no." And I thought, well now, my God, you know, those answers
are right in substance, and what kind of new deal is this? But he went
on to rephrase my answers and I realized what was going on. He was
qualifying each of those answers as if it were a balanced, absolutely
qualified, absolutely proportionately weighted pro-con statement. He
was turning them into categorical, balanced, exactly qualified judg-
ments. I learned it then, in that hour, and I never forgot it. . . . Zeitlin
had a rigorous critical mind. And I have a rigorous, critical mind, an

*Mac and Elsa Lowry in 1937, one
year after their marriage.*

analytical mind, and I suppose that the genes, the tendency must have been there, but I first was conscious of the difference between a mind, an absorptive mind and a critical and analytical mind, through Zeitlin . . . a Columbia Ph.D., who was translator of Montaigne—three volumes published by Alfred A. Knopf—and did the first translation of Montaigne that used each one of the four manuscripts and not only the Bordeaux manuscript of Montaigne's essays. . . . I took *many* courses from him—not only as an undergraduate but all the way through the graduate school, and I never had that problem with him again.

Lowry did not go directly on to graduate school:

You see, when I came to New York when I was twenty-one to be a playwright . . . I also had to earn my living during the day—I was an editorial assistant on a magazine called *The Social Studies,* which in those days was published out of Columbia University. I was writing a play and had an act and a half finished before I met this young woman and after that I was busy going out with her whenever I had an opportunity. That went on for months and months until we decided to get married. She would have moved into my place in New York and worked or let me take odd jobs and I could have been a writer. That would have been okay with her. It wasn't okay with me. I said I can do both. I'll go back and teach at the university and get a Ph.D. *and* be a writer, which I didn't manage to do.

JOVANOVICH, WHEN YOUNG, more easily abandoned the idea of becoming an artist, perhaps because it had never really taken hold in his mind, although he did start a novel while in the Navy during World War II. It was thrown away several years later, during a period in which he seems to have been casting about. At first, after being discharged in 1946, he had some idea of going back to graduate school—he had used only half of his two-year Harvard fellowship.

I went back to Mobile to collect my wife and child, and decided, as the second term of graduate school had started anyway, I couldn't enroll anywhere, that I might as well stay there. I went to work in a radio station. It's the first job I ever had. I wrote news for a Mobile radio station and went also to Spring Hill College, which is a Catholic college, to study German and Latin, assuming that if I did go back to graduate school, I would need to finish my language requirements. . . . By summer, I'd had enough of Mobile, and I'd had enough of the radio station, I'd had enough of the language courses, and my wife and child went off to Denver to live with my younger sister, and I came to New York. I stayed at the YMCA at first. I finally got a cheap room down on Twenty-third Street and went to work part-time for a small publishing house [Heck-

Cattell] Howard Mumford Jones had told me about and to whose pro-
prietors Howard had introduced me. . . . I'd written him several times
during the war. I'd written an article during the war about the Balkans,
which he helped me submit to the *New Republic*. It was a rather
lengthy piece, speculating on the possibilities of a South Slav union
following the war. It was too long and, I suppose, in some ways, too
naïve for publication. But I got in touch with him after the war and said
I was coming to New York and I'd be interested in getting any editorial
job I could get and what would he suggest. He had some relation with
Heck-Cattell at the time. . . . They hired me as a copy editor, but it was
a part-time, scratchy existence. . . . I enrolled in Columbia, where I had
GI privileges, of course, and that fall began work at the university. I
still had no clear notion that I wanted to get a doctorate or what—but
certainly I *did* have a clear notion that I didn't want to teach. . . .

My wife finally joined me in the late fall of 1946—this was after the
summer I'd come to New York—and we got an apartment up on Jackson
Avenue in the Bronx. It was a house that had been built fifty years pre-
viously by a Danish Jutlander couple. . . . They had lived in this house
all that time during the period it became a Jewish neighborhood, which
was following World War I, and then a Negro neighborhood. It was the
only "white" house in the block. . . . I'd go to Columbia during the day,
work in the library in the afternoon, come home and copy-edit until two
or three in the morning, and get up early in order to prepare—I was
taking some language courses as well as seminars in American literature
—prepare for my courses that next day, so I was sleeping about three or
four hours a night. But I couldn't earn enough to keep going. And that
fall, I had gotten in touch with Harcourt, Brace—*again* through Howard
Mumford Jones—and they'd offered me a job selling.

Jovanovich's relations with Howard Mumford Jones soured in later
years when Harcourt contracted for a textbook that would compete with
the one they had already published by Jones (a story the outlines of which
suggest again the differing points of view between the writer and the busi-
ness corporation), but a glimpse of the early relationship between the two
men was revealed by Gordon Ray, who told of evenings in Cambridge,
Massachusetts, at the home of Professor and Mrs. Jones, to which "twelve
or fifteen people would be invited. They had their particular friends, like
the Fainsods and the Lamsons from M.I.T. and so on. I went to those only
occasionally because I was never in Cambridge for very long after the war.
I went almost immediately to the University of Illinois, but when I would
come back, I would often end up on an evening at 14 Francis Avenue and
occasionally Jovanovich would be there. . . . So I know him slightly in
that way, and I've seen him from time to time in New York as you do once
every two or three years. But I really know relatively little about him. He

was very close to Howard, and I think probably still is. Yes, he, I should think, must regard Howard as one of his principal mentors."

Returning to 1946: The person to whom Jovanovich had been recommended by Howard Mumford Jones was James Reid, then editor-in-chief of the college department at Harcourt, Brace. Jovanovich "came down to the office at 383 Madison Avenue for an interview," Reid said, and "I hadn't talked to him more than five minutes before I was trying to hire him."[26] Reid remembered that Jovanovich turned the job down because editors were then expected "to do some traveling and selling,"[27] but Jovanovich remembers the offer to have been solely for the position of salesman.

Jovanovich said:

When January 1947 came, finally I got down to the forty dollars and said to myself I had to do something. I called up Harcourt, Brace and said if that job was still open I'd take it. . . . It was rough traveling—oh my god!—I had then a territory such as now would be impossible at Harcourt, Brace. I traveled all of Canada from London, Ontario, to Vancouver; I traveled Washington, Oregon, northern California, Idaho, Utah, Michigan, Ohio, and Indiana. It was nine weeks on the road, calling on between twenty and thirty professors a day, writing reports late into the night. Then, when I'd get back, I'd call on the high schools on Long Island. . . .

When I came into that office, I immediately asked for any editorial chores that I could undertake during my so-called training period, which amounted to absolutely nothing. Within days, I was out on the road with a book bag, but I kept asking for editorial chores, and the spring of 1947 I got a first book in economics—a college introduction to economics. It was a manuscript by three authors that was 1,600 pages long, not too well written. It obviously needed to be cut and tightened, shaped; and so I started work on it between trips. But this was rather absurd when you stop to think of that enormous territory I had, and then traveling high schools in between college trips. That summer, after I'd been working six months, when the schools and colleges *couldn't* be called on, I was during the day given chores on sales reports and updating name lists— you see, a salesman has to keep track of all the names of the people he calls on to be sure that our mailing lists are accurate. Every night I would go back to the Bronx to my family and the economics manuscript. We only had one armchair, Martha and I, and I got me a plank, just a rough board, which I put across the armchair to work on. It was bloody hot that summer—you can imagine in the Bronx in an old brownstone— and I stripped down to my shorts and sat with this manuscript until the early hours of the morning, hacking away at this manuscript.

Those were sort of glorious days too, you know. I'd get a job—fifty dollars a week doesn't sound like very much, but it sounded like a great deal to me. I was young, Martha was young, and Stefan, who was two

years old then, was the most beautiful baby I think I've ever seen. I know every parent says that, but he was; he was glorious, with a round head, long curly hair, a mass of blond curls and a sort of Slavic round face. Martha used to dress him as Southern women are wont in little E-tawn suits, as she'd call them, but that summer he would have on the halter and sandals. The Third Avenue El was running then, and I'd come home in the afternoon, and Martha and Stefan would come down from the playground by Morris Junior High School, down to the 166th Street (I guess it was) exit of the Third Avenue El, and I remember getting off the open rear-end platforms on the El, and looking down I'd see that golden little boy waving up to me. I used to hoist him on my shoulder and carry him all the way up the hill. And then, as I say, I'd sit around in my shorts and hack at this manuscript till the early hours of the morning.

Somehow, somewhere, Jovanovich had acquired what Harrison Salisbury of *The New York Times* has called "rats in the stomach"[28]—ambition's gnawing pangs. The rats may have been only nibbling that first year because it was not easy to see what might lie ahead. But Jovanovich worked like a demon.

The next year I was selling both colleges and schools, but I began doing more and more editing, in between trips, at night, and very often I would edit on the road. These were, you know, difficult days. College traveling was then, and still is today, a tough occupation. You have to talk about books in a dozen disciplines, you run from building to building through the halls trying to snare professors for five or ten minutes, you miss lunch most days, you try to see thirty people a day, or at least I did in those days. You have to run back to the hotel room and start catching a bus—nowadays the salesmen drive their own cars—for the next town. Rarely did you stay at a college more than one day, you see, so you were traveling each night to get to the next place. Then you have to write lengthy reports on everything you said to everybody, what they said to you, and samples that were sent out, and very often at the end of such a day I would be editing a manuscript. I liked selling; I still like it. I think I was a good salesman. I met a lot of people who subsequently have become authors, and I've known in other connections. Gordon Ray, who is head of the Guggenheim Foundation, was teaching English literature at Illinois; I called on him then. Jack Hilgard at Stanford, the psychologist; Kroeber, the anthropologist, who was at Berkeley. On the whole, though, I was moving too fast and working too hard—we didn't have the luxury of discourse with these people that I hope our salesmen have today, because they don't have as big territories and are under no such pressure. We don't ask people to see that many people now. It was brutal.

At no point during this period does Jovanovich seem to have cast a backward glance at the idea of becoming a writer.

Theodore Roszak looks on the true artist as being incorruptible, and Henry Luce was quoted as saying, "All that I can see that I have done is interfere with the careers of several minor poets."[29] Jovanovich's need for money directed him only haphazardly and superficially. In the new situation in which he found himself, he could take advantage of the previous happenings in his life—and in such a case, success could have been predicted (although not the *extent* of success). Jovanovich could not afford to spend his time asking himself whether it paid to be alienated, nor indeed can any artist: we become what we continue to do, psychologists, philosophers, and others tell us.[30] And it is no longer intellectually respectable to find the issue of alienation, as connected with artists, interesting (although it continues to be popularly discussed in terms of industrial work). Sociologist Daniel Bell tells us that "tension is always present between the self and society."[31] Is the difference between artists and Galbraith's technocrats or other individuals in the *degree* of tension or in the way in which they choose (or are forced) to cope with that tension?

Erik Erikson pointed out two ways of solving identity crises: (1) by becoming neurotic or (2) ideological.[32] But for those with particular talents, Freud suggested another. Freud thought that the artist's connection with society was, simply, different. "If the individual who is displeased with reality is in possession of that artistic talent which is still a psychological riddle," he wrote, that individual "can transform his phantasies into artistic creations. So he escapes the fate of a neurosis, and wins back his connection by this roundabout way."[33]

Lloyd Goodrich said:

> I never did believe it did anybody any good to be neglected, or that an artist is improved by poverty, or by being an outcast. . . . [Ryder] was an example of one of those artists where, I'm sure, it didn't matter at all how the world treated him. With Eakins it did matter, I believe, and I think with most artists it does. There is a relationship to their society and their environment that is very fundamental even for the most introspective artist.

This relationship hinges on the disposition of others toward them.

Goodrich, who has been much involved with the identification of forgeries, told the story of Ralph Blakelock, who was "the most forged American artist, except Ryder. . . . The same problems except they are worse in Blakelock's case, his pictures had been forged earlier when he was still living and when he was in an insane asylum because he couldn't get enough money out of his work to keep his family, and yet when he was put away in an insane asylum they began to forge his pictures, which is a

rather ironic and horrible story in American art. In fact, his daughter's work—his daughter, Marilyn Blakelock—was a painter in her own right. She painted very much like him, and dealers would buy her pictures and forge Blakelock's signature on them. She ultimately went insane too. She helped to support the family by selling pictures, and when she found out what was happening, this was the thing that unhinged her."

Theodore Roszak thought the Museum of Modern Art had preserved its image at the expense of the artist's creativity, and that the Whitney, which hadn't been so concerned about its own image, had sacrificed it in support of the artist's creativity.[34] "We are," said Lloyd Goodrich as director of the Whitney,

> artistically democratic. In other words, not just saying there are a few top men and let's concentrate on them, but there's talent in all kinds of different forms and let's do something about it.

James Rorimer, former director of the Metropolitan Museum of Art,[35] on the other hand said, "I'd rather see a masterpiece by an artist already represented in the collection than a second-rate picture by a painter who isn't."[36]

Magazines like *Art News*, Mr. Goodrich commented, took the Whitney to task for being without standards: "Everything critics don't like they say . . . is inferior art which we shouldn't encourage." But, said Goodrich, "it's simply just a question of their own predispositions." Harold Rosenberg was leaving aside the question of standards when he wrote, ". . . deprived of the heroic concept of masterpieces, [art] tends to blend into the communications and entertainment media."[37] Although McNeil Lowry of the Ford Foundation considers Goodrich is "about" art in the thirties, Goodrich's acceptance of Pop and Op art, etc., containing as it does no criticism of Rosenberg's statement, is curiously modern.

In the early 1940's, elaborate plans were made for the Whitney to join forces with the Metropolitan Museum of Art, which at that time did not have a modern American collection; and architectural drawings actually were made for a building nearby in which to house the Whitney's collection. Lloyd Goodrich said:

> I remember once, Mrs. Force told me that she had taken Francis Taylor [at that time the director of the Metropolitan] around to the annual exhibit and showed him what we were recommending for purchase and said, "Well, what do you think your trustees will feel about these purchases?" He very characteristically said, "I think they will puke."

The Whitney's agreement to join the Met had been verbal rather than written, and it was discontinued after a luncheon for which Francis Taylor was host and during which "a remark was made that a lot of strange peo-

ple came to visit our shows—a lot of people in dungarees and so on. It was a very basic attack," Goodrich felt.

Theodore Roszak, whose works are owned by the Whitney and by MOMA and by many other museums, stated that his connection with the Ford Foundation (where he was the recipient of a grant and also acted as an adviser with regard to grants for others) hadn't affected his work "in the slightest"—just made the conditions under which it was done easier. The real artists, he said, would always remain on the periphery—"it's the lesser creative figures who function more directly in society."

A psychologist, Alice F. Angyal,[38] wrote of two "basic, instinctual drives." One she called the trend toward homonomy, which, she said,

> expresses the tendency of human beings to share and to participate in, to fit into and to conform with, super-individual categories such as the family, the social group, a meaningful world order, etc. Characteristic examples of the trend toward homonomy are social, religious, ethical and esthetic attitudes.

This takes place through a series of identifications which appear to have been most consistent in those of the nine men least likely to have become artists at some point in their careers. Frank Thompson, Harry Ransom, Turner Catledge, and Hedley Donovan all fit into this category. Two journalists, the head of a university, and a congressman.

Lowry, who left behind first playwriting and then journalism, was somewhat closer to what Angyal called "the trend toward autonomy" (these are not mutually exclusive drives). There, Angyal wrote,

> the person has a tendency to master the environment, and by conquest and achievement, to impose his intrinsic determination upon a widening realm of events. . . . In the trend toward increased autonomy, the biologically chaotic items of the environment are fitted into the structure of the individual's life.

This might be said not only of Lowry, Lieberson, and Goodrich but also of Jovanovich and even Frank Stanton. And, interestingly, as managers these men use art more directly than do the others of that nine. Why they did not become artists is suggested elsewhere in these pages.

Is psychologist Roe agreeing that art springs out of the tension between artist and society when she says that painters use autonomy to achieve homonomy—that is, as Freud said, that they use their art as a way to get back into society? If it is true, as Daniel Bell said, that tension is always present between the self and society, then the presence of that tension does not account for the production of art. Says Alvin Toffler, "The theory that art is impossible without alienation is widely held."[39] But perhaps it is held more by those members of the audience who make a

mystique of art or by artists themselves who may feel guilty about the nature of their contacts with society than by such managers as Hedley Donovan, who considers it a dead issue. Just as CBS promotes a kind of excellence, *Time* is an excellent publication for what it is. But both require work related only tangentially to art. Whether one can be creative in an organization is another issue. There is a world of difference between being creative and being an artist.

CHAPTER 12

THE MAKING OF OBJECTS

(*Their value and dissemination*)

ONE DAY I ENCOUNTERED Alfred Kazin on the sidewalk outside of a restaurant in Greenwich Village. "I've just finished writing a poem," said I. "Oh, and is it a good poem?" he inquired. "Well," I replied, "I don't know whether it's good or bad, but it's made." He seemed pleased by my answer. "Yes," he said, "that's all one *can* know."

To see things as "made," however, is only one way of looking at them —and a rather funny one at that, bringing to mind beds or boys and girls together. The differences between objects become not only rather mysterious but also too simple, such terminology failing to take into account that when one person thinks something is made—that is, has been completed—it may not appear that way at all to another person if he doesn't find it satisfying. Why things do or don't satisfy us is a psychological and aesthetic problem that is too complicated to deal with here.[1] But we can note that overmade or overworked objects, too, are likely to be unsatisfying. (Goethe defined genius as knowing when to stop.)

Nor does such a term take into account the kind of object being talked about. A magazine such as *Time* can be considered an event as well as a made object. Hedley Donovan says that the job of the journalist is to identify change. *Time* is terribly good at that, but the magazine remains a notion, either as event or object, rather than art because it does not mask duration—although one of Henry Luce's great accomplishments, as founder and editor, is said to have been that he made it look as though it did. Duration seems shorter: we are in "future shock," Alvin Toffler, a former editor of *Fortune* magazine, claimed.[2] Our mass media help to make it

appear so, but has life really changed so much? Ortega y Gasset, in *The Revolt of the Masses*, spoke generally of these matters in 1930, when such media as now exist were gearing up:

> The tempo at which things move at present, the force and energy with which everything is done, cause anguish to the man of archaic mould, and this anguish is the measure of the difference between his pulse-beats and the pulse-beats of the time . . . each individual feels, with more or less clearness, the relation which his own life bears to the height of the time through which he is passing.

Perhaps we need to be more often reminded of our relation to those things which endure.

Of what value was the duration of an activity for the people who stood in line to see Leonardo da Vinci's *Mona Lisa* when it was exhibited in 1963 at the Metropolitan Museum of Art? There were 1,077,521 of them during a twenty-six-day period: viewing time averaged out at roughly ten seconds per person. And what about the man who paints on Sunday or writes poetry in his spare moments?

PIETER BRUEGEL, THE ELDER. THE SEVEN CARDINAL SINS—"LUST," C. 1558.
COURTESY OF THE ART INSTITUTE OF CHICAGO.

Transmission of the diabolical in the psyche.

These kinds of activities more readily enlist sympathy than does much art. The implications of a particular work may engage us in disagreeable fashion yet it may still be art. Art survives, says Malraux, when the artist transmits either the spark of the divine or the streak of the diabolical in his psyche.[3] And while we may smile fondly, with pride, at our children, the striking things they write or paint are not art, although they may have form and color. Lowry comments:

> I think there is a phase in children when their plastic skills are at a kind of cyclical peak, and they confuse a lot of parents and teachers who think these children are going to be painters or sculptors. And they're not. I think that everything should be done when a child is between the ages of five and nine to give him free vent, and this is how you know he might have talent—but I don't think we're all equally endowed.

Aside from the fact that the creation of art requires a form of intelligence (or intelligence in a form)—and the uses of intelligence are painfully learned only as people grow—obviously a person who works only intermittently is less likely to create something meaningful, no matter how great his talent, than those who spend their whole lives directed toward that end, as Dr. Roe suggests. Art is *not* the process of living, although it is connected with that process.

Of what value is activity *per se*? Frank Stanton told a story about his childhood: it seems his parents had a two-story log structure which they used when his father's teaching schedule permitted, especially in the summers, and which burned down while Stanton was in college. His parents lost much that they had made; furniture of mission oak (Stanton said, "That's why I've got this oak in here," patting his desk at CBS) and "a lot" of their china and metal work. Stanton himself had never lived in the cottage, but his brother had. "He was much closer to my father and to my mother than I ever was," Stanton said incidentally. ". . . I haven't any idea why." But he said, "I felt that my mother never really gave him a chance to see if he could take care of himself. She was always so concerned about his health, and he was, God knows, he was very frail and it was touch and go, there's no question about that." At any rate, his parents "went out in the late spring," Stanton continued,

> and would stay until frost, and I don't think I spent as many as three nights in a row there at any time during the entire period. You asked me whether I was upset or shared in their grief about losing the place. In fact, I was rather relieved in a way because I thought that—I was wrong but at least I thought that it was taking—it was too much of a drain on their energies to maintain the place and to do all the work that they were doing there.

Activity *per se* is valuable (or harmful) only to individuals as such. What is done or not done affects the individual and the society in which he lives.

What we mean by time in relation to art is not simply the duration of an activity. In the Ozenfant illustrations[4] and the chart from *The New York Times*, the lines show time not only with regard to duration but also

SUSPENSE

Our mind always tries to organize what appears unorganized or not organized enough. It also tries to resolve the discontinuous in continuous. Our mind tends to complete the incomplete or interrupted forms. We feel first suspense, then satisfaction of completion. (Phenomenon much in use in music.)

TIME

A form does not yield its full effect instantly. We have to "follow" it. Time intervenes in arts of sight as in music, dance, literature.

FROM OZENFANT, FOUNDATIONS OF MODERN ART.

in other ways. (It might amuse the reader to figure out how many.) Lowry believes that when art is regarded as a commodity, "mere *activity* in the arts" unfortunately becomes regarded as creativity.

Making things is a way of transferring time into an object, but how it is done—and whether it holds—depends on what is being made. Some things gain a peculiar and particular loveliness from the very fact that they are transitory—fragilely growing and dying. No matter how the word is defined, culture—which in our definition is the relationship of the environment to the arts—remains a form of history, founded on intangible as well as substantial objects in the flow of time. History is the matrix—the sack that won't stand up until objects have been added to it[5]—in which they are embedded, and they are what renders it concrete. The observations of men only surround them. The task of the humanities, said Erwin Panofsky in *Meaning in the Visual Arts*,[6] is to make "those frozen, stationary records . . . emerge from the stream of time."

Some other lines also having to do with suspense and time.

ART AND MONEY

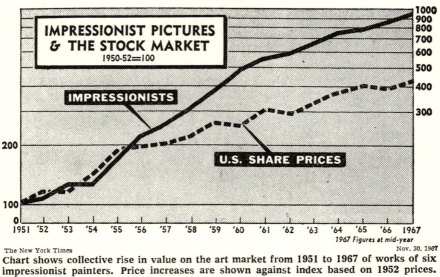

IMPRESSIONIST PICTURES
& THE STOCK MARKET
1950-52=100

IMPRESSIONISTS

U.S. SHARE PRICES

1951 '52 '53 '54 '55 '56 '57 '58 '59 '60 '61 '62 '63 '64 '65 '66 1967

1967 Figures at mid-year

The New York Times Nov. 30, 1967

Chart shows collective rise in value on the art market from 1951 to 1967 of works of six impressionist painters. Price increases are shown against index based on 1952 prices.

When art works are bought for their capital-gains potential, the artist becomes an object himself, a "growth property."

All accretions, including events (actions *and* thoughts) in the lives of real people, approach the condition of art. But events, although distinct (or relatively so, in spite of the other occasions that hang on them), result in social notions which cannot be properly understood as the result of any one person's activity of thought and, indeed, which tend to remain fluid. When they become fixed, they are seldom art and become relatively inconsequential, though not as social forces. "Happenings" are a good example of this. So are journals kept "day by day." And so are newspapers, although *The New York Times* has a special relationship with history.

The structural anthropologist Claude Lévi-Strauss pointed out that savages, in their "science of the concrete"—which consists of exhaustive observation of the environment and the systematic cataloguing of relationships—"arrive at incredibly precise and subtle discriminations which become the basis for institutions designed to annul the effects of historical change."

Biological scientists are keenly aware that life is comprised of endless change even as it continues, though, unlike social scientists, they tend to think the same principles are at work all through man's evolution and history. "Genetic information, passed on from generation to generation in ever-changing combinations, survives so long as there is continuity in the

flow of life."[7] Germ plasm is immortal in that sense. Genetic aspects un-
derlie the creation of human culture systems. Art is a growth process com-
parable to social and biological systems—works of art are nodes in the
same way that a living organism is a nodal point in an extremely complex
network—works of art are histories as well as being in history. And that
same process of discrimination talked about by Lévi-Strauss also goes on
in the breast of an artist and there becomes the basis for his art, which
paradoxically is radical at the time of its birth and becomes conservative
without changing at all.

We have a need for "symbolic immortality," wrote Robert Jay Lifton
in his *History and Human Survival*.[8] He speaks of "the universal need for
imagery of connection antedating and extending the individual life span,
whether the idiom of this immortality is biological (living on through chil-
dren and grandchildren), theological (through a life after death), natural
(in nature, which outlasts all), or creative (through what man makes and
does)." "All art," wrote Malraux, "is a revolt against man's fate."[9] The
making of experience into art provides the continuing line of our culture
and renders it immortal—so long as the objects created exist or are remem-
bered in explicit or implicit ways. A biologist says that physicists are
dealing with fixed immortalities:[10] we are not. The heaps so made are as
susceptible to decomposition as is organic matter. The more we preserve
them, the more interesting our experience, the more stable our present.
André Malraux, French Minister of Culture, speaks of how the past and
present are brought to us in a new way: his "museum without walls" made
possible by the reproduction of works of art.[11] He values the dissemination
of cultural objects, through which "the voices of silence" are heard and
understood in many different ways, and finds dissemination in itself an aid
to stock taking, poising us delicately between training and imposition. But
how much of the clutter surrounding art objects need be preserved? With
the proliferation in the last few decades of oral history collections; Ph.D.
theses; and, as at the University of Texas, the payment of large sums for
miscellaneous papers; etc.—this becomes a hard question.

This book, of course, is an attempt to "fix" my particular view for the
reader, and no doubt I wrote it to try to "confirm" my own intuitions "by
becoming informed." (This, by the way, had proved a compelling motive
for black students during the sixties.) One problem with it, of course, is
that the education one gets as a result can be rather one-sided. My view
may very well change during my lifetime and what others think of it may
change in the course of time, if it is important enough to survive, but hav-
ing been "made," so it will remain, in whatever integrity it possesses.

As will the Kienholz sculpture reproduced on the next page. Entitled
The Wait, it represents another kind of wait or pause as well. Its creator has

Edward Kienholz, The Wait *(1964–65). Collection of Whitney Museum of American Art.*

finished with it. He must have felt that it embodied what he wanted to say so far as he could manage to embody it in that particular structure. He has "made his statement," a complicated bringing together of details into a form which would hold in time and yet which is peculiarly related to our times. As suggested, all art has an invisible content: its intellectual relationship to other works of art.

This piece now stands in the Whitney Museum and is a form of sculpture—so-called environmental—that is unique to our time, as are many of the forms seen in the photograph of one of the Whitney galleries' "changing exhibition space." The design of the building overwhelms. A sight of the ceiling alone, with its elaborate lighting arrangements, suggests why this is so. Set in an affluent neighborhood in New York, the upper East Side at Seventy-fifth Street and Madison Avenue, the newest Whitney seems an odd "artists' museum." This is a far cry from its old days, down in Greenwich Village.

There, in 1908, Gertrude Vanderbilt Whitney opened a small gallery. She herself sculpted. That gallery was to become the Whitney Studio

A gallery at the Whitney Museum of American Art.

Club "and a haven for the nonacademic. Many a young independent whose work was snubbed by dealers had Mrs. Whitney and Mrs. Juliana Force to thank for his chance to be seen and for his opportunity to study abroad."[12]

When Forbes Watson assumed the editorship of *The Arts* magazine in 1923, he brought with him the backing of Mrs. Whitney. "There was an unusually close relationship between the Whitney Studio Club and *The Arts* magazine," Lloyd Goodrich comments. "I think it was the magazine that represented the artists' viewpoint much more than anything that had happened before." Forbes Watson aimed to get the work of American (as opposed to European) artists seen and bought. Goodrich began to write book reviews for him, brought there by Alexander Brook, another writer for the magazine, and in December 1925 Goodrich joined the staff.

About then, he said,

there was introduced in Congress by Representative Tinkham a bill to create a cabinet post for fine arts and conveying to the government or whoever was to fill the post certain powers. There was an immediate reaction against this. We weren't going to have the government tell us what art was or wasn't.

"That's the difference between that period and today," Goodrich said. "You took it for granted that if the government did anything in the field of art it would be wrong, and that it would be on the side of the most conservative and academic interests. The difference is the intervening Roosevelt administration and what they did in the field of art. There's still the same feeling, but it isn't nearly so well based as it was then. There was an official kind of art in this country, an official art world which has been pretty much shot to pieces since then, and we took part in shooting it to pieces."

In 1924, interest in things American began at the Metropolitan Museum "with their decorative-art rooms of American furniture,"[13] and some of Goodrich's early articles, including one on the Hudson River School, became "part of a developing American tradition."[14] The Whitney Studio Club became "the Whitney Studio Galleries for the exhibition and sale of work by young men who had no dealers"[15] in 1928, and the Museum of Modern Art, established in 1929, showed "Living American Painters" in its first year.

When Lloyd Goodrich came back from Europe in 1928, he got to know Juliana Force, the wife of a dentist and adviser to Mrs. Whitney, "increasingly well, and Mrs. Whitney less so." Mrs. Force was "a born scrapper," said Goodrich. He became assistant art critic on *The New York Times* while retaining his position on the magazine, and that lasted more or less for two seasons. Mrs. Whitney was gradually withdrawing her support as she began to think about starting a museum.

A museum meant the purchase and retention of works of art, not merely their showing, and presumably a more tense discrimination. "So vital is the part played by the art museum in our approach to works of art today," André Malraux wrote,

> that we find it difficult to realize that no museums exist, none has ever existed, in lands where the civilization of modern Europe is, or was, unknown; and that, even amongst us, they have existed for barely two hundred years. They bulked so large in the nineteenth century and are so much part of our lives today that we forget they have imposed on the spectator a wholly new attitude towards the work of art. For they have tended to estrange the works they bring together from their original functions and to transform even portraits into "pictures." . . . the modern art-gallery not only isolates the work of art from its context but makes it forgather with rival or even hostile works. It is a confrontation of metamorphoses.[16]

If the modern museum was more than a confrontation of metamorphoses, what was it? McNeil Lowry, in 1974, noted continued (and bloody) conflict over its role and said the question had polarized three ways: "Is the

museum art-historical, educational, or community-minded in its objectives?" Lowry thought least honored was the opening of the career of the contemporary painter and sculptor and the protection of his rights. It was with this that Goodrich had been involved during *his* career.

By 1930, Goodrich had become "a sort of unofficial adviser" to the adviser, while the museum was being planned, taking Mrs. Force, for instance, around to the studio of Reginald Marsh, who was a continuing good friend, lending Goodrich five hundred dollars to do some of his work on Eakins, a painter Goodrich had become especially interested in.

The Whitney Museum opened in November 1931[17] and "was the first institution wholly devoted to this country's art."[18] "The collection we inherited from Mrs. Whitney" was formed on "a democratic basis," said Lloyd Goodrich—"that is, well, it's turned out to be maybe seventy-five percent not in the long run standing up."[19] But, Forbes Watson wrote, "nothing will keep the Whitney Museum . . . more certainly alive . . . than the continued desire to take risks by making those discoveries which committee-ridden institutions never make."[20]

After 1931, Goodrich remembers being paid by the magazine on a piecemeal basis. In addition to his interest in Eakins, he was working on a book about Kenneth Hayes Miller, a teacher as well as a painter and a great influence on Goodrich, and was being subsidized by Isabel Bishop. Mrs. Force asked him to join the staff of the Whitney Museum as the writer of a series of monographs on living American artists, and when he said no, being otherwise preoccupied, she put him on salary anyway, at $5,000 a year (a lot of money at that time), to continue his own work, Goodrich remembers.

About that time Alfred Barr, then museum director of MOMA, asked Goodrich if he would like to take his place for a year. But "it would not have been a permanent thing—I don't think. Besides, I was committed to the Whitney Museum, which, after all, was a rival institution in a sense." Goodrich's subsequent career at the Whitney, which lasted beyond his semi-retirement in 1968, was to consist not only of such things as the "sensitive critical commentaries"[21] he wrote for a survey of landscape paintings in 1938 but also the pursuit of his own interests, frequently resulting in publication,[22] and much work in organizing: museum shows; various artists' groups concerned with government involvement in the arts; and, early, the WPA art project in the New York area.

Goodrich said that for him three happy years of writing "uninterruptedly" were interrupted by the WPA art project, "the first time I really got involved in the museum directly." On December 12, 1933, *The New York Times* announced that Mrs. Franklin D. Roosevelt was the sponsor of a federal plan to hire artists over the country for the purpose of adorning

the nation's buildings. It was a project designed to further employment rather than a measure of government support for the arts. "It was in the public-works-of-art project that I first saw the work of Philip Evergood, or Paul Cadmus, Ben Shahn . . . ," Goodrich said.

"Noguchi was on the project," he added.

At that time he was not accepted. He submitted some wildly impractical designs. One of them was a monument to the American plow to be erected on the plains of the Midwest on top of a pyramid about two hundred feet high. The plow would have been stainless steel about a hundred feet high—something like that. This was a wonderful idea, and I'm afraid we didn't rise to the occasion, but it was a little bit impractical. He also submitted a plan for a children's playground which I must say struck me as extremely lethal for the kiddies. He had a shoot-the-chutes going down in a circular spiral form that would have shot them out at

FABIAN BACHRACH

Lloyd Goodrich

the bottom with a concussion, and so on. Maybe I'm being unfair. Noguchi was very inventive in his ideas. . . .

As a matter of fact, very little did get actually executed. The only thing that did get executed we were not very proud of. [Postella's murals for the Foley Square New York County Courthouse.]

"I never knew the complete inside story of the beginning of that," Goodrich said. "Mrs. Force did. . . . My own connection with it must have been in December 1933. Mrs. Force called me up at home in a state of great excitement . . . 'I'm chairman of it, and I want you on it. It's not going to involve any work.' Famous last words! Because I never worked quite so hard in my life as I did for the next five months or so. The setup was that the headquarters of the New York Regional Committee was in the Whitney Museum of American Art on Eighth Street. . . . My memory is that we accounted for about a quarter of the country's artists . . . something like 750 artists. . . . I had never done any administrative work for [Mrs. Force] before . . . pretty soon I began to find myself more or less running the office without a title."

Oliver Larkin, in *Art and Life in America*, has described the setting:

After years of devil-take-the-hindmost the New Deal of Roosevelt had declared itself responsible for the welfare of the least citizen. . . . The victim of unemployment became a self-respecting beneficiary who earned his benefits by work he was qualified to do, and the victim of floods and drouth saw the transformation of earth's and water's power from a menace to a servant of his needs.

The impact of these new forces was immediate on the smaller world of art. A new confidence replaced cynicism in much of the writing of these years. . . . Through the federal programs for slum clearance and rehousing, the architect and the town planner for the first time could attack those problems from the roots and demonstrate on a national scale the humane validity of their ideas. To painters, sculptors, and designers was given the opportunity to participate in a countrywide experiment whose scale and purpose were something new in the world— the Federal Art Projects. These were the culmination of previous gestures toward patronage by a country which had no Department of Fine Arts. For more than a century such matters had been handled by ten different committees, officials, and departments, most recently by Edward Bruce under the Civil Works Administration and then by the Fine Arts Section of the Treasury Department. It was obvious by 1935 that no present plan could absorb the thousands of jobless writers, musicians, sculptors, painters, designers, photographers, and actors; and in the summer of that year the Federal Art Projects of the Works Progress Administration were established not only to give these people work and relief but, as one of the directors said, to feed the hunger of millions for music, books, plays, and pictures.

The structure of all the projects was essentially the same: a general policy shaped by Harry Hopkins, Holger Cahill, Hallie Flanagan, and others, with regional direction and a local administration in each of the states. The movement of the arts toward a few cities was to be reversed in the hope that art would become the possession of a whole people. Thanks to FAP, the states had their Federal Writers guidebooks, and towns which had never heard music at first hand listened to orchestras. Plays were produced for people to whom actors had been shadows on a screen. The decorative arts of the nation were recorded in thousands of drawings by the Index of American Design. In hundreds of villages there were new post offices, schools, and small art galleries with murals, sculptures, and easel paintings. Talented children were taught to make pictures, and older men and women learned how to plan homes and to weave, spin, or carve their own furnishings.

On the rolls of Federal Art were many of the ultra-moderns, for the projects drew no more distinction on grounds of style than of race, religion, or politics, and the abstract painter was as truly a victim of the depression as his more naturalistic brother.[23]

Goodrich remembers that artists were screened by submitting their work to a three- or four-man committee: Herman Moore, curator of the museum; Edmund Archer, the associate director; Carl Free, curator of prints; and "probably Mrs. Force. . . . I had no part in this because I was in the administrative end, running the project," Goodrich said, working from nine in the morning until twelve at night. "We never went into their political backgrounds. . . . It was well known that artists, the underprivileged citizens of the cultural world, were very much drawn toward Marxism either in the form of socialism or communism. . . . I saw no objection, nor did Mrs. Force, nor did anybody else connected with the project. I mean, to us, this was a democracy, allowing free speech even to people on the government payroll. . . . What did cause great trouble was the organized protest, and the core of it, I'm sure, was Communist. . . .

"Well, of course the government was doing something pretty bold and unprecedented in turning it over to an outfit like the Whitney Museum, which was only in existence for three years—no, two years open to the public—and known as being a protagonist of the liberal wing in art." And, said Goodrich, there may have been some truth in the criticism of favoritism—"I mean, one can't be completely fair-minded." But he was proud that the government was talked out of classifying artists as "grade A" or "grade B."

Leftist elements in the art world, according to Goodrich, "started to criticize the public-works-of-art project . . . because it didn't go far enough. In their view, it was just . . . a capitalist halfway measure . . . every artist should be on the government payroll . . . forever after." The Whitney was

picketed on March 15 by dropped artists or those who felt more were going to be dropped, and delegates were allowed in to speak. Goodrich talked to them: "One of the policemen said, 'Shall we throw them out?' . . . I said, 'No, no! For heaven's sake, these people are artists.'" The project was terminated on April 28, to Goodrich's distress: he felt it was cruel to have taken them on without planning for their futures.

Harlan Phillips, interviewing Goodrich, commented that there appeared to have been no attempt on the part of the Whitney Museum to silence criticism. "We didn't want to get into an argument involving artistic personalities," Goodrich replied.

> This was the kind of thing Mrs. Force always disliked very much—public judgment except in the form of exhibition, or in the case of employment, but this is a policy that we have continued right along the line. Very frequently we are asked for a written opinion of artists who have worked at the Whitney Museum or exhibited, a verbal opinion, criticism, and we just can't do it. This is not our function. That is the function of a teacher, or a school, not a museum person. A museum person acts. When he publishes a book, then he picks his own subject.[24]

The Whitney Museum of American Art was incorporated by the legislature of the State of New York in 1936. The Eighth Street galleries were enlarged in 1939, but about that time it became obvious that economies would be necessary. "Edmund Archer and Carl Free were allowed to resign, which was awfully hard for Mrs. Force, I'm sure, and for them certainly. A certain amount of bitterness came out of this, I'm afraid. At that time I wasn't very much in on the financial picture of the museum. I don't know what the considerations were. I think possibly the trustees had felt that we were a little extravagant. Mrs. Force was an extravagant person. She loved to spend money."

By 1941 only three staff members were left: Goodrich, Mrs. Force, and Herman Moore. The latter was given a year's leave of absence. Goodrich put on several shows that season but didn't get any writing done. He told Mrs. Force this, so he says, and Moore came back the next season, and "from then on we worked together." It was during the war years that the tentative connection with the Metropolitan Museum of Art, already mentioned, formed and lapsed.

"The wandering critic who studied the annual Whitney survey in the fall of 1945, the huge compilation at the Carnegie Institute, *Painting in the United States*, and other shows of the moment, might search for a direction, a predominant approach, but find none," wrote Oliver Larkin shortly thereafter. "In spite of . . . reminders that mankind had just faced one of its crucial moments, it seemed that for most painters the war and its memories were a mental ballast to be cast overboard as one rose above the im-

mediate past. And it could not be said in 1945 that recent events had reconciled opposing factions in the world of art. Into the ranks of native experimentalists had come fresh recruits from Europe. . . ."[25] The next important show at the Whitney, in 1946, was called "Pioneers of Modern Art."

In Goodrich's view, the 1940's were a battleground for anti- and pro-modernists. The events in that battle he listed as: first, a show in Boston, at the Institute of Contemporary Arts, for which the Whitney lent six of the forty or fifty paintings included; second, the subsequent article in *Life* magazine; third, the rebuttal Lloyd Goodrich organized and the ensuing education of *Life* (". . . I think from this episode there was a change of policy on the part of *Life* magazine"); fourth, the drafting and publication of a statement about modern art by three museums (the Institute, MOMA, and the Whitney); and fifth, the breaking off of the plan to amalgamate with the Metropolitan Museum of Art.

However, late in 1947 or in 1948, the three New York museums drew up an agreement dividing "the territory of art" between them. MOMA "was to cover international and modern art in the sense of twentieth century primarily"; the Whitney "was to be all of American art"; and the Metropolitan was to concern itself with "classic art."[26] MOMA was to act as sort of a counterpart to the Metropolitan, passing on works. The idea was that the Metropolitan would pay current value for these and the Museum of Modern Art could then use the money to acquire more recent works. Although this agreement was signed and actually lasted a few years, it didn't work and eventually was called off.

The Whitney had in the meantime found itself more and more in basic sympathy with the Museum of Modern Art, although its tastes were catholic while MOMA specialized in the more advanced. "I personally have been a friend of Alfred Barr since 1926 or 1927," said Lloyd Goodrich, "and I admire him tremendously . . . one of the most extraordinary people in the art world today [1962], a man of complete integrity, a great scholar, a man who has done more for the understanding of modern art in America than any single individual."

The Whitney, also, had outgrown its Eighth Street home. The trustees had their eye on the southeast corner of Washington Square, but Goodrich felt that the move should be uptown, as a "missionary museum"; that their job was to get into the center of things. "Out of the blue," MOMA trustees offered part of the garden on Fifty-fourth Street.

Mrs. Force died about that time, in 1948. She had agreed to a retrospective of Kuniyoshi's work—the first of a living artist—and the catalogue for the show was published as a book for the first time. Since then it has become standard practice. Apparently at the time of her death she did not

know about the offer from the Museum of Modern Art. But, said Goodrich, "it would have pleased her a great deal. She did know and participated in the breaking off of the agreement with the Metropolitan Museum, and I think this was a relief to her, too, to know that the Whitney Museum was going to continue as an independent body."

The land was deeded on the understanding that the Museum of Modern Art would have first option to buy the building put up by the Whitney and the land was to revert free. If a third party bought, the Whitney would give MOMA the value of the land received from the purchase.

"We [the committee] met on the average of once a week for about more than a year, because designing a museum building is a very complicated, a very technical thing," Goodrich said, and the exterior had to be approved by MOMA, who was to use a third of the basement for a restaurant and a third of the ground floor. Philip Johnson designed the exterior,[27] and each floor was completely open, with movable partitions. Goodrich was later to feel that the lighting ssytem had been a mistake but that the building itself was remarkably efficient. Ground was broken in 1950, and Goodrich, associate director at the time, found it exciting to see the new building going up.

> I remember myself saying to Mr. Dunnington, who was secretary-treasurer, "When we get up there, the situation is going to be completely different." I think this was an understatement.

The Whitney Museum opened its doors next to the Museum of Modern Art in 1954, and attendance during the first year proved to be four times as high as that on Eighth Street. "Down there," the Whitney had averaged 75,000 visitors a year without staying open in the summer, since their old home had lacked air-conditioning. On Fifty-fourth Street, in 1963, with attendance between 225,000 and 250,000 and the newness worn off, it was fifth among the art museums in New York, coming after the Metropolitan and the Cloisters, the Brooklyn Museum, and the Museum of Modern Art, in that order, and dropping to sixth place when the Guggenheim opened in 1959.

As it turned out, these new quarters were only a temporary stopping place. Goodrich had become director in 1958. In 1961 a building committee was again formed; the Museum of Modern Art agreed to pay two million dollars to acquire the building erected on their land, which they themselves needed by then; and a search was on for a new site. It was found on the upper East Side and acquired for slightly more than two million.

Marcel Breuer seems to have been chosen as the architect,[28] after the selection had been narrowed down to five men, as much for his flexibility

as for anything else, according to an article by the chairman of the building committee in which he suggests that two of the other architects were washed out because of categorical statements,[29] and from the start Breuer conceived of his work as monumental. So was born "one of the most significant buildings to go up in New York since World War II,"[30] a basic concept meeting "staff requirements, engineering requirements, contractor's requirements, Building Department [city] requirements, and eco-

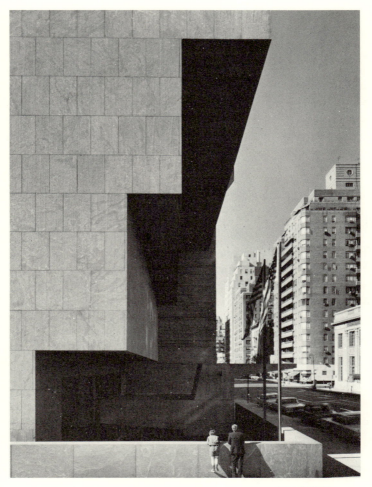

EZRA STOLLER

Whitney Museum of American Art: Detail from 75th Street of the front overhang. The canopy, giving the walkway a ducklike appearance, was conceived as an afterthought.

nomic requirements," as all buildings must, but also designed to meet the needs of "a growing art audience [expecting] well-installed, well-catalogued shows in a building that is comfortable and offers such amenities as dining and auditorium facilities," and the needs of a professional staff "entitled to galleries that are sufficiently large and flexible, adequate administrative offices as well as shipping and storage and restoration areas."[31]

I was astonished by Goodrich's office and by the library at the Whitney Museum as well as by many of the other spaces, for they seemed to me to lack an aesthetic element. The American Institute of Architects *Guide to New York* noted:

> Almost as startling on the city street as the *Guggenheim* [museum building designed by Frank Lloyd Wright], it vends its wares with a vengeance. Reinforced concrete, moated, bridged, cantilevered in progressive steps over-shadowing the mere patron, it is a forceful place and series of spaces. The cantilevered floors recall the machicolations [stepped, overhanging battlements] of *Carcassonne*. Beware of boiling oil! The Whitney joins the list of *must-be-seen modern* "objects" in New York.[32]

In 1966, the Whitney Museum of American Art moved into its permanent home, that "made" structure which met requirements but which was to remain controversial so far as the building itself and so far as the display of art—its main purpose—were concerned. In 1974, John Russell, art critic of *The New York Times*, commented that the Whitney had never borne the mark of a single taste or even the mark of a single generation.[33]

CHAPTER 13

DISTORTIONS
OF PERCEPTION

(*Looking at patterns*)

MANY PERSONS APPEAR to carry in their heads the notion of genius as something which exists apart from the continuing expression of it. There is a natural facility, Lloyd Goodrich remarked, which "comes in youth [and] makes a man's work look very promising, very exciting, and [that] doesn't necessarily last." Ruin of that natural facility is rarely attributed to personality and often attributed to cultural factors. This "genius" is what the mass media tends to focus on, rather than on the works themselves, and so do the worst critics.

TV provides us only with what can be rapidly consumed. A magazine's existence is predicated on whether its contents can be rapidly consumed. Even so-called intellectual magazines such as *Commentary* and *The New York Review of Books* are giving us wrap-arounds—handles into ideas rather than full presentations. Obviously, what constitutes a "full" presentation is a matter of opinion, but if newspapers are at one end of a continuum and books are at the other, then magazines must stand between. (Eero Saarinen said that journalists work in "rabbit" time as opposed to the "elephant" time of art, which is what books more nearly approach.)

Does so much subject matter appear trivial because of the inherently transitory nature of media? Real life appears trivial when we are in its stream—only when we stop and look do patterns emerge. Biologists have pointed out evolutionary oddities which either die or remain singular or,

in flourishing, result in new forms. Art also mutates into forms which flourish or die, and which they do also depends upon the receptivity of the environment. But immediate hospitality can be deceptive (as can immediate hostility). Of what interest, other than historical, will Pop Art eventually be? But television will survive, in spite of everything its critics justifiably find horrible. (Critic Robert Mazzocco might well have had such shows as "The Flying Nun" in mind when he spoke of "the mindlessly banal and the haphazardly corrupt.") William Jovanovich pointed out that its corrupting effects are minimized or dissipated by its very excesses, which sounds like a backhanded argument for letting stations go their own way without government regulation—but the effects of electronic registration are temporary in any case unless they link with the world as it is otherwise encountered. A Gallup poll conducted by phone immediately after President Nixon's televised speech on Vietnam in November 1969 recorded 77 percent of the nation as supporting him, which was clearly true only for the moment, if that, as polls and events before and a longer period after his speech proved. A Twentieth Century Fund report, *Presidential Television*,[1] assumes that command of the frequencies and command of political forces go together. But former presidential press secretary George Reedy commented that Nixon "quieted the public in Southeast Asia *not* by television speeches but by withdrawing ground troops and reducing casualties."[2]

We are highly susceptible to what is currently the main content of television—the fact of the existence of the process. It is not that the medium "is" the message, as Marshall McLuhan stated, but it inevitably acts as the basis for—and is capable of distorting in particular ways—the message or content. Reuven Frank, president of NBC News, said: "The highest power of TV journalism is not in the transmission of information, but in the transmission of experience.[3]

Works that a medium can most effectively display are those inherent in its own nature, which perhaps is why movies are so effective on television.

August Lumière invented the motion picture: remembering that the retina of the eye could physiologically perceive light sensations lasting, at most, for one-tenth of a second, he had the brilliant idea of unrolling motionless (still) pictures on film at the speed of one-twentieth of a second, which gave an illusion of movement. But no matter how fast the film, i.e., a series of still pictures, was unrolled, this succession, however rapid, *could never achieve either the real continuity of movement or of duration, but only its fake and imperfect image.*[4]

The basis for the image we see on the television screen is a continuous succession of bits of information conveyed as they are registered by a scanning device. Although television is an electro-technical medium and film

a mechanical one, both consist of audio-visual information recorded in some manner in order to be reseen at a future (even though sometimes practically instantaneous) date.[5]

All art forms conveyed by electronic or other devices are changed in the process—we see them as if with metamorphopsia, their forms distorted and localized—but the performing arts less so. They, in common with motion pictures, rely on change to give an illusion of reality, as does television—which might explain why none of them show to advantage what must take time to be properly understood (to use Theodore Roszak's phrase), which means complicated ideas in any form. Quickly assimilable material appears as most valuable, and this may be where the real corrupting influence of TV lies.

A Rockefeller Panel reported that while considering the performing arts, they had not dealt with the question of what role electronic devices have played in their development. "Indeed, it may be contended that the live arts and the electronically transmitted arts are two quite different forms," the panel said, and went on to point out that it had not been established "that the viewer of a television program transfers that experience into a desire for a live performance."[6] It seems logical that the direct opposite is true: that the television showing *substitutes* (and I am not using the word pejoratively) for the live performance at least in its use of time and perhaps in other ways.

In the past, economic arrangements of support for the arts were geared to audience size. But it became clear in the late sixties that there was no longer much possibility for the performing arts to support themselves solely at the box office. The size of the audience, in any case, does not necessarily reveal the extent of the impact of a work of art. In the only area where this would seem grossly to be true—the television industry (if one wants to consider that an art at all), where present economic arrangements are geared to audience size—the greatest impact on our culture is made not by specific shows with the highest ratings but by television's mere existence as a medium, which still is not a message. More like a clue. With the arts now being supported by government money, the idea that there must be some relation between numbers of people served and monies given has sprung to life again as needed justification—perhaps because the true justification is subtle and difficult for those in control of spending to grasp. Not only should the performing arts be subsidized; not only should colleges, small and large; not only should museums, whatever the size of their audience, for the influence they exercise, through their role as selectors and repositories, on the creation of art—but only the professional elements of all should be subsidized/fostered: in order to *as firmly as possible identify the amateur as a member of the audience only.* Much of

McNeil Lowry's work at the Ford Foundation has been directed toward this end, which differentiates it from the attitude behind federal spending on the arts.

Lowry has fostered quality and attempted to make live performances more available. Members of the Rockefeller Panel believed there was no possibility for live performances of high quality to reach mass audiences except through electronic methods. Does this then mean that the appropriate role of television may be to subsidize live performances in order to keep them available, even though they may as such be attended only by a relatively small audience to whom the social experience may be primary?

Lowry said:

> I think that the little instruments and people that I'm concerned with and have been concerned with for ten years, in this united arts program as a working out of their place and their standards and their destiny, will go on as a separate endeavor whatever happens to non-commercial television.
>
> Now, I do believe that non-commercial television will inevitably give those people more exposure and ultimately when new devices have been invented . . . I believe that non-commercial television will also be an increased source of financial support for some of these activities, particularly in the performing arts.
>
> That excites but also worries me, because it's another one of those irrelevant and subordinate monsters that can become in control, you see. If you have to handle your programming, your repertory, even your way of handling the artist to be most productive of an obvious new source of financial stability, then you change things. You *may* change things, depending on who you are. And as the arts have often been made the subordinate handmaiden of education in this country or of social prestige, so can they be made the handmaiden of this thing.

Too often the arts seemed the handmaiden of the critic, who also tended to see them as with metamorphopsia. The publisher uses the critic to raise the tone of his newspaper, or magazine, or (sometimes) publishing house, and to sell more copies; the critic uses the work of the artist to support himself and not just financially). Proust sourly remarked that a critic is an incomplete man who completes himself with the work of another.[7]

Leon Edel spoke of the audiences to which a reviewer or critic might address himself. They were fourfold, he said:

1. The educated audience, the one capable of independent thought
2. The academic audience, "only remotely concerned with scholarship; its largest preoccupation is exposition and explication."
3. A wider audience, "somewhat vaguer than the other two and

more difficult to imagine, which aspires to culture and is, in a manner of speaking, an audience in perpetual search for some kind of education. However, it possesses neither the basis, nor the perspectives—nor the standards—for finding out how and what to learn, how to possess what we call a cultivated taste."

 4. The mass audience, which Edel saw as simply inert.[8]

The immediate impact on any of these audiences of a review can be deceptive. Critics on *The New York Times*, for instance, have to reckon with the fact that they must share some part of the blame if an audience does not flock to a Broadway or other show or buy a particular book, or stays away from museum shows, concerts, etc. Clive Barnes wrote (in the *Times*): ". . . it would be hypocritical to deny that in so small a field as dance, the *Times* critic—by virtue of his position—does possess a power over and above any influence he might personally command."[9] Nevertheless, critics cannot make or break fine arts. Nor can the Ford Foundation, although Barnes said it had done more than any other organization for American dance.

A distinction might be drawn here between reviewers and critics: *The New York Times* uses reviewers. Edel pointed out[10] that scholars seek fundamental truths whereas critics seek only relative truths. Reviewers seek even more relative truths, which is somewhat like being more equal. On a time scale, again, reviewers work in the "rabbit" time of journalism, with only a few occasionally approaching the time scale of the critic which more nearly approximates the "elephant" time of art. Critic Stanley Kauffman's experience on the *Times* is instructive in this regard.[11]

Lloyd Goodrich enjoyed writing for a newspaper but saw a difference between the reviewer and the critic.

> When I wrote for *The Arts* [magazine], I always had the feeling of writing for my friends, or by extension, the same kind of minds because the magazine didn't have a big circulation. It was taken by all the artists who amounted to anything, I think. . . . It really had a great influence in those days, the same kind of influence, I think, that *Art News* has now with the avant-garde, so that when I was writing for *The Arts* I always had the feeling that I was writing for people who knew an awful lot, and you had to watch your step and not say anything that wouldn't pass muster, but when you were writing for a newspaper-office audience, you don't have that feeling. You're less self-conscious in a way, and I enjoyed it, and it came quite easily.
>
> . . . journalism brings out something which you don't get when you write for a magazine—the feeling of a big audience, a liberating kind of thing. I had just about enough of it when I did it for a year or so.

Goodrich was for more partisanship on the part of the *Times*, although later on he undoubtedly wished art critic Hilton Kramer less critical of the Whitney Museum.

Gay Talese, in *The Kingdom and the Power*,[12] noted that some 7,500 books were sent to the *Times* each year by book publishers, of which only 2,500 would be reviewed:

> . . . it was a tight selective process from the start. Books by "name" writers would be reviewed, of course, as would books by new authors who had somehow received prepublication attention. . . . As was often the case within the *Times*, "influence" was not necessarily the exclusive prerogative of top editors. Sometimes a clerk, on a busy day, could add a decisive little push that would determine whether or not a single piece of incoming mail . . . was taken from the pile and brought to the attention of the proper editor, or was ignored until it was too late.

The reviewers—authors, educators, politicians, editors, journalists, critics—in general shared the *Time's* traditional respect for the established order and solid middle-class values, Talese reported. "Adolph Ochs had wanted books to be presented 'as news,' to be treated in the *Times* as other news items were treated; he did not want his reviews to become a precious literary forum for intellectuals and critics who were determined to display their erudition or superiority without telling *Times* readers what the books were about."[13] This attitude was pretty much continued by Francis Brown, who became editor of the *Book Review* in 1949. Brown was followed by John Leonard in 1971, whereupon the tone changed, although not as much as some had hoped. Leonard admired *The New York Review of Books*, which had been begun in 1963 during a New York newspaper strike. There, one could read long essay-reviews based more on ideas than on the literal contents of particular books. In 1974, Leonard wrote with approval:

> It [the *NYRB*] appears now to be changing back into a literary magazine: more coverage, say, of fiction; books reviewed closer to their publication dates, which indicates a decent respect for the interests of writers. It is no longer a surprising magazine. But the big thing was to find scholars who could write; to take ideas seriously; to identify and flog moral issues; to provide a regular alternative to the structural analysts in the academic quarterlies, on the one hand, and the middlebrow consumer reports on what X's new opus tastes like this week, on the other hand.[14]

The New York Times Book Review remained more nearly the middlebrow consumer report, even under Leonard's competent direction, limited by the fact that it was still for the more general audience. Leonard, however, felt some responsibility for the arts, particularly fiction.

That responsibility is shared by all those who are concerned not only for but with the arts. *Life* magazine came a cropper, reported Paul Nathan of *Publishers Weekly*:

> *Life* ran a full-page ad in the New York *Times* with huge type—"COME TO LIFE!"—surrounding a photo of Tennessee Williams. "Played out?" says the text. " 'Tennessee Williams has suffered an infantile regression from which there seems no exit. . . . Almost free of incident or drama . . . nothing about "In the Bar of a Tokyo Hotel" deserves its production.' That's the kind of play it is, and that's the kind of play it gets in this week's *Life*. From a theatre review that predicts the demise of one of America's major playwrights to a newsbreaking story that unseats a Supreme Court judge, we call a bad play when we see it. . . ."
>
> Throwing away a used playwright as though he were a thing (after years of helping to build him up), *Life* callously and unwittingly illumines what is wrong with The Season—not just Broadway's, but America's.[15]

Critic John Simon wrote of the audience for the arts and its responsibility:

> "Speed kills!" is the drug-traffic signal displayed on many walls with which Kilroy tries to head us away from methadrine. But an even more dangerous killer is our living speed itself, the speed with which we embrace and drop fashions, tastes, beliefs; the tempo of our race through esthetic and spiritual environments for the sake of being contemporary, mod, new—with it, ahead of the game, out of sight.
>
> . . . when we come to art—and I don't mean pseudo-art, like pop music—this greed for the new becomes disastrous. And it cannot all be blamed on the producers and middlemen; a large part of the guilt is the consumers'. For in the arts, as elsewhere, the obsolescence is built not so much into the product as into the consumer's mind. It is there that, thanks to various overt and covert forms of advertising, the "new" has been implanted as an end in itself. And a very convenient criterion it is for minds that neither know nor care much about the arts; for whereas it is extremely hard to determine what is good and what is bad, anyone can distinguish the new from the old. The Theater of Cruelty succeeds the Theater of the Absurd, and is itself closely followed by the theater of improvisation whose heels are trampled by theater of mixed media, which is jostled by the theater of total participation and theater in the streets, which is tailed by theater in the nude. . . .
>
> There are three main causes of this unappeasable itch for novelty. First, there is the snob value of the new, the one-upmanship in having already bought, read, seen, heard, smelled . . . the latest thing. There is even something vaguely endearing about this: next to being creative and innovative, being a pioneer in recognizing and promoting significant

innovations is held to be best. But there, alas, is the catch: the innovation has to be significant.

Secondly, there is the misunderstanding of the nature of art. Some confuse art with technology (this category, by the way, includes a good many so-called artists). Thus the new painting, which uses a shaped canvas, is seen as an improvement; the new sculpture is better because it moves—as if sculptures were supposed to race one another (some day, no doubt, this too will come); the new stage production is better because it uses mixed media—you get several genres for the price of one. This derives from equating an art form with a contraption, say, a television set, which may indeed be more useful for incorporating ultra high frequency; it is also the ultimate offshoot of that debased and debasing doctrine, "the medium is the message."

Art is also mistaken for news. In our news-oriented culture (which, at all levels, tends to confuse information with gossip) . . . least noteworthy is the serious, speculative critic. . . .

The third, most crucial and disturbing, reason for the Cult of the New is boredom. The same boredom that lies behind far more distressing social ills: divorce, suicide, certain types of crime. One is tired of looking at the same kind of paintings, listening to the same kind of music, going to the same sort of shows. This, regrettably, is tantamount to being tired of the same partner in love, tired of the same *modus vivendi* within the law, tired of life itself. It is, ultimately, a failure of understanding and love; in our case, understanding and love of the arts. . . .

One of the big problems here is over-abundance of money in hands short on culture and taste. This is particularly noticeable in the fine arts, where collectors like Robert and Ethel Scull have been leaping (to adapt a phrase of Harold Rosenberg's) from vanguard to vanguard, without showing the slightest resistance to any new movement. Such people turn art into a vulgar market place. . . .

Observing that "the forcing of creation by promotors of novelty is perhaps the most serious issue in art today," Harold Rosenberg goes on to note, "Novelties in painting and sculpture receive notice in the press as new *facts* long before they have qualified as new *art*. . . . To deny the significance of the new product begins to seem futile, since whatever is much seen and talked about is already on its way to becoming a *fait accompli* of taste. By the mere quantity of interest aroused by its novelty, the painting is nudged into art history."

That is the art-as-news fallacy I spoke of before, at work with a vengeance. . . .

The line of defense against these abuses should be drawn, at the very least, in the reviews and critiques. The public is often just as willing *not* to be duped, but, untrustful of itself, it looks for critical spokesmen to bolster its conservative impulses. The critics, however, tend to fail it. . . .

To be sure, this critical "resistance" must not be overdone. It would be just as deleterious to reject all new art out of hand as it would be to throw the old overboard as if it were so much ballast. Back in 1918, one of the idols of today's American youth, Hermann Hesse, pointed out the absurdity of the categorical rejection of either the old or the new. The critic who nowadays wants to be fair to both, Hesse observed, has "a bitterly hard time of it. But why shouldn't critics have a hard time? That's what they are there for." What precepts can one give critics, even assuming that they wanted them? The basic critical method—perhaps the only one—is still, as T. S. Eliot put it, "to be very intelligent." But what about the public? Are there any practical hints for the audience?

Here, again, the solution is to think more about art, or not to think about it at all. If one's interests do not truly lie in the arts, there is no point in force-feeding oneself or allowing others to do it to one. In that case, though, one should abstain from pontificating, vociferating, and trying to dictate tastes. One should content oneself with the old, much-maligned formula of "knowing what one likes," in whose name much less damage has been done than in that of liking what one thinks one ought to like. But if one is going to get seriously involved with the arts, even as an appreciator, one simply has to drink more deeply from the Pierian spring. And this, inevitably, means reading up on the arts, not just consuming them. Nothing is more meaningless than the ever increasing figures of concert, theater and museum attendance that the foundations are so fond of recording and crowing about. Exposure alone guarantees nothing; it is apt to be just another form of rubbing against, gaping at, and reaching out for the new, without absorbing anything. . . .[16]

Max Kozloff called writers in the newspapers and journals the "cultural attachés" of modern art. "The pressure put upon them to avoid illumination and emphasize 'news' constitutes more their occupational hazard than their professional definition," he said. ". . . what criticism proposes to give, essentially, is an account of an experience, and never, as is sometimes supposed, a substitute for an experience. Indeed, criticism's worth lies precisely in the fact that it is neither a work of art, nor a response, but something much rarer, a *rendering* of the interaction between the two."[17]

Critics should be handmaidens to the arts, as are the do-gooders.

PART III

The Do-Gooders

CHAPTER 14

GREEN THOUGHTS

(*Planning growth*)

In March 1957, a new program was born at the Ford Foundation, with McNeil Lowry as its director. He had "presented the initial action for board approval, outlining a very specific and tight approach to an examination of the field," Marcia Thompson said, "and a small operating program at the same time that the examination and study began." She shifted over into the arts and humanities with Lowry.

Mrs. Thompson began to build an index of professionals in all areas of the arts, since "there was no central place where we could go in any field to get names and addresses." "We've got the best list, but we took years to get it," Lowry said.

> We did what we could. We took obvious things, like the Directory of the American Federation of Arts, which has every museum director and curator, and every college and university department head—Artists' Equity, which is the list of painters and sculptors who belong to it—university catalogues—lists in *Editor & Publisher* of the art reporters or critics on newspapers and magazines—and so on, and gradually built it up.

Invitations to nominate names for possible grants were first sent out in 1958, to "all the people that we can learn about who have some kind of identifiable position in the field or reason."

("We do not appoint a standing committee and say, that's a standing committee for fiction, that's a standing committee for poetry, that's a standing committee for theater," Lowry had said, and had explained that they wanted neither to create their own cliques nor to fall into the hands

273

of an already existing clique. Lowry said, "I remember going, before I had the program, I just had it on paper, it was before the board approved, to Henry Moe, at the Guggenheim, and Henry explained all the reasons to me why he had these standing committees, and I explained all the reasons to him why I wasn't—he explained all the reasons to me why he took direct applications from individuals, and I explained all the reasons to him why I was *not* going to take direct applications—I was going to use the nomination system and then have the nominee fill in his own statement of purpose or application. And at that point I didn't have as much money as Moe in my budget, and we agreed that it would be good if he worked one way and I worked the other—it would give more variety.")

He gave as an example the first selection of painters and sculptors:

We invited nine hundred people in the United States to nominate for that. And they were painters and sculptors, and critics of painting and sculpture, and museum directors, and curators, and heads of university departments in painting and sculpture, connoisseurs and collectors, and so on.

Nominees were then asked whether they wanted to submit work and be considered, "and they would say yes or no. Then later we created a jury in that region, at a collecting point," Lowry said.

We knew by then directly or through consultation a great many artists and curators in various parts of the country, and we'd go over long lists of those, and we'd get on the phone and talk about what kind of person he was and how objective and reasonable, judicious and so forth, and we attempted, in selecting a regional jury, not to get people whose tastes were known to be all of one school, and then draw up a letter and ask them to serve as a juror. . . . [Two members of the national jury of five] sat with these regional juries so that they'd have something to talk about when they came back to the national jury. . . . And then it all came (what had been screened) in to New York. There were thirty-seven hundred works of art moving around the United States that year, in order to make that selection. Of ten people.

How could those two jurors spend the necessary eight to thirteen weeks going around the country? Did they not have careers? Or were they Ford Foundation people?

Oh, they weren't Ford Foundation people. We don't *use* Ford Foundation people in selections. Not even myself. No, they were artists. [They could afford to give that amount of time] because they believed in what we were doing, and they wanted to cooperate with us, and because it was a very exciting opportunity for them. Suppose I said to you, you

know—if you were interested and I'm sure you are—in painting and sculpture—you'll get to see what qualified as the best work going on in every region in the United States right now, and you can see it all in a space of eight weeks. This would be quite a thing in your education. [They were paid] fifty dollars a day and their travel expenses.

Now, when it was all over, the *Art News*—Thomas Hess—said, "They came out beautifully, but why did Lowry do all that? He could have got me, Alfred Frankfurter, or Alfred Barr, or anybody—we'd have come up *almost* with the same list." And they would have. But I wanted to be sure that everybody had been looked at. And I wanted to do what I call "keeping the pores open" and I wanted to be sure that the grass roots had been traveled.

Lowry and one or two of his staff spent much of 1957 and 1958 traveling throughout the United States exchanging information, as he put it. He was concerned with all of the arts. During open-ended discussions, he repeatedly asked such questions as: "What are your problems?" "How did you evolve?" "What has your training been?" "What are your objectives?"

You don't have to know [people], you see [Lowry said], if you begin to develop a foundation program. Coming out of the Ford Foundation, you can talk to anybody. And I remember once talking to Brooks Atkinson [about theater] in 1957. . . .

I was going to begin an exploration of all the people I could find, so I wanted to ask him where and who, and I asked everybody I met, this is how the network grew. But I wanted to ask Brooks too because he was the only critic in New York that had ever been outside. No other paper and very few of the magazines afforded any travel money. The *Times* did. Brooks had been out, though not far. I soon outdistanced him—well, I outdistanced him in the first six months—but he's been. So we talked about New York and then I said, "Well, what about out of New York?" and he concentrated on two people, three theaters, and then we mentioned a fourth. He concentrated on the Alley and the Arena: he mentioned Margo's theater, which was still going in Dallas with a new man. And we talked about the existence of the Actors' Workshop in San Francisco, which he had not then visited. And of course we talked about Paul Baker, who had got a lot of publicity out of Dallas, but with a non-professional theater. And he said that the people who will commit themselves to doing this thing, with this terrible compulsion to create a theater company and try to make it pay in this little town and still pay professional actors, "they have to be crazy," he said. "And they are. Look for people," he said, "who are hopefully crazy." I've never forgotten that combination of the adverb and the adjective.

Mrs. Thompson helped to make up a list of those cities which contained "a complex of institutions—a museum, a symphony, a theater. And

the initial schedule," she said, "was made to those cities where you combined a number of activities in the arts."

"I started out," Lowry said, "and I went across the country in successive trips, sometimes four weeks, sometimes five weeks at a time, I kept asking everybody else, you see. I'd ask about Nina Vance. I got to Baker in Dallas. Well, he didn't think there was anybody outside New York except Paul Baker, and I had to ask him about Nina—he knew about Nina Vance, but I had to ask him about her. 'Oh, yeah.' But 'her repertory wasn't much,' and he didn't think I ought to waste my time going to Houston. Well, I was already booked to go to Houston. I was going everywhere."

The over-all program was developing day by day in Lowry's mind as he coordinated the information he was receiving. Mrs. Thompson said, "The theater was no more important initially as an area of activity than anything else. It seemed, as we went along in interviewing, to have certain problems that we could focus on at a particular level."

Lowry said:

One of the interesting things about what little philanthropy from organized foundations there had been in the arts, which had been on a kind of *ad hoc* scattered basis, Rockefeller a little bit, Carnegie a little bit, and the Mellon Foundation—had left the theater pretty much untouched. There were a few general block grants—fifty or a hundred thousand dollars—to existing theaters, and that was about the size of it. The only focused kind of interest that I knew anything about when we got approval for the Ford Foundation program in the humanities and the arts was that Mr. Stevens, who preceded Mr. Fahs as head of humanities at Rockefeller, had supported a book by ten theater directors, academic, community, and professional. And this was about what there was by 1957.

The little-theater movement had spawned a magazine—which was up and down—*Theatre Arts*. The American National Theatre and Academy had a thing called "The National Theatre Service Department," which was headed successively by two very organized women, and this was useful to theaters around the country, whether academic, community, or winter stock—professional—in suggesting names and places where they could get costumes in a kind of mail and telegraph communication, and this was all.

Theater was thought of generally—it's remarkable what changes have occurred because I'm talking only about 1957, which is really not very long ago—but we seemed to be the only potential source of support who did not think theater was all about commerce or entertainment. And Broadway, of course, was the center of commerce. Off-Broadway was just beginning to make its statement, had made a certain statement—

largely blessed by one man—Brooks Atkinson—because if he had not paid attention to it, very few people outside the theater would have known that it existed. He dug himself squarely around in those holes and basements downtown—he really almost singlehandedly helped express this movement.

In the country there were a couple of places that had made an Equity-actor production on top of a little-theater movement—the little-theater movement going back, of course, to the twenties and thirties. The efforts to start cultural, non-profit theaters with a significant repertoire had all failed. The Eva Le Gallienne Civic, the Group Theatre ending up in the Actors' Studio, and so on. And the Cleveland and Pasadena Playhouses represented the older development on top of the little-theater movement and some effort to attach a training school. This was the whole situation prior to World War II, and after World War II what you had was "now you see them, now you don't." An average of ten to twelve so-called winter stock companies—these are borrowing Equity's technical terms for their contracts—and these companies rose and fell financially. Their existence was about like the existence of stock, except that most of them were tax-exempt with a charter and had, therefore, a board. They were outnumbered by hundreds of community theaters that are avocational playthings for women in a community largely, and just good fun, and some of those were very successful financially. But after the war, for a reason that is very difficult to understand, three women came along and successively moved through the community and Equity Z, which is the least burdensome of the Equity contracts, to a winter stock contract, and had boards because they needed the board for tax exemption, and they helped to raise a little money, but didn't really raise much money—and the boards really just blessed and went along with the creator, the originator of the theater.

Why these three were women, and why they all went into the arena form, is a very interesting thing to speculate about, and some people have really speculated about it, even in Freudian terms. Perhaps for a woman, next to creating a child or maybe even greater—I don't know, I'm not a woman—than creating a child, is to create her own physical environment in a dynamic group of people and have it identified with her. This must be about the ultimate of creativity for a woman, I would think. Margo Jones indeed was the first of these. Margo had two ideas—one was the arena form, though she didn't invent it; the other was new plays. Margo was a great promoter of everything, including the playwright, more than she was a director and even more than she was a producer. . . . Well, I'll tell you what happened in '57 as soon as we got the mandate for this new program. . . .

Lowry said, ". . . I soon began to sort out the difference between a community theater and one of these winter stock companies if they were well led, and I soon began to realize that the first priority—which I had

already announced theoretically and intellectually in that little booklet—
for the Foundation was to extend the opportunities for the professional.
So the community theater I just covered as I would make a survey—I
spent a lot of time with them—but I was also trying to see what was
the difference. For example, could a community theater that had the right
direction leap to be, as Nina Vance had done, professional theater?"

Had Lowry come to any conclusions early on about that? "Yes. It
all depended on who was doing it," and here he laughed a little.

Lowry's vision of the future was to some extent modeled on an epi-
sode in France described to him by a participant:

> When Lugne-Poe came to Paris [Lowry said], and was succeeded by
> Pitoëff, there was a whole crew—Lugne-Poe, Pitoëff, Baty, Dullin, Jou-
> vet—who, without any more money than twenty years later the Alley
> Theatre had for a production, put on so many new plays and so many
> new productions of contemporary plays (they were responsible for the
> first production of Pirandello in Paris) that all the writers—even those
> who should never have been playwrights, like Gide for example—*and*
> composers *and* painters (I happened to meet one, Andrew Girard, who's
> now an American) said, "Well, if they're chewing up so much material,
> they may use some of mine," and the whole of the visual, literary, and
> musical arts for about ten years was set toward the theater.
>
> But they *didn't* have any more money. They had just the same hard-
> ship situations as the U.S. groups I was now looking at. And I remember
> once that Pitoëff had to go down South with some wealthy woman to
> do something she wanted him to do, to get a little money, and he got
> it in advance and sent it back up to Paris so they could go ahead with
> the rehearsal. This was how they scrabbled. Just the way Vance and
> Fichandler scrabbled for some. So I thought maybe *someday*, you know,
> we'll have permanent small institutions like this in the theater which
> would be a counterweight to this hit-or-flop economics on Broadway and
> at least encourage the serious actor, director, playwright, designer, with
> the collaboration of the artist and the poet. Now, I've done something
> for each of these leaders, and all of it pointed toward this. I'm well
> enough educated, I guess, to know that just because you could do some-
> thing at one time in one country doesn't mean you can do it at another
> time in another country. But the French precedent encouraged me.

In 1958, a so-called communications theater conference was held
in New York, and to it came directors from all over the United States
who had never met one another. In addition, four theaters were made
part of a program of support for ensemble work outside of New York
City: the Alley in Houston, Texas; the Arena Theatre in Washington,
D.C.; the Actors' Workshop in San Francisco, California;[1] and the "then
existing Phoenix, which was not typical."[2] Lowry came to be regarded

as being "about" decentralization, wanting professional theater to be not just in New York but rooted throughout the country. But in reality he was simply putting his efforts where artistic leadership existed, regardless of decentralization.

"Well, that was a fascinating period for us, of course," Mrs. Thompson said, "and we were being very, very careful about documenting all of these interviews because we thought we were going to have to file with the trustees a report about the economic and social position of the artist, and on the basis of that report they would decide whether the program would become a permanent avenue for philanthropic activity in the Foundation. As we went along, it was evident that the trustees were not only entertained but were enormously interested in the field."

To what extent would the financial revitalization of artistic leadership throughout the country make a difference in the lives of others? People like Gordon Ray, president of the Guggenheim Foundation, were pessimistic. Speaking of academic theater, already decentralized but inward, he said:

> Before I came to New York, I was a professor and latterly provost for fourteen years at the University of Illinois, where there was a vigorous program of theater and music, and I had the feeling that it touched a relatively small part of the academic community and the surrounding town community hardly at all. So it's a little hard to say whether the impact has been great or not. Urbana, which is an isolated town in central Illinois with nothing at all within a hundred miles of any interest, provides ideal conditions, really, for this sort of development. But even there this hardly affected the lives of most people. They tended to rely on going out of town or television or books. The program in the arts, in music and theater, was not really of any great significance in their lives.

Sandra Schmidt, previewing a Twentieth Century Fund report in the *Tulane Drama Review* in the fall of 1965, found that only 2 percent of the population was regarded as potential audience for live theater. (Lowry commented that even before 1965 this was wrong.)

What Lowry got into in the way of content was more or less accidental. That is, the Ford Foundation in theater (or other arts) supported talent and leadership freely, without dictating repertoire. But timidity, or avoidance of controversy, on the part of foundations, including Ford, did occur—because generally their actions as agents of change were subject to review, and possible subsequent restriction, by the Congress of the United States; because their boards were conservative, as men of position and wealth tend to be; and because, more specifically, the Internal Revenue Code prohibits tax-exempt groups from using a substantial part of their monies for propaganda or to influence legislation.

However, the consequences of grants that are given for particular purposes cannot always be foreseen. Nor can the reactions to grants. Are the following examples of timidity and caution?

Item 1: In 1967, Lowry's division gave $434,000 for the establishment of a black theater in New York, a move long planned as part of the work begun in 1961 to fill professional gaps. McGeorge Bundy announced that the "Negro problem" was America's most urgent, and the Ford Foundation was accused of a willingness to support "black activist separatists." "We have worked both in integrated and separatist black theater movements," Lowry said, depending only on what suited the philosophy of the black artistic director.

Item 2: When the Ford Foundation funded pilot programs for the decentralization of New York City schools, chaos resulted.

Item 3: A voter registration drive was seen by special-interest political groups as interference.

Item 4: In 1967, the Ford Foundation financed with $160,000 a two-year study by the Association of the Bar of the City of New York of "the ethical standards and conflict of interest" in Congress.

Item 5: The Ford Foundation supported the Congress for Cultural Freedom, which supposedly existed to promote the exchange of views between intellectuals in all parts of the world but which seemed to be promoting anti-Communism and did in fact receive CIA funds.

Waldemar Nielsen's Twentieth Century Fund report[3] noted that about 8 percent of Ford Foundation grants could be called "experimental or activist" with comparable figures of closer to 1 percent for most of the large foundations. Bundy's support of controversial projects may have provoked more drastic action on the part of Congress when the Tax Reform Act of 1969 was passed than might otherwise have occurred. This could be regarded as either a failure on his part as president of a major foundation or an incidental by-product of what were otherwise important actions. Foundations as agents of change *were* controversial, and since they existed because of the tax laws, therefore having a quasi-public character, they could relatively easily be held to account. The Tax Reform Act, in which a 4 percent surtax was levied, was certainly regarded by some foundation people as indicating little support for their work or public understanding of it. Lowry noted that it did not give the author a break, only the people who owned his papers; nor did it give the painter a break, only those who speculated on his paintings after buying them. "Now that's got to be changed," Lowry said, "and the new foundation is going to help."[4] "Nonpartisan, objective studies" don't count as lobbying unless they are all about a particular bill that is in the hop-

per, he said. The foundations were going to move more into advocacy questions about the arts—make grants having to do with the legal rights of the artist and his work and the perpetuation of those rights.

Of the Ford Foundation's entry into the field of the arts, Lowry was later to say that it had "changed the whole nature and principles" of their support. Lowry said, "It was not any secret to me what the little start of that program in 1957 might mean on a national basis—even about its effect on the so-called culture boom, its effect on what the government might do, on changes in the whole form, institutional form, in several of the arts. This wasn't hard to anticipate. It's just, you couldn't divulge it, or talk about it, you know—because it was still dream and plan." Lowry said, "This work is . . . a little bit like casting a stone in a puddle, but precisely which stone and precisely which puddle and for precisely which effect [is] the real creative part of it."

The decade following that start by the Ford Foundation was one in which "new financial resources for the arts, while tiny, have been greater than at any time before," Lowry said, and "in this very decade these financial resources have equally blessed the amateur with the professional, the pretense with the craft, the sham with the substance."[5] In the first fifteen years of its existence, the arts and humanities program granted approximately $240 million, and Lowry quickly became a controversial figure. Gordon Ray pointed out that the grants Lowry developed in dance had been

> bitterly resented by a large part of the dance world. They can be defended on his thesis that you pick the really superior professional and back *him* to the hilt. But what happened there with his large grant to the City Center group has, of course, caused an immense imbalance in the field that has had a severely hampering effect on the other dance troupes. But I would say that most people would agree that this was probably the best thing to do if you wanted to put big money into choreography.

But a few years later, Lowry commented that "the Ford Foundation ballet program covered not only the New York City Ballet but every professional ballet company in existence except the American Ballet Theatre, which had more money than any, and in 1972 has the biggest annual budget of all, $4,100,000. The 'bitter resentment' was felt by the modern dance companies, which engaged in more activity in 1971–72 than ever in their history."

But in 1967 Roger Stevens, at that time chairman of the National Endowment for the Arts, could testify before Congress that, unfortunately, "the past two years' experience offers strong evidence that the financial crisis facing the arts is rapidly becoming more acute." And

JACK MITCHELL

*"Festival of Dance—For the first time in history modern dance will
have a full season of performances, made possible by a Ford Foun-
dation grant. The series, presented by the Brooklyn Academy of Music
and Theater 1969, offers programs by twelve leading companies.
Some of the choreographers participating are, in the foreground,
Twyla Tharp, Martha Graham and José Limon and, in the back row,
Merce Cunningham, Erick Hawkins, Paul Taylor, Yvonne Rainer and
Don Redlich." From* The New York Times, *Oct. 20, 1968.*

Lowry, in 1970, said that even if he could disperse to the arts in that
year over twice the amount of money he regularly had at his disposal,
the Ford Foundation still "would not be coping with all the legitimate
needs of this country's art institutions. To accomplish this, we would
require a total fund of $125 million this year alone."[6]

Financial problems, paradoxically, were coming from success. For
instance, in that same period between 1957 and 1969, the Ford Founda-
tion had delivered $86 million in funds to symphony orchestras in the
United States, as their largest single contributor. By 1969, there were
1,400 symphony orchestras, 88 of them with budgets over $100,000—"a
development that cannot be matched anywhere in the world," said Amyas
Ames, president of the New York Philharmonic.[7] In 1965, the American

Symphony Orchestra League had reported that as of the beginning of that year there were in the United States 25 major (annual budget $250,-000 or more) and 33 metropolitan (annual budget between $100,000 and $250,000) orchestras; 287 college and university symphony orchestras; 300 youth orchestras; 470 community bands; 1,060 community symphony orchestras; and 1,600 industry-sponsored musical groups. But apparently more than half of these had come into being only during the preceding ten years. And by the end of the sixties, mergers were being discussed as a possible solution to funding problems.

THE LIVELY WORLD
by Milton R. Bass

There has been a great stirring in our state capital of late because some citizens, disguised as critics, dumped a bunch of musicians in the harbor after refusing to pay a homage tax. The musicians declared war and we are now embroiled in a revolution that has been dubbed "The Boston T. Party of the First Part versus Secondary Figures and Sundries." It's not much of a title but then it isn't a very big war.

It is not well known that Tanglewood is not the only place where the Boston Symphony Orchestra holds concerts. It also plays a few in Boston in a fortress called Symphony Hall that is guarded by little old ladies who played tennis with Chopin and Brahms in their younger days.

The critic for the *Boston Globe* is named Michael Steinberg and he writes sharply about flats. So sharply, in fact, that a steady rage has been building among the musicians, management and trustees of the Boston Symphony. Mr. Steinberg, however, has a loyal following among young adults; the *Boston Globe* has a strong sense of integrity as well as a strong bank balance; and there has been no diminution of his candid appraisals of BSO concerts, personnel and guests.

The music critic for the *Boston Herald* has been a young man named George Gelles, who cut his teeth under the tutelage of Mr. Steinberg. He is not as acerbic as Mr. Steinberg, but being a Princeton man, he does have his moments of stark truth. He has not had time to build a loyal following, the *Boston Herald* is not as secure as the *Globe*, and as a result Mr. Gelles is no longer music critic for the *Herald*. Mr. Steinberg, in a white paper to the press throughout the country, said that Mr. Gelles had been sacrificed as a result of pressures brought on the *Herald* by BSO trustees, some of whom also happen to be ad-

vertisers. The inference all around is that the BSO tried to "get" Steinberg but settled for Gelles.

Symphony orchestras right now are in the throes of disintegration. The Ford Foundation grants of a few years ago, which supposedly were going to put them on a secure basis, have only succeeded in putting the symphonies in a more precarious position. The musicians, who had been grossly underpaid for years, demanded and got substantial raises. This ate up most of the grants. Meanwhile, other costs were skyrocketing while Symphony Hall remained the same size and, consequently, could not take in much more income through tickets. Unlike other corporations, the BSO could not become a conglomerate that would increase its income from subsidiary companies. People started talking about the end of an era.

This made the musicians nervous. Musicians are nervous to begin with, middle with and end with. They like everybody but they do make exceptions of those who do not think they are the greatest musicians in the world. They are nervous, excitable and tend to brood. The problem is that like everybody else in the arts, they have a great deal of time to brood. Even while they are warming up before a concert, they are sitting there staring into space and hating the man in the chair ahead, the chair on the side and the chair behind.

They never read critics because critics don't know what the hell they are writing about, and they will quote you word for word from any review that has mentioned anything to do with them. Therefore, even though they never read Messrs. Steinberg or Gelles, they know every knock these two have delivered and they want apologies and revenge and blood and good reviews in the future.

The pressure has been building for a long time in the BSO as Munch retired and Leinsdorf quit and Steinberg (the conducting one) took over as interim pope. The orchestra is all mixed up as to where the future lies. They want a loving father of a conductor who will take over all the responsibilities and keep them safe and warm and protected. And they don't want any critics yapping at them about their musical qualities, which they are somewhat unsure of themselves right now.

And the little old ladies, the ones who have been going to Symphony Hall every Friday afternoon since time began, want their music like the tea they order from S. S. Pierce— exactly the same as it always has been. They don't want any nasty critics carping about Brahms and Beethoven and Mozart on the programs. They don't want any bing-bong-bang music

or any wild young conductors. They want the BSO led by Richard Nixon.

The trustees and management are worried about where the next dollar is coming from, and they don't want any dissonances from the sidelines. Everybody agrees that a symphony orchestra is a great thing, so why endanger it with adverse criticism. We should all pitch in and carry on and pip pip, the orchestra forever.

Meanwhile, back at the newspapers, the critics are worried about their bosses backing them up and their integrity. Critics aren't allowed to deviate from perfection; they must always be balanced and good and right. Right means writing reviews that the people being reviewed approve of. Which means writing complimentary reviews. Because no matter what they say, people being reviewed only want nice things said about them.

And that's how the situation stands in Boston right now. It's a tempest in a teapot to everybody but those intimately concerned. To them it's a war. And in a war people get killed.
—*The Berkshire Eagle,* December 11, 1969

What had upped costs in that field seems primarily to have been an attempt to supply a decent wage to musicians on an annual basis. On March 10, 1970, *The New York Times* discussed the situation in a long article:

A key factor has been the drive by orchestral players for higher salaries, improved fringe benefits and longer seasons. Threats of strikes by union negotiators have been frequent, and in the last three years there have been strikes in Chicago, Cleveland, Baltimore, St. Louis, San Diego, Cincinnati, Washington, Rochester and Kansas City. . . .

The musicians and their union representatives argue that even with longer seasons and higher salaries, their earnings in some cities are far below standards for professionals in other fields. Thus in Rochester the minimum annual earnings are $7,560 a season and in Indianapolis $5,775 a season. Even with occasional extras and with additional jobs such as teaching, musicians complain that they do not earn enough to support their families, let alone provide money for such essential extras as their children's higher education.

. . . American orchestras [the president of the American Symphony Orchestra League said] have virtually been priced out of the record-making field, thanks to the last contract negotiated by the American Federation of Musicians. Only the New York Philharmonic and Philadelphia Orchestra and possibly the Boston still derive substantial income from new recordings. Some orchestras, eager for the prestige of

being represented on disks, actually underwrite the cost of making records, thus increasing their deficit.

The difficulty, said a Twentieth Century Fund study,[8] came not from inflation or from union practices but rather from the economic structure of live performance. Baumol and Bowen stated, in their report, that deficits of increasing size were to be expected not only in the case of orchestras but also in such other areas as the dance, theater, and the opera.

Roger Stevens by the end of the sixties had decided that "among the principal villains responsible for the arts' financial problems are the foundations, which, according to statistics, give less than 4 per cent of their total income to arts programs."[9] (The foundations were to *blame?*) It was entirely possible that what Lowry called the socio-economic interests presently involved with the arts would not continue. Congressman Frank Thompson even late in the sixties could say that he had not made up his mind "about the extent to which the [federal] government ought to spend money on the arts and humanities, or where, or how." If another depression came along, would someone be able to say years afterward something similar to Stevens' comment that "about 80 percent of the painters and sculptors who gained world recognition in the 'forties and 'fifties were supported during the Depression by government funds—not to develop art but for sociological reasons"?

We have seen that Lloyd Goodrich felt it cruel to take on the support of artists only to drop them. Foundations, he complained, "are apt to think up a project which they want to have executed on an experimental basis and then not continue it." Was it the function of foundations to provide "seed money" or "venture capital"?

> Because foundations want to maintain flexibility in their programs, there is a reluctance to provide funds for making up a deficit or for general operating expenses. There is the fear that annual contributions to general operating expenses would make the performing arts organization the ward of the foundation, discouraging it from developing support from other patrons, and also tying up foundation funds.[10]

Indeed, once a foundation had contributed for a certain number of years to a cause—for instance, to Channel 13 (WNET) in New York—its contribution began to seem not an unexpected benefit but a right, no matter how much in philosophy that foundation might have talked about seed money and not continuing support.

Could the Alley Theatre, with the construction of its new building, become self-supporting through enlarged seating capacity? Lowry made three points: "(1) No non-profit artistic performing group would ever be self-supporting from the box office. (2) The jump from 214 seats to 1,000

would help the Alley gain more funds for professional and artistic expansion, while (3) broadening the public (small gifts from individuals and state and federal) support for the Alley."

The federal government had indirectly provided the chief support for the arts through income and inheritance tax provisions in the Internal Revenue Code that provided incentive for individual private patrons. Direct aid from the government had begun in 1965 with the passage of the National Endowment legislation. In 1970, a year in which the federal government gave symphony orchestras and opera companies some $706,000, testimony before Congress stated that symphony orchestras in the United States were "starving" for funds.[11] No matter how much foundations primed the pump (through matching grants and by other means), they were not going to be able (and undoubtedly would never want) to provide or alone stimulate the flow of dollars necessary to support the arts. And the difficulty with seed money so far as the performing arts were concerned, said Baumol and Bowen,[12] was that

> as an organization reaches a stage of administrative stability and becomes a mature and well-established enterprise, its income gap may well grow all the more rapidly.

They cited the Metropolitan Opera and the New York Philharmonic as examples.

On its face, the situation seemed to be: the more funds available, the greater the growth, the more the deficit. However, much of the new activity was on an amateur level. The difficulties with which we should deal, Lowry believed, were those of the full-time professional practitioner. The shortages, for example, were not of string players but of good string players.[13] The Ford Foundation program was consistently pointed toward the development of the professional. It had not, said former president Henry Heald, been pointed toward "art education or the thin layers of art appreciation for everybody." Lowry believed that the real shortage, "much more than money," was of artists and artistic directors, and that even if they "could be identified in sufficient numbers," which he doubted, it was like asking them to become "candidates for Calvary."

Lowry spoke of the more subtle, unexpected effects of grants: After ten years of the Ford Foundation program, he said, "everything in the arts was being affected by the heavy toll and erosion of personal vitality on the part of artists in useful and key positions and primarily those artistic directors who have to build and control protecting instruments for the artists' outlet." It seemed to him,

> the most meaningful communication, in the highest sense educational, for the public about the creative and performing arts was not through

showing the latest novelty, the latest repertoire, the latest production of any kind and just picturing it, but to get inside the lives, even on a very pedestrian basis, the vocation. What is the vocation? What does it look like? How do you get inside to show that? Perhaps the easiest place to show it is a small group in the performing arts led by somebody who really is motivated and capable of professional standards and aesthetic standards.

Now before the last decade . . . you had the artist and the artistic director either content or not content but going on pretty much in this small dynamic organism, the theater company or the self—committed to doing this and so rewarded by that. And nobody was coming in and saying, "Don't you need more?" or "What's your problem?" So the artist and the artistic director in effect subsidized that art themselves by small salaries and ignored positions. And they had therefore some of the cohesiveness that comes from being ignored. . . . They might not have liked the fact that they were personally subsidizing art, but they were: What could they do?

Then something changed and it changed perhaps in the most comprehensive and organized way on account of the Ford Foundation in 1957. People here went out and, though they didn't at first give grants to these things, said, "We want to know you. We want to know what your problems are. Where do you get your money? How do you feed the development of theater? Where do these people come from? What do they talk about?" Somebody cared, and he represents an institution that potentially might care a great deal—even if they didn't put new resources into it. And other agencies were stimulated, and the work of the Foundation, particularly when it came to making grants, levered the very people around who had never known where the Alley Theatre was. We put a stamp of approval on it and began to give it money right there in their own community. They could have put their own money into it before, but they were not catalyzed, as they were later by the general press and socio-political forces that said, "You've got to fix up the arts in the United States."

. . . [Artistic producers] had to think about "Where does this move us to the next phase?" and in moving they took on costly activities that they had ignored before. And by the very fact that interests were growing, so were they creating their own inflationary pressures. The actor that would have come out before for seventy-five dollars a week now wanted three hundred dollars. In a very short period of time this is what happened. So in order to get that, producing artists had to worry about their subscriptions or worry about taking on other activities. And yet the total absolute number of people able to do this and guide this did not grow in the same proportion.

So they were stretched. And some of them were even shrewd enough to say in advance of a grant, "You're going to stretch me, aren't you?" I'd say, "Yes, I'm sorry, that's an inevitable consequence of this." . . .

Everybody now who had any really significant potential to meet a standard could perhaps be given a chance to stretch. They were already working on a twenty-four-hour day. How could they work any more? But the effect of this is that even more than in '57 or '59 or '60, the people I deal with, because I continue to deal with all of them long after a grant has been given, are tired.

One of them said to me two weeks ago (I wish I hadn't heard it because I've thought too much about it since and I'm afraid there's a real psychoanalytic validity in it), "Sorrow is just another form of anger." And these people often now are full of anger, both at where they're caught up but also at the same things that anger me and that you and I are talking about. They see millions going into the arts, but not to them, not to the people, not to the artist, and they think what they could do with that and they're angry. This is one reason that Lincoln Center as a whole has such a bad name among artists, not just directors. . . . Now, actually, if you listened to some of these conversations and you were not as perceptive as you are or you were just listening to one of them and seeing it aimed at me for the first time and you and I didn't know one another, you'd say, "What an ungrateful person."

"They're complaining about being given too much money. It must be interesting."

Right, and they're also complaining about not being given enough, because it's never enough to take away this horrible muscular and emotional fatigue that goes along with trying to stretch, you see.

The number of artists working, or the size of the audience for that matter, does not establish the meaning of art but indicates aspects of culture. Nor do the funds available for the arts change the possibilities of art. Prosperity aids us in more easily meeting physiological needs, presumably releasing our attention to other kinds of needs. But the motivation of artists remains imperfectly understood, and adequate support may or may not make their lives more comfortable without basically changing their work.

A psychologist[14] described human needs as ordered: (1) the physiological needs; (2) the safety needs; (3) the need for belongingness and love; (4) the need for importance, respect, self-esteem, independence; (5) the need for information; (6) the need for understanding; (7) the need for beauty; (8) the need for self-actualization. Citing these, another psychologist argued that "the most direct way to develop a life at a higher need level is through adequate gratification of the lower needs. It is true that some exceptional persons have achieved such a state by suppression and sublimation," continued Roe, "but these are exceptions, and it is very doubtful that a higher level can be reached by asceticism than can be reached by gratification."[15] She added that "this order of potency is usual

but not invariable for all persons," and that where self-actualization had
become effective, "it seems to organize and to some extent to control these
other needs." The argument for frustration as motivation for achievement
is only hinted at here by that last sentence, but elsewhere she wrote:

> Study of the individual lives, however, makes it clear that this profession
> [of artist] does satisfy emotional needs for most of the men which have
> not been satisfied in other ways, and gives us a clue not only to the
> meaning of creativeness, but to the meaning of all work activity.

Could it not be argued, perhaps particularly for artists (an occupation
unusual by statistical definition), that effective self-actualization provides
for such satisfaction of those other needs as had been missing—including
belongingness, self-esteem, independence, information, understanding, re-
spect, beauty? Certainly Lowry believed that what happened

> to make many people choose and find a vocation in one of the arts—it's
> not the same in my opinion in all of the arts, I've been trying to distin-
> guish among them—in one of the arts is a product of their emotional ex-
> perience and even, in many instances, of emotional deprivation.

Whatever the *artist's* motive, Lowry thought those who *supported* the
arts might do so for any of five reasons—status, social, educational, eco-
nomic, and professional (which meant accepting the artist and the arts on
their own terms)—and that four of these motives for patronage were
wrong. "I've seen cases," he said, "where the giving of money to an artist
or an artistic director to *do* something has diminished or frightened or
worried or weakened that person. Because the motive and the understand-
ing about why it was given was wrong." He said he meant "that their very
past and everything they did to get to that point has been misunderstood,
falsified, and swept up, in some general label or general action, uninformed
action—cynical action. Now I can't blame this any more on arts councils
than I can blame it on a lot of other things, but it's all in that area."

Lowry argued that when that happens the arts become talked about
and fed as a commodity, and he cited two cases of the sort of thing he
meant:

> There's a man right here in New York: he's one of the virtuosi—probably
> one of the two or three greatest virtuosi of the violin—his name is Isaac
> Stern. And Isaac can live in any role, as he has done some very, very
> good things, and for the right reasons—and where he's been able to get
> things done for the right reasons, he's done them. And when he's been
> able to get things done for the wrong reasons, he's done them. He doesn't
> care where it comes from, or what the understanding is, or what the
> motives are. It hasn't hurt his performance on the concert stage a bit.
> It has diminished him six cubits with his own kind. Even though he's

done things for them, his cubits have been diminished by this. Now that's one kind of example. Look, I'm perfectly ready, willing, and able to give money to the good things Isaac Stern wants to do if I understand them and if it's good and he wants it, and so on, because he's smart. He's one of the really focused, driving, intelligent people.

Now there's a man on the other side like Rudolf Serkin. So what should he care—Rudolf Serkin? He plays the piano for a fabulous price: as long as his health holds out he can lead his own life, if he wants to. He can do that thing at Marlboro really for fun but also because it *does* help those other professional musicians but also because he just *loves* to see music made under those informal circumstances. He's a *very* discriminating man, a very intelligent man. But he's not an operator, and he's never lost one cubit of admiration by his peers, and he didn't save Carnegie Hall or do any of the other good things that Isaac did, and he wouldn't have been capable politically of knowing how to do that.

All artists worried about support, Lowry seemed to be saying, but in an ideal world it would not be necessary for the artist to scorn the patron, as Roszak had scorned Stanton, because the patron would understand.

. . . Now the more specific kind of example is what happens to somebody who runs a group activity and they're given something on a purely social basis. Well, if it's just that, they accept this from the ancient days of court patronage, and so forth. But then they have to *pretend* that this person also knows what is going on and shares the director's [or artist's] motivation. As soon as the director's motivation is the same as the patron's, they're diminished.

And finally then you get a great constellation with seventeen million dollars—seventeen million dollars annual budget—like the Metropolitan Opera—where art is created very rarely and only by accident, and where *every* force that I'm talking about comes to bear. And a lot of money, from my point of view, is wasted.

Appropriate support for the arts does not come, Lowry said, from the person "who regards any activity in society as something to be absorbed with and something to find a place in and status in, and then finally to manipulate power. This is the kind. Hangers-on. Noah Greenberg[16] used to say, 'My God! The hangers-on! The parasites!' Barnacles, you know, on the artist and on the arts."

CHAPTER 15

OUR ATTENTION IS DISTRACTED

(*The culture industry*)

THE DIRECTOR OF the Associated Councils of the Arts, Ralph Burgard, said:

> I disagree violently with [Lowry] on a number of issues but I can't help but respect his devotion to [his] convictions. Some of them I think are almost too simple and too naïve in a sense in a very complicated area but still and all I think his insistence and emphasis on the artist in an era of institutions, and increasingly sophisticated institutions, is a good emphasis. There's a lot of it balanced out by other aspects.

During the fifties and sixties, mediating elements had sprung up in American society not founded on but quickly justifying their existence as making those large-scale institutions of which John Gardner and so many others spoke (and which included the federal government) more hospitable specifically to the artist. The benefits such elements bestowed on those involved, with the exception of the artist, were indubitable. What other aspects balanced out emphasis on the artist? Problems of financing, of audiences, and of administration? Which way should the pyramid stand —shakily balanced on its point (art) or "right" side up, with arts institutions imagining themselves as supporting and justifying the artist rather than finding his work the basis for their existence? The pyramid, placed in its correct position with regard to gravity, seemed most natural to these more spohisticated and more organized hangers-on. These arts institutions were not funding agencies—either the old ones (the museums, orchestras, resident theaters, etc., all of which had to be managed) or the new ones.

Alvin Toffler refers to the culture industry that is devoted to producing or distributing the goods and services of artists.[1] Russell Lynes noted that "the attitude of artists and writers and composers toward the entrepreneurs who handle their work varies, as might be expected, with how successfully their works are sold."[2]

But the possibility of an audience and the need to be understood were not quite the same thing. "By and large," Russell Lynes wrote, "the artists do not think that they are understood by nonartists, and, by and large, they don't see why they should be; they are happy to settle for being allowed to do what they need to do." Being allowed to do what they needed to presumably meant being financially supported and let alone.

A new organization, the Associated Councils of the Arts, stated as its purposes:

1. the coordination of state and regional activity in the arts;
2. service as a united public voice for the arts; and
3. the administration and supervision of funds for the arts.

They had expected some of these funds they planned to supervise to come from the Ford Foundation. But they received none.

The mediators, as a "united public voice," took it upon themselves to decide who should be involved with the arts. "At first," said John Mac-Fayden, at that time president of the Associated Councils of the Arts, "we refused to allow just anybody to be involved with our programs, but later on we finally realized it was necessary."[3] He reminded one of the old aristocracy in America, with his sense of privilege. (This feeling of elitism may be the prime motive of the patron in the arts—even for those who are handling the funds of others.) MacFayden had been a practicing architect —had designed the Saratoga arts center. He had been to congressional hearings on the National Endowment which had been presided over by Frank Thompson, Democratic representative to the United States Congress from New Jersey. MacFayden told me quite frankly that he had gotten an impression of Frank Thompson as someone who had little to do with the arts, whose involvement with them was a matter of political expediency.

MacFayden said he believed "good art was what was understood and bad art was what wasn't" and that in the case of the latter, he supposed he shouldn't call it art at all. A strange definition. MacFayden said the question had been whether the arts councils should permit participation on the part of people who didn't know what art was.[4] I supposed he meant the likes of Frank Thompson (Thompson, said *Fortune* magazine, would have been a credit to any U.S. Congress ever convened), but I forbore asking MacFayden how those local groups which had become associated under the ACA's (and therefore his) banner would have fared without that ini-

tial $25,000 grant from the National Endowment for the Arts with which
so many of them had been set up. When the Foundation Act became law
in 1965, only four states had active, functioning arts agencies.[5]

Tocqueville believed that the idea of equality in a democratic society
might be incompatible with cultivation of the arts.[6] But it is worthwhile to
stop and consider that the basis of a democracy is belief in the individual,
not in the equality of his talent with that of all others, or his perceptiveness,
but in his right to exist as a separate person with equal opportunities and
different interests. If MacFayden meant to imply that the element of com-
promise doesn't enter into art, he had a point—but this is true only from
the standpoint of the artist as creator and is an aesthetic problem.[7]

In 1963 Toffler had seen in progress a fight for control of the methods
of dissemination of the arts.[8] Lowry had regarded the arts not as a business
but had wanted his grants administered responsibly: he believed this could
be done adequately by the older kind of institution. The most he could be
accused of was trying to promote reliable behavior in an area not suscep-
tible to it. And where Lowry believed the shortage of artists to be crucial,
Ralph Burgard saw the shortage of administrators as crucial. Burgard
thought the only possible solution was interdisciplinary courses in academia
set up on a graduate level to train such, with arts institutions working with
the universities. Lowry rejected many such programs, from Harvard and
UCLA among others. The Ford Foundation had been training arts admin-
istrators *on the job* long before the Associated Councils of the Arts was
formed. But Lowry had begun to believe that increasingly the profes-
sional artist was going to come from academia in spite of his objections to
the universities as training places for professionals and lack of support for
universities as such. He foresaw a future in which colleges and universities
increasingly imitated the functions of the private conservatory and the art
school, but in 1971 the Ford Foundation added $13 million to its program
for conservatories.

Individual differences in interests are considered related to the tim-
ing of the emergence of basic needs and to the specific environmental sit-
uation at that stage.[9] In America, the basics in the middle of the twentieth
century had been well enough satisfied so that the attention of what tradi-
tionally had been called the upper middle class (what Toffler calls the
"comfort class")[10] had shifted. These people were above the national norm
in income and were better educated. In *The Culture Consumers*, Toffler
remarked:

> At the turn of the century only two per cent of the population stayed in
> school past the age of fifteen. Today [approximately 1963] that two per
> cent has soared to 60 per cent. . . . There is no question but that educa-

tion in a very direct way makes possible greater mass consumption of the arts.[11]

Appreciation of the arts was linked with the ability to think abstractly.

Lowry thought colleges and universities had made an important contribution to the arts in that they had stimulated audiences. "Many of the current stylistic developments," he said, "however transitory they may prove, that have affected literature, the drama, music, painting and sculpture, and the dance, would have found only a meager audience were it not for either the curiosity or the tolerance of the young people coming out of college." And, for better or worse, these developments would also have found meager audiences if it had not been for the changes occurring in the arts institutions, marked at its earliest by the development at the Whitney Museum.

Goodrich believed that audiences for exhibitions were accomplished in a number of ways, one of which was the connection of the museum with the living artist. "The galleries are so crowded on Saturday afternoon," he said during the second half of the sixties, "that you can't get into them sometimes—like that De Kooning show at [a New York gallery], the Marisol show at Janis's: crowds waiting to get in."

I feel that we've had something to do with that—the Whitney Museum. I mean, we were the first really to concentrate in this field and to do everything we could—I mean, not only through exhibitions but through buying it for our collection and publications and so on: we played our part.

And I think that our philosophy is still the way that it was in the very beginning—a more catholic viewpoint than other museums—in other words, not concentration on one or two or three or four schools, but spreading it out, which has its dangers because you can miss—miss the thing that's going to be for the future. Not miss it, but you can fail to concentrate on it, you see.[12]

"In what way do you feel that the people who flock to the galleries now, for instance—do you think that the quality of their lives has been changed?"

I think so. Of course, it's a question of how much the average person who, say, exhibits interest—goes to the Metropolitan Museum—and those huge crowds they have—how much they really get out of seeing a work of art, whether it's just a place to take the kids to on a Sunday afternoon or curiosity, whether they repeat or they come back; but, like everything else, I mean there's yeast in the bread. I mean, a minority may get something out of it and this may spread.

"What is it that spreads, do you suppose?"

Awareness of the visible world, a sensitivity to things of the eye in my field—the art field. I think it's something that we Americans lack. I mean, we did lack it. We were verbal-minded people, in a sense; and our culture was built on the written word. . . . But I think now the situation is quite different—that, well, things like photography, like advertising, like the films,[13] have made us more visually conscious than we ever were before and less verbal—I mean, less concentrating on verbal communication.

But the fine look of art—in other words, the work with design and beauty, if you want to use the word—is in a minority; but I think that exposure to it is something that's going to help us build better cities, to dress better, to be better-looking ourselves. I think this education of the eye is a very basic thing, to me—equivalent to the education of the brain in reading or the ear in music: and I don't say that just looking at pictures or sculpture is going to do that for everybody, but it's part of the whole spreading out of going into a different kind of a field than our ancestors were in. The visible world means more to us. We don't have the sort of puritanical feeling that the pleasures of the eye are evil or something like this, you know—I think that the fact that we're more aware now of planning a city, not only from a standpoint of better living but also from a visual standpoint, is part of the whole process of the American people becoming more aware of visual things.

Goodrich hopped about his office as we spoke, showing me objects. As he grew absorbed, he unthinkingly removed his jacket—an act which revealed the old-fashioned suspenders holding up his pants. They reminded me briefly of his long involvement with art, but primarily they pleasured my eye as, unexpectedly, the only brightness in the drab room, furnished as it was with standard, gray steel office equipment. Its only unusual aspect was a shelf where paintings could stand so that he might live with them over a period of time before rendering judgment.

"Do you think that all this would have happened if we hadn't been as prosperous as this country has been in the last twenty years?"

"Probably not," he replied, "because prosperity and the arts go together, certainly."

Arts centers were a sign of prosperity in the arts, and they rose all over the United States during the fifties and sixties. "Unquestionably, the new buildings have strengthened interest in the arts," Martin Mayer wrote in the *Saturday Review*, "wherever they have been built, have increased audiences for existing groups, and have given impetus to formation of new groups. Unquestionably, too, they have increased the costs of operation for everyone who uses them."[14] Audiences in general had been increasing as access to the arts was easier—Toffler figured "culture consumers" as running between one fourth and one sixth of the total population of the United

States. Art now contained more possibility for participation, and distinctions between artist and audience began to blur. Burgard told me the following story:

> I'll always remember one fellow from Elm Bend, Wisconsin, who got up at one of the ACA meetings and said, "You know, we've got an arts center in our town" (it turned out that a wealthy family had left them their mansion, with a small endowment), so he said, "We've got an arts center, and we're getting some good circulating exhibits in—you know—and we've read the catalogues from the American Federation of the Arts and the Smithsonian; we've got a good lecture program now; and we're doing a film series just like we've been told to; and we're raising some money and that's not really the problem—that's okay. We've got just one problem." And somebody said, "What on earth is that?" And he said, "*How* do you get them to *come?*"

The man from Elm Bend thought of presenting art in the old-fashioned sense, for which the audience was and always would be limited, rather than along modern lines of what viable connections art had with the lives of a possible audience and with the lives of the artists themselves, the publicity for which tended to become the content of their work. Ralph Burgard said this was indicative of the main problem, that in this country "arts are something that you visit." Even as he had been helping to put together an organization, Burgard had thought of arts institutions as being on their way out unless they could in the future provide the artist with instantaneous—and, paradoxically, unmediated—connection with his audience. Beyond the aesthetic problems of the artist, beyond the dissemination of various kinds of works of art (but linked with dissemination), lay the problems of participation with the arts, and the possibilities thereof had been greatly increasing. Fulfillment of what Maslow had ranked as the more fundamental needs was also sought after by becoming a member of the audience for the arts, and this was a form of individuation made possible by affluence. (Affluence seems to have the opposite effect on the artist, that of reducing individuation, since it brought with it temptation toward repetition.) If indeed a businessman had opted for the one thing that many of his contemporaries scorned, becoming a member of an arts council was an organizational way of expanding the prestige to be gained by attending and patronizing the arts. Where art collecting had been an appurtenance of an individual success, where the policies of our institutions of dissemination had been controlled by boards and membership organizations long dominated by the "individual large patron" and "tense with internal politicking and jockeying for position and prestige,"[15] now other options were available, no doubt still tense with internal politicking: Frank Stanton, connected with the CBS Foundation, was also a member of

the advisory board of the New York State arts council from which John Hightower had moved to the directorship of the Museum of Modern Art. The New York State arts council—perhaps the most prestigious and certainly the best funded—dated back to 1960. (Ralph Burgard commented, "New York had the great luxury of a governor [Nelson Rockefeller] for whom art was a part of his education—everyday part of his upbringing—we just don't find that in this country.")

In 1954 Helen Thompson, executive secretary of the Symphony Orchestra League, had invited representatives from city and community arts councils—of which only a handful were then in existence—to attend a national conference in connection with the annual meeting of the League. From that beginning had grown the Associated Councils of the Arts, existing for a decade on an annual budget of less than $1,000 until 1964, when foundation grants made possible an office in New York and, very quickly, an annual budget of some $380,000. Begun as a service organization, the group had some difficulty in defining a national role for itself, as did the federal government's National Endowment for the Arts after it. But the ACA had seen its existence as predicated on the development of state arts councils and so successfully did it foster these—with the aid of the National Endowment—that by 1967 they existed at least on a nominal basis in every state in the union.

The network of communication fostered by the councils would make advice easy—not to the individual artist, with whom the arts councils had little to do, but to each other, so that there could be some sort of uniform development. And, Burgard said, the ACA might force change on those other institutions which had regarded their roles simply as putting on the best in art except as they were involved in educational programs. But now changes would not have to be *forced*, he thought, since times had changed.

As a result, these institutions for the first time have to look outside their immediate board of directors and their immediate membership for solutions to problems which beset them. Not only problems of finance but problems of audiences all fleeing to the suburbs and whether there are new audiences and what is their real role in an urban society that is subjected to such tremendous pressures. So for the first time the symphony begins to realize . . . that their solutions to many of these problems must come through cooperation with other agencies, with other organizations—solutions in the context of a single institution. And this is not only true in the arts, it's true of anything else today: it's true of planning, it's true of housing, it's true of education and welfare—the solutions become more sophisticated, more complex, more multi-institutional—and the arts are just beginning to realize that. The emergence of these councils . . . they are vehicles through which solutions can be achieved.

Solutions for arts institutions or for the integration of the artist into the community? One could only hope for the possibility that not only the artist had confidence that what "art-makers do is essential to their own salvation and equally essential to the salvation of the society in which they somehow manage to live."[16] What art makers do being not what society via institutions thought they needed or wanted them to do.

CHAPTER 16

INVITATIONS
TO THE DANCE

(Participating in the action)

"I CAN GO to my grave now. I've been a broadcaster for seventeen years, and I have finally seen Frank Stanton," said Lewis Freedman in 1967.[1] Surprisingly, my earlier conversation with William Paley had *not* gotten me in to see Stanton. Some of my most delicate work went into approaches. But the fact that you are going to write about them has undeniable appeal for most people. Many of the nine men I approached directly, but Simon Michael Bessie of Atheneum Publishers wrote two letters for me: one to W. McNeil Lowry and a similar one to Hedley Donovan at Time, simply asking them to see me.

Donovan did not respond to Bessie's letter, and I later approached him head on. After many postponements and reapproaches—perhaps the most comical to me, as a flyweight, was my suggestion that we ought to have a look at each other before making up our minds—he finally let me interview him.

Lowry first queried me extensively on the intellectual validity of my project, expressed many doubts not so much out of prudence as because he couldn't see clearly what I had in mind. He agreed to go ahead, however, and once invited me to dinner, where we sat down with his wife and then talked afterward—the evening a curious mixture of the formal with the informal. Lowry's living quarters in New York consist of a small, two-bedroom apartment (he also has an out-of-town place, which I did not see) in good, rather simple taste that occasionally had been sacrificed to comfort.

The Lowrys use the walls of their apartment for ephemeral notations of recent experiences.

> I normally get up [Lowry said] about seven-twenty and have breakfast, read a newspaper and leave home about eight-forty. During the day I sometimes read two [newspapers]. I spend the greatest part of the time on the *Times* in the morning. One aspect of my office operation here is that everything of interest from any part of the country is watched and provided to me on Thermofax, whether it's other New York papers or papers outside the country that have to do with anything [I'm interested in]. And we have two big morgues here—one in the Office of Reports, one in our own Humanities and the Arts. Everything affecting any grantee automatically comes, but even other things too. And we have one girl who does nothing but read and organize magazines, periodicals, newspapers, catalogues, exhibit notices, and so on, and those are routinely circulated, so that I get a lot besides what I read in the papers in New York.

Mr. Lowry does not keep a personal diary, Marcia Thompson said.

> We used to try to send him out with a little dictating machine. He's not mechanical. He has absolutely no mechanical understanding of something like this or anything else, and he would go out with these little dictaphone machines and of course they'd come back sounding like a rabbit and nothing would be on, and so he would have to reconstruct from his shorthand notes. He takes most of his notes in a combination of shorthand and speedwriting. . . . He said he couldn't be a reporter without shorthand. He probably in school learned shorthand and typing. He can type very, very well. I remember when he first came to the International Press Institute, with temporary headquarters in Markel's office at the *Times*, the staff was very small there. This flabbergasted me, because, of course, Markel would only say, "Where is that material?" but if Mr. Lowry saw that a report had to be done and it wasn't being done, he would sit down and type away—you know, not for any length of time, but just to help you get something out. A very pragmatic approach. And it didn't hurt his own view of himself to do something that someone else might consider, "Well, that's not my kind of chore."
>
> He makes the job very exciting because he shares so much of what goes on at his desk with the staff generally. When he was the director of this program, he regularly after board meetings would call in the entire staff—non-professional and professional—and give them a rundown: "So-and-so said this; so-and-so said that." And with total recall he'd play back the whole board meeting, which was fascinating for the members of the staff that put a great deal into getting a paper into the board room but would perhaps never know what happened to it. And this is unusual in terms of officers of the Foundation. They just don't do it.

Henry Heald, president of the Ford Foundation before McGeorge Bundy, said:

> I think sometimes if you spend your life working for a foundation you really don't have any friends.

"Why is that? Because of the peculiar relationship . . . ?"

Yeah—because sooner or later you have to say no to everybody.

"That's a rather sad comment."

> Well, it's a fact. It certainly is a fact that in an organization like the Ford Foundation, it's only a matter of time, if you're going to have any kind of sensible program, before you have said no to everyone you ever knew and a great many of the important people in the country.

Lowry's life appears to glitter because of the idea of his office in the Ford Foundation building, the idea of his position in the culture of the United States at large, and the idea of his associates (as opposed to his colleagues)—that is, people in politics, society, and the arts: those he uses as advisers, those to whom he gives the Foundation's money, those whom he advises. He does not name-drop, however. "I go to openings," Lowry said, "I go to performances if I can, not nearly so many as I'd like. And then, because of my position, I'm expected to go to some openings and performances I wouldn't choose, but they want me there. I guess I could go to five a night if I accepted all the invitations, but that's not it. I can't do that, wouldn't like it anyway." He and McGeorge Bundy went to Texas for the inauguration of the Alley Theatre's new buildings in 1968. Of the $3.3 million cost, the Ford Foundation had contributed $2.4 million.[2] "Many people seeing Mac Lowry in his office or at some official dinner or something would never know that I have seen this man sitting in a theater, watching a ballet, with tears in his eyes," Barbara Weisberger, director of the Pennsylvania Ballet, said.[3] Lowry wanted to make it clear that "for fifteen years my daily existence has been ninety percent with artists and artistic directors and not with board members or people in society except when about ten percent forced into such occasions. I do not either in my office or on a field trip begin discussions or even visitations except with the artist or artistic director and send out in advance warnings against the convening of board members or committees."

Foundation people "come in contact with a lot of people during the course of their lives," Henry Heald said.

> [Lowry's] realistic and he isn't carried away by his contact with the leaders in the field or the big names in an area or anything of that sort. He's realistic and he is objective; he's never set himself up as being the

greatest authority on the arts in this country, although I think in many respects he knows more about them in an over-all sense than almost anybody.

"We ought to get Lowry here at Macalester,"[4] Hubert Humphrey said. "Why? Because he's a good speaker?" "No, but he's knowledgeable—he knows a lot of people." Of that Humphrey was sure, and he thought it really mattered. He looked over the list of the men on whom this book is based and when asked if he knew any of them personally, replied, "Sure, those are the people." He appeared to think they formed a clique of sorts within which the New Yorkers formed a subclique (he might have been surprised at how few of them knew one another or had met only on formal occasions). Gay Talese, in his book about *The New York Times*, wrote of Turner Catledge:

> Now he is a New Yorker, indulging in the sweet urban life that the most successful of Southerners adapt to so quickly, patronizing the better restaurants, knowing all the head waiters by name, living in a large luxury apartment on the East Side where it is the New York landlords who uphold segregation, having honed it down to a fine and polished art. Catledge's second marriage, to a wealthy and attractive New Orleans widow whom he met nine years ago at an editors' convention in San Francisco, is a happy one. He is now earning about $100,000 a year, has a wide and interesting circle of friends. He is not a big celebrity, nor did he ever wish to become one, preferring to function within the corporate code, but his name is nevertheless known in nearly every newsroom in America, and he is regarded with respect and a certain awe by the most powerful politicians in New York and Washington. . . . He has felt at home in a very tough town that a young transplanted Mississippi friend of his, Willie Morris, calls the Big Cave.[5]

Humphrey found Turner Catledge educated and cultured—a professor to his [Humphrey's] undergraduate, he said. Humphrey seemed almost to envy them as a group: he called Catledge "a fascinating man"—and added, "That whole New York crowd is."[6]

Lowry is a likable man. Someone who had known him before his foundation years described him as "a seasoned, hard-working journalist"; someone who met him briefly, as a man of enormous charm, "one of the most winning men I've ever known."[7] Lowry spoke of Marcia Thompson as being a woman "of great strength and maturity of character—also very attractive, which helps in the whole relationship to people outside—but a hair shirt." Those terms can also be applied to him. He did not take gifts, he said, and his apartment and office appeared to testify to that. He and Jovanovich, particularly, emphasized their moral rectitude—both thought of themselves as wearing hair shirts, WJ in his idea of the continuance of

culture and Lowry in his view of the proper role of a foundation official: where Jovanovich had a puritanical rectitude related to ideas, Lowry's related more practically to his everyday life. "My generation seems to me still to be somewhat embarrassed by being human," Jovanovich commented at one point.

Lowry talked about vocation during one of my last interviews with him. I had just read an article about the uses of dreams,[8] in which it was suggested that while we are asleep, our minds operate rather like computers, programming the data we have taken in during the day—reclassifying items so that trivia are fussed with and discarded, disturbances are buried, but other memories are installed on an accessible, more orderly basis. Freud's idea had been that dreams represented emotional drives and conflicts and if they could be deciphered they would reveal our true situation. The author's notion, I said, didn't seem to conflict with Freud's ideas but made dreams seem more *useful*.

"You know, in [the author's] sense, there might be drives and conflicts too," Lowry agreed.

We had talked earlier about daydreaming, because Lowry had that habit and found it useful. "There are people," he said, "who more than others constantly see themselves between the past and the future, and they have an extremely highly developed historical sense, both in their own lives and in the history of mankind. And I'm one of those persons." The cultural web herein described is horizontal in a given segment of time— it lies over the land as a non-sequential mosaic with overlapping parts. What Lowry described was another context: he had shifted to the historical aspect—a linear time scale which might be thought of as vertical, the past being below; the future for which we grasp, above. (C. S. Lewis spoke of that image of infinite unilinear progression which so haunts the modern imagination: the post-modern, McLuhanesque imagination is fascinated by simultaneousness.) I asked Lowry whether he meant that the sense of which he spoke affected what he did minute by minute during the day, and he replied that it was much harder for him to live "in the present moment" than in either the past or the future:

And I have not yet got so old that I'm not still living in the future. So that in this sense I do daydream but it's cerebral, it's organized, and it's analytical. And sometimes I've been very surprised at how different I am from other people in that respect—not all other people but many other people.

I thought that that was an interesting trait for an administrator to have, and I said so.

You see, actually [Lowry said], it's difficult for one to characterize him-self, but my life—my vocations and professions—have really not been administrative. I've always sold myself as a professional, a single person operating professionally, whether as a teacher, as a writer, as a news-paperman, or as a foundation staff person. . . . I'm not fundamentally an administrator. I'm fundamentally a guy who is talking—listening or talk-ing—either on the phone or in a letter or face to face—the variety of people I've seen this week, for example, and the variety of subjects that they've discussed with me or I've discussed with them: if I were an ad-ministrator I wouldn't have time to do that. That's what takes my time, and this is why I'm the despair [and here he laughed slightly] some-times of other people who have to help me, because a lot of things that an administrator would advance and keep current, I won't let go for trivial reasons.

Charles Shattuck called Lowry the most brilliant member of their group at the University of Illinois in the late thirties but not the most spe-cifically motivated. On the magazine they founded, Lowry's talent had been used more on accomplishing things (such as getting an inexpensive printer) than on actual editing, although he had a vote in the acceptance of mate-rial, Shattuck said. *Accent*, started in 1940, had seven founders each of whom put up seventy dollars for the first year of four issues. "Everything else that we had came from subscription, from sales, and from advertis-ing." Most novelists and poets, Lowry said, have been able to find a tem-porary home in the academy or to use academic instruments and vehicles like the quarterlies and journals, literary magazines, and the paperback book audience. "When we were editing *Accent*, the natural market for those magazines was about 1,500 to 3,500 people. And they were all writ-ten and edited for the same people, on subscription, or it was through outlets like the Gotham Book Mart in New York, one or two bookstores in Chicago, and so on. We were not quite at the beginning. We were about a decade after the beginning of a trend which has gone steadily farther in my opinion so that now you almost need birth control among these maga-zines, you know. And yet the paperback book has taken over the same types of writers and found a new kind of outlet for them still. However, even in the drugstores and in the airports, they appeal first to the products of the university—not *only* but *at first*. I think that *Accent* was a kind of in-between manifestation." Lowry said he didn't like to feel that he was part of an exclusive group, "but when we exchanged subscription lists with the other literary quarterlies, we found that we had about a sixty-five percent overlap."

One of the great difficulties in this whole field is that it's almost impossible not to be a part of a coterie influence, and in spite of the number of these magazines that were unrolled, rose and fell, rose and fell, mostly around campuses or in New York, they were all more or less serving the same coterie. That isn't necessarily bad, I'm not saying that invidiously. . . .

"We felt that the only feat we'd made actually was to exist without subsidy." Even at Illinois, Lowry "knew a lot of people," and his acquaintances cut across faculty disciplines.

Between 1940 and 1942, Lowry tried to enlist in the armed services but was "terribly underweight" and could not then get physical waivers. He thought he might get into the war as a civilian and "wrote to a friend, Scotty Reston, James B. Reston of *The New York Times*, who had just come back from the London bureau and was living in Washington. . . . His wife, my wife, and I were all classmates at the University of Illinois in 1934. Scotty got out in '32."

Reston introduced Lowry to Henry F. Pringle, a Pulitzer Prize-winning biographer who was then head of the domestic Writers Division of the Office of War Information:

Pringle had in his writers' group Milton MacKaye, who was the leading rewrite man in New York in his day . . . ; an experienced writer in journalism, Philip Hamburger of *The New Yorker*; Samuel Lubell—and here I came from the university, one year past my Ph.D., having been an instructor in English that year. I had written critical book reviews, of which only three or four had ever been published—outside of that magazine I helped to start, where there was a lot of them—and a few plays, but here I was, and I was supposed to earn my way with all these writers, as if I were an old-pro journalist. And the great thing about Pringle was he never assumed I couldn't. The test he had given me before he hired me was a miraculous invention.

Well, I worked there until something I had written blew up the whole office and led to the resignation of myself and Pringle and a total of thirteen writers and researchers. [It was] a great controversial subject—very politically involved—and tied up with the facts of the war effort. It was the anticipation of the food situation in the United States in 1943.

Why had Lowry sensed that this was such a dangerous topic?

Because I knew a little bit about the political and economic forces that were clashing. Here's what it was about: [Secretary of Agriculture Claude R.] Wickard had announced one set of goals for the crops—but without getting more farm machinery, he couldn't meet those goals. The government people in charge of metals allocation weren't going to

give him that, but they couldn't afford to tell the farm bloc that, because they'd have said "Screw that" and changed the goals—and changed the metals allocation—and Roosevelt and Byrnes didn't want that because in the War Department, they didn't *want* to put more money into farm machinery, and they were *not* telling the people what the results of that was going to be on the total economy. Nobody was going hungry, but it was going to drop like twenty percent on many of these commodities. And I knew that this was going to happen, and I knew something about the political stakes involved—I knew about the farm bloc, having come out of Kansas. [This Kansas background five years later involved Lowry in the presidential campaign as a journalist in charge of the Cox bureau in Washington.]

Later when I won that award in 1948 for the grain-storage story that swung the election of Truman in midwestern states with 101 electoral votes—I knew when I saw the little germ of the story what it would mean politically, anticipated this and kept on writing it through the Truman campaign when everybody thought he was going to be beaten, and our papers [Cox] were saying he's going to win, and he's going to win for *this* reason, and the Midwest is going to go for Truman, and they all just *laughed* at my reporting, and I couldn't even black-sheet them—I couldn't even *give* away the story, 'cause they didn't believe it. But they didn't know anything about that section of the United States, and what the farmer would feel when he couldn't get grain into storage, and if he couldn't get into storage he wouldn't get the support price—and be able to make Truman a hero and the Republican Congress a devil. This is exactly what happened. When Truman said at Dexter, Iowa, September 12th—"Congress has stuck a pitchfork in the farmer's back"—he got that from a story I handed Clark Clifford in August—all the reporters just laughed and howled, you know—this can't be, they said—"Why these farmers have private planes, they're doing so well, flew down here in their own planes—what does Truman think?"

Back [in 1943 in the OWI] it was the same kind of thing. I could see the implications—well, it didn't take *me* to see the implications—we had other people at the OWI who knew about agriculture too—John R. Fleming, the chief of the Bureau of Publications and Graphics, was an old agriculture man and an old Triple A man.

Had Pringle realized the implications at that point?

You know, he was the kind of man who would never let you know. He had such an ability to place confidence but he never did seem surprised when I pointed out the implications. So maybe he knew. I don't know.

Arthur Schlesinger had come six months after Lowry. Had he been one of those who got caught in the aftermath of this affair?

They didn't get *caught*. Some stayed and were transferred—Arthur was transferred to OWI overseas and then went into the OSS. Others just

flat resigned, the way I did. Pringle, MacKaye, Hamburger—a lot of them. But it was an issue, and it was an important issue. What we resigned over was the fact that we couldn't get the document cleared. And it would have taken a united front to get it cleared with Byrnes. He had his reasons for not clearing it—we wanted to tell the truth. If they wanted to change the goals, let them. But if they weren't going to change them, we were going to tell the people what was going to happen. And we took the *hard* line about the war. Trust the people, tell them the facts, you know, say, "Well, look."

When we started getting up in the upper echelons of the OWI, we found sixty-eight advertising account executives that Gardner Cowles had brought in. Gardner Cowles was the assistant director of the OWI, he was supposed to help us on the Republican side of the House—and when the showdown came in the spring and the House voted overwhelmingly to abolish the domestic branch of the OWI, which the Senate later changed, we got *three* Republicans on our side, so it didn't do much *good* to have a paid Republican. Anyway, we found these sixty-eight advertising account executives, and they said, "My God, we're not going to say *this*—that's not our business. Let Agriculture say it," you know, meaning let Agriculture continue to lie about it.

And we said, "Hell no," and we locked horns with all the assistant directors. Then it had to go up to Elmer [Davis]. Elmer came to a meeting where we all took down our hair, and he said, "Don't listen to those jerks," you know, "put it out." We all knew that Elmer was intellectually and temperamentally and loyally on our side, and he *was*, but he took a look and he realized there were going to be one of two exoduses —ours or these guys. And if those guys went, Cowles went, Elmer had a real problem in keeping it bipartisan and nonpartisan. Like many administrators at the top faced with a wholly political choice, he took his choice—he didn't fire Pringle, but he said, "I can't—I can't—" and he fired no one. And I went back to my desk and wrote a letter of resignation, and cleaned out my desk and went home. And I addressed it to Pringle. Well, I was home for nine days, and the phone rang, and a lot of these women down there would say [he whispers], "Mac, get on down here, Henry's talking about resigning." And I'd say, "That's Henry's choice." "Well, we're going to make a statement about Elmer Davis, that he's turning this Office of War Information into an office of war ballyhoo—" I won't tell you who led this front, because she's very well known. She was working in our research division.

But I said, "I'm not going to sign my name to any statement about Elmer Davis. Have you forgotten that there's a war on? I made my statement when I resigned. If anybody wants to dig in the files, they can find it." Well, I went down—finally they pleaded with me—and I went down and there was Henry, and he says, "Mac, what am I gonna do to get all these goddamned women off my neck?" and I said, "Henry, I'm not going to hold it against you if you sign that statement, I don't

think you *should*. You've run this thing as a family—I'm not going to judge you—but I can't sign it." [Pause.]

He did both. He resigned and signed. And Davis then, who had been turning back all these resignations, accepted them and thirteen of us left. I think we did the right thing. But I don't think he should have signed that statement. It was a terrible day when I read it in the paper. But Henry didn't do it. Other people did it to him, and I know who they were.

In November 1943 Lowry got the waivers he had been after and was accepted in the Navy as a trainee in air combat intelligence. "What happened to me in going back to Washington after the war," he said, "was that I was still, when I got out of the Navy, so steamed up about national and international affairs that I couldn't just go back to the university and teach." That was in 1946, and he was then thirty-three. After a year as associate editor of the Dayton *Daily News*, Lowry was hired by Cox, former governor of Ohio and 1920 presidential nominee, to head the Washington bureau of the James M. Cox newspapers. "And I made my own assignments," Lowry said, "wrote my own copy and everything. And I had a real fascinating time."

Lowry's first connection with the Ford Foundation came through an acquaintance he made in Washington during the war. In 1948 William McPeak became a member of the Gaither Committee to study a possible new role for the Ford Foundation. It had been established in 1936 to handle the charitable contributions of the Fords and, during its life as a family foundation, grants had amounted to some $2 million a year. Its assets were considerably increased on the deaths of Henry and Edsel Ford in the late forties. As a result of the committee's report, the Ford Foundation emerged on the national scene completely in the social sciences, oriented toward problem solving.

Now remember, Lowry said to me many years later,

1950 was still postwar crisis-oriented, and problem-oriented, particularly about international affairs—very popular—and it seemed natural to the board to do this. Also it was a different role, supposedly, from other foundations, and here was the big foundation coming. We didn't know how big it was. They thought they were going to have twenty-five to fifty million dollars a year. They didn't know then that in a few years they'd be spending 250 million dollars. But they knew it was big compared to Carnegie or Rockefeller. It could handle some of these things. And the board was made up of very international-minded people and development-minded people. General Electric Charlie Wilson; Frank Abrams of Standard Oil; Jim Brownlee of J. H. Whitney Company; Jack McCloy. They were all very much interested in problem solving and in the international field particularly.

This foundation, said Lowry, "was born a hundred percent in the social sciences: international affairs, public affairs, structure of education, economic development, international training and research, overseas development. There was no direct support of the humanities anywhere in it." And it seemed to Lowry that the explanation for this was obvious. "In the war, so much applied money in research went into the sciences that basic money and basic research suffered attrition. And there was going to be—we didn't know when, I saw it happen when I was a reporter —an attempt to restore this. This was the National Science Foundation. The pendulum was swinging so rapidly—this was long before Sputnik was in the works, which made it swing even more toward sciences or toward technology—that McPeak and some of the others in this study group were concerned, 'What about the humanities? How do we restore the balance about the humanities a little bit, if everybody goes whoring off after the sciences?' "

Well, they'd seen it coming. Bill [McPeak] got Bill Devane . . . Dean of Humanities at Yale. They had a little subgroup for the study, and they wrote a chapter on the humanities. Then when the study group and the Dearborn board of the Ford Foundation came to final consideration of the report, they eliminated that. Devane and McPeak fought that, but they did.

During this period, Lowry was urging McPeak to concentrate on the long-term development of talent without regard to the field. He believed in intellectual resources: "Well, I don't like the word 'intellectual,' but banking on intelligence and the individual and giving a long line of credit to him," whether in the humanities, social sciences, or the sciences. John Knowles, who many years later became head of the Rockefeller Foundation, was to say, "No question, you've still got to bet on individuals."

"I never knew," Lowry said, "when I was talking to McPeak in '49 that I would both work in an organization that was partially supported by the Ford Foundation, which the International Press Institute was, and even be in the Ford Foundation. This was the farthest from my imagination."

Lowry had two sons at the time, the older of whom was to become a Harvard graduate. The younger boy had been born congenitally retarded in 1947. That Lowry felt himself in some way responsible seems likely, for he said, "I've never done anything to mitigate it [as a part of my biography]," as if indeed it needed mitigating. In another context, he told me that as a child he had thought himself responsible for what happened in the world.

By November 1951, Mr. and Mrs. Lowry had decided that for the good of their youngest son and of the entire family, the boy should enter the Bancroft School at Haddonfield, New Jersey, the first in the nation to develop an educational program for the retarded. "The wise people who ran that school did not want us to visit there until the little boy had been there two months," Lowry said. "He had to forget us as *the* people who held out the helping hand, and they had to help him out. I took the first good opportunity that I could find to move my family to Europe, and I took a position as associate director of the International Press Institute in Zurich. We lived in Zurich in 1952–53."

The establishment of the International Press Institute had been a special project for Lester Markel at *The New York Times,* under whom Marcia Thompson was then working. "[Markel] went to Rockefeller, Ford, and Carnegie for the enabling money for the first conference in '51," she said.

> My first meeting [with Mr. Lowry] was when he was being considered for the job of associate director, and Mr. Reston had suggested to Mr. Markel that he might be a good person to explore. . . .
>
> I remember he came in on a Saturday, as a matter of fact. On Saturdays we worked a great deal. And I remember that he'd been put by the porter into the Book Review, where he was sitting with his feet sort of held up when I went in to get him, as the porter was waxing and washing the floor. And he was sort of pale.
>
> As you probably know from his manner, he's a very warm person immediately whether he knows you or not. He manages to communicate a sense of ease and relaxation. I can't remember any real impression about him except wondering probably whether he had the temperament to cope with a tornado—and he's deceptive in that way. There's a gentle exterior but a kind of strength and hardness underneath—hardness not in a pejorative sense at all. There's an element of enormous self-confidence without an overbearingness . . . a sense of rightness and security. It reflects in some remarkable way, I think, a kind of family relationship that must have been created at a very early age in that tribe.
>
> At that stage, the IPI really consisted of Mr. Markel's desk and my desk and the director who had been appointed in Zurich to take over (his name was E. J. B. Rose, an Englishman) and an executive committee of publishers and editors from, I think, fifteen countries. But Mr. Lowry was taken on for a period of one to two years to become associate director of the Institute in Zurich and also to conduct the major research study, which was *The Flow of the News.*

The Flow of the News was finished in September 1953.

While Lowry was so engaged, McPeak had become director of the Ford Motor Company Fund, a company philanthropy, and Gaither had

gone directly from heading the study group into the now national Ford Foundation. It was, in common with other grant-making foundations, "a nongovernmental, nonprofit organization having a principal fund of its own, managed by its own trustees or directors, and established to maintain or aid social, educational, charitable, religious, or other activities serving the common welfare"[9]—and hence tax-exempt.

"This was in the Hutchins-Hoffman-Davis-and-Spaeth stage at Pasadena," Lowry said, and "in '53 a great wind blew, and Hoffman and the entire crew were left on the ground, and only Gaither was left standing up." Hoffman returned to the Studebaker Company remarking, "It [is] a great satisfaction to get back to a profit-and-loss statement. Now I know just where I am every month. Never did at the Foundation."[10] Gaither became acting president and then president, and he brought back his study group, including McPeak, as officers.

> In September 1953 [Lowry said], when I was sitting down here [New York City] in the RKO Building trying to finish that International Press Institute report that I was telling you about, McPeak called me and said, "I'm going to go in the Ford Foundation as a vice-president, and I'm going to be in charge of their education program in the central foundation at the same time, and will you go in with me?" And I said, "I don't want to do anything; I want a vacation. . . ."
>
> At the same time I was getting a couple of pressures from Milton Eisenhower. Milton and I had known one another in the OWI, way back. He was associate director under Elmer Davis, and I'd done a lot of work for him. He was then president of Pennsylvania State University and a brother of the President of the United States. And before I ever left Zurich, without telling me, he had had me cleared all the way through Q clearance in the United States because he had suggested to his brother that I be an administrative assistant at the White House.
>
> But I didn't want to be an administrative assistant at the White House. Well—the nature of the job, for one thing. Then also, I am—not— politically attuned to President Eisenhower. I can put myself above politics for certain jobs—national interests—that are nonpartisan. (I later did write a speech for President Eisenhower at Milton's request but it was on an intellectual subject, it was not on Republican politics.) He came clean with the brother and said, "Mac's not with us, you know. All his friends are Democrats." You see, I had a passel of friends in the Democratic Party after that five years as a Washington correspondent, because I had the only group of Democratic newspapers North and South. And all the people in the Truman administration, the Democratic leaders on the Hill, were my friends, and I would work with them. Humphrey, Russell, Monroney, Douglas. . . .
>
> But—the other job was as a vice-president at Pennsylvania State

University, helping Milton. I was interested enough to go out and talk to him about that. I wasn't exactly ready to do that—I never have been—ready to be a university president. Most of the offers that have come to me for university presidencies have come from that date on, largely since I've been in here. But I never saw one that was as compelling to me as this. But also, it's a dog's life. There's so much fund raising and so on. I'm all for university presidents. But I'm too excited about this.

On October 7, 1953, Lowry became a member of the staff of the Ford Foundation.

Gaither was having his problems in reorganizing the Foundation and found some difficulty in defining relationships with the separate funds already created. The Fund for the Advancement of Education, for example, was a separate entity although entirely supported by the Ford Foundation and was competitive with McPeak's group inside the Foundation, which had come to include Lowry as program director of education and Marcia Thompson (Lowry had discovered that "they were looking for additional staff and knew that I was less than happy [at *The New York Times*]," she said). At that point, no arts program existed, although Lowry was trying to "influence and direct" the Foundation, in the course of the education program, into a large role in the humanities and some role in the arts.

Lowry for the next few years was to work on "starting a National Merit Scholarship Corporation, on the grants made to faculty salaries, on the creation of the Council on Library Resources, on things like that. Then I began to make what we call *ad hoc* grants in the humanities. I'd go and talk to Bill and say, 'I think we ought to do this,' and 'Here's something that somebody wants to do that I think we ought to do,' and we would call it a part of our education program. . . .

"In 1955, in December, we got permission to develop a program in the humanities. And I went after two things. First was a reconstitution of the American Council of Learned Societies, which had already gotten under way—to give more research funds and free funds as postdoctoral fellowships or travel opportunities in the humanities. The other was to strengthen the opportunities of publication in the humanities, including grants to thirty-seven university presses."

In common with many of the other large foundations, Ford works in program areas and makes grants outside of them only in exceptional circumstances. The approval of the board of trustees is needed to change the program structure. Lowry wrote a policy paper, based upon staff research, which was then edited by vice-president McPeak and commented on by president Gaither before being presented to the board. It suggested that a new program called "the humanities and the arts" be

started, removing those categories from the education program. After a brief hiatus, Henry Heald, chancellor of New York University, came to the Ford Foundation in 1956 as its new president, replacing Gaither. Heald was to approve this new area.

Of the Gaither regime, critic Dwight Macdonald wrote at the time:

> . . . the trustees have taken a more active part in running things than they were able to do under the rambunctious Hoffman. In fact, some critics feel that the balance of power has swung rather too far away from the staff. "*Our* trustees are well disciplined," an executive of one of the older foundations said not long ago, with a side glance at Ford. "They know it is bad form for a trustee to try to get money for his own pet causes or to encourage end runs around the staff. A thoroughly trained trustee won't even let a friend use his name in approaching his foundation. Our trustees are there to decide general policy—specific grants are up to us, not them. This business can only be run efficiently on the basis of the trustees' having full confidence in the staff." Such a strict division of labor is still far off at Ford, where trustees have been known to promote their pet causes, give friends introductions to the staff, and otherwise behave in an undisciplined manner.[11]

"I don't believe," Lowry said, "that the world's greatest philanthropy ought to be controlled by factions and manipulations and cultivations of individuals in power. I think the distribution of power in philanthropy —in any important organization—is just as important as the distribution of the power within government. And a staff is a staff. And a board is a board. The staff proposes and the board disposes. And there's never been a better system invented, in my opinion.

"Now, I'm like the dodo in this respect. Somebody said, 'He ought to be shot, stuffed, and sent to the Smithsonian Museum,' you know. But I believe that intensely. And I have *never* lobbied with the board members for anything." But, he noted, this attitude had been resented by his own trustees:

> Because it sounds as if I'm giving a *unique* role to the staff and a *unique* role to the trustees. And once, when somebody said to me, "Lowry, explain to me again why trustees shouldn't overturn rejections," I said, "Well, two reasons. . . ." This was a trustee; well, it was the chairman of the board. "One is, in a foundation anybody can say no, it takes everybody to say yes. But the power to recommend should be in the program director, in the professional who has the staff responsibility." And that power to recommend, if it is respected—if the staff man respects the trustees' role, and the trustees respect the staff man's role, the power to recommend is the greatest power in the Foundation. And it is saved for the staff.

In other words—you *can* imagine, but it would be staggering if you

could see them stacked up in a warehouse—the mail making proposals that I have received since 1957 in the arts, and the humanities. Staggering. At many times we were getting *half* the mail that came to the Ford Foundation, and we were the smallest program—in budget—in the Foundation, in those days.

Well, nothing went forward without my recommendation, when I was director. That's a great responsibility. But that responsibility can only be enforced if that's the way it is. Now, if the board says, "What did Lowry reject that for? I think we ought to do that," they [the applicants] will never talk to Lowry, they'll never talk to a professional again. Why should they? They'll find out where the power is, they'll go *there*. And I said to this chairman, "You just invert the role, you guys get down on the staff, you do it." Because that's what would happen.

This was hard not just for his board but for people outside of the organization to understand.

Lowry said, "I have also been interested in putting philanthropic dollars where they would do the most good, and not in just endorsing the big institutions in the arts and the best endowed. And this hasn't made me very popular with some very potent people in New York who are the boards of the Metropolitan Opera, the Lincoln Center, the Philharmonic Orchestra, the Metropolitan Museum, and so on." He had said that he was "fully aware that New York City is the artistic capital of the United States, naturally. And I've given as much attention to it as to any other city in the United States as a result. But I've treated New York just like any other community. . . ."

In the first five grants I made in the fall of '57, one was to support for the first time a season, a short season, of operatic works at the New York City Opera Company, entirely written by Americans, none of which we'd commissioned—*Susannah, Baby Doe,* and so forth. The next day after the announcement, Mr. Anthony Bliss, the president of the Metropolitan Opera, and Rudy Bing were in my office. And they said they were here to protest the fact that after all these years, the Foundation was in the arts; it was not only in the arts, it was in opera, and it was putting its name on a second-rate opera company instead of on the Met.

So I said, "Mr. Bing, I gave them a hundred thousand dollars to help support twelve productions. How many could I have supported with a hundred thousand dollars at the Met? One?" I said, "Okay. Would it have been a contemporary American work?"

"No. Never. Over my dead body."

So they said, "Well, that's all you've got to say?" I said, "That's all I've got to say." And I said, "What are you doing here protesting this?" So they said they were embarrassed and they were pushed into it by their board, you know, and so on. This world is always divided between

the haves and the have-nots, and they were part of the haves and they were used to getting money and they even then had a budget of seven million dollars a year.

Now the Ford Foundation has made grants to the Metropolitan Opera, the Philharmonic, the Lincoln Center, but they didn't come out of my budget. They came out of the Ford Foundation's support of Lincoln Center, which President Heald committed us to at the first board meeting when he came in and which all but one member of our board supported. I did the staff work for those grants, because that's my field. But they weren't sure how it was going because they were afraid I was far too close to the musicians—and I *was*. The contemporary-opera program, the concert-artists program, all those things we started out with had been planned by locking up twenty or twenty-five musicians in a room for two days and just listening to them talk, you know, without any agenda. . . . We get an idea from that and then we go out and ask a lot of other people, and finally we give it shape and form and instrumentality as a grant or project.

The large institutions knew about that fact. We're absolutely open and non-jurisdictional or prejudicial—so that some of their people had been in those conferences—John Gutman, for example. So they knew that I was very close to the musicians and they didn't think that that was very good training for a guy who was going to give millions, they hoped, to Lincoln Center. So even after we'd made an original grant, they weren't quite sure of this. Now they were really desperate because instead of costing first seventy-five and then a hundred and ten, now it was going to cost 164 million dollars to complete Lincoln Center, and they couldn't do it without us.

. . . In the middle of all this, Rockefeller asked to see Mr. Heald. Now to understand this, you have to understand that for years John Rockefeller had asked me for lunch about every month as they were planning Lincoln Center, saying, "What should we do about this?" and "What should we do about that?" and for no money. He never did once take my advice. But that was all right. He was asking me to endorse plans already made.

But this time, he asked to see Mr. Heald and he brought a very sweet member of his board, Gilbert Chapman, along, but Heald asked McPeak and me to sit in. Rockefeller said: "We think that now's the time when it's a real financial question and a development question and a fiscal question, and we think maybe you'd like to have a representative from the Ford Foundation that really knew about these things, for example Eugene Black."

Mr. Heald said, "Mr. Black is a member of our *board*, and we don't use trustees to do staff work. But, also, these responsibilities are invested in Mr. Lowry, and we don't discuss anything with our board in the arts until Mr. Lowry has made his recommendations."

Apparently McPeak and Lowry had rather similar ideas. "Neither one of these fellows," said Heald, "always agreed with me, and in fact when I was first at the Foundation I had to take some steps, or I felt I had to take some steps which they didn't agree with at all, and they told me so. . . ."

I rather quickly decided that we had to pull the Fund [for the Advancement of Education] into the shop and make it really a part of the Foundation . . . and neither McPeak nor Lowry believed that was the answer. . . . I think Lowry would agree today that it was the right answer. But I always respected them both because they said so, and they didn't go off and sulk about it or anything of that kind. . . . You can count on both of them to tell you what they thought. . . . This is a very useful quality. You know there are a lot of people who won't quite tell the man at the top what they think, they want to find out what *he* thinks. Or if they do feel they have to take issue, then they're forever afterward aggrieved if they don't get their own way.

Lowry was against funding Lincoln Center because "I didn't want to see money that could go to artists and artistic directors or to their outlets put in bricks and mortar for a big deal that was really about banking and real estate." He knew that theaters are not made by buildings nor artists by studios.

Lowry said, "Mr. Heald was chancellor of New York University and George Stoddard of NYU was on the board of Lincoln Center and had been engaged in promotion about it even before Mr. Heald came in. Mr. Heald didn't have time or reason to ask me. I didn't even *have* the arts program. The first grant to Lincoln Center was committed even before we *had* an arts program, and it came out of the general funds, what we call the undesignated reserves of the Foundation. It never came out of my budget, nor did the later grants come out of my budget—the first grants to the Philharmonic or to the Met. But I did the work. . . ." And he painstakingly pointed out that the money given to Lincoln Center— which by 1970 amounted to $25 million—had not reduced his freedom of choice.

"There are many ways to run an arts program," Lowry said. "Universities are panting for it. You could run it through universities, but I haven't done that. You could run it just by dividing it up among the fat cats. They all need money. There's never going to be a time when they don't need money. There's so many different ways to do it. You could create a lot of things on your own."

The pressures these people exerted made themselves felt in a variety of ways, Lowry said: they buttonholed the trustees, buttonholed the president of the Ford Foundation.

Some of it is through the press. Most of it is from the Establishment talking to itself. I mean, the very big private, corporate, legal, industrial, and social figures who are distributed among the voluntary boards of institutions in New York, both in education and in art, and so forth. The board member may be a law partner of one of my board, or something like that. He can't understand why I'm in such good favor here.

Marcia Thompson spoke of the more disciplined procedures instituted in the sixties: "Every letter that comes into the Foundation is given a routing slip of this sort, and we get three copies in this office of each slip, so that one goes into a suspense box and one is circulated to the staff; so that every day everyone on the professional staff or the non-professional staff will know what mail has come in so they can presumably handle telephone calls and so on; and the original slip and letter goes to whomever it's addressed to. [The control slip] gives you a little place to check off if it's been handled by telephone. It doesn't give you anything in terms of the nature of the reply unless it has to be a formal rejection. Then you've got to do something in writing.

"It's really important," she said, "because you find in foundation work that end runs are not uncommon, and if a no is given in one quarter, it might be accepted in another quarter; and without a system of this sort, you could have five replies to the same grant—replies going out from five different sections of the Foundation in any day, and they could be absolutely different. And there are staff people that just don't like to answer mail, you know, and things tend to accumulate in the bottom drawer of a desk. Under this system it cannot. There's a monthly follow-up."

Lowry admitted, "We've done very little to explain ourselves except directly to the people we're working with. We've done very little to explain it to the public. There's been a lot of newspaper coverage of it, but there is a hangover from the old days of foundations that 'you live behind your good works,' you know?"

He gave as an instance of end runs Howard Adams of the Associated Council of the Arts, who didn't write him a letter "without sending copies to McCloy, Stratton, Bundy, and everybody else," Lowry said.

He will write, for example, and say—after he's had fifteen letters—"I know that your policy is not to support—not to do these things: *I* think the Ford Foundation policy in this respect should be changed, and I intend to try to change it." And "I insist on being heard." And then he'll send drop copies to Stratton, Bundy, and so on. I haven't got time to go and educate them about this, you see. So that's an imposition. The less *specific* I make my reasons for not supporting him, the less room there is to have to go ahead and argue with him on it. . . .

In 1962, Lowry's idea of the proper roles within a foundation had been directly challenged when

the chairman of the board stood in front of the senior staff of the Foundation and declared a policy of fraternization between the trustees and the directors.

"Why?"

Because he thought that was the way it ought to be and that there was a lot of talent among the directors and the trustees wanted to buttonhole them and the directors wanted to buttonhole the trustees, and this was just fine, we were all in a cooperative endeavor here and to hell with the officers and control and so forth. I wasn't even an officer then, I was a program director. And after it was done, three of my friends on the board came to me and said, "Okay now, Mac, you're going to have to change," and I said, "Never."

"Well, when you come to my town, you're going to do it."

"I'm not."

I went to Heald and I said, "I'm not going to do it—what was announced. I'm not going to do it. If a trustee has a legitimate business problem to take up with me, I will take it up with him, and I will report it to you. But I will only take it up if it's an item of business, and I'm not going to go and explain anything to those trustees unless you have it in a formal document." And I've lived this way since.

"Why did you go and tell him that directly rather than simply have it be what you did?" I asked.

After a long pause, Lowry answered:

Because the poor man needed a little encouragement.

"Encouragement? How do you mean that?"

He was being sandbagged by end runs from the program directors and trustees; he was being positioned, and the poor man didn't know it.

"You mean as a result of that decision?"

It had been going on before; they were only now making it the rule rather than the crime. Vice became virtue, and I told him that it still looked like vice to me, and he wasn't going to be sandbagged by me. And I didn't believe in it, and any persuasiveness I had, in the Foundation staff, was going to be on the side of saying, "Ignore that policy of fraternization."

So Lowry had gone directly against policy on a matter of principle: he had not himself followed the advice he had given me on another occasion, to not "proclaim too loudly to them [CBS] a policy—which might get

them into an argument. Just do it. By precept. And let them see if they like it."

Heald said, "Mr. Lowry has strong convictions about how a foundation ought to operate and what the procedures are. I think he's much more concerned about that than some people." McGeorge Bundy and Lowry, he said, had known each other for a long time before Bundy came to the Ford Foundation (after an interim during which Lowry served as acting president), and they were "quite different in temperament." Bundy had no interest in the arts, others told me. Would he continue the program with Lowry due to leave the Ford Foundation in 1974?

Starting in 1967, the Ford Foundation had begun to anticipate the continuing rate of payouts and the possibility that grants to performing-arts institutions would come to seem moral if not legal requirements. (Unlike other foundations, Ford had often stayed with a key artistic group as long as seventeen years.) Lowry proposed ways in which terminal actions could be made, but he was determined to leave beneficiaries in viable positions: although the Ford Foundation would not provide endowment funds, there should still be risk capital available. Staff—Marcia Thompson, Richard Seldon, and Richard Kapp—under Lowry's supervision also tried to find a formula for a way to consolidate other theater, dance, and operatic groups that were needed as outlets for the careers of artists.

In October 1971, the so-called Cash Reserve plan of grants was announced. The press release commented on two key features:

> First, if a group has an accumulated deficit, as indicated by certified audit, the Foundation will pay 50 per cent of the liability after the group has raised the other half within a specified time, usually one year. Second, the grants will provide each company with a cash reserve fund, separate from the company's operating account. The reserve will amount in the first year to 15 per cent of the company's operating budget for a selected base year, and an additional 10 per cent for each of three subsequent years if all conditions of the grant are met. Funds withdrawn from the reserve during the year to meet current operating expenses must be replaced at the end of the year from earned or contributed income, not from loans. A group that does not replace withdrawals from the reserve, or fails to raise matching funds to eliminate the deficit within the specified time, will be dropped from the program. The program gives the group and its board of directors inescapable incentives both to broaden the base of contributors and to avoid the creation of new deficits.

At the outset, the new program was "confined to professional companies under independent audit with annual budgets ranging from $100,000 to approximately $1,000,000." (This was later changed to include

budgets of up to $4.5 million.) The first grants went to theaters, dance companies, and operas (the program did not include symphony orchestras since these had already been substantially funded). The hope was that in four years those groups that could meet the terms of the program would have what the businessman calls "working capital." Lowry pointed out that this would be the first time that this happened in the history of the performing arts in the United States. The board was "enamored" of the plan: they could see discipline and incentive in it, Lowry said. In addition, terminal settlements were made to some of the more selective groups.

In 1972, the trustees of the Ford Foundation "reaffirmed the main-

THE NEW YORK TIMES, NOV. 13, 1966

Staff Conference: Bundy, left, with (clockwise) W. McNeil Lowry, foundation vice-president; Joseph M. McDaniel Jr., secretary; F. Champion Ward and Verne S. Atwater, vice-presidents. Not shown: vice-president David Bell. "The idea," says Bundy, "is to do things the society is going to want after it has them."

tenance of a major presence in the arts through the next decade," although, as Bundy pointed out, the declining value of Ford's investment portfolio necessarily meant a lower level of spending in all areas. Lowry noted that the humanistic scholarship side of his program was "disappearing in some respects on the part of the officers, particularly Mr. Bundy."

Bundy had depended a great deal on Lowry when he first came in, Heald said, but he wondered whether Bundy had recognized "Mr. Low-

ry's philosophy of operation."[12] He didn't think Bundy had any particular philosophy himself but rather was inclined to believe grants could be made off the top of one's head. "You can," Heald said, "but you can also live to regret it. And it isn't really the way to do it." Joseph Kraft described Bundy as "sensitive to the contrasts between changing realities and fixed generosities,"[13] which was perfectly exemplified by his query to Lowry that resulted in the cash reserve grants.

That Bundy had had no previous experience in the foundation field was not unusual, Heald said. "There is a great deal to be said for a certain amount of change in the staff of a foundation. I think people tend to get stale. . . . Ten years is a good long time to work for a foundation —and probably too long in most cases—now Lowry may be an exception." Bundy thought people should not make long-term careers in foundation work, Heald said, and noted that there had indeed been quite a change in personnel since the new president had arrived at the Ford Foundation.

Not infrequently members of the staff went out as university or college presidents, where ten years had also been suggested as the ideal tenure. When queried on whether he thought foundation work ought to be a profession in itself, Heald replied that the individual role was not particularly important—that after all they were only helping someone else to do something, were not really operational in their own right. To what extent did they impose their will on recipients simply by virtue of their resources? Lowry said,[14] "We are catalysts rather than reformers, participants rather than backers, communicants rather than critics." They furthered action rather than rendered it. Foundation work was high-prestige and very pleasant, Heald said, but it was an artificial existence, "sheltered from a lot of the normal vicissitudes of an institution."

What kind of temperament did Heald believe was particularly suited to foundation work? "That's a hard question to answer," he said with a laugh.

> I think it requires a very well balanced temperament to recognize that it isn't your money and just because you happen to be there giving it away doesn't make you anything different from other people and that so many people will treat foundation officers with a degree of special deference which they may or may not deserve and by and large they *don't* deserve, simply because there is so much money involved. If you aren't very careful this does something to your personality. [He laughed.] You either begin to feel you really are important or else you tend to become kind of cynical about the whole business.
>
> And the things *good* people will do in an effort to secure a grant are sometimes quite discouraging. . . . It isn't a matter of who you know but what the proposal is. This is difficult for people to recognize. A good

many people waste a great deal of time trying to figure out how to *approach* a foundation.

The poet Robert Lowell was one of Bundy's cousins. He came in to talk to Lowry not long after Bundy took over the presidency. Lowry spoke to me of "the synapses of people's lives and careers." Lowell's *Benito Cereno* "was written first as an opera libretto, on a grant from the Ford Foundation, to help poets and novelists test their capabilities in the theater form. And Lowell spent time at the Met and time at the New York City Opera Company. He later decided that *Benito Cereno* would go better as a play.[15] The only way that he could get it put on was with another Ford Foundation project, already running at the American Place Theatre, designed to give new material some kind‎ of form, with actors and a director, either in the state of a stage reading, or what was called work-in-progress, or a finished production, finally, which is what this was. And then there were Lowell's relations with some of the other writers who were in that same Ford program in other theaters. Some of whom, like Lowell, were very much interested in translation. So it ends up that Lowell is coming in here to help *me* corral some of these other writers, who are now on the board of [the National Translation Center at the University of Texas]. And who is going to say whether Lowell will stay on the executive committee or not? Lowry is, of course. . . . Robert Lowell was already, in 1959, a highly identified poet, you know. But even with a man at that stage in his career, there are the tentacles that radiate out, between myself and this program and Lowell and other people in at least three different important contexts—and this is only *one* [example]."

On another occasion, Lowry said, "I have been riven and shaken and *transfixed* by people and influences in this job. But there is a combination of a kind of confidence that goes with passion and humility also, it is not anything for which an individual can take credit—it is an inheritance, I think, from the kind of childhood I had—where, you know, you were never in any doubt about being loved and never in any doubt about having a calling. You were taught that every human being enjoys certain rights by virtue of possessing common humanity. . . . I was determined to make a difference for other people. And the Ford Foundation was a great instrument for that." But he would not say that it had satisfied his creative impulse, because "that would be having it both ways—that would be self-indulgent—because, well, I didn't do this for compensation, you see, for not being a playwright. I've found a calling," he said,

> that no matter what I do stirs me up and makes me grapple with a whole different range of ideas and personalities every day, and you're revved up and because you're revved up, what you can accomplish in a relatively brief compass is more.

He said that his feelings about the future and the past, which affected all of his days and gave them their intensity (that intensity he spoke of as the "morality" of his vocation), was "fantasizing but not in the sense that an analyst uses fantasy to mean that I'm substituting for a real life with a fantastic life. It's not Miniver Cheevy[16]—although I think when I was a young man I had a hell of a lot of Miniver Cheevy in me.

"There is a strong temperamental family—hereditary—thing in me," he said, "about history and atavism and daydreaming and vision: envisioning the future, my own and other people's, as an art form."

"When you daydream, perhaps you do the same thing the author of that article on dreams was talking about," I suggested, meaning that he was organizing data. I wondered if an ability to organize was something all nine men have in common, but I decided their ways were so individual that a definition broad enough to cover them all would be so vague as to be useless. The important point was that all of their different ways of organizing were creative: to the extent that if destructiveness existed—and it certainly did—it was an accidental by-product. They were not negative people.

Lowry felt it wasn't always possible for people who had "a high degree of emotional intensity and a high degree of awareness and [felt] themselves always very conscious and very sentient and even exposed" to find a calling which would enable them to have an outlet. That took, he thought, a great deal of sheer luck.

But here I disagreed with him: "You say that they haven't found an outlet but that they have an involvement and an intensity that they can't make anything of. To me, it's not so much a matter of finding an outlet, because I think these people would tend to find one if they did not lack some additional necessary element"—perhaps even only stamina, as Donovan suggested.

"The reason that I use the word 'luck' is that there is only one such job in the United States," Lowry said.

"But you made the job."

"Okay. So you say, okay, you create your own job. I did in a sense. I asked for approval of this program with these principles. Okay, so you created it. Yet, look at all of the things that had to happen to have an institution in which such a job could be created and look at all of the things that were accidental that led to my being in it—my acquaintance with William McPeak, his decision about what I was like when I wasn't even close to a foundation. . . . I asked McPeak why he wanted me to come in here. And he used to say, 'Well, goddamnit now, Lowry, anybody who's been in as many professions as you've been in by the age

of forty must be a generalist. And what foundations need is generalists, people that can very quickly handle any subject matter.' "

"I understand all that," I said, "and I agree with you that there's an element of luck in your landing in the particular place in which you are, but I don't think that anyone would argue you wouldn't have functioned much as you do, in a creative sense, no matter where you landed"—remembering Lowry's own statement that

> every profession I've had, and every opportunity I've had, I have not only thoroughly enjoyed, but thoroughly immersed myself in, with the greatest sense of involvement and activity and excitement.

But in spite of Lowry's case, who would want to believe that "the natural aristocracy of intellect appears to be basically homogeneous in the sense that those people who excel do so generally and those who fail tend to fail in all fields"?[17] Failure is not a function of I.Q. Certainly many who excel in the arts tend to fail elsewhere. And even in the field of intellectual activity different sorts of talents appear.

Lowry said, "I couldn't talk like this except I have survived. I've succeeded. I've succeeded in a variety of ways." He had spoken before of the fact that "even to the people who don't like some of the precepts—if this is what it's about, if it's about principles and policies of grant making or foundation staff work, foundation operation—I'm the pro. I didn't know I was going to be the pro when I came in here. But everybody's gone but me. Do you realize that I'm the last officer in charge of program and policy—to survive? All are gone . . . some of the men retired for age. Others—[a long pause]—didn't survive the squeeze and the strain. Others—were offered things that they thought were better or easier." Now Lowry said one of the ways in which he had succeeded was that

> everybody in the Foundation from top to bottom knows that I don't cling to the Foundation for security, that I can go tomorrow, happily. I wouldn't go as happily as I'd appear to go, but I could do it. I have no security economically but I have the security to know that I could do something else than this, and you can be sure of this, it's been thought about on occasion. That is, don't push too hard or, you know, it may vanish. This is one thing. I'm not seeking a career. I'd never held a job more than five years, I never thought I'd be here thirteen years. This was just another experience. But here I am, and nobody thinks that I'm a fixture, that I can't leave or can't be dispensed with. We don't even have contracts, you realize. We have no tenure, no letter of agreement, only an annual salary. There's a retirement plan at sixty-five. But I've got more than a dozen years, if I do that. I'm even with the Ford Foundation every night. And they all know that. That's one way. The other way has been—maybe—the guy always has an answer, maybe he talks back,

maybe he's stubborn, but he always has facts. This is another way. And the third way is to judge by the results. And the Ford Foundation Program in the Humanities and the Arts characterized the Ford Foundation in those years after '57 more than any single thing the Ford Foundation did. And they know *that*.[18]

DRAWING BY ALAN DUNN; © 1967
THE NEW YORKER MAGAZINE, INC.

CHAPTER 17

SUPERSTRUCTURES

(The action is surrounded)

MARCIA THOMPSON POINTED OUT that Lowry has been generally involved with reviewing the cultural-affairs policies of New York City under Mayor Beame as well as under his predecessor. Lowry said:

> When the Lindsay administration took over, and it was clear that a former curator of the Metropolitan Museum of Art, Thomas Hoving, was going to be Parks and Recreation Commissioner,[1] there was an opportunity . . . to make some different arrangements for the museums, libraries, and other cultural institutions in New York that receive a total of $45 million a year from the city, usually in maintenance support.

With so much happening in the country as a whole, it was recognized that the activities of the City of New York as a corporate body in the arts were only "going to go up."

In 1966, Mayor Lindsay set up a series of reorganization task forces, including one on the arts. It was headed by Eugene Black, Jr., of Lazard Frères; McNeil Lowry was on it, as were Thomas M. Messer of the Guggenheim Museum; Roswell L. Gilpatric, a lawyer who had been Undersecretary of Defense (see page 226); James McN. Hester, chancellor of New York University; Frederick B. Adams, Jr., of the Morgan Library; Robert E. Blum; and a lawyer, John R. Stevenson. "He put us to work," Lowry said, "at the same time he and Hoving started to draft the executive order and the new legislation. And this has made some of us wonder whether we were sort of window dressing." Then, while celebrating ten years of Lincoln Center (it had been incorporated in 1956), Mayor

Lindsay called for the establishment of a New York City Arts and Humanities Foundation.

The task force went "this way and that way about it," Lowry said, but had come to "a unanimous conclusion that we should not endorse the establishment of such a foundation." Lowry could understand, he said, why Lindsay and Hoving wanted the foundation:

> . . . because when money is given to the city, when you get it out again if you're a city administrator, it's very hard. You have to go through all this stuff with the Budget Bureau and Comptroller; everything is a lot of red tape. They'd just rather take a check and spend it, you know, and the foundation, as a private philanthropy, would make this easier. Well, shoot. We haven't found any difficulty in giving money to the city either directly or through an intermediary, and it's tax-exempt to do so.

The advisory task force agreed on a "standard-setting, program-planning, budget-scrutinizing, advisory board." Such a board ought not, thought the Black Committee, deal with the raising or disseminating of funds: too many conflicting interests were involved. It preferred to have actual expenditures remain in the hands of the Comptroller and the Budget Bureau of the City of New York. Such a board or council, Lowry said, had been designed to keep the Commissioner of Recreation and Culture from becoming a czar. "We're fortunate in having as mayor and administrator now people with apparently sincere interests in the arts," Lowry said—that is, Lindsay and Hoving—but, he asked, how could anyone be sure that this would always be so?

While the Mayor was speaking at the Lincoln Center celebration, eight feet away sat czar Roger Stevens, at the top of the federal hierarchy which included the newly formed National Foundation on the Arts, and when Mayor Lindsay addressed himself to the relations that would exist between the national and the city foundations, he said that "the federal government—Roger—wouldn't have to decide what he wanted to give money to in the arts, he'd just give it to this New York City foundation and they could give it." This was Lowry remembering that speech, at which he had been present. "Well, I understand from Mr. Hoving that [Lindsay-Stevens-Hoving] don't now mean that, but that's what they said," bringing up another issue to which Lowry was also opposed: the growth of superstructures with relation to the arts. "Even with our [proposed] council," he said, "we're getting about as much superstructure as we ought to get." The problem had been how, practically, to resolve what on the surface appeared to be irreconcilable opposites—to put less apparatus between the artist and money for him but to make sure no one person would decide where the funds were to go.

Lowry had seen this problem as one to be faced in Washington when, as vice-president in charge of policy and planning for the Ford Foundation, he had conceived it part of his job to spend time with government officials on the proper role of public as opposed to private philanthropy. "If you're in charge of policy and planning for the world's largest philanthropy," he said, "then a lot of things besides internal things are your responsibility." He felt that the apparently single issue of separation was not just another policy question but involved the actual survival of private philanthropy. "It was with this conviction that I went to Washington," he said, "and set up Miss Lavelle and myself in a hotel because we couldn't have a regular office, and then tried to work back and forth on the phone, keeping things going [in New York]. Getting sucked into Thompson's problem, or this bill's problems, was a diversion, but of the same subject . . . I had nothing to gain down there except to help," he said.

Henry Heald said of Lowry:

> I think he's an adequate administrator. I don't think his fame will rest on his ability as an administrator, but this isn't the kind of a job where that's really tested too much. . . . If he has shortcomings as an administrator, it's perhaps doing too much himself.

Richard Goodwin, then in the White House, said later that the Ford Foundation (meaning Lowry) "just came by one day and gave their opinion." "They" went on the Hill and did some lobbying. Goodwin felt they wanted to block the arts legislation. Why? "Some resistance to the idea of government getting into their field even though the amount of money was small." Lowry said, "My only argument with Goodwin was that he was *not* advising Johnson to set up a permanent and independent body like the National Science Foundation. . . . I wanted the government heavily in the field, and a mix of private patrons, foundations, corporations, and municipal, state, and federal tax dollars."

Steven Wexler, Senator Claiborne Pell's assistant, said later that Lowry was a very "pompous and negative" person—that his attitude had been that the $5 million the government was planning to give away through the National Endowment for the Arts was inconsequential alongside the amounts the Ford Foundation had available. If Lowry had heard Wexler's remark, he might have replied that total federal assets considerably outweighed foundation funds and that who could foresee what amounts of public money might be spent on the arts in the future.

". . . I suspect that if you really push Roger Stevens," Lowry said, "and he and I push each other for fun lots, he'd say that his biggest discrepancy with the Ford Foundation is, even though he's Government,

he's got less money in his budget than we have for the arts. But that's not the biggest discrepancy. Someday, ideally, the National Endowment for the Arts will also be this field of inquiry, this catalytic role. . . . None of the state councils in the United States has been, although the New York State council has done some very significant things. Someday that will happen but, to [the end of the 1960's], the underpinning for all that has been not purely the money of the Ford Foundation for the arts but in the way that it went about it and in the way the people have been broken out of their isolation and put together. . . . I'm talking about the philosophy of the approach more than I am about the administrative structure."

"There's a tendency to look back and see what Lowry thinks about this move or that move because he represented the first national influence or national organization that had taken any interest. That's reflected with both resentment and, obviously, a need for endorsement or understanding," said Marcia Thompson at the Ford Foundation.

Hubert Humphrey, who had been interested in federal involvement with the arts—specifically, in the idea of an advisory council—before either Frank Thompson or Claiborne Pell was elected to Congress, felt warmly toward Lowry. He wrote him from time to time, Humphrey said, either suggesting ideas or forwarding other people's ideas. Lowry was not moralistic, Humphrey added—"not one of those people who gets upset" by an artist's possible past connections with Communists: he simply was interested in people's self-expression. He'd had "some conversations," he said, with Lowry in Washington: Lowry had thought that "we would get less than we did" out of Congress. Was Lowry displeased by the increase? No. He just didn't want the government and the Ford Foundation to be subsidizing the same thing. Lowry was not trying to keep government out of the arts, Humphrey added after some thought.

That government got into the arts was due to Frank Thompson as much as to anyone. "He had a lot of help," Lowry said, "but if you had to pick one, he's it. And he's strangely—for most congressmen who can lay claim to something—strangely modest about it. Partly because he also understands political realities, and he *knows* that [Congressman] Fogarty, with Lister Hill on the Senate side, changed the whole scale of support of health and welfare activities in the United States. If your book were about *that*, Fogarty would be it. But it's about the arts and that's about Thompson, with Fogarty's consent."

Thompson:

I'm not—very creative, but—I'm an activist. I look around for what doors are open, and how to open them, if they aren't, and what strings there are to pull, and when to pull them.

You can't—you don't really deserve—down here, in Washington, anybody who takes all the credit for anything is not a realist, because one individual can't accomplish anything.

"But still, people do."

Oh well, I make claims, for the benefit of my district, from time to time —you know, "Thompson passes a bill to make the Small Business Administration permanent"—a condensation, sort of.

As you go along in this business, you get credit where it's due, ultimately, without screaming or claiming it yourself, yeah. Yeah. Ultimately you get recognition. I think it comes easier if you don't stand up and demand it, if you really deserve it.

You can take a bill and have 435 sponsors for it, and it will pass, and 435 members can rightfully claim in their districts that it's their bill.

Thompson had entered politics as naturally as a deer goes into the orchard for apples. He had been raised in a semi-detached house in Trenton, New Jersey, for which his parents had paid about $6,500, and there he lived from the time of his birth in 1918 up until his marriage. He had a very happy childhood, he thought—

the sidewalk, in a relatively quiet neighborhood, on which we skated and—roller-skated, and rode bicycles, and played—a form of hockey on roller skates, and, well, there was our front lawn, and then the street, about twenty-five feet wide, and then a canal which was called the Water Power. Actually its real name was the Sanheeken Creek, after the Sanheeken Indians, but actually it was built to power some factories down in the town. I learned to swim in it. And boat. We had kayaks and canoes and rafts and everything, sure. And then there was a park about two hundred, a hundred fifty yards wide, called Stacy Park, and then the river. So that—one looked out the front window and saw the street, the Water Power, the park, and the river. That park ran for, I'd say, about—two miles, up and down the river. It was beautiful. Yes, sure, I had a very happy childhood. I never went hungry, and I was always looked after, and I was loved by my parents, and had nice playmates and so on.

But:

. . . I don't think that I, until I got to college, that I ever spent one whole day in school that I enjoyed. I just hated it.

His troubles had begun his first day in a parochial school, and he enjoyed himself telling the story:

I was in fourth grade then, and went to a school called Blessed Sacrament. My teacher was the Mother Superior; her name was Mother Alico, and I remember my father saying, "Oh, I know what that stands for: it's

American Locomotive Company." She was a very formidable woman.

We studied catechism, you know, and they put the boys on one side of the room and the girls on the other, and they'd ask you questions, which you answered by rote, of course, and the nun kept score.

I happened to be with the boys on one side of room which was lined with lockers for our coats, and on the faces of the doors were pictures of the Christ child at various stages of his youth up until the time he disappeared into the synagogue, you know, and astounded the elders. These pictures were behind me and I turned to look at them, and when it came my turn to answer a question, I didn't respond. Mother Alico gave me a couple of good whacks with a pointer.

I raised hell. I think I ran home at lunch hour, screeching about it. I don't remember what my mother thought, but as between her son and the cloth, she'd likely choose the cloth, knowing her son was inclined to be naughty. My father was incensed though, he didn't like the idea of the nuns hitting the youngsters, went up there and raised hell about it. I think she stared him down or something. He went in full of fire and brimstone and came out and said to me, "Well, you're not going to get hit any more, but by God, you pay attention!"

His father had been a volatile character, opinionated, Frank Thompson said. "I've been told that he never lost an argument. But his relations with me were different than they apparently were with outsiders. I was his son, and he was more tolerant of me, I suppose. Yet he was a very popular, well-liked man. He was a Republican, a strange combination of a traditionalist and a conservative in fiscal matters, I would suppose, and a liberal on race relations, on civil rights and civil liberties. He was a highly respected newspaperman and writer." Apparently he guided young Thompy's reading, and Frank Thompson thinks he got his attitudes not so much directly from his father as from the things his father had him read:

Well, you know, he took the motion pictures and the Rover Boys and the Horatio Alger from me at the age of about ten, and said, "You've read enough of that junk. Here. Here is a whole set of Mark Twain. Read it and enjoy yourself."

Thompson could not remember a time when his father had not been ill, but in spite of that and in spite of his being "easily the world's worst driver," he would take the whole family for drives almost every day in the afternoon. A few years after they got their first car, just before Frank Thompson's thirteenth birthday in 1931, his father died. "It was quite shattering," Thompson said, "because I was terribly insecure about it, you know. I remember saying to my mother, 'Daddy's dead, who's going to look after us?' And she said, 'I am,' and—he'd left her a little something for us to start with, and 'We'll be all right.' But it *was* shattering."

His mother went to work a few months later as a social worker and continued for over twenty-five years. She was terribly strong in most ways, Thompson said, with "great strength of character and determination." She never remarried, perhaps because of her two young sons. "She had a lot of offers. I don't know why she didn't remarry, except that she said to me, 'Well, I just don't think I could live with someone else.' She had a little trouble, here and there, with herself, but she did very nicely. She must always have been very lonely really, in all these years. And she was really —if not beautiful, a wonderfully handsome woman. A lot of people said beautiful. I won't argue that."

His mother had taken him into New York in his early teens, to the Music Hall at Rockefeller Center. And he went on his own to the city while in high school, to hear jazz:

You know, Benny Goodman and—and, the Casa Loma Band, Hal Kemp, and then I, I followed the Negro orchestras. Well, if Duke Ellington were within three or four hours' commuting of Trenton, appearing anywhere, I was there. Or Fats Waller or Jimmie Lunceford. I used to play hooky . . . I was kind of trying to manage a band made up of my high school friends. I couldn't play well enough, really, to play. I used to sort of fake at playing the bass fiddle. You know, I could keep the rhythm and—I couldn't do much other than hit an occasional proper note. But the Negro community had a place called the Sunshine Elks, see, a really wonderful Elks Club, and they had great bands. For instance, I saw Ella Fitzgerald at age sixteen, and she had this big hit, "A-Tisket, A-Tasket." She was with Don Redmann's band. They appeared in Trenton. And I was there, and very frequently, you know, there were only two or three of us who were white, who'd go.

Thompson said he played hooky approximately two days every week of his high school career and had been caught about twelve times in four years. He'd gotten at least passing grades, he said, but had to spend an extra year in high school, reading in the meantime everything he could: "I'd play hooks and lie in the sun, in a canoe, or, or in the park, and read," getting books from the branch library where his next-door neighbor, Dorothy Clark, was an assistant. And there were perhaps a thousand books, he estimated, in his home.

"There was no dramatic group that I remember in town," Thompson said. Of the other arts: "We had a little symphony orchestra, as we still do in Trenton, and my mother ran a benefit one time for the Tuberculosis Association and had a soprano, a Wagnerian soprano . . . I think I was about fourteen, possibly fifteen. More like fourteen. She was a—typical Brunhilde type—big, handsome, buxom dame, you know, with a great, huge voice. I guess really—no, well, she was a soprano, but she seemed

to me like more mezzo than—a contralto, in a way. I thought she was just magnificent." Among painters, his favorites came to be the French Impressionists, and he commented that he was perhaps "more sensitive to use of color almost than anything else rather than the shape or the form." He and his wife occasionally went to art museums, but Thompson said he really wouldn't know how to define a work of art. Dali's *Crucifixion*, for instance, could be a work of art even though it might "offend the hell out of an awful lot of people." Of another Dali painting, he commented, "*The Last Supper* is [in the National Gallery]. That's another—that's a gas, as they say."

Before Thompson was ten years old, he had seen where the New Jersey legislature sat. It had been his father's beat for years, and he had taken his son with him in the evenings, "perhaps even before I started school, I don't remember that," Thompson said.

After my father died, an uncle of mine was a newspaperman, uh, in the State House, and as a matter of fact his office was in one of the rooms off the back of the Assembly chamber, and I used to go there very, very frequently. So that's, in a very real sense the State House in Trenton has been a home for me since I was a child.

. . . I used to go and listen to the debates, and enjoy them, and . . . when I was about twelve I decided that I was going to be in that legislature someday.

. . . A great-grandfather of mine ran for office in Trenton. My grandfather [a lawyer] ran for office in Trenton. My uncle ran in Trenton. And I. And I expect that some others will follow. And on my mother's side—my grandfather was very active in Republican politics. He was a Bull Mooser, Teddy Roosevelt man. Matter of fact, he was his campaign manager for New Jersey. I used to listen to politics from him. He'd take me to the polls when he voted in—I'll never forget 1928. Somehow or other—ten years old, I was all for Al Smith. I distributed literature around the streets for Al Smith . . . went down—to the Democratic headquarters and got it. They knew who—who I was, you know. I'd—would go in and I'd say, "I'm Frank Thompson, or Thompy, I'd like some Al Smith literature." "Well, what are you going to do with it, kid?" You know. "Throw it down the gutter? Your father's for the other fellow." "No, I'm not gonna do that, I'm for Smith." . . . my father was for Herbert Hoover. He took me to the polls with him, and—I actually went in the polling booth. I didn't see him mark his ballot, but when we went out, my father handed his folded ballot to the election officer and said, "There's a blow for the 'Sidewalks of New York.'" I was crushed.

Thompson's uncle was the Democratic county leader. "Well," Thompson said,

when I was fifteen, I started with a broom in Democratic headquarters, and used to sweep it up and help around, and then when I was seven-

teen and got a driver's license, I drove people to the polls, delivered
pints of whiskey around to the polling places on the night before elec-
tion, and when I was eighteen, I drove people to the polls and knocked
on doors. I did that—every election—till I went in the Navy.

 . . . just before I went—in the Navy—I went all over central New
Jersey. Well, by all over, to eight or ten places, and made speeches for
Governor Edison, who, he was Secretary of the Navy and was running
for governor of New Jersey. I worked very hard in that campaign.

"How does that work, campaigning for someone else?"

Well, that's fun. You know, you—they have a Grange meeting or some-
thing like that, and they want a speaker in behalf of a candidate who
can't appear himself, and you go, and they introduce you, and you make
—a pitch for your candidate, finish, and off you go to the next place.
That's fun.

"And in a sense you're making yourself known."

Oh sure. That's part of the idea.

"How did you feel about the issues? Do you remember any specific ones
from that campaign?"

Oh, heavens no, I can't remember what the issues were. Just sort of,
our fellow's better than their fellow, you know. I don't even remember
who the Republican candidate was. . . . But I was terribly, as were so
many of my generation, pro-Roosevelt . . . and we talked more about
Roosevelt than anything else, really. "This is President Roosevelt's Secre-
tary of the Navy. He's just like Roosevelt. Roosevelt wants him." Roose-
velt *did* want him to be governor of New Jersey—I've often suspected
to get rid of him from Washington.

 Thompson went to Wake Forest College in North Carolina on a
basketball scholarship. His English professor wrote some thirty years later
that Thompson had been one of those students a teacher doesn't forget.
"Frank was an interested and interesting student with an inquiring mind
and an eagerness to learn for himself," said Edgar Estes Folk.

He listened and studied and then weighed all in his own balances, swal-
lowing only that which his intelligence told him to digest. As a student
Frank was concerned with still other things beyond assimilating informa-
tion which would lead to a degree and later to making a living. He was
interested in fine arts, and I was not surprised years later to read in *The
New York Times* that a columnist, writing about a fine-arts center in
Washington, said that Frank Thompson of New Jersey was one of only
two congressmen whom he would trust in matters of fine arts.

 I knew him first in freshman English in 1937–38, and I remember
that I filed for him one of the very few grades of A I ever gave in that

course in the years I taught it. Later I came to know him better in a small advanced class in essay writing, and there his work confirmed that I had not misjudged him as a freshman. His writing had both substance and life, products of his will to be his individual self as a thinking young man.

I recall his wrestling with one particular experience and trying to find in it a meaning that could be crystallized into an essay. In the summer he had worked on the right-of-way for the future New Jersey Turnpike, and his crew had been assigned to "move the graves" in an old cemetery. In one of the graves, of a Civil War veteran, I believe, Frank had found only a gold collar button. That projected essay was never written. The young man could not clarify his reaction to focus upon a meaning. To meet the deadline of an assignment he could have described the experience and let it go at that. [But] Frank had to find his own meanings.

Thompson's LL.B. was dated 1941. He was commissioned in October 1941 but not assigned to active duty until December 8, the day after Pearl Harbor. Before he got out of the Navy, he was to receive the Bronze Star and the Gold Star as decorations. He said:

I got out in about November 1945, on terminal leave, which technically left me in until February of '46. And then the Navy asked me to go back on active duty—eight or ten months later—to organize the Naval Reserve for the central New Jersey area, as an officer on active duty, and I did that from '46 to '48, and then—I was commanding officer of a battalion of Naval Reserves in Trenton, New Jersey. That was, oh, approximately 600 men and 100 officers, and a lot of them began to get called up when the Korean War thing broke. And I came to Washington to find out why they were calling all enlisted men from my battalion and none of the officers. And—an officer under whom I had served during the war said, "Well, we've called for volunteers for officers. Why haven't you volunteered?" You know, he sort of threw the gauntlet down. And so I said, "Well, by God, I volunteer. Furthermore, I volunteer to go to sea." He said, "That's fine."

"Why did you volunteer? How did your wife feel about it?"

Oh, my wife—I rather think that she was under the impression that I was called. But it doesn't matter one way or the other. She didn't feel badly about it at all, because she was born and brought up as a Navy junior, and, well, actually I *was* called. You know, I said, "Volunteer, okay, if I volunteer, I volunteer. If you call me, I go. I don't care one way or the other." So they called me, really.

I was just beginning the practice of law . . . well, had been, I guess for about eighteen months. I was admitted to the bar in April of 1948.

Frank Thompson at a hearing on arts legislation

"Weren't you worried about going off and leaving your practice, and what you would do when you came back?"

Yes, I was. But I felt that that wasn't as important as—if I was needed to go. I love being at sea, but I didn't get to sea during the Korean thing. I got assigned to an admiral's staff in New York City, and commuted to Trenton. Hm!

"I can see why your wife didn't miss you!"

Yeah. Yeah, it was a disappointment. I mean—I spoke too quickly. No, no, it wasn't a—it was what you'd call good duty but I didn't really feel that I performed any really worthwhile function during that tour of duty.

Thompson had been elected to the state legislature in November 1949, and was sworn in in January 1950. "Oh, that was a big thrill!" he said. "My wife was there, my mother, our daughter Ann, who was then about five or six." He had found it even more thrilling to be sworn in later in Washington. "And you know," he said, "you come down here and you take a look at that great Capitol dome, and I still get a kick out of it every time I see it."

After getting out of the Navy he had finished law school, gotten admitted to the bar, and presented himself to county chairman Thorn Lord, whom he'd known for many years. There had been a scramble for the nomination, and Thompson had gone to see some twenty or thirty Democratic Party people, and "a great many of them in turn went to see Thorn on my

behalf." Lord organized the campaign. "All we did," Thompson said, "was run around and make speeches and campaign and knock on doors and shake hands and—work like hell." He said:

> Mercer County, my home county, had been overwhelmingly Republican for many, many years, and in the session before 1950, of three assembly-men we had one Democrat and two Republicans and for a number of years had had a Republican state senator. An uncle of mine had been the last preceding Democratic state senator, Crawford Jameson, my mother's brother. So in 1949, after some years of very hard work by a whole lot of people, we took all three Assembly seats and the Senate seat, the Democrats. I was lucky enough to be one of them. We still have all of them.

"I was a member of the state legislature when I went into the Navy," he said, "and I simply didn't resign. As a matter of fact, I ran for re-election from the Navy, without being able to campaign, but I ran and was re-elected in '51."

"Didn't they need you?"

"Who, the legislature? I was able to show up occasionally. No, I don't think they really needed me. They didn't seem to miss me. But I didn't give up my seat in the legislature. It was suggested that I do that, but I refused."

Thompson commented that the New Jersey legislature was fairly casual in what went on in the sessions: it was much more disorderly than the House of Representatives, and,

> you know, in state legislatures the words aren't taken down, so the debates are hot and heavy, and irresponsible, for the most part. They're fun.

What plans Thompson had for resuming the practice of law after he got out of the Navy went awry:

> I had been law clerk and then an associate in a law office established by my grandfather. His name was William Jameson. And my uncle, my mother's brother, William Jameson's son was the head of the office. So I did—you know, I just left it and assumed that I'd go back and planned on going back. And I did go back, for a very short time. Two or three days. . . . I was deeply immersed in politics, and I found that, uh—according to the members of the firm, that they thought they could do, having done without me for sixteen months, that they could continue to do quite well without me. And, in short, they had made other plans. And so—I established my own office, at that point. That was in January of '52.
>
> Well, I had a difficult time, during '52, and then—in '53, I had a partner, fellow named Harry Walsh, and we'd built really a quite good

practice, enough for us to, with our two families, to live on reasonably well. In those days [the pay] was 3,000 dollars a year, as a member of the legislature. It's now 7,500 dollars. . . .

We had a general practice. We did a lot of work for New Jersey civil servants, before the New Jersey Civil Service Commission. We did negligence work, we did condemnation work. . . . I have retainers [now] from two or three small corporations and mostly give them advice. No, I wouldn't say as a business lawyer. I'm—I'm sort of a plaintiff's lawyer and always have been, or defendant's lawyer. I do it in New Jersey. I have associates who look after the day-to-day matters. I have to maintain something of a law practice for two reasons. First, as an anchor to windward, something to go back to, and secondly, and perhaps most important, to supplement my income so that I can live on my—I can't live on my congressional salary, I have to supplement it. And I do that.

Thompson added that he did not own a single share of stock; "I have no savings account," he said, "I don't own anything, I guess—some insurance policies, a retirement fund, and most of a house. That's all." And

I don't do any federal court practice at all, even—cases where actually I'm eligible, or where it's not a conflict of interest. I refuse any federal court work of any description, in order to avoid conflicts. . . . I haven't seen the recent statistics: I think somewhere around fifty-five percent of all of the members of Congress are lawyers. Most of the lawyer members from the Northeast and the Midwest, to some degree or another, maintain either a law practice or a connection with a law establishment. Basically, as insurance. You know, you don't know from two years to the next whether you're going to be a member of Congress or—practicing law, so you have to keep at it. . . . I, for one, have been against a four-year term for members. Well, because the House of Representatives is the closest of the two bodies, by far, to the people, and the people ought to be able to rectify their mistakes every two years. . . . I enjoy campaigning. It's arduous, it's expensive, it's difficult, but it's part of the process, I believe. I don't relish it, but I don't hate campaigning. As a matter of fact, I rather like it.

Thompson was elected to the Eighty-fourth Congress of the United States on November 2, 1954.

When had he first become interested in arts legislation?

"I was sort of fiddling around when I went to Congress with what to do," he said,

and had some very good advice from a number of people, one man in particular, to look around for a specialty or two, otherwise I'd get lost in the mob of 434 colleagues.

I'm referring to a man who died a year or so ago [1966] named Ralph Cogland, who was—was a great newspaperman and at one time

the editorial chief of the St. Louis *Post-Dispatch*. He was a Pulitzer Prize winner, was a great speech writer for Charles Wilson of General Electric, Jack Kennedy, and for Governor Meyner and others, and a very dear friend of mine.

Well, I met Ralph when I was in the New Jersey legislature, and on a couple of occasions had gone to him with ideas for short speeches for me to give there. He wrote them and I learned to—love Ralph—and Ralph learned to love me: we were great buddies. He was a much older man. And—following my election [to the U.S. Congress], he—we were having lunch one day and he said, "Now what are you going to do when you get to Washington?" and I said, "Well, the first thing I have to do is learn what my job is, and what it's all about." I'd been frightened during the campaign by my lack of knowledge of a lot of the federal issues—and—fortunately I had an opponent who knew less.

One thing led to another, and Cogland said, "Well, that's a good idea. When you learn your way around you oughta meet as many of the influential and effective members of the House and Senate as you can, and look around for a specialty for yourself or a couple—get to be considered a specialist in one or another field, and you'll have some identity in the House that you wouldn't have except in the Senate."

So I *did*—and I decided that education would be one, and then I got on the Labor and Education Committee, and I suppose I'm something of a specialist in those general matters—labor and education. Many [representatives] become specialists over the years by virtue of their committee assignments—it's different from seeking out a specialty and sort of establishing yourself in it before your normal—season, shall I say? —or the ripening process that the seniority system brings about.

The arts were identified as education, so far as Congress was concerned.

Thompson said that he had also been influenced by his wife. "I'd been interested in college in writing and literature, and I'd always been a jazz buff but knew very little about classical music. I knew very little about architecture or painting or the dance. As a matter of fact, I don't know much about those things now, but my wife had been interested in the theater and had studied music at Peabody in Baltimore and had gone to the Philadelphia Academy of Fine Arts—so she gave me a tremendous amount of encouragement—toward developing federal programs in the arts. So she's very—you know—largely responsible. . . ."

Thompson said, "Of course you can't achieve much—anywhere—particularly in public life—without a tremendous amount of support from your family. That's *sine qua non*, in my judgment. I don't mean that corny business of trotting them around in campaigns and campaigning on the basis that you're the father of seven little children or something like that, but— that's an indispensable part of American politics. It's sort of ridiculously overdone by a lot of people. What I *do* mean is that you can't campaign

every two years, as a member of the House does, without a sympathetic wife, and if you have children, some help and sympathy from them, because it's a grueling process and involves a tremendous amount of sacrifice on their part."

"Wouldn't arts legislation have been a rather unpopular specialty?" I asked John Hawke, who had been counsel for Thompson's subcommittee.

"Well, nationwide or even in Congress as a whole it might have been, but don't forget he represents Princeton, New Jersey, which is of course a university town and the center for a lot of cultural-minded people. I don't mean to suggest that his interest in the arts is purely expedient. I think his interest is one of real substance." Hawke said:

> I think he has some feelings of insecurity that may not be apparent until you really come to know him fairly intimately. We were talking before about his relationships with intellectuals. . . . I think he welcomes the approbation of the intellectuals, but I also think he has a great appeal for intellectuals, not as an academic-type intellectual, but the impression he creates is one of real surprise. I think most people from the arts or from the academic community are very surprised to find an attractive, politically successful guy who knows a lot of their language and does have a great dedication to the things that they're interested in.

Although Senator Claiborne Pell called Thompson a "working intellectual," John Hawke believed that he was

> not an intellectual in the sense that Henry Reuss from Wisconsin is. Reuss is an economist and a university professor and, and really not terribly politically operational. I think many of the real intellectuals of *that* sort in Congress tend to almost be self-defeating in their congressional activities. They don't get the things done that they want to get done, because they don't have the kind of political talent that Thompy does.

Marianne Mantel, co-owner of Caedmon Records, had moved from New York, where, she said, she and her husband had been "what Thompson would call 'not politically active but politically vociferous,'" to Mercer County in 1958—into "a forest of Nixonites"—and there the Mantels had worked for the Democratic Party.

> I think, in terms of a congressman [she said], he's far superior to 430 of them. I mean, he's in the top five. . . .
> Thompson politically has charted a very interesting course, because his instincts are very good. I think he's a guy who really has a lot of, you know, what used to be called "heart." You know, the little old Negro ladies whose children are put in some public welfare hospital and the mothers don't get any information and that kind of stuff, you call him,

and he does something about it. . . . He's very well known to his con-
stituency . . . the population bloc are Polish, Italian, and Irish, and if
you want a better definition of reactionary, I don't know how to give you
one. I mean, labor unions. He's the big labor guy. I think probably what
gave him the continued leverage to push this arts thing was the Ameri-
can Federation of Musicians. I'm not sure of my facts on this, but I
suspect this was the beginning of it. . . .

Through Thompson's efforts on the education bill, Caedmon now
has a whole floor in a large building—you know, our volume is immense,
and a very large percentage of it goes to school. We've recorded "The
Star-Spangled Banner" and "I pledge allegiance to the flag of the United
States of America" with an introduction by a teacher telling them where
to put their hands, like where their heart is so they can put their hands
over it. Because if we don't do it, after all, somebody else is going to
do it, and we might as well sell it. Well, we use the proceeds not to
feather our nests but to do things that aren't commercial.

It sounded as if she and her partner, Barbara Holdridge, had gotten into
a situation where they functioned the way a publisher does when he uses
text proceeds to support his trade department. "Right," she said, and
pointed out that when Caedmon had been started in 1952, John Dewey
and a number of other important people had still been alive: Caedmon
had recorded many of them—T. S. Eliot and the like, she said—but there
were many

whom we couldn't record because we didn't have the money, and you
know, we went to Ford and we went to Rockefeller, and here were these
guys making fifty thousand dollars a year with huge staffs—Barbara and
I were literally starving—you know, we used to have like one meal every
two days—and they told us [she laughs] they couldn't give us any
money because we were commercial.

"Thompson is the kind of a guy," she said, "who—not really having an
intellectual background—he enjoys consorting with professors and show-
biz people and so forth. That's nothing against him. . . . I see him up here
and no political purpose is served by it and his time is precious, so it can
only be that. But I like him. He's a very nice guy. . . ."

A politician is in a situation where it's hard for anyone, sometimes in-
cluding himself, to know how valuably he is using his time. "He probably
spends a disproportionate amount of his time here," Marianne Mantel said,
"to the extent that these people represent a small proportion of his con-
stituency, but he likes them—and I suppose they provide him with ideas."
She commented that in the course of the year he was in the Princeton area
to make speeches, and "We see him socially," she said. "He tends to drop

in. . . . Maybe he just wants a drink, I don't know. He just likes to be so-
ciable. Sometimes he rings and sometimes he doesn't."

"I daydream," Thompson suddenly remarked. "You do?" "Sure. . . . You
get a lot of ideas daydreaming, I think. Well, how to do things or what to
say. I rehearse speeches in my daydreams all the time, or *write* speeches
in my daydreams. I don't write many speeches—only the very important
ones—but I deliver all of my daydreamed speeches at one time or an-
other. In other words, they really aren't extemporaneous as they sound.
. . . As a matter of fact, I settle most of my arguments with people I
don't like in my daydreams. . . . Oh, it's almost always when I'm shaving
because shaving's a bore and I try not to think about it except not to cut
my face—or when I take a shower. I can't sing. I can't carry a tune, so
instead of trying to sing, I just write speeches or make speeches, rehearse
them—for all sorts of occasions.

"I occasionally get caught not paying attention to conversations, you
know," he said. "That's embarrassing. I'll drift off, especially if someone
bores me. I'll sit and look at them and try to look interested and then drift
off into one of my daydreams" (he chuckles).

. . . We used to have a lot more [in the way of boring obligations] than
we do now. We just don't go to boring things if we can avoid them.
Cocktail parties, for instance. Big cocktail parties are tremendous bores
and the cocktails usually aren't any good.

Did he ever get anything done at cocktail parties?

Yes, occasionally, and some of them are very much fun. I love Roger
Stevens' cocktail parties, for instance. Because there are always a lot of
interesting people there and people whom you might not see or it would
be difficult to see in the usual course of events—people from the gov-
ernment, people from the world of arts and so on.

How frequently did he go out in the evenings?

I've never been one much for this—Washington diplomatic or social cir-
cuit, because it can—consumes awful amounts of your time, and you sort
of get in little orbits and see the same people over and over again and
talk about the same things over and over again. [Evenings were spent]
very largely either listening to music and talking, or listening to music
and reading, or just talking. We used to watch television a great deal,
but in the last four or five years, hardly ever watch it. Well, we have a
number of people in, but not terribly frequently, no, actually. Yeah, by
the time one finishes a day, up here on the Hill, a typical evening will
be this evening. I'll go home and—oh, usually get home between six-
thirty and seven-thirty, and relax and have a couple of cocktails and talk

to the teen-ager before she takes off to do her studies. She'll go up and
study for a while, my wife and I have a drink, and then she'll come
down and help her mother—put dinner on. We chat during the meal,
and through the evening, and go to bed reasonably early. Yeah, eleven,
eleven-thirty—usually after the eleven-o'clock news. That's the one thing
that we use television for. You know, we have a lot to talk about. What
I've done during the day, what she's done during the day, what the chil-
dren have done during the day. . . .

I want my children first of all to be happy, and I think they are. . . .
The eldest is twenty-two, and she's been a civil-rights activist. She's
terribly interested in government and knowledgeable—she went to a very
wonderful college [Oberlin] and did extremely well. She was elected Phi
Beta Kappa and was way up in her class. . . . What contributions they
make are dependent largely on either what opportunities come their way
or what initiative they take. Now, the young one said to me the other
day, she has said consistently for years that she'd like to teach. She's just
fifteen. She says she's re-evaluating that now, and she thinks that she'd
like to go into politics. Well, that's perhaps just a transient idea, I don't
know, but *that* would be fun, to see her go into politics. I've seen a
number of women in politics—they do very well, *very* well. I don't think
that there're enough *of* them. In politics at any level.

Didn't he think that was a tough life for a lady?

. . . I think politics is tough for anybody . . . I think the thing that prob-
ably makes it toughest of all is the decision making at *every* level. Ah—
it's difficult to decide sometimes what course of action to take, and in
many instances the expedient thing to do isn't the right thing to do,
and it's difficult to do the right thing in the face of the criticism that you
know it's going to engender. Well, various people make their decisions in
various ways. I make mine on the basis of—when a problem presents it-
self I try to learn as much as I can about it—either study it, go to some-
one whom I *know* knows more about it than I—consult with my wife,
with my colleagues, with my staff, and decide what's the right thing to
do and then do it.

His wife didn't particularly like politics, he said, "or me being in it, but
she's, sure, she's very politically minded. . . . Actually," Thompson said, "I
try to leave as much of my work behind me at the office as I possibly can,
because you just can't tolerate too much of it. An awful lot of it's just dull,
anyway, you know."

Thompson suggested, and I agreed, that one of our interviews be held
in Trenton. From New York City the trip took one hour on the Pennsyl-
vania Railroad, round-trip special $4.15, on a gray, wintry morning in Feb-
ruary 1967. My taxi went by the old State Capitol building, then a new
Cultural Center with historic old Trent House standing right behind it.

The driver stopped at 383 West State Street, which perhaps originally had been built as a private house and as such undoubtedly had seemed enormous and rather elegant. Now it housed a few offices, including that of Congressman Thompson, and its large halls and board floors were bare and drafty.

Thompson had been chairman of the National Registration Drive during the 1960 election. I set my tape recorder on the desk and looked at the man of whom John Hawke, now a Washington lawyer, had said:

> Well, I think that anybody's first impression of him is that he's a striking-looking guy. He's a very attractive figure. Then when I was still starry-eyed about being in Washington, and the Kennedy aura was hanging over everything, and he had been closely identified with the Kennedys—he was really an exciting figure.

"This goddamn job!" the man across the desk burst out. "You know, somebody has to be nuts to want it and to stay in it. I haven't felt well today. Oh, it's terrible. It gets just awful. You get streaks—nuts calling, you can't get your work done, you know; the desk is always stacked up with a whole lot of stuff. Well, that's irrelevant. Some days it's great."

What sort of people called him? "Oh, John Birch Society nuts and Vietnam nuts—on both sides—and every other kind of nut, mostly with axes to grind at this time of the year, because legislation is shaping up and they want their point of view known and, you know, they haven't read the legislation or the messages and they don't understand what it's all about. It's the draft today; last week it was the crime report; and God knows what it's going to be next week."

For politicians, the primary means of communication is by voice. "Usually any memo or any piece of written matter that runs more than two pages they balk at," noted Wes Barthelmes.[2] "You haven't got a lot of academicians or scholars up here—they want to get it quick and fast." Robert Sherrill, in an article called "Who Runs Congress?"[3] remarked: "If it is true, as some claim, that the work load of the men and women of Congress has been doubling every five years, the accumulation does not seem to be measured so much by weight as by speed. In talking to aides one gets the feeling of desperate haste, of their bosses' rushing to keep ahead of some out-of-control machine."

The use of the word "politician" as a persuasive talker is considered slang;[4] the unabridged dictionary[5] says its definition as a "politic person" or "schemer" is obsolete. Bergen and Cornelia Evans[6] offer the following:

> A *politician* is considered by many of us to be one who resorts to various schemes and devices, who engages in petty politician maneuvers for purely partisan or personal ends. . . . Among those who accept politics as

a necessity or a profession, there is no such contempt and the term, though freely granting many of the implications that make it pejorative to idealists and non-politicians, is even used in admiration.

Thompson said he came back perhaps two days a week to Trenton, to "politick," by which he meant talking to various city groups, the governor, local political organizations—"things like that."

He had cheered up somewhat by the end of our interview and when we came out of his office into the anteroom, furnished with a secretary's desk and a long, heavy table surrounded by weighty chairs, Thompson commented that Adam Clayton Powell had a similar table. A Negro with a not unamiable countenance was waiting, smoking a cigar in a self-assured manner. ". . . he's also a very valuable political contact with the Negro community in Trenton," Thompson had said. "He came with me in September. He was unemployed. He's a waiter by profession, but he fell on some ice several months ago, or last year, I guess, and hurt his back, and I heard that he was unemployed and didn't know what to do. And so I needed someone to help me out, and I hired him, and I liked him so much I kept him. I never had one before. He's not really a chauffeur," Thompson said, but more like a man-of-all-work.

Thompson drew my attention to a picture on the wall, of President Kennedy signing the act to amend the National Cultural Center.[7] I asked who the lady was, and he laughed and said she had edged right up front there close to Kennedy when she hadn't even voted for the bill. Thompson pointed out Charles Buckley from the Bronx. Three of them, he said, on a Monday had come marching into "Jack's" office in order of seniority—and here Thompson acted out the marching—and "the President had sort of peered around the first guy at Buckley and Jack had said, 'Do my eyes deceive me? Charles Buckley in Washington on a Monday?' Buckley sort of mumbled, 'I can be in Washington when there's something important, Mr. President.'"

Thompson tells such stories with great relish. Willie Morris, commenting on the Texas legislature, noted that it was an environment in which "the heavy hand was not only ineffective, it was usually irrelevant."

> Humor was essentially a way of surviving, and it was no coincidence that every good man I knew in the political life of the state had a deep and abiding sense of the absurd.[8]

Thompson not only had a sense of humor. "I have a very bad temper, unfortunately," he said. ("I cannot remember his ever expressing *serious* anger with someone," said John Hawke.) What did he do when he got mad?

My face gets scarlet, my voice rises, I throw my glasses.

"Do you ever break them?"

Oh yeah, I break eight or ten pairs a year. I'm such a good customer of the optometrist here that recently he gave me a pair on the house [said in a humorous, rather proud tone of voice].

"Do you ever throw anything else besides your glasses?"

Yes. I throw dishes.

"Do you throw them at people or just at the floor?"

No, no, usually at a fireplace or something like that. We have brick floor in our house—the dining room is at basement level—English-type dining room. It's a brick floor and it's got a great big brick fireplace. It's fun to scoot dishes into it. I shouldn't do it.
I kick wastebaskets.

"Do you ever kick them hard enough to hurt your toe?"

Yes, I have, as a matter of fact. I wear fairly heavy shoes, but—yeah, had a pair of loafers on one day and kicked a wastebasket that I didn't realize was quite as loaded as it was with paper.

"Did it make you madder than ever?"

No, it settled me down instantly, as a matter of fact [he sort of laughed].

"Can you think of any characterization in general of the things that tend to make you mad?"

Oh—stupidity makes me mad. Or bumbles. Or catching people lying. Or blatant inefficiency. Things like that. Things that make everybody mad, really.

"Do you think it is important that people don't lie? How about evasions? Do they make you angry too?"

They make me angry but they don't make me really mad. [Pause.] Because I *expect* them in this business—you expect them all the time.

"Aren't lies fairly frequent in this business?"

Yes! But it depends on whether it's—lots of times, you know, you have to—white lies are used in the business of politics, and they're kind of a merciful thing at times.

"You use them too?"

Yes, I'm afraid so.

"Do you think you've changed much over the last ten years or so?"

I—yes, I guess I have. I've quieted down some. Considerably, I guess. I do much less talking in public than I used to do. I don't mean speaking, I mean—I don't take the well of the House very often any more. I used to. 'Cause I just don't want to overdo it and undo whatever influence I might have *built* up, as a member of the House.

Thompson was chairman of the Democratic Study Group in the House of Representatives for the Eighty-ninth Congress. John Hawke commented: "When the Democratic Party itself was split, with the Southerners going one way and the rest going one or more ways, the liberals, in order to accomplish *their* objectives, had to be as nearly monolithic as possible. The Democratic Study Group had its own whip system, which was kind of a system within a system. It was separate from the Democratic leadership and not always identified with the positions that the leadership itself was taking. . . . Its primary value, in practical, pragmatic terms was its ability to get its members to the floor for crucial votes. If you're familiar with the way the House operates, you know there's a tremendous problem of just communicating information. . . . Thompy, I think, was instrumental in molding this whip system into a really effective operation by disciplining the members of the Study Group to understand that they had to operate this way and that it was essential for them to react to whip calls . . . this pyramidal structure with the whip at the top and then sub-whips, each of whom had a number of people to call, so that one phone call would set the system in operation."

Was Thompson especially good on that kind of practical detail?

Yes, this is the kind of political and legislative operation that he really revels in. He loves this. . . . The thing about his job that really appeals to him the most is the legislative infighting.

. . . The chairman of the very important committee, who has all sorts of favors to dispense and has a lot of people looking to him for favors and for position and legislative concessions and so on—has a very dramatic kind of power. It's a blunt kind of power. Well, take the Speaker of the House or the chairman of the Ways and Means Committee—they are in the position of exercising life-and-death authority over an awful lot of legislation, an awful lot of other things that go on in the House. I really don't think that Thompy is attracted to that kind of power. I think that he would find much more enjoyment in a conflict situation such as the Rules Committee fight, where it really takes some ingenuity and wheeling and dealing to accomplish the political end that you're after.

Thompson's routine "depends on the time of the year. Typically from now on, it being, what?—March the 6th, I'll be here [in the Rayburn Build-

ing] in time to go to committee in the morning, and listen to witnesses, or mark up a bill in executive session. Come into my office—as much of the morning as I can—and look my mail over, give my staff directions, or answer their questions." (Thompson's secretary, Mrs. Charlotte Bouton, had been with him ever since he had arrived in Washington some twelve years before.) "About that time," Thompson said, "it's noon, and the bells ring for a quorum, so you run over and answer your name, and then go to lunch, usually with colleagues, or—"

"And usually in the House dining room?"

"No, very seldom. Very seldom. I go over to a Democratic Club in the Congressional Hotel or to a nearby restaurant. And perhaps go back to the floor and listen to some of the debate, or, again, answer quorum, vote on amendments. And then come back in the office and work on my mail and telephone calls, until time to leave for the day. It sounds pretty much like the same routine every day. In a sense, it is, but the problems are different every day. That's what makes the job so interesting."

Members of the House generally have only one important committee assignment as compared with the Senate. "I'm on two committees, one major and one so-called minor," Thompson said.

I'm on the Committee on Education and Labor. I'm on the Committee on House Administration, which is sort of the internal-affairs committee, of the House of Representatives. Then, I'm chairman of the Special Subcommittee on Labor, and I'm a member of the Special Subcommittee on Education, which deals with higher education. Then I'm a trustee of the John F. Kennedy Center for the Performing Arts. I'm a member of the Franklin D. Roosevelt Commission. I've just learned recently that I'm a member of the James Madison Memorial Commission. I'm a member of the Subcommittee on the Library of Congress, and, uh, I'm a member of the Subcommittee on the Disposition of Executive Papers, and Lord knows what else.

In 1955, I introduced some legislation on a very broad scale which would establish a national commission on the arts and give money to the states and the individuals and so on for the arts and build a national cultural center—just sort of a big omnibus bill. And we had some hearings on it and it didn't do too well. . . .

We would never have had a cultural center built in Washington, in my judgment, without it being a memorial to Jack Kennedy, and the Congress putting up half the dough. We might not even have it as it is, if they don't stay with the estimates. But I remembered when, right after President Kennedy was killed, what happened in the Taft case, and talked to some colleagues and friends of mine on the Hill, and said, "Well, you know, if they do this for Taft, who died a natural death, perhaps premature but a natural death, well, they may do it for the Presi-

dent." And it turned out that they would. So we just moved in real quickly. If you got a J. F. Kennedy Memorial up today and asked for the money for it, you wouldn't get anywhere with it.

I talked with Senator Fulbright, who was the co-author with me of the original Culture Center Act. Then I talked with Bob Jones of Alabama, who was chairman of the Subcommittee on Public Buildings of the Public Works Committee. Then I talked with Leverett Saltonstall, who is a Republican but was a great friend of President Kennedy. And then I talked with, oh, I don't know, a number of others, and then I talked with some of the Kennedy family and asked what they thought of the idea. And we went on from there. It was all done in a matter of a month or two.

CHAPTER 18

CONTRIVED CORRIDORS

(The action becomes focused)

HAVING ARRIVED in Washington, Thompson introduced his first bill concerning the fine arts. From then on, he worked on arts legislation constantly and went down to defeat constantly—for years, Lowry said. Coincident with Thompson's arrival, President Eisenhower put into his 1955 State of the Union message a request for a Federal Advisory Commission covering all of the arts. "I think that this was arranged by Nelson Rockefeller with René D'Harnoncourt,"[1] Lloyd Goodrich said, remembering that the draft of a bill had been sent to him, for his opinion, by Rockefeller. During the early Eisenhower years, legislation had been introduced in both houses, much of it

sponsored, as I remember [said Goodrich], by Representative [Charles] Howell of New Jersey, of the Princeton district, a very intelligent man who ran for senator a few years later and was defeated, a great loss to the Congress, I think. However, he was succeeded in his own district by Frank Thompson, who is now, I think, one of the outstanding liberal representatives in Congress and has taken a greater lead in legislation affecting the arts than anybody else in the lower house.

Early in the Kennedy administration, Thompson introduced a bill to establish an advisory council on the arts "to assist in the growth and development of the fine arts in the Nation's Capital and elsewhere in the United States." Although by then the so-called cultural explosion was going strong, as could be proved by "amiable statistics" (Arthur Schlesinger's term), Thompson could not get a rule on it, said Robert McCord,

351

Thompson's associate, which meant that Thompson had to bring the bill up on the floor of the House of Representatives

> under what we call suspension of the rules, where you have twenty minutes of debate for and against the bill and then it takes a two-thirds vote to suspend the rules and pass it.

It failed of passage on September 21, 1961. Comments on it were illiterate, lacking respect for art as a part of the life of an educated man, Thompson felt. The congressman had by that time introduced a total of 269 bills and resolutions during his more than six years in Congress, 74 of them broadly concerned with the arts or with some facet of education.[2] By then he had served long enough on the House Education and Labor Committee, headed by Adam Clayton Powell, that aggressively black preacher from the Abyssinian Church in Harlem, to have acquired a subcommittee chairmanship. Thompson and others continued to sponsor bills promoting the arts, some simply by establishing a federal advisory group, others designed to provide financial support for the arts.

Never had there been legislated support, although the idea of some sort of federal involvement had come up from time to time throughout this country's history. Thomas Jefferson had been notably interested in the arts. During the administration of John Quincy Adams, Jonathan Trumbull had suggested government support for the arts. In 1877 Representative Samuel S. Cox of New York "unsuccessfully introduced H.R. 126 to establish a council on art matters. In 1890, President Harrison signed a bill designating a New York music school as the National Conservatory of Music; the following year, under President Cleveland's administration, Anton Dvořák began a three-year stay in America as artistic director of the Conservatory."[3] This conservatory still technically exists, as its charter set no expiration date, but Congress had made no provision for its financial support. Teddy Roosevelt was a personal patron of the poet Robinson Jeffers, and a Commission of Fine Arts was established in 1910 under President Taft. "Although the enabling legislation authorized the Commission to 'advise generally upon questions of art when required to do so by the President, or by . . . Congress,' as well as to make recommendations on the District of Columbia's architecture and art, the Commission ultimately elected to restrict its attention to the District of Columbia, unless specifically requested to undertake any project with broader implications."[4] During the 1930's, the arts were made part of WPA by executive order—not legislated. In the late forties Senator Hubert Humphrey brought out a proposal: in fact, he was one of the pioneers whose work led ultimately to the establishment of the Federal Arts Foundation. "On January 26, 1951, President Truman chose to utilize the [Fine Arts] Commission's broad advisory

powers when he asked that it investigate ways in which the arts could be aided on a national scale by the Federal Government. The Commission failed to report during President Truman's tenure, and when the Report was delivered to President Eisenhower on May 15, 1953, no action was taken on the many recommendations contained therein, with one notable exception. The Report recommended the establishment of a music center in Washington under the jurisdiction of the Federal Government in which operas, symphony concerts and ballets could be performed; on September 2, 1958, President Eisenhower signed Public Law 85-874 establishing a National Cultural Center which would provide impressive facilities for all the performing arts in the Nation's Capital."[5]

Also in 1958, McNeil Lowry was studying the operation of government arts programs in the United Kingdom, France, Italy, and Denmark. He then made

> a confidential report, an internal report, to the president of the Foundation and for my own purposes. . . . I speculated a little bit on what safeguards could be erected for a government program in the United States, not an analogy with those in Western Europe but really in contradistinction to those in Western Europe, and looked forward, if possible, ideally to a way in which federal money could be drawn upon by municipalities or by artistic groups in municipalities on a matching basis and bypass both a central administration in Washington called a federal foundation and bypass the states. Well, none of this happened, but that's a later story.

In 1961, Frank Thompson, from time to time running into Richard Goodwin, whose wife was a painter, discussed federal support of the arts with him as with so many others. Goodwin, who had been working on speeches for John F. Kennedy since 1959, was—like Lowry—a "supreme generalist."[6] At that time, officially he was Assistant Special Counsel to the President. Kennedy's efforts in behalf of the arts tended to be random, Goodwin later said, but "he had more impact than if he had given away five million dollars a year."[7]

In the summer of 1961 two other White House assistants, Arthur Schlesinger and Pierre Salinger, recommended that Kennedy appoint a special consultant on the arts—Schlesinger having in mind August Heckscher of the Twentieth Century Fund. The Kennedys "were wholly unaffected in their attitude toward the arts," Schlesinger believed, and painter William Walton thought the arts part of the pattern of their lives.[8] Early in December the President invited Heckscher to proceed "without fanfare." Of Kennedy, Heckscher later was to say, "To assume that the varied, unpredictable, and sometimes oddly expressed cultural life of our country could in any way be dependent on government, or be derived from gov-

ernment, was impossible for him. He was skeptical of any idea that government could do more than sometimes stir things up, and sometimes give recognition and support to what had strangely or wonderfully occurred." Schlesinger agreed.[9]

To McGeorge Bundy at the White House, Lowry took an idea that year:

> The idea was in opposition to all this talk about the cultural interests and the Kennedys' interest in the arts, and the President was making the arts respectable by these "do's" at the White House and the Capitol Theatre or National Theatre in Washington, you know, and so on, where Bill Walton was running around talking about it, that people couldn't touch it, that it didn't mean anything to the layman. But there were two things that the people touched every day—one was coins and one was stamps. There was no way to get around the accretion of official government committees and commissions ruling and advising the Bureau of Printing and Engraving or the Mint. They'd been encrusted since the nineteenth century, and that's one reason our coins and stamps were so lousy, but also one reason that living artists with any real graphic genius weren't involved in the designs of coins and stamps, and this was not true in every country in the world, but it was true here. Borrowing an idea from Lincoln Kirstein, I said, "Let's have somebody like Theodore Roszak strike some designs for coins. Let's let somebody like Robert Frost be the iconographer on what subjects of American life those designs should be about, and let's let somebody like June Wayne or Leonard Baskin execute some designs for stamps—again following Frost's iconographic insight into American culture, American life. And then let's have the President, or the wife of the President, put up the results around the White House, and when people say, 'What are those doing there?' say, 'Well, he just liked them,' hoping that everybody was trying to please our shining young new leader and that the guys in the Mint and the Bureau of Printing and Engraving would get an idea and say, 'Now, wait a minute. That's what he likes; now, maybe we can think about something like that.'"

The government didn't have any money for that purpose. So I said the Ford Foundation through an intermediary would put the money up. It wouldn't take much—like thirty thousand dollars. But it's got to be through an intermediary, because nobody wants the Ford Foundation to tell the country what stamps and coins should be like.

"Well," Bundy said, "that's way out of my bailiwick, but I like the idea and I'll see that the President hears about it—maybe through Arthur" [Schlesinger].

I said, "Well, I can talk to Arthur."

Well, then he said, "Why don't we get Kennedy to name Arthur and then you come down and treat with him."

And I said, "No, let Kennedy name Arthur and I'll name somebody to come and treat with Arthur, not because I don't like the President of the United States, but just to keep the Ford Foundation out of it."

And Mac said, "Well, look, we're all working on the messages for January." This must therefore have been December or November. "I may not do it right away and you'll hear from me or from Arthur."

Well, lo and behold, I didn't, but the response that came back was, about three months later [officially, in March 1962], August Heckscher was named a special consultant to the President on arts, which was not what I had asked for.

The stage had been set for a final push toward arts legislation when, in 1961, passage of the Fulbright-Hays Act had provided for mutual educational and cultural exchange between America and foreign nations. But "the movement from a small program," Lowry said, ". . . from sending something abroad to show that this country wasn't a bunch of savages . . . and getting actual money given to artistic groups in the United States—that was a tremendous transition."

> The congressmen didn't particularly care about what went abroad until they had made some mistake about something in their district. . . . And Thompson, who was very much interested in the State Department Advisory Committee on the Arts and what it did, and the Fulbright exchange thing—Thompson was the broker really between using what little cadre of support there was for this, saying, "Well, does it make any sense not also to honor artists over here? Why should we honor them over in Ghana when we can't honor them here?"

Heckscher was assigned "to make a survey of policies and progress within the executive departments and agencies affecting the arts, and to make recommendations for raising standards and encouraging the fullest use of the opportunities available."[10] He submitted his report, along with his resignation, to the President on May 28, 1963. It "evaluated the impact of existing government programs and policies upon the arts and made recommendations for action in various areas. Among the recommendations was a proposal that the post of Special Consultant on the Arts be made permanent, with its rank raised to that of Special Adviser, and that the President establish an Advisory Council on the Arts. The Report further noted and endorsed legislation already pending in Congress which would create a National Foundation on the Arts."[11]

Heckscher wished to return to foundation life at the Twentieth Century Fund. "When he got ready to leave," Lowry said, "he was sent by Schlesinger and 'the White House' to ask me if I would take a job as special adviser to the President on the arts, and staff secretary of the National Council. And I said no." Lowry continued:

Then they said, "Well, look, the next thing is to try to get a national foundation. Would you take the job if you moved from that to heading a national foundation in the arts?"

And I said no. I also said I didn't think that was going to happen very fast, but I didn't know that the President was going to be shot, because I think that that's what made it happen so fast. But it wouldn't have made any difference. I didn't want the job.

But apparently Richard Goodwin did. Goodwin had "won friends and enemies in about the same proportion and with equally high devotion," *Time* magazine reporter Hugh Sidey said.[12] "Abrasive, driving, often impatient and arrogant"—in Arthur Schlesinger's words—he also had an "uncommon intelligence, perception, charm, speed, wit, imagination and passion."[13] In November 1961, because of his "ambitious efforts on Latin America,"[14] President Kennedy had put him into the State Department, "where he was among those who, advising on policy and attending conferences, produced some dismay among the State Department professionals and some disarray in the continuity of policy, but more activity and interest in Latin America than that region had ever seen."[15] Eventually even JFK could not preserve his usefulness in a department that did not want to use him: he bore his clipped wings with quiet dignity, Arthur Schlesinger was later to report,[16] but when Sargent Shriver asked him to join the Peace Corps, he did so. This was his situation when he was asked by JFK to replace August Heckscher.

Kennedy had accepted Heckscher's resignation and established the arts council by executive order on June 12, 1963. As Secretary General of the International Peace Corps Secretariat, Goodwin had been working in other countries. Now he made it his business to find out what was going on in the arts. Finally, he drew up a list of possible U.S. council members with the British experience in mind, although he had decided that what went on abroad was not especially relevant.

Frank Thompson had by then already "put into the record very good, documented evidence of the need for something more than just an advisory council," Robert McCord said. But the House Rules Committee had again refused to permit hearings on a bipartisan bill supported by President Kennedy. "Philistines in the House," read one headline. Thompson then conducted a "study"—so called because there was no bill under consideration at the time—of the economic conditions of the performing arts. "A number of hearings were held," Lloyd Goodrich said. "I used to go down to Washington about once a year."

Unlike many museum directors, Goodrich has an idea about extending the interests of the artist and the curator into a social position that would merit the taxpayers' interest and government support and sub-

sidy. But so did a lot of others. He more than most worked on it in a political way in the best sense of the term,

said Lowry, who was no mean politician himself and who also had testified at congressional hearings. (After the Tax Reform Act of 1969 foundation testimony had to be formally invited by the chairman of a committee or subcommittee.)

Goodrich had been concerned at various points in his career with the development of committees within the art field so that the visual arts could have an organized voice "vis-à-vis" government. But even in the organizational context—of his Committee on Government in Art, for instance, which he had some time earlier suggested and formed—he said, "As in anything like this, it has to be one person who does it."

It was "almost silly," Goodwin said at one point, "to have a committee running something because then there could never be any real imagination or drive, you know. One guy can be much more innovative than a group will ever be."

On Thursday, November 21, 1963, President Kennedy was in Texas and Goodwin telephoned him from Washington with a minor problem. "*The New York Times* had learned of [Goodwin's] new job and had decided to make him tomorrow's 'Man in the News.' So far he had declined comment; what should he do? The President instructed him to prepare an announcement of his own appointment, dating it for release [the next day]."[17] That night Goodwin attended a "Latin American" party, at which Ted Kennedy too was present. The next day, Friday, November 22, Goodwin had a hangover and decided to stay home, drafting the announcement of his new appointment. That afternoon, wanting some facts, he called Ken O'Donnell's secretary at the White House: ". . . she choked, stammered, and at last said apologetically, 'Maybe you didn't know it, Mr. Goodwin, but the President has been assassinated.' "[18]

John F. Kennedy had not named any members for his advisory council on the arts. "Johnson naturally had other things to do, and the whole question was deferred."[19] Executive Order No. 11113 was never put into effect. Eventually the new President selected Roger L. Stevens as his Special Assistant to the President on the Arts, the first full-time arts adviser in American history, and Stevens' appointment was announced on May 13, 1964. That same month President Johnson delivered his Great Society speech, the text of which, though "rooted in Lyndon Johnson's restless soul,"[20] had been written by Richard Goodwin.

If presidential power is the power to persuade, as political scientist Richard Neustadt has written,[21] then some of that power had been taken up by Richard Goodwin's talented hands. By now he was in the Executive Office Building across from the White House Executive Wing, although

no one was supposed to know that he was working on the signposts of history, "puffing his way through a collection of large cigars."[22] He had first written one of the new President's messages the week after Kennedy had been assassinated. Then, late in January 1964, he had gone to the White House with Sargent Shriver, where Johnson had caught sight of him and mentioned problems with an already drafted statement. Goodwin offered to help. After that, Johnson's Special Assistant, Bill Moyers, a former deputy director of the Peace Corps, increasingly gave Goodwin assignments, and eventually he was moved into the White House itself, where he felt he was "obviously much closer to the President [than Roger Stevens was]," so "I thought I'd better stay away from [Stevens]."

Stevens was assigned the task of developing congressional support for a permanent arts agency. He "began concentrating his efforts on passage of one of several bills pending before the 2nd Session of the 88th Congress, which had been introduced by Representative Frank Thompson (D., N.J.), the then Senator Hubert Humphrey (D., Minn.), and Senator Jacob Javits (R., N.Y.), as well as by numerous other Congressmen."[23]

"Now, here's one thing in writing about this that you want to understand," Robert McCord said:

> In the Senate, if you want to introduce a bill and have co-sponsors, you introduce a bill for yourself and in behalf of bang, bang, bang, bang, and there's just one bill. And then you can partially introduce it and have it lie on the table for a week or five days so other members can add their names to it, but you have one bill with *all* of the senators on it as co-sponsors. In the House, you can't do that. If Congressman Y wants to join Congressman X in co-sponsoring a bill, each one of them has to introduce a separate bill. They can be precisely identical bills.[24]

These bills originate in committee, where, in both chambers of Congress, chairmen of particular subcommittees are responsible for developing what are called "legislative ideas." Before these subcommittees appear witnesses; a report is drawn up, which is then submitted to the full committee. Only after that report has been approved is the actual wording of a law put together. This is done mostly by the Legislative Drafting Service, a staff of professional lawyers some of whom are assigned to specific committees and work mostly within the jurisdiction of those committees. With regard to the National Foundation bill, such details would be submitted to the lawyers as, Thompson said,

> the fields of the arts to be covered: painting, sculpture, music, dance, drama, architecture, landscape architecture, museums, and ultimately at Jack Javits' insistence, fashion design, which horrified me. We accepted it. I guess his wife's couturière wanted to be a member of the Council,

and she did—she was for a one-year term. I forget her name. Her dresses are awful.

When the lawyers have come up with language to implement the basic idea, "then you do some revisions of it yourself perhaps," Thompson said, "have hearings on it, and then you go over it word by word in the legislative process and do your writing in that way."

Hearings during which a large number of artists and other private citizens had testified had been held in the fall of 1963 before the Senate passed *their* bill: "The Senate Special Subcommittee on the Arts, under the leadership of Chairman Claiborne Pell (D., R.I.), had unanimously recommended passage to both Houses; and the Senate, on December 20, 1963, had passed S. 2379 which would have created a National Council on the Arts and a National Arts Foundation."[25] In the spring of 1964 hearings were held before the Special Subcommittee on Labor in the House of Representatives on that same bill, now H.R. 9587. Suggestions for witnesses came from both congressional subcommittees involved and their staffs, with invitations in the form of telegrams in this case being sent out signed by Frank Thompson as chairman of the House subcommittee. Congressman John Lindsay, a Republican from Manhattan's "Silk Stocking" district but allied with Democrat Thompson, testified.

MR. THOMPSON: Mr. Lindsay.

MR. LINDSAY: Mr. Chairman, and members of the committee, I do not wish to testify very long because you have heard a good deal of testimony. I want to congratulate you, Mr. Chairman and members of the committee, for undertaking these hearings. You have shown intelligence and caution.

. . . What I am trying to say is to throw out a caveat that this should not be regarded as the answer to the elevation of excellence of art in the United States because I doubt if it would be. It would create environmental conditions under which existing art forms could more easily exist.

Second, there are problems about priorities of importance. That is why I am so enthusiastic about the Arts Council as a first step. No one in Government has as yet any idea as to what the order of priority should be of governmental attention to the arts. Thus far it has tended to be a Scotch tape approval. Most people don't even know the areas in which Government is already involved. In the personnel directories of the Pentagon you will find whole lists of people under the category of "art" engaged in all kinds of artistic work, in and out of uniform, making decisions of some kind in this area of the arts.

The same is true in the State Department. Embassy architecture is improving. There has been an improvement of U.S.-sponsored theatrical

and other tours. The recent reorganization in the State Department on advisory panels is an excellent one. I think Mr. Battle in the State Department is doing a first-class job and is to be commended for a wide range of thought and imaginative work. . . .

There is a need for a pulling together, for coordination, and a clarification of priorities. And if money is involved we must be clear that governmental meddling must be guarded against. This applies just as much to Congress as to the Executive.

Recall what has happened on the House floor on a few occasions, where the Government has experimented in artistic expression. This has thrown a fear not only into the people in the outside world involved but it has thrown fear into the Executive branch.

I think in some cases they have been unnecessarily timid, but they still have tended as a result to cut corners, to retreat, and to reach out for the mundane and the center rather than move out in any new direction.

Meanwhile, Mr. Chairman, in New York City there are any number of things that could be done by levels of government, including the Federal Government, that would not involve direct cash subsidy. It is utterly ridiculous that there are no storage facilities for scenery for the living dramatic theater. Scenery is burned because the only storage facilities are across State lines and therefore the rates are immediately doubled. We go out of our way in New York City, at least it appears that the local administration goes out of its way, to make it impossible for our artists to hold on to such loft and studio space as they presently have. They are being evicted. There are few studios left for the young artist.

The taxation, real estate and otherwise, of art expression is still a hundred years behind times. The city makes no distinction at all between a ballet or a live dramatic performance and the flea circus next door.

Recently in the Congress we made an adjustment in the new income tax law in respect of the spreading of income. A lot can be done on admissions taxes on live dramatic performances. To me they ought to go. Something can be done in the copyright laws. There is no reason to me why we should not give a copyright owner who creates a play or drama or musical composition of capital gains right, which a patent owner enjoys. The only reason that a distinction exists is pure accident. The patent lobby was a very strong one and copyrights had none.

. . . There is an Executive order relating to the Arts Council which has been pending which is unimplemented. It ought to be implemented and it ought to be backed up by legislation. It should have the imprimatur of Congress.

Finally, if the Foundation bill is the will of this committee it will have my complete and total support. I only hope that it can survive the House of Representatives. I do not wish to take another beating on this

subject. It would set us back even further than we were set back four years ago when the Arts Council bill was beaten.

So again, Mr. Chairman and members of the committee, I congratulate you on having the hearings and having the courage to take on this task again. I commend you for your carefulness and your caution and I do hope that the subcommittee and the full committee will reach a result before we move into the congressional silly season, the hot months of the summer, and the trying preconvention period during which results on the House floor are unpredictable at best.

Mr. Thompson: Thank you very much, Mr. Lindsay. Your statement has been wonderfully helpful. We appreciate it.[26]

Robert McCord said, "Thompson did a little nose counting on the floor, and he saw that there were not enough votes in the House to pass a bill that had the foundation aspect of it, the grant-making authority," even though it had already been passed by the Senate. Would they in fact be able to get an arts council?

. . . in the House of Representatives, the Committee on Rules thus far had taken no action to release arts legislation of any sort for floor debate.

The White House staff, meanwhile, informed Mr. Stevens that because its attention would necessarily focus on the forthcoming Democratic Convention and national campaign, the Administration could not consider the arts legislation a priority item at that time. However, Mr. Stevens was assured that the Administration was fully in favor of the bill as passed by the Senate, and would support the legislation when it reached the House floor for a vote.

Mr. Stevens began visiting the leadership of the House Committee on Rules and key Congressmen in the House. He made the journey daily from the White House to the Hill during the month of July and talked with numerous Congressmen. It was evident that there was considerable resistance among some members of the House to arts legislation, whether to establish a Council (advisory) or a Foundation (permanent and funded); Representative Howard W. Smith (D., Va.), who was then Chairman of the Committee on Rules, was finally persuaded to release H.R. 9586, establishing only the Council, and report it for floor consideration.

A communications breakdown almost caused the bill to reach the floor for a vote on a day when sufficient numbers of supporting Congressmen would not be present, but through the good offices of the Majority Leader, the bill was held up and placed on the calendar for consideration on Thursday, August 20, 1964, when the bi-partisan support so vitally necessary could be depended upon. The National Arts and Cultural Development Act of 1964, H.R. 9586, passed the House of Representatives by a vote of 213 to 135; the following day, the Senate

by voice vote also passed H.R. 9586. On August 22nd, Congress recessed for party conventions.

On August 20, 1964, Roger Stevens had appeared before the Democratic Platform Committee in Atlantic City to urge increased government recognition and support for the arts. This resulted in the following statement included in the Democratic Platform for 1964, "One Nation, One People": "We will encourage further support for the arts, giving people a better chance to use increased leisure and recognizing that the achievements of art are an index of the greatness of a civilization."

After the Convention, on September 3, 1964, President Johnson signed Public Law 88-579, establishing the National Council on the Arts, an advisory body of 24 distinguished citizens prominent in the arts, to recommend ways to maintain and increase the cultural resources of the Nation and to encourage and develop greater appreciation and enjoyment of the arts by its citizens.[27]

What remained to be done? Goodwin remembers discussing the general idea of some sort of *financial* support for the arts with Johnson that year. He thought the President not especially interested: "Somebody had told him it wasn't a good idea," Goodwin said. But good or bad, the idea of a bill to establish a national arts foundation was in the works, and late in 1964, out of Goodwin's typewriter, in the form of a draft of the State of the Union message, came Administration support. "I probably talked to Bill Moyers and asked, 'Do you think we can get away with this?' " Before Congress in January 1965, the President of the United States duly read, "To help promote and honor creative achievements, I will propose a National Foundation on the Arts."[28] Once given priority by the White House and made part of the Great Society programs, support built up in both houses. Frank Thompson, as noted earlier, was chairman of the appropriate House subcommittee: he was asked, along with Claiborne Pell in the Senate, to sponsor the Administration's bill, and they were delighted to have White House backing.

When Pell, a Democrat from Rhode Island elected in 1960, had become chairman of a special subcommittee on the arts (to which, later, the humanities were added) under the Senate Labor and Public Welfare Committee, he and Thompson had agreed on coordinating efforts in order to introduce identical legislation in both houses. Neither Thompson nor Pell could remember when they had first met. Although they came from dissimilar backgrounds, Pell having inherited wealth, they liked one another. Now they decided to hold joint hearings, which was unusual. "Our interests are parallel," said Senator Pell, and added that Frank Thompson was "a good man in every sense of the word."

Senator Pell's assistant, Livingston Biddle, worked closely with Rob-

ert McCord on Thompson's staff. Biddle had attended Princeton with Pell and had joined the senator's staff in 1963, with the arts as his office specialty. McCord's official title was Director of the Special Subcommittee on Labor in the House of Representatives. He was an old-timer, a tough and indispensable staff member. Work was begun in February 1965. The hearings commenced on the twenty-third and continued through March 24. "Almost all of the testimony was enthusiastic and favorable."[29] Frank Stanton of CBS was a friend of the cause and sent a statement down from New York.

On March 10, the President transmitted to Congress S. 1483 to establish a National Foundation on the Arts and Humanities. "This bill, which encompassed the main objectives of legislation introduced earlier, was sent to all the witnesses who had appeared at the February–March hearings. It was generally agreed that S. 1483 improved upon the previous proposals, and Congressional Committee work began on the Administration bill. On March 11, 1965, Roger L. Stevens was officially appointed Chairman of the National Council on the Arts."[30]

Goodwin's sardonic sense of humor—for instance, of the tapes (including his own) for the JFK Oral History Collection, he was later to say, "Marvelous to hear all of those egos speaking over the generations!" —must have caused him trouble from time to time, but he was not appointed by Johnson, said Senator Pell, because he was identified as a Kennedy man. This is an easy answer but seems inadequate. Pell added that perhaps the President had wanted an older man and one who was maybe slightly less controversial—with a non-controversial record. Stevens was very well qualified for it, said Pell—either man was, but Stevens was a fine choice.

"Roger is just a very special kind of person to head such an office," McNeil Lowry said.

> He can't ever change from being the big real estate operator and [Broadway] producer surrounded by a bunch of secretaries, you know, really. Well, you know, to do the job of a national network with the artists, you need a gestalt and respect for data. . . . I don't mean statistics. I mean the hard reportorial facts of a situation in the arts, that you can walk on.[31]

Lowry believed in the philosophy he had evolved while at the Ford Foundation. He believed in his own way of working and his own principles. He must have wondered if Stevens too would be a man intent on playing a catalytic role.

"We're now down to the first of 1965," Lowry said, "and I was operating in Washington about half the time between the end of February

and the end of June." He was, he said, "setting up machinery for liaison and separation between the government and the Ford Foundation," but no more in connection with the arts than a lot of other fields. Lowry worked with

> Lindsay and Thompson and Brademas and Brownie Reid and other people who were on the House Education and Labor Committee, on that subject, and they'd immediately start talking back to me about "What about this bill? What do you like about it and what don't you like about it?" and so on. And that's when I got in with Thompson and Lindsay and found that they were stuck on some principles that I thought were terribly unhelpful in the legislation and which proved to be so. . . . I didn't go and inject myself in this. They found the criticism meaningful and helpful and they said, "Well, now, what can we do about this?" . . . they said, "We'll change it if you can get the White House to change it."

Lowry said, "There was a woman down in the bowels of the Bureau [of the Budget] who had taken the President's message about the bill written by Goodwin and honored it just as it was, and she didn't want to change it. But when I went down there and asked discussions of it with Kermit Gordon, who was the director of the Bureau, and others, they saw what I was talking about and they agreed. They said, 'It's a lousy bill compared to the National Science Foundation bill, and we'll change it—sure.' "

Kermit Gordon and McNeil Lowry were already acquainted, and if it had not been for that, perhaps their discussion—which lasted some two and a half hours—might not have taken place. The $5 million proposed for the arts endowment was a very small item in the over-all federal budget. But Hubert Humphrey was to comment that Lowry knew a lot of people: this really mattered, Humphrey had said. In this instance, it changed the situation only on the surface, however. "The politics of art are even more Byzantine than the politics of Massachusetts," Kermit Gordon later said while remembering that at the time he hadn't been exactly sure what it was that Mac Lowry wanted. However, the director was amiable, and Lowry took the message back up the Hill: "Boys, they'll change it." So that an independent board, like that at the National Science Foundation, could help give the chief executive (in this instance called the chairman) more freedom.

But a few weeks later, when Lowry would next be in Washington, he would be told, "You said they'd change it but they won't." Finally a meeting was held in Thompson's office. Senator Pell came for a few minutes, said Lowry,

and then his assistant stayed behind; Lindsay couldn't come; Reid was there, and the staff people on the House Education and Labor Committee, and Roger [Stevens].

And Roger said, "Well, I got to catch a plane. I got to go to a dinner in New York, but I agree. Lowry's had a lot of experience with this, and if he can get it changed, okay."

I said, "Well, they will and I'll get Kermit Gordon on the phone and let him tell you." So I got Gordon on the phone and Thompson took the phone and Gordon said, "I'll change it." And so they said, "Well, boy, it's done." And then nothing happened. And then I found that Thompson had made a visit to Goodwin, and Reid made a visit to Goodwin representing the Republican side. Goodwin said, "No." I made a visit to Goodwin, and he said, "No." I said, "You're wrong. If there is any whoop-de-doo about one of Roger's grants in the arts, he hasn't got anybody except the President for it to fall back on, in this bill." And he said, "For the first three years that's the way we want it." Well, when I talked to Cater [Douglass Cater at the White House], he didn't see any reason why that was the way they wanted it, but that's the way Goodwin wanted it.

Lowry thought perhaps the problem was that, for a presidential assistant, there was more onus in changing what the President had already delivered in a message to Congress than would have adhered to the President himself if *he'd* tried to change it. And, added Lowry, "you can't bother the President with these things when he's busy." According to Goodwin, though, "the White House" called the president of the Ford Foundation, complaining that Lowry was trying to block the bill.[32]

"They *talked* about it not being insulated enough from Congress," Richard Goodwin said, "but I always had the feeling that was a sort of a lever by which to sort of kill the idea—I don't really think they were the best judges of that particular problem. They were arguing the President wasn't well enough protected, and he had decided he was well enough protected . . . in the guise of supporting some obscene thing. Anyway, if the country turns that way, there's no protection. To think you can do it structurally is rather mythical."

"You know the way the Foundation is set up," Livingston Biddle said,

> there's an over-all foundation and then there's two endowments which are the funding branches . . . parallel in structure . . . each guided by a council of private citizens. Each council is in an advisory role to its endowment and to its chairman.
>
> The chairman of each council is also the chairman of the Endowment, so he is the one full-time federal employee on the council and then carries out the program.

Some thought—and Mr. Lowry was a supporter of this idea—that the councils should in point of fact be more like [corporate] boards of directors than simply in an advisory position, but the Bureau of the Budget . . . took the position that private citizens . . . should not actually be directing the government on the expenditure of federal funds. They can advise but they cannot control.

Biddle said Goodwin's desires didn't really affect this because the Budget Bureau was convinced eventually that this was the only way in which it could be done. "Standard government procedure," he said.

By the time the bill came up [Lowry said] and the message had to be written, which Goodwin *did*, it was already clear that he wasn't going to get the job and he *hated* it, and this was why—one reason, not the only reason—he was so tough with me and tough with Thompson.

So the bill went through against the form that Thompson by that time had been convinced it should have, Lowry said,

but he wanted it, and it was time, and you were riding still on the great emotional thing about Kennedy. But by now—and this is the way history always is; it always takes away your neatness and gives you the complexities—why did they get it through like that? Why was the White House writing legislation that couldn't be changed? Because it was following not merely the assassination of Kennedy but the election of '64, and the White House's majorities in the House were so great that they and the Bureau of the Budget were writing the legislation and the congressmen were passing it. And anything that came out of subcommittee, let alone full committee—whoosh, it went through. Kennedy wouldn't have had that majority for that bill, and he wouldn't have got it in that year. Johnson had it. The steam had come from the President's assassination, but the going of it was easy with Johnson's control. And Goodwin was also relying on that, you know. He knew that. Well, everybody was saying, "Goddammit, they're writing all the legislation uptown; we're not writing it," because the President had only to say, "Boys," and there it was. Thompson knew that even as a Democrat. Now, I don't know how much pain it cost him, although he was sincere in trying to change it if he could have got the collaboration of Goodwin.

Frank Thompson said, "Well, I was less worried about it because I knew less about it. And I still do know less about it than Lowry does. But—although he persuaded me that his was a better idea than mine—I didn't think that it was a *sine qua non* to the legislation. In other words, I didn't feel that if it couldn't be done the way Lowry, Lindsay, and I thought it should be that it shouldn't be done at all."

The work that Richard Goodwin at the White House put in on the

"Thanks — Thanks A Lot — Thanks Again — Can I Lean Back Now?"

—FROM THE HERBLOCK GALLERY (SIMON & SCHUSTER, 1968)

"*. . . the President had only to say 'Boys,' and there it was.*"

bill during the period from February 1965 to September 15, when it was signed into law by President Johnson, totaled only a few days. Goodwin was actively involved with other legislation at the time. He later said he never remembered the names of the bills on which he'd worked but did remember problems. Some of his time was taken up by meetings in the White House's Executive Mansion during which Lawrence O'Brien and Henry Wilson suggested that Congress might look more favorably upon the legislation if the Foundation were to become technically part of the Smithsonian Institution. Secretary of the Museum Dillon Ripley,

also present, insisted that in such an event the Smithsonian would have to have full control. Many possible ramifications of this and other ideas were discussed. Although the arts bill was a relatively small matter, it appears to have taken well over a hundred people to pull the pieces together.

> "There is a heartfelt need by members of all other parliamentary bodies —in Germany, France, England—for what exists only in the Congress of the United States [said John Blair]. Those bodies are rubber stamps. If a member is with the Government, he votes for the Government's legislation. If he isn't, he doesn't. They would like to make contributions of their own. They can't because they don't have staffs. The U.S. has— in a way that hasn't been recognized anywhere in print that I know of —responded correctly to what is an absolute necessity for a technological age: a competent staff."[33]

As a rule, said Robert Sherrill,[34]

> it is the administrative assistants, the legislative assistants, the staff counsels and the staff economists—not the members—who think up the legislation, make the deals, listen to the lobbyists, keep the back-home political pipes flushed out, determine what mail the member sees and what he misses and determine who gets to see him and who has to settle for a flunky. They rewrite *The Congressional Record* to make their employers sound coherent. They write the immortal speeches, the magazine articles and books that carry their bosses' names (Senator William Proxmire recently remarked, "I was reading a book the other night . . ." and then decided that was not quite the way to speak of a work he was supposed to have written).[35]

Sherrill is exaggerating, but there is some truth in what he says. Senator Pell remarked that he made it a habit to try to forget the details once a piece of legislation had been accomplished—otherwise his mind would become impossibly cluttered.

Lowry appeared to remember nearly verbatim the details of anything with which he had ever been connected. Where Goodwin said he thought the bill providing support for the arts was uncomplicated—the only real question had been the amount, Goodwin said, but even that was relatively simple because there were no direct economic interests involved that might have clashed—Lowry saw the whole question of an underlying philosophy as complicated and extremely important.

"There is disagreement," he said, "on what philanthropy, whether it's corporate, private, government, or foundation, ought to do in the arts. . . . You see, many people still don't quite accept the fact that there

is room in the country for the largest activity in the arts [the Ford Foundation] to be motivated straight toward the professional artist or director, or the potentially trainable one, and those groups potentially capable of strict standards in craft. . . . They think that we ought to be just as interested in all of the corollary objectives for support—the social instruments, the educational cultivation of audiences, and so forth. We've done a lot of that, but it's always taken a third, fourth, fifth, or sixth priority in this."

Biddle talked about "a whole segment of debate":

> . . . whether this should support only professionals or whether it should support only amateurs or whether it should support both and in this respect we were a great deal with Actors' Equity, who had a very fine representative in Washington, Jack Golodner. . . . It was Jack's feeling that if we were to support amateur performances, that we might well be opposing the whole idea of professionalism, and there were instances, let us say, in Washington itself [of competition between amateur and professional groups enacting the same play on the same night]. On the other hand, there were the educational interests who said if we have a theater group in our institution, these are the people who are learning their trade, these are the people who will someday become professionals and they need help. . . . So there were two rather divergent viewpoints here, almost at opposite poles.

Biddle's job was to make a suitable compromise, he said, and the bill came out stressing professionalism but also allowed for help to amateur groups. Both Pell and Thompson were more inclined to support the professional, Biddle said, neatly showing his value as a "special assistant," because the idea had been the promotion of "excellence in the arts," but in small towns amateur groups were likely to provide the only chances for people to see live theatrical performances. In any case, Biddle felt the bill was sufficiently flexible to advance its basic concepts.

Lowry said:

> Lawyers will tell you there is more Mickey Mouse in that bill than in any other bill in modern times except the International Assistance Act. . . .
> Congress said, "Here's so much authorization for money. You can get this outright if you can get it appropriated. Now, here's another way. If you take gifts of money unrestricted to the Foundation, every year we'll appropriate the sum of those gifts and you can have that too," which means that people had to write a check to the government of the United States, and the government would then give the money to something in the arts or the humanities, you know—to unfreeze that part of of the thing. I said, "That'll never get any money. No foundations, no

private foundations will ever give you any money on that basis, very few individuals will, and that's window dressing, but it's also a trap."[36]

This was to become a problem when the Ford Foundation wanted to give funds to the National Endowment specifically for the American Film Institute. In 1967, "one of the very triggers loaded into that bill had exploded," Lowry said. "I had to go down [to Washington] and call on a bunch of lawyers and try again to find a way to get around what was obviously deliberately imperfect legislation—Section 11(b) and 10(a)(2) of the act that Thompson got through.[37] And in the course of this, I had to haggle with Roger Stevens and talk to his lawyer and talk to another lawyer in Washington. And as we did this, we were all so beside ourselves with the very inhibitions that I knew the legislation would bring about—toward their freedom of action [presumably to accept funds for specific projects]—that they all began to spill the beans in their irritation." Lowry discovered, approximately four years later, the promise John Kennedy had made to Richard Goodwin.

> And Stevens and Ruttenberg, who was then the lawyer for the National Science Foundation, and Marx, another lawyer, all gave me keys that I could put together, and I said to Roger, "What about it?" and he said, "Yeah, didn't *you* know that?" And I said, "You mean when you sat out there in Thompson's office with me that afternoon that you knew that and I didn't?" And he said, "Yes." I said, "This is one of the problems."
>
> It made a difference in my understanding and my ways of dealing with Goodwin and my ways of trying to go around him. Yes, it would have. . . . Thompson thought that it was an open-and-shut question of could they convince Goodwin or could they convince the White House. He couldn't convince him [that no one person should be completely in charge]. I knew that, but I didn't know why. Well, knowing why helps, you know, often.

What had finally gotten support for the arts through Congress? Senator Pell believed that combining it with support for the humanities had done the trick. "The arts had a constituency in Chicago, Boston, New York, San Francisco," he said, "but not across the country. But when you get the humanities in, you get fifty states and the state universities."

Culture in the United States, as Lowry had pointed out, was generally considered to be a mixture of the arts and humanities, the aesthetics of the environment, and "the exposure of people to artistic and creative influences." But Lowry's working concerns were narrower. "You will find that in practically all of our statements," he said, "about what we have been doing [in his division at the Ford Foundation], the word 'culture' doesn't exist. We're talking about the arts and in order to be more specific, we talk about the creative and performing arts. And when

we talk about the theoretical and critical aspects of the arts, we talk about the humanities."

An exchange between Senator Ralph Yarborough of Texas and James Rorimer, director of the Metropolitan Museum of Art in New York City, during the hearings in 1965, made the difference vividly clear:

> SENATOR YARBOROUGH: Since the question has been raised here about Federal control, suppose that you started to have an exhibition of some artist who was interested in a different way of life than the average, and there was objection to your exhibition, by someone on the Federal level, that money was being put into a matter, that is, if this bill were passed. I assume that in that case you would have your exhibition anyway, that you would not submit to domination. There have been times all over the country in recent years in art museums in this country where they had put Picasso paintings on the wall, and they had to take them off. I am not attempting to judge that art. They have had to pull his paintings off the wall because he painted the dove of peace and things like that. That has happened to a number of museums in this country. It has happened in cities that are among the 20 largest in the Nation.
>
> Assuming that anyone on the Federal level tried to direct that you not have an exhibition by certain artists, I presume that you would reserve that right to have an exhibition by a particular artist or you would reject the Federal money, am I correct in that assumption?

Rorimer replied that he could think of about twenty answers to what appeared to be a simple question.

> MR. RORIMER: . . . Speaking for [the Metropolitan] board of trustees I think that we are free to exhibit competent work of any citizen of the United States, whether the man is capable of being a citizen is another question which is not in our control. . . .
>
> I think that Picasso and others are going to express themselves, and we had better show their works of art and then reach our conclusions about them. As to what their thinking is is another thing. That is the way humanistic studies develop.[38]

Panofsky had spoken of the humanist as being, fundamentally, a historian.[39]

In the proposed legislation, the term "humanities" was defined as including but not limited to the study of: "language, both modern and classic; linguistics; literature; history; jurisprudence; philosophy; archeology; the history, criticism, theory, and practice of the arts; and those aspects of the social sciences which have humanistic content and employ humanistic methods."[40] Livingston Biddle said, "I must say that the humanities constituency was very helpful to us. It's very difficult to organize the arts community in any cohesive fashion, whereas the humanities,

having been experienced in the educational field for many years, had a better kind of an organization. And we were successful, I think, in part because the humanities and the arts became allied—because it gave us a broader base and a better organization to work with."

Barnaby Keeney, then president of Brown University in Rhode Island, headed a commission on the humanities set up by President Kennedy at Keeney's suggestion. Keeney also shrewdly arranged honorary degrees at Brown for Senator Pell and Representative Fogarty, also of Rhode Island, reputedly with every intention of keeping their feet to the fire if necessary. ("Barney's a pretty good politician too," Thompson said.) The commission published its report in 1964. Aside from anything that might be done in the way of support for the arts, the commission concluded that the humanities needed a national foundation. Representative William S. Moorhead (D., Pa.) was "one of the first Congressmen to act on this";[41] during the first session of the Eighty-ninth Congress, stealing a march on Fogarty and Pell, he introduced a bill to establish a separate humanities foundation.

In mid-February 1965, "discussions began to determine whether the Administration should transmit legislation to the Congress asking for an arts foundation, a foundation for both the arts and humanities, or two separate foundations."[42] During that spring, witnesses before the congressional subcommittees would address themselves to the legislative ideas then current, and most of these witnesses favored the establishment of a joint foundation. Dillon Ripley testified quietly:

> I believe in terms of the humanities that there is a very great need. The need is not for very much money. It is just for small supplementary grants, especially like projects of the sort of thing which were enumerated earlier as to what Mr. Henry, my immediate predecessor, used to do with his premiums to help those things. The humanities scholar is generally fairly content with access to a library, some facilities for travel, some facility with peace and quiet, and a minimum of hardware to surround himself with. And so I would never envisage a humanities and arts foundation becoming a matter of millions and millions of dollars, the way the National Science Foundation is, which is so much a strategic agency.[43]

"During the basic hearings," Biddle said, "the Administration had not yet made its view clear." Thompson, Fogarty, and Pell felt that "combining Congressional support for both the arts and the humanities would enable both to secure adequate funding."[44] Goodwin had initially been against including humanities with the arts but was persuaded, he said, by the argument that educators would help put the arts through. Drafting of the Administration's proposals was assigned to the legal staff of

the Bureau of the Budget, with instructions for two separate but equal endowments under the umbrella of one foundation.

Roger Stevens had been appointed chairman of the National Council on the Arts March 11: its first meeting took place on April 9 in the Fish Room of the White House. "Meanwhile, during the spring and into the summer of 1965, executive sessions of the House and Senate Subcommittees continued, with the Senate Committee on Labor and Public Welfare reporting out, on June 7, 1965, an amended S. 1483, to establish a National Foundation on the Arts and the Humanities."[45] It was passed on June 10, 1965, by voice vote—without ruffles and flourishes, as Biddle said.

> On June 24, 1965, the House Committee on Education and Labor reported out H.R. 6050, also to establish a National Foundation on the Arts and the Humanities, and ordered a clean bill introduced. . . .
>
> The House Education and Labor Committee on July 8, 1965, reported out its version (H.R. 9460) of the Senate-passed bill (S. 1483) so rapidly that it prompted a Minority Report by Representative Albert Quie (R., Minn.) and others. In their view the hasty approval by Committee was "a mockery of the legislative process," and the bill itself was objected to on the grounds that it was "creating Federal czars over the arts." Six out of a total of 31 Committee members joined Mr. Quie in his protest despite the compromises and adjustments that had been made and approved by the full Senate and by the majority of the House Committee members.[46]

In the House of Representatives legislative ideas originating in subcommittee, after approval by full committee, progress to the Committee on Rules, where they are policed. During the Eighty-ninth Congress its chairman, Judge Smith from Virginia, was opposed to the idea of federal involvement in the arts and humanities. He would not "give a rule" for consideration of the bill by the House as a whole.

However, a twenty-one-day rule then in effect allowed the House as a whole to petition a bill out of this committee. ". . . strategy was developed to invoke this procedure to obtain a House vote on the Foundation bill, together with six others, during the month of September."[47] The debate, which began on September 13, was more on whether the Rules Committee would retain its prerogatives than on the merits of the legislation being considered. It was touch and go, Livingston Biddle said, with "all sorts of delaying tactics being used." "Those opposed used parliamentary procedure to delay the session, which lasted from noon until 12:31 a.m. the following morning (the 14th) and forced an unprecedented 22 quorum roll calls."[48]

If you don't have a quorum in the House [Biddle said], then everything has to stop and you must begin from the beginning. [At the start of that legislative day, there were] not sufficient numbers of representatives on the floor to establish a quorum, therefore the objectors, and these were primarily Congressman Gross from Iowa and Congressman Hall from Missouri, would immediately rise in their seats and say, "I suggest that there's an absence of a quorum," and then the speaker, Mr. McCormack, would count heads and see that there was not a quorum present and then the clerk calls the roll, Mr.—I believe, oh, Mr. Abernethy all the way up to Mr. Zablocki—all the way from A to Z and that takes about twenty minutes. . . . Now as the roll was being called that day a substantial number of congressmen would come from their offices onto the floor and this is standard procedure, and answer their names and then disappear again. So after the quorum call, they'd start the debate again and then there would be an objection and another quorum call and then the same procedure repeated. . . .

I do know that sitting there watching this you could see more and more people coming onto the floor and staying. And then, however, as the hour grew later and later and later and people had been there for a considerable period of time, some without having a dinner break, you just had the feeling that an erosion eventually would occur, and that at some point there wouldn't be a quorum mustered and of course the legislation would not have been considered. . . . It was midnight before *any* of these bills surfaced, and I was sitting there through the whole thing, and I was helping in any way that I could but there wasn't very much I could do at that point. . . . The thing that concerned me most deeply was that this was the last day of the Eighty-ninth Congress when our bill could be released from the Rules Committee under this special kind of petition. We were so near the end of the term and the days when the petition could be heard had dwindled to one, so it was all or nothing on that particular day.

Biddle wasn't sure what constituted a legislative day and wondered if it stopped at midnight but discovered it ran as long as the body stayed in session. "Bob McCord was working vigorously and Frank Thompson was working vigorously just to muster enough strength on the floor to permit a debate to eventually ensue," Biddle remembered. Thompson was on the floor almost throughout, as well as others who were the prime defenders, Biddle said, including "Congressman Fogarty from Rhode Island . . . Congressman Moorhead, and several others who were vitally interested in the bill, but it was really Frank Thompson who was the key mover." As chairman of the House Committee on Education and Labor, Adam Clayton Powell led the night debate.

Biddle said he was sure that Thompson and Powell had many conversations on that particular night. "Mr. Powell was a defender of our

cause in a very eloquent way, but there had been a great deal of ground-work laid for that." Powell thought of the Foundation as an extension of the field of education because the humanities were included. It was "an idea that was readily accessible to him," Biddle said. "I do think, though, that Frank Thompson had persuasive powers with a great many in the House on this whole idea, as did Senator Pell in the Senate."

"As the hours passed, word had been sent to the White House that it appeared as if it would be possible to withdraw three of the seven bills from the Committee on Rules, but that the Arts and Humanities bill was fourth on the list. President Johnson, reportedly through Law-rence O'Brien (his Special Assistant for Congressional Relations, later to become Postmaster General), sent word to Speaker McCormack that consideration of the Arts and Humanities bill was a 'must' even if the House had to be kept in session until early morning hours."[49] It was the last bill considered that day. "Shortly before adjournment, the House by a vote of 260 to 114 passed House Resolution 478 to allow the House to 'work its will' on H.R. 9460, the Foundation bill, and the only one of the seven in question clearly supported by the Johnson Administra-tion."[50] "The vote that was taken that night," Biddle said, "gave us the feeling that we had enough strength to pass the bill when it came up for final debate."

"So far as legislative fights go," however, Richard Goodwin thought that it had been "unexpectedly easy" to get the bill out of the Rules Committee. "We [at the White House] did some calling," he said, "get-ting people like Laurance Rockefeller to call their congressmen." Some of those on the Hill might have thought his remark cavalier. Of Frank Thompson, Goodwin had to say that he "had worked rather intelligently": of intervention from the White House, Frank Thompson remarked, "We had the votes."

"On September 15, 1965, the Foundation bill finally reached the House floor for a vote, and lengthy, spirited—and at times even ludicrous —debate followed."[51] Now, in the House, Biddle said, "the clerk reads the bill in its entirety [Biddle presumably means just this bill, since that is not usually done] and members offer their amendments at the partic-ular moment when they're applicable to what the clerk is reading." The proposed legislation, on the advice of people in the various fields who had testified at the hearings, defined the arts as follows:

> . . . includes, but is not limited to, music (instrumental and vocal), dance, drama, folk art, creative writing, architecture and allied fields, painting, sculpture, photography, graphic and craft arts, industrial de-sign, costume and fashion design, motion pictures, television, radio, tape

and sound recording, and the arts related to the presentation, performance, execution, and exhibition of such major art forms.

The clerk was proceeding in a matter-of-fact voice when what was to be known as "the belly-dance amendment" was introduced by Representative H. R. Gross (R., Iowa). Gross had been successful in the past, Biddle said,

in ridiculing bills of this kind to the point where he got a great deal of laughter from his audience, and laughter is the best way to kill a great many things. The clerk's face, as I remember it, actually flushed . . . and it did get a howl of laughter from the whole house.

Mr. Durward Hall, who was working closely with Mr. Gross in this case—and in some others—had perhaps helped Mr. Gross compose this. . . . And then it had to be debated like any other amendment. Congressman Thompson led the forces in opposition and a great colloquy ensued. . . . [At one point] Mr. Gross said he would not know a professional practitioner of the humanities from a bale of hay, and his remarks had been so involved with this other belly-dance amendment that Frank Thompson got up and said, "The most astounding development that so far has come out of this debate is that the gentleman from Iowa doesn't know the difference between a belly dancer and a bale of hay," and that produced roars of laughter and it was turning slightly the frame of reference that Gross was talking about at the moment, and then he seemed a bit confused and said, "You're putting words in my mouth, I do have some vague idea about the difference between a belly dancer and a bale of hay," and Mr. Thompson said, "I amend my remarks, the gentleman from Iowa does have some vague idea of . . . ," or words to that effect. What it did was to turn the laughter around against Mr. Gross and his objections seemed to lose strength. That was Frank's great ability on the floor—to think on his feet and ad-lib and direct the attack back on the attacker.

"A motion to recommit the bill to Committee failed by a vote of 251 to 128; the bill subsequently passed by a voice vote. The following evening (September 16), the Senate concurred by voice vote with the House-passed version. Thirteen days later, on September 29, 1965, the National Foundation on the Arts and the Humanities came into being [with funds authorized for a period of three years] when President Lyndon B. Johnson signed Public Law 89-209. Two hundred and fifty Congressional, humanistic, and cultural leaders were invited to the signing ceremony,"[52] which was held in the Rose Garden at the White House.

Certain changes then occurred:

Barnaby Keeney, former president of Brown University, became chairman of the National Endowment for the Humanities and chairman of its advisory council.

Roger Stevens, already chairman of the National Council on the Arts, Special Assistant to the President on the Arts, and chairman of the Board of Trustees of the Kennedy Center, retained these positions and became, in addition, chairman of the National Endowment for the Arts and head of the National Foundation. When a Republican president came into office, Stevens retained the Kennedy Center position but was replaced in the others.

Livingston L. Biddle, Jr., "who as Senator Pell's Special Assistant had worked closely with the Congress and with Mr. Stevens on the arts legislation, became first a Consultant and on December 21, 1965, Deputy Chairman of the Endowment"[53] for the Arts.

Richard Goodwin was gone from the White House.

It is hard to say exactly why. Some thought he left because of family problems, that his wife objected to his long and irregular working hours. Goodwin himself attributed his departure to a disagreement with the President's Vietnam policy, although he is said not to have indicated opposition while still at the White House.

Although Goodwin acknowledged that he did not have the temperament to become an expert, he had many of the artist's character traits, which made those who found him useful look as if they were embracing him rather awkwardly at times. Goodwin could not be entirely loyal to those whom he served with that typewriter. He was trying to serve two masters: he wanted personal credit. But a leader loses credibility if the public is reminded that the words he spoke on a certain occasion were not his own. Most speech writers, of necessity, remain virtually anonymous. Of course, they all want to get closer to the man and in on what goes on, James Keogh[54] said: a speechwriter would be concerned that his work accurately reflect the President's personality and positions. But Johnson began to have the feeling that Goodwin was leaking stuff, and others got the same idea.[55] Johnson asked Jack Valenti to make sure that only "need to know" people attended National Security meetings, and Goodwin was among those to whom this limiting edict was applied.[56] The attempt to keep Goodwin under wraps was regarded—especially in some journalistic quarters—as misguided secrecy and suppression, perhaps based on jealousy.[57]

Theodore White later wrote that, "along with Bill Don Moyers, [Goodwin] had in 1964–65 done more to shape the legislation of the Great Society than any other man in Lyndon Johnson's administration. . . . He had been Johnson's favorite speech-writer, author of the first Johnson peace proposal at Johns Hopkins on April 7th, 1965, as well as the Great Society speech of 1964 and the Civil Rights ('We Shall Overcome') speech of 1965."[58]

Goodwin was a superb phrasemaker and genuinely believed this ability gave him great power. When Seymour Hersh became Eugene McCarthy's press secretary for the presidential campaign in 1968, Goodwin reputedly told Hersh, only half humorously, "You and me have a typewriter, and we'll overthrow the government."[59] Goodwin had a nose for sniffing out men and ideas whose time had come. But power seemed to elude him, and the world of Washington went on without him.

The programs of the new Endowments functioned adequately but on scarcely significant funds during the remaining years of Johnson's administration, occasionally exhibiting bias rather than being methodical, as in their early grants to poets, but generally staying out of trouble. Henry Heald, who as president of the Ford Foundation had approved its arts program, said that the federal Endowment had to "pay more attention to satisfying everybody and also to sufficiently satisfying the congressmen to a sufficient degree so that they can get another appropriation. A foundation doesn't have to do that." Toffler, in *The Culture Consumers*,[60] suggests it was Henry Steele Commager who said: "Of course government intervention [in the arts] is dangerous; government is dangerous; life itself is dangerous."

When at its second meeting in 1965 the arts council professed its desire to (1) "support and aid the expansion of the highest standards of professionalism in order to provide better opportunities for our most talented artists"; and (2) "provide a postgraduate training program for our young artists by the creation of performing organizations to utilize their talents in cooperation with local support,"[61] they were to a certain extent modeling themselves on the early work, in the arts, of the Ford Foundation. However, the council imagined its aims as being to "increase standards of education and appreciation of the arts" and also decided to support projects with primarily sociological purposes, one example of which was Budd Schulberg's Writers' Workshop in the Watts section of Los Angeles. If Lowry's work resulted in others being educated to appreciate the arts and in an improvement in the quality of life for the underprivileged, he certainly did not mind. But, as already seen, these were not the primary goals he set the Foundation to effect.

The National Endowment for the Arts promptly:

1. set up liaison with state arts councils with regard to the acquisition of funds from a variety of sources: "At the time the Foundation Act became law, only four States had active, functioning arts agencies. Half of the States had made some effort to form arts agencies, but almost all of these efforts resulted in privately chartered 'paper organizations' lacking funds. . . . By the spring of 1967 virtually every State and Territory had an arts agency functioning with at least some degree of

effectiveness," said the Foundation.[62] Initial grants of $25,000 had been made;

 2. established rapport with the Business Commitee for the Arts, originated by David Rockefeller. The idea was to encourage good-sized contributions from business on a regular basis;

 3. contributed to the support of educational television and, through the U. S. Office of Education and state and local boards of education, backed theater;

 4. sponsored a variety of conferences, including one at the Whitney Museum of American Art in December 1966;[63]

 5. established interchange with other countries concerning the arts;

 6. set up (in 1967) an American Film Institute to which the Ford Foundation gave an unrestricted $1.3 million, a grant that freed an equal amount of federal money from the Endowment for this purpose. In addition, $1.2 million came from the seven member companies of the Motion Picture Association of America, headed by Jack Valenti;

 7. made grants to museums for the purchase of contemporary art;

 8. brought artists to college and university campuses;

 9. funded a variety of projects "interrelated" with the arts, such as grants to ten schools of architecture and design for environmental projects, "including design internships, community design and training in ghetto areas, design in growing suburban communities, reclamation and design of strip-mined coal areas in Appalachia, and program development in environment research."[64]

Endowment programs were coordinated with those of the Ford Foundation to a certain extent. For instance, nothing was done at that time for symphony orchestras because the Ford grant of $80 million "was so far and away above what the Arts Endowment had," Biddle said, that "they removed the onus from us of supporting orchestras." And the "czar"—Stevens—turned out to be a politician.

 "In reality," said Biddle, "the way this all has worked, the two councils are as close to being like boards of directors as we could make them." He thought this was especially true of the Arts Endowment. "If Roger Stevens as chairman of the National Council on the Arts felt that even a minority of his council was opposed to a certain concept of support, a certain program, a certain way of carrying it out, we would shelve that until another meeting or we would abandon it, so the council had considerable voice in how the program ran. . . . I did find one very interesting development," Biddle said. "In the beginning, it seemed to me that the spokesmen would speak for their own discipline—for instance, Miss De Mille, who was an early council member, would speak in terms of the dance, and Isaac Stern would speak in terms of music, and René D'Harnoncourt would speak in terms of museums, and Paul Engle, let

us say, would speak in terms of poets, but as time went on and we exchanged views and exchanged thoughts and saw this program developing as a whole, you would find Isaac Stern talking about what were the needs for poets and Paul Engle talking about music and René D'Harnoncourt talking about dance and Agnes De Mille talking about what was needed for museums."[65]

Lowry, as already noted, had held conferences for the Ford Foundation. He said:

> We settle sometimes basic principles, concepts, and alternatives, but we *never* give to a formal or informal conference of artists the job of approving or structuring a program or a project, and just sit there as recorders and take it down and *do* it, you know. A suggestion or an idea prompts itself and then others comment on it, we ask questions about it, we begin to search it and to ask more systematic questions, they can begin to see that this is something we see as a possible program, a possible action that we could assist or synthesize. So they are not surprised probably, a few months later, if we do something that seems to have sprung from that.

The implication here seems to be that Lowry had confidence in himself, if not in others, as a czar. But he is said to be uneasy about what has been called his enormous power. "In another part of our program—" he commented, "individual awards to artists—we do the opposite. The final panel to approve them on artistic criteria is always made up of professional artists, not laymen." Lincoln Kirstein said the best thing about Mac Lowry and the Ford Foundation program was that they "made it possible for some standards to be demonstrated. Mac is not exactly a political idiot," Kirstein said to me.

Ford Foundation staff seemed somewhat ambivalent about the fact that the Endowment did not appear to be interested in the enormous amount of information already collected. Mrs. Thompson thought they may have

> respected the fact that as a private foundation we couldn't necessarily open our files to others, because we feel very much that when someone comes to the Foundation they've got to be able to speak openly about their situation. And in the early stages the Endowment had no staff of its own; it was using consultants, and sometimes they were consultants from organizations that we dealt with on another level. They might take someone on a leave of absence from an art council or from a museum who would be doing legwork on a particular section of the Endowment program as it developed, and you might not want—as much as you respected that individual—to turn back figures and relationships with

other organizations. But that really is never an issue. They never raised it.[66]

The National Endowment structured their staff very much on their own, Mrs. Thompson said, "although Mr. Lowry was asked from time to time what he thought of X or Y as a possible staff person for the Endowment."

". . . Stevens and I have associations now, officially, you know," Lowry said. "The relations are very good, incidentally. For a time he had a big chip. That's gone. Anyhow, relations are very good between us and the National Endowment."

Biddle commented that once everything got going and grant making began, whatever misgivings Lowry may have had in the beginning were not lasting. But perhaps also the possibility for and the awarding of a grant from the Ford Foundation helped to improve relations after the Endowment had initially asserted its independence. Lowry had the ability to accept what happened and then try to make something out of what had become the new "given," so it seems to this author. Biddle pointed out that Lowry came down and testified for a renewal of the authorization for the program "in very enthusiastic terms" and, Biddle said, "this was very helpful because of his great prestige."

Authorization of funds for the Endowment during its first three years of life had come from the original act passed in 1965, but Congress had not, however, in any one of those fiscal years appropriated the legally possible amount. It would have taken a new act of Congress to eliminate the Endowment as a structure but it could be killed just as effectively by lack of funding. It was obvious that Congress gave the arts low priority. And since so much of their time had to be spent on getting money, it was understandable that the Endowment staff found it difficult to take a long-range view of their programs. "During the second year," Biddle said, "because of the legislative cycle, you must begin to put in for your reauthorization, and those bills have to be introduced and the whole procedure gone through [again]." No doubt the process seemed unending.

> . . . on June 29, 1967, Senator Pell had introduced S. 2061, authorizing further funding of programs under the Foundation Act. On July 10th, Representative Reid (R., N.Y.) had introduced a similar bill, H.R. 11308, in the House. It was announced by Senator Pell and Representative Thompson that their Special Subcommittees would hold Joint Hearings on the bills on July 12 and 13; further hearings were later held by the House Special Subcommitee on July 18 and 26, and by the Senate Special Subcommittee.[67]

The arts had severe and worsening financial problems, testified the witnesses.

. . . on January 30, 1968, the House Committee on Education and Labor reported out H.R. 11308. Less than one month later, on February 27th, the bill reached the floor of the House. . . . [When amended] the bill limited the entire Foundation's authorization to $11.2 million (plus administrative funds and provisions to match gifts), authorized its continuance for only one year (Fiscal 1969) instead of for two, and revoked the Arts Endowment's authority to make individual grants. The first two provisions had resulted from an amendment offered by Representative Ashbrook (R., Ohio) which had passed the House by a vote of 261 to 130, and the latter provision had resulted from an amendment offered by Representative Steiger (R., Wisc.) which had passed by a vote of 111 to 92. One constructive action taken by the House, in line with the Endowment's request, authorized the special Treasury fund to match restricted as well as unrestricted gifts, subject to a prior recommendation from the Council on acceptance of the gift.[68]

So it appeared that that particular fight was won.

. . . on May 3, 1968, the Senate Committee on Labor and Public Welfare reported out [the equivalent of] H.R. 11308; the Committee had revised the language of this bill and had reported it out in lieu of the original Senate bill, S. 2061. And on May 7th, the Senate passed its amended H.R. 11308 by a voice vote. The Senate bill restored a two-year authorization for the Foundation, and the authority of the Arts Endowment to make individual grants. On May 28th, conferees selected by both Houses agreed to file a Conference Report, having settled their disagreements in conference. That Report (H. Rept. 1511), recommending a two-year authorization and the authority to award grants to individuals "of exceptional talent," was agreed to by the Senate on May 29th and the House on June 5th.

On July 26, 1968, President Johnson signed Public Law 90-425, appropriating to the Arts Endowment for Fiscal 1969 a total of $5.4 million ($3.7 for programs, $1.7 for the States) plus some portion of $1 million to match donations.[69]

"It is interesting," said the Arts Endowment in its annual report for 1968, "to look back from this $5.4 million appropriation to the $32.5 million originally recommended as the Arts Endowment's Fiscal 1969 authorization by the House Committee on Education and Labor when it reported out its ill-fated H.R. 11308. Several months after the Committee made this recommendation, the Bureau of the Budget cut this $32.5 million to $10.05 million in its annual budget request submitted in January of 1968. When the new authorizing legislation finally passed, it further reduced the amount to $8 million plus some portion of $13.5 million to match donations. This downward trend in the fortunes of the Arts Endowment continued, and, indeed, resulted in the $5.4-plus-some-portion-of-$1 mil-

lion finally available for Fiscal 1969. The agency could only conclude for the future that it had nowhere to go but up."[70]

The end of the sixties, however, saw a reversal of this trend. In 1969, Richard Nixon did not renew the Stevens appointment but instead nominated Republican Nancy Hanks to serve as head of the National Endowment. Of course, "everyone agreed that art must be divorced from politics," Livingston Biddle said, but "the heads of governmental agencies were usually of the party currently in power." After all, "when you're dealing with an administration, you want ready access to it."

Politics played no part in the awarding of specific grants, Biddle insisted. The whole problem was the amount of support a particular administration was willing to give to the National Foundation. Because, Biddle said, "arts institutions large and small, particularly the large ones, are in such financial difficulties. They see that their whole private sources of philanthropic support are simply not substantial enough to fund them." The whole purpose of the legislation, as Biddle saw it, was to fill this increasing vacuum.

Nancy Hanks had been executive secretary of the Rockefeller Brothers Fund during the time in which it had produced a report providing documented evidence that the arts could never pay their own way in this country,[71] and she had been president of the Associated Councils of the Arts. This private association has already been described, but increasingly those individual state and community councils of which it was comprised were looking to Washington not only for funds but also for guidance. They formed a natural political base for support of the arts, and to move Miss Hanks from the ACA to the National Endowment was not illogical. She considered the enabling legislation "brilliant"[72] and called for "arts expansion": she wanted "something in every district."

Lowry commented that she "did not understand so much about quality support of artistic goals. . . . Pardon the dirty word," he said, but

to talk about quality in a *group* that has a great leader rather than talking about quality just in terms of an individual, that doesn't go either with the National Endowment or with the other private foundations of any size who are in the arts—there're not many. It does still go with many private patrons.

Lowry said, "The Ford Foundation's continuity on that has been the most important." Lincoln Kirstein commented that Nancy Hanks "doesn't give a damn or know a damn about art but she's politically skillful." A man who had worked with her at the Rockefeller Brothers Fund commented that she saw "the relation of the arts to *social* problems, something artists themselves don't always realize. . . . With artists, and writers as well,

there is a lot of infighting—cliques and schools jockeying for power. Nancy not only doesn't take sides; she has no real opinions on the controversies that boil up in the field."[73] She got along fine with Richard Nixon: appropriations for the following five years increased over sevenfold.

Such success must have seemed ironic to the Democrats: after all, they had been responsible for the existence of the arts legislation in the first place, over the continuing objections of Republican congressmen. But Nancy Hanks was moving federal funding for the arts inexorably toward the support of institutions, which presumably made it more acceptable to conservatives. In 1970, an orchestra grant was announced. Biddle said:

> If you look at the major arts institutions around the country, preponderantly the representation of their boards of directors, of their corporate structures, is composed of conservative people, often Republicans in philosophy.

Kenneth Sherrill speculates that the mere perpetuation of large-scale organizations such as symphony orchestras inevitably generates alienation and powerlessness among orchestra members, and conservative policies —symphony orchestras become bureaucratized institutions that maximize

FORD FOUNDATION GRANTS FOR THE ARTS
1957-73 (in millions)

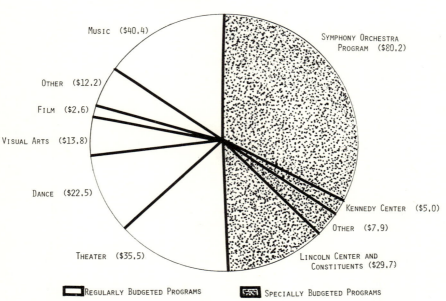

MUSIC ($40.4)
OTHER ($12.2)
FILM ($2.6)
VISUAL ARTS ($13.8)
DANCE ($22.5)
THEATER ($35.5)
SYMPHONY ORCHESTRA PROGRAM ($80.2)
KENNEDY CENTER ($5.0)
OTHER ($7.9)
LINCOLN CENTER AND CONSTITUENTS ($29.7)

☐ REGULARLY BUDGETED PROGRAMS ▨ SPECIALLY BUDGETED PROGRAMS

values other than the pursuit of music for music's own sake. Thus a conservative cycle was perpetuated.[74]

Lowry noted that the National Endowment emphasis had been on "interpretive" (or performer) grants as opposed to the "creative" (under which the composer would qualify). He said Stevens had gotten by with direct grants but that "Nancy's still doing more than her sense of political risk would seem to justify—not in any proportion that I think she should but more than I had thought for a political, taxpayers-congressionally-approved operation."

By the end of the decade, the federal government had gained some of the spotlight although its spending in the arts had not begun to match Ford Foundation funds. By 1974, it began to look as though this might change. In the period 1966–73, the National Endowment had spent $123.7 million, including allocations to state arts councils, compared with $249.8 million from Ford in the 1957–73 period.

PART IV

"Thoughts of a Dry Brain"

WHAT'S THOUGHT CAN BE DISPENSED WITH

(The protection of information as property)

CONGRESS WAS ALSO concerned during those years with an issue even more vital to the artist than financial support or personal encouragement: an outmoded copyright law. It had been revised only three times since the original copyright act had been passed in 1790, and the last thorough revision had occurred in 1909. Since then not only had dazzling technological changes taken place but existing law as it had developed since 1909 through court decisions needed to be codified.

"The effort leading to the revision offers an outstanding example of thorough, conscientious legislative work," wrote *Science* magazine.[1] "The Copyright Office started detailed studies in 1955 and reported to Congress in 1961. A draft bill—for discussion only—was introduced into the 88th Congress. A second bill was introduced in 1965. The House Committee on the Judiciary listened to more than 150 witnesses during 22 days of public hearings, devoted 54 committee meetings to revision, and then introduced a revised bill which, with some amendments, was adopted by the House of Representatives on 11 April [1967]." The vote had been 379 to 29. Twelve years and only through the House.

Unhappily, it would take many more years before a new copyright law would be enacted by Congress. In the face of loud outcries on the part of various special-interest groups who felt their differences had been compromised unsatisfactorily, the Senate suggested that a commission might be needed to study the matter for three years and "recommend methods by which the widest possible use of works of authorship for

purposes of education, scholarship and research can be encouraged and facilitated without depriving authors and other copyright owners of the remuneration to which they are fairly entitled for such uses or of the exclusive rights necessary to insure that remuneration"—words that contained the gist of the problem.

"The fields to be considered by the commission," read the draft bill, "shall include, among other things, the reproduction and use of copyrighted material in information storage and retrieval systems, performance and displays by means of broadcasting and other forms of transmission, and various forms of facsimile reproduction." Twentieth-century technology was making the rights of both publisher and author increasingly difficult to protect.

But technology was not the only problem. The following appeared in the trade journal *Publishers Weekly*:

> An author's home may be his castle, but his book is something in which the public feels entitled to a share, maybe with payment and maybe without. There is nothing particularly new in this situation. Literary property traditionally has been less sacrosanct than other property rights. The public's "right to know" traditionally has been invoked more often than the author's right to be paid for his creation.[2]

Historically, protection of the right to copy, through the passage of statutes, seems to have developed largely because of the complaints of authors,[3] who before the invention of printing tended to be anonymous. This is an anonymity to which, said Marshall McLuhan, we in the electronic age should have returned.[4]

McLuhan's statement, at least in context, may have sprung from a desire to have no one hold him responsible for his own remarks because, as he said, he is always changing his mind.[5] Perhaps his evasion is fear of shame: to disclaim the past is to permit anything in the present without the possibility that one will be ashamed of it in the future—an idea that made the behavior of young revolutionists possible.[6]

Rather than expressing a new way of being, appropriate to the electronic age, McLuhan's behavior appears as an extreme of responsive man's reaction to his environment. McLuhan, because he sees so much more than most people, can duplicate our culture like a chameleon—its linear qualities becoming less apparent than the overlapping mosaics, hence his fragmentation. McLuhan's compulsions force him to structure information into new pieces of information no less than do those of other authors, without regard for the consequences. When aesthetic considerations are involved, we call the new construction "art" (or attempted art). McLuhan has a kind of artlessness because his collections have no ultimate meaning.[7]

His mode certainly was part of a trend, however, as this book hopes to have pointed out, in the world of visual art and elsewhere. It is wrong—and too pejorative—to call this trend a lack of discrimination. Andy Warhol may well have summed up the sixties when he said, "I like boring things."[8] Boring things draw to no conclusion.

In spite of his irresponsibility, McLuhan is interesting because his provocations (or probes, as he calls them) are brilliantly aimed, instinctive and educated responses. They force re-examination of content by emphasizing conduits. William Jovanovich could say, "Well, Marshall McLuhan is a mystic, I'm convinced. . . . When he says, for example, that pure information is light—that General Electric really isn't in the business of making light bulbs but information—the purest form of information is light, that isn't nonsense. There's something there but one can only arrive at it, I think, by a suspension of ordinary rational belief." Yet Jovanovich was a staunch supporter of McLuhan, even going to see McNeil Lowry at the Ford Foundation in McLuhan's behalf (his only meeting with Lowry), albeit unsuccessfully.

Unlike McLuhan, Jovanovich insisted that "we need to know who is speaking."[9] He had in mind, presumably, the bias caused by the life histories of every individual and was in clear opposition to the practice of group journalism. He believed in "the expression and composition of information as the product of individual intellection and sensibility,"[10] although his belief ran counter to certain trends in our culture, as he himself pointed out.

In the late thirties, Robert Ingersoll argued that "the concept of 'group journalism as opposed to impresario journalism' had been implicit if not clearly articulated in *Time*'s original prospectus and the time had come to emphasize it and improve its practice."[11] Luce himself did use the phrase "group journalism" but finally in 1947 wrote a memo asking that it "be expunged from the Time Inc. vocabulary":

> It goes without saying that we are both devoted and addicted to what is mis-named group journalism. We believe in teamwork, in cooperation, in division of labor; i.e., we believe that two or more heads are often better than one. We believe in intellectual partnership and in what might be called "basic agreement," etc. But we do not believe in any such subordination of individual responsibility, or in any such subordination of individual imagination or whim or fancy, or in any such subordination of individual intellectual sweat as is suggested by "group journalism."[12]

"It pained and puzzled Luce that his magazines met frequent rebuff where he most wanted them to be taken seriously—in the intellectual community."[13] Why that might be so perhaps was shown in a memo written

by managing editor Manfred Gottfried to the writers and researchers of the organization, in which he said, "The price of the degree of intellectual democracy that we try to practice is that virtually no one can ever have any story exactly as he wants it."[14] Time Inc., of course, is no democracy. (But lack of democracy in the internal workings of an organization does not guarantee the production of art any more than does its opposite.) "It is still the privilege of higher ranking editors to make the bigger mistakes that get into print," wrote Gottfried in that same memo. Donovan said:

> Writing on *Fortune* is very different . . . from writing on *Time* because *Fortune* articles are almost all signed by the writer and almost always he's done his own reporting and research. He goes out with a researcher, but he's essentially gathered much of his own information and he writes it himself. The *Time* writer is not normally gathering the information himself but is writing it from the files of those who did.

Donovan felt this was not incompatible with the concept of individual creativity, although

> . . . our correspondents in our news service feel they're not writing directly for publication . . . somebody on *Time* is going to piece together things in here . . . which is totally different from a newspaper correspondent filing for *The New York Times*. . . . *The New York Times* will print almost exactly what he files and then they chop the two paragraphs off the end for space reasons. But he will be practically unedited and he'll have his own name on his own piece. A lot of people like that kind of reporting and writing better than our kind, but they know our method before they come here, so, as a rule, we don't get people quitting because of that or they never would have come here in the first place. Some people leave, not because they're surprised at the system or disagree with it as a general method, but they've just reached a point in their career where they want to do something different and maybe write five long pieces a year under their own name for—on a free-lance basis or whatever.

Reporter Andrew Kopkind quit after deciding *Time* was so powerful as to "produce mass ideological manipulation, create worthless demand, and impose a whole range of values which are important to the interests of the corporation but destructive of the individual."[15]

If the composition of information was not the work of one particular individual, those paying for the composite expected to own it. On the other hand, if it was the work of one individual, on salary, those paying that salary still expected to own it. So far as the work I had performed "for hire" at CBS was concerned, I had failed to understand the terms of my employment. I had gathered that the rewards of status are considered necessary to maintain hierarchies. The kind of status that is usually to be

gotten within a hierarchy was not what I wanted. I did not understand what those who worked in organizations saw as rewards—access to high officials, inclusion in information and meetings, salaries, bonuses, conveniences, etc. I wanted my own truth acknowledged as a truth and was naïve enough at that point to see no reason why it should not be among these apparently friendly people. But by putting my name on a book, I was insisting on a kind of recognition that is reserved to the officials of a corporation or to the corporation itself. Because of a number of circumstances—including, I suppose, my indignant naïveté—nobody wanted to tell me to take my name off the book, although it was suggested that "editor" was more tactful than "edited by." The quality of my work and the fact that the book was my and Ira Teichberg's work were irrelevant. The two publishing companies involved treated me uneasily, I presume being concerned about their relationship with such a powerful organization as CBS but perhaps because I had become terribly defensive even while I was unsure of the value of what I was defending. I was most kindly treated, in the midst of my troubles, by Robert Kennedy, and I valued him accordingly. All this is why Jovanovich's interests inevitably predisposed me toward him. "What shall constitute authorship and what shall constitute publishing in the contemporary world?" he asked as "the most relevant and serious questions of [his] enterprise."[16]

The publishing enterprise had begun in America when the first press was brought to Cambridge in 1638. By 1763 there were printing presses in every one of the thirteen colonies and newspapers were being published. "Votes and Proceedings of the American Congress" went to thirty-two printings in 1774, and Thomas Paine's *Common Sense* sold 100,000 copies in ten weeks. Up until the nineteenth century, authors usually paid for the printing of their own books and used publishers as wholesale distributors on a commission basis. Verner W. Clapp states that "copyright developed from the needs of publishers for protection of investments in expensive mass-copying systems."[17]

By 1830 Harper & Brothers had become the largest book-manufacturing and book-publishing company in America. Publishers had begun to pay costs but no royalties until they had recovered their original investments. A "culture boom" occurred in the second quarter of the nineteenth century, demonstrated by elementary schools, town libraries, lectures for adults. The outbreak of the Civil War fostered the dime novel (a cheap paperback flurry had taken places in the 1840's—quality paperbacks were to become a twentieth-century phenomenon). Publishing by 1900 was a "fairly big industry," with a number of trade associations being formed.[18]

The publishing situation in the early 1960's resembled that toward

the end of the nineteenth century, wrote Charles Madison in his *Book Publishing in America*. Then, wrote publisher Robert S. Yard, there was a

> "crazy period," when royalties, advances and advertising costs exceeded reasonable returns. [Publishers were] "spending their profits in rash advertising" under the temporary delusion that "books are like everything else; advertise enough and they'll sell any amount!" Soon enough, he added, they learned "the old publishing fact that each book has its own natural limit of sale, beyond which it can be advanced by advertising only at a loss."[19]

So publishers claim to this day.

In the late sixties, the president of the American Association of University Presses, Miodrag Muntyan, considered that the two major problems facing publishers were (1) copyright and the incentive to create and (2) information duplication and transmission as a substitute for publication.[20] (But publishers have many other "major" problems, of course, including distribution, rising costs, and the like.) An Authors Guild Bulletin pointed out that "since the early 1960s typesetting has been in a technological revolution" and that manufacturers of composition systems, publishers and printers, and "even some writers" have begun to ask how precisely authors would be affected.[21] By the early seventies it had become obvious that although these problems were of primary importance and perhaps had their insoluble aspects, authors would be affected much less than had originally appeared.

"What is changing," said Muntyan, "is the medium for storing certain information and making it available as needed. To use it, however, we still read the information 'printed' in some form, since we have no way as yet for electronic impulses to bypass language and implant computer 'bits' (seven to a letter) directly into our nervous system. . . . With the new information systems, we will have in effect electronic books with individual copies produced on demand instead of being stored in advance in a publisher's warehouse, a bookstore, or a library." Too, he said, "in the going jargon, we're really differentiating between hardware and software. The input (software) is going to look *remarkably like what scholars and authors now bring to publishers to convert into books*."[22] (My italics.)

Fred Cole, president of the Council on Library Resources, in the early seventies said he had discussed with his colleagues the matter of the impact on publishing and especially copyright of automated storage and retrieval systems. "We are of the opinion," he said,

> that, while the long-range potential for automated storage and retrieval of large bodies of textual material may be very significant indeed, no

one yet has anything but the haziest notion of what the effect of these systems will be. In the near term (say five to ten years) we believe that systems costs, especially as reflected in the input of large bodies of text, its storage, and the relative inability of most systems to search and otherwise manipulate textual information, are so high as to preclude the emergence of any systems which would have significant impact on the way information is recorded today.[23]

Marcia Thompson commented: "Live hard material is more useful to us than something that is spewed out of a computer in terms of an organization. If you're dealing with a museum you care about the quality of paper or the layout of the page or who the designer was of a catalogue— not simply the date it was published. And this is something that is sometimes a little hard to communicate with administrative types."

That everything depended upon the creativity of a particular individual was a concept administrators at CBS could not possibly accept. But that a lack of recognition at CBS of my individual voice seemed to me an injustice was due to my—looking back, rather incredible—lack of sophistication. When it became apparent what was happening, I began to read books such as the one that pointed out:

> . . . most inventors are "engineers" who work on a salary basis for corporations. Although . . . law forbids granting patents to corporations, the obligation to assign individual patents to the corporation is often made a provision of the employment contract.[24]

Copyrights, unlike patents, can be obtained directly by corporations. The copyright law specifically provides that "in the case of works made for hire, it is the employer, and not the employee, who is regarded as the author."[25]

When I joined CBS, I did not know what group journalism was, nor even that it was commonplace for men to hire "ghost writers," especially for speeches. I had been brought in as an editor and did not think of myself as a journalist, among other reasons because that would have meant to me that I had hired out as a writer, which I did not want to do, and would have had to accept the implications of that fact. People frequently give up property rights to what they have created;[26] what I had not understood was that in giving up property rights to CBS I had also, effectively, lost authorship—that is, in the case of the Kennedy book or any others I might do for the firm, the right to be known as the composer of the information.

CBS asked me—along with their other employees—to sign an agreement on this subject, although that agreement was not specifically concerned with what I was doing, which was unique there; and I took care

to write in a sentence exempting my own writings, unrelated in subject matter (I was working on a book at home at the time), from their claims of ownership. (Such an agreement was later on to become a point of contention at Holt, Rinehart, & Winston after that publishing house became a CBS subsidiary.)

This move was scoffed at by their legal department, for, like the agreement eventually requested as a condition of employment by Harcourt, Brace,[27] the CBS agreement endeavored to retain for the corporation all rights to any *technical knowledge* secured or discovered by an employee while working for them. That is, to retain these rights for as long as possible. The organizations, in spite of any such agreement, were vulnerable after an employee left, although, if I remember correctly, papers of this kind usually specified that a former employee could not work in the same area for another firm until a certain period of time had elapsed.

Edward Wallerstein, for instance, when he retired as head of the Columbia Record Company was prevented from working in the industry for five years, but during that time he remained as a consultant to CBS, for which he was well paid but hardly kept as well informed. And although Fred Friendly had signed an agreement, CBS (in the person of Stanton) when Friendly resigned freed him in this regard, taking into account such problems as he might face in trying to earn his living in another industry. Even the most strictly worded legal contracts are subject to circumstance.

Adolf Berle commented that "technical knowledge is rarely if ever assignable to any single individual, groups of individuals or corporations," and that technical knowledge "is part of the heritage of the country and of the race."[28] Art, however, is more than technical knowledge, more than information.[29] Should an artist not own his compositions? Just what the author, or his agent, does not control during that period in which he holds a copyright is a moot point.

"Most people cannot long retain, and therefore cannot effectually use, information that is fragmentary and uncomposed," said publisher Jovanovich.[30] The public's "right to know" is not blocked, since this uncomposed information is usually available no less to one person than to another except by accident. In telling the story of *The New York Times*,[31] Meyer Berger commented that where one hundred years ago a reporter would be rewarded for a story stolen from another newspaper, "today" he would wind up with a reprimand, if not dismissal. Property rights in news have been established. Information when composed becomes property.[32] "At the moment of creation,"[33] property rights are inherent. These rights, however, in the days of manuscript copies, were vested in the physical

paper and not in the composition itself.[34] The historical precedent for ownership of information is a short one.

If art is defined as a form of information, does the public have the same right of free access that it does with certain other kinds of information? If ownership of what a person himself has created is purely statutory, can this right be taken away or changed by the passage of different laws? In 1909, the congressional committee recommending adoption of that new act reported:

> The enactment of copyright legislation by Congress under the terms of the Constitution is not based upon any natural right that the author has in his writings, for the Supreme Court has held that such rights as he has are purely statutory rights, but upon the ground that the welfare of the public will be served and progress of science and useful arts will be promoted by securing to authors for limited periods the exclusive rights to their writings. . . .
>
> First, how much will the legislation stimulate the producer and so benefit the public; and second, how much will the monopoly granted be detrimental to the public? The granting of such exclusive rights, upon the proper terms and conditions, confers a benefit upon the public that outweighs the evils of the temporary monopoly.[35]

If the intent of the Constitution was that in this area the common good should be placed above the rights of the individual, then what was to prevent the removal of all composed information from any regard as property? If artists do not have an inalienable right to what they can create, and even perhaps to be paid for their work, their freedom as individuals would be so impaired that discrimination against them would outrank that against any other minority group in America. But how much they should be paid and whether they should be repaid were questions posed by the libraries and other special-interest groups when it came to revision of the copyright law.

Congress, when it passed the original copyright act in 1790,[36] conceived that the rights of the individual had to be protected *in order to* protect the commonweal, which was its primary interest. That act gave exclusive rights to the author for fourteen years (with an additional fourteen available) in exchange for the creation of a work that would belong to the public. The copyright act of 1909 granted authors a possible total of fifty-six years. Permission was needed, as a rule of thumb, to quote over five hundred words. The bill passed by the House of Representatives in 1967 would have extended copyright coverage to the author's lifetime plus fifty years, which would have brought American practice into line with that in many other countries. Whatever the original intent of Congress, Jovanovich insisted that "copyright laws ought to be perceived as one of the

central controls that safeguard the definition of individuality within the society."[37] And the U.S. Register of Copyrights said:

> We hear a lot these days about freedom of the press, but what we are really talking about is a system that assures the freedom of each separate individual to write what he wants, to get his writings past all the powerful people who are seeking to change or suppress them, and to make them available to everyone who will read them. Copyright is nothing if it does not provide this assurance.[38]

Copyright does not provide this assurance, but it is vital protection.

But, said Zechariah Chafee, "progress would be stifled if the author had a complete monopoly of *everything* [my italics] in his book for fifty-six years or any other long period."[39] "The work goes ahead because each of us builds on the work of our predecessors," he pronounced grandly. But is this not less true in the area of the arts than in the area of ideas, and most true in the case of technical information?

Berle, as a footnote in his chapter on the changing content of property,[40] wrote that "the rapid increase in technical development necessarily downgrades the position of physical or tangible things and upgrades the factors of organization and technical knowledge." Yet curiously enough just the opposite has happened in art, which by definition includes the technical knowledge or ability to achieve personal expression in a form. In currently popular forms, organization and technical knowledge are downgraded while the physical and tangible aspects are upgraded out of all proportion to their worth, as in the Claes Oldenburg sculpture shown on page 404, which might be called a cultural curiosity. ("Whether it *remains* amusing is another question," wrote *Times* critic Hilton Kramer.)[41] Pre-organized materials—"found" objects—went through a period of popularity for presentation as art. They better illustrate the point, since Oldenburg is no mean craftsman. But both Pop Art and found objects are primarily social evidence.

Of course an artist will build on the work of his predecessors even if he wants to do something that hasn't been done before. I have already mentioned the invisible content of art—that is, its relationship to other works of art. In any case, building on the work of predecessors, whether negatively or positively, means the availability of material for consumption and availability is predicated on property rights. Copyright means turning material into legal property: publication, or transmittal, which is intimately connected with the act of copyright,[42] is what provides availability, and that publication, or transmittal, has its costs. Copyright ensures the profitability of that act. It is necessary for something to be in some sense profitable for it to be done.

I have already noted Adolf Berle's remark that, depending on cultural

pressures, the area between personal use and public interest wavers. Copyright struck educators, librarians, researchers, equipment manufacturers, as a monopolistic device to hamper the spread of information which was, they claimed, public property—especially as devices to spread it became easily available (and profitable, to them).

> Five hundred years after the Western world was introduced to printing by means of movable type, 32-year-old Chester Carlson completed a simple chemical experiment in Astoria, New York. Using a piece of waxed paper and a sulphur-coated aluminum plate, Carlson was able to utilize the principle of static electricity to produce the world's first example of xerography (*xeros* from the Greek for "dry," *graphos* for "writing"). The date was October 22, 1938, and a new era of copying technology had begun, an era that historians of the future undoubtedly will hold to be as significant as that which started with Johannes Gutenberg.[43]

Yet previous to that, libraries had permitted hand copies or transcription by typewriter, and as early as 1901 the Library of Congress permitted photographing of copyrighted materials. Librarian Verner Clapp said, "Originally it was no doubt normal for a library user to make his own copies by hand, and the earliest library manual (1627) stresses the importance of providing copying facilities." He stated categorically that "libraries exist for a (or even the) principal purpose of facilitating copying, and their arrangements to this end antedate statutory copyright by several millennia."[44] He had no doubt but that,

> when a public body such as a library that has lawfully acquired a copy of a copyrighted work is prevented from making normal and traditional use of it, not because the use is profitable but merely in order that the copyright proprietor may make additional profits by charging for such use, the public interest is injured.[45]

Publishers' interests in this matter were antithetical to those of libraries. A Publishers Copyright League had been organized as early as 1840. The American Copyright League was formed in 1883. *Publishers Weekly,* bought by Bowker in 1878, urged international copyright; in 1891 an international copyright law was passed by Congress. In 1952 the United States initiated a "Universal Copyright Convention." The basic problem, the *new* problem at home as well as abroad, was how to set up a system of permissions and payments for the right to print out stored information, however "print out" might be defined—cable TV, made-to-order texts transmitted via electronics, photocopying, etc.

A lawyer for International Business Machines (IBM) seemed to feel that copyright was not applicable to computer programs since it related to publication, which computer printout is not—he said. Nor were the majority

of the programs patentable since they began with obvious concepts, he further said. He suggested a registration system.[46]

Of the record industry, Read and Welch wrote:

> The reality of the individual and his special creative abilities within the history of the phonograph have become submerged in the welter of collective cycles of activity created for the most part by others.
>
> . . . Many inventors of phonographic devices, in common with many others, have often fought unsuccessfully for years to reap some profit from the monopoly ostensibly granted them by letters patent. Often an inventor has lived to see his inventions utilized through the corporate devices to create a monopoly for others, which he knows by the basic intent of the patent laws, should have been reserved to himself. Thus, the fictional corporate devices have proven more important in shaping our *available* commercial phonographs than the collective contributions of countless innovators.
>
> . . . two of the three essentials for inventive success [*sic*] . . . money and the services of competent attorneys.[47]

Publishers and other distributors of information, more organized than authors who were only loosely federated under such structures as the Authors Guild, had batteries of lawyers fighting for their interests. And there was quite a lot at stake. A Harcourt internal report made no bones about the fact that "heavy concentration on elementary and secondary schools" was "the main thread in the fabric" of that company's publishing activities. Interests of the publishing industry were threatened by Xerox and computer technology just as broadcasting industry interests have been threatened by the technology that has resulted in cable television. Senator Keating said, "[Copyright is] the jugular of the book publishing industry. And book publishing in this country is a two billion dollar industry."[48] Unauthorized reproduction for library and school use was a major issue.

Bella Linden, attorney for the American Textbook Publishers Institute as well as for Harcourt, saw as crucial "the copyright status of input for educational data storage and retrieval systems."[49] (And, incidentally, the cadences of Mrs. Linden's opening remarks as she testified before Congress in 1965 sounded remarkably like those of Jovanovich.) She "made the point that educational materials, whether presented in book form or through some mechanical device, are intended primarily for the school market. If publishers and others are to continue producing these materials, they must have copyright protection against educators' unauthorized uses of these materials. As an example of newly developing technological patterns in this field, Mrs. Linden reported that Harcourt, Brace & World, one of her clients, had just entered into a long-term agreement whereby Harcourt would create educational materials specifically compatible with Radio Cor-

poration of America's computer equipment." She noted that Harcourt is an independent company and that RCA has a publishing house of its own. "Harcourt will make a large investment in producing these materials and will retain copyright in them,"[50] she said.

"About two years ago," Jovanovich said, "General Electric was said to favor the notion that all scientific information should be placed in the public domain two years after its publication." (In 1967, a legislative assistant to Representative Robert Kastenmeier proposed a two-stage copyright which would give the originator of information both traditional literary copyright protection and, for a briefer period, the exclusive right to reformat that material or to license others to do so.)[51] "General Electric later combined with Time-Life to form a publishing house," Jovanovich said, "General Learning Corporation, and now it would seem to support the idea that written expression, not unlike patents, is a long-term property."[52]

If it is not profitable to produce educational materials, who will do it for non-profit? As now, primarily foundations and the federal government presumably. Which means they are paid for by the taxpayer. Where can materials be produced most cheaply and efficiently, most free of bias and adequately distributed? Perhaps the only question is what balance can be effected between the various sources in order to maintain an open marketplace of ideas. For the common good may depend less on *free* access to information than upon *access*. "Upon what meat doth this our democracy feed? It feeds upon facts brought into the minds of its citizens by the press, the radio, and the supplementary media of information."[53] All of which is paid for somehow, though not necessarily directly by those who read the books and newspapers, listen to the radio, or watch the television set. "I must strongly protest the apparently mistaken notion that communication is encouraged by making it free from copyright protection," Jovanovich wired to members of Congress.[54]

During congressional hearings, it was suggested that a specific statement might be inserted in the new copyright act stating that a copyright owner did not have the right to deny the use of his work to an educational computer operation. Publishers and others who represented authors were opposed to this even when payment might be adequate. Perhaps the appropriate role of the government lay in making access to needed materials possible for everyone, if necessary by paying for it, rather than in creating those materials.

The Senate Judiciary Subcommittee on Patents, Trademarks and Copyrights was supposed to vote out a bill in spring 1974. There was no significant sentiment within that subcommittee for a general education exemption. The Register of Copyrights also held the view that the copyright proprietor should be able to profit from any use of his work even though

that use was not for profit. The House of Representatives Committee on the Judiciary had justified its elimination of the "for profit" requirement by the argument that "many 'nonprofit' organizations are highly subsidized and capable of paying royalties," with specific mention of educational broadcasters.[55] Verner Clapp declared indignantly:

> Thus, because some educational broadcasters are well-heeled, an established principle is to be overthrown, many tens of thousands of nonprofit users, including public agencies such as public libraries, are to be taxed for the use of materials for which they have already paid, and the public interest is to be permanently damaged, all in the interest of additional profit to an already highly protected industry.[56]

It had been presumed by the House Committee when it reported out its bill that the use of a copyrighted work was not "fair" if it obviated the possibility of any sale, "no matter how minor the amount of money involved." Section 108 of Senate bill 1361 makes "fair use" principles available to libraries for "single copy" reproduction rights.[57] This provision was intended to meet objections to the kind of photocopying involved in the *Williams & Wilkins Co.* v. *The United States* case.[58] A preliminary report to the U.S. Court of Claims in *Williams & Wilkins* had brought panic by stating that photocopying constituted a real and substantial threat to copyright proprietors' interests and that they were entitled to recover reasonable and entire compensation for infringement of copyright. Clapp commented:

> The previous use of the word [copy] in copyright law (beginning in 1735) had been as the equivalent of to "print," i.e., to mass produce copies for purposes of publication; and there is nothing in the legislative history of the Act of 1909 to suggest that its meaning was there being changed or that the framers of the law had any intention whatever of extending its meaning to single-copying. In consequence, it is incorrectly presumed to apply to the making of single copies.[59]

Ninety-seven percent of library photocopying consists of single copies.[60]

However, in 1974, four major libraries (New York Public, Columbia, Yale, and Harvard) decided to save money by cutting back purchases and systematically exchanging photocopies of previously published writing. They would be able to buy only one copy among them of expensive books, for instance, or little-used journals. The scheme was denounced by Townsend Hoopes, president of the Association of American Publishers, as "wholly [ignoring] the rights of copyright owners, and indeed seems to have been taken with the deliberate intention of avoiding the payment of royalties even for avowedly systematic and unlimited photocopying." He spoke of the urgent need for basic copyright revision and of the absence

of prompt congressional action which, with every month's delay, was add-ing to a tangled and uncertain situation.[61] At a meeting in Washington shortly after the preliminary report on *Williams & Wilkins*, in 1972, mem-bers of the Ad Hoc Committee of Educational Organizations on Copyright Law Revision (which included a variety of libraries) planned to continue their present copying practices and hoped to avoid royalty payments.[62]

Libraries believed that setting up a system of permissions and pay-ments not only was impractical, although eventually it might be made pos-sible through the increasing use of computer technology, but would amount to charging libraries for the normal use of material for which they had already paid. The solution so far as artists were concerned might be subsi-dies—guaranteed annual incomes. But this left the other interests involved. The squabble was among three main groups, two of which—artists (in-cluding writers) and the commercial distributors of their works—tended to side with one another against the third. Other distributors—libraries, CATV operators, educational television, educators—claimed to more nearly represent the consuming public. The interests of the public were presumed to be antithetical to those of the commercial distributors. But was this in fact necessarily true? Even on the face of it, the position of some members of this relatively non-commercial third grouping was ambiguous. And Jovanovich pointed out that "some university instructors who complain that copyright regulations impede their teaching have also been known to protest the Office of Education policy that places all government-funded research into the public domain, simply because they want their own au-thorship to be recompensed on the principle of its continuing usefulness."[63] Utility of a product was always more a function of its form than of its con-tent. Art is not useful because when its form is changed, it loses content, so inextricably are they entwined.

John Diebold spoke of a "library without walls," taking Malraux's "museum without walls" in another direction:

> You know, they're able to project a television image onto a flat screen—well, you'll have this sheet of lucite with a light attachment on your bedside table. You can dial page 132 of Voltaire's *Letters*, such-and-such edition, from the Cleveland Public Library, and the page will appear on the screen. No reason to keep those messy bits of paper around if you don't need them. If you want to remember a passage, you simply circle it and the machine will Xerox off a copy for you. Of course, the copyright laws will have to be completely revised. I should think that authors would be paid somewhat as composers are paid today—by the number of times their book is read. The publishers, you understand, will not be selling a *thing*, they will be selling a service, and publishing houses will serve the same function that libraries do today.[64]

Words, however, will always have to be composed into a "thing" before that service—which does not in any event look likely in the near future—can be performed.

The idea was to get equity for the educational system, the author, and the publisher—to use the narrowest categories. *The New York Times* sturdily declared:

> The copyright laws provide the mechanism through which society provides assurance that intellectual and artistic creativity of the most varied sorts is rewarded and stimulated. Those who use the fruits of such creativity for private profit without paying are taking property without compensation. Even worse, they weaken rather than strengthen the forces of imaginative and artistic endeavor that society so desperately needs.[65]

The editorial left unanswered the question of whether the taking of property without compensation for the *public* profit did not do the same thing.

By 1973, Representative Robert W. Kastenmeier alone remained on the House subcommittee among those who had gone through the hearings that resulted in the copyright legislation passed by the House in 1967. Although Congress had been told during those hearings that "of all the ways in which the federal government affects literature, music, art and scholarship in our society, none compares in its importance with copyright legislation"[66]—although Congress tended to agree on remuneration for authors and other copyright owners—as midpoint in the seventies approached, passage of a suitable law was still nowhere in sight. Cable-television issues had proved thorniest and were the cause of congressional failure to complete action. The old copyright act had been repeatedly extended.

Claes Oldenburg, Ice Bag—Scale C *(1971). 138 by 160 inches. Collection of Whitney Museum of American Art. Gift of Howard and Jean Lipman Foundation.*

CHAPTER 20

FOCUSING ON WHAT HAS JUST MOVED

(*Information as news*)

LEAVING ASIDE the question of ownership, we may ask: What *is* information? Information can be regarded as that which is endowed with form, which presupposes that someone has done the endowing. Art is information in this sense. It is knowledge communicated to persons, already shaped by other human beings and hence to some degree contaminated. *Time* magazine may be said to provide us with information but no information is verifiable to the extent that it goes beyond facts, and even the definition of what a fact is, is a problem.

Was "information" or "fact" to be stored in the proliferating data banks? Time Inc. had theirs; as did *The New York Times*, announced in 1969 as "the world's first fully automated general information system."[1] Diebold commented:

> Newspaper morgues, law libraries, libraries of medical records are growing so fast that they'll soon become impossible to use without a new system of information retrieval. For the newspapers, the solution is probably for the major newspapers to combine their morgues, feed the information into a computer and make the service available to all the other newspapers. . . . Though there are immense problems involved, the professional groups will have computer "memories" working for them in a relatively short time. They need the service to survive.[2]

The Ford Foundation had established the first data bank on the performing arts, but only on their economic support. A National Research Center on

405

"Not tonight, Miriam. Edgar's fallen behind again."

the Arts was announced in 1971. The subsidiary of a polling firm, Louis
Harris and Associates, this research center worked piecemeal and by con-
tract: the data it collected was largely attitudinal. William Jovanovich saw
a dangerous possibility that information as knowledge, simply because it
existed publicly, would come to be regarded as neutral and hence generally
trustworthy (as in Donovan's point about the perpetuation of false data).
The verification of all useful data by one's own senses has long since ceased
to be possible, and literally hundreds of studies have been made in the last
fifteen years or so by government agencies as well as by non-governmental
organizations on improving the communication of research and disseminat-
ing information.[3] The problem now, as Diebold saw it,[4] was how to pre-
serve the integrity of facts *in* machines when the interlocking on which
decisions are made was beyond the grasp of any individual. But John
Gardner believed that the leader does not depend on facts alone for his
decisions.[5]

Gay Talese commented that "truth" in the journalistic sense is limited

but verifiable. Information regarded as fact is apparently more trustworthy: the *what, when,* and *where* of the newspaper world, traditionally presented immediately to the reader with the *how* coming later. But even here we are dealing with preselected information in a variety of categories which is unpredictable. We read the daily paper more to get a sense of the on-goingness of events: although the data may not be entirely accurate, in the best of newspapers it is accurate enough to enable us to perceive trends and gain realistic impressions. Walter Lippmann, taking a page from John Stuart Mills's essay *On Liberty*, noted that the theory of a free press was that the truth would emerge from free reporting and free discussion, not that it would be presented perfectly and instantly in any one account.

But it was *Times* policy that a person mentioned derogatorily or crit-ically in a story be immediately given a chance to respond.[6] Television's "Fairness Doctrine" was designed to protect the right to respond of those who believed themselves injured by a broadcast. It had, however, fallen into disrepute. But Eric Sevareid thought the central point about a free press was not that it be accurate, though it must try to be, not even that it be fair, though it must also try to be that—but that it be free from the power of government to coerce or intimidate or police it in any way.[7]

The Nixon administration had created a climate damaging to the news media (print and broadcast journalism having a community of interest).[8] The pressure created went beyond usual criticism to become intimidation. Subpoenas from a variety of sources were issued against newspapermen around the country: they were being dragged into the law-enforcement process regarding confidential sources. There were numerous episodes of conflict between government and the press—Agnew's speeches, controversy over publication of the Pentagon Papers, controversy over various aspects of the reporting on Watergate. What was new was an administration that saw itself as the "arbiter of truth."

The regulated industry of broadcasting was especially susceptible to pressure, but there is evidence that Frank Stanton and Richard Salant (president of CBS News) attempted to insulate their newsmen.[9] The Water-gate and grain-scandal stories on CBS were offered by Walter Cronkite as evidence that the network had not been intimidated by the Administra-tion.[10] (Cronkite noted that CBS went on the air with a lot of material handed them by a press agency but that they did have a special staff for investigative reporting.)[11] The corporation had a good record of indepen-dence in the area of the news, because of Frank Stanton. (The question of bias, however, was another matter.)[12] Would this change on his retire-ment? Worried observers saw Paley halt the practice of "instant analysis" following presidential speeches on television, but on reconsideration it was resumed.

An Address by Frank Stanton, President, Columbia Broadcasting System, Inc., before the International Radio and Television Society, Inc., New York, November 25, 1969:

Television news is broadcast in this country by four networks, all with different and fiercely competitive managements, producers, editors and reporters, involving hundreds of strongly individualistic people; by a dozen station groups, initiating and producing their own news broadcasts wholly independent and distinct from those of any network they may otherwise be associatied with. Moreover, it is estimated that, on the average day, 65 percent more hours of viewing are devoted to station-originated news broadcasts than to network news broadcasts. In addition, there are 6,717 radio stations in this country—the overwhelming majority without network affiliations. All this hardly represents monopolistic control.

The Vice-President [Agnew] seems to maintain that the First Amendment applies differently to NBC from what it does to *The New York Times,* because NBC's audience is bigger and because television has more impact. That the First Amendment is quantitative in its application is a chilling innovation from a responsible officer of the government. . . . As for the impact of the television medium, it may be true that combined picture and voice give television a special force. On the other hand, print can be reread, it can be lingered over, it can be spread around, it can be consulted over and over again. Should, on the grounds of these advantages over television, the print media have less freedom?

The Vice-President asked how many "marches and demonstrations" there would be if there were no television cameras. An elementary textbook in American history might prove instructive. There was no television to record the demonstrations against slavery; demonstrations against the Mexican War; demonstrations against the Civil War draft; demonstrations for women's suffrage; demonstrations for Prohibition; demonstrations for the League of Nations; demonstrations against child labor; demonstrations for economic justice. That there would be no disturbing news except for television is a canard as dangerous as it is egregious. . . .

From George Washington on, every administration has had disputes with the press, but the First Amendment assured the press that such disputes were between equals, with the press beyond the reach of the government. . . .

Criticism is an essential ingredient in that mix. It is central, not tangential, to a free society. It is always a free society's

strength and often its salvation. Television itself is not and should not be immune to such criticism. As a matter of fact, it is the most criticized medium in the history of communications. . . . The first fatal symptom of political decay was an effort to control the news media.

A journalist's main job was to identify change, Hedley Donovan said. He spoke calmly of how this could be done:

1. by separating talk from the actual (the pressure to be first misleads, he said);
2. by recognizing that talk may have consequences;
3. by penetrating bland vocabulary from businessmen and politicians presenting changes as merely the continuation of long-established policies;
4. by deciding whether the changing elements or the static ones were dominant in a given situation;
5. by judging when a change in degree became a change in kind;
6. by noting that sometimes the signal of great change is when something fails to happen—a non-event.

Donovan read constantly, mostly magazines, watching for signs of change also in competitive publications:

So I read *Newsweek* versus *Time*. I read *Business Week* and *Forbes* versus *Fortune*. Without intending anything invidious about any of those magazines, I don't think that I would read any of them, probably, if I weren't in the job that I'm in. It wouldn't be necessary for me to. I wouldn't read as many magazines in general as I do, I think. I would read somewhat more books. And if I were in an entirely different kind of work—I don't know just what that would be—but I probably wouldn't have as much time to read magazines. I mean, I can perfectly within—sit here all morning and read magazines if I want to, and occasionally I do, but if I were a vice-president of the Chase Bank, I suppose it would look kind of funny if I were reading magazines all morning. . . . You know, it's terribly hard to separate really what's work and what isn't.

Newspapers and magazines compete with each other and with television for the amount of time the person who intends to read or to view has available. They tend to be different in kind as purveyors of information. Indeed, the president of NBC News considered the "highest power" of TV journalism not to be the transmission of information but the transmission of experience.

In Chapter 12 it was said that journalists work in "rabbit" time as compared with the "elephant" time of art. Wilfrid Sheed has commented that Luce's memory span "was just great for a weekly news magazine."[13]

Donovan's tempo seemed hoppy compared with his apparently even dis-position. He noted other magazines (*Commentary, Atlantic, Harper's, New Republic, The New York Review of Books, The Reporter, The Economist, New Statesman, The Nation, National Review, Foreign Affairs*) and books: "Well, I like to have three or four books going at the same time. And then this vacation that I just had—I took home about ten, or, had about ten books that I wanted to read. Naturally, I didn't get anywhere near to that many, partly because I was doing so much work around the yard, but I—besides *Our Crowd*, then I read this new life of Sir Richard Burton, which is very good, and Nicholas and, as I say, a bit of *The Arrangement*. So I guess that's all that I read, but I had all of them going simultaneously. But then in between I'd be doing some magazine reading of course. I think that if you do a great deal of magazine reading, it gets you into a slightly jumpy pattern where you don't like to stick uninterruptedly with some-thing for eight or ten hours. So, if I read two hours' worth of *Our Crowd*, then maybe I'd want to put it aside for a couple of days and do something else and then come back to it and so on." Donovan said:

> After being in journalism awhile, I think I could not have gone back to the kind of scholarly concentration on one subject for a year or two because, in journalism, the whole tempo that you get accustomed to of turning from one thing to something else pretty rapidly, I think is part of the fascination of journalism. And, in my present job, one of the things that is most fun about it is that I'm legitimately entitled to be interested in practically anything because anything may fit somewhere into one of our magazines. And, if I want to spend a lunch hour with somebody talking about the problems of the New York Philharmonic, that's just as pertinent perhaps as talking about the foreign policy of Israel or whatever. And you do get—I think you get rather spoiled by that kind of intellectual life, and I've been in it for a good many years now, so I would say now I would find it temperamentally impossible to settle down and do the necessary research and concentrate enough to write a book on one subject.

At one point in his life, Donovan thought he might become a historian. He majored in history at the University of Minnesota but while there also had jobs on the student paper and was writing editorials in the *Minnesota Daily*, being paid twenty-five dollars a month in his senior year. He was interested, particularly, in public issues and public affairs. In Oxford as a Rhodes Scholar, he continued to study history but also acted as a United Press stringer. Applying from Oxford, he was offered a six-hundred-dollar teaching assistantship at Harvard but turned it down. Although he believed to the day of our interviews that entering the academic world had been a serious possiblity for him, he must have lacked a real interest, because he

reported himself as thinking, "Well, this doesn't seem too terribly inviting and it would be terribly difficult financially to manage." Perhaps in a few years . . .

He decided to look for a newspaper job, "that being sort of my second-choice profession of some years standing anyway."

> . . . it turned out to be a very bad time to apply for newspaper jobs. Of course, the Depression in general was still on. This was 1937. But also, the New York *Journal* and *American* had just been folded into each other in New York, and that had thrown several hundred experienced newspaper people out of work in New York, so they weren't eager for twenty-three-year-old new reporters. I think the best offer I developed in New York was to be a copy boy on the New York *Daily News*, which was somewhat tempting, actually.

Donovan went to see the editor of the Washington *Post*, another Rhodes Scholar, who passed him along to the then managing editor of the *Post*, "who had been the managing editor of one of the Minneapolis newspapers. And it also turned out, though I had forgotten this, but he lived on the paper route that I was speaking to you of last time and remembered me as being his paper boy, so this commended itself to him sentimentally." Donovan continued:

> And so I started that fall on the *Post* as a cub reporter. Then, almost immediately, I liked it enormously and my interest in going back into university work had pretty well evaporated in a few months because I was liking the reporting so much and felt I'd like to stay in journalism. . . . And part of the attraction of the Washington *Post* as a place to start in as a reporter was that, although you started in on the normal kind of city-desk assignments for a cub reporter of police reporting and fires and accidents and local feature stories and civic banquets and that kind of thing. But still you were in the city where all of these other things were going on, and it wasn't hard to merge over into the other kind of reporting . . . some of the local assignments did get you into national and international politics to some extent.

John Oakes of *The New York Times*, Ochs's nephew and another Rhodes Scholar, roomed with Donovan for a while in Washington, in a bachelor household of six. During that time, Turner Catledge and Donovan became acquainted. Catledge had been a first-class political reporter, Donovan said. Later on, their organizations placed them back to back, with views that were almost directly opposite: at the *Times*, the board stood behind Catledge, he facing and being responsible to an amorphous crowd called "the people"; Donovan was responsible to his organization. *Time* magazine told stories; *The New York Times* reported. But more and more this was changing—not at Time Inc., but at the *Times*.

Hedley Donovan not unnaturally took his organization's way of doing things as the correct model. "Occasionally, especially on the better papers," he said, "like *The New York Times*, Los Angeles *Times*, Washington *Post*—occasionally on the inside pages you'll see a story that is told with some dramatic flow rather than by the convention of blabbing everything to begin with." How did he feel about that? He was torn, he said,

> because if newspapers got a whole lot better at that, they'd be tougher competition for us. In a sense, *Time* thrives by doing things that newspapers don't do. However, also, it's no question that good newspapers in the long run, by making people both more informed and more curious, I think also improve the audience for magazines essentially. That is, I think information breeds information and the appetite for more. So that our relationship, or degree of competition with newspapers, is a fairly subtle thing. I, as a reader of newspapers, often wish that they would do things a different way. Well, I don't mean that I'd spend less [time] but enjoy it more.

To change the form or flow of which Donovan speaks above is to change the status of information. Polls show the public tends to believe television more reliable than newsprint when there is a conflict. Although newsprint is more thorough, television is the top source of news in America.

Magazines can elaborate, but that elaboration is not always news. Time Inc.'s truth may to a certain extent be verifiable in the journalistic sense of being based on ascertainable facts but its editors tend to rely on confirmation from each other and, as Donovan said, to seek dramatic flow. Stories to be dramatic must have endings, and an ending is a conclusion in a double sense. *Time* is, in fact, old-fashioned: "Narrative deals with a sequence of events, that is, with a becoming, with a process rather than a pattern," pointed out Malcolm Cowley, but Cowley believed that the spatial form could not be recommended as a model superior to the temporal form simply because it happened to be newer—working in both dimensions was the ideal.[14] An ideal toward which *The New York Times* happened to be moving although no doubt not thinking of it in those terms. Whether it is a correct *journalistic* ideal (rather than one for the artist) is another question.

Time does not try to be neutral, and the way in which it presents material (similar to that of a work of fiction, some have argued) makes us believe we know what has happened when in fact what we may know goes beyond that and has become what its editors want us to think about what happened. Donovan, reviewing an issue of *Time* after publication, spotted what he considered a gratuitous comment to the effect that a monologue by President Nixon had been "self-serving."[15] All politicians

are self-serving, Donovan said: that's taken for granted. He intended to point this out to managing editor Henry Grunwald. Unlike television, serious and mass-audience magazines are not responding to their readers so much as their editors are listening to their own reactions. This is not to say that either way of doing things is *per se* bad, but overly shaped information tends to be more propaganda than fact (as art ceases to be art when it is too much shaped by events external to the artist). And journalists are supposed to be objective.

Just what this objectivity consists of is arguable. Henri Peyre of Yale University noted:

> In a snapshot, the eye fixes the world in an instant of flux. Snapshot photography is a technique that attempts to retain the totality and diversity of the world in space while neglecting the diversity and the movement of the world in time, in consciousness, and in history. And so the title [*Snapshots*] summarizes reasonably well the program or intention of the New Novel according to Robbe-Grillet. The writing aims for the greatest possible clarity; it is pure objective observation, a simple list of particulars.[16]

Jovanovich assured us that we tend "to assume that the information in the press is authoritative *because* it does not, all together, present an argument—because it has no rhetorical purpose," but the fact is, he said, "fragmentation and lack of continuity in the news does not assure its accuracy and disinterestedness."[17] This could be clearly seen in the reporting from Little Rock in 1957.[18]

At CBS in the thirties, Paley thought newscasters should not editorialize: CBS wanted "analysts," not "commentators." Staff announcer H. V. Kaltenborn found the distinction unreal, Barnouw comments in his history of broadcasting.[19] "As for influencing opinion—even the selection of one news item over another tended to influence opinion. Terminology and tone of voice influenced opinion. The newsman could scarcely help influencing opinion. To pretend otherwise was a charade. But the pressure on Kaltenborn continued." Barnouw quotes the following story by Kaltenborn:

> Vice President Edward Klauber would call me up to his office for a friendly heart-to-heart talk . . . "Just don't be so personal," he'd say to me. "Use such phrases as 'it is said,' 'there are those who believe,' 'the opinion is held in well-informed quarters,' 'some experts have come to the conclusion . . .' Why keep on saying 'I think' and 'I believe' when you can put over the same idea much more persuasively by quoting someone else?"

Barnouw said, "To Kaltenborn, such arguments point up that the *analyst* idea was pretense." This argument in one form and another has contin-

ued, with Eric Sevareid providing "interpretative analysis" at CBS through the early seventies and Howard K. Smith at ABC providing "commentary."[20]

Journalist Alfred Friendly believed that attribution was the best way of handling news and information about "an event or conditions or situations" of which reporters did not have direct, eyewitness knowledge themselves. Presenting news by secondhand ways gets newspaper people into a great many misunderstandings, he said.[21] Yet Tom Wicker's classic report from Dallas the day President Kennedy was shot contained very little that was eyewitnessed.[22] But secondhand ways, said Friendly, were "in many cases a means by which officials seek to evade responsibility for knowledge and information for which they should be willing to assume responsibility. In many cases, citizens have a right to know, not only the information, but the source of it."[23] As Jovanovich said, we need to know who is speaking. But even when we do, we must remember that both the speaker's memory and our memory are very unreliable references for any matter of fact[24] and that bias can be present even in a statement of fact. Professor R. G. L. Waite commented of the situation at the University of Texas that "the ancient truism about different people seeing past events very differently was confirmed."[25]

Nieman Fellow[26] James Pope noted that objectivity simply meant that "the reporter tries to keep himself out of his report. He gives the reader full information, avoiding words that throw a favorable or unfavorable light on the event."[27] Journalist Robert Lasseter found this somewhat more complicated than Pope did. He wrote, "A newspaper can crystallize, consolidate existing public opinion, can bring dormant opinion into life, but it cannot autocratically *make* or *mold* public opinion as desired, except as it interrupts the stream of news, distorts the image, by concealment, falsification, calculated selection or misinterpretation."[28] We have seen, in Chapter 1, Stanton and Paley agreeing with the first part of this statement so far as the influence of television is concerned: Paley did not speak to me of interruption, distortion, concealment, falsification, calculation, but Stanton certainly knew they existed and just as certainly wanted to do away with them *just as much as it could be done within the context of the organization and within the context of the industry.* A. J. Liebling, in a footnote in his book *The Press,*[29] noted:

Albert Camus, the brilliant and versatile young French novelist, playwright, and critic, who was also editor of *Combat,* a Paris daily, once had an idea for establishing a "control newspaper" that would come out one hour after the others with estimates of the percentage of truth in each of their stories, and with interpretations of how the stories were slanted. The way he explained it, it sounded possible. He said, "We'd

have complete dossiers on the interests, policies, and idiosyncrasies of the owners. Then we'd have a dossier on every journalist in the world. The interests, prejudices, and quirks of the owner would equal Z. The prejudices, quirks, and private interests of the journalist, Y. Z times Y would give you X, the probable amount of truth in the story." He was going to make up dossiers on reporters by getting journalists he trusted to appraise men they had worked with. "I would have a card-index system," he said. "Very simple. We would keep the dossiers up to date as best we could, of course. But do people really want to know how much truth there is in what they read?"

Clifton Daniel was sure editors and reporters know when a piece is biased.[30] Perhaps the point is that there is *enough* truth in what is communicated as things presently stand and that this will continue to be true so long as American life is a "cacophony of colliding interests," as Daniel put it.[31] It has long been thought that a choice of competing newspapers was necessary for a truly responsive press—responsive to the people, that is. But a variety of forms compete to bring us information nowadays. It may be heartening that, in spite of the trend toward one-newspaper towns, by the end of the sixties successful newspapers were springing up in the suburbs of our cities: heartening but perhaps not very significant. (*The New York Times* diversified by acquiring ten automated papers in Florida, among other properties.)[32]

Robert Lasseter further wrote:

In an important sense, America does not want a free press: it does not want a press free *from* the people, which is the sort of press that Germany had. America wants a press bound to the people, bound so tightly that the people cannot stir, however slightly, without that movement becoming visible in the newspapers.[33]

Much effort on the part of young radicals went into gaining publicity during the sixties, and they felt they knew slanting of the news occurred through lack of sufficient attention on the part of editors and journalists to the radical cause. But these dissenters also had to deal "with claims that in fact the mass media has given enormous exposure—many would say over-exposure—to revolutionary protest and disarray, that the press remains open to a variety of views and above all to news that reinforces conflicting opinions, that today in fact a man can utter the most flammatory words without realistic fear of governmental reprisal."[34] Even Richard Nixon during his stay in the White House could not change that, although he tried to intimidate people by implying reprisals and although his Supreme Court appointments may, with consequences for some years to come, be somewhat insensitive to civil liberties.

Of course omission *has* to occur. Someone must decide what is worth

reporting (or ignoring)—"what to throw away, what to cut down, what to let run at some length. . . . The executive function of arraying the news in a scale of importance lodges in a small group of newspapermen— sometimes, for all practical purposes, in a single person," wrote William M. Pinkerton in his article "The Newspaperman,"[35] this single person most often being the managing editor (which was not changed when the transition took place in the city room as specialization moved up from reporter to editor). The processes of newspaper work are each generally associated with a group of positions, Pinkerton noted: "coverage (reporters, rewrite, special correspondents, feature writers, press services); play (copy readers, desk editors, news editors); interpretation (editorial writers, political correspondents, columnists)." *Interpretation*, Pinkerton said, was explaining the news; filling in the background; forecasting the future; and passing moral judgment. He thought this last most understood by the public and most accepted. The play of the news, he commented,

> seems to be a compound of the newspaper's own tradition, the composition of the particular public to which the newspaper is addressed, certain general principles of human psychology, "hunches" and a kind of directed intuition developed within the craft.[36]

Tradition at *The New York Times* had come as much from the man who bought the paper in 1896, Adolph Ochs, as from its founder, Henry Jarvis Raymond.

Raymond, born in western New York on a farm, had been backed by two bankers he'd met while a New York state assemblyman and brought out the first issue of his newspaper in September 1851. He had promised "all the news" (for one cent) free from the morbid and the scandalous. In spite of some hard competition from James Gordon Bennett's "sensation-mongering" *Herald* and Horace Greeley's advocate of social reform, the *Tribune*, the new paper was on its financial feet by the end of its first year. Commented Meyer Berger, its centennial historian:

> *The New York Times* was on its way. Except for a few faltering steps, it was to march steadily from one building to another, expanding to meet advertising demand for more and more space. Within the century it was to grow from the windowless little brownstone in Nassau Street to the largest and best-equipped newspaper plant in the world; to the point where the $70,000 that went into the first year's operation would barely pay for twelve hours' expenses in 1951.[37]

Leonard Walter Jerome, grandfather of Winston Churchill, bought stock in 1858 and by the Civil War held some fifteen or twenty of the original hundred shares, each of $1,000 par value. Raymond, who served as a United States congressman during Abraham Lincoln's second term,

died in 1868, whereupon George Jones, one of the bankers from Albany, took over the editorial as well as the financial end. By that time the stock had gone up to $11,000 a share. Jones, says Berger, was the first great businessman publisher.[38] He was a crusading one as well and editorials on Boss Tweed and his Ring began to appear in 1870. In 1871 Mrs. Raymond's thirty-four shares of capital stock were hastily bought by Colonel E. D. Morgan, one of the *Times*'s original investors, to prevent them from falling into the hands of the Tweed Ring. When Jones died in 1891, his heirs were bought out by a group of *Times* men headed by Edward Cary and the editor-in-chief, Miller. But by the middle of the nineties, when Ochs came on the scene, "the *Times* seemed past all saving."[39]

Adolph Simon Ochs at the age of fourteen had gone to work for the Knoxville *Chronicle*. Taken on in 1872, he stayed for three years, successively chore boy, carrier, and printer's devil. He worked in Louisville briefly on the *Courier-Journal* but after that returned to Knoxville, where he found a job on the *Tribune*. Already, Greeley was his idol, and he wanted to be a publisher: he had little talent for writing. Before he came of age, he bought the Chattanooga *Times* on less than a shoestring and by 1892 had made it into "one of the richest newspaper properties in the South."[40] He established a policy of independence—political, social, religious—with, like Raymond, a "fetish for 'all the news.'"[41] It is not known what, if any, model he used.

On Ochs's thirty-eighth birthday, a Wall Street reporter for *The New York Times* told him of that paper's situation, and Ochs pursued its possibilities diligently. After much effort in New York, a new company was formed in 1896 with capital of 10,000 shares of par value $100, 5,001 of which were acquired by Ochs within the next four years. In order to provide operating capital, 5-percent bonds were sold to holders of the *Times*'s outstanding obligations. Taking over as publisher (Ochs had left his brothers to run the Chattanooga *Times*), he again announced a policy of nonpartisanship. He did not change basic *Times* policy; that is, he aimed to reflect, not to make, public opinion. Ochs immediately founded the Sunday Supplement (the first Sunday run had been in 1861) and the Saturday Book Review and adopted the slogan "All the News That's Fit to Print." In 1901, Ochs acquired another newspaper, the Philadelphia *Public Ledger,* which was run for him by his brother George until it was sold in 1913. In 1904, the Times Tower on Forty-second Street was opened, and Longacre Square became, officially, "Times Square." Ochs loved his Tower but his enterprise rapidly outgrew it, and the building was vacated by 1913 for yet another new one on Forty-third Street.

Ochs's only child, his daughter Iphigene, had made the acquaintance of a young man named Arthur Hays Sulzberger while she was at Bar-

nard and he at Columbia University. But it was not until, during World War I at a Plattsburg officers' training camp, Sulzberger met Iphigene's cousin, Julius Ochs Adler, that Sulzberger got to know Miss Ochs better. They were married in 1917, and shortly thereafter Sulzberger came to the *Times*, new to newspaper work. Adler too joined the *Times*, a hero by the end of the war.

The Wide World photographic service was founded in 1919, and, by 1921, circulation had gone from the 9,000 paying when Ochs took over to 323,000 daily. Edwin James, who would be managing editor with Turner Catledge as his assistant, was chief of the Paris bureau. Carr V. Van Anda retired as managing editor in 1925, and before James was to come in, Frederick T. Birchall occupied the job, though without that exact title, which, Ochs thought, was not suitable for a "foreigner."[42] Also in 1925, Ochs equated what was expected of a reporter with what was expected of a gentleman:

A reporter is assigned to a task; he arrives too late, or not at all, accepts from another reporter what occurred and writes it as his own observations. Deserving the same censure is another who does not take the trouble to confirm his facts; one who gets his own views tangled with the views of the person interviewed; one who fails to give the person affected by his story the benefit of the doubt; still another who needlessly gives pain and disregards, or is perhaps oblivious to, the sensitiveness that persons have about their personal affairs; one who, to appear smart and witty, misrepresents or exaggerates; one who is indifferent to the responsibility of his newspaper, who is careless with its reputation for truth and accuracy; one who plagiarizes, one who is cynical, offensive, discourteous, vulgar or impertinent; one who regards himself as an editor when he should be a reporter. No one can conscientiously represent a decent newspaper and be guilty of any of these offenses against the ethics of the profession, and what is expected of a gentleman.[43]

The *Times* hired what Berger describes as perhaps the first science editorial writer anywhere to be on any newspaper board, in 1927, and that same year, Adolph Ochs saw a crude TV scanner at the Bell laboratories. The year 1928 saw the purchase of a Canadian paper mill and the beginnings of the Forty-third Street Annex as well as a Brooklyn plant. Both were completed in 1930. That same year, William L. Laurence was hired and became the first newspaper reporter ever assigned exclusively to daily science coverage. The excellent reputation he was to achieve brought him the atomic-bomb story during World War II. Notably, in 1933 Arthur Krock started his signed Washington columns.

In the meantime, back in August 1929, a young newspaperman

named Turner Catledge had come to work on the *Times* in New York. He regarded it as an opportunity although the paper struck him as dull and stodgy,[44] and when the stock market crashed that year, he felt little affected by the nation's financial disaster, as he was "getting good assignments and rapidly securing [his] place on the *Times*."[45]

How had he gotten there? While on the *Commercial Appeal*, in Memphis, he had covered "the big, disastrous flood of 1927 . . . which was perhaps the greatest flood since Biblical times" (or, at least, so it seemed to Catledge).

> . . . in covering that story, I got acquainted with Herbert Hoover, Secretary of Commerce. He was sent down by President Coolidge to sort of oversee the federal efforts in trying to relieve first the dramatic phases of the flood, the refugee problem of which Hoover'd had some experience, of course, then followed by the economic rehabilitation and reconstruction and things of that sort. But anyway, the day he came to Memphis, he wanted to find somebody who could give him a very quick glance at the flood, and the major mentioned that there was a reporter on the *Commercial Appeal* who'd seen more of it than anybody else, because he'd been everywhere in it, in a boat, small airplane, horseback, and every other way he could get around, and I had met the flood at Cairo, Ilinois—you call it Ki-ro, but they call it Kay-ro down there, it's spelled the same—and the flood lasted for several months and just had dramatic phases all along the watershed.
>
> And Hoover sent for me early one Monday morning, he'd arrived in town by special train from Washington, and he took a liking to me as Mr. Mooney had, almost in the same way, and as a result of that—association with him, he wrote a letter to Mr. Ochs, who was then the publisher of *The New York Times*.

Leland Speers on the *Times* many years later told Catledge what had happened to that letter. Speers recalled a luncheon he and Mr. Ochs happened to have with Hoover at his desk in 1929. Reputedly, Hoover told Ochs, "Well, you missed that fellow I wrote you about, he's now with the Baltimore *Sun*. I understand he's doing a very fine job over there."

"I used to go to Washington for weekends," Catledge said,

> because Hoover had become President in the meantime, and the people who were around him—his secretaries, his press attaché, who was a man named Ackerson, father of the present publisher of the Boston *Herald*—I knew them very well and I was buddy-buddy with them, used to go down and spend weekends—that suited me fine. . . .
>
> Well, Mr. Ochs took the name . . . called Mr. Birchall and said, "What happened to this?" Well, what had happened was that Mr. Birchall did like all of us do—a recommendation is sent down from

the publisher or someplace else, and unless there's some urgency about it, he thinks he just sends it along as a matter of course, so [Birchall] just threw it in his file. It was in his file: he dug it up.

(. . . Mr. Hoover was then Secretary of Commerce and not as big a man as he later became. Many times we get letters in here from senators and other people: "I know so-and-so, he's a good friend of mine, and so on; I think he would make you a good man and would be interested in journalism"—and that sort of thing, and if you're not in any immediate need or it doesn't attract you in some specific manner, you just push it aside. Mr. James [managing editor after Birchall] used to keep all those things, but . . . he used to put them on top of his pile, and later they'd wind up on the bottom—what he called his filing system—he'd put everything on the top and as soon as it wound up on the bottom it was no good—but anyway, that was—now you asked the decisive things in my life. . . .)

Lucky it was in the file. And Birchall sent for me.

What Birchall saw was an attractive, fast-talking young Southerner.

Catledge tells of having been born on his grandfather's farm

about six miles south of Ackerman, Mississippi—actually, in a little settlement known as New Prospect—on the seventeenth of March 1901. My parents were in the process of moving to Philadelphia, Mississippi, and a short time thereafter, we did.

This little town of about twenty-five hundred people was largely populated by my mother's relatives. I don't know when my people came to the United States. They were so-called Scotch-Irish—they'd gone from England to Scotland and into Northern Ireland, and then come into Mississippi through the Carolinas. My mother's people were small slaveowners and my father's people were not. I'm sure they were later immigrants, and I think perhaps they were English—I think the name Catledge actually was Cartledge, and somebody couldn't spell it and dropped the "r." It's a name I've never known except in my own family.

My mother was a very dominating woman. Whenever any of them got into trouble of any kind—when their wives died, which a lot of them do, or their babies were born—they'd always come to Willie for help. A lot of women in the South are named Willie. I'm sure she was named for her step-grandfather. His name was William Lamey. Anyway, her name was Willie Anna Turner.

She was the oldest of fourteen children, all of whom survived into adulthood and had families of their own. They gravitated towards Philadelphia in the early part of the century. My mother's people had begun at that time to get into the hardware business, and my grandfather was made head of the store by his sons. Eventually the family had a drugstore and a grocery store, and a building-supply store.

You hardly knew how to separate your brothers and sisters from your cousins by the dozens. From the time I can first remember, when I was five years old, I was in that group. Every summer, on weekends or Saturdays I knew I was gonna work for one of my uncles, because he would come and tap me and say, "Why don't you work for me this year?" They didn't want me on the street running around. They were very kind people but very strict in their requirements.

"You mean, like going to church . . . ?"

That's right.

"And get good grades . . . ?"

Right! Right!

"And work in the store—"

Yes!

"And—"

Bring credit to my mother and to her people.

Catledge said they paid him regular wages for his work in the store, and I asked him what he did with the money.

Oh, I suppose I—I don't remember what I did with it. It wasn't a great deal of money, more of an occupation than anything else. They were people that knew how to handle children. . . . It wasn't until I was grown, practically, that I broke out of the family shell, broke out of this family group, and I think that I was about the first person of any importance, that is, of any note, to do it. Then's when I was getting interested, sort of on the sly, you might say, in printing, and I started to hang around the town printing shop, which also produced the newspaper, the Neshoba *Democrat.* . . .

I was about fourteen. . . . Then I would work at odd hours for nothing, just to go around, just to be around machinery too, the machinery in the printing office, which was very intriguing, and I got to know it pretty well.

And along about 1921, when I was in college—I went to Mississippi State College, which is Mississippi State University now—and in the summers I either worked for my uncles or I would try to get in a few licks at the printing office, even if I would have odd hours, or to play hooky a bit from my other chores to go to the printing office. I was interested in anything that was going on where there were human clashes, like in the courthouse, or political speaking and things like that —I got very interested in what were then, I suppose—they're public affairs in a small community. And then I also got to writing for the paper very silly little things, little local things.

I was fourteen when I first started writing for the paper, and I can't remember what I wrote. I guess it was school news or something like that. And the editor, having nothing else to print, would print that stuff. And you'd see your material in print and it was very exciting. I volunteered this—practically no other children seemed to have much interest in it.

The editor of the paper, first a man by the name of Mr. Ray, was a kind man, a very nice person, and everybody in the community like that knew everybody else, and they would give you words of encouragement—and along in the early 1920's—it was about 1919 or 1920, a young, very aggressive, smart, personable young man came to town as a lawyer, working in land titles and things to do with real estate transactions, because they were promoting a drainage district. I don't know whether you know what that is or not—that is, draining a lot of land and reclaiming land out of the swamp—and he came in there to handle some legal phases of that—and in a land transaction he and two or three other people made, all of a sudden—it was noised around about the courthouse square that they had made quite a deal and had some money—and Mr. Ray, who was the editor and owner of the paper, felt himself under some pressure to sell out and leave that town because his wife was in bad health. . . .

So he went around to this man, this man's name was Clayton Rand, went around to him and made a proposition to him to sell him the paper, and that was exactly what—I don't know that Rand had ever thought about it before, but just the idea of editing a paper and getting what he wanted to say into it, because he was very aggressive, very expressive, getting what he wanted to say in print—and so he bought the paper.

. . . One year when I was working on the paper, 1920, I believe it was—'20 or '21—Rand and I cooked up a scheme where I would go out in the country and live for three or four days, and I would sell subscriptions, take notes where I visited, come back in the middle of the week, say around Thursday—I think the paper came out on Friday—no, the paper came out on Wednesday. Come back here the early part of the week and write—a lot of times just set it in the typecase and set up items—the people I'd visited, where I'd eaten, this, that, and the other. God knows what. What nice watermelons Mr. Lynn Cumberland has, and what chickens Mrs. Ross Brantley had. First thing you know I had more invitations to go places than I could shake a stick at.

I'd show up at revival meetings—that time of the year they were always holding revival meetings in churches. Usually they'd have what people called "dinner on the ground"—basket dinners—I'd show up there. And oh Lord, before the summer was over I was about to be elected. I would come back and in the back of this Ford car, this

Model-T Ford car, I'd have more junk than you could unload. I'd have chickens, buckets of cane syrup, I'd have watermelons that were given me, or swapped me for subscriptions—barter.

. . . It was after he bought the paper that I got very much interested in Rand. I knew him around town as quite a character—everybody was pointing him out and he was—he was sort of irreverent when he came to the mores of the town, the traditions of the town, so he was cutting quite a swath, and he knew it, he's that way. . . .

I thought he was just—he sort of had—he was doing, I think really he was sort of expressing my repressed desires. You see, I was living under this pressure of a very big, highly respectable, highly disciplined family. And he was—I envied him, I'm sure I did subconsciously, I envied his being out of restraints of that kind. He was expressing himself in the way I'd have liked to express myself, and he just was somebody who intrigued me a great deal, doing some of the things—he had some of the independence that I wanted but lacked.

It was nothing ever expressed: it was just something you felt. Just a conformity to—you had to contribute—I don't know any other way of expressing it—to the family respectability, to its standing in the community, to its—and it's still that way. I've got quite a few relatives down there now. All hang together. It's just one of those things where you— I was institutionalized!

Turner Catledge as a young man

CHAPTER 21

GRADATIONS OF NON-DISSENT

(Signs are taken for wonders)

TURNER CATLEDGE'S CAREER was no less institutionalized. Later in 1929, the same year he began work at the *Times*, he was sent to its Washington bureau, where he remained for some fifteen years, heir apparent to Arthur Krock. But Krock, who had become bureau manager in 1932, was considered irreplaceable in Washington. He improved daily performance without being everyone's favorite:

> . . . every agency in the government had a *Times*man watching it. . . . Reporters would become more knowledgeable and would presumably write with more depth, would be less likely to make mistakes, or to misinterpret, or to be duped by government spokesmen. But . . . reporters could become too familiar with their subject, eventually assuming, unconsciously, a familiarity on the reader's part that did not exist; and reporters might also become victims of what Walter Lippmann considered the bane of the newspaper business, "cronyism." [1]

Catledge's first assignment was to the House of Representatives, where "some of the most glaring excesses of House mismanagement have been reported with singular lack of enthusiasm by House Regulars," noted James McCartney.[2]

"In the simplest sense, on virtually any beat in Washington, or possibly elsewhere," wrote McCartney, "there are likely to be two kinds of reporters—the 'ins' and the 'outs.'"[3] He went on to say that a good reporter could probably do it either way, depending upon the circumstance. "In my experience," Catledge wrote in his autobiography,

politicians rarely forget that they are dealing with a reporter, and a reporter is a fool if he ever forgets that he is dealing with a politician. He is a fool, too, if he ever thinks that his company or his advice is being sought because of his own charm or brilliance, rather than because of his position with a newspaper. But reporters and politicians can get along quite well, so long as both remember the realities of their relationship—that each has something the other wants. The politician wants publicity, and the reporter wants news.[4]

"A reporter may hesitate to take a critical view of regularly tapped sources for the very human reason that he prefers to be greeted pleasantly when he walks into an office, rather than to be treated as though he were poison. . . . No reporter can operate successfully without friends," McCartney added.[5] Catledge, Lowry, Donovan, had friends aplenty, Catledge's most important being—in order of time—Clayton Rand, Herbert Hoover, Arthur Krock, and young Punch Sulzberger. He himself noted that Gay Talese, in *The Kingdom and the Power*, credited him with an exceptional ability to attract the attention of older, particularly self-made men.

Journalists who remain long in any one area (say, the political) and in any one place (say, Washington) tend to identify themselves with the interests of the powerful people there. But Catledge's attachment grew to the institution, and not even especially to its Washington office, which he called "very bureaucratic." He was later to note that "most of its people resented queries and criticism from the New York office. . . . Their loyalty appeared to be to the bureau, not the paper."[6] It is legendary that the Washington-based bureaus of New York organizations—including that of Time Inc.—prefer to be autonomous. From the first, however, Catledge says he knew that his check "came from New York and that the decision-making power was and had to be in New York."[7] Richard Oulahan, head of the Washington bureau when Catledge came in, had allowed his reporters to cover what they pleased; Arthur Krock had made them a team when he took over in 1932, but *his* team. Some years later, when Catledge became first an assistant managing editor in New York at the end of the war and then succeeded Edwin James as managing editor in 1951, he "set about deliberately" to enforce controls from New York but came to know, he said, that "this kind of bureaucratic sentiment is almost incurable in the operation of a large newspaper."[8] But it may have been as much the addition to *The New York Times* of an inexperienced and impolitic chief executive that led to Catledge's early retirement in the late sixties as it was the intractability of the Washington bureau, personified at that time by James Reston.

When Ochs died in 1935, his son-in-law Arthur Hays Sulzberger

was elected president and publisher by the board of directors. He was forty-four and had been on the newspaper for eighteen years. "Keep calm, smile, don't be smart," he advised himself.[9] (If smartness is defined as being clever, only one of the nine men in this book was really that, the least successful. Critics are allowed to be smart and clever without being suspect. But managers and artists are not.) The title of general manager was given to Julius Ochs Adler, and Meyer Berger, in *The Story of the New York Times*, describes how Adler once explained their respective jurisdictions:

> Both he and Sulzberger were trustees of the Times-controlled stock. "Mr. Sulzberger," he said, "is senior officer of The New York Times, and is president of the company. I am vice president. He is first in command and I am second in command of the corporate structure. Mr. Sulzberger is publisher, which means that he is in direct charge of all operations. Actually, he gives his more direct attention to the news and editorial departments. My title of manager gives me supervision of the business, circulation, promotion, production, and mechanical departments. We confer on all matters of paramount policy, on both sides of the business. Naturally, if Mr. Sulzberger's views would differ from mine, his judgment would prevail."

It is noteworthy that in 1938 Sulzberger listed the executives who directed the policy of the *Times* as Edwin L. James, Lester Markel, Arthur Krock, and the editor in charge of the editorial page.[10]

Ochs had left controlling interest in the *Times* in trust to his four grandchildren, with their parents and Adler as trustees. The four had also inherited the Chattanooga *Times*, to which one granddaughter's husband was to devote himself. A second granddaughter married Orvil E. Dryfoos, who became his father-in-law's assistant at *The New York Times* and eventually himself the publisher. The third granddaughter was relatively removed from the newspaper business, being a medical doctor; but on the grandson, Arthur Ochs Sulzberger, hangs a tale.

When Edwin James died in December 1951, Turner Catledge inherited the position of managing editor, "a showcase position on the *Times*, one that should offer the ultimate in social mobility, a passport through all the prejudicial barriers of the American democratic system. . . ."

> Power has almost always been a rather nebulous thing at *The Times*, losing much of its bold line and shape as it achieved height. A sharp, clear display of power by a top *Times* executive was not good form, was in conflict with the Ochsian maxim on modesty, was considered unwise. . . . Each step up, it seemed, cost the individual part of himself. With greater power went greater responsibility, more caution, more modesty, less freedom. Those who finally attained great power did not

seem to use it, perhaps could not use it. If they could not use it, what was the point in having it? And, more important, how could its existence be confirmed? A politician must win elections, a star actor must make money at the box office, a network-television commentator must maintain ratings, but a titled *Times*man may go on for decades on the momentum of the institution, facing no singular test, gaining no confidence from individual accomplishment; and yet he is personally catered to by statesmen, dictators, bankers, presidents of the United States, people who believe that he possesses persuasive powers within the institution—but they cannot be sure; *he* cannot be sure. . . . It often seems that nobody really did anything.[11]

And this was particularly true of Catledge.

"The interesting thing about Catledge—and I've known many men on the *Times* many years," McNeil Lowry said,

—is that it was probably almost twenty years ago when he stopped being his own pro—his own professional, his own independent journeyman. I don't mean that he began to occupy administrative posts—so did I. Catledge stopped being—the reporter, independent entrepreneur, and moved over and gave up a good deal of the unbuttoned freedom and shoving on his own. . . .

I guess you'll think I'm mystical about this but, you know, he's a small boy from Mississippi, as I'm a small boy from Kansas. Now—one of the things about American life in this country is that, going on our fathers' traditions, the world is open to you, which is a romance, you know, but there it is, the world is open to you, make your own way—there's nowhere you can't go. So every now and again . . . society *is* permeable, this society, and these small boys *do* get in positions of influence. Well, Catledge—executive editor of the greatest newspaper in the United States—all right, then is the test. What is he then? Well, if he stays, they say not any longer this was just a small, driven but successful boy who made it. They say, he was always an instinctive aristocrat, he was always marked out. And this poise and security and confidence is not the result of his class or his new position. He's not dazzled. He's not diverted. He's not basically compromised. He's himself still, wherever he is, even if he's shaking worlds, like Harry Truman.

Lowry had occupied Rudolph Bing's box at the Metropolitan Opera with Turner Catledge on one or two occasions. "It was absolutely clear," he said, "that this was a Turner Catledge that didn't exist. But apparently when Catledge gets in a cab with his wife and goes off to something that's, you know, official, he leaves himself at home."

"[Catledge] was certainly superior in his ability to get along with people," Marcia Thompson said. "He had a warmth and an outgoingness

that I felt very much even though I was within that other department. He couldn't have been warmer and more friendly and really a very nice human being. . . . I think in some cases the person was more kindly regarded than the ability." Talese commented that "the character of Catledge himself has remained ill-defined even by those who think they know him."[12] Few saw Catledge's ability clearly. Did this mean he was not an able man? It may have meant he had a different conception of his job than his watchers did, and perhaps was too conscious of the fact that when he went to the opera, for him that was work, just as his drinking with Sulzberger was work and his relationship with young Punch had turned out to be work.

Mrs. Thompson had gotten a job at the *Times* in 1946:

> It's very funny. You know, the *Times* has a way of becoming a part of your life, I think, for anyone who's worked there in any capacity. For many years after I'd been with the [Ford] Foundation, I kept thinking of the Foundation as a new, sort of temporary job, with the *Times* really being my main job. I was only there six years. I've been with the Foundation since 1953, so you can see the disparity in time.

She said that while she was at the *Times*, "there appeared to be a very great tug of war going on between Markel and Catledge—I guess simply the daily [versus] the Sunday represented by Markel—in which Catledge seemed to have effectively won." "Actually," Gay Talese noted, "Catledge was probably the shrewdest managing editor of them all. While lacking Van Anda's brilliance or the busy-beaver quality of Birchall, Catledge was their master when it came to handling men and manipulating situations without seeming to be doing so."[13] But Catledge had inherited a kingdom filled with dukes each of whom had built up his own stronghold, as Gay Talese put it.

"Lester Markel saw himself as one of the great editors of his time," wrote Talese. "Or, now that Harold Ross of *The New Yorker* was dead, perhaps *the* great editor. Markel had joined the *Times* before its peak period of accelerated growth, and he had expanded his Sunday department as the paper itself had expanded, both forces riding the crest of a rising American economy that would produce after World War II a larger, better-educated, more concerned, more prosperous, more acquisitive society."[14] Markel's staff had a love-hate relationship with him, Talese thought.

Markel had been a perfectionist, Marcia Thompson said,

> and I learned a tremendous amount from him, really—but it was the feeling or the need to conquer, dominate and control, you know, in a kind of ruthless way.

When it was pointed out to her that Lowry too was a perfectionist, she quickly replied:

> Yes, yes, but with love, and Markel never had that kind of personal security. [Lowry's success] in foundation areas [came from] an ability to relate and sympathize with the problem of the individual artist or director in his field of the arts, an ability in some respects to be almost more insightful about their problems than they are themselves because they're so close to them. . . . I think this is equally true in his dealings when he worked in Washington as a reporter. It's just a quality of the man that is particularly appropriate in this field, in foundation work.

Did she feel that was enough to account for Lowry's effectiveness?

> No. He's got great political skills, I think . . . a sense of timing . . . he's never at a loss for words and manages to, I think, instill in the board and in his brother officers a sense of direction. But I mean political in the sense of political currents.

Had not that instinct sometimes been defined as being able to know when to give things away in order to achieve other things? "Oh," she replied, "I think anyone in any administrative role does this every day. To know when to be flexible and when to be inflexible is a terribly, terribly important thing."

The extent to which one yielded to the institution had been the subject of a discussion between McNeil Lowry and James Reston of the Washington bureau of *The New York Times*, before the organizational upheaval at the *Times* during the latter half of the 1960's. Lowry said:

> My wife and I had one of those regular but unscheduled reunions with two couples—our oldest friends, Scotty Reston and his wife and then Kenworthy, also on the *Times* in Washington, and his wife—all four of whom we've known for thirty-odd years. . . . [Reston] was trying me out to see where my emotional commitment was to the Ford Foundation now that Bundy was here, recognizing that if there ever were two contrasting styles of temperament and operation, they might be Mac Bundy and Mac Lowry.
>
> We got to the subject of compromise and was there necessity for compromise between Bundy and [myself]. I told him how I saw the necessary autonomy and opportunity to carry out the philosophy of this program and of philanthropy . . . which means a great deal to me, probably more than it should. And then [Reston] said, "What if you don't have that kind of autonomy and freedom?"
>
> And I said, "Well, then—"
>
> "Well," he said, "That's terrible! What do you think about the rest of us?" He said, "Do you suppose Ned here hasn't had to compromise with *The New York Times*? And I haven't had to?"

And I said, "Well, Scotty, I'm not saying, you know, that I'm too moral or too precious or whatever. The fact is, I haven't had to for thirteen years, so why should I? Also, this is not a profit-making enterprise. Sure, journalism is a profession. *The New York Times* is a business. Philanthropy is a profession, but it's not a business. And policies— the *Times* can knock along for five or six years on one policy, and then there's a shift in personnel, and they go off some other way, and it goes back again, and it looks better to the guy who hasn't liked it for the last five years. If he likes his job, okay. But that can be far more pervasive and corrosive and destructive in something that is *itself* about policy, which is what philanthropy is."

James Reston had joined *The New York Times* in 1939, coming from the Associated Press, one of those wire services which, having developed vastly in this century, now largely determine the flow of the news, serving newspapers and broadcasting equally.[15] Reston is said to have quickly become admired and envied by the rest of the staff. *Prelude to Victory*, his first book, was published in 1942. He believed that the twentieth century was the era of the journalist just as the nineteenth century had been the era of the novelist. In London during the war, he returned to New York to serve briefly as Arthur Sulzberger's assistant but found traveling with the publisher onerous. Suggesting Turner Catledge might be more suitable as a drinking companion—which indeed Catledge turned out to be—Reston went to Washington in 1944 as Arthur Krock's diplomatic correspondent. He replaced Arthur Krock as bureau chief in 1953, Krock stepping down reluctantly and only after some pressure as Reston debated quitting.[16]

Catledge might himself have become head of the Washington bureau if he had not left the *Times* in 1941, feeling that he was hitting his head "against the bottom of Arthur Krock's chair."[17]

> He accepted what appeared to be a dream job, that of roving chief correspondent for the Chicago *Sun*, founded by Marshall Field III to compete with the Chicago *Tribune*. But Field's ambition was never fulfilled, and Catledge was never happy in Chicago. . . . Even his later promotion to the position of editor-in-chief of the Chicago *Sun* did not elate him. . . . There is a very agreeable sense of privilege about employment on *The Times* that can forever spoil an individual who identifies personally with corporate greatness and tradition.[18]

Catledge was rehired by the *Times* in the spring of 1943 and given the title of national correspondent. His salary was $12,000 as against the $26,500 he had been making in Chicago, but, based in New York, he quickly became assistant managing editor and then managing editor in 1951 before the title of bureau chief was transferred from Krock to Res-

ton in 1953. Catledge had outstripped Reston in the administrative hier-
archy but their respective positions were appropriate, Catledge being
less interested in writing (although he worried about losing contact with
his sources in case he had to go back to it) and Reston being the author
of a distinguished column regularly appearing on the editorial page of
the *Times* by 1953. Their administrative styles were different:

> Unlike Reston, Catledge could not, or would not, become so personally
> engaged in the singular affairs of individual staff members. Reston,
> with his smaller force in Washington, could be the *paterfamilias*, the
> champion of individualism, but Catledge's problems were too large, the
> men under him too numerous, for him to devote himself to the cause of
> an individual unless that individual were part of a larger plan that
> Catledge was trying to master.[19]

Catledge's main idea on becoming managing editor seemed to be
that the *Times* moved too slowly, that it could compete with television
by moving faster and digging more deeply. However, Talese notes that
Catledge was "mindful of the fact that *The New York Times* was an im-
mensely successful enterprise, and that any changes that were introduced
or permitted by him might adversely affect the winning combination."[20]
But by 1955 he was insisting that all of the hiring be done in the central
office, in an attempt to unify the paper and firmly establish authority in
New York.

Perhaps Catledge had another reason as well. During this period
when the influence of Senator Joseph McCarthy was pervasive, *The New
York Times* was vulnerable: some of its four thousand employees had
been members of the Communist Party in America. Arthur Hays Sulz-
berger thought it proper to dismiss any *Times* employee who took the
Fifth Amendment.

The *Times* had been singled out for attack by Senator James O. East-
land's Internal Security Subcommittee, apparently because it condemned
segregation, challenged abusive methods employed by various congres-
sional committees, attacked the McCarran Immigration Act, and criticized
a security system that concealed the accuser from his victim. But Sulz-
berger insisted that, "nowhere is it written that a person claiming pro-
tection against self-incrimination should be continued in these sensitive
departments where trust and confidence are the tools of a good work-
man."[21] John Oakes, a nephew of the founder who was to take over the
editorial page in 1961, disagreed, and so did Turner Catledge. Since
the *Times* had been more conservative than otherwise, its editorials
against McCarthyism could only have come from a continuing sense of
responsibility.

Not only the newspaper but Catledge himself went through hard

times in the 1950's. He had separated from his first wife before he be-
came managing editor, was to be divorced in 1957, and had begun to
drink heavily, so much so that at times he seemed to have relegated the
running of the news to an assistant.[22] Catledge during this period appar-
ently thought he might be replaced and spoke of a sense of frustration
and failure.[23] He had established a daily news conference (taking re-
sponsibility away from the strategic desks of the editors who handled
assignments and copy flow) and, increasingly, his office had a political
clubhouse atmosphere, especially after the four-o'clock conferences when
some of the *Times* people would linger. Among these was young Punch
Sulzberger, Ochs's grandson, who had been put on the paper but to whom
no one paid much attention. He lacked those qualities of a top reporter
that are essential but are rarely cultivated by such men, Gay Talese wrote
in *The Kingdom and the Power*, "the properly reared sons of the rich."

> Prying into other people's affairs, chasing after information, waiting
> outside the doors of private meetings for official statements. They found
> newspaper reporting interesting, as did John F. Kennedy, but not for
> very long. The reportorial ranks are dominated by men from the lower
> middle class. It is they who possess the drive, patience, and persis-
> tence to succeed as reporters; to them reporting is a vehicle to a better
> life. In one generation, if their by-lines become well known, they may
> rise from the simplicity and obscurity of their childhood existence to the
> inner circles of the exclusive. They may gain influence with the Presi-
> dent, friendship with the Rockefellers, a front-row seat in the arenas
> of social and political power. From these positions they might not only
> witness, but influence, the events of their time—as did Reston, the son
> of poor Scottish immigrants; as did Krock and Catledge, Daniel and
> Wicker, the sons of the rural South; as did A. M. Rosenthal and dozens
> of other Jewish Americans whose forebears escaped the ghettos of
> Europe.[24]

Young Sulzberger, like Catledge, was separated from his wife during
this period. He remarried in 1956, and his new wife saw in her husband
qualities "that had long been obscured by his more obvious easy man-
ner and his old image."[25] Catledge, who had become something of an
uncle to him, felt Sulzberger capable of major responsibilities if given a
chance. That chance came when Dryfoos, with whom Reston tended to
deal, died unexpectedly in 1963 after having been publisher for only two
years. His successor might in any event have been a foregone conclusion
in so family-oriented an institution, but young Sulzberger's mother, Iphi-
gene, happened to control about two thirds of the voting stock. (That
Dryfoos' widow later married Andrew Heiskell of Time Inc. would nor-
mally be only a footnote but is more than that in a book attempting to

News conference at The New York Times. *Turner Catledge is
in front.*

show many kinds of interconnections between these institutions.) Arthur
Ochs Sulzberger came to power at the age of thirty-seven with, in Cat-
ledge's words, "no circle of contemporaries to advise and assist him." As
it turned out, that was to be Catledge's job. No one else "had expected
[Punch] to be publisher and few people had bothered to cultivate him."[26]

It seems to have been typical of Sulzberger to be generally more
interested in the mechanics of a thing than in its content, and if that is
true perhaps it might go some way toward explaining why he seemed to
have a strong sense that he was not merely a trustee of the paper but
owned it as one might own an object. No doubt the fact that he was a
direct descendant of Adolph Simon Ochs also made a difference: the pre-
vious two publishers had married into the family. Punch set about involv-
ing himself aggressively, wanting a more neatly organized company.
Catledge's ideas, too, tended to be less about over-all policy and more
about working details,[27] and in September 1964 he was named executive
editor, with Lester Markel being moved out of his editorship of the Sun-
day paper, over which Catledge was to have control. The only possible
exception to his authority was John Oakes. "Catledge had been envision-
ing this arrangement for nearly twenty years," Talese wrote. "Now he
had it."

Turner Catledge, at the age of sixty-three, slightly overweight, ailing with the gout, a large, tall, flaccid man with a round, red face, slack jaw, quick darting dark eyes that missed almost nothing, a soft and courtly manner that had long defied description, preventing most people in the newsroom from knowing exactly whether he was a corporate genius or a lucky bumbler—Catledge was now to become so eminent in the *Times'* News department that Arthur Krock in Washington would remark with an inflated sigh: "I hesitate to breathe his name." [28]

Shortly before the announcement about Catledge was to become final,

> Reston made one last attempt to get Sulzberger to reconsider, talking to Sulzberger in the concerned, public-spirited way that Reston spoke with presidents and senators, suggesting that the youthful publisher might be wise to surround himself not with older men but rather with the bright young men of his own generation. . . .
> Reston could not, under these conditions, continue to serve as bureau chief. And so at his own request, Reston asked to be relieved of his title and to select his successor. Reston would become, like Markel, an "associate editor," and would continue to occupy an office in the Washington bureau from which he would write his column.[29]

Reston chose Tom Wicker as his successor, and Sulzberger agreed to this without, apparently, consulting his executive editor. One guesses at his inexperience, at the extent to which he felt he wanted Catledge but at the ease with which Reston was then able to undercut Catledge with him. Reston arranged for Wicker and his wife to travel to Europe with the Sulzbergers, and it had the anticipated effect, Talese said.

Catledge was not by nature a crusader.[30] His aim was toward the establishment of an internal structure which would enable the *Times* to perpetuate itself. "Well, it sounds perhaps vainglorious to put it this way," he said, "but my main objective right now is to so solidify what we've been doing in the last fifteen years on the *Times*—I mean to solidify it, to guarantee that the forward motion that we have started, that we've been carrying on, carries on into the future, keeps on and on and on. . . .

"I'm vain about the success of this paper," he said. "We're not working for the estate of the late lamented Adolph Ochs as such, we're working for ourselves, and we've just got to have—got to guarantee the leadership and keep those people keyed up—combination of coach and a cheer leader." Continuity of character had been attained because of the several generations of family ownership. Sulzberger

> sought to improve morale by sharing the wealth more generously with higher salaries to employees and with stock options and other benefits to ranking editors and executives. The New York Times Company's

stock splits in 1964 and 1966 helped to make relatively rich men of such executives as Catledge and Reston, Ivan Veit and Monroe Green; and numbers of editors and executives on a lower level were earning between $45,000 and $65,000 a year; critics were in a $20,000 to $30,000 class; and the very top reporters were receiving between $350 and $500 a week.[31]

Catledge believed his specific role was to enable the paper to adjust itself continuously "to the requirements of progress" by leaving the place staffed—

> or so institutionalized if you want to call it that—you can't institutionalize people too much but you have to have something that will guarantee continuity—and my primary job as opposed to anything else is to set up this office, both as to its operation and especially as to its succession, that it can carry on.

Catledge went on to say that a newspaper was "nothing in the world but a collection of human beings. . . . What you see on *The New York Times* is a product of human ingenuity, a product of human thought. It's a product of human imagination. It's a product of human organization, of joint human effort." Catledge's style is nothing if not grandiloquent. He pointed out that the most immediate job they had to do, of course, was to get out tomorrow morning's paper. And "you're testing all the time," he said, "without realizing it, you're testing the other human beings that you're going to count on. We have to be very conscious of getting in younger people all the time—it's a matter of succession—you've got to contend with nature, nature doesn't cooperate very much, people will get older and die, they're unfortunately mortal. Another unfortunate thing about it—they're so damn full of human nature, these newspaper people. [And here, during our interview, he laughed.] These people have an excess of human nature." Hedley Donovan had commented, "When a Managing Editor is feeling sorry for himself, he can make quite a grievance out of this Ping-Pong movement between different issues and different problems and different sets of people, but secretly he likes it."[32] Not so secretly, Catledge liked it.

Catledge liked it so well, in fact, that in spite of what he said he did not set up a clear successor to himself. Clifton Daniel, who became managing editor in 1964, might have been seen as such except that Catledge stood in the way of his establishing a stronger relationship with the publisher, as did his own personality perhaps in more ways than one. Unlike Reston, Daniel had never gone over Catledge's head.[33]

By 1967, things seemed to be going satisfactorily. Daniel had acquired a deputy, A. M. Rosenthal, who had joined a group of four as-

sistant managing editors: Theodore Bernstein of Winners & Sinners[34] fame, the bullpen editor; Robert Garst; Emanuel Freedman; and Harrison Salisbury, who did as he wished, being answerable to Daniel for special stories. The overseas edition had been losing money during most of its eighteen-year history, and Sulzberger folded it in 1967. He thought of starting an afternoon paper in New York but decided not to. He did pay $500,000 for a 51 percent interest in the Teaching Systems Corporation of Boston and also bought the Microfilming Corporation of America. The book division of the *Times*, in collaboration with outside publishing houses, had produced more than fifty books between 1963 and 1967. Sales of the whole corporation in 1967 amounted to $194,253,000; the *Times* employed 5,861 people; its net income was $11,290,000. "Oh, my God, I feel excitement every day," Catledge said.

> This is a daily newspaper. It comes out every day. Even though every day is a fresh beginning, nevertheless it hangs on what happened yesterday. This is an attempt—and a feeble attempt at that—to capture a moment in history and to help the people who are involved in this moment of history to understand what's going on, understand what's happening to them now, know what's happening around them now, and have some way to connect it to the past and project into the future.

From the selection of material, Catledge said, they went on to try and present that material in as interesting a manner as possible. "Simplified sentences," he said, "more interesting feature material. . . . I don't want people to do like I used to do when I'd pick it up in the morning: I was going to read it, damn it, if it killed me. . . . Now we've made our volume a virtue." Catledge noted that "we made considerable changes in this paper the last few years, but we've done it very slowly, so imperceptibly, that I can hardly tell you what the changes were myself."

But the problem of Wicker's bureau in Washington remained. Catledge, in his autobiography, noted that Wicker had been finding it extremely difficult to carry on as top administrator in the bureau while keeping up his aggressive pace as a reporter. The Washington bureau was failing to meet more and tougher competition:

> Punch was urging me to "do something," and even urged several times that I take a more direct hand in the day-to-day dealings between New York and Washington. I took the position in this case, as I did in general, that as executive editor I should not grab the wheel from the hands of people who were driving the car—the managing editor and his assistants.[35]

After all, the reins of the Washington bureau had been rather suddenly dropped, he told the publisher, and given over to an inexperienced

younger man. "Wicker was well liked by the bureau," Catledge said, and suggested that "part of the problem was Tom's instinctive desire to be liked by his associates; it detracted from his leadership and made him unnecessarily defensive toward New York." Daniel was not to escape criticism, however: sharp-spoken in a way that Wicker interpreted as needless harassment, Wicker sometimes "probably was correct," Catledge said.[36] "Wicker, who possibly did not even want the job at this point, was stuck with it. He had to hold on to it as one must often seem to cherish an unwanted gift from a very important donor. Reston's vanity was involved. . . . It was obvious to nearly everyone, however, that Wicker was devoting most of his time and energy to the writing of his column, which had become an excellent addition to the *Times*' editorial page."[37] Rosenthal's idea was to replace Wicker with James Greenfield (who had been an employee of *The New York Times* for only seven months at that point), an idea ". . . endorsed gradually by Daniel, Catledge, and finally by Punch Sulzberger." Talese continues:

> . . . But when Reston was informed, he suggested that any personnel changes in Washington be postponed until after the Presidential election. Reston wrote a long memorandum to this effect. When he received no reaction to it, he assumed that his recommendation was being followed in New York.[38]

Delay tactics are those of a politician to defeat an issue. It undoubtedly was convenient for Reston to be able to say later he had "assumed," so that the opposition would be put on the defensive by his assertion of betrayal. Of course, often, if one doesn't hear, it means negative.

Reston would not keep a dinner date in Washington with Punch Sulzberger and Wicker. Reston, while perhaps not wanting to appear as sanctioning the move he knew was coming, also ensured that Wicker would be uncomfortable during the dinner, and he was. Sulzberger had come to tell Wicker about the move. The editors in New York had told the publisher that Wicker was "quite willing, and possibly eager," to step down, and perhaps he was that, too. But during the dinner, "Wicker was tense and obviously upset, agitated by the forces of his loyalty to the bureau, to Reston, to himself." He apparently felt bullied by New York. He wanted to announce his resignation but Sulzberger asked him to delay it, and Sulzberger delayed in releasing the official announcement. One can surmise Sulzberger was going through a re-evaluation of the situation and take a certain amount of pity on him were it not that he might have assessed the situation more thoroughly before it had gotten that far. He had not pressed hard for clarification, perhaps afraid of the risks in doing so. As the situation continued, Reston did not say he would resign but instead, shrewdly, said, "I'm with the younger men,"[39] a statement

that apparently left Sulzberger thinking Reston might resign if Greenfield were put in as bureau chief but left Reston free *not* to resign under such circumstances. Reston was manipulating what Professor Louis L. Jaffe at Harvard has called "the margin of doubt."

Reston probably would never have left the paper:

> Reston believed that the *Times* alone had the audience that moved America. The President of the United States read it every morning, and so did the Congress, and so did seventy embassies in Washington, including the Russians. More than half the college presidents in the United States read the *Times*, and more than 2,000 copies were sold each day at Harvard, more than 1,000 at Yale, 700 at Chicago, 350 at Berkeley. These were the people that Reston wished to influence—the Establishment of today, the Establishment of tomorrow: he was the Establishment columnist, and he could be that only on the *Times*.

And he loved the paper, Gay Talese was to write.[40]

But Sulzberger was not willing to chance it and seems to have blamed Catledge and Daniel for getting him into this bind. He did not, apparently, conceive of it as hinging on his own behavior—behavior being not doing something as well as making moves—and he certainly did not resemble his grandfather in this instance as one who forcefully took responsibility into his own hands. Sulzberger consulted his family and the few executives who worked outside of the news department. He had qualities different from those who had worked their way up, such as the nine in these organizations. As indeed did Reston, who won: for in spite of —or perhaps because of—what has been called Reston's impulse toward uplift, it was for the *Times*'s possibilities as a vehicle that he prized it, a vehicle for what he saw as various needs external to it as an *organization*, which placed him in a position to see those possibilities for transcending the institution. As indeed he did transcend it when he spoke of those individuals in the vanguard of what he saw as a new class of public servant, "a group operating within the 'triangle' of the university-foundation life, the communications media, and the government."[41]

Rosenthal, Daniel, and Catledge felt betrayed when Sulzberger announced a reversal of the decision to replace Wicker. The three men then had to deal with their loss of face inside the organization, and how they handled that helped to determine their futures. In wondering where he stood, Rosenthal realized that Catledge had lost his influence with Sulzberger. He received a phone call from Reston: Wicker had suggested the three of them get together. Rosenthal invited Reston and Wicker to his apartment and apparently defended himself. The next morning, Rosenthal saw Sulzberger, who embraced him and invited Rosenthal to his country home for the weekend. "Returning to the newsroom, Rosenthal informed

Daniel and Catledge of his weekend plans; he hoped that they also would attempt to reach an understanding with the publisher."[42] Daniel's response was to ignore Sulzberger, and when he finally did speak to him at any length, lectured him roundly.[43] It is to be remembered that Daniel was married to the daughter of a former President of the United States.[44]

Catledge had told Sulzberger that he was contemplating retirement, and shortly thereafter, in 1968, Sulzberger did ask for it, replacing him with —James Reston. Before long, Rosenthal took the position of managing editor, and Daniel became an associate editor, as did Tom Wicker: Reston himself had removed Wicker as head of the Washington bureau.

Reston as executive editor wanted what was news redefined to include "news of the mind": the conflict of ideas would be reported (and in that lay the possible seeds of his own downfall as a corporation executive).

> Reston believed that the new role of the press was in the field of thoughtful explanation. The *Times* and other newspapers had already begun to rely more heavily on news analyses, articles that ran adjacent to news stories and interpreted controversial facts and statements, and counter-balanced them with the views of other authoritative spokesmen. Turner Catledge had been an early advocate of the news-analysis article, recognizing a need for modernizing Ochs's definition of objectivity, but Catledge later became disturbed, perhaps more so than Reston, by what he believed to be occasional abuses of this innovation. Catledge had not wanted the news analysis to become a reflection of a reporter's opinion, for opinions were to appear only on the editorial page and in the critics' columns.[45]

This new area was considered by Catledge to be very dangerous. News in depth meant adding "why" to the *what, when, where*, and *how*—for in the "why" not infrequently lay the truth. Episodes with arbitrary beginnings and ends could not tell the story properly. Thus the newspapers themselves were beginning to go beyond verifiable information. Catledge thought they had been getting near the point of advising people what to think—just as, according to McGeorge Bundy, *Time* magazine "fudged the line between reporting and judging."[46]

Most of the interpretation at *The New York Times* had hitherto been done in the Sunday "Week in Review" section, so that when Catledge came to feel it had to be done daily as well, he automatically came into conflict with Markel. Catledge pointed out that the "Week in Review" could only address itself to less than one tenth of one percent of the material that came into the *Times*:

> In the first place, you see, this paper contains this morning about a hundred and fifty thousand words, just about. There came into this office last night during a twenty-four-hour period almost two million words

offered for publication this day. . . . Our first big job is to select that hundred and fifty thousand words. It starts out as a rather easy process. In the first place, this story here about the machinists rejecting the airline agreement: we got that from three different sources. We got it via the AP, we got it by UP, we got it from our own man Jones. So in the first place, you select one out of that. Maybe you have a little criss-crossing. . . . The national news desk would have all these things. If there is any question about it, we always favor our own writers. . . .

It's not as if somebody has to say, "Well, on the front page we'll have so-and-so." Those things come up to the top. The decision that was finally made that this should be the first-page story was made practically by the story itself and the other stories that happened during the week. If Johnson died last night, this would be over somewhere else and the Johnson death would be the lead story. Those things do not require people sitting here and pulling their hair and smoking one cigarette after another. Those things come on in a rhythm that has been established from these people working together and the kind of direction they have and the kind of direction they contribute to it and it goes in a rhythm where it's just as natural—if you would have been here last night when these selections were being made, you would have thought that you were either at a gathering of relatives or the most noisy place in the world. . . . But it would have been very, very quiet so far as the big things are concerned. You might have heard some noise, some people yelling at each other or a foursome back playing bridge or something like that. This is rather peculiar to us. I think it's peculiar. I hate to put it this way, but I have to be honest. I think we're so used to dealing with these big stories in a big way that it becomes less of an occasion for us. There's less drama in it. . . . You don't have to impose that calmness. It's just the natural result of these people having worked together for so long.

"I should think perhaps the assassination of John F. Kennedy was perhaps the biggest single story," he said, "although I wasn't here when it happened. I was in Miami. I was down there for an editors' meeting and just had attended a meeting of the Associated Press managing editors and was staying over for a meeting of the Inter-American Press Association. But I was able when I heard this to get a plane and get back up here for the first edition. But they didn't need me here. If they had needed me, I wouldn't have been a very successful managing editor. . . ." Harrison Salisbury had supervised the *Times*'s story of the Kennedy assassination.[47] "What a hell of a news story," Catledge said.

"The next day I thought about it in my own terms," he said, "in my own life and for my own purposes, because it was something that I could sit down and think about, how bad it was; I had to do something about it. So I had to think about it in terms of what I was going to do."

Had he gotten to the point where it was connected more to his personal life than to his professional life?

"No."

Did that happen to him with news stories?

"I haven't had one yet," he said. "I think perhaps that the thing that would come nearest to that would be the race situation, being a Southerner and growing up in the southern tradition and so on. But it doesn't trouble me."

"Did you go to school with Negroes?"

Played with them all the time. You had to respect them. Especially the oldest. We had to call them Aunt and Uncle; after they got around forty-five years old, you never called one by his name, you called them Aunt or Uncle—Uncle Joe or Uncle Tom or Aunt Lucy or something like that as a measure of respect, and you never called one a Negro—

"You mean 'darkies' was better than 'Negro'?"

Oh yes! That was a token of respect. It's only in the last few years that the name Negro has been adopted by the race. It used to be a— down there it used to be a badge of—well, disrespect for someone. If I were to say to a nigger, "Get away from here, you little nigger," or something like that, he'd run tell my mother, and my mother wouldn't even *ask* me whether I said it or not; she'd just cane me. You had to respect them. That is, especially the older ones. Things were changing at the time I was there, there was no question about it. But you find in Philadelphia, Mississippi, right now—you find a residue of what I'm telling you. You won't find perhaps the same expressions, you won't find it expressed in the same form, but you have—even there today, with all the trouble they've had—you'll find lines of communication between certain white people and certain Negroes, which is a line of affection and respect. . . . I remember in my home town, every Negro there, everyone was known of course, and every Negro had his white man. The white man was a duck on water for a Negro. A dozen Negroes may have the same white man, a man they could go to when they're in trouble, a man he'd go to and borrow money, one he'd hang around and just liked him. And also, just had to get the handouts from him and worked for him and—well, like a trusted dog, I suppose. But they're that way. I have an uncle who's still living who just—they just hung around him all the time. They still do.

. . . My uncle doesn't even have a lock on his door. . . . He might come home at night and find a couple of people sitting there waiting for him—or who just decided they'd go into his house and sit for a while. I imagine there're many houses in that town that have no locks on them . . . my Uncle Joe used to say, "Leave a little something around for people to steal."

We had quite a few colored people in the community who we knew were members of our family—their names were Turner or Hannah or Kennedy, because those names were all in the family—Lamey. And I know when I was growing up, we were taught to respect those people very much and—this was up around where my father's people came from, because my mother's people came to the same section originally —but I used to—there on my grandfather's farm I had people pointed out to me, "He was your grandfather's slave," "He was your great-grand-father's—son of your great-grandfather's slave," and they would—in the little church—they had a little Presbyterian church called Beth-Salem, and a lot of those Negroes would come and stand in the back of the church on Sunday, and they would also want to be buried in the same graveyard, they didn't want to leave the white people—and they didn't leave. After the war they just stayed right there. And, incidentally, those particular Negroes prospered pretty well, because they were good workers—they had learned to work. . . .

I was there along about the first of June 1954, just after the Su-preme Court decision—before any of this backlash started, and I got into a town—I drove with my uncle—met me down at the coast—Phila-delphia's about halfway between the coast and the Tennessee line—and he met me down there, and they were going to give what they call a potluck supper for me out at the country club—people coming in bring-ing—certain ones would furnish chicken, certain others would furnish the roast beef, certain others would furnish the salad—and the women would fix it all up and they'd just serve dinner. And while I was there —you got there late in the afternoon—and while I was there some of the youngsters came in—four or five of them came in—particularly young girls and boys—when I say "youngsters"—they were eighteen and nine-teen years old—asked me if—they were going out to the club that night —asked me if anybody brought up this integration question, would I discuss it? Well, I said I'd discuss anything anybody brings up, because when I go down there they always want me to talk—they think I bring in outside information. Maybe so, but I'll let them think it anyway.

. . . And it was the most rational discussion you've ever heard. Just absolutely couldn't be better. Only one time did anybody bring up anything, and they—there was one woman there, the wife of a doctor, a chiropractor rather. Jumped up and asked me, "Would you want your daughter to marry a nigger?" Well, I have a way with—I've had *some* experience in this sort of thing, questions and answers, and speak-ing and, you know, public discussion, and if I can hold my temper and hold myself, which I try to, I have some tricks. One of them is, when you have a very embarrassing question like that, is to make them repeat it—pretend that you didn't hear it. Put them on one hell of a spot be-cause everybody turns around and looks at them. So I sez, "What is that question, Lucille?" [his tone mild and deceptive]. And so she

sez, "Would you want your daughter to marry a nigger?" I said, "Well, that hadn't occurred to me, that question hadn't occurred to me, I must say. I don't think so necessarily, I wouldn't go out and make a choice of that kind." But, I sez, "After all, that's a personal matter, between her and whoever she selects." I said, "My problem with my daughter right now is not with her marrying a nigger but with her marrying a white man I don't like"—so then everybody just howled and this poor girl—this poor fat gal—she just was terribly embarrassed and nobody else tried anything like that. I think one was about to but he decided not to. But they all still talk about that now. When I go down there they remember that story—that crack. Of course, it was sheer demagoguery, no question about it. . . . I am one person they will not criticize. . . . They'll say, "He's one of us," you know. It's that herd instinct, that clannishness that now—it used to relate to my family, it relates to the whole community. And I'm quite certain—I don't know—I don't know how I would react if I got out—how I would act if I got down there in one of these mob scenes: I just don't know. I'm sure perhaps I wouldn't even be listened to. . . .

. . . see, the difficulty in understanding a situation of that kind, in terms we deal with now, is you try to get some simplification and you go too deep for simplification; you want too many absolutes where absolutes are not as absolute as you want them. Of course, I know now—looking back, I knew then they were sensitive but I didn't know how to realize it—there was a latent, certainly a hidden, resentment of their lot, but they never expressed it—nobody ever articulated it for 'em, nobody ever enlivened it for 'em, nobody ever ignited it. They took their lot and that was it. One of the greatest expressions of their attitude I've ever seen was Joe Louis, in a book that Mike Berger ghosted for him. He said it had never occurred to him until he went to Detroit that there was even a race question. He said that's the way it was because that's the way it was. I know Mike asked him why was that the way it was and he sez, "Because that's the way it was." And he accepted it. . . .

I suppose I'm more frustrated—people of my kind, who grew up this way, because there're lots and lots of them—we've got a number, quite a few of them right here in this office who grew up in similar circumstances, circumstances that had this sort of thing I've been describing to you as more or less a common denominator. And it affects their speech, it affects their attitude about everything—it affects mine, I know it does; I'm sure it does. I've never been any other person except what I am, that is, gone from one person to another. I never have been another individual—but I've had many attitudes in the South—they say there's not one South but many Souths—there's a number of Souths in any Southerner; he has many conflicting attitudes, and also he's—because of the pressures of circumstances and events here, he must consider them. There they are—they're active. You can't pass them by like your

blood people can; you can't pass them by to save his neck. How can I pass a nation like this by when I know that people in Philadelphia, Mississippi, are going through this terrible—when some of them are contributing to it—when I get so outdone with some of the attitudes they express and some of the actions they take or don't take—for my own people, that's the main thing: the actions they don't take. And up here, when I see the oversimplifications—what I consider to be the utter damnfoolishness of some people about this problem—what they can accomplish and also the irresponsibility of people on this side. They think they're carrying a great load, they don't feel it a damn bit—they have no feeling for it whatsoever.

The daily requirements of Catledge's work at *The New York Times* were simplistic in comparison with the reality of his background and by comparison with intellectual ideas about the psychology or sociology of the black person in America. Catledge noted that "the men who handle practically all our [*Times*] racial stuff are Southerners." Did vestiges of prejudice crop up? "Oh, sure," he said, "we deal with prejudice every day in every way." In his men in writing about these things? "No. There's more of a tendency to bend over backwards. Several of them are carrying a conscience load on their shoulders almost consciously. One of them, a reporter here we had not long ago, who came here from the South, got so bad about it we just had to take the story away from him.

"You referred to prejudice," Catledge said. "You could call this prejudgment to make it more in a scientific sense and less in a moral sense. Your Southerner comes here and he sees people here who are really blind to the situation, and of course they think having passed a lot of laws that they've solved everything. . . . The Southerner's conscience is much more involved than the Northerner's because the Northerner has washed his hands of it long ago. He passed the laws. But so far as the man caught in the race situation is concerned—I'm talking about the Negro—he comes here and he is doubly frustrated, much more so than in the South. You take the South and it's relatively calm. They do accept certain things down there which are bad, terribly bad, but he's not fooled about them. The Negroes in the North, especially the ones who have migrated here, are just terribly frustrated; and that's where you get your most vicious leadership."

Of course, Catledge had just finished pointing out that the Negro *was* fooled by conditions down South. He did not organize his thoughts in an objective, intellectual manner, pulled this way and that as he was by conflicting emotions and by changing news. But naturally inquisitive, as a journalist must be, he instinctively identified change, as a journalist must.

Change: The Forty-third Street Times *building in 1967*

CHAPTER 22

THE REAL POWER

(Positioned)

THEY WERE "INSTITUTIONALIZED," all nine of these men, and to that extent their lives did not change: I have offered the reader no news. Only perhaps something new. One concept in psychotherapy is that understanding may be a first step in effecting change, but understanding does not *necessarily* effect change. Neither Catledge nor the others in this book found that it did (see Sulzberger in the contretemps of 1967; see Ransom with his crew); or, that if it did, since differences between people and groups are real, the changes effected by understanding were so slow as to be almost imperceptible and so more in the category of history than of news (see Catledge at home in the South; think about data banks on the arts). Our history can never quite keep up with our news.

The problem has been and will remain, how to improve the quality of our lives. And this is a practical problem about which all nine men ought to have been thinking constantly. The answer, of course, is the fostering of constructive dissent. Stanton's position was not radical, which ought not make it less valuable on its face than the position of a radical, C. Wright Mills, about whom Harold Rosenberg had to say that he

> undervalued the personal and social expression of the white-collar worker on the job, with an effect of melancholy that seems unreal when one looks at actual men and women coming out of an office building. On the other hand, the salvation through improvement of taste proposed by Riesman, or through a psychic resistance based on private life (far more impoverished for the clerk than his job) suggested by Whyte, are . . . equally unreal.[1]

We cannot value or disvalue things because of how they are labeled but must look at them. A psychic resistance based on opposition to the labeled purposes of the organization within which one works has already been seen as self-deceptive but as sometimes moving the organization, although usually at the expense of the individual (see Fred Friendly and CBS). Would some of these nine men have been equally effective in terms of the organization *and* benefited those outside of it to a greater extent if they had put up more psychic resistance? Resistance, that is, in the direction of improving the "product" or wanting a different product. The answer must be, probably not.

Changes within such organizations as this book encompasses were based on temperament as much as anything, as indeed are changes in art. Success came by virtue of personality more than from the force of ideas, although these are hard to separate. Men in organizations operate in contexts where "commitment and participation," in McLuhan's words, are normally more important than substance, the exact opposite of the context in which the artist operates, where all the commitment in the world and all the participation won't necessarily produce a work of art. (Some artists have made careers on the basis of such, but not art.)

Each of these nine men had the job of creating and sustaining effective production systems and participating in the dissemination of (tangible or intangible) objects. Although they chose to work through organizations, no less than artists they had the ability to synthesize, to create. We have seen various views as to why artists are creative; Lawrence S. Kubie posits that all men are instinctively so:

> The creative potential in each of us is *not* dependent upon nor is it derived from the neurotic potential. But the creative process can be distorted by neurotic mechanisms. These arise in early childhood, not out of exceptional circumstances, but out of simple and ubiquitous human experiences. With age, the conflict between the two processes usually is intensified by later stresses, one of which we euphemistically call "education." And when any man succeeds in being creative, he does this *in spite* of this neurotogenic conflict. Indeed, the conflict between his creative process and his neurotic process causes his actual creative productivity to fall far short of his potential productivity. That fragment of his potential creativity which survives the impact of the neurotic process is distorted in content and becomes rigid and stereotyped.[2]

Managers no less than artists were rendered uncreative by their neuroses, but Lowry believed the artist to be motivated by talent and neurosis in the first place. What the nine men created was process. As noted, they were consumers and managers of intellectual and artistic items. Their weight, or power, depended on complex sets of circumstances, over which they had

only partial control, and even if they had wanted to, they could not have closed the world to or for others. Each life had its special theme, but it is interesting to note how little, in general, content seemed to matter—even in Ransom's bibliographies; Lieberson's special projects; Goodrich's examination of forgeries; or Stanton's quantification of interest. John Hawke could say of Frank Thompson, "In a sense, the technique is more important to him than the substance," while Thompson himself said gaily, "I *love* dealing with power: it's fun." Lowry had said that his work was like casting a stone into a puddle. But, he said, "precisely which stone and precisely which puddle and for precisely which effect" was the creative aspect of his job. He explained his work as being broadly about the quality of American life. Donovan had no great scheme: "Just a series of little ones," he said, having already inherited his father's kingdom. Jovanovich had grandiose dreams, as if the distance he had come made the world seem more open than it appeared to many others. That we live in an open world, psychologically as well as economically, has been called a modern notion. But Stanton perceived himself as locked into the structure not simply of a business or of an industry but of society as a whole apparently even while believing that he could effect certain changes. Catledge believed—apparently always—in getting along without upsetting traditions.

Stanton's efficient use of time and his constant activity provide some clue to his success—the most successful in all fields, including the arts, hold themselves as a rule to a long and regular working day—but it is noteworthy that much of Stanton's activity was not directly and obviously related to his position at CBS. His résumé is worth reading (see note 39, Chapter 1). We all know that effort is not necessarily rewarded but nevertheless is crucial. Rodin said to Helene von Hindenburg: "Do not be astonished if your drawings do not please you. You think they are without life, but life comes as a reward for the time you have spent. It comes like a blessing when one has ceased to expect it. It is a work of longing which makes saints, and I might almost say which makes artists."

A biographer of a past president of the Radio Corporation of America aptly pointed out that "personal rewards are part of the psychological equation even in the most public-spirited careers."[3] Stanton's effort has been well rewarded, as has been that of the other men on whom this book is based—but still perhaps not as much or in a way they might wish? "The fortunes of men seem to bear practically no relation to their merits and efforts," wrote the classicist Gilbert Murray; and one of Jovanovich's lieutenants said that Jovanovich was not "nice"—that he did not do things for nice reasons, he did them because they were profitable, not necessarily financially but one way or another. This person said it would upset WJ to be called nice, and he did not mean that WJ was modest or that he lacked

merit. "Merit" in this context does not mean those who are good in the Christian sense (nor does it in the case of the artist). Such traditionally are not rewarded in this world, however much a society—or an individual—must protect itself when a gross lack of morality appears.

Those appetites which may impel the development of a "manipulative" talent have given that word its pejorative connotations, but manipulation always exists in human situations whether we acknowledge it or not and can only be characterized as good or bad according to, not its proposed end, but what actually happens. To many, the idea of human beings using one another seems pernicious. But if one considers "manipulation" as "working together," it seems not so bad.

How is what happens decided? The bare bones of Stanton's schedule provide only minimal clues to his success. The men who succeed in breaking into particular circles are inimitable, even though the more general means of entry into an establishment do not especially differ. This is not to say that the men do not have certain aspects in common. Psychologists tell us that typically success within an organization comes to those who are sociable, self-confident, cooperative, and masculine.[4] These are the characteristics which are the most efficient for dealing with other people. Typically, artists are not such. However, they too are manipulative, in their different way. What happens may be decided by a natural process:

> Life, growth and development are essentially opportunistic in their progress. That is because every act requires some implementation, and any impulse shifts about—or perhaps, is shifted about with the flow of its situation—until it finds a medium for its expression. This medium may be simply a material to act upon [as in the case of the artist] . . . or it may involve a constellation of other acts, which may be in progress or ready to be induced, to support the actualization of the impulse in question.[5] [Which constellation is already an organization.]

Then it was not really luck that all nine found an appropriate medium for their expression.

It was, however, their good luck to be born with a certain amount of intelligence (and at least two I would call brilliant). Their parents tended to have high I.Q.'s, and in such the focus is "upon such immediately visible virtues as cleanliness, good manners, studiousness. In contrast, the parents of the creative adolescents focus upon less visible qualities such as the child's openness to experience, his values, and his interests and enthusiasms."[6] Contrast the childhoods of Goodrich, Lowry, Lieberson, with those of Catledge, Jovanovich, Ransom. The measurement of intelligence has in the last twenty years shifted away from convergent thinking—responses that fit the known and specified—to include divergent thinking—"originality, fluency of ideas, flexibility, sensitivity to defects and missing elements, and

the ability to elaborate and redefine"—those things which measure crea-
tivity. The creativity of these nine tended to be defined by the limits of
the structure of their organizations but less so in the cases of those few
who tended toward the artistic. In speaking of the "psychometric measure-
ment of creativity," Razik noted that "the inference of MacKinnon and
Barron's findings is inescapable—that our present identification methods
may be keeping many of our potentially creative producers out of college
and graduate schools."[7] Lowry agreed with this, though he disbelieved
that a college or university in the fifties and sixties was the most appro-
priate place for artists.

The men had strikingly different personalities. A rundown of their
chief attributes might go something like this: Donovan, aggressive judi-
ciousness; Catledge, inquisitiveness; Jovanovich, pride; Stanton, precise
service; Thompson, pleasure in process; Lieberson, trying to get the best of
all possible worlds; Ransom, the community as substitute for private life;
Goodrich, responsiveness; Lowry, the drive to orchestrate. All nine had
luck in the timing of their careers and luck in their timing within organi-
zations: widespread prosperity prevailed while they were hitting their
strides. They were, in general, well organized emotionally, and the divorce
rate among them was lower than it is for the population at large. But other
men have all these and work hard, with equal stamina, yet, being without
luck and that indefinable thing called "talent," are fated to achieve only
moderate success and perhaps fail to understand why. (Conversely, Paley
commented he was sure some men within his organization didn't under-
stand why they had been successful.) A prime factor in the success of these
nine was the ability to handle others, whatever the basis (as above), and
to balance potentially conflicting elements. But manipulative talent can't
be the definition of a person's worth—only the definition of his usefulness
in particular contexts: in the cases of these men, institutional contexts; in
the case of the artist, the context of his art. How useful one's particular
personality is depends upon the specific situation in which he finds him-
self (although the natural tendency may become perverse). But some qual-
ities, more than others, make men more broadly useful. For instance, an
artist would be likely to become blocked if he persisted in judging every-
thing he did as he went along; whereas Donovan has made a great success
with this trait and undoubtedly would have done so no matter where he
was placed so long as it was within an organization.

Although Murray Kempton considered Catledge a servant to the owner
of *The New York Times*[8] (and by that same reasoning probably would
consider Stanton a servant to William Paley), neither managers nor artists
tend to be notably service-oriented in their personal relations. Indeed the
first, as a group, tend to be exploitative—but using serviceability in order

to get their way—while artists, although strongly narcissistic, are more interested in nurturing their own work than in either exploiting or serving others, in the usual senses of those terms. Kempton should have said Catledge and Stanton were "staff" persons, a term of which Lowry was proud. They served organizations and held power by virtue of their positions, as indeed did all of the nine men. Where they went and whom they saw was based on their jobs (and their jobs were based on whom they saw), and such relationships preclude friendship, which perhaps is why so many were said to have no friends.

Desirable change tends not to occur naturally. Institutional definition became the job of these men. An organization must maintain the essential validity of the reason for its existence in spite of changes in its environment which change what it is required to do. The sixties and early seventies saw the university as a good example of an institution re-examining its purposes and television as an industry on the verge of great change. The person apparently in control of an organization—the power holder (or "holders," because these powers, in spite of Jovanovich's thinking he could do what he wanted, are much divided)—must see the need for re-examination before it is forced on the institution by crisis, if some sort of breakdown is not to occur. Dealing with change is said to be the manager's principal function, just as describing change is the journalist's.

There will always be people who disagree not only with how someone else—say a Jovanovich or a Stanton—handles a particular situation but also with the other's perceptions. Museums are in a peculiar position in relation to change because they are founded partly to nullify the effects of change, and are closest to the arts on that account. Goodrich understood this paradox and in his position chose to act on that understanding in a particular way, maintaining the integrity of his understanding while under considerable attack. But within a profession, or type of organization, the arguments stay more or less within defined boundaries. When they are carried outside, another method of organizing appears as more appropriate. My argument with CBS was a good example of that. As is the broader view of intellectuals. And also the Washington bureau of *The New York Times*.

Reston had spoken of that group operating within the " 'triangle' of the university-foundation life, the communications media, and the government."[9] Lowry thought that the Ford Foundation was close to "a nexus" for the blending of activities between the academy and the government—"the scholar operators influencing government action and government policy"— and yet that the tightness of the mix was "dangerously wrong to assume." If it *were* assumed, he said, then scholars within a few decades would lose their identity. Speaking of a series of articles by Theodore H. White for *Life* magazine,[10] Lowry said that what White missed entirely,

unless he got it in the third article, is that the very thing he [and Reston] is applauding may be the seed of great deterioration of the whole system of higher education. We are equally concerned in the sixties with what happened to the place that these men enlarged to become an operating laboratory for national and international problems and what this has done to higher education, taking undergraduates, is already visible; and many of us are worried that the tide cannot be even modified—you know, that it will engulf the whole higher educational system. The system of values for the young potential scholar or teacher now is so perverted by his seeing what these men do and where the honors go—the honors go in the university today to the sort of man that White's talking about. The honors that go to the teachers of undergraduates are minimal compared to this. And this value split is affecting class after class of young highly selected undergraduates now.

Lowry added that he had "had six men for eight months two years ago looking for signs of a reversal [of this trend toward blending of activities]. . . . They spent about six months going around the country either looking for signs or suggestions as to devices to help reverse it. And it all ended up very intangible."

Managers need special skills. They are concerned with a wider variety of structures than are artists. "Artistic directors" are positioned halfway between the middleman and the artist—even more removed from the audience—and have training in the arts but, working in organizations, they are unlikely to remain or to become effective artists. ". . . if you're going to work with people, you can't afford to be too different," said a character in a C. P. Snow novel.[11] The technocrat, the middle middleman, is most effective when he is well liked. Both artists and top administrators to be most effective must not need too much to be liked by their associates, as Wicker did. Management is the art of handling men so as to utilize their talents without participating in their experience. So Ransom with Silber; so Stanton with Friendly; so Jovanovich with Hiram Haydn. So Lowry. And so the swan with Leda. In 1923, William Butler Yeats wrote a beautiful and terrifyingly complex poem on the subject of power:

> A sudden blow: the great wings beating still
> Above the staggering girl, her thighs caressed
> By the dark webs, her nape caught in his bill,
> He holds her helpless breast upon his breast.
>
> How can those terrified vague fingers push
> The feathered glory from her loosening thighs?
> And how can body, laid in that white rush,
> But feel the strange heart beating where it lies?

A shudder in the loins engenders there
The broken wall, the burning roof and tower
And Agamemnon dead.
 Being so caught up,
So mastered by the brute blood of the air,
Did she put on his knowledge with his power
Before the indifferent beak could let her drop?[12]

Each subordinate undoubtedly thought he was participating in the experience of his superior and, like all subordinates, each had the power to force his superior to act in certain ways (sometimes if only by his presence). But any efficient manager attempts—or should attempt—to exploit short-run troubles for long-term benefits. Managers believe they are participating in the experience of the artists with whom they may want to deal, but they are not, except superficially.

These nine then—or their representatives—were the people with whom the artist had to deal if he expected any reciprocal dealing with his work in institutions that operated under a set of guidelines defining their area of interest, although the attitudes toward that area of interest might vary from company to company within an industry. A balance has to be maintained between the interest of the artist and that of the institution, a balance that is not a compromise of substance, for where the arts are concerned, substance is all-important. These organizations did indeed set the ground rules for stability and change in the cultural life of America. But the ground rules can be changed and cultural life must finally be differentiated from the arts, whether artists form a significant part of their own audiences (as with little magazines) or not. Strindberg called the immobility of the soul a middle-class idea.

Catledge remembered his father "instructing me one time on my rights in a democratic society." He continued:

I was on a debating team, or something anyway, in school, and got terribly upset because my side hadn't prevailed. I just wasn't going to take it. And so he said, "Let me tell you something, young man," he sez. "In a democracy, the greatest right a minority has is the right to be heard. After it has been heard, the majority makes the decision." And I've always thought of that—what are the minorities' rights in making democratic decisions.

Artists as a minority *can't* become part of those decisions without self-destructing, which means that the majority (for its own benefit) has a special duty to allow this particular minority its function.

It sounds dull and absurd to say that Leda might have negotiated with the swan. Nevertheless, some compromises can be effected—between government and the arts, for instance—based perhaps on the behavior of the

artist as opposed to the substance of his art. The artist finds it useful for his work to attempt to regress to primitive modes of thought and feeling. He must, however, for his own sake and the sake of his art, maintain control even while regressing, since the psychotic loses its validity—as do political statements made in the wrong arena.[13] Artists ought not stock arsenals, as playwright LeRoi Jones did. But to what extent individual artists can control tendencies toward alienation, rebellion, insolence, untrustworthiness, hostility, apathy, importunement, intrusiveness, and so forth, is an open question. Genius is aligned with madness in non-recognition of, or unwillingness to enter into, usual patterns of behavior calculated to reassure others because they *are* usual, says Goffman in *Relations in Public*.[14] But genius defined as high general intelligence has a low correlation with creativity. Genius defined as that aptitude which qualifies a person for success in a given pursuit finds its appropriate expression in said pursuit, heightening creativity and the chance for art.

Donovan tries to achieve a balance within his organization; as does the university president who puts a poet-in-residence on his campus or deals with young revolutionaries; as does the television network with its producers, directors, actors. In dealing with complicated issues, various alternatives, not mutually exclusive, are available; there can be varying combinations of flexibility and rigidity in an approach and which is proper depends on the particular situation. Different people are responsive to different elements within the same situation—artists are least responsive to social or business situations; most responsive to aesthetic.

An ideal balance undoubtedly is not possible when both sides work within an organization the purpose of which has been agreed to by the one but will never be agreed to by the other. They can use each other's work—the artist needs not only distribution and support but also criticism, and organizations (especially such as these) feed on the arts—but their frames of reference will never coincide. Lowry said:

> As a matter of fact, you can do as much for people almost by belief as you do by money. . . . Trustees of foundations are not used to *facts* in the arts, you know—making facts of each proposal seem as mundane and as palpable as facts about economics or overseas development. . . . If these people on my board really happened to understand about music or theater, they wouldn't be comfortable about supporting it sometimes. But they *can* understand, and they've learned to have a right to expect to understand, about each proposal, program, project, put in front of them, to ask questions.

There may be nothing wrong *per se* with the federal government supporting artists, or with Time Inc. peddling books, or with television using art of various sorts: but "hands off content" is a necessary motto for the organi-

zation. ("The state is no academy of arts," wrote a German philosopher; "when it abandons power in favor of ideal strivings of mankind, it denies its own essential being and goes down.")[15] Of course, this is not to say that the content of any artwork has to be accepted by any organization. The artist has no automatic right to an audience for anything he may create. Both sides retain the right of choice. The "Spartan effect," said Lowry,

> has much to do with the drive or fanaticism or whatever of the person who has made his choice, and will eschew anything else—money, the elite identification of a university degree, even health—to develop the talent he hopes he has. . . . It comes, finally, from the acceptance [by the artist] of such distortion as a way of life, a way of life, you will note, that is in some ways completely antithetical to the ideal objective of a liberal and humane education.[16]

Which came first, being inculcated with the values of specific segments of our society or choosing to identify with those segments because already inculcated? As with Stanton versus Murrow and Friendly, the functions of the men involved are dissimilar and their personalities appropriate for their particular work—and the tensions between them inevitable.

Within an organization, it is impossible to see how the situation could not become tense. Donovan may see a need to let non-administrators at Time Inc. function on a loose rein so far as the expression of their personalities is concerned but he cannot let them make effective choices for themselves so far as their work is concerned, unless those choices coincide with what he conceives to be the best interests of the organization. If they don't, then direct veto power must be exercised. And away goes individuality defined as "the expression of a person's 'real,' autonomous self and of his capacity to attain psychic security in group situations without surrendering his power to make effective choices for himself or to maximize his self-expression and creativity."[17]

> The more the creator has freedom to choose his own objective and to determine the structure of the situation within which he arrives at a solution, the more we can speak of a truly creative process.[18]

Of course, the artist usually gets veto signals in a number of different ways from the society in which he lives, both least and most likely from his own peers, and then has to decide either to give up being an artist or to compromise his art so that it becomes something else or to stubbornly continue on his own way. Herbert Gutman speaks of two fundamental trends, one adaptive, or toward self-maintenance; the other creative, or toward self-development.[19] These have previously been described as being toward autonomy or homonomy. We can see them operating in the lives of the nine men. John Gardner, aiming at equilibrium between the two, at

the end of the sixties and into the seventies was actively attempting to re-design those large-scale institutions of which he had spoken, in order to make them more hospitable to the individual;[20] but in the case of the artist, where individuality apparently has to be extreme in order to have a chance to be successful, it might be a better idea for the artist to try to do his work outside of such institutions. And of course many individuals who are not artists are effective and successful when they do not join institutions but become one themselves, such as Henry Luce or Ralph Nader: they build their lives out of the substance of their work just as artists do.

Gutman[21] classifies man-made structures as:

1. existential (passively serving a purpose)
2. operational
3. human social
4. artistic and symbolic

Regarding the human-social structure, we have seen that the organization allows the man to lead it; that if a position is appropriate for an individual, it brings power; that such power puts a man in a position to exploit conflict; that individuals are more efficiently exploited when not suppressed; that power consists of being able to manage change (with men coming into positions of power not only because they are effectively manipulative but also because they are lucky); that a continuing structure weighs more than most single individuals in the pluralism of forces that work to create change. (These things are true for artists as well as for men in organizations but frequently cannot be seen over the short run.) And we have seen men going along with institutions whether they be broadcasting companies or families or universities or publishing enterprises—people both inside and outside of the organizations.

Participation means attempted manipulation, so that there is constant tension and shifting even as balances are being struck (see Stanton in his pursuit of "talent"). In the case of the regulatory agencies, including the FCC, the idea generally had been to try to ensure a state of affairs rather than to see that a set of rules was scrupulously followed. James Q. Wilson, in an article entitled "The Dead Hand of Regulation,"[22] pointed out that goals are likely to be ambiguous and the cases all different, and that the greater the codification of substantive policy, the less power could be wielded. The more an artist's work is finished, the less power anyone else has over its content. One attempts to look at the organizations herein framed by this idea: then it was to the advantage of these organizations to deal flexibly with their artists. Fluidity was the essence of power, but only for men in organizations.

And it is not enough simply to respond flexibly. Those in organizations

(by "organizations" always meaning such institutions as have been de-
scribed herein, since everything, everywhere, is organized to some extent
or other) were far and away more skilled at manipulating people (as op-
posed to forms), for that was their job. What did work most effectively
was being alert to the possibility of *directing flow*. Each of the nine men
had his particular philosophy engendered by his personality as to the direc-
tion that flow should take, and each was successful to the extent that his
concern with the flow was identical with the institutional concern or that
he was able to move the institutional concern to make it more identical
with his.

"The form of the corporation is changing," wrote Donald Schon in
Technology and Change,

> from a pyramid, with white-collar slaves arranged in spreading layers
> beneath a boss, into a circular design where different groups of people
> with their different interests work together but are linked to a central
> core which provides them with services and a bank for funds, and most
> important, acts as a broker among the different linking parts in arranging
> deals and doing jobs. . . . The model is repeated with variations in the
> large conglomerate corporations; multiversities are not unlike it, with
> graduate institutes and laboratories surrounding the central bank, or
> administration; and perhaps the most striking similarity is to the design
> of a computer operation, with the computer clients arranged in a circle
> around the great machine, all waiting for a crack at its problem-solving
> abilities.[23]

Intelligence matters in pattern making.

The men had grown up taking what models they could from the world
around them, and they were good at operating on such a basis. This book
can be combed for instances: Catledge's connection with Rand; Donovan's
connection with Luce; Jovanovich's teachers; etc. Schoolteachers turn out
to serve as models even when they are not the biological parents,[24] but
quite a few of these nine men had schoolteacher parents, and a majority
grew up in homes where reading was valued. Lowry tells of a meeting at
the Ford Foundation where Wystan Auden kept talking about an elite:

> He kept saying, "Stop worrying about educating the masses about this.
> Only the elite is going to read my poetry and have any understanding of
> it anyhow. It's these people you're talking about." And to make his point
> once, when he got the floor, he said, "Suppose somebody grew up fifty
> years ago in the wilds of Kansas. . . ." And having the prerogative of
> being in the chair, I said, "Okay, let's suppose that: that's exactly what
> I did. That is exactly what I did." Well, he was taken aback, and then
> he said, "What happened? What explains it? What were your parents?"
> And I said, "They were schoolteachers." "Okay," he said, "that explains
> it."

But their models were borrowing organization from themselves. That is: "The analogous relationship between these structures in their functional aspects and man's own functional organization is not a mere coincidence. It exists by virtue of the fact that 'models' as any other creation of man are externalizations of their creator."[25]

The nine were creative in their use of models but less clever at inventing, which stands to reason. The artistic and symbolic structure is of a different order than the human social. (However, a common error is to think of art as based on an assumption of the superiority of emotions to reason and intellect.) But, wrote Ralph Ross and Ernest van den Haag in *The Fabric of Society*,[26] "there are men who find, in some few activities of life, the kind of demand on personality that art makes combined with the kind of freedom that it allows. For these men the resources of the self may be utilized in action somewhat as they are utilized by the artist in his work." As we saw, Lowry appeared to think he was one such: the others were less self-conscious about it. They could exploit situations for personal advantage (which in turn worked to the advantage of others: see Thompson and the arts) because they had made appropriate occupational choices, which is one guarantee of success. Money *per se* was a relatively unimportant motive: their work was prestigious. Although involved with culture, their individual taste with regard to the arts was not so important as might be thought.

The men both make and complete their settings. The architect as artist and sculptor is able to achieve a setting in which modernist art makes sense as part of a fragmented, multi-patterned, juxtaposed and interrelated, finally unitary world in all of its complexity. The individual pieces have only minimal interest as visual (or other kinds of) objects; more interest historically; most interest as pieces in a designed whole. The entire setting becomes the work of art (McLuhan's inclusive image) in this most modern of fashions. In the photograph on page 459, the architect has placed himself to complete the picture, and his equivalent—dark suit and all—might be constructed in fiber glass to stand there forever so long as the gallery survives. So, too, I have tried to give you a designed whole, with the pieces "equivalents" in Ozenfant's sense,[27] but also "fragmented, multi-patterned, juxtaposed and interrelated, finally unitary"—and these nine men are the pieces.

Stanton understood that scrupulous care with which individual parts had to be wrought to accomplish a whole—in situations as well as with objects. (It was typical of him to have agreed to be a member of the board of a foundation called Experiments in Art and Technology [EAT]—and it was typical of the sixties that there should have been such a group.) One

"In the spectacular glass-roofed gallery he built for his own sculpture collection at New Canaan, architect Philip Johnson is flanked by a Robert Morris (left) and a relief by Claes Oldenburg (right). On the floor below: Robert Morris' nine-piece minimalist sculpture, and a construction of crushed automobile bodies by John Chamberlain."—Time, October, 1970

gets the impression that Donovan finds the details of his own life uninteresting.

Richard Goodwin thought that if I was trying to find elements that the nine men had in common that would account for their rising in their respective worlds, I would fail. Coming up in a museum is very different from coming up in a competitive business world, he said, and added that

the latter had to "produce" while the former does not. It was also a very different thing for Frank Thompson, the congressman, he said: Thompson had to get elected and that took drive, especially when he knew that he was going to take a job which wasn't going to pay him very much. Thompson, said Goodwin, had "a very minor impact on our culture." Yet Lowry had said, "If you had to pick just one member of Congress, one politician [re government and the arts]—about which I include more than the Congress: governors and so on—I'd still take Thompson. I think he's the one."

Goodwin acknowledged that Thompson's behavior had *some* effect, but, he said, "compared to the impact of *Hedley Donovan*" (his emphasis), it didn't "amount to very much." He said their getting up could all be reduced to the drive for power but added, "That's diffusing the concept of power so much that it's meaningless. To say a guy who wants to be a congressman and a guy who wants to run *Time* magazine are after the same thing: then you're not defining the terms any more." But their powerlessness in the crude sense of "doing whatever they want to do" has been shown. From their effective organization they got a feeling of power, but it was severely circumscribed.

The manager initially organizes his work (see Stanton on page 111 setting up a department, as one instance). But once it has been effected, the organization takes on its own life in a transfer of power. The initial organizer has lost some of his power to affect the thing he has created. Stanton's "free rein" was considerably less in dealing with Friendly by the end of the chapter than it had been earlier in setting up his department. The artist, too, loses his power to affect the thing he has created when it takes on a life of its own.

An egotistical person (read "man," because in our society it is a rare woman who holds the kind of power we have been talking about), the person who is devoted to making the organization serve his own needs, has to change its purposes in order to effect this and, in so doing, warps the organization—as Fred Friendly attempted to do. But if such a man's needs are similar to those of many others in the society at large at the particular time when he is in a good position to effect change, then he may become peculiarly successful at reshaping the institution even to such an extent that the main reason for its existence changes. Then it becomes, to all intents and purposes, essentially a new organization. For a while it seemed as if this might happen at *The New York Times*.

Stanton's organization faced a decision on reshaping itself to incorporate cable television but was forced by the society in which it operated to let a new organization come into existence. Since the original activity of network television was still valid, the old institution—and its counter-

parts—continued to exist. Lowry's group had also to make a basic decision, with different results. "Even in the third year of this program," he said,

we proposed the creation of a private national arts council that would take that very role on in perpetuity, that is, by endowment. It didn't happen but it was certainly in the forefront of our thinking. My assumption was that, if that national independent council were created, it would be just a larger envelope for the same people, the same approach, the same kind of work in the field—in other words—and I knew that we can never say this—that it would have been to simply rip out one part of the Ford Foundation and give it a separate, independent thrust in perpetuity with myself and those few people who are working with me running it, is what we were talking about. It was the trustees' and the president's decision that this could go on inside the Ford Foundation with a sufficient degree of autonomy to have this effect even though spending a great deal more money, which after 1962 we started to do.

. . . In 1959, something happened in the controversial area that was indirectly related to one of the programs I had granted from the Ford Foundation, and it created a nine-day wonder in the press and a very difficult cast of mind on the part of some of our trustees about operating in the arts, and increased all the layman's normal insecurity and fear about operating in these very explosive fields with very explosive individuals. And on the eve of our board meeting where this big thing was to be discussed, the rage and temperature of our trustees—or at least a few of them—about working in the arts was at its highest point. . . . There were men in that room who before I came in to face them were ready to vote to abolish the program we had in the arts, let alone consider the creation [Lowry laughed slightly] of a large national arts council or huge program in the Ford Foundation. Now, there ensued what amounted to an inquest on the program led by the chairman of the board, John J. McCloy, and that went on for forty-five minutes, and it took forty-five minutes to determine whether there was going to be a Mac Lowry or a continuing program in the arts.

Now, they did not abolish the program. I freely argued they had to follow these policies if they wanted to be in the arts—if they didn't want to be in the arts, they shouldn't be in the arts, but they couldn't be in the arts without these policies—which meant no control of the grantee or his repertoire once a grant was made and meant that in the process of selecting individual artists, the artistic criteria alone, not any other criteria—political, moral, personal, or anything else—should affect it. And finally first one and then another of the trustees came to the support of these principles, and the ruckus subsided: "Well, what about our current program?" And they reinstituted that with a vote of affirmation, not a formal vote. And then they said, "Let's double the budget of the current program." So I went all the way from death to growth.

The creation of a private, separate art foundation of the sort Lowry had been discussing might have ruined the more general pattern of support for the arts in America, if it had been done at that time. "Seldom, if ever, in history," wrote Toffler, "have the arts of a nation drawn patronage simultaneously from so many diverse sources. Individuals, corporations, foundations, universities, voluntary organizations and city, country, and state governments are all, in their different ways, channeling funds into the nonprofit sector of the culture industry."[28] "A Warning Against Idle Culture Factories," read a headline in *The New York Times* on May 21, 1966. "Which is the real power and which the false: the state's history of arts and letters or its history of might, its industrial and military strength?" wrote De Grazia.[29]

The legislation establishing federal participation in television and in the arts might work to change the pattern of support for the arts. Some time after the establishment of the National Endowment, which Lowry had worked hard for, he predicted that

> . . . the flourishing or improvement of the state of the arts in the United States will *not* come from a joining of hands by organizations—foundations, federal, state, local trustees, trusteeships and so on. Will *not* come that way, but through very concretely focused activities that spring out of a person's or an institution's own expression—whether it's a foundation or just a group—or even hopefully someday a government official serving as a minister of the arts, which I suppose we'll come to.

What Lowry himself "came to," in 1973, was the planning of a private, national foundation of which he would be chairman and chief executive. It was to be called the Foundation for the Humanities and the Arts and would only exist, Lowry said, if it could come into being as one of the larger foundations in the world. The new organization was to have broad-based support, perhaps to a certain extent even including funds from other small foundations lacking expertise in these areas.

Lowry had been able to identify a few potential associates during his years at Ford. The incorporators he chose included artists and humanists along with "some extremely wealthy patrons of the arts, as well as some people with renowned abilities for raising money for the arts."[30] They also included Goddard Lieberson and Frank Thompson.

Bundy, caught somewhat by surprise, spoke up in favor of a healthy pluralism. Except for a declining stock market, the time seemed ripe. For Lowry himself, it was soon or never, so far as his own leadership might be involved. There were too many other things he would like to do and say, for himself, if launching the new foundation had to be postponed. Lowry's characteristic behavior was to seem to be holding back but, when the direc-

tion of a change became focused, to lean with a weight that was heavier because he had come to sincerely believe in it. The artist's belief in his own weight did not position him to reshape institutions.

In fact, when the artist functions successfully inside an institution, his purpose has changed. Or perhaps never was that of the fine artist. "Bohemianism, then, seems to have been on the verge of capitulation to industrial society's apparent capacity to nullify any form of dissent," wrote a sociologist.[31] But bohemianism was only a superficial aspect of the mode of an artist, only a surface manifestation. His deepest dissent was a stubborn insistence on the unique thing he has to offer. "Apparent" is the most interesting word in the above-quoted sentence.

Neither dissent nor its opposite—that is, functioning in organizations, which implies acquiescence—prevents loneliness. Individual separateness is not obsolete as McLuhan has claimed: loneliness is still part of the life of every individual be he scholar or businessman, journalist or artist, or President of the United States. Fred Hechinger believed we could be taught to see it as something other than a threat just as, he thought, we had been taught to see it as a threat—by television, etc.[32] But television did not teach us that. Loneliness is an uncomfortable fact of human existence and what is uncomfortable is perceived as threat. In fact, television has not taken away loneliness but mitigated and disguised it, reducing the need for bravery and helping us if not to master then at least not to kneel under its weight.

Other things help us too. "All art," wrote Malraux, "is a revolt against man's fate."[33] The drive for environmental mastery is a universal motivation. And art is such a mastery over the human situation, as are values. The nine men were attempting to master their immediate environment and were better at it than most. Authoritarian behavior characterized them all, more masked in some cases than in others, and least apparently characteristic of Lloyd Goodrich.

But just as authoritarian behavior is characteristic of many who cannot be characterized as authoritarian types, so manipulative behavior, so crucial in the success of all these men, does not mean they can all be characterized by what Adorno describes as the manipulative type. Stanton most directly fits that description. Adorno wrote:

> This syndrome, potentially the most dangerous one, is defined by stereotypy as an extreme: rigid notions become ends rather than means, and the whole world is divided into empty, schematic, administrative fields. There is an almost complete lack of object cathexis and of emotional ties. . . . The break between internal and external world, in this case, does not result in anything like ordinary "introversion," but rather the

contrary: a kind of compulsive overrealism which treats everything and everyone as an object to be handled, manipulated, seized by the subject's own theoretical and practical patterns. The technical aspects of life, and things *qua* "tools" are fraught with libido. The emphasis is on "doing things," with far-reaching indifference towards the content of what is going to be done. The pattern is found in numerous business people and also, in increasing numbers, among members of the rising managerial and technological class. . . . Their sober intelligence, together with their almost complete absence of any affections, makes them perhaps the most merciless of all. . . . The ingroup-outgroup relationship becomes the principle according to which the whole world is abstractly organized.[34]

Adorno, of course, is describing a type, not a person.

Adorno's description somewhat fits both Stanton and Donovan. Evidence of emphasis on "doing things," the technical aspects of life, is scattered throughout Stanton's biography. Of the ingroup-outgroup aspects, Adorno further says, ". . . the only moral quality that plays a considerable role in the thinking of this subject is loyalty, perhaps as a compensation for his own lack of affection. By loyalty he [the manipulative type] probably means complete and unconditional identification of a person with the group to which he happens to belong."[35] (See specifically the description of Stanton's behavior on page 189.) The power of the ingroup when seen from the perspective of the insider can easily be exaggerated. In the illustration on page 167, Time Inc. meets with the government of Russia on a formal basis. Then there is the weight with which *Life* shifted its position on Vietnam.

Although Edgar Friedenberg, in reviewing Willie Morris's autobiography,[36] pronounced it an archaic faith that society has enough structure to permit one to care which are the important people, one can easily see the ingroups in this book. One feels the loneliness of outsiders. Psychologically, to see one's self in a mirror is to verify one's existence. Perhaps that is what artists are doing when they create. To have to look is to have to be reassured that one is important, in fact perhaps that one even exists, a form of self-recognition. No matter if the basis is as spurious as it is in *Time* magazine's advertisement "See Yourself as Man of the Year." What manner of dispossessed could gain reassurance from being reminded that one is *not*? But the ad is more comic than sad in its utter vulgarity.

There is another point at which one could guess Adorno's description might meet Stanton: " 'Organizers' are frequently persons who want to exercise domineering control over those who are actually their *equals*—substitutes for the siblings over whom they wish to rule, like the father, as the

Advertisement in Time, *September,
1970*

next best thing, if they cannot kill them."[37] Stanton's situation in a home
where his mother had to attend primarily to his brother is worth thinking
about (see page 14). But Stanton also was clearly more brilliant than
most of the people with whom he worked. Jovanovich seemed to feel he
could only be recognized as equal if he dominated. In curious fashion, he
was always giving too much to the other person, as well as too little.
Donovan was extremely close to his brother, and it was not possible to dis-
cover what effect his brother's premature death (in adulthood) had on him.

Adorno considered the manipulative type as differentiated from the
authoritarian type "by the simultaneity of extreme narcissism and a certain
emptiness and shallowness. This, however, involves a contradiction only if
looked at superficially, since whatever we call a person's emotional and
intellectual richness is due to the intensity of his object cathexes. Notable

in our case [the individual Adorno used as type] is an interest in sex almost amounting to preoccupation, going with backwardness as far as actual experience is concerned."[38] Opposed to these types is the construct of the Genuine Liberal, which Lowry most nearly approaches and which, according to Adorno, "may be conceived in terms of that balance between super-ego, ego, and id which Freud deemed ideal."[39] The person who most nearly embodied the liberal was also the only one of the nine to have what vocational psychologists call a multiple-trial career—perhaps someday a correlation will be shown. By the end of the sixties Freud's terms had become somewhat outmoded (as Adorno had to a certain extent fallen into disfavor among political scientists); nevertheless, those paradigms have value.

For all of these men, then, the world was organized into ingroup-outgroup relationships, a characteristic apparent in artists—so at least it seems to me—primarily in the organizers and politicians among them who are more concerned with the distribution of awards than with what might be supposed to be their work. Again taking the definition of a politician as not pejorative: yet a politician is not a fine artist, though creative he may be.

Politicians in a general sense these nine men were, and as America moved into the mid-seventies their ability to deal with differences and change continued to be tested. Many had to find new roles that were self-supporting: some were ousted, some went into retirement and some into precarious health, while one or two seemed still to be moving toward personal fruition.

The outlines of their lives are plain: what is missing compels the imagination. ". . . of the awareness of transitional stages, of the alternation of struggle and acceptance; of the need for sympathy and the rejection of sympathy; of the onslaughts of childhood memories and the attacks of philosophy in endless interior dialogues about the meaning of life"[40]—of these I have only hinted. The men themselves could not express them. To attempt to embody them fully is the work of the artist.

I have tried to give the reader an equivalent to the cultural process. All process quickly becomes submerged, and the way the importance of it fades once things have been accomplished stands in great contrast to the stability and permanence which is the meaning and value of art. Process, frequently invisible, crops up in the dreams of restless men or is repeated as the experienced eye surveys the scene (which may be a work of art or a board-room meeting) where the small events of which it is comprised undergo a kind of sorting according to the unique life experience of the individual. Forms emerge. Order comes about through education, which is the transmission of culture; education through the use of forms, models.

Ransom believed almost exclusively in the cultural world. Loren Eiseley calls the cultural world the second order of stability, the first being the natural world.[41] Stable because the cultural world is based on regularities and patterns in the same way that the natural world is, since it is equally natural.[42] My problem has been, how to find that order.

Many of the incidents included in this book may appear as tiny events indeed. But realization and deeper understanding of *process* has been understood in this psychologically oriented age as a device for lessening hostility which may affect not only the way in which people work together but also the way in which they permit others to work apart on what must be seen, too, as common cause—even though hostility may motivate such work. Art is work in which even the ugliest feelings benefit mankind.

Of this Malraux speaks beautifully:

> Nietzsche has written that when we see a meadow ablaze with the flowers of spring, the thought that the whole human race is no more than a luxuriant growth of the same order, created to no end by some blind force, would be unbearable, could we bring ourselves to realize all that the thought implies. Perhaps. Yet I have often seen the Malayan seas at night starred with phosphorescent medusas as far as eye could reach, and then I have watched the shimmering cloud of the fireflies, dancing along the hillsides up to the jungle's edge, fade gradually out as dawn spread up the sky, and I have told myself that even though the life of man were futile as that short-lived radiance, the implacable indifference of the sunlight was after all no stronger than the phosphorescent medusa which carved the tomb of the Medici in vanquished Florence or that which etched *The Three Crosses* in solitude and neglect. What did Rembrandt matter to the drift of the nebulae? Yet if it is Man whom the stars so icily repudiate, it was to Man, too, that Rembrandt spoke. Pitiful, indeed, may seem the lot of Man whose little days end in a black night of nothingness; yet though humanity may mean so little in the scheme of things, it is weak, human hands—forever delving in the earth which bears alike the traces of the Aurignacian half-man half-brute and those of the death of empires—that draw forth images whose aloofness or communion alike bear witness to the dignity of Man: no manifestation of grandeur is separable from that which upholds it, and such is Man's prerogative. All other forms of life are subject, uncreative, flies without light.[43]

Anything that gives us power over death (including death in life) brings us the real power. Some have argued that living in an interdependent society we are all inexorably subject to much besides death. And so we are. But the artist cannot be conditioned to produce art and, to be an artist, must serve his own daemon. Things don't work as in a cartoon.

"One lyrical landscape—heavy on the Wyeth, light on the Expressionism."

It needs to be said that the artist is both undervalued and overvalued in our society at one and the same time.

It needs to be said that not everyone is or can be an artist.

It needs to be said that any organization has to exist for the sake of the individual, and the question is how to use organizations appropriately.

It needs to be said that neither diversity nor singularity is adequate in and of itself and that rote formulas solve no problems (for example, either for the television industry or for those who stand outside criticizing).

This book outlines what I have encountered. It is not journalistic truth

469 · The Real Power

any more than it is the other kinds of disciplinary truth of which I spoke in the preface. But it is my truth and done under my own discipline, and it means to say no man can serve two masters unless the interests of those two masters happen to coincide, as in the interests, say, of the person and the organization. The interests of artists and of institutions do not coincide. I once told the playwright Arnold Weinstein[44] that (like Lieberson, although I did not tell Weinstein that) I was trying to get the best of all possible worlds, to which he soberly replied that it was hard enough to get the best of one.

Now some publishers keep on as editors men of whom they sometimes say such things as "he's too damn intellectual." Which is another way of saying the editor is not sufficiently involved with the financial interests of the organization. (Nevertheless, these publishers tend to be rather proud of this display of their cultural interests.) But such employees can't really be so "damn intellectual" or they wouldn't and shouldn't stay on. They serve themselves.

Lowry served himself, as witness his conversation with Reston (and so did Reston, along with whatever else he served), but Lowry also served the Ford Foundation and the artist. He whistled up the wind occasionally, but his whistling had more authority than that of, say, any Kansas preacher, with regard to his work, and this too is what power really consists of: it is always relative. The situation with the nine men has been laid out. But as a footnote on Donovan it should be told that when asked if he daydreamed, he replied that he preferred to call it thinking. He would never have made an artist.

Hedley Donovan

NOTES

PREFACE

Material from interview notes and transcripts: Eric Goldman, Barnaby Keeney, W. McNeil Lowry, Theodore Roszak.

1. Irving Howe, "The New York Intellectuals," *Commentary*, October 1968.
2. Leonard B. Meyer, *Music, the Arts, and Ideas* (University of Chicago Press, 1967).
3. Adolf A. Berle and Gardiner C. Means, *The Modern Corporation and Private Property* (rev. ed., Harcourt, Brace, 1968).
4. *Ibid.*
5. John Kenneth Galbraith, *The New Industrial State* (Houghton Mifflin, 1967).
6. *Ibid.*
7. Nicholas Johnson, *How to Talk Back to Your TV Set* (Little, Brown, 1970).
8. Harold Cruse.
9. C. H. Waddington, *The New York Review of Books*, June 5, 1969.
10. "The unfailing mark of modernity is the feeling deep in the bones that everything is connected with everything else." Joseph Kraft, *Profiles in Power* (New American Library, 1966).
11. Sir Isaiah Berlin, *The Hedgehog and the Fox* (Simon & Schuster, 1953).
12. William Jovanovich, "Information as Property," *California Monthly*, April–May 1967.
13. *Webster's New International Dictionary* (unabridged), 2nd ed.
14. Elizabeth Simpson commented that Kroeber and Kluckhohn found 257 different definitions of "culture."
15. T. S. Eliot, *Notes Towards the Definition of Culture* (Faber and Faber, 1948).
16. This point is well made in Arthur Miller's play *The Price*.
17. *Complete Poems of Robert Frost* (Holt, Rinehart & Winston, 1949).
18. Lawrance Thompson, *Robert Frost: The Early Years, 1874–1915* (Holt, Rinehart & Winston, 1966) and *Robert Frost: The Years of Triumph, 1915–1938* (Holt, Rinehart & Winston, 1970).
19. *The Poems of Gerard Manley Hopkins* (Oxford University Press, 1967).
20. Amédée Ozenfant, *Foundations of Modern Art* (Dover, 1952).
21. Rudolf Arnheim, *Art and Visual Perception: A Psychology of the Creative Eye* (University of California Press, 1954).
22. William Jovanovich, *Now, Barabbas* (Harper & Row, 1964).

CHAPTER 1

Material from interview notes and transcripts: Erik Barnouw, Lloyd Goodrich, Henry Heald, W. McNeil Lowry, William Paley, Frank Stanton.

1. I did not have a tape machine with me, and at the end of our conversation Paley asked me if I had total recall. I got the impression he wanted to be sure nothing he had to say was lost. Exactly one hour after I had been shown in, I was shown out.

2. Abraham Kaplan, "Power in Perspective," in Robert L. Kahn and Elise Boulding, eds., *Power and Conflict in Organizations* (Basic Books, 1964).

3. Joseph T. Klapper, *The Effects of Mass Communication* (Free Press, 1960).

4. Frank Stanton's notebooks, Volume IV, Remarks Before the Anti-Defamation League Freedom Forum, December 6, 1958.

5. Figures taken from the 1967 CBS report to stockholders.

6. The brief account of Sarnoff's life that follows was drawn from Eugene Lyons, *David Sarnoff* (Harper & Row, 1966).

7. Information about the formation of RCA comes from Lyons' book, cited above, as well as Erik Barnouw, *A Tower in Babel* (Oxford University Press, 1966).

8. This story comes from Barnouw's *A Tower in Babel*.

9. *Ibid.*

10. ". . . the Communications Satellite Act authorizing creation of ComSat, a corporation owned one-half by the federal government and one-half by private investors. The proportion of investment by current communications enterprises such as A.T.&T. was severely limited, despite the fact that the primary function of the new facilities to be provided in outer space was to offer A.T.&T. and like corporations new avenues of communication." Adolf A. Berle and Gardiner C. Means, *The Modern Corporation and Private Property* (rev. ed., Harcourt, Brace, 1968).

11. *The New York Times*, October 19, 1969.

12. Barnouw, *op. cit.*

13. *Ibid.*

14. *Ibid.*

15. Barnouw reports that "Mrs. Holmes, good sport . . . held stock, which she is said to have sold eventually for some three million dollars."

16. Oliver Read and Walter L. Welch, *From Tin Foil to Stereo* (Howard W. Sams, 1959).

17. The last of this paragraph and much of the text are drawn from Barnouw's *Tower in Babel*.

18. *Ibid.*

19. *Ibid.*

20. *Ibid.*

21. Willie Morris, *North Towards Home* (Houghton Mifflin, 1967).

22. Berle and Means, *op. cit.* Mr. Berle's preface to the revised edition.

23. *Ibid.*

24. *Ibid.*

25. Barnouw, *op. cit.*

26. Meyer Berger, *The Story of the New York Times* (Simon & Schuster, 1951).

27. Frd M. Hechinger in *The New York Times*, June 2, 1969.

28. Peter H. Rossi, "Researchers, Scholars and Policy Makers: The Politics of Large Scale Research," Robert S. Morison, ed., *The Contemporary University: U.S.A.* (Houghton Mifflin, 1966).

29. Paul Lazarsfeld, "An Episode in the History of Social Research: A Memoir," in Bernard Bailyn, ed., *Perspectives in American History*, Vol. II (Harvard University Press, 1968).

30. Rossi, *op. cit.*

31. Lazarsfeld, *op. cit.*

32. This particular story was taken from the interview with Goodrich conducted by Harlan Phillips of Brandeis University for the Archives of American Art.

33. Gallup was already working in this area, but so far as I can figure out, Stanton's *device* was original.

34. Figures from "Columbia Broadcasting System, Inc., Notice of Annual Meeting and Proxy Statement 1968."
35. Eldridge Cleaver, *Soul on Ice* (McGraw-Hill, 1967).
36. *Time*, February 28, 1969.
37. David Bazelon, *Power in America* (New American Library, 1967).
38. Footnote in CBS "Notice of Annual Meeting," 1968, already cited.
39. Frank Stanton résumé as of 1967:

FRANK STANTON, Columbia Broadcasting System, Inc., President 1946–
 Chairman: United States Advisory Commission on Information, 1963–
 Birth: Muskegon, Michigan, March 20, 1908.
 Degrees: Ohio Wesleyan University, BA/30
 Ohio State University, PhD/35
 Memberships: American Academy of Arts and Sciences (Fellow)
 American Association for the Advancement of Science (Fellow)
 American Psychological Association (Fellow)
 The Architectural League of New York
 The Business Council (Graduate)
 Council on Foreign Relations, Inc.
 Institute of Electrical and Electronic Engineers
 International Radio and Television Society
 National Academy of Television Arts and Sciences
 Radio-Television News Directors Association
 Sigma Delta Chi (Fellow)
 Sigma Xi
 Clubs: The Century Association (New York); Cosmos Club (Washington);
 Harvard Club of New York City; The International Club of Washington;
 National Press Club (Washington).
 Directorships: Columbia Broadcasting System, Inc.
 CBS-Columbia SA
 CBS Foundation, Inc.
 FRU Foundation, Inc.
 Holt, Rinehart & Winston, Inc.
 Lincoln Center for the Performing Arts, Inc.
 New York Life Insurance Company
 New York Yankees, Inc.
 William S. Paley Foundation, Inc.
 Pan American World Airways, Inc.
 Planned Music, Inc.
 Radio Free Europe Fund, Inc.
 Stanford Research Institute
 Current
 Trusteeships: American Craftsmen's Council
 American Heritage Foundation
 Carnegie Institution of Washington
 Center for Advanced Study in the Behavioral Sciences
 Committee for Economic Development
 The Rockefeller Foundation
 Other
 Current
 Memberships: Board of Visitors, Air Force Systems Command
 Joint Committee on Education and Business, The American Council on Education
 The Buffalo Fine Arts Academy (Honorary Member)
 Business Council for International Understanding (Councillor)

Design and Visual Arts Visiting Committee, Board of Overseers of Harvard College
Advisory Committee, Harvard University Program on Technology and Society
National Citizens Committee for Community Relations
Advisory Committee on the Arts of the National Cultural Center
Citizens Advisory Committee, New York Public Library
New York State Council on the Arts
Information Center, United States–Japan Television Exchange
Licensed Psychologist: State of New York.

Formerly: Member of staff, Department of Psychology, Ohio State University, 1931–35. Columbia Broadcasting System, Inc.: Research staff, 1935–38; Director of Research, 1938–42; Director of Advertising, 1941–42; Vice President and General Executive, 1942–45; Vice President and General Manager, 1945. Associate Director, Office of Radio Research, Princeton University, 1937–40; Member, Market Research Council (of New York), 1938–66; Member, Advisory Committee, Office of Radio Research, Columbia University, 1940–44; Consultant, Office of Facts and Figures, 1941–42; Consultant, Office of War Information, 1942–45; Expert Consultant, Secretary of War, 1942–45; Expert Consultant, Navy Department, 1945; Domestic Broadcasting Committee, Board of War Communications, 1942–45; Governing Committee, Bureau of Applied Social Research (Columbia University), 1944–56; Governing Board, Cooperative Analysis of Broadcasting, 1945–46; Civilian Advisory Committee, Navy Department, 1946–47; Executive Committee of Joint Committee on Measurement of Public Opinion, Attitudes and Consumer Wants of National Research and Social Research Councils, 1945–49; Member, Board of Overseers of Harvard College Visiting Committee, Department of Social Relations, 1946–49; Advisory Board, Public Opinion Quarterly, 1946–51; Editorial Board of Sociometry, 1946–53; President's Committee, National Employ the Physically Handicapped Week, 1947–53; National Citizens Committee and National Corporations Committee, Community Chests and Councils of America, 1948–50; Mental Health and Planning Committee, 1949; Advertising Advisory Committee to the Secretary of Commerce, 1949–53; Board of Trustees, Sarah Lawrence College, 1948–50; Committee on Analysis of Pre-election Polls and Forecasts, Social Science Research Council, 1948–49; Marketing Executives' Society, 1950–63; Advisory Committee, National Conference on Aging of the Federal Security Agency, 1950; Communications Unit Committee, New York City Office of Civil Defense, 1950–62; National Association for Mental Health, Inc., 1951–56; Industry Advisory Committee, Federal Civil Defense Administration, 1953–62; Advisory Board, Ford Foundation TV-Radio Workshop, 1953; National Board, American Cancer Society, 1954–56; Active Member, Business Advisory Council for the Department of Commerce, 1956–60 (Vice Chairman, 1959, Executive Committee, 1957–59, Committee on World Economic Practices, 1958–59); Consultant, Office of Civil and Defense Mobilization, 1956–62; Trustee, The RAND Corporation, 1956–67 (Chairman, 1961–67); Member, Advisory Panel, Security Resources Panel, 1957 (Gaither Report); Board of Overseers of Harvard College Social Relations, Psychology, and Psychological Laboratories Visiting Committee, 1958–64; Trustee, Educational Services, Incorporated, 1958; 1961 National Fund Committee of the American National Red Cross (Vice Chairman); Advisory Board, 1963 CIOS XIII International Management Congress;

Member, United States Delegation, Second United States–Japan Conference on Cultural and Educational Interchange, 1963.

Member, Board of Directors: The American Film Center, Inc., 1944–46; Broadcast Measurement Bureau, 1944–46; National Association of Broadcasters, 1944–47; The Advertising Council, Inc., 1946–66; Planned Music of Kentucky, Inc., 1946–66; American Management Association, 1950–53; National Citizens Commission for the Public Schools, 1950–56; Film Council of America, 1954–56; Educational Facilities Laboratories, 1957–61; The Roper Public Opinion Research Center (Williams College), 1957–65; Council for Financial Aid to Education, 1953–66.

First to develop and use automatic recording device (placed in home radio sets) to determine accurate records of radio set operation . . . conducted early research in comparative measurement of "eye versus ear." Edited (with Dr. Paul F. Lazarsfeld): "Radio Research, 1941"; "Radio Research, 1942–43"; "Communications Research, 1948–49." Co-developer of Lazarsfeld-Stanton PROGRAM ANALYZER. Author (with Willard L. Valentine, *et al.*): *Students' Guide–The Study of Psychology*, 1935. Contributor: *Experimental Foundations of General Psychology*, 1938. Films (silent): "Some Physiological Reactions to Emotional Stimuli," 1932; "Factors in Visual Depth Perception," 1936.

Office: 51 West 52 Street, New York 10019.

Subject
Articles: *New Yorker*: "Let's Find Out," January 18 and 25, 1947; *Time* cover story: December 4, 1950; *Park East*: "CBStanton," July 1951; *Business Week* cover story: July 21, 1951; *National Biographic*: "FS/CBS," June 1953: *Forbes* cover story: March 1, 1956; *Printers' Ink*: November 28, December 5, 1958; *Television*: "The Fight for Editorial Freedom," January 1961; *Saturday Review*: "Dr. Frank Stanton," January 21, 1961; *TV Guide*: "Stanton of CBS: TV's Most Successful Professor," January 12–18, 1963.

Recipient: Special Art Directors Club Medal–1954 (Art Directors Club of New York); Show-management Award–1954 (*Variety*); Parlin Award–1956 (American Marketing Association); Paul W. White Memorial Award–1957 (Radio-Television News Directors Association); Keynote Award –1958 (National Association of Broadcasters); Honor Award for Distinguished Service in Journalism–1958 (University of Missouri School of Journalism); Distinguished Service Award–1959 (Radio-Television News Directors Association); Advertising Gold Medal Award–1959 (*Printers' Ink*); George Foster Peabody Award–1959 (Henry W. Grady School of Journalism, The University of Georgia), also 1960, 1961, 1964; Trustees' Award–1959 (National Academy of Television Arts and Sciences); Sigma Delta Chi Fellow–1960; Roll of Honor, The Continuing Conference on Communications and the Public Interest, 1961; Gold Medal Award–1962 (Radio and Television Executives Society); Gold Medal Award–1963 (National Institute of Social Sciences); Michael Friedsam Medal–1964 (The Architectural League of New York); Key Man Award–1965 (Avenue of the Americas Association, Inc.); Grand Award–1965 (Art Directors Club of Philadelphia); Gold Medal–1965 (New York City); Special Honor Award–1967 (American Institute of Architects).

Honorary
Degrees: Ohio Wesleyan University, LLD/46; Birmingham-Southern College, LLD/46; Ohio State University, LLD/49; Hamilton College, LLD/61;

Bowdoin College, LLD/62; Colby College, LLD/62; Boston University, LHD/63; Oberlin College, LLD/65; Brigham Young University, LLD/66.

40. Christopher Jencks and David Riesman, "On Class in America," *The Public Interest,* Winter 1968.

CHAPTER 2

Material from interview notes and transcripts: Turner Catledge, Ronnie Dugger, William Jovanovich, W. McNeil Lowry, Harry Ransom, John Silber.

1. Murray Kempton, reviewing *The Kingdom and the Power* by Gay Talese in *Life,* June 27, 1969.
2. An article in *The New Leader* claimed that the term "New Class" originated with the Russian philosopher Nikolai Berdyaev, who first used it in 1938. It became prominent when Milovan Djilas used it to describe Communists, or members of a one-party system. Since then, Adolf Berle, James Burnham, John Kenneth Galbraith, and David Bazelon are among the writers who have given it currency in this country.
3. Christopher Lasch in *The New York Review of Books,* September 28, 1967.
4. Adolf A. Berle and Gardiner C. Means, *The Modern Corporation and Private Property* (rev. ed.; Harcourt, Brace, 1968).
5. Daniel Katz, "Approaches to Managing Conflict," in Robert L. Kahn and Elise Boulding, eds., *Power and Conflict in Organizations* (Basic Books, 1964). Student activities during the 1960's in behalf of peace in Vietnam were a striking example of this.
6. Ralph Ross and Ernest Van den Haag, *The Fabric of Society* (Harcourt, Brace, 1957).
7. Paul Lazarsfeld, "An Episode in the History of Social Research: A Memoir," in Bernard Bailyn, ed., *Perspectives in American History,* Vol. II (Harvard University Press, 1968).
8. David Bazelon, *Power in America* (New American Library, 1967).
9. *Who's Who in America,* Vol. 35, 1968–69.
10. C. Wright Mills, *The Power Elite* (Oxford University Press, 1956).
11. Paul Weiss, "Science in the University," in Robert S. Morison, ed., *The Contemporary University: U.S.A.* (Houghton Mifflin, 1966).
12. Norman Birnbaum, *The Crisis of Industrial Society* (Oxford University Press, 1969).
13. Arthur M. Schlesinger, Jr., *The Coming of the New Deal,* Vol. II of *The Age of Roosevelt* (Houghton Mifflin, 1957–60).
14. Marshall McLuhan, *Understanding Media* (McGraw-Hill, 1964).
15. *Ibid.*
16. Erik Barnouw, *The Golden Web* (Oxford University Press, 1968).
17. McLuhan, *op. cit.*
18. Some of the history of Harcourt, Brace has been recounted in James Reid's memoir published by R. R. Bowker but the transcripts in the Oral History Collection at Columbia University, which comprised a verbal history, were withdrawn at Jovanovich's request and returned to those interviewed. Jovanovich considered the material in them embarrassing, not to him, he said, but to those involved. Jovanovich points out that the interviewees had complete and the only control over their own transcripts. He however had and used the power to disband the collection as a collection.
19. Richard Todd, "Where Money Grows on Decision Trees," *The New York Times Magazine,* November 10, 1968.
20. Frederick Rudolph, *The American College and University* (Knopf, 1962).
21. Todd, *op. cit.*

22. *The University and the City*, a pamphlet from the office of the president, Harvard University, 1969.

23. *The New York Times*, December 15, 1968.

24. Kenneth Keniston, "Social Change and Youth in America," in Erik H. Erikson, ed., *Youth: Change and Challenge* (Basic Books, 1963). See also Kenneth Keniston, *Young Radicals: Notes on Committed Youth* (Harcourt, Brace & World, 1969).

25. Attributed, in the Richard Todd article already cited, to the dean of the Harvard Business School.

26. Annual Report, Harcourt, Brace & World, Inc., 1968.

27. Mark Rudd was a former student at Columbia University, SDS radical leader in the 1968 unrest there. Cited in Todd's article.

28. Mrs. Lester Seligman.

29. "Determinants of Occupational Behavior" as stated by D. E. Super, in "A Theory of Vocational Development," *American Psychologist*, 1953, 8, cited in Anne Roe, *The Psychology of Occupations* (Wiley, 1956).

1. People differ in their abilities, interests, and personalities.

2. They are qualified, by virtue of these characteristics, each for a number of occupations.

3. Each of these occupations requires a characteristic pattern of abilities, interests, and personality traits, with tolerances wide enough, however, to allow both some variety of occupations for each individual and some variety of individuals in each occupation.

4. Vocational preferences and competencies, the situations in which people live and work, and hence their self concepts, change with time and experience, making choice and adjustment a continuous process.

5. This process may be summed up in a series of life stages characterized as those of growth, exploration, establishment, maintenance, and decline, and these stages may in turn be subdivided into (a) the fantasy, tentative, and realistic phases of the exploratory stage, and (b) the trial and stable phases of the establishment stage.

6. The nature of the career pattern (that is, the occupational level attained and the sequence, frequency, and duration of trial and stable jobs) is determined by the individual's parental socioeconomic level, mental ability, and personality characteristics, and by the opportunities to which he is exposed.

7. Development through the life stages can be guided, partly by facilitating the process of maturation of abilities and interests and partly by aiding in reality testing and in the development of the self concept.

8. The process of vocational development is essentially that of developing and implementing a self concept: it is a compromise process in which the concept is a product of the interaction of inherited aptitudes, neural and endocrine make-up, opportunity to play various roles, and evaluations of the extent to which the results of role playing meet with the approval of superiors and fellows.

9. The process of compromise between individual and social factors, between self concept and reality, is one of role playing, whether the role is played in fantasy, in the counseling interview, or in real life activities such as school classes, clubs, part-time work, and entry jobs.

10. Work satisfactions and life satisfactions depend upon the extent to which the individual finds adequate outlets for his abilities, interests, personality traits, and values; they depend upon his establishment in a type of work, a work situation, and a way of life in which he can play the kind of role which his growth and exploratory experiences have led him to consider congenial and appropriate.

30. "Work in America," report from the Department of Health, Education and Welfare task force, released winter 1974.

31. Erik Erikson, *Young Man Luther* (Norton, 1958).

32. Norman Podhoretz, *Making it* (Random House, 1967).

33. Super's article cited above.

34. Adolf A. Berle, *Power* (Harcourt, Brace, 1969).

35. Arthur M. Schlesinger, Jr., *The Crisis of Confidence* (Houghton Mifflin, 1969).

36. W. A. Swanberg, *Luce and His Empire* (Scribner's, 1972).

37. Harold Rosenberg, *The Tradition of the New* (Horizon, 1959).

38. *Ibid.*

CHAPTER 3

Material from interview notes and transcripts: Ronnie Dugger, Ben J. Grant, Harry Ransom, John Silber, Logan Wilson.

1. According to Christopher Jencks and David Riesman in *The Academic Revolution* (Doubleday, 1968).

2. *Ibid.*

3. Ronnie Dugger, *Our Invaded Universities: Form, Reform, and New Starts* (Norton, 1974).

4. See Kirkpatrick Sale, *SDS* (Random House, 1973).

5. Robert Nisbet, "The Future of the University," *Commentary*, Vol. 51, No. 2 (February 1971).

6. Wilson Carey McWilliams, in a review of the Sale book already cited, *The New York Times Book Review*, May 6, 1973.

7. Ronald Berman, "An Unquiet Quiet on Campus," *The New York Times Magazine*, February 10, 1974. Berman at the time was chairman of the National Endowment for the Humanities in Washington, D.C.

8. Morris became editor-in-chief of *Harper's Magazine* in 1967. His memoirs, entitled *North Towards Home*, include his experiences as editor of the student paper at the University of Texas.

9. William Cowper Brann (1855–98) was a Texas newspaperman who owned and edited a small periodical called *The Iconoclast*.

10. Cited in "A Message to Alumni, Parents, and Other Friends of Columbia from Grayson Kirk, President," June 1, 1968.

11. *Violence in America: The Complete Official Report to the National Commission on the Causes and Prevention of Violence* (New American Library, June 1969).

12. Gay Talese, *The Kingdom and the Power* (World, 1969).

13. Lewis Feuer, *The Conflict of Generations* (Basic Books, 1969).

14. Michael Miller. Cited by David M. Gordon in " 'Rebellion' in Context: A Student's View of Students," in Robert S. Morison, ed., *The Contemporary University: U.S.A.* (Houghton Mifflin, 1966).

15. Ronnie Dugger in *Our Invaded Universities*, already cited, quotes Daniel Bell, *The Reforming of General Education: The Columbia College Experience in Its National Setting* (Anchor, 1968), citing the Muscatine report by a committee of the Berkeley faculty.

16. Gordon, " 'Rebellion' in Context: A Student's View of Students," in Morison, ed., *op. cit.*

17. James Reston pointed this out in a column in *The New York Times*.

18. Edward Grossman, "In Pursuit of the American Woman," *Harper's Magazine*, February 1970.

19. Joseph Kraft, *Profiles in Power* (New American Library, 1966).

20. *Ibid.*

21. Letter from Harry Ransom, chancellor emeritus, dated May 9, 1974: "In order to be sure of legal interpretations, I requested and received the following comment from the law office of the U.T. System":

The Texas Legislature never has passed a law making any regulation passed by the Board of Regents of the University of Texas System a state law.

The statement may refer to certain language found in the case styled *Foley* v. *Benedict*, 555 S.W. 2nd 805 (Comm. of App. of Tex., Sec. A, 1932), which reads as follows: "Since the board of regents exercises delegated powers, its rules are of the same force as would be a like enactment of the Legislature, and its official interpretation placed upon the rules so enacted becomes a part of the rule."

The Board of Regents has never ruled that anyone participating in a disruptive demonstration would automatically be expelled. The rule governing obstruction or disruption of campus activities is found in Subsection 3.9 of Section 3 of Chapter 6 of Part I of the Regents' *Rules and Regulations*. That Subsection provides that obstruction or disruption of campus activities shall subject a student to discipline, including expulsion.

The statement may also refer to Subsection 3.(15) of Section 3 of Chapter 6 of Part I of the Regents' *Rules and Regulations*, which authorizes the dean of students, the institutional head, or the Chancellor to take immediate interim disciplinary action, including suspension pending a hearing, against a student for violation of a rule and regulation of The University of Texas System or a component institution. However, it should be noted that the courts have consistently ruled that an immediate hearing must follow any such suspension, and the University has never questioned that requirement.

22. Kenneth Keniston, "The Faces in the Lecture Room," in Morison, ed., *op. cit.*

23. Silber himself thus was engaging in "classic American politics."

24. In 1972, John Silber, having subsequently gone through an upheaval at the University of Texas, from which he departed to become president of Boston University, remarked, "My experience with Frank Erwin and the Board of Regents at the University of Texas has fundamentally altered my views about the participation of politicians and people of political influence on the governing boards of public universities."

25. *New Republic*, May 20, 1967.

CHAPTER 4

Material from interview notes and transcripts: William Arrowsmith, McGeorge Bundy, Ronnie Dugger, John Fleming, Frances Hudspeth, William Jovanovich, Barnaby Keeney, W. McNeil Lowry, Celia Morris, Harry Ransom, Roger Shattuck, John Silber, Logan Wilson.

1. "A. Lawrence Lowell Justifies the Control of the University by Laymen, 1920," in Richard Hofstadter and Wilson Smith, eds., *American Higher Education*, Vol. II (University of Chicago Press, 1961).

2. Laurence R. Veysey, *The Emergence of the American University* (University of Chicago Press, 1970).

3. Robert A. Nisbet, "Crisis in the University?" *The Public Interest*, Winter 1968.

4. Lee A. DuBridge, "Research and Academic Policy," in Stephen Strickland, ed., *Sponsored Research in American Universities and Colleges* (American Council on Education, 1968).

5. James Ridgeway, *The Closed Corporation* (Random House, 1968).

6. Ronnie Dugger, *Our Invaded Universities: Form, Reform, and New Starts* (Norton, 1974).

7. From the preface of the volume edited by Stephen Strickland, already cited.

8. Robert A. Nisbet, *The Degradation of Academic Dogma: The University in America, 1945–1970* (Basic Books, 1971).

9. "Abraham Flexner Criticizes the American University, 1930," in Hofstadter and Smith, eds., *op. cit.*

10. Christopher Jencks and David Riesman, *The Academic Revolution* (Double-day, 1968).

11. Conrad Hilberry, "Conflict as a Spur to Education," *Antioch Notes*, Vol. 44, No. 3 (November 1966). The study was conducted on a grant from the Carnegie Corporation.

12. *The Texas Observer*, October 21, 1960.

13. *Ibid.*

14. Paul Weiss, "Science in the University," in Robert S. Morison, ed., *The Contemporary University: U.S.A.* (Houghton Mifflin, 1966).

15. *Ibid.*

16. Robert Sherrill in *The Texas Observer*, December 23, 1960.

17. Celia Morris said that when she was a student at the University of Texas this was a common expression.

18. In *The Texas Quarterly*.

19. Noted Gay Talese in *The Kingdom and the Power* (World, 1969).

20. Mrs. Hudspeth died in 1972.

21. Robert Sherrill in *The Texas Observer*, December 23, 1960.

22. Hoyt Purvis in *The Texan*, December 13, 1960.

23. "John Lehmann on a Visit to the Humanities Research Center, University of Texas," *The Times Literary Supplement*, July 10, 1969.

24. This brief account was drawn from "The Market in Authors' Manuscripts," by Jenny Stratford, *The Times Literary Supplement*, July 24, 1969.

25. By Miss Stratford. And a letter from John Carter in the *TLS* of August 21, 1969, referred to another's suggestion "that the Texas steer has over the past decade [the 1960's] devoured, with its eyes on A.D. 2000, more fodder than its 1969 cud can fully cope with."

26. Stratford, *op. cit.*

27. Reported in *The Texan*, September 13, 1966.

28. I also talked with her husband, Willie Morris, editor of *Harper's Magazine* at the time. (The Morrises were later divorced.) He too had been a student at UT.

29. Quoted in *The Alcalde*, March 1961.

30. To visiting historian Robert G. L. Waite, who relayed it in a letter to the author.

31. 1969. Perhaps some already thought of the University of Texas as "an outstanding school," considering its reputation as "one of the two or three most eminent institutions in the South and Southwest" (James Cass and Max Birnbaum, *Comparative Guide to American Colleges*). And Logan Wilson proudly cited the Carter study, in which "Texas showed up better than any Southern university."

32. Dugger, *op. cit.*

33. Although what an institution (or person) can or wishes to afford sometimes bears little relation to the amount of their funds. In a letter to *The Times Literary Supplement*, printed July 17, 1969, Oliver Stallybrass suggested that some of Texas' funds be used to provide a person who would answer research questions from those " 'bona fide research students and authors' [quote from the John Lehmann article a week earlier] who can by no means afford the journey to Texas." This was answered in the *TLS*, on August 7, by the gentleman who heads the Manuscripts (Permissions) Committee at the University of Texas, C. L. Cline, who suggested that Mr. Stallybrass spend his own funds to hire researchers.

34. John Gunther, *Inside U.S.A.* (Harper, 1947).

35. *The Times Literary Supplement*, July 10, 1969.

36. Harvard endowment at that time was worth $843,149,000, over twice that of Yale.

37. Logan Wilson.

38. Dugger, *op. cit.* Dugger reports: "Universities' investments make them factors in the financial markets and implicate them in the ethical consequences of corpora-

tions' behavior. . . . At the end of fiscal 1972, the UT permanent fund held $207 million worth of the bonds of privately owned utilities and $30 million worth of their common stocks, along with common stocks in oil and gas worth $38 million; chemicals, drugs and cosmetics, $36 million; food and soap, $21 million; banks, $16 million; electrical and electronics companies, $15 million; and auto companies, $12 million."

39. 1963 figures from *College and University Endowment: Status and Management*, Pub. OE-53024 of the Office of Education, U. S. Department of Health, Education and Welfare, U. S. Government Printing Office, Washington, D.C. 1965.

40. *Ibid.*

41. Robert S. Morison, "Foundations and Universities," in Morison, ed., *op. cit.*

42. *Ibid.*

43. The rate of compensation to university professors had been rising faster in the public sector than in the private, according to the *American Association of University Professors Bulletin*, 1967–68, and Texas by the end of the decade had become second in state universities so far as salaries were concerned. The Ford Foundation had used some of its money to try to raise academic salaries.

44. William Jovanovich's phrase.

45. Dugger, *op. cit.*

46. Alvin C. Eurich, first president of the State University of New York.

47. Both quotes from *The Texan*, January 8, 1965.

48. Dugger, *op. cit.* He says with some ill feeling among "Harry's Boys."

49. *The New York Times*, April 16, 1967.

50. In a conversation with the author.

51. Mr. Bundy commented later to this author that the grant to Perkins "was nothing unusual," that the Ford Foundation had given "many educational grants."

52. At a general faculty meeting, he spoke on "The Changing University Community." Mimeographed speeches.

53. The Houston *Post*, July 28, 1965.

54. "The Purposes and the Performance of Higher Education in the United States: Approaching the Year 2000," report by the Carnegie Commission on Higher Education, 1973.

55. Ronnie Dugger's phrase in a letter to the author.

56. *The New York Times*, June 10, 1946. Gunther citation, *op. cit.*

57. *Time*, January 13, 1961.

58. Logan Wilson, "A President's Perspective," in Frank C. Abbott, ed., *Faculty Administration Relationships* (Washington, D.C.: American Council on Education, 1958), from Harold Orlans, "Criteria of Choice in Social Science Research" (Washington, D.C.: The Brookings Institution, 1973).

59. I am indebted to a column by James Reston in *The New York Times* for this general summation.

60. *The New York Times*, January 28, 1973.

61. "Mean": near the average, occupying a middle position between the highest and the lowest.

62. Table A-1, p. 12, *Higher Education Salaries*, 1966–67, National Center for Educational Statistics, OE-53015-67, Office of Education, U. S. Department of Health, Education and Welfare.

63. A university-supported "little" magazine established and edited by Ransom. Texas also published the excellent *Graduate Journal* and various pamphlets in connection with its collections. The National Translation Center published *Delos: A Journal On and Of Translation.*

64. A. Crichton, "Role Conflicts in Social Work Agencies," *Case Conference*, February 1966, cited in Brian J. Heraud, *Sociology and Social Work* (Pergamon Press, 1970).

65. Arrowsmith: "I think it's hard work, with obstinate people—work that would require him to be mean to someone or to tell someone off or to be personally un-

482 · Notes to Pages 75–88

pleasant. That's Ransom's great failing. He is a coward through fear of unpleasantness."

66. All of C. L. Cline's remarks in this paragraph were taken from *The Times Literary Supplement* of August 7, 1969.

67. *Ibid.*

68. *The New York Times*, January 2, 1973.

69. Dugger, *op. cit.*

70. Talcott Parsons and Gerald M. Platt, *The American University* (Harvard University Press, 1973).

71. Sebastian de Grazia, *Of Time, Work, and Leisure* (The Twentieth Century Fund, 1962).

72. Report issued in 1969.

73. John Gardner, Godkin Lectures, Harvard University.

74. "A Message to Alumni, Parents and Other Friends of Columbia from Grayson Kirk, President," June 1, 1968.

75. "Meru," from *A Full Moon in March*, published in 1935.

76. Gardner, *op. cit.*

77. Meyerson subsequently moved to the University of Pennsylvania.

78. Jencks and Riesman, *op. cit.*

79. Dugger, *op. cit.*

80. Kirk, *op. cit.* (see note 10, Chapter 3).

81. Dugger, *op. cit.*

82. *Ibid.*

83. *The New York Times*, January 24, 1971.

84. Dugger, *op. cit.*

85. 1973 International Conference on "The Crisis of the University," sponsored by the International Council on the University Emergency, Charles Frankel, chairman.

86. Joseph Kraft, *Profiles in Power* (New American Library, 1966).

CHAPTER 5

Material from interview notes and transcripts: William Arrowsmith, Erik Barnouw, William Jovanovich, Paul Lazarsfeld, W. McNeil Lowry, Frank Stanton.

1. David Bazelon, *Power in America* (New American Library, 1967).

2. Adolf A. Berle, *Power* (Harcourt, Brace, 1969).

3. Christopher Jencks and David Riesman, *The Academic Revolution* (Doubleday, 1968).

4. Hedley Donovan, speech at Vanderbilt University, April 8, 1967.

5. Jencks and Riesman, *op. cit.*

6. David Riesman, in collaboration with Reuel Denney and Nathan Glazer, *The Lonely Crowd* (Yale University Press, 1950).

7. Loren Eiseley, *The Unexpected Universe* (Harcourt, Brace, 1969).

8. Erik Barnouw, *A Tower in Babel* (Oxford University Press, 1966).

9. Arthur M. Schlesinger, Jr., "McCarthyism Is Threatening Us Again," *The Saturday Evening Post*, August 13, 1966.

10. Thomas Griffith, *The Waist-High Culture* (Grosset & Dunlap, 1959).

11. Barnouw, *op. cit.*

12. Adolf A. Berle and Gardiner C. Means, *The Modern Corporation and Private Property* (rev. ed., Harcourt, Brace, 1968).

13. Barnouw, *op. cit.*

14. From Frank Stanton's mimeographed notebooks.

15. Marshall McLuhan and Harley Parker, *Through the Vanishing Point* (Harper & Row, 1968).

16. *Wall Street Journal*, May 17, 1968.

17. Eugene Lyons, *David Sarnoff* (Harper & Row, 1966).

18. Stanton's *Curriculum Vitae*, note 39, Chapter 1, is enlightening in this regard.

19. Irving Howe, "The New York Intellectuals," *Commentary*, October 1968.

20. "Television and the Public," report by Robert T. Bower, director of the Bureau of Social Science Research, using Roper interviews, commissioned by CBS.

21. Leo Rosten, "The Intellectual and the Mass Media: Some Rigorously Random Remarks," in Norman Jacobs, ed., *Culture for the Millions* (Beacon Press, 1964).

22. Frank Stanton, "Parallel Paths," in Jacobs, *op. cit.*

23. Herbert J. Gans, "Popular Culture in America," in Howard S. Becker, ed., *Social Problems* (Wiley, 1966).

24. Stanton, *op. cit.*

25. Much of the information on cable television in this and succeeding pages was drawn from Ralph Lee Smith, "The Wired Nation," *The Nation*, May 18, 1970.

26. Quoted in *ibid.*

27. Roger C. Noll, Merton J. Peck, and John J. McGowan, *Economic Aspects of Television Regulation* (The Brookings Institution, 1973).

28. Ralph Lee Smith, in the article cited above, pointed out that this never became an issue and wondered why not.

29. Barnouw, *op. cit.*

30. Erik Barnouw, *The Golden Web* (Oxford University Press, 1968).

31. Berle and Means, *op. cit.*

32. A Brookings Institution monograph cited in Barnouw, *A Tower in Babel*, already cited.

33. Barnouw, *The Golden Web*, already cited.

34. *Ibid.*

35. *Ibid.*

36. *Ibid.*

37. *Ibid.*

38. *Ibid.*

39. First two figures from Lyons, *op. cit.*, last figure from Barnouw, *The Golden Web*, already cited.

40. 1967 figures.

41. In 1974, a "major policy statement" from the Justice Department urged the FCC to "ban single ownership of daily papers and TV stations in the same city," there being an estimated 83 such combinations in 78 cities. (*Time*, May 27, 1974.) Early in 1975, the FCC did ban future purchases by newspaper owners of radio or television stations serving the same market. "It also ordered 16 such existing combinations to be broken up." (*The New York Times*, January 29, 1975.)

42. *The New York Times*, February 28, 1969.

43. Nicholas Johnson in *The Humanist*, July–August 1972.

44. Smith, *op. cit.*

45. Marquis Childs in *The Berkshire Eagle*, August 13, 1969.

46. *The New York Times*, June 9, 1968.

47. Nicholas Johnson, "No, We Don't," *New Republic*, December 6, 1969.

48. Louis Jaffe, "The Role of Government," in John E. Coons, ed., *Freedom and Responsibility in Broadcasting*, cited in Barnouw, *The Golden Web*.

49. James MacGregor Burns and Jack Peltason, *Government by the People* (Prentice-Hall, 1966).

50. Johnson, "No, We Don't," already cited.

51. See *New York Times* editorial, March 11, 1974.

52. Smith, *op. cit.*

53. "Cable Television: A Handbook for Decision-making," 1973 RAND Corporation study undertaken for the National Science Foundation.

54. Berle, *op. cit.*

55. Ralph Kaplan presiding over an ABPC–AEPI panel. *Publishers Weekly,* June 9, 1969.

56. William Jovanovich, "Information as a Property," *California Monthly,* April–May 1967.

57. Alvin Toffler, *The Culture Consumers* (St. Martin's Press, 1964). This feedback relationship can also be put in biological terms: "An evolving population, by the behavior of its members, chooses—or creates—the environment which exerts natural selective pressures on it" (C. H. Waddington in *The New York Review of Books,* June 5, 1969); and in social-science terms: "The flow of influence is not, of course, unidirectional; the communication often serves to activate or intensify the extra-communication processes, which in turn mediate the effects of the communication" (Joseph T. Klapper, *The Effects of Mass Communication* [Free Press, 1960]).

58. Quoted in Alexander Kendrick, *Prime Time* (Little, Brown, 1969).

59. Robert Eck, "The Real Masters of Television," *Harper's Magazine,* March 1967.

60. Lyons, *op. cit.*

61. CBS Annual Report.

62. Barnouw, *The Golden Web,* already cited.

63. Quote from Smith, *op. cit.*

64. *The New York Times,* April 19, 1973.

65. A Ford Foundation "Letter," dated June 15, 1974, explained that their aims had been: "1) to help develop a decentralized public television system, with programs reflecting the wide range of thought and opinion in the United States, 2) to separate program production by a variety of centers from centralized distribution, and 3) to preserve local editorial control over the choice of programs to be shown in particular communities."

66. *The New York Times,* April 26, 1973.

67. *The New York Times,* April 22, 1973.

68. *The New York Times,* May 28, 1973.

69. *The New York Times,* June 1, 1973.

70. But by June 1974 that same bill proposed by the White House Office of Telecommunications was "flatly rejected" by President Nixon without discussion or explanation, and his terse statement suggested that federal support for public television be decreased. Many in public broadcasting saw this as reneging on what had been understood as a deal. (*The New York Times,* June 10, 1974.) In July 1974, the President changed his mind again and decided to support the bill after all.

71. Rosten, *op. cit.* Rosten adds this footnote: "It is unthinkable, for instance, that any open competitive system would have barred from the air someone like Winston Churchill—who was not given access to BBC, for his then-maverick opinions, from 1934 to 1939. Nor is it likely that a government-controlled network would be able to withstand the furore that followed CBS's initial interview with Nikita Khrushchev. Nor would a governmentally supervised program dare to present a show such as *The Plot to Kill Stalin.*"

72. However, during the early 1970's, public television began to develop a reputation for distinctive, high-quality programming.

73. *Saturday Review,* October 11, 1969.

74. Rosten, *op. cit.*

75. Not everyone agreed. When Stanton retired as vice-chairman of CBS in 1973, he received the annual award of the Four Freedoms Foundation "in recognition of his notable leadership and achievement in behalf of freedom of information."

CHAPTER 6

Material from interview notes and transcripts: Paul Lazarsfeld, William L. Shirer, Frank Stanton.

1. Paul Lazarsfeld.
2. Paul Lazarsfeld, "An Episode in the History of Social Research: A Memoir," in Bernard Bailyn, ed., *Perspectives in American History*, Vol. II (Harvard University Press, 1968). CBS also helped to support publications. One such was a book by Raymond Klapper of CBS, *The Effects of Mass Communication* (Free Press, 1960).
3. James Reid, *An Adventure in Textbooks* (R. R. Bowker, 1969).
4. Herbert J. Gans, "Popular Culture in America," in Howard Becker, ed., *Social Problems: A Modern Approach* (Wiley, 1966).
5. Conversation reported in *Life* magazine, spring 1969.
6. Erik Barnouw, *The Golden Web* (Oxford University Press, 1968).
7. The Godkin Lectures were delivered by John Gardner in 1969.
8. Gay Talese, *The Kingdom and the Power* (World, 1969).
9. Among them, historian Arthur M. Schlesinger, Jr., and literary critic Alfred Kazin.
10. *Life*, spring 1969.
11. What is the definition of "abrasiveness"? Of "vulgarity"?
12. Estimated by a network executive for 1966 and reported in 1967 in *Fortune* magazine.
13. Lawrence J. Friedman, *Psychoanalysis, Uses and Abuses* (Eriksson, 1968).
14. *Commentary*, September 1968.
15. *Violence in America: The Complete Official Report to the National Commission on the Causes and Prevention of Violence* (New American Library, June 1969).
16. Robert Wallis, *Time: Fourth Dimension of the Mind* (Harcourt, Brace, 1968).
17. Donald M. Kaplan, "Psychopathology of Television Watching," *Performance*, July–August 1972.
18. Arthur M. Schlesinger, Jr., *The Crisis of Confidence* (Houghton Mifflin, 1969). The National Commission on the Causes and Prevention of Violence, in its report released in December 1969, also linked television violence to real violence.
19. For an advocacy report on some psychological studies made on the destructive effects of TV violence on children, see Robert M. Liebert, John M. Neale, and Emily S. Davidson, *The Early Window: Effects of Television on Children and Youth* (Pergamon, 1974).
20. Seymour Feshbach and Robert D. Singer, *Television and Aggression* (Jossey-Bass, 1971).
21. *Television and Growing Up: The Impact of Televised Violence*, report of the Surgeon General's Scientific Advisory Committee on television and social behavior, 1972.
22. So said Dr. Bernard L. Pacella, an officer of the American Psychoanalytic Association as reported in *The New York Times* in the fall of 1969, but there are a lot of sources for this idea.
23. Kaplan, *op. cit.*
24. Wallis, *op. cit.*
25. T. W. Adorno, "Television and the Patterns of Mass Cultures," *Mass Culture* (Free Press, 1964).
26. André Malraux, *The Voices of Silence* (Doubleday, 1953).
27. Cited in William Jovanovich's article "Information as a Property," *California Monthly*, April–May 1967.
28. Gans, *op. cit.*

29. Charles Madison, *Publishing in America* (McGraw-Hill, 1966).

30. "An Address by Frank Stanton, President, Columbia Broadcasting System, Inc., Before the International Radio and Television Society, Inc., New York, November 25, 1969."

31. Fred W. Friendly, *Due to Circumstances Beyond Our Control* (Random House, 1967).

32. Alexander Kendrick, *Prime Time* (Little, Brown, 1969).

33. Gould would exaggerate, presumably in an effort to help the crusaders.

34. Friendly, *op. cit.*

35. *Ibid.*

36. Kendrick, *op. cit.*

37. Stanton considers himself a broadcaster, obviously defining the term less narrowly.

38. Kendrick, *op. cit.*

39. *Ibid.*

40. *Ibid.*

41. *Ibid.*

42. I'm not suggesting he should have.

43. Barnouw, *op. cit.*

44. Controversial people, it seems, were also bad for the book business. James Reid, at the time an officer of the Harcourt, Brace publishing company as well as editor-in-chief of both its high school and college departments, tells the following story in *An Adventure in Textbooks* (already cited):

> Henry Steele Commager, the great writer of American history and a fine literary critic, was originally one of the authors for the Olympic *Adventures in American Literature,* the eleventh-grade book and consistently not only the best-seller of the series but also the best-selling textbook of HB. . . . Early in the preliminary work on the Olympics, Henry invited Mary Bowman, John Gehlman, and me to his farm in Vermont for a delightful long weekend of talk and planning. Over the next couple of years he did his part as promised, writing a new and fresh history of American life and literature. . . . Then, a year or so before publication, the sales department, especially [——], the general sales manager, and [——], the top Texas man, got panicky. There was still some Senator Joe McCarthy poison in the American social system and they were afraid of Commager's well-known liberal position. They did not object to anything in the history that Commager wrote for *Adventures in American Literature;* they said his name as an author on the title page would permit competitors to do some dirty infighting and harm their chances in state adoptions, especially in the South. It was an agonizing decision and I finally felt I had to give in. I had to persuade Henry Commager to permit us to use his history without using his name and of course at no reduction of his royalty. Not only were the royalties and sales of the eleventh-grade book at stake but also those of the other books in the series, for "AmLit" was the pivotal book. I made the "right decision" for sales and royalties (echoes of Alfred Harcourt: "No point in publishing a good book if nobody buys it") but a smelly one for the integrity of the series and of HB. It's wrong when the names of the true and responsible authors do not appear on the title pages of textbooks! After this, Henry Commager bore little good feeling toward me or HB.

45. Barnouw's phrase.

46. Barnouw, *op. cit.*

47. *Ibid.*

48. Quoted in "It's Tricky Work, Being Board Chairman," by Perrin Stryker, *Fortune,* May 1960.

49. Quoted by Irving Howe in "The New York Intellectuals," *Commentary,* October 1968.

50. Friendly, *op. cit.*

51. James MacGregor Burns.

CHAPTER 7

Material from interview notes and transcripts: Hedley Donovan, Mark Donovan, William Jovanovich, John McCallum, Richard Scammon, James Reid, James Shepley, William L. Shirer, Frank Stanton.

1. John Kenneth Galbraith, *The New Industrial State* (Houghton Mifflin, 1967).
2. Christopher Jencks and David Riesman, *The Academic Revolution* (Doubleday, 1968).
3. Perrin Stryker, "It's Tricky Work, Being Board Chairman," *Fortune*, May 1960.
4. *Ibid.*
5. John Fischer, "The Easy Chair," *Harper's Magazine*, May 1968.
6. Charles Madison, *Book Publishing in America* (McGraw-Hill, 1966).
7. *Ibid.*
8. *Ibid.*
9. *Ibid.*
10. *Ibid.*
11. *Ibid.*
12. *Ibid.*
13. A Harcourt employee.
14. Two Harcourt officials.
15. Madison, *op. cit.*
16. *Ibid.*
17. *Ibid.*
18. Tiedeman, O'Hara, and Matthews (1958), referred to by Donald E. Super in *Perspectives on Vocational Development*, John M. Whiteley and Arthur Resnikoff, eds. (The American Personnel and Guidance Association, 1972).
19. David Rapaport, *Emotions and Memory* (Science Editions, 1961).
20. *Ibid.*
21. *Ibid.*
22. John Kobler, *Luce: His Time, Life and Fortune* (Doubleday, 1968).
23. *Ibid.*
24. *The New York Times*, May 1, 1967.
25. Kenneth Keniston, *Young Radicals: Notes on Committed Youth* (Harcourt, Brace, 1968).
26. Quoted by Donovan in a speech, also cited by Kobler, *op. cit.*
27. *Ibid.*
28. Dwight Macdonald reviewing W. A. Swanberg's *Luce and His Empire* in *The New York Times Book Review*, October 1, 1972.
29. Thomas Griffith, *How True* (Atlantic–Little, Brown, 1974).
30. Joseph Epstein, "Henry Luce and His Time," *Commentary*, November 1967.
31. *Time*, April 9, 1973.
32. Kobler, *op. cit.*
33. *Ibid.*
34. *The New York Times*, March 6, 1967.
35. Robert T. Elson, *Time Inc.: The Intimate History of a Publishing Enterprise, 1923–1941* (Atheneum, 1968).
36. Donovan notes (in a letter dated April 22, 1971, to Don Oberdorfer) that Time Inc. editors in the 1964–65 period "tended to be more hard-line" on Vietnam "than the writers and researchers."
37. Henry Luce interviewed by Eric Goldman on the NBC program "The Open Mind."

38. W. A. Swanberg, *Luce and His Empire* (Charles Scribner's Sons, 1972).
39. Griffith, *op. cit.*
40. *The New York Times*, August 17, 1973.
41. Swanberg, *op. cit.*
42. *Ibid.*

<div align="center">CHAPTER 8</div>

Material from interview notes and transcripts: Hedley Donovan, Mark Donovan, Lloyd Goodrich, Thomas Griffith, Howard Mumford Jones, Willian Jovanovich, W. Mc-Neil Lowry, John McCallum, James Reid, Anne Roe, Harry Scherman, James Shepley, Frank Stanton.

1. Time Inc. reported revenues of $728,266,000 for 1973, up 20 percent from 1972.
2. John Kobler, *Luce: His Time, Life and Fortune* (Doubleday, 1968).
3. Dwight Macdonald reviewing W. A. Swanberg's *Luce and His Empire* in *The New York Times Book Review*, October 1, 1972.
4. Andrew Kopkind, "Serving Time," *The New York Review of Books*, September 12, 1968.
5. Time Inc. 1973 Annual Report.
6. Kopkind, *op. cit.*
7. Roy E. Larsen, "The Thinking Man's Medium," *Saturday Review*, November 14, 1970.
8. In 1973, *The Best from Life*, put together by David Scherman, was published and sold incredibly well. Plans were made to revive the old magazine on a new basis.
9. William Jovanovich, *Now, Barabbas* (Harper & Row, 1964).
10. This brief rundown is based on a number of the sources already cited in the footnotes to the preceding chapter, including Robert T. Elson's *Time Inc.: The Intimate History of a Publishing Enterprise, 1923–1941* (Atheneum, 1968). It also includes information from a 1944 series in the newspaper *PM*, founded by former Time Inc. employee Ralph Ingersoll. See also Ralph M. Ingersoll, *Point of Departure* (Harcourt, Brace, 1961).
11. Kobler, *op. cit.*
12. Harry Scherman tells this in a transcript deposited with the Oral History Collection at Columbia University.
13. From *The Writer as Independent Spirit*, Proceedings of the XXIV International P.E.N. Congress, New York, 1968.
14. Mrs. Huxtable's review of *American Architecture and Urbanism* by Vincent Scully in *The New York Times Book Review*, November 23, 1969.
15. *Newsweek*, December 11, 1972.
16. Kobler, *op. cit.*
17. T. S. Matthews, "Henry Luce's Life & Time," *Encounter*, October 1968. See also T. S. Matthews, *Name and Address* (Simon & Schuster, 1960).
18. Daniel Bell compares journalism and sociology in "Henry Luce's Half-Century," *The New Leader*, December 11, 1972.
19. *The New York Times*, May 23, 1969.
20. Reported in *The New York Times*, February 15, 1967.
21. T. W. Adorno, Else Frenkel-Brunswik, Daniel J. Levinson, and R. Nevitt Sanford, *The Authoritarian Personality* (Part Two) (Science Editions, 1964; Wiley, 1950).
22. *Ibid.*, T. W. Adorno, "Types and Syndromes."
23. *Ibid.*
24. James Reid, *An Adventure in Textbooks* (R. R. Bowker, 1969).

25. Federal funds were, however, to be considerably reduced by Nixon administration policies.

26. Christopher Jencks and David Riesman, "On Class in America," *The Public Interest,* Winter 1968.

27. Adorno, *op. cit.*

28. The material on Goodrich's life that follows was drawn from the Dr. Harlan B. Phillips interview made in 1962 for the Archives of American Art at Brandeis University, as well as from a follow-up interview made by this author.

29. André Malraux, *The Voices of Silence* (Doubleday, 1953).

30. *Ibid.*

CHAPTER 9

Material from interview notes and transcripts: Robert Cato, Midge Decter, Hedley Donovan, Hubert H. Humphrey, Goddard Lieberson, Vera Zorina Lieberson, Theodore Roszak, Frank Stanton.

1. "We put a ring of concrete columns around the perimeter and a concrete core containing services and vertical transportation in the center. It permitted clear office space. We devised a plan to eliminate wasteful public corridors. We made efficient use of the mechanical system by putting one mechanical floor at the bottom and another at the top with office floors between them."—Eero Saarinen (*Eero Saarinen on His Work,* Yale University Press, 1962.)

2. Robert Frost wrote about the "color" white (it really is all colors combined) in his poem called "Design":

> I found a dimpled spider, fat and white,
> On a white heal-all, holding up a moth
> Like a white piece of rigid satin cloth—
> Assorted characters of death and blight
> Mixed ready to begin the morning right,
> Like the ingredients of a witches' broth—
> A snow-drop spider, a flower like froth,
> And death wings carried like a paper kite.
>
> What had that flower to do with being white,
> The wayside blue and innocent heal-all?
> What brought the kindred spider to that height,
> Then steered the white moth thither in the night?
> What but design of darkness to appall?—
> If design govern in a thing so small.

Although it is possible to go off the edge of madness by seeing too many connections, by being unable to differentiate, linked tones of feeling can be picked up that are psychologically valid though difficult and perhaps impossible to define and explain directly. Although the response is personal, it is caused by the environment. This is the stuff of poetry.

3. According to the magazine *Cultural Affairs.*

4. Randall Jarrell in *A Sad Heart at the Supermarket* (Atheneum, 1962).

5. Donovan's son Mark believed that his father was not interested in making money; that was only a by-product of his job. Mark recalled his parents drove a 1964 "beat-up" Volkswagen even after one of the doors had to be tied shut and the Donovan children wouldn't drive it. He said his parents had no "status problems."

6. Adolf A. Berle and Gardiner C. Means, *The Modern Corporation and Private Property* (rev. ed.; Harcourt, Brace, 1968).

7. This and the quotes directly above from Eero Saarinen, *Eero Saarinen on His Work* (Yale University Press, 1962).

8. *Ibid.*

9. Abraham Kaplan, "Power in Perspective," in Robert L. Kahn and Elise Boulding, eds., *Power and Conflict in Organizations* (Basic Books, 1964).

10. From *The Writer as Independent Spirit*, Proceedings of the XXIV International P.E.N. Congress, New York, 1968. The conference recorder was paraphrasing him.

11. George Caspar Homans, *Social Behavior: Its Elementary Forms* (Harcourt, Brace, 1961).

12. *Ibid.*

13. Muzafer Sherif and Hadley Cantril, *The Psychology of Ego Involvements* (Wiley, 1947).

14. *Ibid.*

15. Anne Roe, "Artists and Their Work," *Journal of Personality*, 1946.

16. N. C. Meier.

17. Anne Roe, "Painting and Personality," paper presented at the seventh annual meeting of the Rorschach Institute, New York, 1946.

18. That last is an amusing conclusion, considering what passed for art in our society during the 1960's.

19. Roe, "Painting and Personality," already cited.

20. John Kenneth Galbraith, *The Affluent Society* (Houghton Mifflin, 1969).

21. Kaplan, *op. cit.*

22. *Ibid.*

23. David Bazelon, *Power in America* (New American Library, 1967).

24. Edward Ziegler, *The Vested Interests* (Macmillan, 1964).

25. Nathaniel Weyl, *The Creative Elite in America* (Public Affairs Press, 1966). A peculiar book.

26. *The New York Times*, December 1963.

27. The publisher of the Kennedy book, Simon Michael Bessie of Atheneum, told me the following story: He went to lunch in the private dining room which is part of Lieberson's suite of offices. A number of Columbia Records officials were there (but not Lieberson). Everyone sat down at the huge, round table, and eventually the butler got around to Bessie and asked what he wanted to drink. He named a wine. "I'm sorry, sir," the butler said, "but we don't have a bottle open." Bessie leaned back in his chair, confident that one of these important fellows would speak up and say, "Well, *open* one." But no. He was ringed with silence. Again, the butler asked what he would like to drink and again he gave the name of the wine. Again, the butler gave the same reply. Then the silence became embarrassing.

Did that incident measure his importance to those men as compared to, say, Lieberson's? Perhaps none of them dared use the wine without permission. But perhaps the incident also says something about how behavior in organizations can be calculated —or uncalculated—on other than such standards as politeness.

28. Donald Schon, *Technology and Change*, quoted and paraphrased by James Ridgeway in *The Closed Corporation* (Random House, 1968).

29. Thomas S. Szasz, *The Myth of Mental Illness* (Harper & Row, 1968).

30. "Whatever interrupts the even flow and luxurious monotony of organic life is odious to the primeval animal." —George Santayana.

31. James Lord, *The New York Times Book Review*, July 2, 1967.

32. Reference in Ziegler, *The Vested Interests*: "The Sociology of Charismatic Authority," in *Wirtschaft und Gesellschaft*, Part III, Chap. 9, pp. 753–57, *From Max Weber*, p. 245.

CHAPTER 10

Material from interview notes and transcripts: Lincoln Kirstein, Goddard Lieberson, Vera Zorina Lieberson, James Lyons, Frank Stanton, Edward Wallerstein. Also

a number of people at CBS and in Rochester, who are not quoted. (Some of the dates regarding Lieberson's life may not be exact—he himself was vague about them, and it was hard to get people to talk about him in terms of fact. People at Eastman, for example, were evasive.)

1. Thomas Griffith, *The Waist-High Culture* (Grosset & Dunlap, 1959).

2. Lieberson did not mention this; George McKay did, in a letter to the author.

3. Lieberson did not mention his first marriage, nor is it in his biography in *Who's Who in America*. I learned about it first from Wallerstein and then from a woman in Rochester.

4. One example of which was provided some years later when Hanson in a 1969 article in the Rochester *Times-Union* objected to the expenditure of public funds (through the New York State Council on the Arts) for the performance of avant-garde music, a position applauded by Winthrop Sargeant in *The New Yorker* magazine.

5. A 1952 *Time* magazine interview with Lieberson remarked that, "while he was not formally kicked out, he and his pals knew they weren't going anywhere at Eastman."

6. *The New York Times Book Review,* July 2, 1967.

7. CBS 1973 Annual Report to the Stockholders.

8. Oliver Read and Walter L. Welch, *From Tin Foil to Stereo* (Bobbs-Merrill, 1959).

9. *Ibid.*

10. By 1974, the juke box in many ways seemed obsolete.

11. Read and Welch, *op. cit.*

12. *Ibid.*

13. *Ibid.*

14. *Ibid.*

15. Figure from the *Wall Street Journal,* May 17, 1968.

16. Stravinsky was said to have been enchanted by her performance in his *Perséphone,* produced by the Santa Fe Opera in 1961. She was "a dear friend of his and an artist he admired profoundly." (*Saturday Review,* May 29, 1971.)

17. Goddard Lieberson, "What Happened Since LP," *Saturday Review,* August 26, 1967.

18. Fred Friendly, *Due to Circumstances Beyond Our Control* (Random House, 1967).

19. In a speech to the Central States Group of the Investment Bankers Association of America on March 31, 1954.

20. Read and Welch, *op. cit.*

21. Lieberson, *op. cit.*

22. *Saturday Review,* August 26, 1967.

23. *The New York Times,* August 28, 1967.

24. Alvin Toffler, *The Culture Consumers* (St. Martin's, 1964).

25. William J. Baumol and William G. Bowen, *Performing Arts: The Economic Dilemma* (Twentieth Century Fund, 1966).

26. *The New York Times,* August 28, 1967.

27. *Time,* February 12, 1973.

28. *Ibid.*

29. *The New York Times,* June 5, 1973, and June 8, 1973.

30. Myra Friedman, *Buried Alive: The Biography of Janis Joplin* (William Morrow, 1973).

31. William Safire on the Op. Ed. page of *The New York Times,* June 20, 1973.

32. *Time,* December 31, 1973.

33. *Ibid.*

34. *The New York Times,* July 11, 1973.

CHAPTER 11

Material from interview notes and transcripts: Robert Brustein, Hedley Donovan, Lloyd Goodrich, Howard Mumford Jones, William Jovanovich, W. McNeil Lowry, Gordon Ray, James Reid, Theodore Roszak, Harry Scherman.

1. Andrew Marvell, "The Garden," from *Elizabethan and Jacobean Poets,* Vol. II of *Poets of the English Language,* W. H. Auden and Norman Holmes Pearson, eds. (Viking, 1950).
2. *Commentary.*
3. *The Writer as Independent Spirit,* Proceedings of the XXIV International P.E.N. Congress, New York, 1968.
4. Harold Rosenberg, "The Orgamerican Phantasy," in Alfred Kazin, ed., *The Open Form* (Harcourt, Brace, 1961).
5. W. McNeil Lowry, "The University and the Creative Arts," *Educational Theatre Journal,* Vol. XIV, No. 2 (May 1962).
6. Alvin Toffler, *The Culture Consumers* (St. Martin's, 1964).
7. Lowry, *op. cit.*
8. W. McNeil Lowry, "The University and the Creative Arts II," speech delivered April 16, 1967, at the First Annual Fine Arts Festival, Edwardsville, Illinois.
9. Harold Rosenberg, "The Art World," *The New Yorker,* May 17, 1969.
10. Lowry, "The University and the Creative Arts II," already cited.
11. Eric Larrabee, "The Artist and the University," *Harper's Magazine,* June 1969.
12. Lowry, "The University and the Creative Arts II," already cited.
13. M. Prados, "Rorschach Studies on Artists-Painters," quoted in Anne Roe, *The Psychology of Occupations* (Wiley, 1956).
14. John Galsworthy, *The Forsyte Saga* (Scribner's, 1934).
15. Toffler (*op. cit.*) refers to other kinds of connections business has with artists: "Whether through the creation of such advisory groups employing professional artists, or through a great expansion of the purchase of service of outside artists and arts institutions, or through an extension of entrepreneurial activity in the arts, the business firm is going to come into increasingly intimate contact with the artistic personality." Presumably so long as our society is affluent.
16. *Newsweek,* May 12, 1969.
17. Eero Saarinen, *Eero Saarinen on His Work* (Yale University Press, 1962).
18. *Newsweek,* January 19, 1970.
19. Randall Jarrell, "A Sad Heart at the Supermarket," in the book of the same name (Atheneum, 1962).
20. *The Writer as Independent Spirit,* already cited.
21. *Ibid.*
22. Harold Rosenberg in *The Open Form,* already cited.
23. Transcript in the Columbia University Oral History Collection.
24. This is not to say that Book-of-the-Month Club selections are fine art.
25. Lowry notes: "This Kansas county had the highest concentration of Populist votes in the nation in the election of 1892, when the Populist Party reached two million votes."
26. James Reid, *An Adventure in Textbooks* (R. R. Bowker, 1969).
27. *Ibid.* Reid and Jovanovich understood his situation differently.
28. Gay Talese, *The Kingdom and the Power* (World, 1969).
29. PM, 1944. Luce subsequently disclaimed the quotation, but it seems not out of character and in a backhanded way buttresses Roszak's point.
30. For one, Allen Wheelis in "How People Change," *Commentary,* May 1969.
31. In *The Writer as Independent Spirit,* already cited.
32. Erik H. Erikson, *Young Man Luther* (Norton, 1958).

33. M. Spiaggia, in an article published in 1950, "found that the art students had significantly higher mean scores on: D, Psychopathic Deviate, Interest, Paranoia, Psychasthenia, Schizophrenia, and Hypomania, but not on Hypochondria and Hysteria. In short," said Dr. Anne Roe, in whose *Psychology of Occupations* (Wiley, 1956) this account appears, "art students deviate markedly from others, but the nature of these deviations would suggest that there is no general pattern typical of the art student group, but rather that there may be a few very marked deviants on each subtest (not the same in each instance)." Is Spiaggia saying art students tend to have more deep-seated, serious psychiatric disorders rather than mere neuroses?

34. Harlan Phillips interview for the Archives of American Art.

35. Mr. Rorimer died prematurely in 1966.

36. From an interview with Aline B. Saarinen, *The New York Times Magazine*, August 14, 1955.

37. Harold Rosenberg in *The New Yorker* article already cited.

38. Cited by Roe in a monograph.

39. Toffler, *op. cit.*

CHAPTER 12

Material from interview notes and transcripts: Hedley Donovan, Lloyd Goodrich, W. McNeil Lowry, Frank Stanton.

1. See especially the work of Susanne K. Langer.

2. Alvin Toffler, *Future Shock* (Random House, 1970).

3. André Malraux, *The Voices of Silence* (Doubleday, 1953).

4. Amédée Ozenfant, *Foundations of Modern Art* (Dover, 1952).

5. Idea roughly taken from the introduction to Pirandello's *Six Characters in Search of an Author.*

6. Erwin Panofsky, *Meaning in the Visual Arts* (Doubleday-Anchor, 1955).

7. *The New York Times Book Review.*

8. Robert Jay Lifton, *History and Human Survival* (Random House, 1970).

9. Malraux, *op. cit.*

10. C. H. Waddington, in *The New York Review of Books*, June 5, 1969.

11. Malraux, *op. cit.*

12. Oliver W. Larkin, *Art and Life in America* (Holt, Rinehart & Winston, 1960).

13. Harlan Phillips interview, "Lloyd Goodrich Reminisces," Archives of American Art.

14. *Ibid.*

15. Larkin, *op. cit.*

16. Malraux, *op. cit.*

17. Said Lloyd Goodrich. Oliver Larkin wrote "1930."

18. Larkin, *op. cit.*

19. Harlan Phillips interview already cited.

20. Larkin, *op. cit.*

21. *Ibid.*

22. *Who's Who in America*, 1968, listed him as "Author books including: Thomas Eakins, 1933; Winslow Homer, 1944; Yasuo Kuniyoshi, 1948; Max Weber, 1949; Edward Hopper, 1950; John Sloan, published 1952; Albert P. Ryder, published 1959. Co-author: Am. Art of Our Century, 1961. Editor, Research in American Art, 1945; Mus. and the Artist, 1959. Contbr. New Art in America, 1957."

23. Larkin, *op. cit.*

24. Harlan Phillips interview already cited.

25. Larkin, *op. cit.*

26. Harlan Phillips interview already cited.

27. According to Phillips' interview with Goodrich. Larkin, in *Art and Life in America,* mentions another architect: "When the Whitney Museum of American Art moved uptown to a site adjoining the Museum of Modern Art, the chief problem of Auguste Noel was to find a tactful relation to the latter; the pleasant interiors were designed by Bruce Buttfield, and the galleries were lighted with fluorescent units through a ceiling, although daylight was available on three sides of this four-story building."

28. B. H. Friedman, "The Whitney Museum's New Home," *The Whitney Review,* 1965–66.

29. *Ibid.*

30. *Ibid.*

31. *Ibid.*

32. Norval White and Elliot Willensky, eds., *AIA Guide to New York* (Macmillan, 1968).

33. *The New York Times,* June 29, 1974.

CHAPTER 13

Material from interview notes and transcripts: Lloyd Goodrich, William Jovanovich, W. McNeil Lowry, Theodore Roszak.

1. Newton Minow *et al., Presidential Television* (Twentieth Century Fund Report, Basic Books, 1973).

2. George Reedy in a review of *Presidential Television* in *The New York Times.*

3. In *Trans-action,* October 1970.

4. Robert Wallis, *Time: Fourth Dimension of the Mind* (Harcourt, Brace, 1968).

5. I am indebted to Peter Alexander Meyers for this explanation.

6. *The Performing Arts,* Rockefeller Panel Report on the Future of Theater, Dance, Music in America: Problems and Prospects (McGraw-Hill, 1965). Frank Stanton was one of thirty panel members.

7. Quoted by Leon Edel in *The Arts and the Public,* James E. Miller, Jr., and Paul D. Herring, eds. (University of Chicago Press, 1967).

8. Leon Edel in *ibid.*

9. *The New York Times,* March 2, 1969.

10. Leon Edel in *The Arts and the Public,* already cited.

11. See, for instance, an account of this experience in Turner Catledge, *My Life and The Times* (Harper & Row, 1971).

12. Gay Talese, *The Kingdom and the Power* (World, 1969).

13. *Ibid.*

14. John F. Baker, "A Look Inside the *New York Review of Books,*" *Publishers Weekly,* March 11, 1974.

15. Paul Nathan, "Rights & Permissions" column, *Publishers Weekly,* July 1970.

16. John Simon, "New, Newer, Newest," *The New York Times,* September 21, 1969.

17. Max Kozloff in *The Arts and the Public,* already cited.

CHAPTER 14

Material from interview notes and transcripts: Brooks Atkinson, Lloyd Goodrich, Henry Heald, W. McNeil Lowry, Gordon Ray, Frank Thompson, Marcia Thompson.

1. Later on the Workshop was raided for Lincoln Center personnel and subsequently went out of existence.

2. Marcia Thompson.

3. Waldemar Nielsen, *The Big Foundations* (Twentieth Century Fund Study, Columbia University Press, 1972).

4. See the last chapter of this book for a description of Lowry's proposed new foundation.

5. Speech delivered at the First Annual Fine Arts Festival, Edwardsville, Illinois, April 16, 1967.

6. *The New York Times,* January 16, 1970.

7. Address to the Presidents' meeting of U.S. Symphony Orchestras, November 20–21, 1969.

8. William J. Baumol and William G. Bowen, *Performing Arts: The Economic Dilemma* (The Twentieth Century Fund, 1966).

9. "America's Stake in the Arts," *Saturday Review*, February 28, 1970.

10. Marilyn L. Shapiro, *Foundation Support for the Performing Arts*, background paper prepared for the Rockefeller Brothers Fund Panel on the performing arts, 1964.

11. *The New York Times*, March 17, 1970.

12. Baumol and Bowen, *op. cit.*

13. Irwin Shainman.

14. A. H. Maslow, quoted by Anne Roe in *The Psychology of Occupations* (Wiley, 1956).

15. Roe, *op. cit.*

16. Noah Greenberg, founder and director of Pro Musica until his premature death in the late 1960's.

CHAPTER 15

Material from interview notes and transcripts: Ralph Burgard, Lloyd Goodrich, W. McNeil Lowry, John MacFayden.

1. Alvin Toffler, *The Culture Consumers* (St. Martin's Press, 1964).

2. Russell Lynes, "The Artist as Uneconomic Man," *Saturday Review*, February 28, 1970.

3. These words from John MacFayden and those following were said at a formal luncheon where I sat next to him. They were written down immediately after the luncheon.

4. The problem with that point of view is shown clearly by the fact that his earlier statement (quoted in the same paragraph) made me think *he* didn't know what art was.

5. "The History of the National Council on the Arts and the National Endowment for the Arts during the Administration of President Lyndon B. Johnson," an in-house document issued November 1968, for which Ana Steele was primarily responsible.

6. Alexis de Tocqueville, *Democracy in America* (Knopf, 1945).

7. Saarinen, for example, remarked that compromise is alien to good architecture.

8. Toffler, *op. cit.*

9. *Ibid.*

10. *Ibid.*

11. *Ibid.*

12. Here is Hilton Kramer in *The New York Times* on February 15, 1970—an example of a good critic at his worst: "Dear Reader, I know what you must be thinking. Do we have to have still another Sunday sermon on the stupidities of the Whitney Museum? Believe me, Dear Reader, I sympathize with your impatience. It is, I agree, a boring subject. And it isn't as if one had any reason to believe that any-

thing would ever be changed! The Whitney never changes. Every decade or so, it moves to a new building. These moves seem to exhaust whatever fugitive traces of intelligence, taste, or imagination may, by accident or stealth, have crept into the enterprise. But there is never anything remotely suggesting a change in the intellectual weather. . . ."

13. I would add electromedia—TV—to his chemical and mechanical categories.

14. Martin Mayer, "Where Do the Dollars Go," *Saturday Review*, February 28, 1970.

15. Toffler, *op. cit.*

16. Lynes, *op. cit.*

CHAPTER 16

Material from interview notes and transcripts: McGeorge Bundy, Hedley Donovan, Henry Heald, Hubert H. Humphrey, William Jovanovich, W. McNeil Lowry, Charles Shattuck, Marcia Thompson.

1. In a transcript made for the Associated Councils of the Arts magazine, *Cultural Affairs.*

2. *The New York Times,* November 27, 1968.

3. Letter to the author.

4. College in Minnesota, where the former Vice-President was himself lecturing late in 1969.

5. Gay Talese, *The Kingdom and the Power* (World, 1969).

6. Humphrey was interviewed for this book by Kate (Mrs. Douglas) Rose.

7. William Goodman.

8. *Trans-action,* 1967.

9. Definition from *The Foundation Directory,* Ann D. Walton and Marianna O. Lewis, eds. (Russell Sage Foundation, 1964).

10. Dwight Macdonald, *The Ford Foundation* (Reynal, 1956).

11. *Ibid.*

12. The Ford Foundation Annual Report for 1966, issued under McGeorge Bundy, refers to Lowry as "a true professional."

13. Joseph Kraft, *Profiles in Power* (New American Library, 1966).

14. In 1962.

15. This author's life somewhat overlapped as well, since I put together, while at CBS, written material (including a piece by Robert Brustein) for a recording of Lowell's play *Benito Cereno.*

16. Miniver Cheevy, character in a poem by Edwin Arlington Robinson, was the frustrated dreamer, sighing "for what was not."

17. This quotation comes from a rather strange book: Nathaniel Weyl, *The Creative Elite in America* (Public Affairs Press, 1966).

18. Trustees of the Ford Foundation include Roy E. Larsen, chairman of the executive committee of Time Inc. He is also on the executive and auditing committees at Ford.

CHAPTER 17

Material from interview notes and transcripts: Richard Goodwin, John Hawke, Henry Heald, Hubert H. Humphrey, W. McNeil Lowry, Marianne Mantel, Claiborne Pell, Frank Thompson, Marcia Thompson, Steven Wexler.

1. Having returned to the Metropolitan Museum of Art as its director.

2. Quoted in an article by Robert Sherrill, "Who Runs Congress?" *The New York Times Magazine,* November 22, 1970.

3. Sherrill, *op. cit.*

4. *Dictionary of American Slang,* compiled by Harold Wentworth and Stuart Berg Flexner (Thomas Y. Crowell, 1960).

5. *Webster's New International Dictionary* (Unabridged), 2nd ed.

6. Bergen Evans and Cornelia Evans, *A Dictionary of Contemporary American Usage* (Random House, 1957).

7. The National Cultural Center opened in 1971 as the John F. Kennedy Center for the Performing Arts.

8. Willie Morris, *North Toward Home* (Houghton Mifflin, 1967).

See also *Biographical Directory of the American Congress, 1774–1971* (U. S. Government Printing Office, 1971).

CHAPTER 18

Material from interview notes and transcripts: Livingston Biddle, Lloyd Goodrich, Richard Goodwin, Henry Heald, Hubert H. Humphrey, Lincoln Kirstein, W. McNeil Lowry, Robert McCord, Claiborne Pell, Frank Thompson, Marcia Thompson.

Additional information from informal conversations with Kermit Gordon, James Keogh, Harry C. McPherson, Jr., Jack Valenti.

1. Harlan Phillips interview with Lloyd Goodrich for the Archives of American Art.

2. Figured from the compilation done by Evelyn K. Mayhugh for the Legislative Reference Service at the Library of Congress, American Law Division, June 7, 1966.

3. 1968 Annual Report of the National Foundation on the Arts and the Humanities.

4. *Ibid.*

5. *Ibid.*

6. Arthur M. Schlesinger, Jr., *A Thousand Days* (Houghton Mifflin, 1965).

7. The sum initially appropriated by Congress for the Arts Endowment.

8. Schlesinger, *op. cit.*

9. *Ibid.*

10. 1968 Annual Report of the National Foundation on the Arts and the Humanities.

11. *Ibid.*

12. Hugh Sidey, *A Very Personal Presidency* (Atheneum, 1968).

13. Schlesinger, *op. cit.*

14. Theodore Sorensen, in *Kennedy* (Harper & Row, 1965), describes Goodwin as having been "accused of meddling in diplomacy."

15. *Ibid.*

16. Schlesinger, *op. cit.*

17. William Manchester, *The Death of a President* (Harper & Row, 1967).

18. *Ibid.*

19. Said Richard Goodwin.

20. Sidey, *op. cit.*

21. Richard Neustadt, *Presidential Power* (Wiley, 1960).

22. Sidey, *op. cit.*

23. 1968 Annual Report of the National Foundation on the Arts and the Humanities.

24. "House rules now permit joint sponsorship of bills, although I must confess

it has become a great nuisance reading hundreds of 'Dear Colleague' letters each year imploring one to sponsor this or that bill," said Frank Thompson in 1972.

25. 1968 Annual Report of the National Foundation on the Arts and the Humanities.

26. From *Hearings Before the Special Subcommittee on Labor of the Committee on Education and Labor,* House of Representatives, Eighty-eighth Congress, Second Session, on H.R. 9587, "A bill to provide for the establishment of a national council on the arts and a national arts foundation to assist in the growth and development of the arts in the United States." Hearings held in Washington, D.C., April 3, 15, 16, and 17, 1964.

27. 1968 Annual Report of the National Foundation on the Arts and the Humanities.

28. *The Congressional Record,* January 6, 1965.

29. 1968 Annual Report of the National Foundation on the Arts and the Humanities.

30. *Ibid.*

31. An economic survey by the Ford Foundation was issued in 1974.

32. Lowry comments that there is no record of such a call "either to President Heald or Vice-President Lowry."

33. Blair was chief economist for the Senate Antitrust and Monopoly subcommittee before moving to the Library of Congress. Quoted in "Who Runs Congress?" by Robert Sherrill, *New York Times Magazine,* November 22, 1970.

34. Sherrill was connected with *The Texas Observer,* a member of the remarkable little group of editors and journalists that included Ronnie Dugger, Lawrence Goodwyn, and Willie Morris.

35. Sherrill, *op. cit.*

36. "Closing this fourth meeting on an encouraging note, Mr. Stevens announced that the Endowment had received its first unrestricted donation from a private organization: $100,000 ($20,000 annually over a five-year period) from the Martin Foundation of New York. . . . And four days after the first-year anniversary, the National Endowment for the Arts announced that the Bristol-Meyers Company had made an unrestricted donation of $300,000, freeing an equal amount from the special Treasury fund; this generous gift, combined with several smaller amounts, confirmed the Council's wisdom in deciding to announce priorities for these funds. . . ." These excerpts from the Annual Report suggest that the National Foundation had found itself able to get around difficulties caused by the wording of the legislation.

37. Public Law 89-209:
"Section 11(b) In addition to the sums authorized by subsection (a), there is authorized to be appropriated to each Endowment an amount equal to the total of amounts received by that Endowment under section 10(a)(2) of this Act, except that amounts appropriated to the National Endowment for the Arts under this subsection may not exceed $2,250,000 for any fiscal year, and amounts appropriated to the National Endowment for the Humanities under this subsection may not exceed $5,000,000 for any fiscal year. Amounts appropriated to an Endowment under this subsection shall remain available until expended.

"Section 10(a)(2) [. . . the Chairman of the National Endowment for the Arts and the Chairman of the National Endowment for the Humanities, in carrying out their respective functions, shall each have authority] to receive money and other property donated, bequeathed, or devised, without condition or restriction other than that it be used for the purposes of the Foundation or one of its Endowments, to the National Endowment for the Arts, or the National Endowment for the Humanities and to use, sell, or otherwise dispose of each property for the purpose of carrying out the functions transferred by section 6(a) of this Act . . ."

(Section 6(a) refers to the transfer of the functions of the National Council on the Arts to the National Endowment for the Arts.)

38. *Joint Hearings Before the Special Subcommittee on Labor . . . and the Special Subcommittee on Arts and Humanities . . .* , Eighty-ninth Congress, Bills to establish National Foundations on the Arts and Humanities, February 23 and March 3, 1965 (U. S. Government Printing Office, Washington, D.C., 1965).

39. Erwin Panofsky, *Meaning in the Visual Arts* (Doubleday Anchor, 1955).

40. See Public Law 89-209.

41. 1968 Annual Report of the National Foundation on the Arts and the Humanities.

42. *Ibid.*

43. *Joint Hearing . . .* , already cited.

44. 1968 Annual Report of the National Foundation on the Arts and the Humanities.

45. *Ibid.*

46. *Ibid.*

47. *Ibid.*

48. *Ibid.*

49. *Ibid.*

50. *Ibid.*

51. *Ibid.*

52. *Ibid.*

53. *Ibid.*

54. James Keogh, formerly of *Time* magazine, was speech writing for President Richard Nixon at the time he made this remark.

55. Per Jack Valenti.

56. Per Jack Valenti.

57. Sidey, *op. cit.*

58. Theodore White, *The Making of the President 1968* (Atheneum, 1969).

59. Told to me by Albert Meisel, deputy director of the Woodrow Wilson International Center for Scholars.

60. Alvin Toffler, *The Culture Consumers* (St. Martin's, 1964).

61. 1968 Annual Report of the National Foundation on the Arts and the Humanities.

62. *Ibid.*

63. *Ibid.*

64. *Ibid.*

65. It is interesting to note as one of many interconnections that when new council members were appointed by President Johnson in December 1966, they included Donald Weismann from the University of Texas at Austin, one of Ransom's University Professors.

66. The economic survey mentioned in note 31 was originally supposed to ensure that data would be available to all without special request.

67. 1968 Annual Report of the National Foundation on the Arts and the Humanities.

68. *Ibid.*

69. *Ibid.*

70. *Ibid.*

71. Rockefeller Brothers Fund report on the performing arts.

72. Quoted by David Dempsey in "Uncle Sam, the Angel," *The New York Times Magazine*, March 24, 1974.

73. *Ibid.*

74. Kenneth Sherrill review of *Bach, Beethoven, and Bureaucracy: The Case of the Philadelphia Orchestra* by Edward Arian, in *The American Political Science Review*, September 1973.

CHAPTER 19

Material from interview notes and transcripts: Hedley Donovan, William Jovanovich, W. McNeil Lowry, Frank Stanton, Marcia Thompson, Edward Wallerstein.

1. Editorial, *Science,* April 1967.
2. Editorial, "Copyright Revision: The Great Giveaway?" *Publishers Weekly,* May 8, 1967.
3. For example, according to Philip Wittenberg, *The Protection of Literary Property* (The Writer, 1968), Noah Webster was largely responsible for state copyright laws enacted in America between 1783 and 1786, because he worried about the protection of his speller.
4. Marshall McLuhan in *The Writer as Independent Spirit*, Proceedings of the XXIV International P.E.N. Congress, New York, 1968.
5. *Ibid.*
6. I believe this is a relatively common psychiatric idea.
7. See Malcolm Cowley, "Storytelling's Tarnished Image," *Saturday Review,* September 25, 1971, regarding temporal plots vs. spatial structures. See also Marshall McLuhan, *Understanding Media* (McGraw-Hill, 1964).
8. Warhol reported by *The New York Times,* December 1968.
9. William Jovanovich, "Information as a Property," *California Monthly,* April–May 1967.
10. *Ibid.*
11. Robert T. Elson, *Time Inc.: The Intimate History of a Publishing Enterprise, 1923–1941* (Atheneum, 1968).
12. *Ibid.*
13. John Kobler, *Luce: His Time, Life and Fortune* (Doubleday, 1968).
14. *Ibid.*
15. W. A. Swanberg, *Luce and His Empire* (Scribner's, 1972).
16. Jovanovich, *op. cit.*
17. Verner W. Clapp, *Copyright—A Librarian's View*, prepared for the National Advisory Commission on Libraries, Washington, Copyright Committee, Association of Research Libraries, 1968.
18. For further elaboration of these events, see Charles A. Madison, *Book Publishing in America* (McGraw-Hill, 1966).
19. *Ibid.*
20. Miodrag Muntyan, "What Lies Ahead?" *Saturday Review,* June 10, 1967.
21. Authors Guild Bulletin, September 1971.
22. Muntyan, *op. cit.*
23. In a letter to the author dated October 3, 1972.
24. Oliver Read and Walter L. Welch, *From Tin Foil to Stereo* (Howard W. Sams, 1959).
25. *General Information on Copyright,* The Library of Congress Press, Circular 1, April 1968.
26. Although, surprisingly, according to M. B. Schnapper, *Constraint by Copyright* (Public Affairs Press, 1960), many government employees seem to have been extremely efficient at obtaining copyright—i.e., property rights—in their own names for work supported by public funds which were given as salaries, not grants.
27. The Harcourt request was made to employees in the second half of the sixties after a woman editor (not the one mentioned elsewhere in this book) left the firm taking with her the idea for a textbook series in which Harcourt was investing heavily.
28. Adolf A. Berle and Gardiner C. Means, *The Modern Corporation and Private Property* (rev. ed.; Harcourt, Brace, 1968).
29. The editor of *Commentary* magazine, Norman Podhoretz, suggests it might

be a good thing if technology proves to have relieved literature of the burden of conveying information. I disagree, partly because I don't think of it as a burden but as one of the many interesting aspects of art. Daniel Bell says that a writer knows truth by experience; a scientist by trying to transcend experience and find "common norms." Neither do I agree entirely with that statement but point out that it says both writers and scientists rely on information. (These comments occurred during a P.E.N. meeting, the proceedings of which have already been cited.) I'm cheating a bit in my argument because Podhoretz probably had in mind the crudest possible aspects of conveying information—perhaps of the "how to do it" sort. But the term "information" ought not to be used in such a limited way in such a sweeping statement.

30. Jovanovich, *op. cit.*

31. Meyer Berger, *The Story of the New York Times: 1851–1951* (Simon & Schuster, 1951).

32. The following cannot be property, according to the *Regulations of the Copyright Office* (Library of Congress), U. S. Government Printing Office: 1968, 0-315-890. Or, at least, they cannot be copyrighted: (1) "words and short phrases" or "mere listing" of content; (2) "ideas, plans, methods, systems, or devices, as distinguished from the particular manner in which they are expressed or described in a writing"; (3) "works designed for recording information which do not in themselves convey information . . ."; (4) works consisting entirely of information that is common property containing no original authorship; etc.

33. Phrase used by Wittenberg, *op. cit.* Of course there is no single moment of creation.

34. This is a situation that has been almost completely reversed. Our present law provides: "Only the author or those deriving their right through him can rightfully claim copyright. Mere ownership of a manuscript, painting, or other copy does not necessarily give the owner the right to copyright." *General Information on Copyright,* The Library of Congress Press, Circular 1, April 1968.

35. Report No. 2222, House of Representatives, Sixtieth Congress, Second Session, 1909. From Schnapper, *op. cit.*

36. Laws of the First Congress, Second Session, Chapter 15, from Wittenberg, *op. cit.*

37. Jovanovich, *op. cit.*

38. Susan Wagner, "Ringer: What Copyright Means," *Publishers Weekly*, February 25, 1974.

39. Zechariah Chafee, Jr., "Reflections on the Law of Copyright," *Columbia Law Review*, 1945.

40. Berle and Means, *op. cit.*

41. Hilton Kramer, "Hamburger Heaven," *The New York Review of Books*, December 4, 1969.

42. The law requires registration with the Copyright Office at the time of publication, otherwise the property rights are lost forever. This, of course, requires a definition for "publication."

43. George A. Gipe, *Nearer to the Dust* (Williams & Wilkins, 1967).

44. Clapp, *op. cit.*

45. *Ibid.*

46. *Publishers Weekly*, August 11, 1969.

47. Read and Welch, *op. cit.*

48. Gipe, *op. cit.*

49. *Publishers Weekly*, May 29, 1967.

50. *Publishers Weekly*, May 8, 1967.

51. Paul Zurkowski, who became the executive director of the IIA (Information Industry Association), reporting in *Publishers Weekly*, August 11, 1969.

52. Jovanovich, *op. cit.*

53. Herbert Brucker, *Freedom of Information* (Macmillan, 1949), cited in James

MacGregor Burns and Jack Walter Peltason, *Government by the People* (7th ed.; Prentice-Hall, 1969).

54. Undated telegram asking support of House Bill 2512 "as reported by the House Judiciary Committee without repeat without crippling amendments."

55. Clapp, *op. cit.*

56. *Ibid.*

57. For a section-by-section comparison of the 1909 copyright legislation with the proposed law, see "Omnibus Copyright Revision: Comparative Analysis of the Issues," American Society for Information Science, Washington, D.C. 1973.

58. Susan Wagner, "Proposed New Copyright Bill," *Publishers Weekly*, November 12, 1973.

59. Clapp, *op. cit.*

60. *Ibid.*

61. *The New York Times*, April 12, 1974. For a general article, see "Librarians and Copyright Legislation: The Historical Background," by Chin Kim, *American Libraries*, June 1971.

62. Verner W. Clapp, "The Suit of Williams & Wilkins Co. v. The United States: Recent Developments," *Newsletter of the American Council of Learned Societies*, Vol. XXIII, No. 2 (Spring 1972).

63. Jovanovich, *op. cit.*

64. Quoted in Frances FitzGerald, "The Blue Chip in the Sky," New York *Herald Tribune*, October 17, 1965. See also John Diebold, *Man and the Computer* (Praeger, 1969).

65. *The New York Times*, editorial, April 13, 1967.

66. Dan Lacy, quoted in "Librarians and Copyright Legislation: The Historical Background" by Chin Kim, *American Libraries*, June 1971.

> For the impact of communications on copyright-revision legislation, see "Omnibus Copyright Revision: Comparative Analysis of the Issues," perpared by the Cambridge Research Institute for the American Society for Information Science, 1973.

CHAPTER 20

Material from interview notes and transcripts: Turner Catledge, Hedley Donovan, William Jovanovich, Arthur Krock.

1. "Times Talk," April 1969.

2. Frances FitzGerald, "The Blue Chip in the Sky," New York *Herald Tribune*, October 17, 1965. See also John Diebold, *Man and the Computer* (Praeger, 1969).

3. *Publishers Weekly* is a good source for many of these.

4. Diebold, *op. cit.*

5. Preface to the 1965 Annual Report, Carnegie Corporation of New York.

6. *New York Times* "Winners & Sinners" Bulletin #344, May 9, 1974.

7. Eric Sevareid on the CBS Evening News, reprinted in *The New York Times*, November 24, 1970.

8. Ford Foundation grants helped to clarify issues involved, including a grant to the Aspen Institute for Humanistic Studies.

9. See Daniel Schorr, "Shadowing the Press," *The New Leader,* February 21, 1972. Adapted from Schorr's testimony before the Senate Subcommittee on Constitutional Rights.

10. *The New York Times*, March 12, 1973.

11. *Ibid.*

12. See Edith Efron, *The News Twisters* (Nash, 1971) and *How CBS Tried to Kill a Book* (Nash, 1972).

13. Wilfrid Sheed, "The Good Word: More Light on Luce," *The New York Times Book Review*, November 5. 1972.

14. Malcolm Cowley, "Storytelling's Tarnished Image," *Saturday Review*, September 25, 1971.

15. *Time*, May 27, 1974.

16. Quoted by Cowley, *op. cit.*

17. William Jovanovich, "Information as a Property," *California Monthly*, April–May 1967.

18. See Harry S. Ashmore, "The Story Behind Little Rock," in *Reporting the News*, Louis M. Lyons, ed. (Belknap Press, 1965).

19. Erik Barnouw, *The Golden Web* (Oxford University Press, 1968).

20. See Jack Gould's column in *The New York Times*, March 10, 1970.

21. Alfred Friendly, "Attribution of News," in Lyons, ed., *op. cit.*

22. Gay Talese, *The Kingdom and the Power* (World, 1969).

23. Friendly, *op. cit.*

24. Louis M. Lyons, "Introduction," in Lyons, ed., *op. cit.*

25. R. G. L. Waite in a letter to the author.

26. The Nieman Fellowships were founded in 1938 for the purpose of bringing newspapermen on leave for a year from their papers to Harvard University.

27. James S. Pope, "The Full Dimensions of the News," in Lyons, ed., *op. cit.*

28. Robert Lasseter, "No Other Allegiance," in Lyons, ed., *op. cit.*

29. A. J. Liebling, *The Press* (Ballantine, 1961).

30. Clifton Daniel, "Responsibility of the Reporter and Editor," in Lyons, ed., *op. cit.*

31. *Ibid.* See also Hutchins Commission Report on Freedom of the Press, 1947.

32. *Newsweek*, May 20, 1974.

33. Lasseter, *op. cit.*

34. James MacGregor Burns, *Uncommon Sense* (Harper & Row, 1972).

35. William M. Pinkerton, "The Newspaperman," in Lyons, ed., *op. cit.*

36. *Ibid.*

37. Meyer Berger, *The Story of the New York Times: 1851–1951* (Simon & Schuster, 1951).

38. *Ibid.*

39. *Ibid.* (Most of the information on the history of *The New York Times* comes from Berger; some of it comes from Gay Talese's later book, *The Kingdom and the Power*, already cited.)

40. *Ibid.*

41. *Ibid.*

42. *Ibid.*

43. *Ibid.*

44. Turner Catledge, *My Life and The Times* (Harper & Row, 1971).

45. *Ibid.*

CHAPTER 21

Material from interview notes and transcripts: Turner Catledge, Hedley Donovan, Arthur Krock, W. McNeil Lowry, James Reston, Marcia Thompson.

1. Gay Talese, *The Kingdom and the Power* (World, 1969).

2. James McCartney, "Vested Interests of the Reporter," in *Reporting the News*, Louis M. Lyons, ed. (Belknap Press, 1965).

3. *Ibid.*

4. Turner Catledge, *My Life and The Times* (Harper & Row, 1971).

5. McCartney, *op. cit.*

6. Catledge, *op. cit.*

7. *Ibid.*

8. *Ibid.*

9. Talese, *op. cit.*

10. Meyer Berger, *The Story of the New York Times: 1851–1951* (Simon & Schuster, 1951).

11. Talese, *op. cit.*

12. *Ibid.*

13. *Ibid.*

14. *Ibid.*

15. Lyons, ed., *op. cit.*

16. Talese, *op. cit.*

17. *Ibid.*

18. *Ibid.*

19. *Ibid.*

20. *Ibid.*

21. *Ibid.*

22. *Ibid.*

23. *Ibid.*

24. *Ibid.*

25. *Ibid.*

26. Catledge, *op. cit.*

27. Hedrick Smith and others.

28. Talese, *op. cit.*

29. *Ibid.*

30. Catledge remarks of himself in his autobiography already cited.

31. Talese, *op. cit.*

32. Hedley Donovan, "But What Does an Editor *DO?*" *The American Oxonian,* July 1957.

33. Talese, *op. cit.*

34. The "Winners and Sinners Bulletin" is a sheet gotten out irregularly at the *Times* by Theodore Bernstein in which he points out errors that have been printed in the paper and gives due praise to staff. Those outsiders on the mailing list were at one point held to have a certain cachet.

35. Catledge, *op. cit.*

36. *Ibid.*

37. Talese, *op. cit.*

38. *Ibid.*

39. *Ibid.*, including three previous quotes.

40. *Ibid.*

41. *Ibid.*

42. *Ibid.*

43. *Ibid.*

44. Margaret Truman.

45. Talese, *op. cit.*

46. From *How True* by Thomas Griffith (Atlantic–Little, Brown, 1974).

47. Catledge, *op. cit.*

CHAPTER 22

Material from interview notes and transcripts: McGeorge Bundy, Turner Catledge, Hedley Donovan, Lloyd Goodrich, Richard Goodwin, John Hawkes, Edward Hodge,

William Jovanovich, Goddard Lieberson, W. McNeil Lowry, Harry Ransom, Theodore Roszak, Frank Stanton, Frank Thompson.

1. Harold Rosenberg, "The Orgamerican Phantasy," in Alfred Kazin, ed., *The Open Form* (Harcourt, Brace, 1961).
2. Lawrence S. Kubie, "Blocks to Creativity," in Ross L. Mooney and Taher A. Razik, eds., *Explorations in Creativity* (Harper & Row, 1967).
3. Eugene Lyons, *David Sarnoff* (Harper & Row, 1966).
4. Anne Roe, *The Psychology of Occupations* (Wiley, 1956).
5. Suzanne K. Langer, *Mind: An Essay on Human Feeling* (Johns Hopkins, 1967). Her idea is derived from biologist George Gaylord Simpson.
6. Jacob W. Getzels and Philip W. Jackson, "Family Environment and Cognitive Style," in Mooney and Razik, eds., *op. cit.*
7. Taher A. Razik, "Psychometric Measurement of Creativity," in Mooney and Razik, eds., *op. cit.*
8. Murray Kempton reviewing *The Kingdom and the Power* by Gay Talese in *Life*, June 27, 1969.
9. Gay Talese, *The Kingdom and the Power* (World, 1969).
10. Theodore M. White, "Action Intellectuals," *Life*, June 9, June 16, and June 23, 1967.
11. C. P. Snow, *Last Things* (Scribner's, 1970).
12. *The Collected Poems of William Butler Yeats* (Macmillan, 1959).
13. See Norman Mailer's career for a good example of this.
14. Erving Goffman, *Relations in Public* (Basic Books, 1971).
15. This is called Treitschke's "mordant phrase" in *Power and Society* by Harold D. Lasswell and Abraham Kaplan (Yale University Press, 1950).
16. W. McNeil Lowry, "The University and the Creative Arts," *Educational Theatre Journal*, Vol. XIV, No. 2 (May 1962).
17. James MacGregor Burns, *Uncommon Sense* (Harper & Row, 1972).
18. Herbert Gutman, "The Biological Roots of Creativity," in Mooney and Razik, eds., *op. cit.*
19. *Ibid.*
20. By founding Common Cause, a public-interest organization.
21. Gutman, *op. cit.*
22. James Q. Wilson, "The Dead Hand of Regulation," *The Public Interest*, Fall 1971.
23. Donald Schon, *Technology and Change* (Delacorte, 1967).
24. Morris Ernst compiled autobiographical essays on the role of particular teachers in individuals' lives. See *The Teacher* (Prentice-Hall, 1967).
25. Gutman, *op. cit.*
26. Ralph Ross and Ernest van den Haag, *The Fabric of Society* (Harcourt, Brace, 1957).
27. From the preface of Amédée Ozenfant, *Foundations of Modern Art* (Dover, 1952).
28. Alvin Toffler, *The Culture Consumers* (St. Martin's, 1964).
29. Sebastian de Grazia, *Of Time, Work, and Leisure* (The Twentieth Century Fund, 1962).
30. Stephen D. Isaacs, Washington *Post*, December 5, 1973.
31. Norman Birnbaum, *The Crisis of Industrial Society* (Oxford University Press, 1969).
32. Fred Hechinger is education editor for *The New York Times*.
33. André Malraux, *The Voices of Silence* (Doubleday, 1953).
34. T. W. Adorno, Else Frenkel-Brunswik, Daniel J. Levinson, and R. Nevitt Sanford, *The Authoritarian Personality* (Part Two) (Science Editions, 1964).
35. *Ibid.*

36. Willie Morris, *North Toward Home* (Houghton Mifflin, 1967), reviewed in *The New York Review of Books*.

37. Adorno, *op. cit.*

38. *Ibid.*

39. *Ibid.*

40. Igor Stravinsky on Tolstoy, interviewed for *Harper's Magazine*, February 1968.

41. Loren Eiseley, *The Unexpected Universe* (Harcourt, Brace, 1969).

42. As Elizabeth Simpson points out.

43. Malraux, *op. cit.*

44. Arnold Weinstein's works include *The Red Eye of Love* (Grove, 1962).

BIBLIOGRAPHY

Adorno, T. W., Else Frenkel-Brunswik, Daniel J. Levinson, and R. Nevitt Sanford, *The Authoritarian Personality* (Part Two) (Science Editions, 1964).

Agee, Warren K., *Mass Media in a Free Society* (University Press of Kansas, 1969).

Arnheim, Rudolf, *Art and Visual Perception: A Psychology of the Creative Eye* (University of California Press, 1954).

Auden, W. H., and Holmes Pearson, eds., *Elizabethan and Jacobean Poets*, Vol. II of *Poets of the English Language* (Viking, 1950).

Ayer, Alfred Jules, *Language, Truth and Logic* (Dover, 1952).

Bailyn Bernard, ed., *Perspectives in American History*, Vol. II (Harvard University Press, 1968).

Barnouw, Erik, *A Tower in Babel* (Oxford University Press, 1966).

——, *The Golden Web* (Oxford University Press, 1968).

——, *The Image Empire* (Oxford University Press, 1970).

Barron, Frank, *Creativity and Psychological Health* (D. Van Nostrand, 1963).

Baumol, William J., and William G. Bowen, *Performing Arts: The Economic Dilemma* (The Twentieth Century Fund, 1966).

Bazelon, David, *Nothing But a Fine Tooth Comb* (Simon & Schuster, 1970).

——, *Power in America* (New American Library, 1967).

Becker, Howard S., ed., *Social Problems* (Wiley, 1966).

Berger, Meyer, *The Story of the New York Times* (Simon & Schuster, 1951).

Berle, Adolf A., *Power* (Harcourt, Brace, 1969).

——, and Gardiner C. Means, *The Modern Corporation and Private Property* (rev. ed.; Harcourt, Brace, 1968).

Berlin, Isaiah, *The Hedgehog and the Fox* (Simon & Schuster, 1953).

Birnbaum, Norman, *The Crisis of Industrial Society* (Oxford University Press, 1969).

Brown, Les, *Television* (Harcourt, Brace, 1971).

Bruner, J. S., J. J. Goodnow, and C. A. Austin, *A Study of Thinking* (Wiley, 1956).

Burns, James MacGregor, *Uncommon Sense* (Harper & Row, 1972).

——, and Jack Walter Peltason, *Government by the People* (Prentice-Hall, 1966).

Carr, Edward Hallett, *What Is History?* (Knopf, 1961).

Cass, James, and Max Birnbaum, *Comparative Guide to American Colleges*, 1968–69 edition (Harper & Row, 1968).

Catledge, Turner, *My Life and The Times* (Harper & Row, 1971).

Clapp, Verner W., *Copyright—A Librarian's View*, prepared for the National Advisory Commission on Libraries, Washington, Copyright Committee, Association of Research Libraries, 1968.

Cleaver, Eldridge, *Soul on Ice* (McGraw-Hill, 1967).

Coser, Lewis A., *Men of Ideas* (Free Press, 1965).

Diebold, John, *Man and the Computer* (Praeger, 1969).

Dobriner, William M., *Social Structures and Systems* (Goodyear, 1969).

Dugger, Ronnie, *Our Invaded Universities: Form, Reform, and New Starts* (Norton, 1974).

Efron, Edith, *The News Twisters* (Nash, 1971).

——, *How CBS Tried to Kill a Book* (Nash, 1972).

Eiseley, Loren, *The Unexpected Universe* (Harcourt, Brace, 1969).

Eliot, T. S., *Notes Towards the Definition of Culture* (Faber and Faber, 1948).

Elson, Robert T., *Time Inc.: The Intimate History of a Publishing Enterprise, 1923–1941* (Atheneum, 1968).

——, *Time Inc.: The Intimate History of a Publishing Enterprise, 1941–1960* (Vol. II) (Atheneum, 1973).

Erikson, Erik, *Young Man Luther* (Norton, 1958).

Evans, Bergen, and Cornelia Evans, *A Dictionary of Contemporary American Usage* (Random House, 1957).

Feshbach, Seymour, and Robert D. Singer, *Television and Aggression* (Jossey-Bass, 1971).

Feuer, Lewis, *The Conflict of Generations* (Basic Books, 1969).

Friedman, Lawrence J., *Psychoanalysis: Uses and Abuses* (Eriksson, 1968).

Friedman, Myra, *Buried Alive: The Biography of Janis Joplin* (William Morrow, 1973).

Friendly, Fred, *Due to Circumstances Beyond Our Control* (Random House, 1967).

Frost, Robert, *Complete Poems* (Holt, Rinehart, 1949).

Galbraith, John Kenneth, *The New Industrial State* (Houghton Mifflin, 1967).

——, *The Affluent Society* (Houghton Mifflin, 1969).

Galsworthy, John, *The Forsyte Saga* (Scribner's, 1934).

Gipe, George A., *Nearer to the Dust* (Williams & Wilkins, 1967).

Goffman, Erving, *Relations in Public* (Basic Books, 1971).

Gouldner, Alvin W., *Studies in Leadership* (Harper, 1950).

Grazia, Sebastian de, *Of Time, Work, and Leisure* (The Twentieth Century Fund, 1962).

Griffith, Thomas, *The Waist-High Culture* (Grosset & Dunlap, 1959).

——, *How True* (Atlantic–Little, Brown, 1974).

Gunther, John, *Inside U.S.A.* (Harper, 1947).

Hall, Stuart, and Paddy Whannel, *The Popular Arts* (Beacon, 1967).

The History of the National Council on the Arts and the National Endowment for the Arts during the Administration of President Lyndon B. Johnson (in-house ducument issued November 1968).

Hofstadter, Richard, and Wilson Smith, *American Higher Education*, Vol. II (University of Chicago Press, 1961).

Homans, George Caspar, *Social Behavior: Its Elementary Forms* (Harcourt, Brace, 1961).

Hopkins, Gerard Manley, *Complete Poems* (Oxford University Press, 1967).

Ingersoll, Ralph M., *Point of Departure* (Harcourt, Brace, 1961).

Jacobs, Norman, ed., *Culture for the Millions?* (Beacon, 1964).

Jarrell, Randall, *A Sad Heart at the Supermarket* (Atheneum, 1962).

Jencks, Christopher, *Inequality: A Reassessment of the Effect of Family and Schooling in America* (Basic Books, 1972).

——, and David Riesman, *The Academic Revolution* (Doubleday, 1968).

Johnson, Nicholas, *How to Talk Back to Your TV Set* (Little, Brown, 1970).

Jovanovich, William, *Now, Barabbas* (Harper & Row, 1964).

Kahn, Robert L., and Elise Boulding, eds., *Power and Conflict in Organizations* (Basic Books, 1964).

Katz, Elihu, and Paul F. Lazarsfeld, *Personal Influence* (Free Press, 1955).

Kazin, Alfred, ed., *The Open Form* (Harcourt, Brace, 1961).

Kendrick, Alexander, *Prime Time* (Little, Brown, 1969).

Keniston, Kenneth, *Young Radicals: Notes on Committed Youth* (Harcourt, Brace, 1968).

Klapper, Joseph T., *The Effects of Mass Communication* (Free Press, 1960).

Kobler, John, *Luce: His Time, Life and Fortune* (Doubleday, 1968).

Köhler, Wolfgang, *The Place of Values in a World of Facts* (Mentor, 1966).

Kraft, Joseph, *Profiles in Power* (New American Library, 1966).

Kris, E., *Psychoanalytic Explorations in Art* (International Universities Press, 1952).

Langer, Susanne K., *Mind: An Essay on Human Feeling* (Johns Hopkins, 1967).

———, ed., *Reflections on Art* (Johns Hopkins, 1958).

Larkin, Oliver W., *Art and Life in America* (Holt, Rinehart, 1960).

Lasswell, Harold D. and Abraham Kaplan, *Power and Society* (Yale University Press, 1950).

Lehman, Harvey C., *Age and Achievement* (The American Philosophical Society, Princeton University, 1953).

Liebert, Robert M., John M. Neale, and Emily S. Davidson, *The Early Window: Effects of Television on Children and Youth* (Pergamon, 1974).

Liebling, A. J., *The Press* (Ballantine, 1961).

Lifton, Robert Jay, *History and Human Survival* (Random House, 1970).

Lyons, Eugene, *David Sarnoff* (Harper & Row, 1966).

Lyons, Louis M., ed., *Reporting the News* (Belknap Press, 1965).

Macdonald, Dwight, *The Ford Foundation* (Reynal, 1956).

Madison, Charles, *Book Publishing in America* (McGraw-Hill, 1966).

Malraux, André, *The Voices of Silence* (Doubleday, 1953).

Manchester, William, *The Death of a President* (Harper & Row, 1967).

Matthews, T. S., *Name and Address* (Simon & Schuster, 1960).

McLuhan, Marshall, *Understanding Media* (McGraw-Hill, 1964).

———, and Harley Parker, *Through the Vanishing Point* (Harper & Row, 1968).

Meyer, Leonard B., *Music, the Arts, and Ideas* (University of Chicago Press, 1967).

Miller, George A., *The Psychology of Communication* (Basic Books, 1967).

Miller, James E., Jr., and Paul D. Herring, eds., *The Arts and the Public* (University of Chicago Press, 1967).

Mills, C. Wright, *The Power Elite* (Oxford University Press, 1956).

Minow, Newton, *et al.*, *Presidential Television* (The Twentieth Century Fund, Basic Books, 1973).

Mooney, Ross L., and Taher A. Razik, eds., *Explorations in Creativity* (Harper & Row, 1967).

Morison, Robert S., ed., *The Contemporary University: U.S.A.* (Houghton Mifflin, 1966).

Morris, Willie, *North Toward Home* (Houghton Mifflin, 1966).

National Foundation on the Arts and the Humanities, 1968 Annual Report.

Neustadt, Richard, *Presidential Power* (Wiley, 1960).

Nielsen, Waldemar, *The Big Foundations* (The Twentieth Century Fund, Columbia University Press, 1972).

Nisbet, Robert A., *The Degradation of Academic Dogma: The University in America, 1945–1970* (Basic Books, 1971).

Noll, Roger C., Merton J. Peck, and John J. McGowan, *Economic Aspects of Television Regulation* (The Brookings Institution, 1973).

Ozenfant, Amédée, *Foundations of Modern Art* (Dover, 1952).

Panofsky, Erwin, *Meaning in the Visual Arts* (Doubleday Anchor, 1955).

Parsons, Talcott, and Gerald M. Platt, *The American University* (Harvard University Press, 1973).

The Performing Arts, Rockefeller Panel Report (McGraw-Hill, 1965).

Podhoretz, Norman, *Making It* (Random House, 1967).

Rapaport, David, *Emotions and Memory* (Science Editions, 1961).

Read, Oliver, and Walter L. Welch, *From Tin Foil to Stereo* (Howard W. Sams, 1959).

Reid, James, *An Adventure in Textbooks* (R. R. Bowker, 1969).

Reston, James, *The Artillery of the Press* (Harper & Row, 1967).

Ridgeway, James, *The Closed Corporation* (Random House, 1968).

Riesman, David, in collaboration with Reuel Denney and Nathan Glazer, *The Lonely Crowd* (Yale University Press, 1950).

Roe, Anne, *The Psychology of Occupations* (Wiley, 1956).
Rosenberg, Bernard, and David Manning White, eds., *Mass Culture* (Free Press, 1957).
Rosenberg, Harold, *The Tradition of the New* (Horizon, 1959).
Rosner, Stanley, and Lawrence E. Abt, eds., *The Creative Experience* (Grossman, 1970).
Ross, Ralph, and Ernest van den Haag, *The Fabric of Society* (Harcourt, Brace, 1957).
Rudolph, Frederick, *The American College and University* (Knopf, 1962).
Eero Saarinen on His Work (Yale University Press, 1962).
Sale, Kirkpatrick, *SDS* (Random House, 1973).
Schlesinger, Arthur M., Jr., *A Thousand Days* (Houghton Mifflin, 1965).
———, *The Coming of the New Deal*, Vol. II of *The Age of Roosevelt* (Houghton Mifflin, 1957–60).
———, *The Crisis of Confidence* (Houghton Mifflin, 1969).
Schnapper, M. B., *Constraint by Copyright* (Public Affairs Press, 1960).
Schon, Donald, *Technology and Change* (Delacorte, 1967).
Schramm, Wilbur, ed., *Mass Communications* (University of Illinois Press, 1960).
Seligman, Ben B., *Molders of Modern Thought* (Quadrangle, 1970).
Shapiro, Harry L., ed., *Man, Culture, and Society* (Oxford University Press, 1956).
Sherif, Muzafer, and Hadley Cantril, *The Psychology of Ego Involvements* (Wiley, 1947).
Sidey, Hugh, *A Very Personal Presidency* (Atheneum, 1968).
Snow, C. P., *Last Things* (Scribner's, 1970).
Sorensen, Theodore, *Kennedy* (Harper & Row, 1965).
Strickland, Stephen, ed., *Sponsored Research in American Universities and Colleges* (American Council on Education, 1968).
Swanberg, W. A., *Luce and His Empire* (Scribner's, 1972).
Szasz, Thomas S., *The Myth of Mental Illness* (Harper & Row, 1968).
Talese, Gay, *The Kingdom and the Power* (World, 1969).
Television and Growing Up: The Impact of Televised Violence, The Surgeon General's Scientific Advisory Committee on Television and Social Behavior, 1972.
Thompson, Lawrence, *Robert Frost: The Early Years, 1874–1915* (Holt, Rinehart, 1966).
———, *Robert Frost: The Years of Triumph, 1915–1938* (Holt, Rinehart, 1970).
Thomson, Virgil, *Virgil Thomson* (Knopf, 1966).
Tocqueville, Alexis de, *Democracy in America* (Knopf, 1945).
Toffler, Alvin, *The Culture Consumers* (St. Martin's Press, 1964).
Veysey, Laurence R., *The Emergency of the American University* (University of Chicago Press, 1970).
Violence in America: The Complete Official Report to the National Commission on the Causes and Prevention of Violence (New American Library, June 1969).
Wallis, Robert, *Time: Fourth Dimension of the Mind* (Harcourt, Brace, 1968).
Walton, Ann D., and Marianna O. Lewis, eds., *The Foundation Directory* (Russell Sage, 1964).
Wentworth, Harold, and Stuart Berg Flexner, *Dictionary of American Slang* (Thomas Y. Crowell, 1960).
Weyl, Nathaniel, *The Creative Elite in America* (Public Affairs Press, 1966).
White, Norval, and Elliot Willensky, eds., *AIA Guide to New York* (Macmillan, 1968).
White, Theodore M., *The Making of the President 1968* (Atheneum, 1969).
Whiteley, John M., and Arthur Resnikoff, eds., *Perspectives on Vocational Development* (The American Personnel and Guidance Association, 1972).
Who's Who in America, Vol. 35, 1968–69 (Marquis).
Wilensky, Harold L., *Organizational Intelligence* (Basic Books, 1967).
Williams, Oscar, ed., *A Little Treasury of Modern Poetry* (Scribner's, 1946).
Wittenberg, Philip, *The Protection of Literary Property* (The Writer, 1968).

The Writer as Independent Spirit, Proceedings of the XXIV International P.E.N. Congress, New York, 1968.

Yeats, William Butler, *Collected Poems* (Macmillan, 1959).

Ziegler, Edward, *The Vested Interests* (Macmillan, 1964).

ACKNOWLEDGMENTS

Many of the chapter and section headings are taken from T. S. Eliot's "Gerontion."

Illustrations, including columns and material other than photographs and drawings, are used by permission.

Quotations in Chapter 5, credited in footnotes, abridged from pp. 276–8, 293–8, and 304 in *David Sarnoff: A Biography,* by Eugene Lyons. Copyright © 1966 by Eugene Lyons. Reprinted by permission of Harper & Row, Publishers, Inc.

Material from Erik Barnouw's *The Golden Web* reprinted by permission of Oxford University Press.

Permission for use of excerpts from his article "New, Newer, Newest" (*The New York Times,* September 21, 1969) was granted by John Simon.

"Design" is from *The Poetry of Robert Frost,* edited by Edward Connery Lathem. Copyright 1936 by Robert Frost. Copyright © 1964 by Lesley Frost Ballantine. Copyright © 1969 by Holt, Rinehart and Winston, Inc. Reprinted by permission of Holt, Rinehart and Winston, Publishers.

"Leda and the Swan" reprinted by permission of Macmillan Publishing Co., Inc., from *The Collected Poems of W. B. Yeats.* Copyright 1928 by Macmillan Publishing Co., Inc., renewed 1956 by Georgie Yeats.

Material from *Art and Life in America* by Oliver Larkin reprinted by permission of Holt, Rinehart and Winston, Inc.

This book could not have been done without the invaluable help of secretaries, public relations people, and some researchers, including Zona Sparks and Catherine Burns. I was grateful to have use of the Williams College library.

INDEX